THE ARTS
OF MANKIND

EDITED BY ANDRÉ MALRAUX
AND ANDRÉ PARROT

ROME: THE LATE EMPIRE

Roman Art AD 200-400

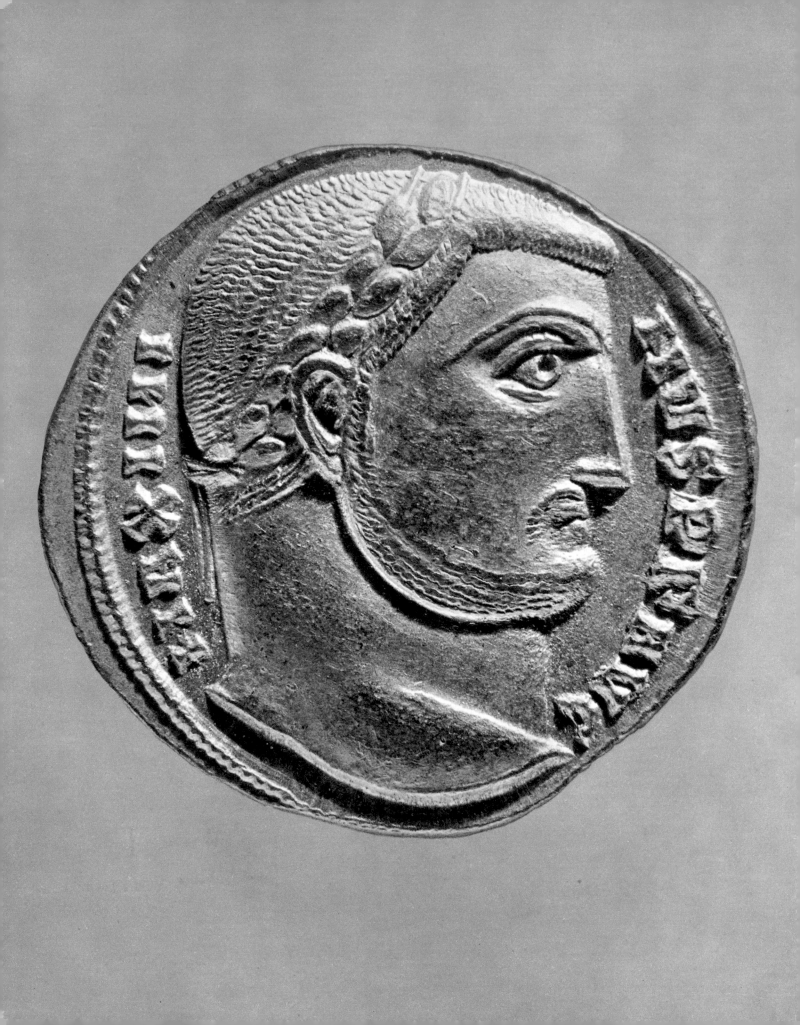

RANUCCIO BIANCHI BANDINELLI

ROME
THE LATE EMPIRE
ROMAN ART AD 200-400

TRANSLATED BY PETER GREEN

THAMES AND HUDSON

It may with likelyhood be spoken, that there is a kind of *Abecedarie*
ignorance, preceding science: another doctorall, following science:
an ignorance, which science doth beget: even as it spoileth the first.
MONTAIGNE, *Essays* (trans. Florio), I. 54

Translated from the French
ROME. LA FIN DE L'ART ANTIQUE

Published in Great Britain in 1971 by
THAMES AND HUDSON LTD, LONDON

English translation © 1971 by Thames and Hudson Ltd, London
and George Braziller, Inc., New York

© 1970 Editions Gallimard, Paris

Printed in France

0 500 03014 6

Contents

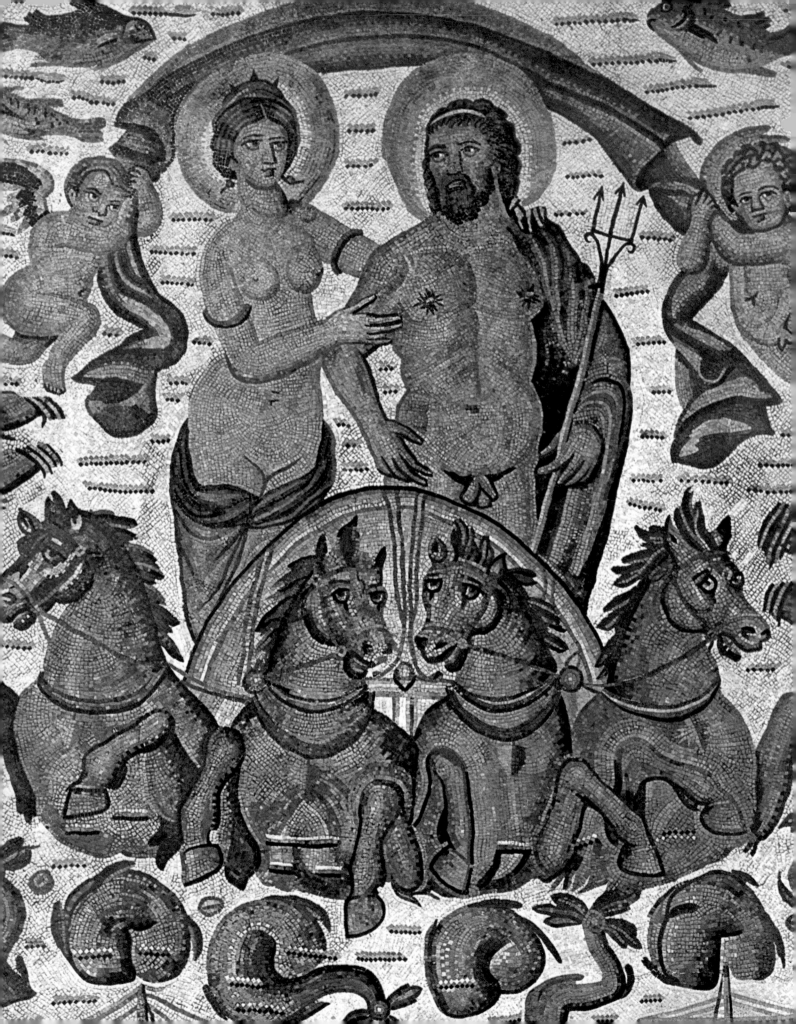

Foreword

THIS book forms the direct sequel to another work of mine, *Rome: The Centre of Power*, also published in the 'Arts of Mankind' series. This earlier work traced the development, in Rome, of a specifically Roman art, from the city's first beginnings to the end of the second century AD – or, more precisely, until the death of Commodus (AD 192). When I was a student, this was the point at which any account of Roman art came to an end. The third century was left severely alone, being regarded as a period of confusion and decadence. Only with the so-called 'renaissance' under Constantine did this later epoch regain any favour in the eyes of art-historians. In the present volume I have attempted to draw a complete picture of the art of the Roman Empire during the third and fourth centuries, from the death of Commodus to the end of the reign of Theodosius the Great (AD 395).

My field of study covers not only the capitals and great artistic centres, but all the provinces as well, since they, too, participated in the transformation of ancient art, from Hellenistic to Medieval, from Mediterranean to European. This shift of geographical centre and metamorphosis of visible form constitutes one of the events which have most profoundly influenced the history of artistic civilization in the West. As far as the figurative arts are concerned, the break is definitive: it marks the dividing-line between two worlds.

The present study attempts to highlight certain moments in this process of transformation, and to illustrate them with selected evidence. We shall watch the progressive weakening of one culture, to a point at which it ceases to be of general use, and the confused genesis of a new one, at first sight coarser and less sophisticated, but with a richer content in human terms.

It is virtually impossible, when discussing this period, to trace any hard-and-fast, systematic line of evolution. The history of art in the Roman era is still a shapeless mass which offers few firm landmarks. This state of affairs is due, first and foremost, to the conservatism of classical archaeologists the world over, who obstinately cling to categories of thought far removed from contemporary developments in historiography.

That is why the text presented here is not even a chapter in the history of Roman art, but concentrates exclusively on the problem posed by the formation of artistic modes of expression during the Late Empire – by which term I mean, precisely, that period of profound transformation which saw the germination of the Byzantine East and the Medieval West.

The end of Antiquity is defined as the end of a conception and expression of art bound up with a specific ruling class, followed – after radical change and upheaval – by the crystallization of a different formal pattern. What we have here is not a catastrophe, but a process of historical evolution.

To demonstrate the path which artistic form took during these centuries, I have relied primarily on sculpture. Mosaics only partially compensate for the gap left by the almost total loss of painting in this period. I have, also, made only occasional reference to specifically Christian art and architecture, although in the period under discussion Christianity became established as the official State religion, and the central unifying force behind the Empire. The reason for this omission is the fact that two volumes dealing with these problems – in particular those relating to architecture – have already been published in the 'Arts of Mankind' series: *The Beginnings of Christian Art* and *Byzantium*, both by André Grabar. Consequently these two studies and the present work must be regarded as complementary sources for the overall artistic documentation of the period.

Finally, I should like to express my indebtedness to all those directors of museums who helped to provide the illustrations for this volume. In particular, I should like to acknowledge help received from the following: H.E. the Ambassador of the United Arab Republic in Rome; among my colleagues, M. Giovanni Becatti, Rome; M. Berciu, Alba Julia; M. and Mme Bordenache, Bucharest; Fr. Pierre de Bourguet, Paris; M. Antonio Giuliano, Genoa; Mme Hedwig Kenner, Vienna; M. Tomislav Marasovic, Split; M. Henri Rolland, Saint-Rémy-de-Provence; Mme Roksanda and M. Swoboda, Graz; and lastly M. Filippo Coarelli, Mme Luisa Franchi, and Mme Clementina Panella, Rome, who carried out bibliographical research on my behalf.

Ranuccio Bandinelli

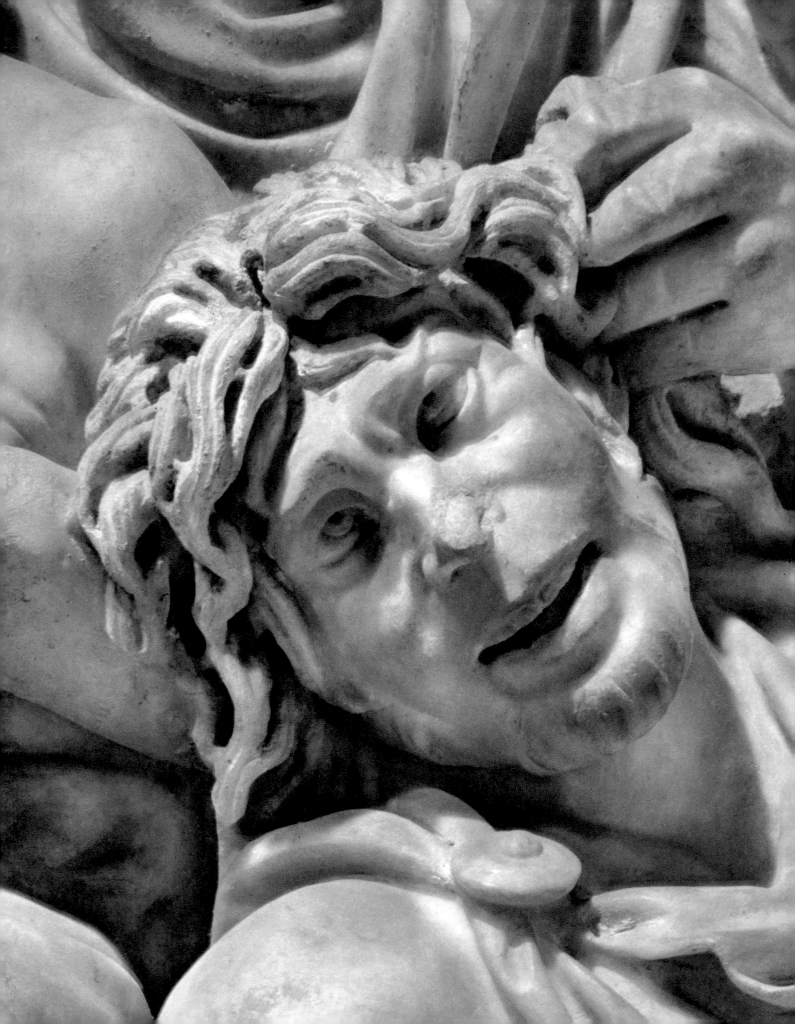

Introduction

THE AGE OF ANXIETY

MODERN historians are generally agreed that the nineteenth century – as regards its way of life and culture – went on until August 1914. At this point the outbreak of World War I highlighted all the contradictions which had disturbed it so deeply below the surface, and almost every trace of the past hundred years was swept away. In the same way the third century AD – recognized by all historians as a period of major crisis for the ancient world – really began on AD 31 December 192, when Commodus, at the age of thirty-one, was strangled after a twelve years' reign. The historian Dio Cassius, himself a member of the Senate, placed the break even earlier, in the time of Marcus Aurelius. 'After the death of Marcus,' he wrote, 'history passed from a golden empire to one of rusty iron.'

Commodus's successor Pertinax, the Prefect of Rome, was killed after three months in power. The next man to win the throne was Lucius Septimius Severus, born at Leptis in Tripolitania, the Governor of Lower Pannonia (now Hungary). He became Emperor, with the support of the Rhine and Danube legions, after defeating two other candidates: Didius Julianus, a wealthy and generous senator backed by the Praetorian Guard, and Pescennius Niger, the nominee of the Eastern legions. After his victory he took as his associate in power Clodius Albinus, the candidate of the army in Britain, who, like himself, had been born in the province of Africa. On 9 June 193, Septimius Severus entered Rome, on the pretext of avenging Pertinax, and the Senate acclaimed him Emperor. His first measure was the disbandment of the existing Praetorian Guard, which he then proceeded to reconstitute at four times its previous strength, with recruits drawn mainly from the provincial armies of Syria and Illyria. The reign of Septimius Severus not only broke the power of the great families who had controlled affairs in Rome ever since the Republican era, but also witnessed the end of Rome's – and Italy's – pre-eminence as the centre of Imperial power. It was now that there first arose that rigid, highly centralized State bureaucracy that reached its height with Diocletian's major reforms, nearly a century later. So perished the concept of the Roman State as the inheritor of Alexander's empire and the Hellenistic tradition: it is not only in the sphere of art that we find this tradition abandoned.

1

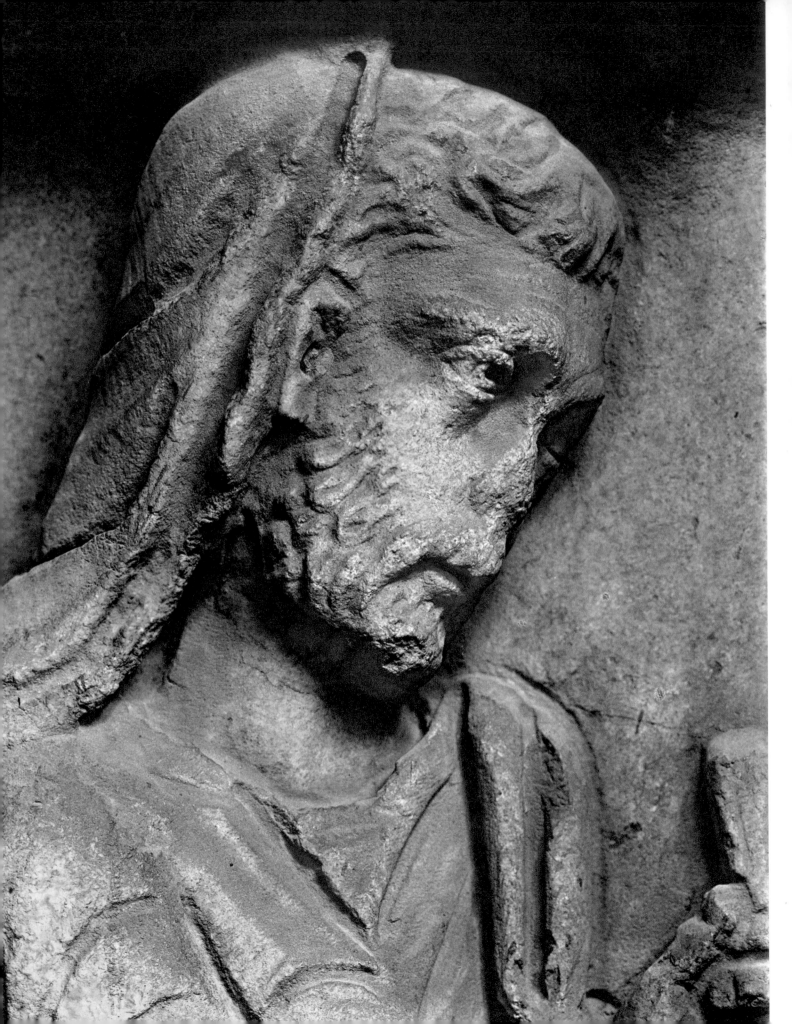

Already the crisis was there, below the surface. It was at this point – as I have shown in my book *Rome: The Centre of Power* – that artistic form took a new turning, and abandoned, even in its more official manifestations, certain elements that were fundamental to the Hellenistic tradition in art. The equilibrium of Hellenistic form was destroyed, and for the first time in Western art we observe the irrational element predominating: it was not to disappear for centuries to come. The crisis, in fact, was one which had a profound influence on the whole future history of Mediterranean and indeed Western civilization: so profound, that for long it was thought to mark the beginning of a period of decadence in art and civilization alike.

The problem is, in reality, a far more complex one. It was at this moment that there first emerged the pattern of a new society and art, which, moreover, continued to develop in accordance with the same principles (even if these seemed, at the time, of secondary importance) for nearly a thousand years. Modern historiography prefers to regard this as the beginning of a new era rather than of a period of decadence – though it is true that in the process many achievements of the human intellect were lost, and only with great pains recovered thereafter.

In the field of artistic culture, too, the crisis had been brewing up for some while. I have shown how the age of Commodus marked a turning-point, a rejection of principles fundamental to the structure of Hellenistic art. This led, during the course of the third century, to a total break with Hellenistic form, even though in certain fields some characteristic features of ancient form and iconography long survived. At the same time a new style was coming into being, which, as the evidence makes clear, lasted without a break from the fourth to the eleventh century.

The present work must necessarily restrict itself to the analysis of artistic form. One prime duty of the art-historian, in my opinion, whatever his age or country, is to bring out any new, original features in a period or an artist, and to explain how and why they came about. This means investigating both their origins (from the strictly formal viewpoint) and their semantic implications. In point of fact, artistic form always functions as an index and, to some extent, a symbol of the human condition at some particular stage in its development.

When we study the sculpture from the main centres of the Roman Empire during the third century A D, what strikes us, first and foremost, is the agonized or unhappy expression which these faces so often display – and the way in which traditional Hellenistic concepts of form are modified to make such an expression possible. What we have here is not so much an expression of physical pain: that had already been expressed, by quite different methods, in Hellenistic art. One need only recall that well-known group the *Laocoon*. To express moral agony or affliction, on the other hand, by means of facial expression, was something quite new. We can see it in portraits, even in ornamental busts; in likenesses of the young (e.g. the 'young prince' on p. 5) no less than the old, and even in that of an Emperor (Claudius Gothicus, opposite). Previously the Emperor had been either idealized as a hero, or else shown in virile awareness, and assertion of his own power, or, later, represented in all the divine majesty which, men assumed, had descended on him. But moral agony and uncertainty do not appear in portraits of the sovereign before this period.

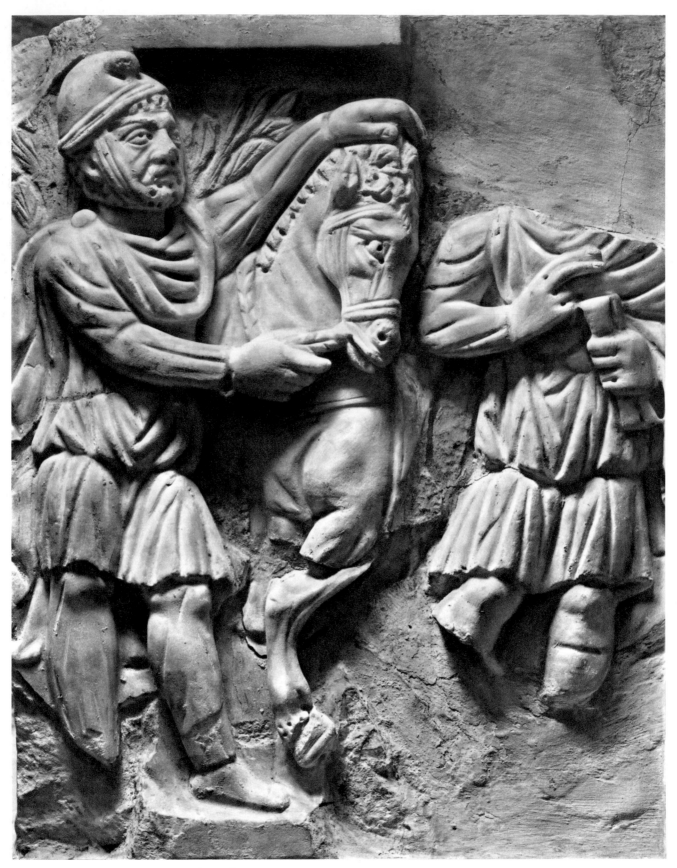

4 ROME, SARCOPHAGUS WITH LION-HUNT (DETAIL). ROME, MUSEUM OF S. SEBASTIANO

4

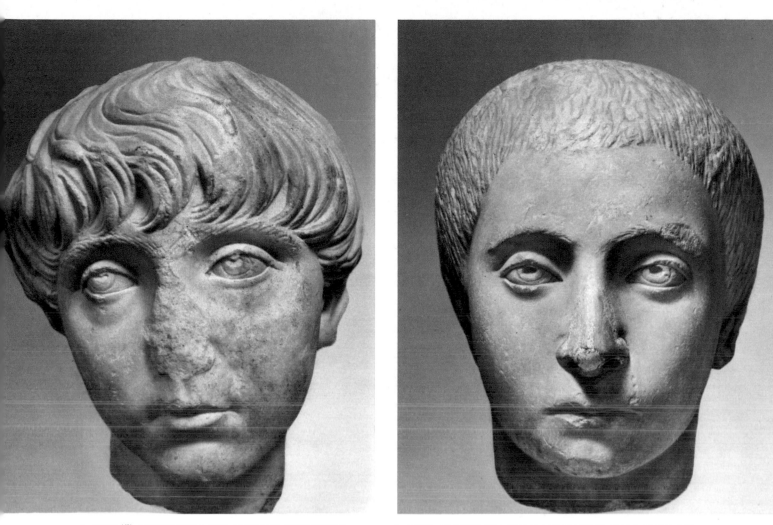

5 ROME (?). PORTRAIT OF A BOY. FLORENCE, PRIVATE COLL. 6 ROME. PORTRAIT OF A YOUNG PRINCE. ROME, MUSEO NAZIONALE

It is easy enough to isolate the technique by which this new expression is conveyed. The eyes – formalized, slightly larger than lifesize – are the principal element in it; and, within the eye itself, from Hadrian's time onwards, we find the pupil and iris not just coloured in, but shown by means of an incision in the marble (as had always been the case with terracotta and bronze). The expression of pathos is often accompanied by an inclination of the head, as can be seen in the portrait of a young boy, dating from about AD 160. It is a touching and likable portrait, in which the plastic form is still firm and solid. During the third century, however, tone increasingly takes precedence over solidity, and we see a deliberate break-away from correct anatomical representation of the facial structure. By these means the sculptor enhances whatever expression he wants, showing scant respect for classical correctness. Some historians of Roman art, such as Rodenwaldt, have gone so far as to employ the modern term 'expressionism' in this context; but in view of the substantial difference between ancient form and that of 1920s Expressionism, it is dangerous to use the term even as a convenient label.

Hellenistic plastic form was composed of clearly defined planes and delicate shadings of chiaroscuro, sustained internally by that solid, four-square structure which went

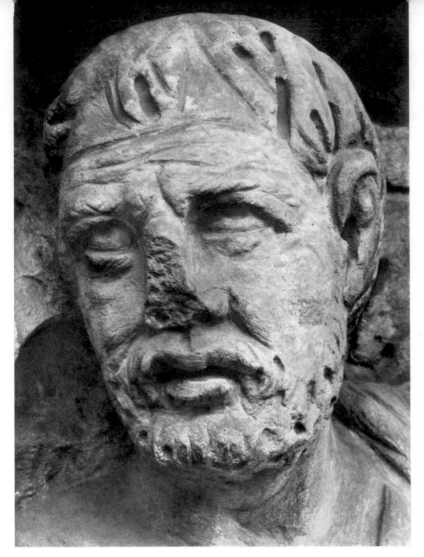

back to the great school of the Greek archaic period. Now we often find it changing into a mobile surface where the eye is never held, but encouraged to slip from point to point. Facial chiaroscuro tends to be weak; the features are sometimes scored through with deep shadow-lines, and circumscribed in a brusque, almost brutal fashion by the mass of hair and beard, the latter indicated either by small, rapid chisel-strokes, or else by a peppering of tiny holes in a slightly raised surface. The portrait of the Emperor Decius (249–51) at Rome, in the Museo Capitolino, is among the most typical examples of this new plastic form; at the same time it still maintains the old naturalistic correctness of line almost *in toto*. Nevertheless, one cannot help being struck by the air of anxious uncertainty that is stamped on this prince's features. Less correct, and far less strict from the formal viewpoint, are the heads of the various directors of athletics which once adorned the capital of a column in the Baths of Alexander Severus. These baths, begun in 227, were an extension of those built by Nero; their site on the Campus Martius is now occupied by the Palazzo Madama, meeting-place of the modern Italian Senate. The fact that this attempt to express anguish (marked by a jettisoning of anatomical form) should be found in an ornamental work, e.g. figures on a capital, and also in official Imperial

6

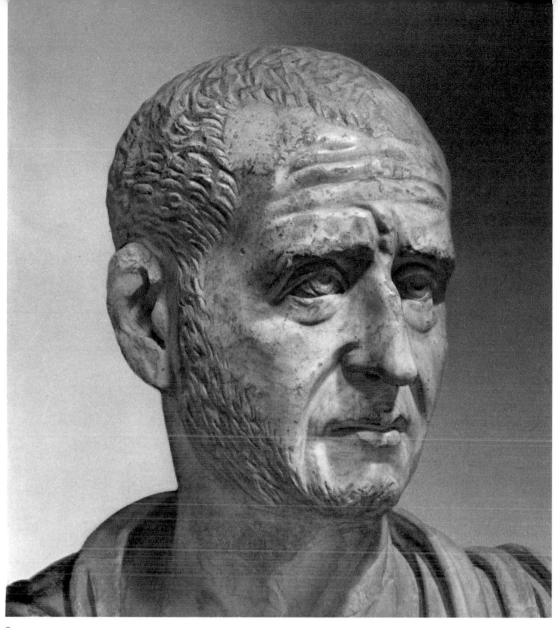

8 ROME. PORTRAIT OF THE EMPEROR DECIUS. ROME, MUSEO CAPITOLINO

portraiture, is of great interest. It shows beyond doubt that this development must be regarded as an artistic trend in the real and vital sense, a genuine formal experiment, which was followed up by several generations of artists, working in widely scattered groups. In fact, one characteristic feature of all new formal experiments throughout antiquity is that they manifest themselves, to begin with, in ornamental works, or in the less important parts of official commissions, and are accepted as part and parcel of more prominent works only at a later date.

The first signs of any relaxation of formal standards (in the traditional sense), of any slackening in the cohesion of those elements which go to make up a portrait, can be seen in the relief-work on the coins of Antoninus Pius (between 150 and 160); but such signs are still only visible if one has recourse to the artificial device of enlargement. They are already much more obvious when we turn to the coins of Septimius Severus struck between 193 and 196.

7

This relaxation of organic and structural cohesion in plastic form corresponds to a concept of artistic expression very different from that approved by tradition. This concept is fundamentally anti-naturalistic, since for naturalistic form it substitutes an illusory technique of optical suggestion, which can very easily become altogether arbitrary and symbolic. It tends to crop up early in painting, where, taking off from Hellenistic 'impressionism', it produces what we may term *tachiste* art: this destroys the impressionistic vision's prime aim, naturalism. As regards high-relief sculpture, we can trace the introduction of this new formal expression in official art to the reliefs representing Marcus Aurelius's *res gestae*. (Though these were afterwards transferred to the Arch of Constantine, they probably date from Commodus's reign.) I have already discussed these reliefs in *Rome: The Centre of Power*, where I suggested that there might be a connection between them and the studio-workshops that developed at Ephesus in the time of Hadrian and Antoninus Pius.

I have said enough, for the present, to indicate the nature of this formal language. The expression of distress which we have noted, and which the art of this period consciously strives after, is conveyed by stylistic devices; but the use of such devices is restricted neither to this expression nor to this period. We must therefore try to ascertain where and when the tendency to express moral rather than physical distress first began.

Its origins lie, once again, in the Hellenistic art of Pergamum, a constant mine of new ideas for sculptors of the Roman period: more specifically, in the figures of Galatian barbarians, of which *The Dying Gaul* (Rome, Museo Capitolino) and *The Gaul committing suicide* (Rome, Museo Nazionale) are the chief examples. A special importance attached to representations of wars between Greeks and barbarians: this was a topic much explored by sarcophagus-sculptors during the Roman period. They would either repeat some earlier composition unchanged, or else substitute for the Galatian type one of those other barbarian peoples against whom Rome was fighting. At the same time, it should not be forgotten that copies of warrior-reliefs portraying the struggles between Greek and barbarian had been introduced long before, in the Etruscan period, when they already figured on urns and sarcophagi as part of the pre-Roman sculptor's stock-in-trade. However, the expression given to the barbarians in such works is one of sorrowful pride rather than anguish; the inspiration which third-century artists got from them related exclusively to formal problems. The content was new, and reached an intensity of expression that foreshadows Christian art (Rome, the great Ludovisi sarcophagus).

Such origins explain well enough why the earliest examples of this sorrowful, afflicted expression in Roman art are found in portrayals of barbarians – especially those who are shown chained beside a trophy. We find characteristic instances of this motif in the art of Roman provinces in the West as early as the first century, notably in Gallia Narbonensis (e.g. the arches of Carpentras and Orange). The fact that Narbonensis was particularly exposed to the Hellenistic tradition confirms the influence I adduce here.

One could perhaps also find certain affinities with the 'severed heads' from the Gaulish sanctuary of Entremont (near Aix-en-Provence), conquered by the Romans in 123 BC; but it does not seem likely that this motif could have developed except as a borrowing from the Greeks on the south coast.

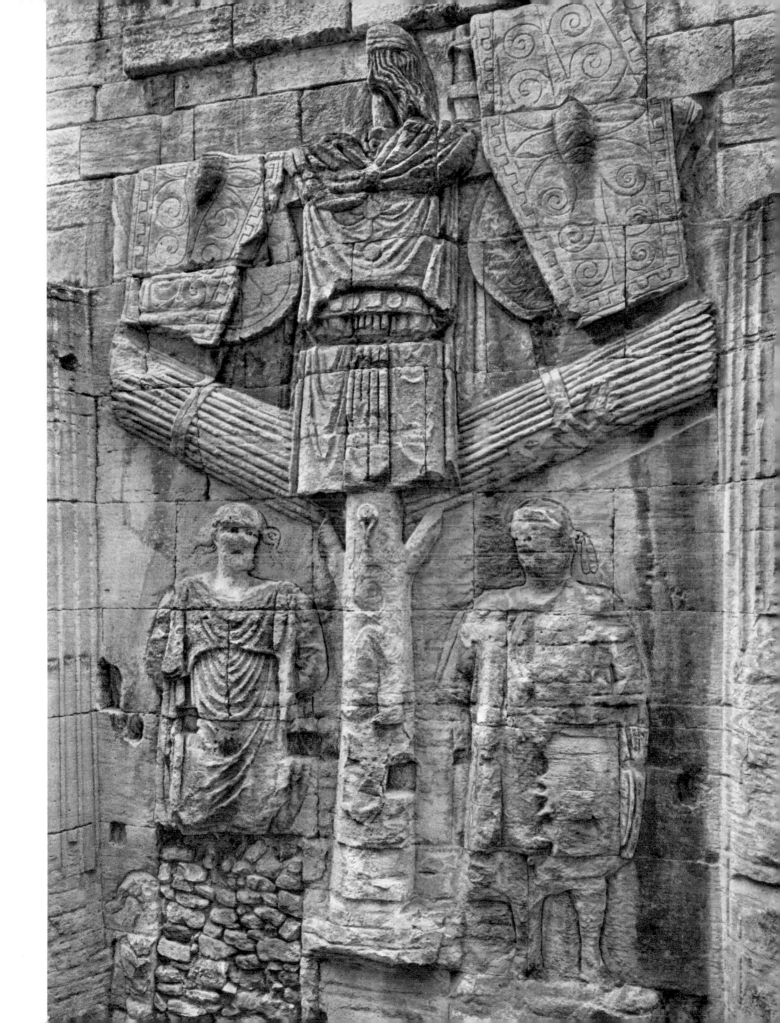

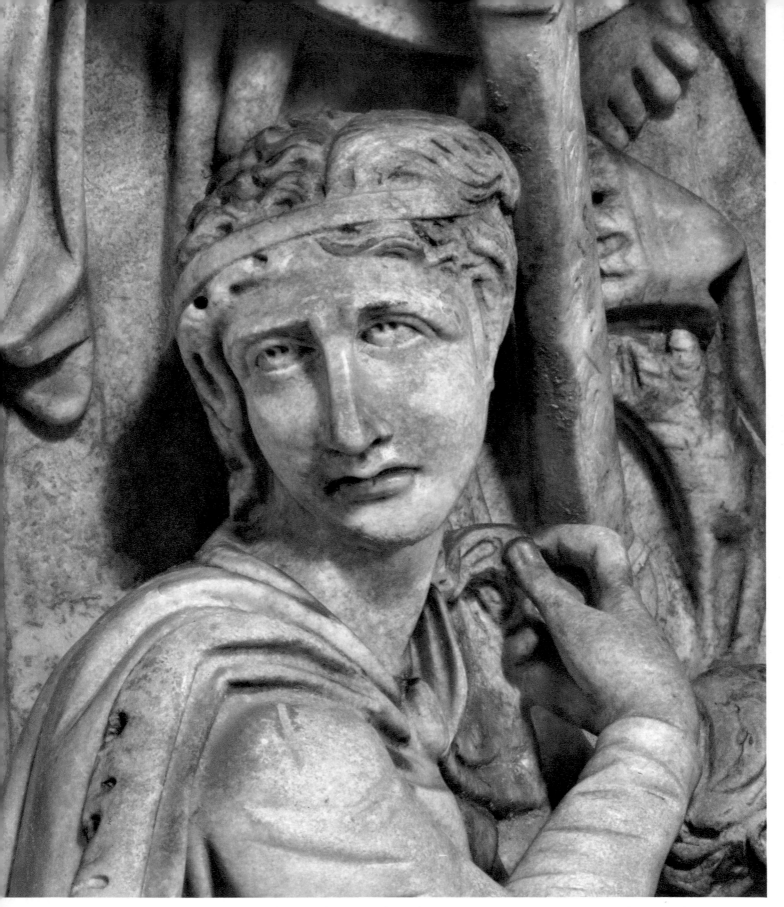

10 ROME. SARCOPHAGUS OF ONE OF MARCUS AURELIUS'S GENERALS (DETAIL): FEMALE BARBARIAN PRISONER. ROME, MUSEO NAZIONALE

10

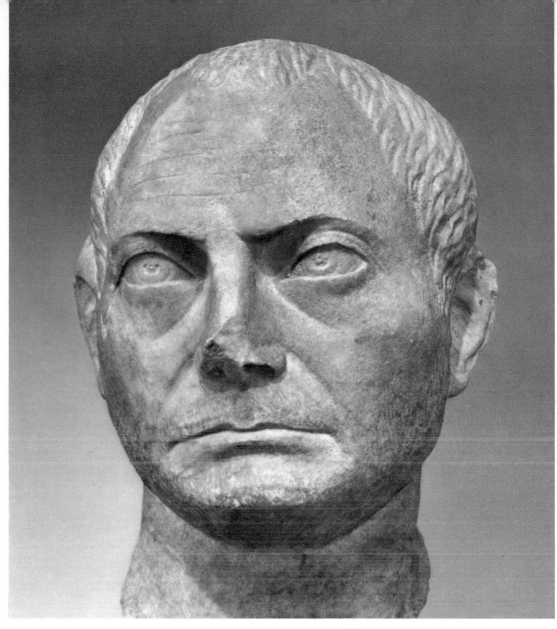

11 AQUILEIA. PORTRAIT OF A MAN. AQUILEIA, MUSEO NAZIONALE

I am not sure if we can posit a connection between the Roman monuments of the Western provinces, on which there appear suffering, chained barbarians, and the occurrence of a similarly agonized expression, very early on, in provincial art – where it turns up, not only on representations of barbarians, but in official and funerary portraiture. Such art stands in the line of 'plebeian art' at Rome, a basic ingredient of which has always been its individualistic and expressive character, brought about by that close link with daily realities that belongs to all 'popular' art.

We shall see this more clearly when we come to the chapter dealing with art in the provinces. For the present, one instance will suffice: that of certain portraits, datable to before the second century BC, from Aquileia or Este. Sarcophagi found in Aquileia confirm the diffusion of a type of large coffin, fitted with a heavy lid and without ornamentation, which first appears in the Greek cities of Asia Minor. The Roman West

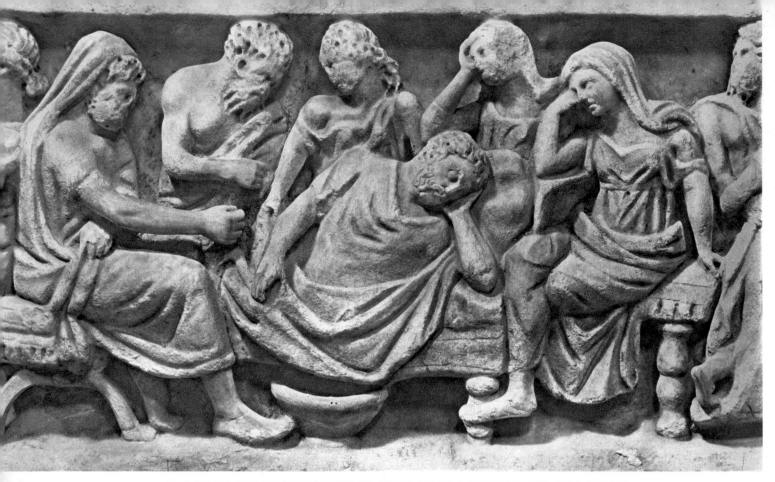

12 ROME. SARCOPHAGUS (DETAIL): MOURNING WOMEN AROUND A DYING MAN. ROME, MUSEO TORLONIA

adopted it, but with one significant addition: the corner acroteria of the sarcophagus were adorned with portraits of the deceased person who lay inside it. This typological variant thus combined the characteristically Roman tradition of the portrait, and the widespread use of figurative antefixes, which had adorned temples and sacred sites when terracotta figures were in vogue as decoration.

These, then, were the stylistic and iconographical factors which provided both the impetus and the technical means for the development of this type of portrait in the third century. We must now try to determine what sort of environment let it emerge, concentrating in particular on the expression of anguish and spiritual uncertainty. What we have here is not simply an artistic phenomenon, but the expression of a specific cultural and human attitude. It appears not only in scenes of battles or funerals (Ostia, Museo Torlonia), but also, as I have already mentioned, in commemorative reliefs and official portraits.

This attitude was clearly formulated, in about 251, by a Christian writer. In the *Letter to Demetrianus*, Cyprian, Bishop of Carthage, draws a decidedly pessimistic picture of contemporary conditions: 'In those mountains where excavation and quarrying take place, the numbers of marble slabs extracted has fallen off. Mines are becoming exhausted, and yielding less wealth in gold and silver: little by little their veins are running out. The number of peasants has fallen, and they are steadily vanishing from the countryside. The same applies to sailors on the high seas and to soldiers in barracks.

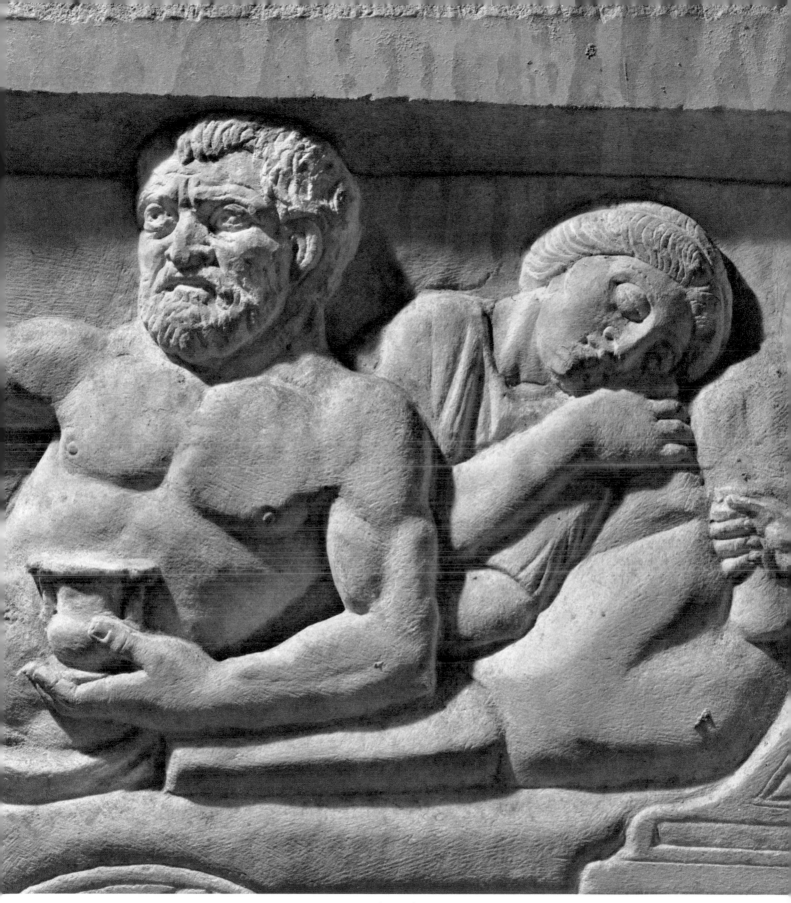

13 OSTIA, THE ISOLA SACRA NECROPOLIS. SLAB COVERING A TOMB (DETAIL): FUNERAL BANQUET

Simultaneously we find integrity vanishing from public affairs, and justice from the courts; honour is no longer found among friends, nor true skill in the arts, nor self-restraint in manners and morals. Do you imagine such a multitude of old, worn-out things can hope to survive much longer? Do you really believe we are getting back to that first youthful vigour we once enjoyed? All things must inevitably decline as they approach their end, must fall and vanish into oblivion.' This pessimistic vision must, undoubtedly, be regarded as part and parcel of Christian polemics against pagan society and the Empire. But it is also an answer to the accusation (made, in various contexts, by Demetrianus and others) that such public misfortunes had been brought about by the Christians, and by their opposition to the State and its religion.

Christian apologetics had had to fight this accusation for a very long time. In his *Apologeticum*, written about 197, Tertullian devotes three whole chapters (XL–XLII) to the subject. But in Cyprian's writings, the essential part of the argument rests on assertion rather than refutation: 'The world is decrepit.' The Christian opposition, by pointing to the collapse of all values, natural and human alike, put great emphasis on the inevitability of a final break-up, to be followed by some sort of moral regeneration. Such arguments, however, would have had no force if the malaise had not been so widespread – if it had not, in fact, circulated so generally throughout the Empire as to provide material for anti-Christian polemics.

The first signs of trouble go back to the time of Marcus Aurelius, but it was at the beginning of the following century that the crisis became acute. Our own age should have no difficulty in recognizing the symptoms. Vast military expenses were accompanied by a sharp decline in the purchasing power of money; this in turn had a paralysing effect on trade. The real value of money fell in the most terrifying fashion. A silver piece, which had previously contained 97 per cent silver, contained no more than 30 to 50 per cent by about 260; by the end, this amount had been whittled down to a mere 5 per cent. A point was reached at which silver denarii were no longer struck at all, except to celebrate some special occasion. The gold piece fell from about 8.175 gr. to 1.513 gr. During the reign of Aurelian, in 271, there was a revolt in the Mint at Rome, which remained inactive till 273, at which point it was reopened under Illyrian direction. (Other Mints were in operation at the same time: that of Milan, which opened in 259, that of Cologne, founded in 257, as well as those of Siscia, Ephesus and Antioch – which goes to show how far Rome had already slipped from her position as the centre of power.)

With the economic crisis, taxes became increasingly heavy, thus aggravating the crisis further. Already the poll-tax (*tributum capitis*) and the land-tax (*tributum soli*) were resented as a mark of the provinces' subjection to the Empire: a 'badge of slavery', to use Tertullian's phrase (*Apologet.* XIII). Subsequently the general sales-tax (*venalium*), which had stood at 0.50 per cent under Tiberius, was increased to 2.50 per cent, to which was added a 4 per cent tax on the sale of slaves, and one of 5 per cent, the *vicesima libertatis*, on their manumission. Caracalla raised the inheritance tax from 5 to 10 per cent immediately after his *Constitutio Antoniniana* of 212, which extended Roman citizenship to all free subjects of the Empire. The effect of this concession on Italy was wholly negative: being henceforth subject to the same fiscal system as that in force in the provinces, she had lost her privileged position. On the other hand, this measure did

(quite unintentionally) ameliorate the legal position of Christians in the Eastern and North African communities.

During the third century, occasions for extraordinary levies multiplied, in the form of services and contributions in kind. The most onerous was the *aurum coronarium*. To begin with, this had been a subscription raised for the purpose of offering gifts to victorious generals. Latterly it became a regional contribution, advanced to the Treasury by the wealthiest local citizens, who then proceeded to recoup it from the other inhabitants of the area, with all the abuses to which such a system gives rise. Other taxes included the *annona militaris*, for the upkeep of the army, which was generally levied in kind, and the *lustralis collatio*, an 'offering' which merchants were required to make once every five years. Big landowners who wanted to avoid the obligation of providing men for military service paid the *aurum tironicum*; but this did not exempt them from the *vehiculatio*, the transporting of Imperial post from one relay station to another over the Empire's immense network of trunk roads. After a certain period, various landowners suffered expropriation of territory, this being taken over by barbarians who were brought in to defend the frontiers. As Rostovtzeff has pointed out, it was the middle classes, the merchants and farmers, who ended up impoverished.

The fact that soldiers were called to the colours for long periods, up to twenty consecutive years without a break, is a characteristic feature of life during this century. Over and above the massive sums that had to be earmarked for the maintenance of the army, there arose the problem of what to do with 'veterans' – an important category of citizens – after their demobilization.

It was, above all, in the provinces that misery and depression was greatest, and aroused a sullen hostility against the Empire and the power which its administration represented. To provincials, any escape from Rome's oppressive authority must have seemed out of the question. Thus there arose an agonized longing for change, for a complete new deal. Christian proselytizing owed much of its success to the fact that, confronted with the Empire's claim to be eternal, inevitable and unchanging, it announced the possibility of a new type of universal community: the Church. Thus a document such as Cyprian's treaty *On the unity of the Catholic Church* had a value that was not merely doctrinal, but also in the deepest sense political – for which its author subsequently paid the price of martyrdom.

This double crisis, economic and constitutional (the latter manifesting itself in a swift succession of Emperors imposed by the army, and then violently eliminated), could hardly fail to produce an equally profound crisis in the spiritual sphere. One result of this was a swing towards Christianity. Until their recognition by Constantine, which represented a compromise between Church and Empire, the Christian communities acted as full-blown revolutionary centres; after it, they rapidly switched about and began to buttress the Imperial regime. The full cathartic force of the Gospel was thereupon utilized to establish a new domination over men who had hoped for something very different – their freedom. Such a phenomenon is by no means unique in history.

On the other hand, this spiritual crisis did find some sort of outlet in various philosophical trends, and above all in the religious doctrines of the Oriental mystery cults. The forms which this movement assumed were many, and all the more in evidence in

that the authorities were less hostile to them, and indeed on occasion gave them active support. Greek civilization's greatest achievement had been man's acquisition and use of a rational system of thought, on which he could, for the first time, base his claim to rule and exploit the world. This conquest was now gradually abandoned. On all sides we find the tide turning against reason; and, with the eclipse of reason, scientific thought, too, disappears for centuries. Although Christianity, the mystery religions, and the various philosophical doctrines might quarrel fiercely with one another, nevertheless they were all forces moving in the same general direction: towards a denial of the reality of the world, towards a shifting of men's hopes from their present condition to redemption in the hereafter. During this era men who start out from totally different positions, and follow what seem to be diametrically opposed paths, are all caught in the same web of irrational thought, to which they abandon themselves with uneasy satisfaction – as always happens when man feels himself alienated, the victim of forces which he cannot control, and which may well end by destroying him. When one thinks about this state of affairs in third-century society (both Roman and provincial), it is hardly surprising that art learnt to represent anguish.

The idea of 'detachment from this world' had been first taught by the Stoics and Epicureans. However, the tranquillity (*ataraxia*) which they preached was available only to a restricted elite, and not always to them. Moreover, even Stoicism shows a tendency towards mysticism in its propagation of the concept of 'bearing witness' (*martyria*). The 'sage' who, as late as Seneca's day, drew all his strength from himself, from his own reason and intellect, is now looked on as a 'witness of divinity'; Epictetus imagines Jupiter summoning him 'as a witness cited by God; come then, step forward and testify'. And the philosopher rejoices at the thought that 'Jupiter wishes to assay me, to see if there resides in me a soldier and citizen fit to be sent among other men, as witness of what one must needs achieve' (Epictetus, *Encheiridion*, Diss. III).

In 205, at Lycopolis in Egypt, Plotinus was born, the founder of Neo-Platonism. He had originally been a fellow-student of Origen, who subsequently became one of the most important and controversial of all Christian thinkers. Plotinus exercised great influence in the upper echelons of Roman society, including the Court of the Emperor Gallienus. With him, the notion of escape from this world, already popular among earlier philosophers, assumes the aspect of a secret doctrine, withheld from the common run of mankind. A person should not only avoid involvement; he should actually welcome ill-health: 'Men must reduce and enfeeble their bodies to show that the true man is something other than the outer matter enfolding him.' The 'sage' will not forgo acquaintance with sickness, 'he will even desire to gain the experience of suffering' (*Enneads* 1.4.14). This is a far cry from the athletic ideal which had held sway in classical Greece and had determined the canon of formal beauty.

It would, I think, be wrong to infer that the teaching of Plotinus had any direct effect on the art of his day. But some of his statements do make it easier for us to appreciate the nature of those sentiments current in third-century society which found expression in artistic form. Their chief characteristic is the loosening of organic cohesion, the accent being now on expression rather than on harmony based on anatomical correctness. Plotinus says: 'The more matter loses its form, the closer it resembles its original model,

16

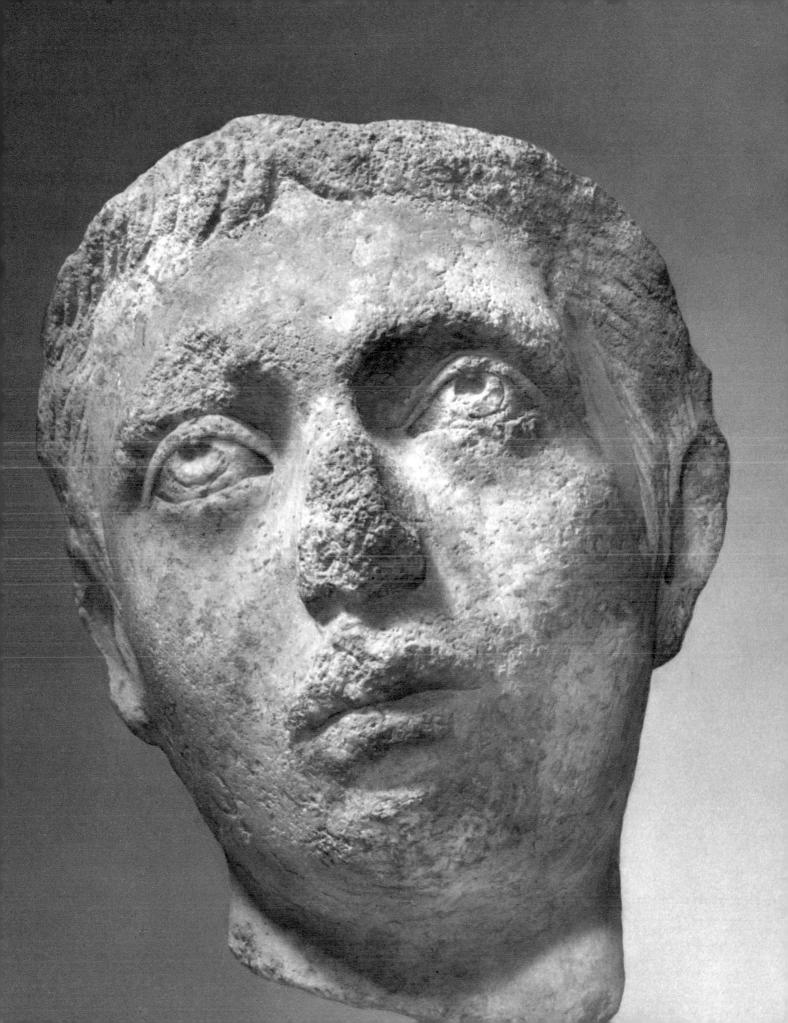

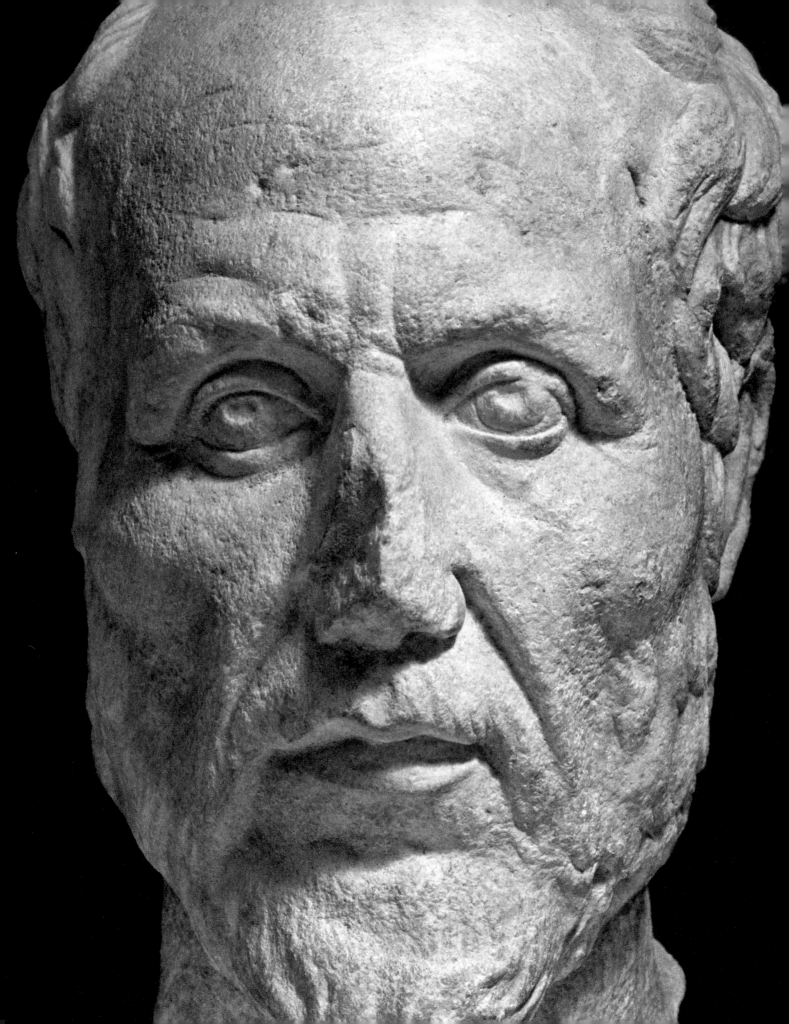

the idea . . . When an artist gives form to what he has within him, his work can be called beautiful. The eye sees in the work that which exists in a man's mind' (*Enneads* 5.8.1). Imitation, the old Platonic concept of *mimesis*, does exist, but it is the body which imitates the soul: it is an *eidolon* or *mimema* of the soul. On the basis of such principles there developed, by the end of the century, that ideal of the spiritual man (*homo spiritualis, pneumatikos*) which permeates so many portraits from now until the fifth century. Yet when one considers these ideas in their application to the portrayal of the inner man, by way of tangible and material form, one cannot but be struck by their similarity to that saying attributed to Paul the Apostle: 'The visible is but a veil set before the invisible' – a notion that was to guide not only the mystical speculation, but also the artistic iconography, of the Middle Ages, that of the eleventh and twelfth centuries in particular.

While these philosophical doctrines affected mainly the highest social classes, the spread of Oriental cults based on 'mysteries' and the concept of *catharsis*, regeneration in a better life, produced an even greater swing away from reality towards the irrational, with particular emphasis on mysticism and magic. These cults became extremely widespread from the time of Septimius Severus, Caracalla and Marcus Aurelius Antoninus (perhaps Caracalla's son), who in his capacity as priest of the Sun-God at Emesa, assumed the name of Heliogabalus. Special encouragement was given to these Oriental cults by the Syrian princesses (and their families) installed at Court in Rome: Julia Domna, the wife of Septimius Severus, and her sister Julia Maesa. Such religions, with their so-called 'cathartic' ceremonies, offered something more emotive (and thereby more alluring) than did Greek anthropomorphism; by now the latter had been drained of its genuine religious content, partly by philosophical criticism, and partly by the ritual formalism of Roman cult-practice as the civil magistrates observed it. In the East, cult-ritual (by virtue of which an individual was to achieve purification and redemption) assumed such importance that henceforth in could be celebrated only by a full-time minister. The portrait of a priest of Cybele (*archigallus*) found in the necropolis of Ostia is equally impressive in human terms and as a work of art.

There is no room here for an examination of Hermetic doctrine, nor of the various Eastern cults. Among the latter the most important were those of Cybele, the Great Mother (whose priesthood involved the bloodstained sacrifice of one's virility), Jupiter Dolichenus, Isis, and Mithras (a cult celebrated throughout the Empire); there were also numerous minor local cults. All we can do here is to remind ourselves of certain facts which explain the appearance, towards the close of the second and throughout the third century, of a profound spiritual crisis, directly occasioned by the crisis which had already taken place in the social and economic sphere. It drove men towards the irrational, and away from the mundane realities of life: whether their chosen medium was religious belief or philosophical doctrine, it all came to the same thing in the end. The new form of figurative art, which is broken up and lacking in solid structure, and conveys a powerful impression of anguish, depression and inner torment, finds its proper explanation in this particular human attitude. It has nothing to do with external influences or fleeting fashions, but springs directly from the inner nature of Roman society in the second and third centuries, as an inevitable, and natural, historical phenomenon. Seldom in the history of art has the relationship between society and formal language been so

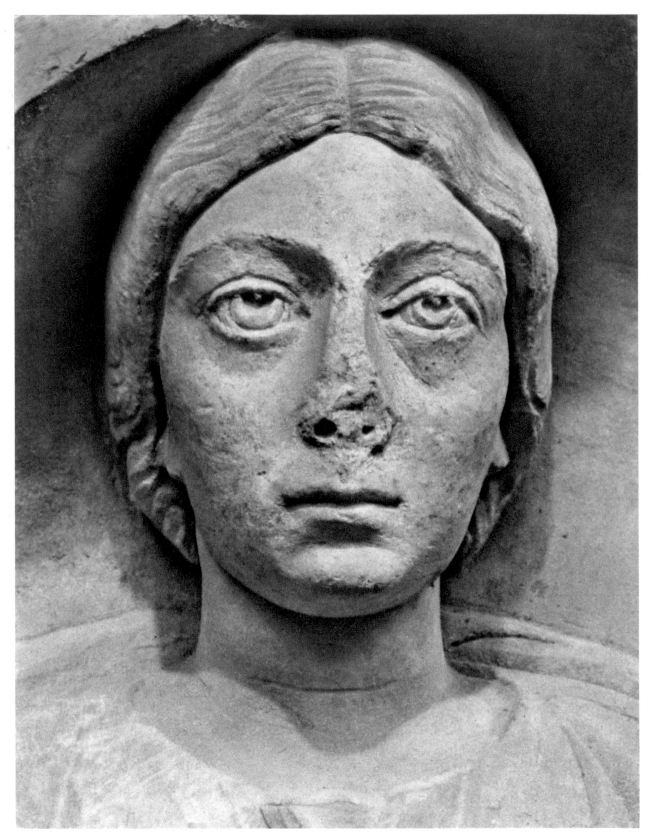

16 AQUILEIA. SARCOPHAGUS-LID (DETAIL): PORTRAIT OF A WOMAN. AQUILEIA, MUSEO NAZIONALE

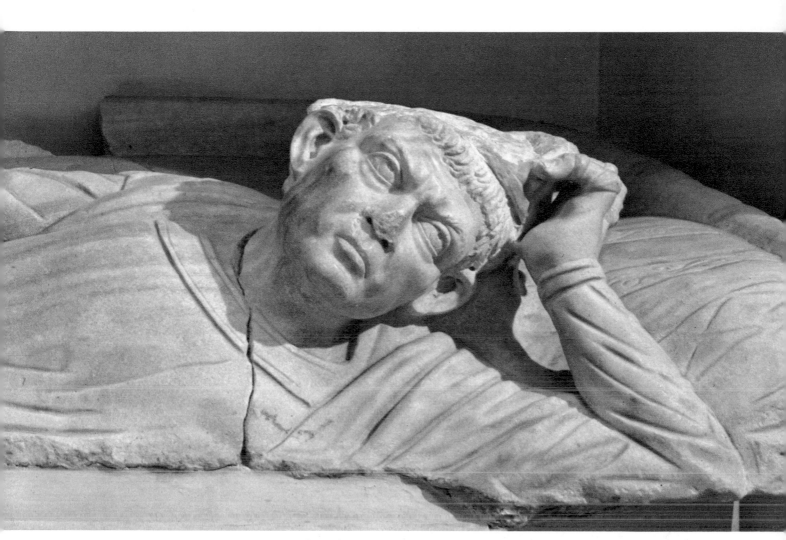

17 OSTIA, THE ISOLA SACRA NECROPOLIS. SARCOPHAGUS-LID (DETAIL): PORTRAIT OF HIGH PRIEST OF CYBELE. OSTIA, MUSEO OSTIENSE

close, or so self-evident. This, too, is what gives the art of the period (written off as 'decadent' so long as the neo-classical vision dominated European culture) its special freshness and intensity of expression – something Roman art had never achieved as a whole, but only in isolated works by a few great artists, such as the *Maestro della gesta di Traiano*. During the third century, however, it is anonymous master-craftsmen from the great studio-workshops who turn out whole series of sarcophagi, portrait-statues, and commemorative or funerary reliefs. It is these workshops, in fact, which must take the credit for a new art-form – and one which, even in the West (at least until the second half of the third century), reveals great technical skill.

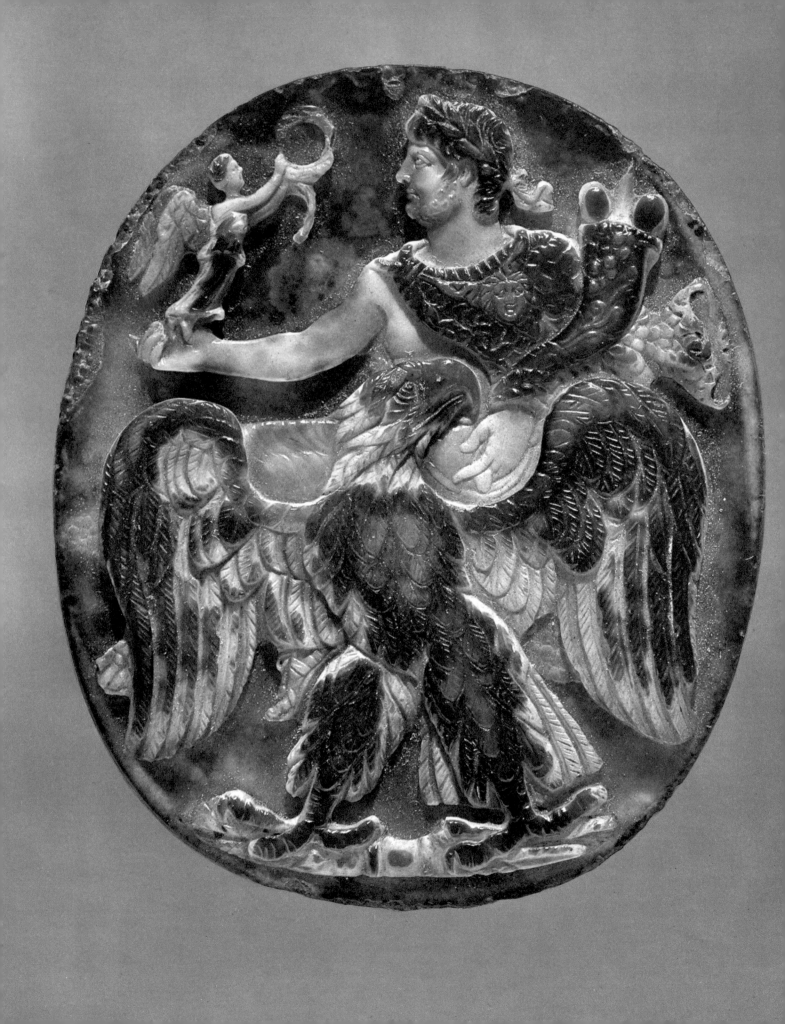

THE WILL TO POWER

The expression of spiritual anguish was by no means the sole theme of third-century sculpture. Its basic feature is the jettisoning of classical canons, the accentuation of relief-work to produce colour, with the object of emphasizing the expression as strongly as possible. Although anguish reflected a widely felt mood, this century also reveals a will to power that sticks at nothing in its struggle for self-assertion.

According to the traditional organization of the Roman State, it lay with the Senate (that is, originally, the patrician class) to designate the Head of State, since the legal fiction of the Republic's survival was still maintained under the Empire. In actual fact, the last occasion on which the Senate chose a candidate who stayed the course (though the choice was not entirely spontaneous) was in 238. Their nominee, Gordian III (or Pius), was thirteen at the time of his elevation to the Imperial throne; in several of his early portraits he has the air of a small and terrified rabbit. Two previous Senatorial nominees, Pupienus and Balbinus, had been assassinated after a ninety-nine days' reign. Gordian himself lasted six years, and was then killed, during a campaign against the Parthians (244), by his own troops, who mutinied and went over to his new Praetorian Prefect, Philip. This person, who was born in Transjordania, has gone down in history by the name of Philip the Arab. From then on, every emperor was an army commander, raised to the purple for a brief and ephemeral reign, with the result that real power remained in the hands of top-level civil servants. The most tragic period was the fifty years between Maximinus Thrax (235) and the accession of Diocletian in 284. With the latter, a stern Illyrian, the great reform of Imperial administration began.

Marcus Aurelius had been the last emperor nurtured on the *paideia*, the Greek system of education based on reason and tolerance. There succeeded to the throne a series of coarse and grasping men, little better than common adventurers, whose position at the head of that vast Empire had no backing save from the legions whence they had sprung, and whose only aim was the enjoyment of unlimited power. Art in this period scorns traditional classic symmetry and restraint; it is avid for self-expression, and skilled at getting what it wants by simplifying the general outline where possible, concentrating

23

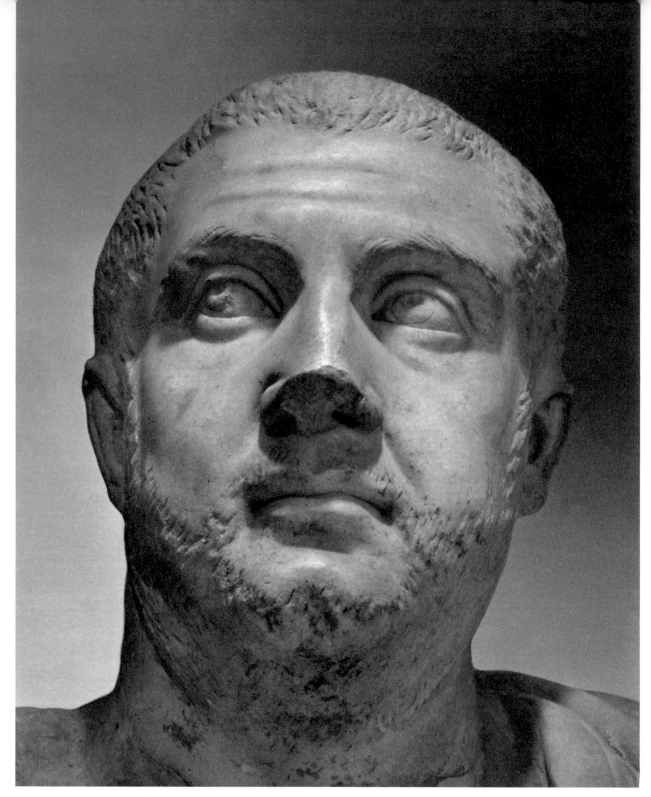

19 ROME. SARCOPHAGUS-LID (DETAIL): PORTRAIT OF THE EMPEROR BALBINUS. ROME, MUSEUM OF PRETESTATO CATACOMBS

rather on characteristic details. It contrives to portray these men in absolute terms, so that the representation rises above mere personal anecdote through the sheer force of its formal language. These portraits clearly convey the new concept of power behind the

24

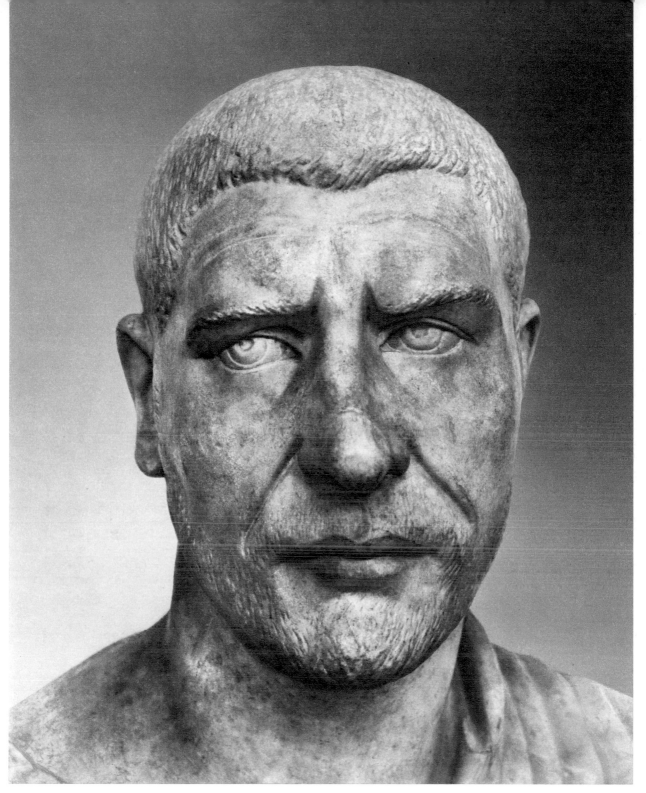

20 PORCIGLIANO. PORTRAIT OF THE EMPEROR PHILIP THE ARAB. THE VATICAN, BRACCIO NUOVO

Principate, which is no longer a leadership exercised over free men, but the domination of subjects.

In this category we must place the portraits of Maximinus Thrax (235–8, Rome,

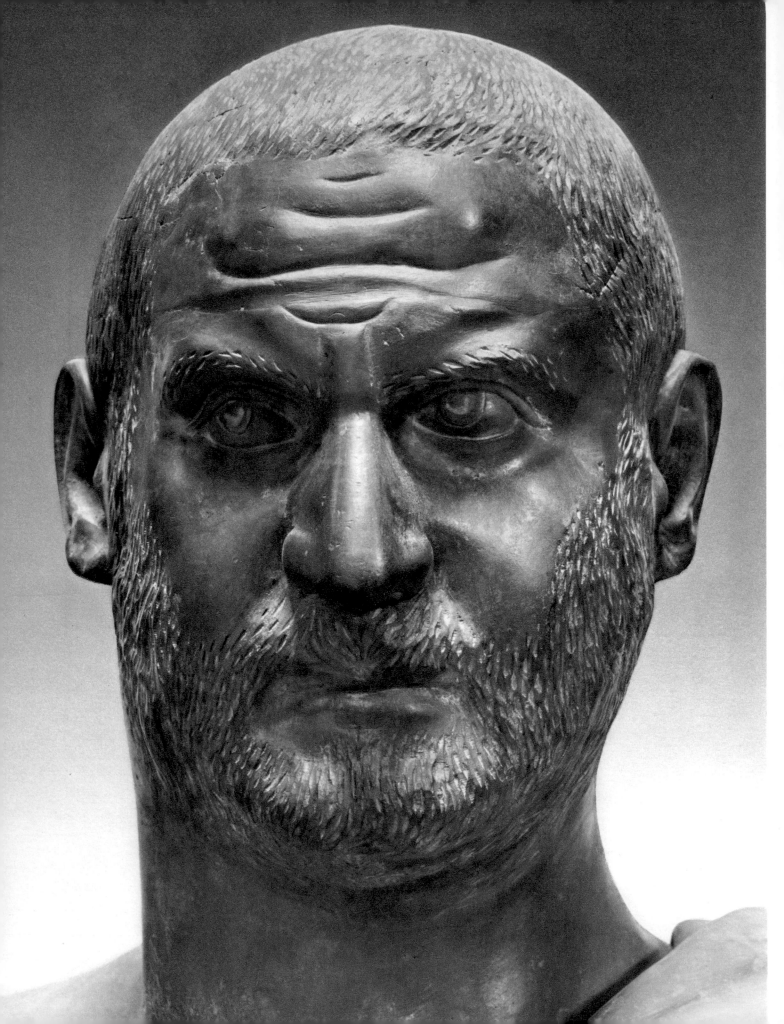

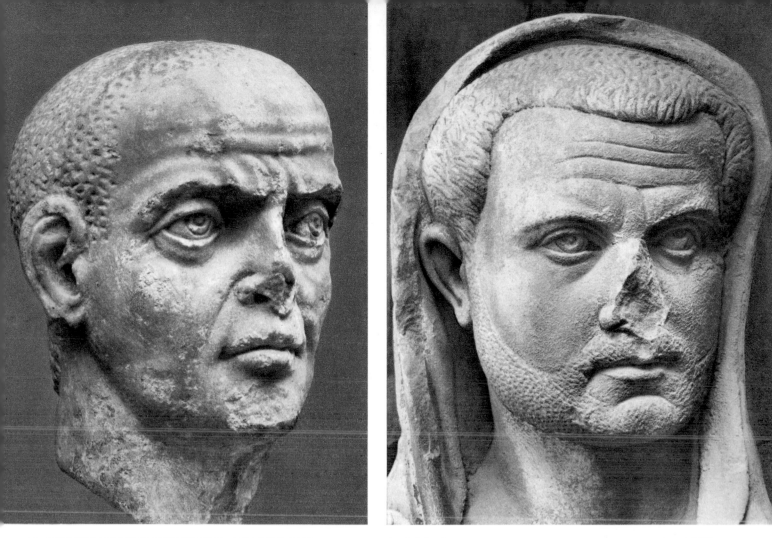

22 ROME. THE EMPEROR DIOCLETIAN. ROME, VILLA DORIA PAMPHILI 23 ROME, ARCH OF CONSTANTINE. THE EMPEROR CONSTANTIUS CHLORUS

Museo Capitolino), Philip the Arab (244–9, Musei Vaticani), Trebonianus Gallus (251–3), and Diocletian (284–305, Rome, Villa Doria Pamphili), together with other portraits of persons whom history cannot identify, which reveal individuals of relentless energy and indomitable vitality, such as no portrait-sculpture, before or since, has dared to show so frankly. The artists have managed to find the means to convey their sitter's personality without recourse to any existing iconographic formula. We find an unusual number of artists who can adapt the technique for conveying expression in each new work they undertake, improvising within a framework of simplified technical procedure.

This change becomes emphatic and explicit during the reign of the Severi: Severan art has an enduring value, position and influence. Members of the Imperial Court continued to be glorified in large monuments, such as Septimius Severus's arches in Rome and at Leptis, but also with a new efflorescence of glyptic work (e.g. the Nancy cameo).

With Gallienus (253–68), a deliberate return to traditional Hellenistic sources produces an Imperial portrait which picks up the old notion (long ago borrowed from the East by Alexander the Great) of a divinely inspired prince and leader. Eyes upturned to the empyrean, the sovereign is engaged in a supernatural dialogue, whence he derives higher ratification of his claims to power and authority.

◀ 21 ROME (?). PORTRAIT OF THE EMPEROR TREBONIANUS GALLUS. NEW YORK, METROPOLITAN MUSEUM OF ART

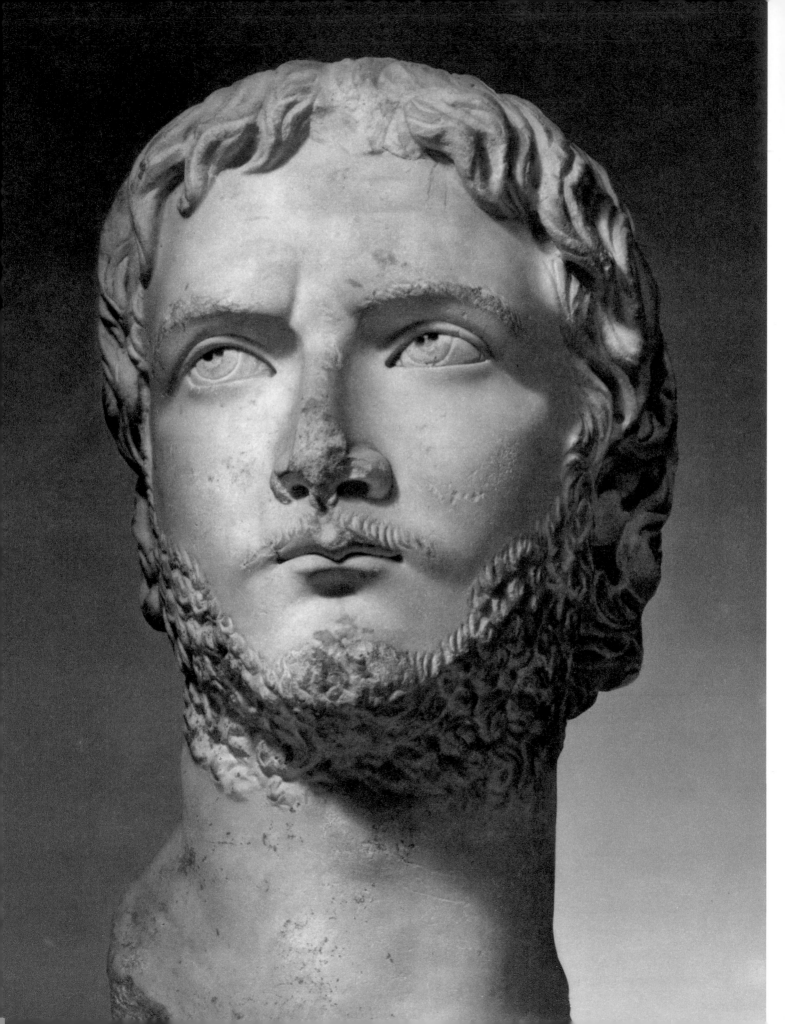

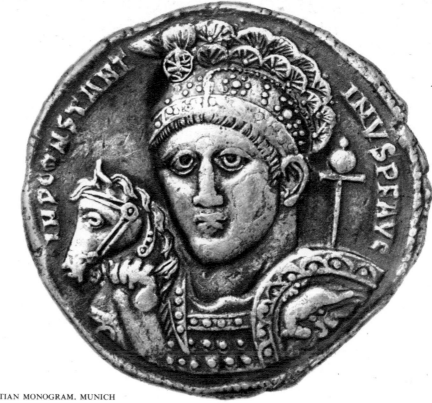

25 PAVIA. CONSTANTINE WITH THE CHRISTIAN MONOGRAM. MUNICH

Hadrian had already translated the idea of power as a gift of the gods into visual imagery. His second monetary issue includes an *aureus* which shows the Emperor receiving the globe, symbol of universal power, not from the hands of the Senate's Genius, but from Jupiter in person. Later, in 119, he struck coins bearing the legend PROVIDENTIA DEORUM. In the third century, this notion of the Emperor as Providence's gift to the Empire is clarified and expanded. To assert the monarch's divine essence (which was henceforth done not only after his death, by means of apotheosis, but also in his earthly person, his *divina maiestas*) provided a means of transforming the military emperors' vulgar power-mania into an expression of inaccessible grandeur. With Constantine, the representation of the 'inspired leader' reappears on coins, though we have no example in the field of statuary. The Imperial portrait now took on a fixed quality that embraced its carnal and divine aspects alike. It could be expressed with equal facility in the limited scope of a coin as in a colossal likeness: in the silver coinage struck at Pavia (Ticinum) in 315, where for the first time we see the Christian monogram on the helmet, or the gigantic bronze head from the Palazzo dei Conservatori in Rome, which was formerly attributed to one of Constantine's successors, but now (because of the monetary iconography) is taken to portray Constantine himself. The occasion for erecting so colossal a statue may have been provided by the thirtieth anniversary of his reign, which fell in 335. Alternatively, it may have been a posthumous honour. The coins of 330 correspond exactly to this portrait. If we compare this solemn grandeur with the portrait we see on Constantine's coins in the days of the Tetrarchy, where he appears as a clever party-politician (*pl. 330*), it becomes plain that the portrayal of reality has undergone a remarkable metamorphosis over the years.

◀ 24 ROME. PORTRAIT OF THE EMPEROR GALLIENUS. ROME, MUSEO NAZIONALE

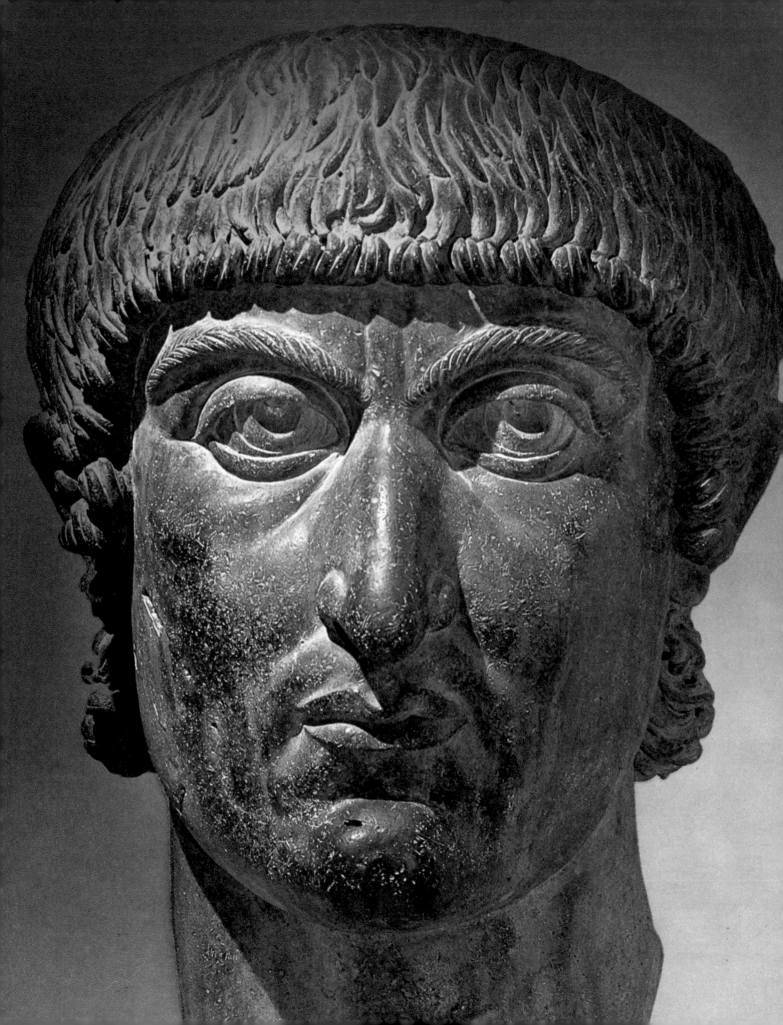

27 AQUILEIA, CONSTANTIUS II. BERLIN, STAATLICHE MUSEEN

28 MILAN. THEODOSIUS I. ROME, MUSEO NAZIONALE

On the coins of Constantine's successors, from Constantius II (337–50) to Theodosius (379–95), we see an increase in that contempt for the enemy which found its first expression on the reliefs of the Antonine Column (but of which Trajan's Column shows no trace) – a consequence of the augmented sense of authority which Christian emperors derived from the knowledge that they were champions of the One True God, unique and all-powerful. The captive foe is dragged by the hair, trampled underfoot, a minuscule worm wriggling in vain, like the dragon beneath the feet of the Archangel: 'Thou shalt tread upon the lion and adder: the young lion and the dragon shalt thou trample under feet' (Psalm 91.13). Victory, whose altar was removed in 357 from the chamber of the

31

Roman Senate, no longer flutters above the Emperor's head, a divine dispenser of favours. Now she crowns him, standing on the globe which he himself, as Cosmocrator, holds balanced in his hand. This iconography is already to be seen on the Nancy cameo, which supposedly portrays Caracalla. As regards the Victory on the globe which the Emperor holds, it is important to distinguish the image of Victory as a mere *attribute* (both object and representation being lifeless, a statuette affixed to the globe) from the Victory who, though occupying the same position, is on the contrary performing an *action*, as an animated being: she holds out the crown towards the sovereign, and crowns him with it. In both cases the iconography is much the same, but conceptually there is a profound difference. In the first, the Victory on the globe is a symbol of the goddess Nike; and if Nike crowns the Emperor, she does so in her own right, following him as he advances or flying above him. In the second, Victory has lost her autonomy as a goddess, and is a symbol and nothing else. The former type of representation first appears in Roman coinage on the denarii which Octavian struck after Actium, and the second on issues of Carinus and Numerianus (282–4). The Nancy cameo, however, prefigures this iconography, which was a novelty in Rome, but had already been employed on the tetradrachms struck by Orodes I, King of the Parthians (date of issue 38–37 BC). Thus we have a transformation of both ideas and iconography, strengthened by influences from the East. The latter preserve their ideological impact, and in that capacity shape the iconography. But as regards the formal expression of artistic language they contribute nothing.

Following the Persian example, the Emperor came increasingly to identify himself with divinity. After the Tetrarchy, Court protocol referred to the Emperor's *divina maiestas*; his bodyguards were known as 'defenders of the divine person', while the Imperial robe became the 'sacred garment'. All this terminology was taken over by the Byzantine age, together with ceremonial which still survives at the Pontifical Court of the Vatican. Representations of the Emperor show him ever more distant and impersonal, enclosed in a formal pattern laid down by Court etiquette. In coins struck as early as 364–75, the enthroned portraits of Valentinian I and Valens have that fixed quality which later came to characterize the holy icons of Byzantium.

From Constantine's day on, artistic production became not only increasingly official in tone, but aulic as well. It was, in short, a Court art, specializing in cameos, jewellery, silverware, ivory diptychs. These diptychs were something quite new in art, and achieved widespread popularity in the fourth century. Originally the diptych had consisted of two tablets, hinged together and used to write on. From this was derived the so-called 'codicillary diptych', employed for the promulgation of Imperial decrees. The next step was a diptych carved in ivory, and decorated with representations of the Emperor and the consuls. Such diptychs were presented, on taking up office at the beginning of the year, to private persons and high-ranking officials, perhaps even to the Emperor in person. A law of 384 (Theodosian Code 15.9) laid down that ivory diptychs could be presented only to the consuls; for lesser officials special authorization had to be obtained from the Emperor. This law, however, must have soon fallen into abeyance. The Church subsequently adopted the diptych for liturgical use (reading the list of bishops and of members of a community). At first this type had no decorations; but figured specimens

29 TRÈVES. COIN OF VALENTINIAN I AND VALENS. ROME, MUSEO NAZIONALE

33

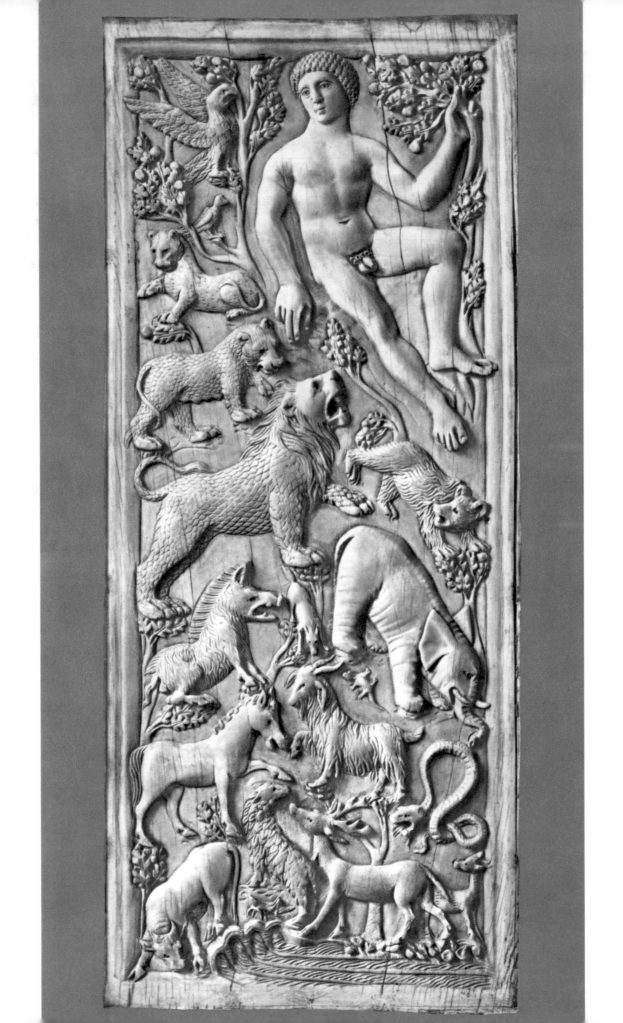

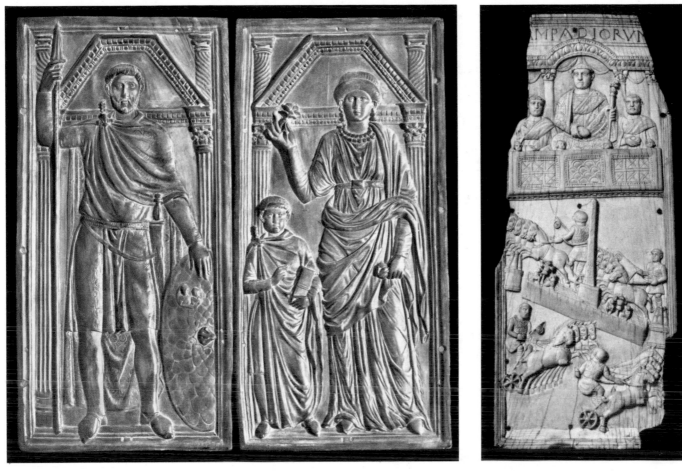

31 MILAN (?). DIPTYCH OF STILICHO. MONZA, CATHEDRAL 32 DIPTYCH OF THE LAMPADII. BRESCIA

begin to appear by the end of the fourth century. A good example is that depicting both Adam and the story of Paul (Florence, Bargello), in which Adam is portrayed like ancient Orpheus, surrounded by animals. The fidelity shown in both form and motifs suggests that this piece was produced in the Eastern half of the Empire (Constantinople?); but the coherent vertical structuring of the composition features regularly in fourth-century mosaics from Algeria and Tunisia. Secular diptychs disappear with the abolition of the consulship in 541; those employed by the Church were still being produced as late as the seventh century. It is possible to distinguish a number of production-centres, both in the East and in the West. The diptych portraying Stilicho (consul in 400), together with his wife Serena, Theodosius's niece, and his son Eucherius, who since 395 had held various honorary posts, was probably made in Milan (Monza Cathedral). This diptych is a good example of the aulic or Court style, a highly decorative variety of representative art. On the other hand, the fragmentary piece which bears the name of the Lampadii, and was probably turned out by a Roman workshop, once more recalls the conventions of Roman 'plebeian art'. It shows us a scene from the Circus. The President of the Games, wearing triumphal attire and flanked by persons in togas, sits there, completely impassive, separated from the rest of the scene, a hieratic and official figure. In his hand he holds the symbol of his function, the napkin (*mappa*), with which he gives the signal for the races to start.

35

◀ 30 CONSTANTINOPLE (?). ONE LEAF OF A DIPTYCH: ADAM IN PARADISE. FLORENCE, MUSEO NAZIONALE

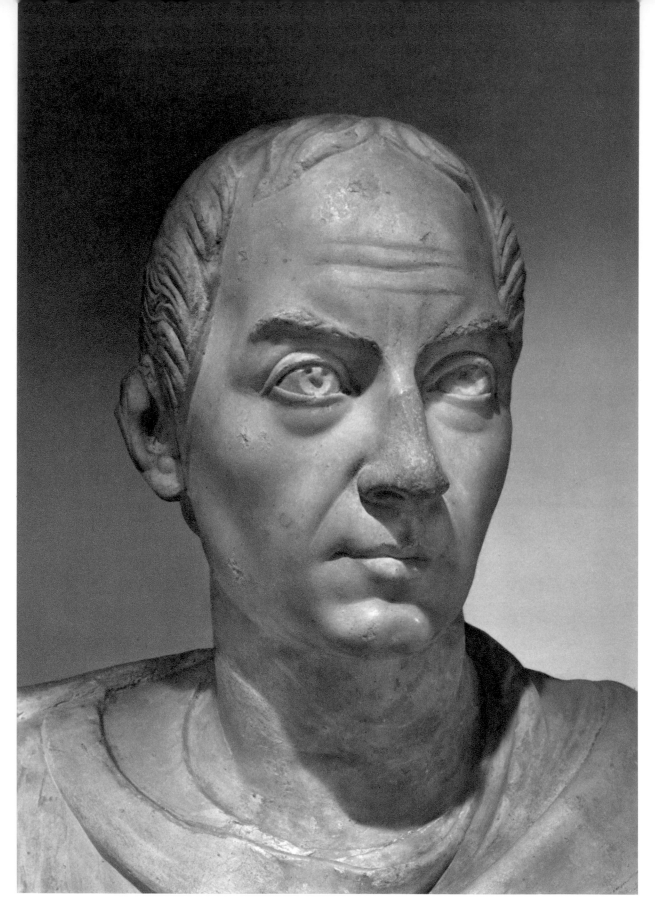

33 ROME. STATUE OF A CONSUL (DETAIL). ROME, PALAZZO DEI CONSERVATORI

36

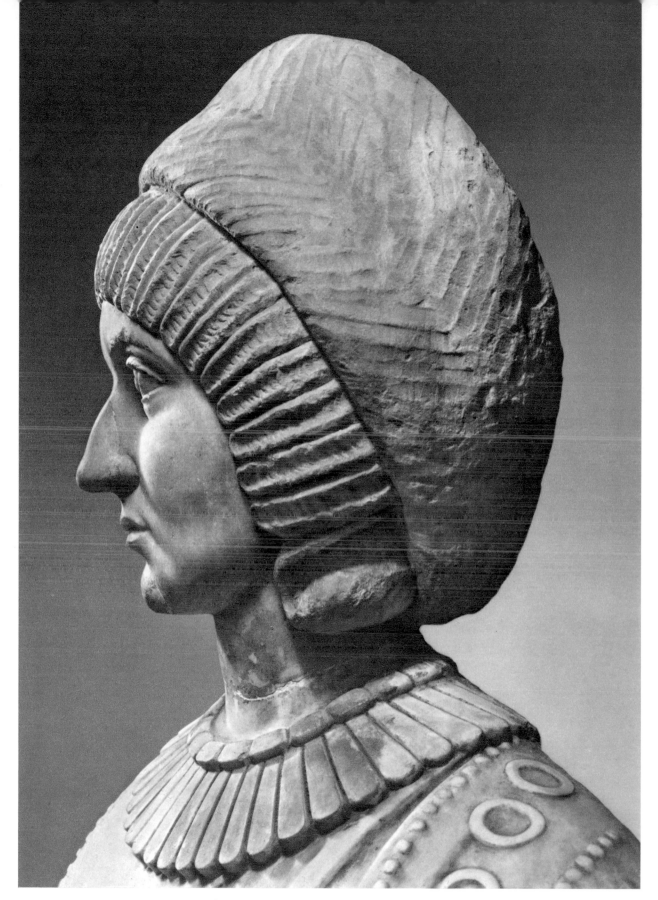

34 ROME. PORTRAIT OF A LADY: EUDOXIA (?). ROME, MUSEO TORLONIA

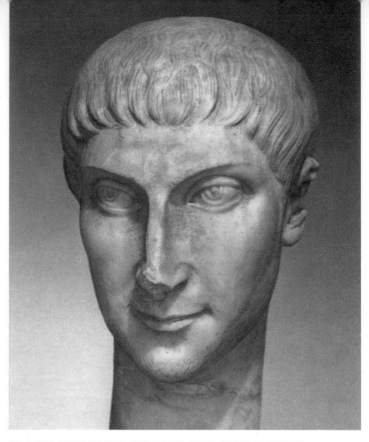

35 ROME. PORTRAIT OF A YOUNG MAN. ROME, MUSEO NAZIONALE

The surface polish and clarity of outline which characterize ivory artefacts exactly suited the taste of the times – especially that of high-class society. We find the same attention to detail in sculpture: see, for example, the statue of a consul (Rome, Palazzo dei Conservatori) who is also about to give the starting-signal at the races. The same applies to a fine portrait of a woman (Rome, Museo Torlonia), which seems to date from this period, that is, the close of the fourth century. Since it was discovered in the mauso-leum of Constantine's mother, Helena, scholars have suggested that it may represent Eudoxia, first wife of the Emperor Arcadius, who died in 404. This identification remains hypothetical, but the style of sculpture – polished and mannered – is more consonant with such a dating than with other proposals that have been made (e.g. the identification with Eutropia, Maximian's wife, who lived a century earlier).

All this goes to show how little we know about art in the centuries when Antiquity was drawing to a close, and the Byzantine age had not yet established itself.

The anguished state of Roman society is apparent also in its passion for the Circus, for chariot-races and gladiatorial combats – a passion which in the third century assumed fanatical proportions. In terms of modern psychology, this obsession with aggressiveness and the spectacle of bloodshed is the reflection of a repressive society, where violence – as constantly applied to the individual by those wielding power – becomes a transferred emotion which the individual himself directs against others, in unconscious reaction against his own alienated state.

38

PART ONE

Rome and the West

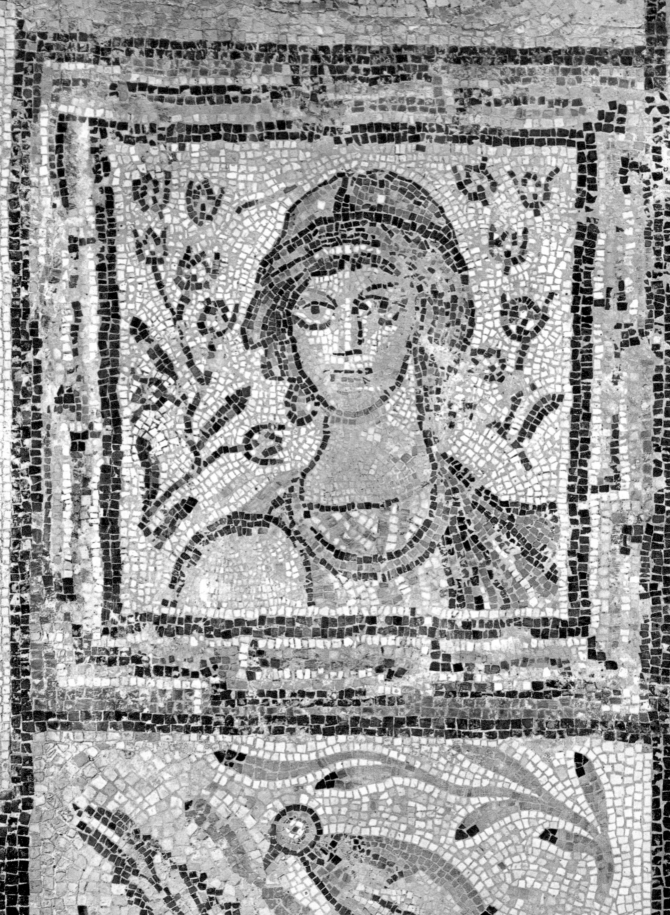

1 Rome

AT the beginning of the third century, under the Severi (Septimius Severus, 193–211, Caracalla, 211–17, Heliogabalus, 218–22, and Alexander Severus, 222–35), Rome was still the political and economic centre of power. The ruling class, however, had undergone a radical transformation. Power no longer lay with the old patrician families, while the Equites had become a class of merchants and bureaucrats. After the centralizing and authoritarian reforms of Septimius Severus, the State bureaucracy – many of its posts now filled by provincials – became increasingly important. Later, indeed, it assumed *de facto* responsibility for running the Empire. The extension of citizenship to all freeborn men (the *Constitutio Antoniniana* of 212), with the sole exception of the *dediticii* (who were, at best, no more than groups of conquered barbarians), did away with Italy's privileged status. It also brought social climbers flocking to Rome, and encouraged trade throughout the Empire. The newcomers came, for the most part, from the Eastern provinces (the Severi themselves had family connections with Syria). The Roman ruling classes, despite their efforts – during the late Republic and early Empire – to assimilate the culture of their Hellenistic counterparts, had in fact done no more than adopt its outer aspects. They were wide open to the influence of the philosophico-religious ideologies that were spreading from the Hellenistic East. This swing towards irrationality, which had begun already under the Antonines (and in some respects as early as Hadrian), was general by Commodus's day; it became steadily more intense and complex, and ended up by stifling all attempts to interpret the real world in rational terms. Experimental research fell completely out of favour, and art moved away from the objective interpretation of reality. But naturalist rationalism (which had been behind the great artistic movement of the Hellenistic world) still retained the power, sanctioned by tradition, of imposing formal classical patterns. However, since an allusive symbolic vision of reality was now beginning to prevail, the old tradition gradually lost hold, especially in commemorative monuments, which should have had (and until Trajan's reign, as regards official art, *did* have) a realistic character where their historical narrative was concerned. The symbolic aspect of commemorative representation, hitherto only noticeable in works which can be connected with the 'plebeian' side of Roman art, now comes to the fore in official works as well – sometimes by way of a different,

41

and more complex, ideological process. There was no further intellectual speculation on aesthetics, such as we find in the literature of ancient Greece or, later, in that of the European Renaissance. Consequently a number of contrasting trends in art managed to coexist, and the only factor linking them was the vast technical experience handed down in the marble-workers' studios. Our few literary sources, when they do speak of art, invariably remain faithful to the old formulae. As for the doctrines of Plotinus, I have already indicated the limits of their potential influence in my Introduction.

The sculpture of this period is primarily represented, in Rome, by an enormous number of marble sarcophagi. These provide a vast repertoire of stock compositions, which the workshops continued to turn out over a long period. This transmission took place without any fresh contact, on the artist's part, with reality – a process on which any new and original creative development must depend. The work was thus a mere exercise in style, and those who executed it ended up as its prisoners. The style suggested new solutions to them, but always of a purely formal character. This is only too clear from the progressively greater emphasis placed by Roman workshops on effects designed to enhance expression – effects which afterwards vanish almost without trace.

The confrontation with reality still exists in the portrait. Although here, too, we find an admixture of traditional elements, and a general movement, in the fourth century, towards schematism, nevertheless the excellence and novelty which third-century portraiture displays make it one of the main art-forms of its time. As we shall see in the next chapter, this confrontation with reality tended to appear more often, and more spontaneously, in the European provinces, where art was still directly bound up with the life of the purchaser, whose requirements seldom involved any cultural presuppositions. This is why we often find provincial art working out formal innovations that are taken up only later by the capital – a phenomenon which has, absurdly, led some scholars to infer the 'influence' of provincial art on that of Rome. It is not a matter of influence, but of analogous cultural and social situations flourishing at different periods.

During these years, Rome still remains the crucible for every sort of artistic experiment, while the Hellenistic centres still provide the artists and the works of art. As for sarcophagi, over and above home production in Rome we find a flourishing import trade from Attica and Asia Minor. The various types of imported sarcophagus are easily distinguishable. We find, first, Attic sarcophagi in the form of a bed (*kline*), with decorations imitating tapestry-work (*pl. 38*), or representations of the deceased stretched out on the lid. We also have Asiatic sarcophagi with niches and arcades. All these correspond to the type of monumental sepulchre found in Asia Minor – architectural in form, with an inner chamber. The sarcophagus would be placed in the middle of this chamber, and was therefore decorated on all four sides. Since Latin and Etruscan custom prescribed that coffins should be placed against the walls of the vault, sarcophagi produced in Rome had their rear side left blank – except those of oval design, most of which were decorated throughout, even if of Roman manufacture. Rome imported sarcophagi of Pentelic marble from Athens, others from the many quarries in Asia Minor, and – to a lesser extent – marble sarcophagi from Proconnesus (the island of Marmara), with roof-shaped lids, and shells decorated with garlands, the latter supported by Cupids or

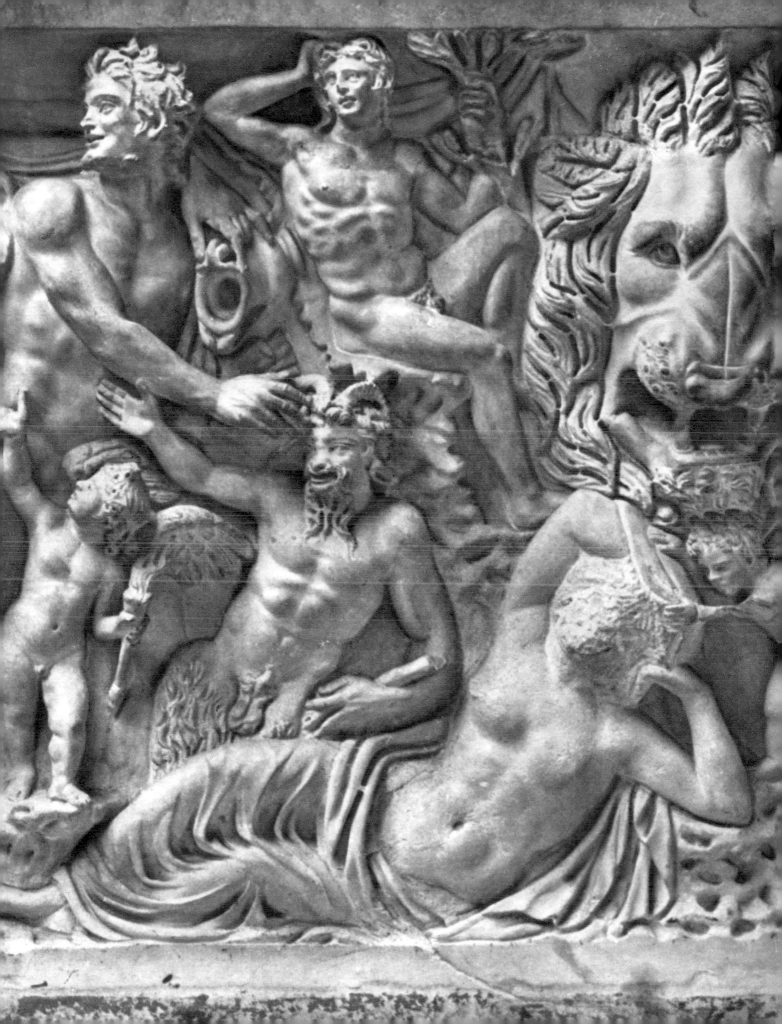

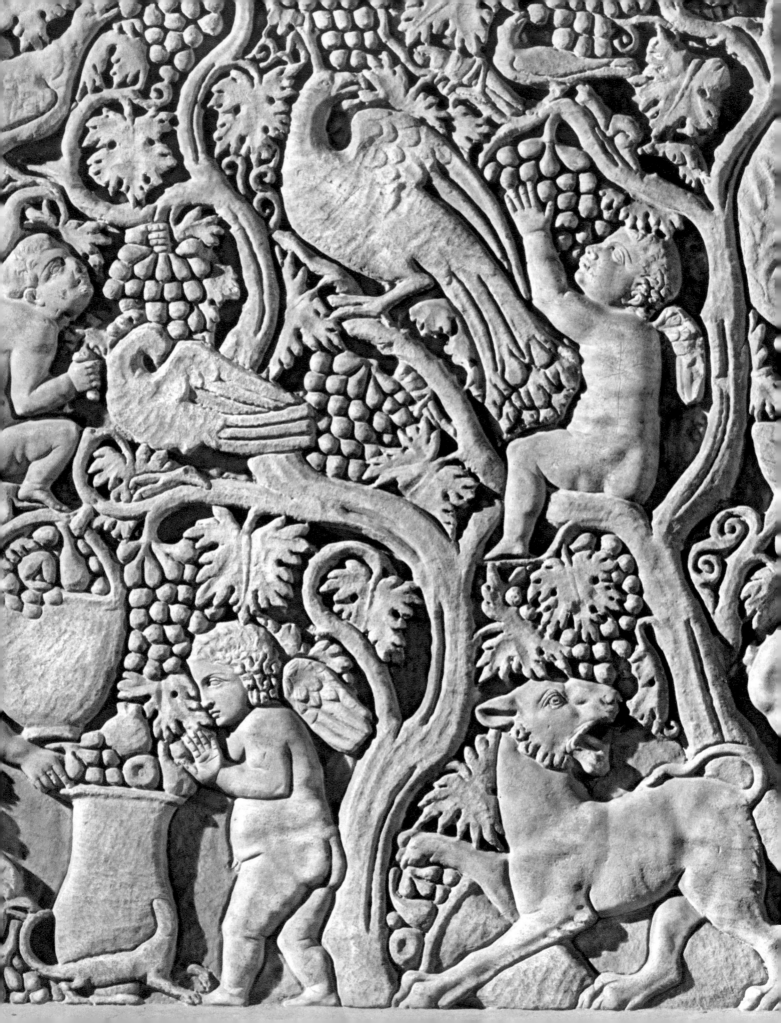

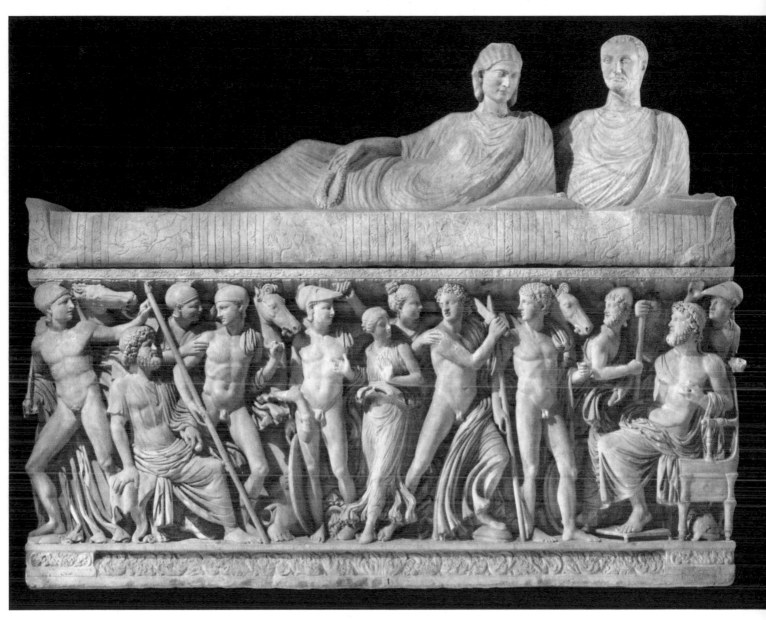

39 ROME. ATTIC SARCOPHAGUS: ACHILLES AT THE COURT OF LYCOMEDES. ROME, MUSEO CAPITOLINO

Victories. The recent discovery, off Taranto, of a wreck from the first half of the third century, with 24 sarcophagi as cargo, has revealed that coffins were often dispatched to Rome with their relief-work merely blocked in – the work, presumably, to be finished off on arrival. This being so, we have to infer the presence, in Rome, of monumental masons and sculptors from the same country as that which dispatched the sarcophagi, since not only in the iconography, but also in the style and workmanship, there are no detectable discrepancies. Such a set-up could hardly fail to have some influence on the Roman workshops.

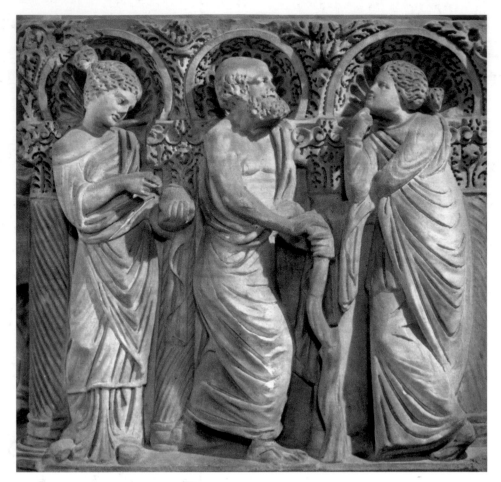

40 ROME. ASIATIC SARCOPHAGUS: MUSES AND MEN OF LETTERS. ROME, MUSEO NAZIONALE

The great sarcophagus of Velletri (discovered in 1955) is particularly illuminating as regards the ideological content of the sculptures on sarcophagi generally. It is certainly of Roman manufacture, and a somewhat coarse piece of work; but its complex and superabundant iconography is based on a 'pattern-album' which must derive from the Eastern provinces. It can be dated to the mid-second century, and I mention it here because its overloaded programme (as B. Andreae remarked) provides an exhaustive picture of the eschatology underlying all symbolism associated with Roman sarcophagus-decoration of the third century. At the heart of this symbolism we find the idea that the essence of humanity is immortal, and that upon the death of the body it passes into a world beyond the grave, with which one can communicate by means of love. Hence the representations of Eros, and of various myths like those of Protesilaus, Proserpine and Alcestis – the latter actually turns up in a fourth-century *Christian* sepulchre on the Via Latina. Man goes through life like an actor playing a part (theatrical elements, masks), and must bravely shoulder the trials which his destiny imposes on him (like Hercules, the hero who becomes a god). He must not – as did the Giants – oppose the Gods, but must show them respect (scenes of sacrifice) and conduct himself with patience and humanity (like the shepherd). Tritons, nereids and eagles accompany the deceased to the Islands of the Blest. On the Velletri sarcophagus all these ideas are brought together and expressed by means of symbols or allegories. But in other cases a

46

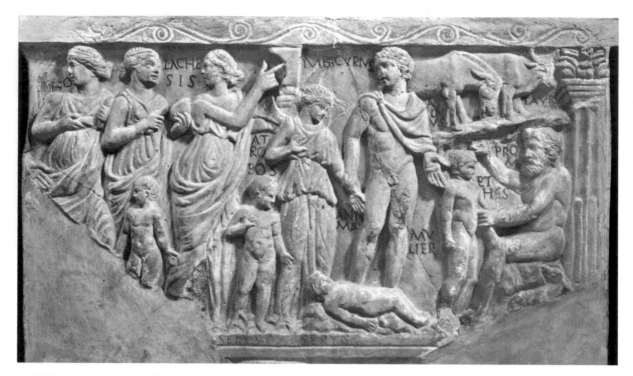

42 ROME. FRAGMENT OF SARCOPHAGUS: THE PROMETHEUS MYTH. THE VATICAN, MUSEO PIO CLEMENTINO

single symbolic scene suffices to recall the general substance of these eschatological beliefs, which in themselves suggest how widespread, in this period, were the feelings of spiritual anxiety I have described. This anxiety, fed by Hellenistic philosophical texts (such as that pseudo-Platonic dialogue the *Axiochus*), and based on the Hermetic tradition, with its doctrines of mysticism and *gnosis*, was further reinforced by the spread of the mystery cults. But not everything here can be summed up in the general notion of 'immortality'.

In this respect, the sarcophagi portraying Prometheus are particularly instructive. As A. J. Festugière has demonstrated, in addition to the promise of astral immortality, emphasis is laid on the positive content of a well-led life here on earth, in a world which reveals its own special bounteousness, and has its own eternity in the cycle of the seasons: a world from which man, his work once accomplished, vanishes at the Fates' bidding. But other men, and new life, spring up continually to take his place. Prometheus never ceases to shape fresh human beings, the seasons produce their fruits for ever. Ox and ass represent the earth that awaits fresh sowing, while Mercury escorts and reassures the Soul (fragment of sarcophagus bearing explanatory inscriptions, in the Vatican). In fact, as far as the various groups of pagan intellectuals were concerned, among the many minor sects none was so important as the doctrine of devotion to Mercury-Hermes (Hermetism), into which there also entered certain Platonic and Pythagorean elements. With the sarcophagi of the third century, bas-relief art entered a world where form was eclipsed in importance by symbolic spiritual content. It is precisely this which marks the division between the medieval world and that of Hellenistic and classical antiquity.

Side by side with these popular philosophico-religious ideologies (and whether or not they led to a genuine initiation into 'revealed truths', their essential tenet was always the

48

43 ROME. SARCOPHAGUS (DETAIL). PISA, CAMPOSANTO (CEMETERY)

promise of new life after death) we find, during the first half of the third century, another equally widespread motif. Many sarcophagi are decorated with scenes taken from the myth-cycle of Dionysus (Bacchus), the god who died and was reborn. Some have a vat-like shell decorated with a row of parallel S-shaped flutings (known as 'strigils'), and two lions' heads in front. Its very shape bespeaks Dionysiac inspiration; it was, in fact, derived from the vat in which the grapes were trodden out, where the must fermented, and whence, in due course, wine ran out, through the ornamental mouths in the lions' heads – purified, life-saving, sacred to Dionysus. Here we have a plain allusion to the prospect of a new, better, and purer life after the death and dissolution of the old self.

49

As early as 149, Marcus Aurelius had himself portrayed on a medallion, with Faustina, in a chariot drawn by centaurs – like a new Dionysus with Ariadne – to indicate his hope of eternal bliss. In the third century such symbolico-religious elements multiply: the Severan period provides magnificent examples of oval sarcophagi representing Dionysus's Indian triumph, or the awakening of Ariadne, welcomed by the god as a soul torn from death's clutches. The fact that Ariadne has the features of the deceased perhaps suggests a hope for personal salvation rather than any more generalized expectation. Sometimes the scene of triumph or Bacchic rout (*thiasos*) represented on the shell is completed, on the lid, with a portrayal of the birth and childhood of Dionysus. The most beautiful group of Dionysiac sarcophagi, dating from 180–225, is that discovered in two funeral vaults belonging to the family of the Calpurnii Pisones, near the Porta Pia in Rome (Baltimore, Walters Art Gallery; two less beautiful pieces are at Rome, in the Museo Nazionale). The Dionysiac sarcophagus built into the façade of the Villa Medici in Rome, and the sarcophagus from the Palazzo Taverna, also in Rome (now in the Pushkin Museum, Moscow), are very similar in feeling.

All these pieces show clear traces of literary inspiration, something which marks them off from run-of-the-mill products turned out during the Roman period, and relates them to sources of inspiration still rooted in Hellenism. Their exuberant use of chiaroscuro and landscape motifs has led some writers to talk of 'baroque' art, and strongly suggests that their themes may derive from pictorial compositions.

We find confirmation of such an origin in a piece of material from Antinoe (Paris, Louvre), designed as a wall-hanging, and decorated with stencilled figures. The composition on this material is identical with that on the sarcophagi. A narrow band at the top (corresponding to the rim of the lid) tells the story of Dionysus's birth. Next comes a strip with vine-branches full of birds, and finally a major composition featuring Bacchic dances, in the presence of a majestic Dionysus. The figures are accompanied by their names, in Greek. Bearing the sarcophagi in mind, one might place the execution of the 'Antinoe veil' about the end of the third century (as De Francovich proposes); but I myself would put it about the middle of the fifth. Yet the iconographic pattern must be older, and its persistence – even when Dionysiac sarcophagi were no longer being produced – confirms the existence of a pictorial iconography which showed some predilection for these topics.

In the third century people preferred Dionysiac sarcophagi to those decorated with epic or mythological themes, which had been the rage a hundred years before. Yet we still find certain isolated themes – of quite transparent symbolism – that still took people's fancy in the early decades of the third century. The myths of Medea, Phaethon, Meleager, of Phaedra and Hippolyta, of Endymion and Diana, continue to turn up: we find a fixed basic pattern on which the artist works dramatic variations, sometimes with great skill. It was from sarcophagi of this period that Italian Renaissance artists drew inspiration, even for New Testament iconography (the Birth of Christ, the Deposition from the Cross), finding in this 'antique' sculpture a reality rendered truer than nature through art. One obvious instance of this sort of borrowing is the tomb of the Florentine merchant Francesco Sassetti, for which Giuliano da Sangallo found his inspiration in a *Death of Meleager* (late 1480s, Florence, S. Trinità).

45 ANTINOE. THE 'ANTINOE VEIL': BIRTH OF BACCHUS, AND BACCHIC THIASOS. PARIS, LOUVRE

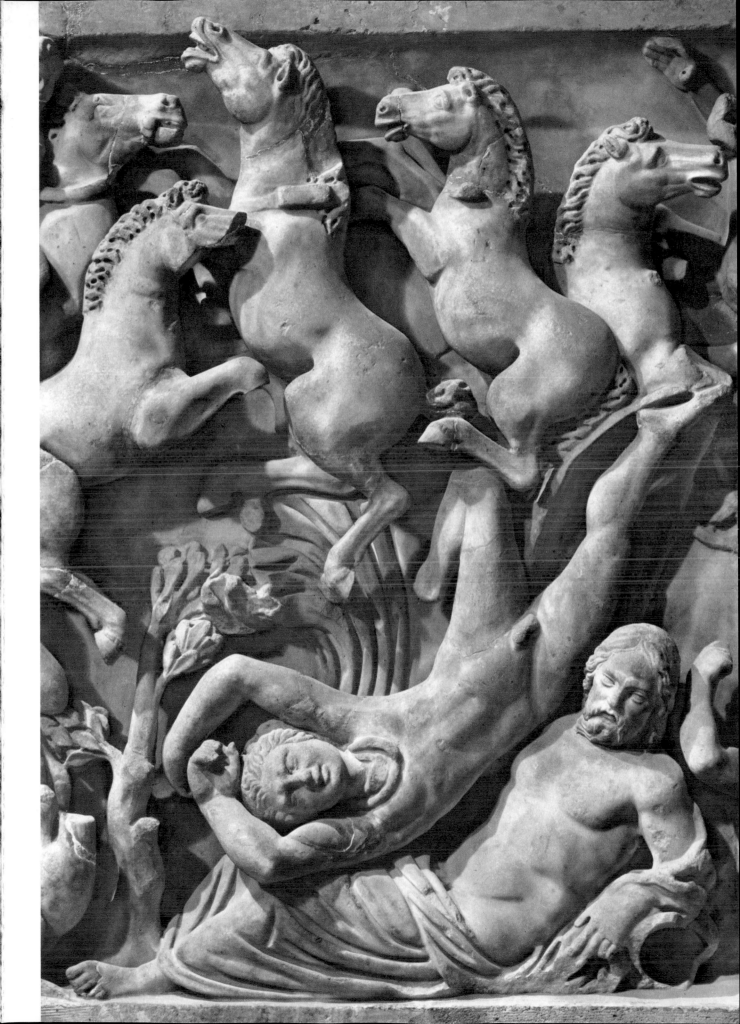

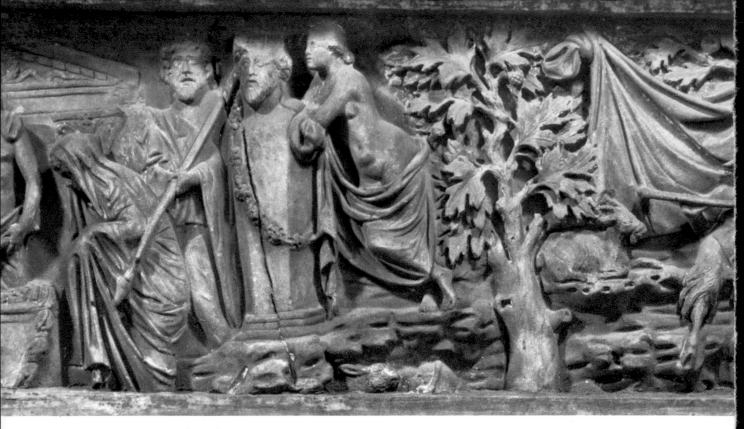

44 ROME. SARCOPHAGUS (DETAIL): BACCHIC INITIATION AND THE MEETING WITH ARIADNE. ROME, VILLA MEDICI

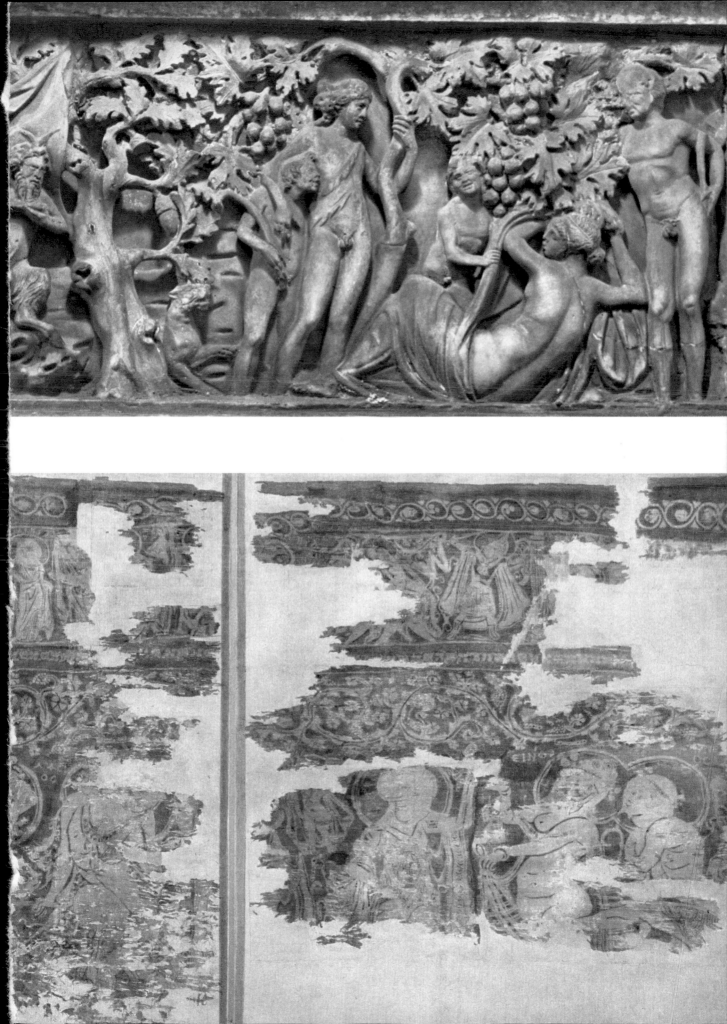

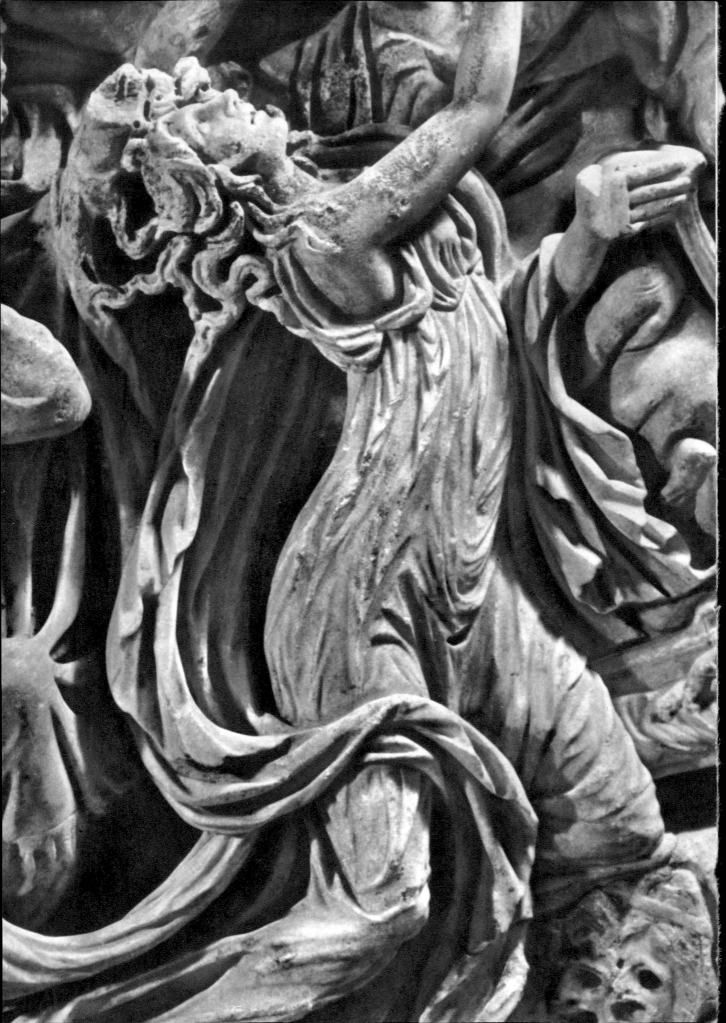

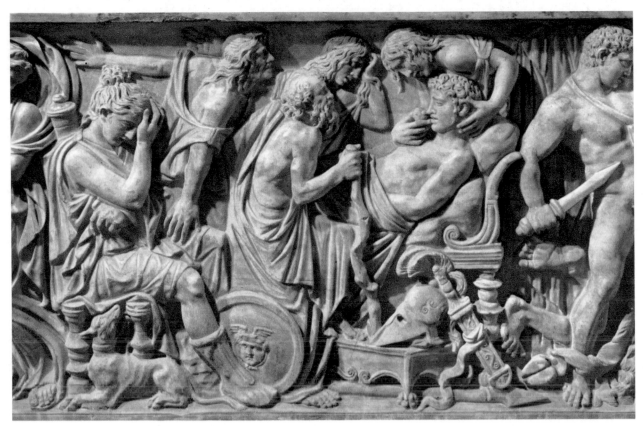

48 ROME. FRAGMENT OF SARCOPHAGUS: THE DEATH OF MELEAGER. PARIS, LOUVRE

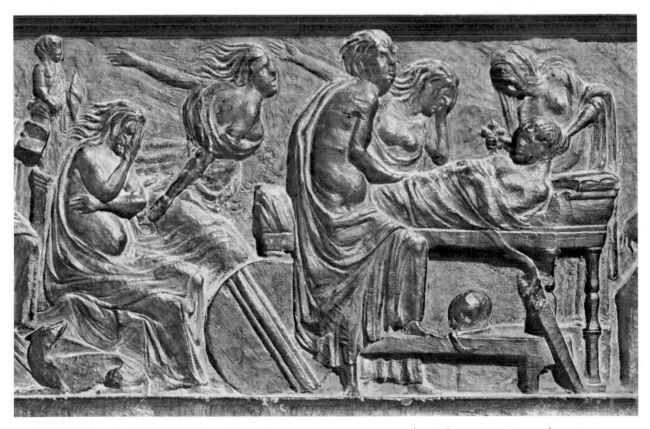

49 FLORENCE. GUILIANO DA SANGALLO: FUNERARY MONUMENT OF FRANCESCO SASSETTI (DETAIL). FLORENCE, S. TRINITÀ

◄ 46 ROME (?). SARCOPHAGUS WITH THE STORY OF MEDEA (DETAIL): THE DYING SPOUSE. BASLE, ANTIKENMUSEUM

◄ 47 ROME. SARCOPHAGUS (DETAIL): THE FALL OF PHAETHON. PARIS, LOUVRE

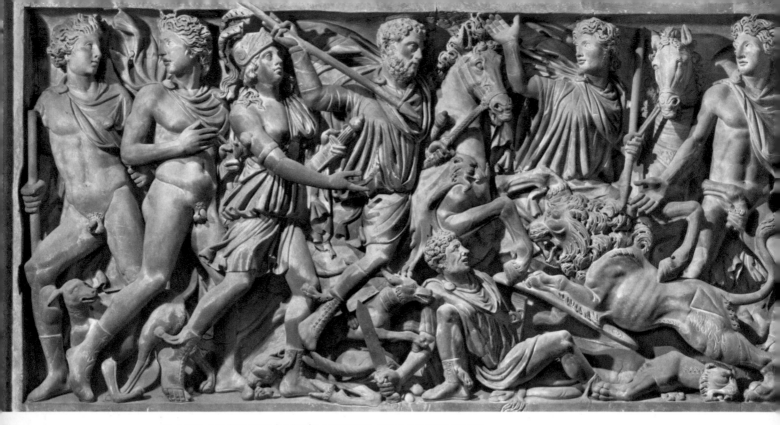

50 ROME. SARCOPHAGUS (DETAIL): LION-HUNT. ROME, PALAZZO MATTEI

Another series of sarcophagi presents figurative decorations which refer to the deceased, some in a symbolic manner, others by allusions to his life. The latter, however, are framed in such a way that they could be adapted to the requirements of a large clientele: marriage, military career, the offering of a sacrifice; country, family, religion – the pattern of every well-established bourgeoisie. In other words, a sarcophagus was seldom executed to order, with the sculptured reliefs being specially created to suit the personal circumstances of the deceased. More often it is mass-produced work, with the heads of the leading figures left blank, so that the features of any client could be inserted at need. Very often this last stage has not been carried out; and when the portrait *is* there, it tends to contrast sharply with the rest of the work.

These sarcophagi adorned with episodes from the 'life of the deceased' stand in the Roman tradition of commemorative reliefs. Others derive from concepts that are Graeco-Oriental in origin: e.g. those in which the deceased is shown lion-hunting (a symbolic expression of his physical and moral courage, *virtus*), or those – more frequent in the second half of the century – in which the deceased is shown as a philosopher, among other sages and the Muses. One of the best and latest examples in this series reveals that such a portrayal was purely symbolic: the stripling officer Peregrinus (Rome, Museo Torlonia) was certainly no philosopher. The upper classes, it would seem, preferred above all other symbolism that which represented the deceased as a 'spiritual man' (*homo spiritualis, aner pneumatikos*), a philosopher in the Plotinian sense of that word, reading or teaching among other philosophers. The philosophers on Peregrinus's sarcophagus are no longer individually characterized as representatives of different schools; their iconography could be, and was, taken over later to portray the Christian apostles. It is in this series of 'philosopher' sarcophagi, during the last thirty

56

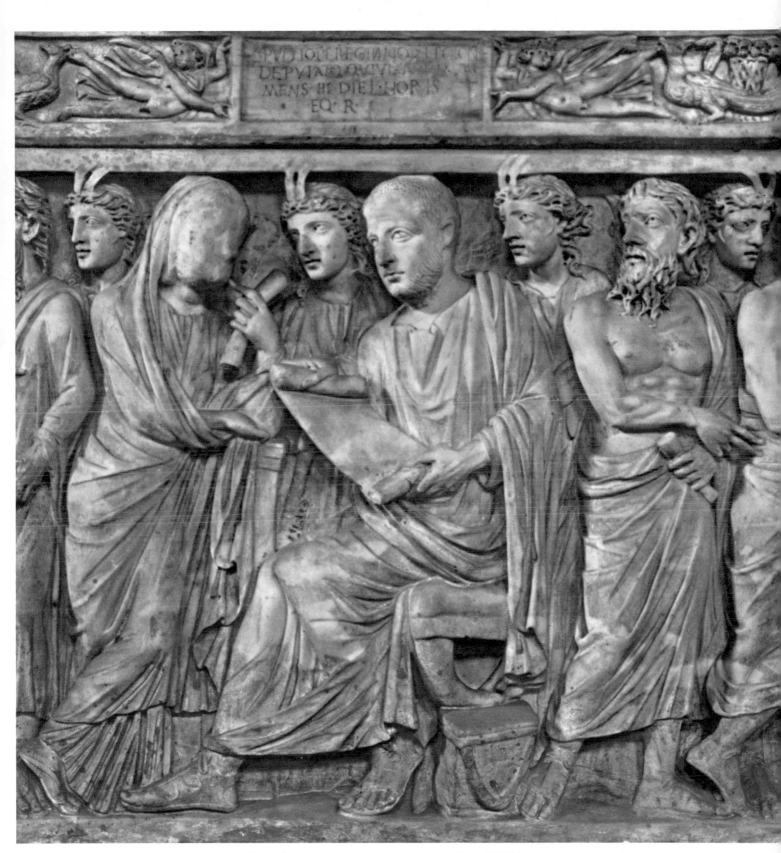

51 ROME. SARCOPHAGUS OF PUBLIUS PEREGRINUS (DETAIL): MUSES AND PHILOSOPHERS. ROME, MUSEO TORLONIA

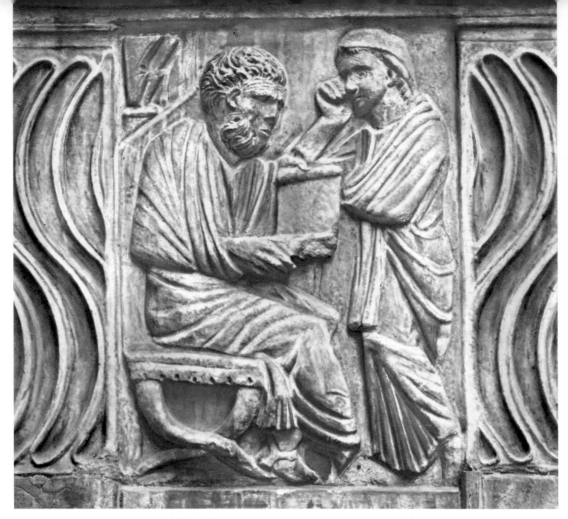

52 ROME. CHRISTIAN SARCOPHAGUS (DETAIL): THE TRUE PHILOSOPHY. ROME, PALAZZO SANSEVERINO-RONDANINI

years of the third century, that we find the first representations – crypto-Christian still – of the Master who brought the 'true philosophy', the tidings of great joy, the Gospel itself. St Peter's 'chair' was not yet regarded as a throne, the symbol of authority (that came later), but truly as a chair of learning and teaching. Crypto-Christian art takes over the traditional image of the philosopher, but translates it into a less refined plastic format, closer to the 'plebeian' tradition, perhaps even identical with it. The 'plebeian' tradition now assimilated the tendency to accentuate facial expressions; and it had always dealt with factual narrative in an allusive, symbolic fashion. The result was such works as *The Sermon on the Mount* (Rome, Museo Nazionale). From now on, this symbolic approach becomes more pronounced where the subject-matter is Christian. The facts narrated are *exempla*, drawn from the Old or New Testament. The earliest Christian sarcophagi in Rome adhere faithfully to the 'plebeian' trend in art – the term being used, of course, to denote an artistic category, not a social one.

The marble sarcophagus had always been an expensive type of sepulchre, and in the second half of the century its luxury increased still further – with a corresponding rise in price. The famous 'battle sarcophagus' from the Ludovisi collection (*pl. 54*) is quite exceptional in its sheer grandeur and the richness of its relief-work. Its date now appears to be firmly established. It has been convincingly suggested (by H. von Heintze) that the

58

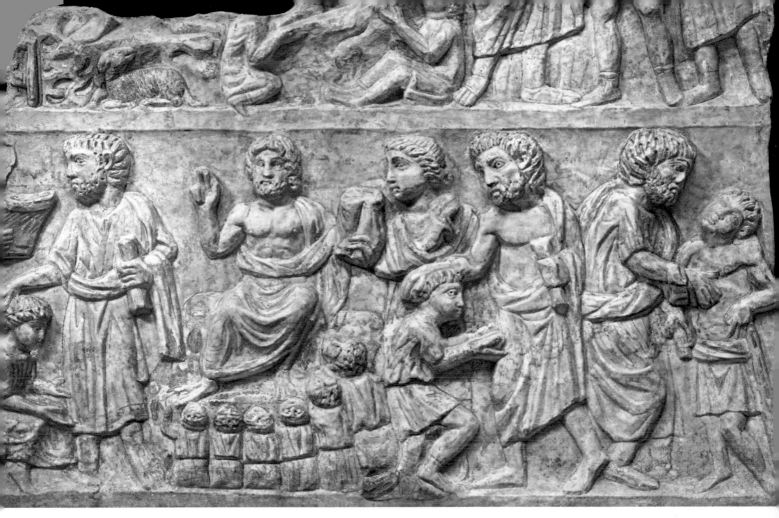

53 ROME, VIGNA MACCARANI. THE SERMON OF CHRIST ON THE MOUNT. ROME, MUSEO NAZIONALE

heroic figure on horseback, whose forehead is marked with a cruciform scar (the distinguishing mark of a Mithraic initiate), is the same person as the sitter for a certain bust in the Museo Capitolino, generally identified as Hostilian, son of the Emperor Decius, who died in 251. Moreover, the emphasis on vertical composition is apparent also in certain paintings (e.g. miniature XXXVII of the *Ilias Ambrosiana*) derived from models which go back to the mid-third century. The Ludovisi sarcophagus is the last major example of the so-called baroque trend. The high-polish technique imparted to its marble is altogether too much of a good thing. Its formal structure is brilliant, but strained and lacking in inner warmth.

In view of the mannered frigidity which lurks behind the highly professional technique evident in Gallienus's reign (253–68), I cannot accept the suggestion of such a date for the sarcophagus fragments found at Acilia, between Rome and Ostia (*pl. 55*). From the stylistic viewpoint, the Acilia sarcophagus has a certain grandiose rhythm, a warmth of expression in the faces of its figures, that at once place it in a quite different category from the Ludovisi sarcophagus. In my opinion, it is one of those rare sarcophagi that were made to special order. It belongs to the tub-shaped group, and is decorated with a procession of Muses and philosophers, escorting a bridal couple. But the traditional pattern has been modified by the introduction of an unusual figure who can only be

59

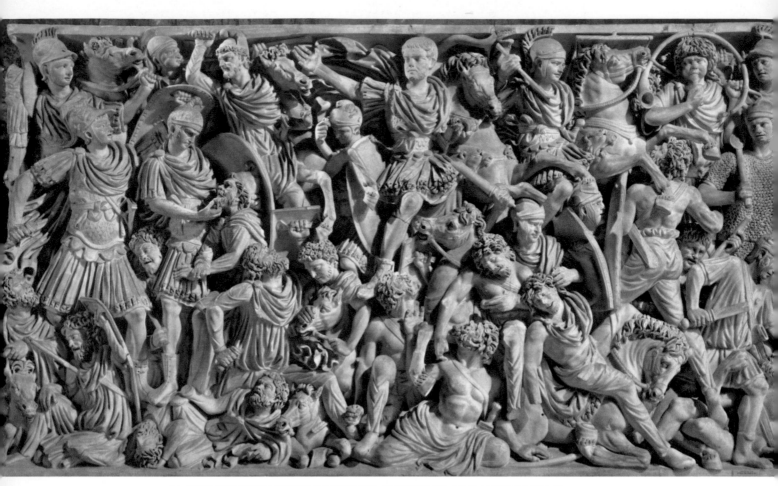

54 ROME. THE GREAT LUDOVISI SARCOPHAGUS: BATTLE-SCENE. ROME, MUSEO NAZIONALE

interpreted as the Genius of the Senate. This figure appears to be pointing at something with his outstretched hand. The gesture used to be taken to refer to the young man whose head – surely a separately sculpted portrait – stands out noticeably among those of the stock-figure 'philosophers'. The only person whom this supposed designation seemed to fit was Gordian III (the Pious). Early in July 238 the Senate hurriedly proclaimed this mere child Emperor, before he could be foisted on them by the rioting populace – to whose clashes with the Praetorians Pupienus and Balbus, the pair of Senators proclaimed three months previously, had already fallen victim. But recently Andreae has suggested (*Festschrift U. Jantzen*, 1969) that this sarcophagus may in fact show a procession accompanying the newly elected consul on his entry into office. Though such a hypothesis does not get rid of every difficulty, it seems eminently plausible. Nevertheless, the chronology of these pieces – around the middle of the third century – needs careful re-examination.

Another specially commissioned sarcophagus offers us most expressive portraits of a married couple amid symbols of the *cura annonae*, which dealt administratively with the import of grain (and other victuals) and their distribution to the Roman populace. The grain came primarily from Africa, and was off-loaded at Ostia. This sarcophagus can be

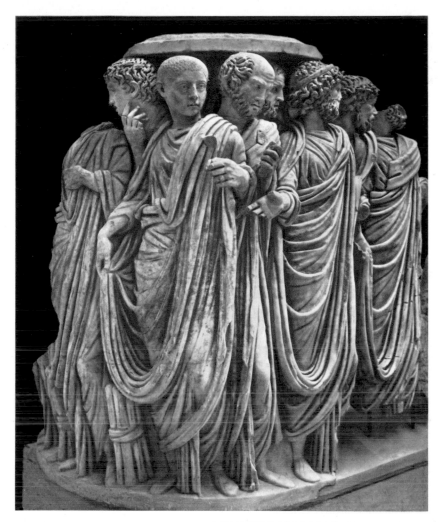

55 ACILIA FRAGMENT OF SARCOPHAGUS: SUPPOSED DESIGNATION OF GORDIAN III. ROME

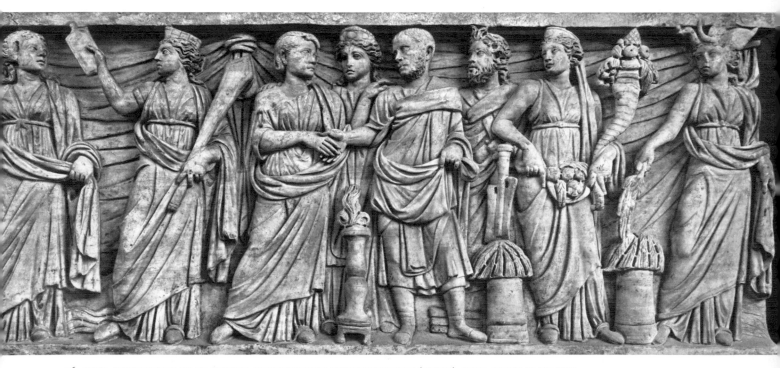

56 ROME. SARCOPHAGUS OF AN OFFICIAL RESPONSIBLE FOR THE COMMISSARIAT (DETAIL). ROME, MUSEO NAZIONALE

dated to the closing decades of the third century BC. The portraits of husband and wife give us a good instance of that 'anguished expression' discussed in the Introduction.

A study of surviving sarcophagi substantiates the claim that the 'expressionist' trend was a typical feature of Roman stonemasons' workshops in the second half of the third century. But side by side with it there persisted another tradition, based on neo-Attic, would-be classical models. The latter serve as a point of departure, especially after 250 (Gallienus's period), for the emergence of a special type of winged Genius, very stiff and finicky in design, which represented the Seasons: symbol of time, passing, changing, yet enduring for all eternity. These guardians of eternity (into which the deceased is about to pass) are, along with the Victories, the immediate precursors of the angel-figure, as developed in Christian iconography. Here, as with the philosopher-apostles, we find another element which survives from antiquity into the culture of Byzantium. During this period even the representations on official monuments undergo various irrevocable transformations – though they still remain the meeting-point of different artistic trends, each with its own tradition.

This is clearly illustrated by the arch which the Senate put up in the Forum Romanum to honour Septimius Severus and Caracalla. From its dedicatory inscription we can work out that the inauguration must have taken place between 10 December 202 and 9 December 203. Septimius Severus returned to Rome on 13 April 202, after defeating the Parthians in two successive campaigns (195–6 and 197–8) – Rome's most stubborn opponents for centuries. Since 198 Septimius Severus's son Caracalla had acted as his associate in power: the old man did not celebrate his triumph in person, since he was a martyr to gout and could not keep on his feet for so long a ceremony (*Vita* 16.6). The erection of the arch was decided on by the Senate after the second Parthian victory, and was almost complete at the time of the Emperor's return, which allows four to five years for the work to be carried out. It was the most magnificent arch ever built in Rome. A coin shows it surmounted with bronze statues: a six-horse chariot in the middle of the attic storey, flanked by two equestrian statues, each with a foot-soldier following behind. The architectural effect was enriched by the positioning of the columns, with their sumptuous composite capitals. They were not included in the structure as engaged columns, but separate, creating a strong chiaroscuro effect, very much in the contemporary sculptural fashion. (The arches dedicated to Caracalla in Africa, at Djemila and Tebessa, are similarly designed.) The Victories at the back of the main archway, and the little Genii of the Seasons placed underneath, show no departure from the stock pattern. The large river-figures at the back of the side-arches are more original, but still based on a pre-existing model, and still enriched by a certain Hellenistic spirit. In the small frieze set above the side-arches, the tradition of narrative relief is maintained. Such reliefs are always located in the same part of a commemorative arch (cf. those of Titus and Trajan), and they habitually follow the pattern which 'plebeian' art evolved for the commemorative relief. Here, the frieze shows a triumphal procession: chariots laden with war-booty, a large seated figure symbolizing a conquered province, soldiers and prisoners. The procession is coming to a halt before the personified figure of Rome (again, huge and seated), who awaits the submission of these barbarians, holding in her hand the globe, symbol of universal power.

59 ROME, FORUM ROMANUM, ARCH OF SEPTIMIUS SEVERUS. SMALL FRIEZE (DETAIL): TRIUMPHAL PROCESSION

Already this frieze presents features that are characteristic of the Late Empire. Rows of dumpy figures follow one another without connection, in a purely narrative sequence; their physical shape is crudely blocked in, and their drapery is suggested by a few linear incisions. Here is a very clear instance of the decisive role which the 'plebeian' art played in forming Late Empire style at Rome. This frieze much resembles certain sarcophagus-lids which portray banqueting-scenes or processions, both secular and religious, relating to the career of the deceased. They all follow the normal thematic pattern of 'plebeian' art, in that their iconography and formal language is determined without direct reference to models of Hellenistic origin – though these do supply certain details.

The four fragments of the small frieze on the Severan arch are in a bad state of preservation, which makes it impossible to distinguish the different hands that have patently been at work. There is, however, a clear stylistic similarity between the south-west section of the frieze and the four large relief-panels which occupy the central section above the side-arches. These panels, set in a framework of horizontal cornices and vertical columns or pilasters, constitute an innovation in the decorative design of com-memorative arches in that they form a single composition. Their theme, not so much represented as narrated, is a series of episodes from the Parthian campaigns. The three scenes of investment, complete with siege-engines and a domed building typical of Iranian architecture, probably commemorate the reduction of the Parthian capitals, Seleucia, Babylon and Ctesiphon. Our main concern here, however, is with the *manner* in which the narrative has been expressed. When we look at the arch as a whole, it seems that these great panels, with their tiny swarming figures, do not form part of the struc-ture: they are like tapestries hung from a balcony, and give the impression of having been conceived as paintings, not as sculptures integrated into an overall architectural pattern. The architectural impact of the monument suffers as a result. In this context, a piece of evidence provided by Herodian takes on considerable interest. This Syrian-born historian was an official at the court of Commodus, and later at that of the Severi. He

60 ROME. SARCOPHAGUS-LID: PROCESSION WITH IMAGES OF DIVINITIES. ROME, S. LORENZO FUORI LE MURA

61 ROME. SARCOPHAGUS-LID (DETAIL): BANQUETING-SCENE. THE VATICAN, MUSEO CHIARAMONTI

tells us that after the Emperor had wound up his final campaign with the capture of Ctesiphon, he sent dispatches to Rome reporting the news, and with them certain large descriptive paintings, which the Senate exhibited in public (*Herod.* 3.9.12). Rodenwaldt's hypothesis (*CAH* 12.546) of a connection between these paintings and the reliefs on the arch is highly persuasive. But there must have been another factor involved, which made the acceptance of this innovation possible, and I believe it was the historical narrative technique used on the columns of Trajan and Marcus Aurelius. The effect produced by

66

the reliefs on these columns when one studies them from a fixed point, without walking round them to follow the narrative, is identical with that produced by the panels on the Severan arch. There are other resemblances: the devices employed to break up the scenes, or to portray the land, rivers and towns; the small, squat figures, set in compact groups or stretched out in long files, all moving in like fashion. From the formal viewpoint, it is impossible to deny the link between these reliefs and the groups on the Antonine Column, which was finished a bare ten years before the inauguration of the

67

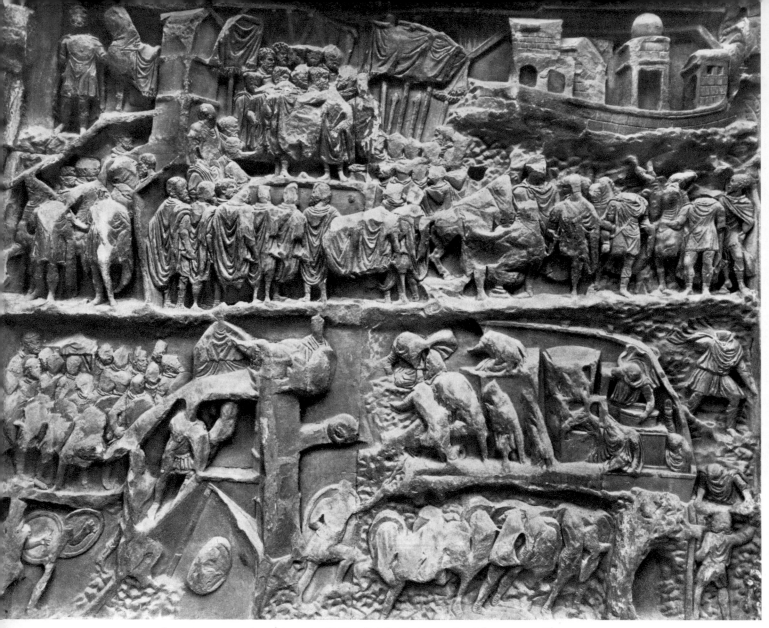

62 ROME, FORUM ROMANUM, ARCH OF SEPTIMIUS SEVERUS. ONE OF THE 'GREAT RELIEFS'

Arch of Severus. But the artist in charge of the work had a taste for the linear, rather than the plastic, and took little trouble to vary his figures, whose heads all look alike. Only one or two characters, on the fringes of the main narrative, contrive to avoid the monotony. It follows, then, that this is the work of a local, Roman, workshop-team, led by an artist who was concerned more with the narration of complex episodes than with formal rhythm and richness of relief-design. With the reliefs of Marcus Aurelius's *Res gestae* (later transferred to the Arch of Constantine) we have an instance of official Roman sculpture in the Hellenistic tradition evolving into something new. But from now on, historically orientated reliefs deliberately abandon this tradition. The characters in a scene are – as here – shown in compact, almost geometric groups; the technique foreshadows what is to be a constant feature of Byzantine painting, what indeed had already become the rule at Rome by the first half of the fifth century, as we can see from the mosaics at S. Maria Maggiore illustrating the life of Joshua.

63 ROME, FORUM ROMANUM, ARCH OF SEPTIMIUS SEVERUS. RELIEF (DETAIL) ▶

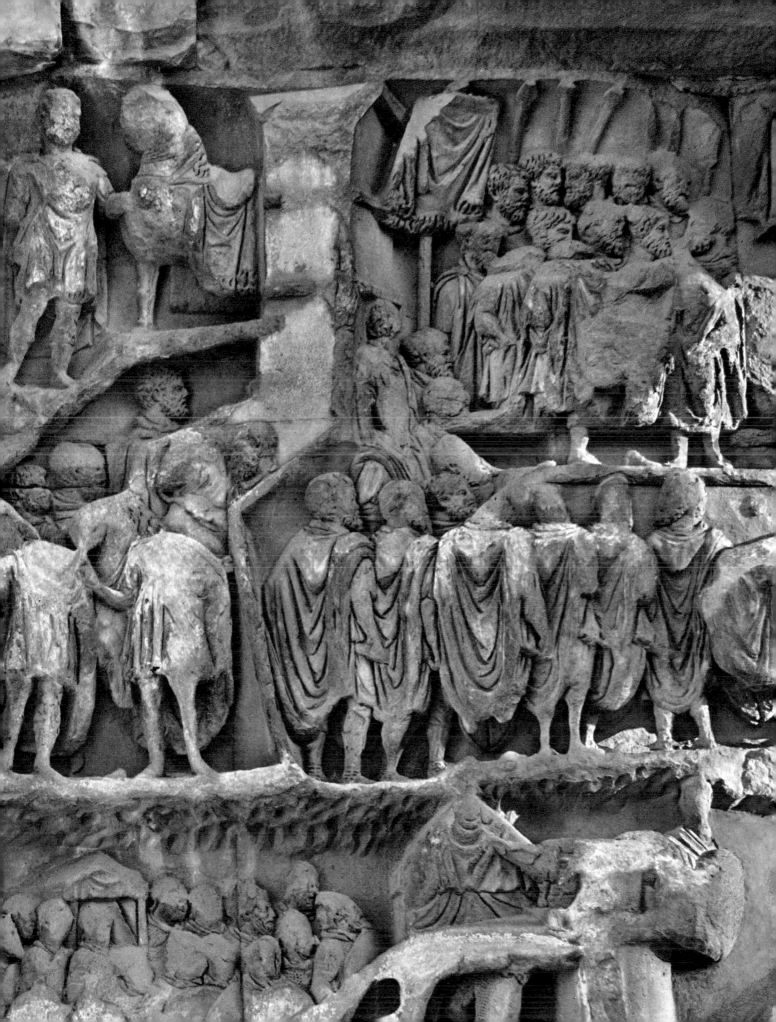

Another sculptured monument dedicated to Septimius Severus and Caracalla adds one or two new features to our picture of art in this period. This is the door which was set up near the Forum Boarium by the cattle-dealers (*negotiantes boarii*) and *argentarii* (who were, in all likelihood, money-changers rather than silversmiths). The dedication refers to one official year during which the Augusti held office, from December 203 to December 204: this dates it a year after the arch in the Forum. To judge from the part that survives (a quarter is lost), the team which executed the sculptures is not the one which worked on the arch. The most interesting scene is that which shows Septimius Severus and Julia Domna sacrificing in front of a tripod. The right-hand side of the picture was to have been completed with a third figure, but this was suppressed, and as a result the left arm of the female figure was somewhat clumsily redesigned. The various hypotheses concerning this suppression, and another (equally visible on the panel) which showed Caracalla in the act of sacrifice, need not detain us. Of greater interest for our purposes is the uncompromising full-face position assumed by the figures. The action which Septimius Severus is performing makes this strained – which suggests that the frontalism is deliberate. The same can be said of Julia Domna's gesture (which, despite the figure's poor state of preservation, can be confidently reconstructed). She has her right forearm raised vertically, with the palm of the hand turned forward. This is a ritual gesture of prayer among Semitic peoples: it turns up in Phoenician art, in statues from Hatra in Mesopotamia and Palmyra in Syria, the region from which Julia Domna came.

The strong chiaroscuro of the relief harmonizes with the heavily emphasized cornices and leaf-and-branch decoration on the pillars framing the central figured relief. At the top of this panel, in less prominent relief, are two Victories holding a heavy garland, balanced at the bottom by a scene showing the sacrifice of a bull. These two minor reliefs could come straight out of the stock repertoire for official monuments, and even the relief of the sovereigns offering sacrifice would be in the direct traditional line were it not for the rigid frontal position assumed by the woman. This is something quite different from the early frontalism found in 'plebeian' reliefs, which was designed to throw the main character into prominence – as is shown, in a late example, by the stele of a centurion in the Praetorian Guard, similarly represented in the act of sacrificing (*pl. 65*). With the Imperial couple of the *argentarii*, by contrast, the composition assumes a ritual quality. This is the 'presentation' of persons belonging to a superior, almost a divine, sphere of existence: some people have even taken it to be a representation of Septimius Severus as Serapus. My own belief is that the composition suggests, rather, the sacral concept of the Imperial person, which is a Partho-Iranian idea, very different from the specifically Roman tradition of the Emperor's posthumous deification. It seems to me, then, that the work displays an Oriental influence, not so much in the plastic form or the style as in the iconography.

These Severan monuments, in my opinion, introduced to Rome two elements which were brought together and developed in a revolutionary fashion, as regards style, in the Arch of Constantine: the heritage of 'plebeian' form, and Eastern ideological attitudes.

On 28 October 312, Constantine defeated Maxentius at the Milvian Bridge; this put an end to the long struggle against a 'usurper' who had, nevertheless, represented Rome's last period of splendour as an Imperial city. As the elder of the two Augusti,

64 ROME. DOOR NEAR THE FORUM BOARIUM (DETAIL): SEPTIMIUS SEVERUS AND JULIA DOMNA OFFERING SACRIFICE ▶

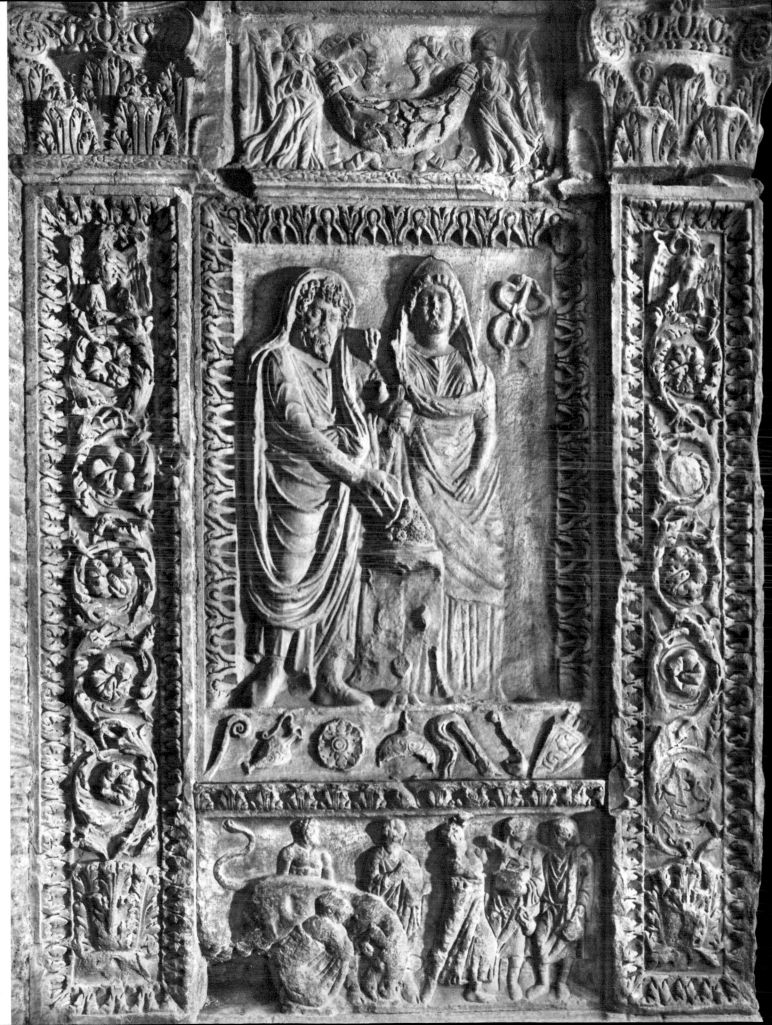

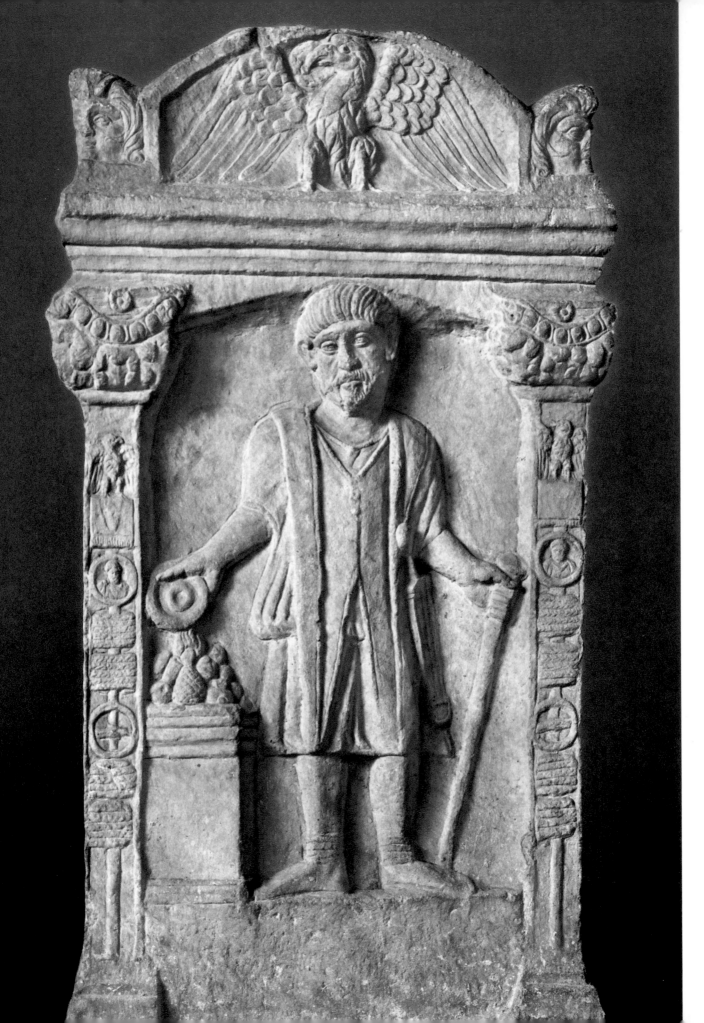

Constantine took precedence over Licinius (to be defeated and deposed in 324). In 315 Constantine returned to Rome, residing there from July to September. He no longer regarded Rome as the power-centre of the Empire; the first place he picked as his seat was Trèves. From there he moved to Sirmium (Sremska Mitrovica, on the Save) in Illyria, and thence to Serdica (Sofia) in Thrace. Finally he founded the New Rome, Constantinople, at Byzantium. It was in Rome, however, that he celebrated the completion of his first decade of rule. It was on this occasion, in 315, that the Senate finally dedicated to him the arch which had been begun immediately after the battle at the Milvian Bridge.

The campaign against Maxentius, from Milan to Verona and Rome, forms the subject of the frieze which runs along the upper part of the side-arches; and the inscriptions which proclaim Constantine 'Liberator of the City' (in the passageway of the main arch) and 'the State's avenger upon the tyrant and his faction' (in the great dedicatory inscription) refer to his victory over Maxentius. The inscription begins with a phrase which has provoked much discussion. It attributes Constantine's success not only to his superior intelligence (*mentis magnitudine*), but also to the counsel of the divinity (*instinctu divinitatis*). Since the victory at the Milvian Bridge was bound up with the legend of Christ's Cross appearing to the Emperor (who had already, a year previously, together with Licinius and Galerius, proclaimed the Edict of Toleration to Christians from Milan), attempts have been made to read into this phrase an allusion to the 'conversion' of Constantine. There had been a conversion, though of a rather different kind, which took place somewhat earlier and is the only one mentioned by the panegyrists who wrote in the Emperor's own lifetime. As a result of a 'vision' which came to him in a Gaulish sanctuary, he was converted from the cult of Jupiter and Hercules of the Tetrarchs to that of Apollo Helios, the Sun. A panegyric of the year 310 refers to 'your Apollo' (7.21.4). Another text, written in 313, contains a passage which appears to anticipate the dedicatory inscription of the arch: it refers to the effect of 'divine counsel', or, 'in other words, *your* counsel' (9.4.5). We have here explicit evidence of the growing tendency to identify the Emperor with the divinity according to Persian custom; the way in which Imperial court protocol encouraged this notion has already been mentioned. There is probably a deliberate ambiguity about the inscription, with a covert reference to the protection offered by the Emperor's tutelary deity, Apollo-Helios, here identified with his intelligence or spirit. But at the same time it was acceptable to the Christians, whose symbol (in the form of a monogram) was placed at the top of Constantine's helmet in coins struck that same year (315).

The frieze on Constantine's arch occupies the same relative position as does the triumphal frieze on the arch of Septimius Severus, and the processional frieze on those of Trajan at Beneventum and Titus in the Forum. The style of these friezes was always different in tone from that of the rest of the decorations on the arches, being linked to the 'plebeian' trend in art. But here is something new. The frieze begins, on the west side, with the army marching out of Milan. On the south side we see the siege of a town, which can be identified as Verona, in view of the fact that there is an allusion to an episode mentioned by the historians, and that this hard-won victory was of great importance for the rest of the campaign. The relative proportions between the persons and

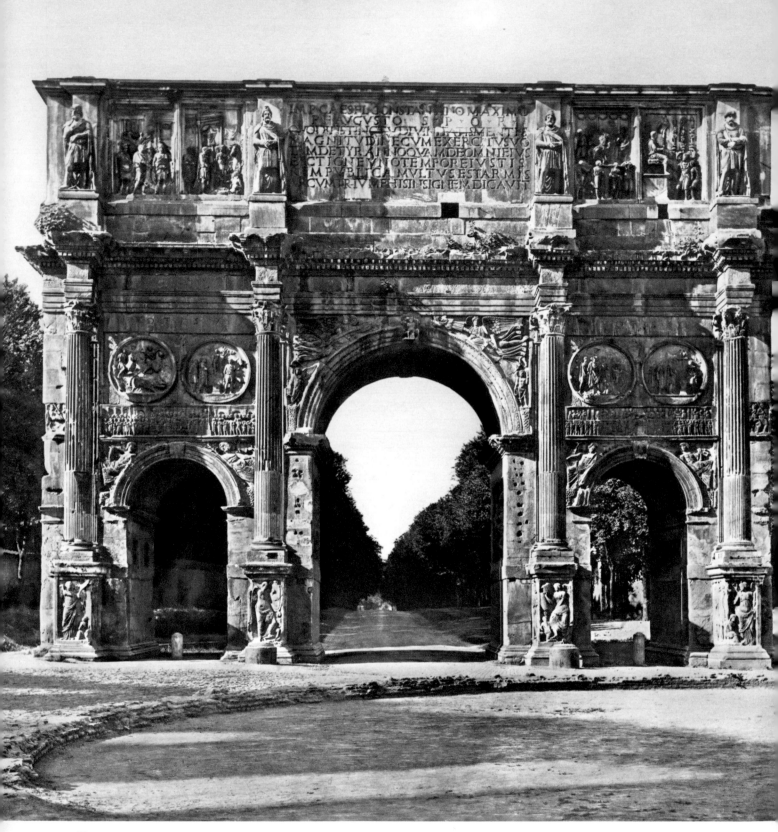

66 ROME, ARCH OF CONSTANTINE. NORTH FAÇADE

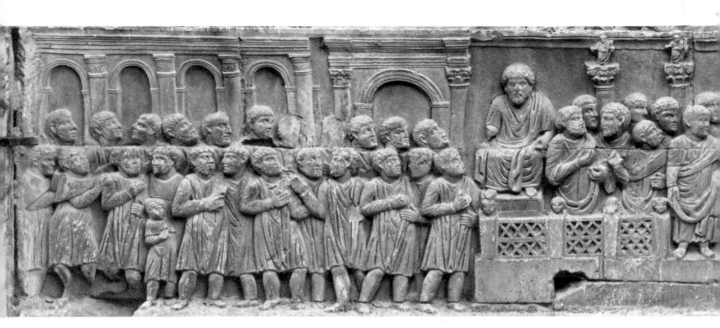

69 ROME, ARCH OF CONSTANTINE. FRIEZE (DETAIL): CONSTANTINE'S ADDRESS

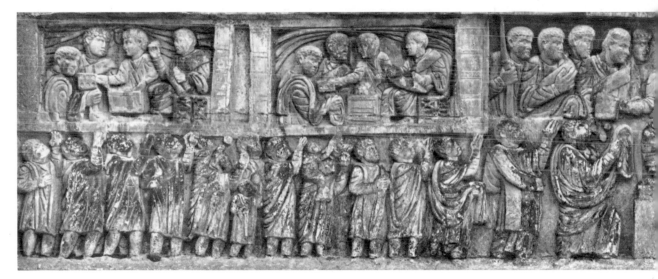

70 ROME, ARCH OF CONSTANTINE. FRIEZE (DETAIL): DISTRIBUTION OF LARGESSE

If we examine that section of the scene which shows the distribution of largesse (*liberalitas*), we can find parallels with reliefs from the European provinces depicting similar scenes of payment. But it would be wrong to infer that provincial art-forms had any influence on the capital. On the contrary, it was the culture of the capital which, in many respects, adapted itself to the level of that in the provinces, with the political ascendency of the large administrative and military middle class that dominated provincial life. In the mid-second century, iconographic formulae were still as clear-cut and composed as Augustan cameos. When we consider how drastically these same formulae had been transformed a hundred years later, and the dramatic force that was injected into them by means of sharply contrasting types of relief-work, it becomes apparent

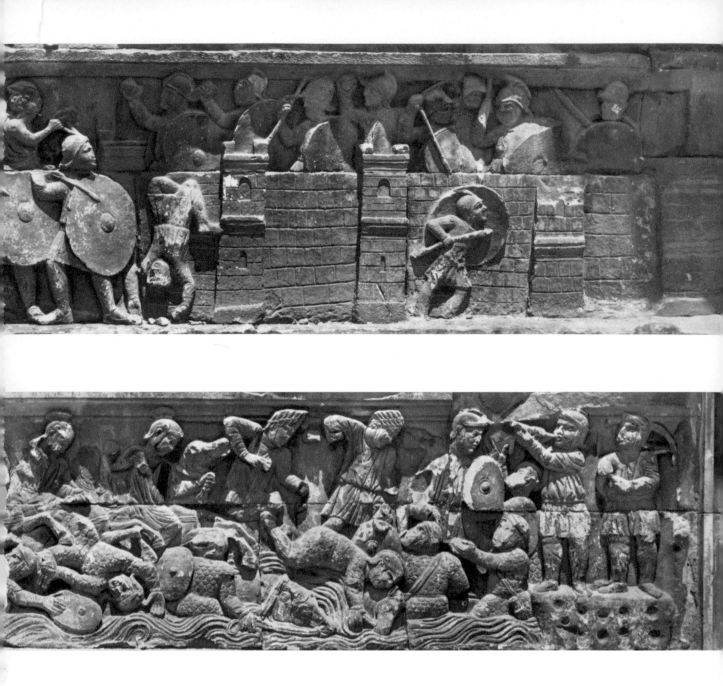

In these last two compositions, narrative has given way to representation. As far as details go, the mode is unchanged; but the composition follows an unusual rhythm. Whereas earlier attempts at this kind of expression could have been mere improvisation, everything here clearly forms part of an organized system – a system, moreover, which has completely broken away from the Hellenistic tradition, and stands at the beginning of a new tradition altogether, one that persists in European art until the fourteenth century. What we have here is not 'decadence' or incapacity (as critics have alleged), but a new beginning. As is well known, every fresh start looks like aberration and decadence to those who view it from the standpoint of tradition.

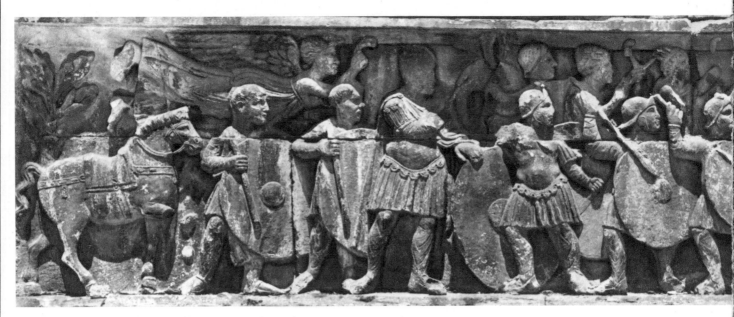

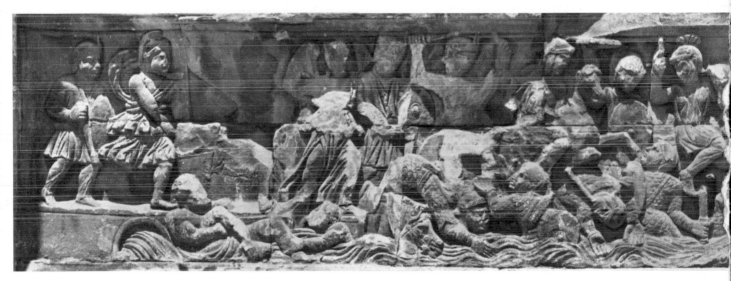

buildings are symbolic, rather than realistic; the formal language lacks elegance. The siege of Verona is followed by a battle on a river, clearly that of the Milvian Bridge. There is no trace of supernatural intervention here; but the pattern of this memorable battle later served the craftsmen who carved the first narrative compositions of Christian art in Rome – Moses' people crossing the Red Sea, with the tidal wave that overwhelmed their oppressors. On the short side facing east, we see the entry of Constantine's victorious troops into Rome; and finally, on the north side, two vast compositions, one of them representing the Emperor's address (*oratio*), and the other the distribution of largesse (*liberalitas*).

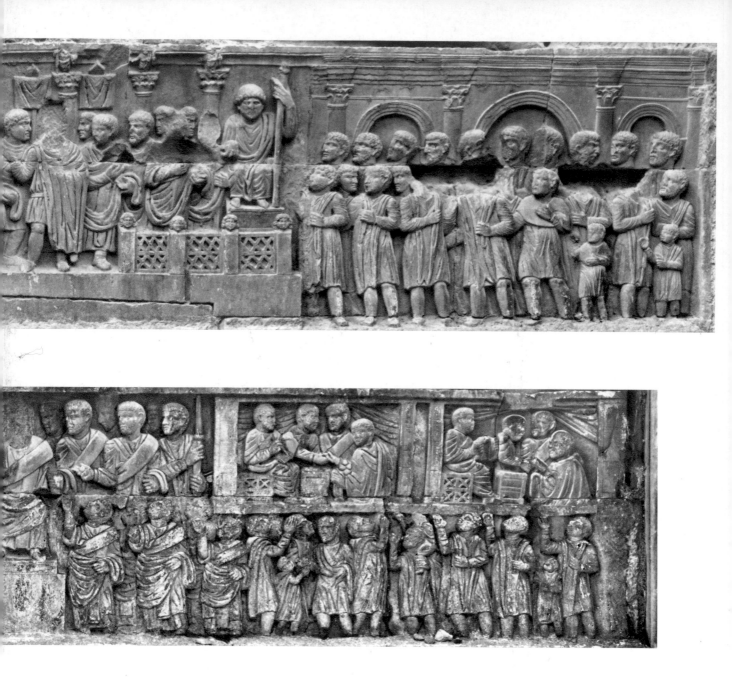

that the Roman sculptural workshops of the third century were responsible for a quite
new and original mode of artistic expression. This powerful expression of art, the roots
of which went back to a new involvement in human suffering, broke down the barriers
separating official from plebeian art. The two trends met, mingled, and revitalized one
another. This is the road by which we come to the Arch of Constantine.

But in this frieze we can detect yet another new element. With the address to the
citizens (*oratio*) and the distribution of largesse (*liberalitas*), the thematic pattern is no
longer that of the usual triumphal frieze; it employs novel methods to tackle a theme
generally reserved for official art. Here is where the new factor appears, in the type of
composition – and in the rules governing it, which are those of rigid Court protocol,

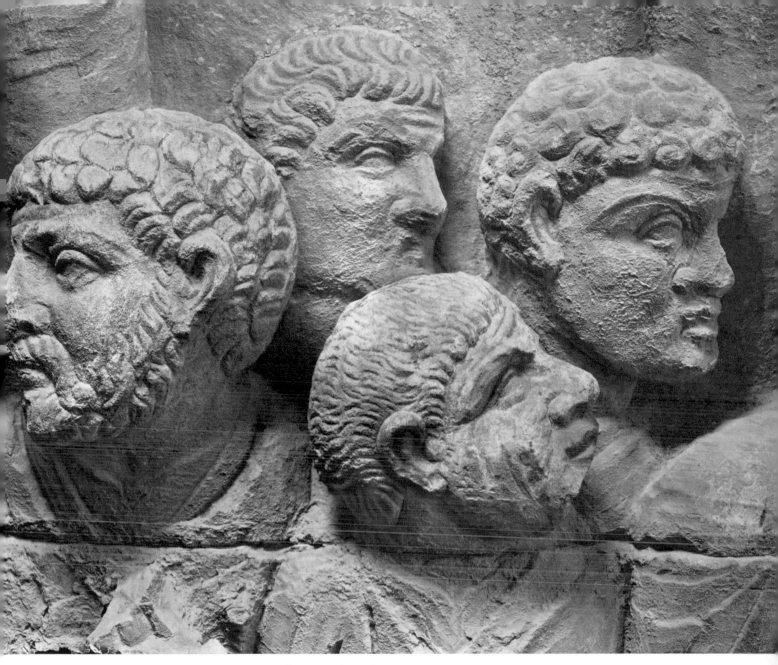

71 ROME, ARCH OF CONSTANTINE. CONSTANTINE'S ADDRESS (DETAIL)

matched by an equally clear-cut ideological attitude. The Emperor sits in the middle, in a stiff, full-face position. No other figure (except the two statues of Emperors adorning the dais) is given this uncompromising frontal stance, though all the persons represented are shown on two levels, without any foreshortening. What we have here is that absolute immobility which etiquette prescribed, and the observance of which was commended by contemporary writers. It is the Emperor's divine appearance which manifests itself in this fashion, and which is emphasized by the fact that, though seated, he still dominates the figures on either side of him (his head has been lost, but traces of it still survive). Even these lesser persons are carefully graded in size according to their rank. Besides the Emperor himself, we have four further categories: top government officials, on the

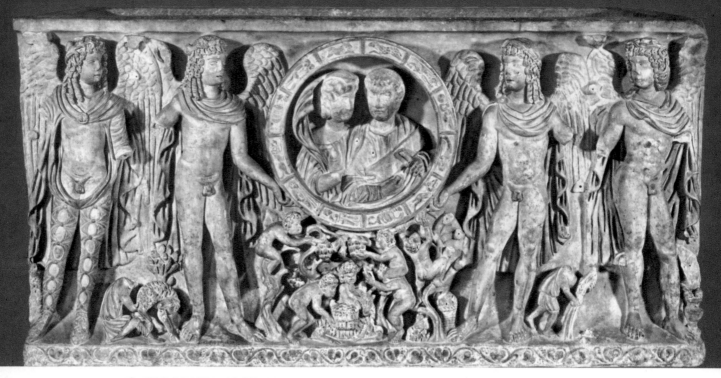

72 ROME. SARCOPHAGUS WITH SYMBOLS OF THE SEASONS. WASHINGTON, DUMBARTON OAKS COLLECTION

central dais; bureaucratic accountants in the four other upper compartments; high-ranking beneficiaries, grouped in the middle of the lower register, muffled hands outstretched to the Emperor, from whom they receive their largesse in person; and an anonymous crowd of petitioners.

This, then, was the effect of the emergence, under Constantine (though the process had already begun with Diocletian's reforms), of a reorganization of Court and bureaucracy, which continued unbroken into the Byzantine era, and had its roots in a concept of sovereignty peculiar to Iranian culture, as found in the Persian kingdoms of the Parthians and Sassanids. In this sense, we can identify an Oriental influence, but (once again) it is ideological rather than artistic. The full-face convention, that foreshortened perspective which relegates to a position beside the central motif what actually stood in front of it, hierarchically graded proportions – all these devices had been utilized by plebeian art at least since the middle of the first century. The iconographic structure of the composition, in fact, is determined by its ideology, yet at the same time worked out through local formal elements, in which plebeian and official trends have met and fused. This fusion, moreover (at least in commemorative works and representations of State occasions), remains consistent throughout, even though the style of the Constantinian frieze did not survive much beyond 325.

At the time of the arch's construction, this mode of artistic expression had attained especial importance, in connection with the new social pattern that was a by-product of the Tetrarchy. Gallienus had already stripped the senatorial class of some of its more important functions; henceforth it was the *coloni* and the military (often one and the same thing) who formed the backbone of the Empire. This class brought with it the type of art that it had always employed. But the generation that followed resented the need to abide by an art-form which had been the hallmark of senatorial authority. In other

80

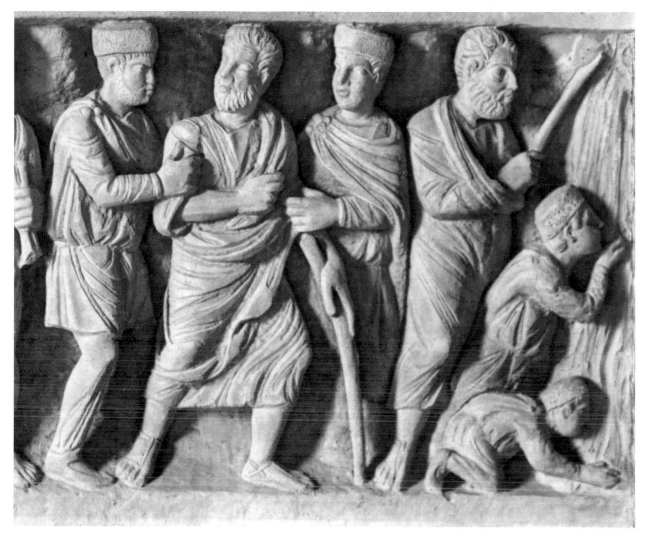

73 ROME. SARCOPHAGUS (DETAIL) ARREST OF PETER, AND THE MIRACULOUS SPRING. THE VATICAN, MUSEO LATERANO (DEPOSITORY)

words, they used art as an instrument for asserting and confirming their own power. Hence the development of what is usually referred to as 'Constantinian classicism'.

This classicism reveals itself most clearly in works directly linked with the Court and the old patrician class. Symbolic figures of the Seasons continue to be repeated on sarcophagi, only now they are given a neo-classical appearance, as on the great Dumbarton Oaks sarcophagus. But the classicizing tendency also infiltrates works of Christian inspiration which had previously followed the 'plebeian' pattern; these subsequently even took over certain groupings from the Arch of Constantine (e.g. for a sarcophagus depicting the Creation of Man and episodes from the New Testament). By the middle of the century, with the sarcophagus of Junius Bassus, Prefect of Rome, Christian iconography has attained a correct and polished style, in which the suffering of the third century is transformed into an appearance of serenity (a new kind of official conformism). Of the stormy past there remains no trace save the disappearance of that symmetry and elegance which characterized ancient art in the representation both of persons and of ornamental patterns – even when these are of a type akin to the classical models of antiquity.

The Arch of Constantine is decorated with what the French call *remplois*: that is, reliefs and sculptures which originally belonged to other monuments, from the period of Trajan, Hadrian and Marcus Aurelius. Why should this arch have been decorated with sculptures of an earlier age? Shortage of time, and a lack of monumental masons who could complete the design by carving original reliefs? Or deliberate policy, the desire to proclaim Constantine as successor to the best of the second-century emperors? In the latter case, did the designers break up and despoil existing monuments? Or were the sculptures they used lying ready to hand in some storeroom, the monuments for which they were intended having never been completed? This second hypothesis has found few adherents; yet in view of the difficulty of locating despoiled monuments, it should not be rejected. We should also note that the unfinished statue of a Dacian prisoner, which was brought to light in the storeroom of a marble-sculptor's studio (Via dei Coronari 211), corresponds not only to the statues of the Arch of Constantine, but also to the head of a similar statue from the Forum Traiani (now in the Vatican Museum, Braccio Nuovo, inv. no. 2293). Not all the works sculpted, then, found a billet.

Be that as it may, the builders' intention – to erect the most magnificent arch ever set up in Rome – is self-evident. The huge river-figures on the side-arches follow a conventional pattern, yet even here we can already detect a marked preference for linear design in the drapery. The predominance of incised line over modelled relief becomes obvious when we turn to the column-bases, and the Victories and barbarian prisoners with which they are adorned. On the one hand, such a style maintains, in a simplified manner, that effect of optical illusion which Roman art, with its highly coloured vision, had adopted from Commodus's day. On the other, we see here the beginning of a style which regards the thickening of line as the basic structural feature of a sculptural image. In this linear approach we can recognize the emergence of a taste that will culminate in Byzantine art – and which derives from a fully Hellenistic iconography. We shall find other, still clearer, examples in the art of Constantinople and the provinces of Asia Minor during the fourth century: so much so, in fact, that one might suppose these sections of the monument to have been executed by a team trained in the workshops of the Hellenistic East.

As a pendant to the sumptuous Arch of Constantine there was the statue of the victorious Emperor himself – shortly (324) to gather the reins of empire into his hands alone, as Cosmocrator – which was set up (at the same time as the arch) in a new basilica on the Forum Romanum, begun by Maxentius, and now brought to completion. This building remained the greatest of all the basilicas erected in Rome, whether as law-courts or for the holding of official ceremonies. During the Renaissance it had a direct influence on the architecture of the largest of all Christian basilicas, St Peter's in the Vatican. The remains of the colossal statue it housed are preserved in the courtyard of the Palazzo dei Conservatori on the Capitol. The height of the head (2.60 m., neck included) means that the whole statue must have been some ten metres tall. It represented Constantine in a sitting position, right hand grasping a spear or rather a sceptre, since he was undoubtedly wearing a robe, not a breastplate. The body was, it would seem, constructed from masonry faced with stucco, and the drapery may have been worked in metal. This is a new type of Imperial statue, which sets the sovereign far above the common run of humanity: almost a cult-image. The construction is reduced to a series of large, harsh,

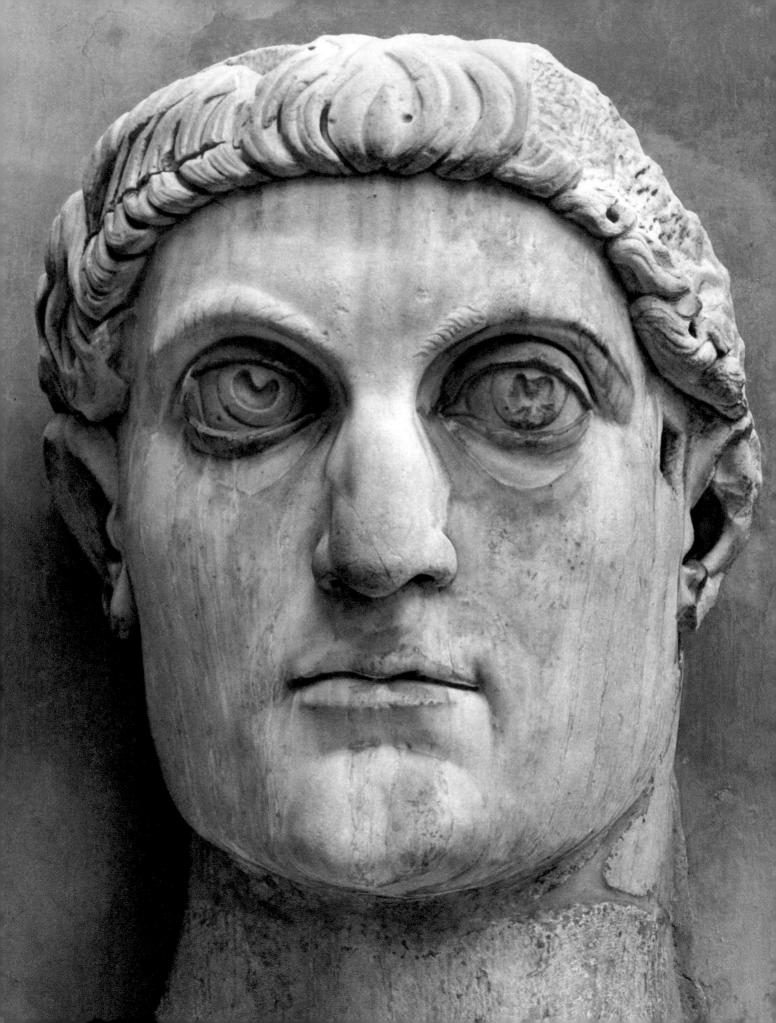

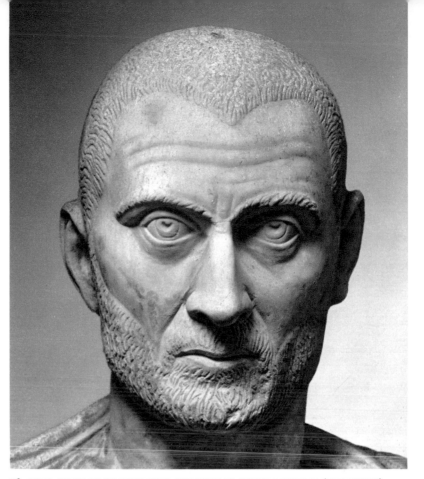

76 ROME. PORTRAIT OF DOGMATIUS. THE VATICAN, MUSEO LATERANO (DEPOSITORY)

inert planes. The only point at which it comes alive is in the enormous eyes, which express a supernatural power and inner, spiritual grace. Here, too, we have a fore-shadowing of the Byzantine style, of those huge eyes found in icons, whether painted or mosaic. The eye had already become, in third-century portraits, the means whereby artists expressed mental anguish. From now on, however, it assumed another function: inner illumination, and direct contact with the spectator.

This remains a characteristic feature of official portraits in the fourth century. An example is the portrait of Caius Caelius Dogmatius, a most distinguished official, as his inscription tells us: '*vir clarissimus*, among those citizens elected by the Senate to consular rank, counsellor of Our Lord Constantine the Victorious, Deputy City Prefect, judge on the Court of Sacred Enquiries, *praefectus annonae* for Rome, Under-Secretary to the Privy Council', and so on. As a member of the Supreme Court, he drew a salary of 60,000 sesterces. His son erected a statue in his memory, to which the inscription alludes, and which is almost certainly the one we possess. Yet only the head of the portrait was specially executed for this occasion. The toga-draped body, which reveals much better workmanship and is carved from superior marble, belonged to a work assignable to the mid-third century, whereas the date of the inscription is 326–33. We see in this portrait the result of a fusion between two different third-century trends: expressiveness and 'Constantinian classicism'. In view of the status and financial resources of the person honoured, it might be thought surprising to find an ancient statue utilized in this manner;

85

◀ 75 ROME. FRAGMENT OF A COLOSSAL STATUE OF CONSTANTINE. ROME, PALAZZO DEI CONSERVATORI

77 ROME, VILLA UNDER THE BASILICA S. SEBASTIANO. MURAL DECORATION

but the practice of re-using old honorific statues had begun to provoke deprecatory remarks as early as the first half of the second century (see Dio of Prusa, *Discourse to the Rhodians, Orat.* 31.20–141).

Little survives of Roman painting during the third and fourth centuries apart from decorations in the Christian catacombs. In fact, however, Christian painting, of which there are abundant examples from 235 onwards, does not differ formally from that executed by non-Christians. The difference is merely in the iconography and subject-matter. For the purpose of art-history, pagan and Christian painting should be studied as one. That no formal distinction exists becomes clear when we examine the decoration of a villa underlying the Basilica S. Sebastiano on the Via Appia. There is no trace here of Christian influence; the pattern of decorative lines on the walls derives directly from a late simplification of the decoration used in Commodus's day (Ostia, the 'Yellow Room': see *Rome: The Centre of Power, pl. 370*). The scheme of this linear decoration is itself derived from a basic pattern of the last phase in Pompeii's 'Second Style'. We have a central *aedicula* with two smaller lateral openings; even the triangles which surmount the *aedicula* can be regarded as a survival from those architectural scenes in *trompe-l'oeil* perspective which formerly appeared behind it. In the villa underneath

78 ROME, VILLA UNDER THE BASILICA S. SEBASTIANO. DECORATION OF A WALL AND VAULTING (DETAIL) ▶

79 OSTIA, CORTILE DELL'AQUILA. REMAINS OF MURAL DECORATIONS IN TWO DIFFERENT STYLES

S. Sebastiano, which dates to the first thirty years of the third century, this linear decoration, executed on a white ground, achieves both precision and elegance. And we find the same system employed – though with less attention to detail – in the Christian catacombs, between 200 and 240: those of Domitilla (*cubiculum* of the Good Shepherd), Pretestato (crypt of the *coronatio*), and Callisto (crypt of S. Lucina, a more elegant example). One interesting piece of evidence on the origins of this type of decoration comes from a house on the 'Cortile dell'Aquila' at Ostia. A door was walled over, and then covered with new decoration: that on either side of it was typical early-third-century.

In this linear decoration, the small figures which adorn the middle of the white panels are executed in a swift, casual manner. The image is built up by a direct juxtaposition of light and dark, without gradations. As I observed in *Rome: The Centre of Power*, this 'tachiste' painting, though directly derived from the 'impressionist' form adopted by painting in the Flavian period (the Pompeian 'Fourth Style'), nevertheless differs sharply from it in content. While the 'impressionism' of Romano-Hellenistic painting tended (as did sculpture) to place increasing emphasis on naturalism, the 'tachiste' painting of the third century destroyed these naturalistic conventions by annihilating mass and ignoring details. What emerged were insubstantial images, barely sketched in, and

80 ROME, CATACOMBS OF DOMITILLA. CUBICULUM OF THE GOOD SHEPHERD

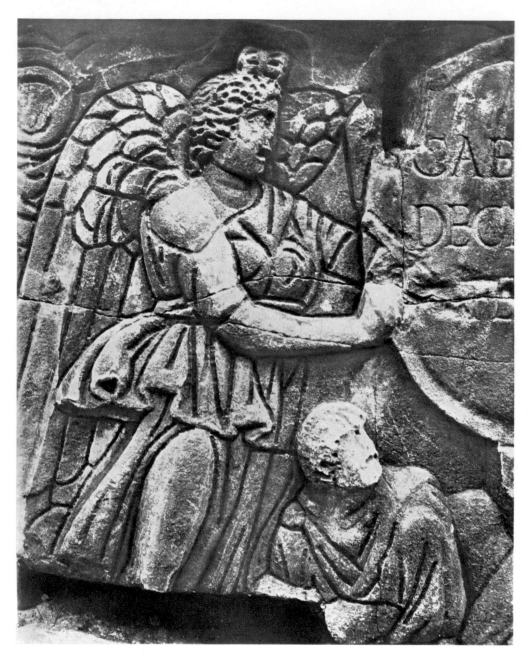

81 ROME, FORUM ROMANUM. BASE OF A MONUMENT OF THE TETRARCHY (DETAIL)

valuable as symbols, or mere touches of colour, rather than as representations. There is identity of taste between this decorative painting and 'illusionist' sculpture, which likewise led to the disintegration of form – as on the base of one of the columns of a monument put up in the Forum by the Tetrarchs for the *Decennalia* (303).

But there are signs which lead one to believe that during the third century painting returned to a genuinely original creative vein. We shall, later, consider examples from further afield: Africa, Egypt, Asia Minor. Even in Rome we find some examples that hint at novelty, at painting which has broken free from the Hellenistic tradition in style and iconography, characterized by formal solidity and freshness of technique.

90

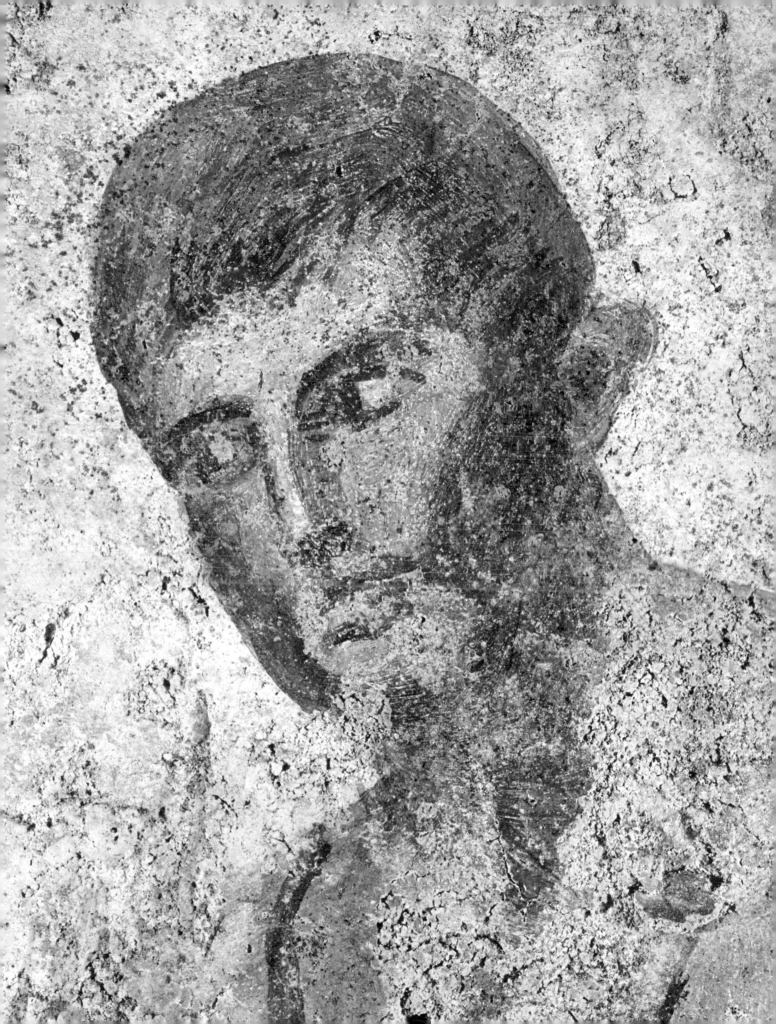

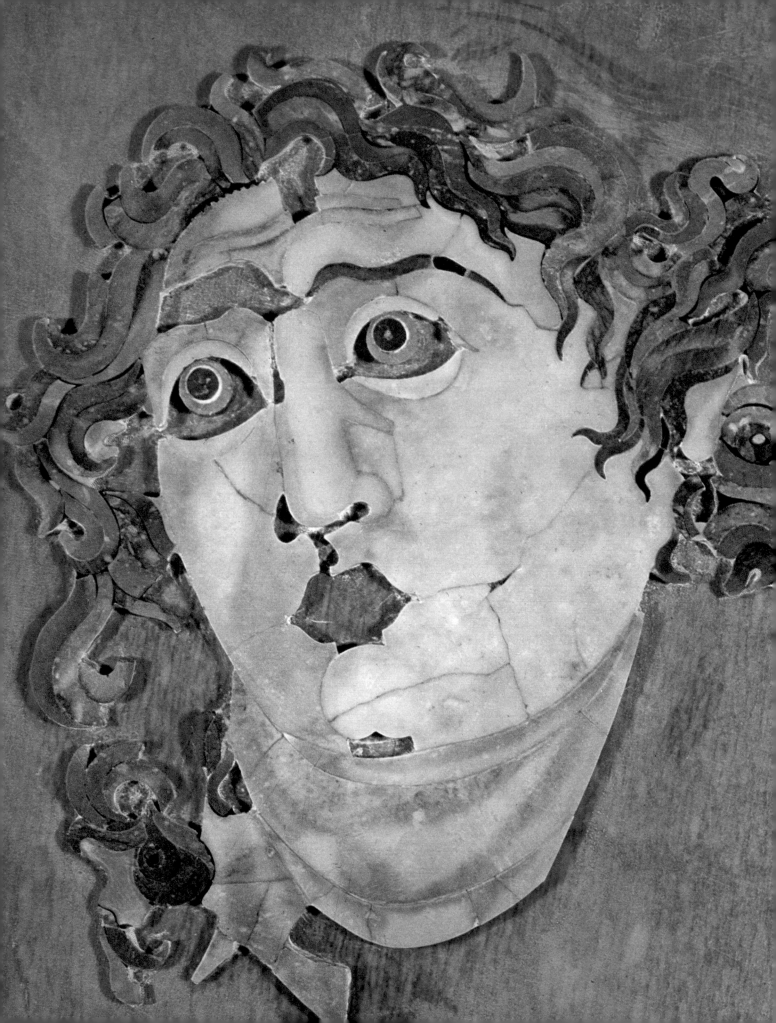

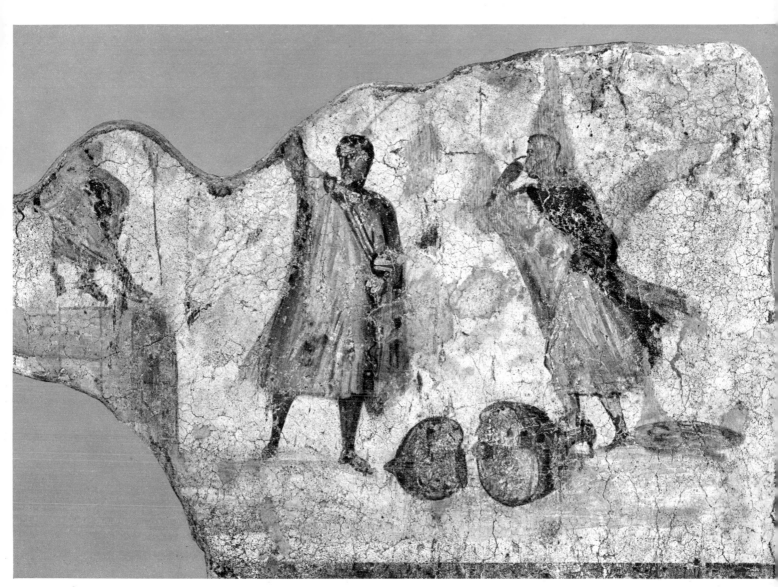

84 OSTIA, CASEGGIATO DI ERCOLE. ALTERCATION BEFORE A JUDGE. OSTIA, MUSEO OSTIENSE

In this context we may also consider the paintings of the Mithraeum of S. Prisca, executed between 202 and 229. From this source comes the dramatic head of the divinized Sun (opposite), made with coloured pieces of marble. Another fragment which should be noticed here was found in an *insula* (apartment block) at Ostia, and can be dated between 230 and 250: it represents a violent altercation before a judge. This theme recalls the series of scenes before a judge from the black-based frieze in the House near the Farnesina, datable to the Augustan period; but it would be hard to imagine a greater difference in form and content. The earlier piece was a pleasantly elegant anecdotal narrative, as typical as it was fashionable. The later one is violent and dramatic, simplified in form, reduced to the bare essentials. As with all art of the third century, we have here a deepening of human content (which wrote finis to the pastoral conceits of Alexandria), and a development of the more popular rival trend in art.

93

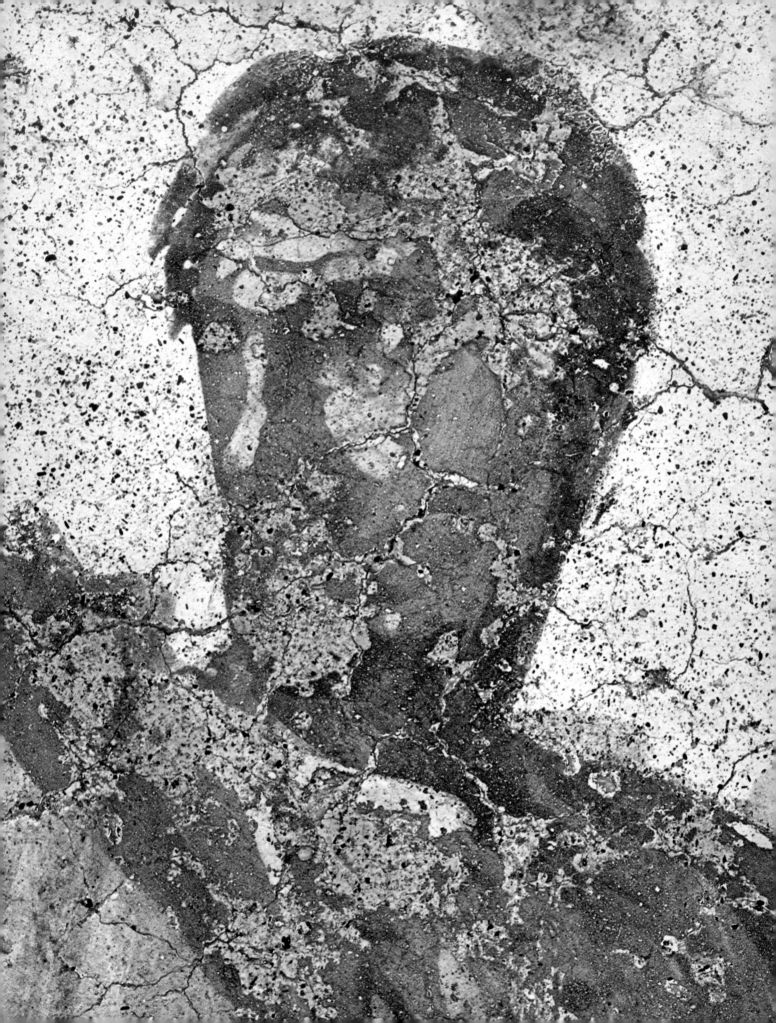

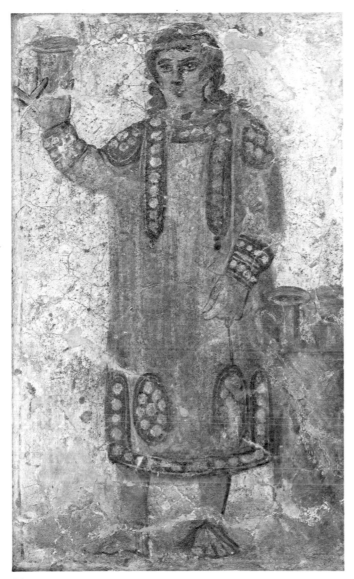

86 ROME. CUP-BEARER. NAPLES, MUSEO NAZIONALE

87 GARGARESH, TOMB OF AELIA ARISUTH. CANDLE-BEARER

From the time of the Tetrarchy on, there is a spread of new iconographic motifs, which testifies to a renewed originality in painting, and provides a common factor between all countries bordering on the Mediterranean. Changing fashions in dress, such as the widespread practice of sewing broad strips of coloured material to garments – a device which originated in Egypt, and was subject to official regulation – serve both to renew and to standardize iconography. Thus the young slave holding a drink, from a fresco belonging to a house on the Caelian Hill in Rome, can bear considerable resemblance to the young candle-bearer in a tomb-painting from Tripolitania (Gargaresh, tomb of Aelia Arisuth), without there being grounds for assuming any direct influence.

95

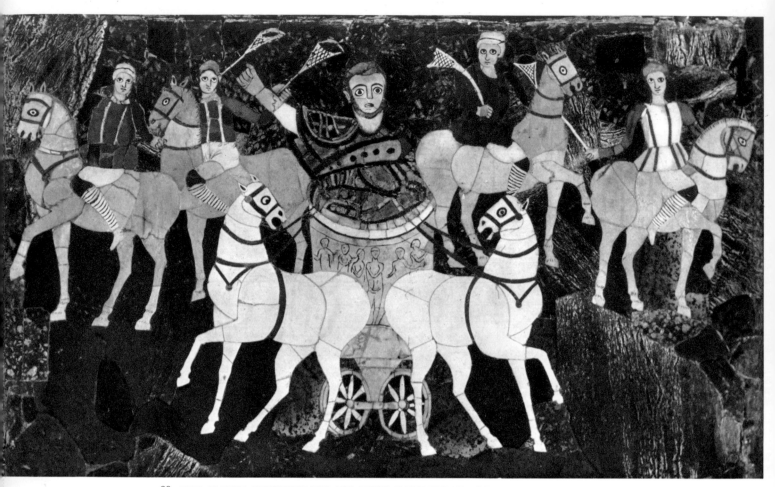

88 ROME, BASILICA OF JUNIUS BASSUS. THE CONSUL AMONG THE CIRCUS FACTIONS. FORMERLY ROME, PALAZZO DEL DRAGO

During the fourth century it became fashionable to decorate the more sumptuous type of edifice with marquetry-work in coloured marble, rather than with ordinary paintings. There is reason to believe that this technique was Egyptian, and that sometimes complete panels would be dispatched by the studio workshops there, ready to be set up on the wall. Such panels were known as *opus sectile*, i.e. work done with sawn pieces of marble. We have some from a secular basilica, built (according to an inscription now lost, whose substance, however, is on record) by a certain Junius Bassus – probably the consul of 331, and father of the City Prefect, who died in 359 as a Christian neophyte. The basilica itself was of rectangular apsidal construction, 18.30 m. by 14.25 m.; we know what its decorations were like from sketches made between the fifteenth and the seventeenth centuries, after which it was incorporated into a monastery and destroyed. Only a few panels from the facing of the walls survive: scenes of animals being attacked by tigers (a popular decorative motif in this period); one panel showing a consul in his chariot among the racing-factions at the Circus; another decorated with a mythological motif (Hylas and the nymphs); and a third which takes the form of a wall-hanging, its wide border decorated with ancient Egyptian motifs.

89 ROME, BASILICA OF JUNIUS BASSUS. THE CONSUL AMONG THE CIRCUS FACTIONS (DETAIL) ▶

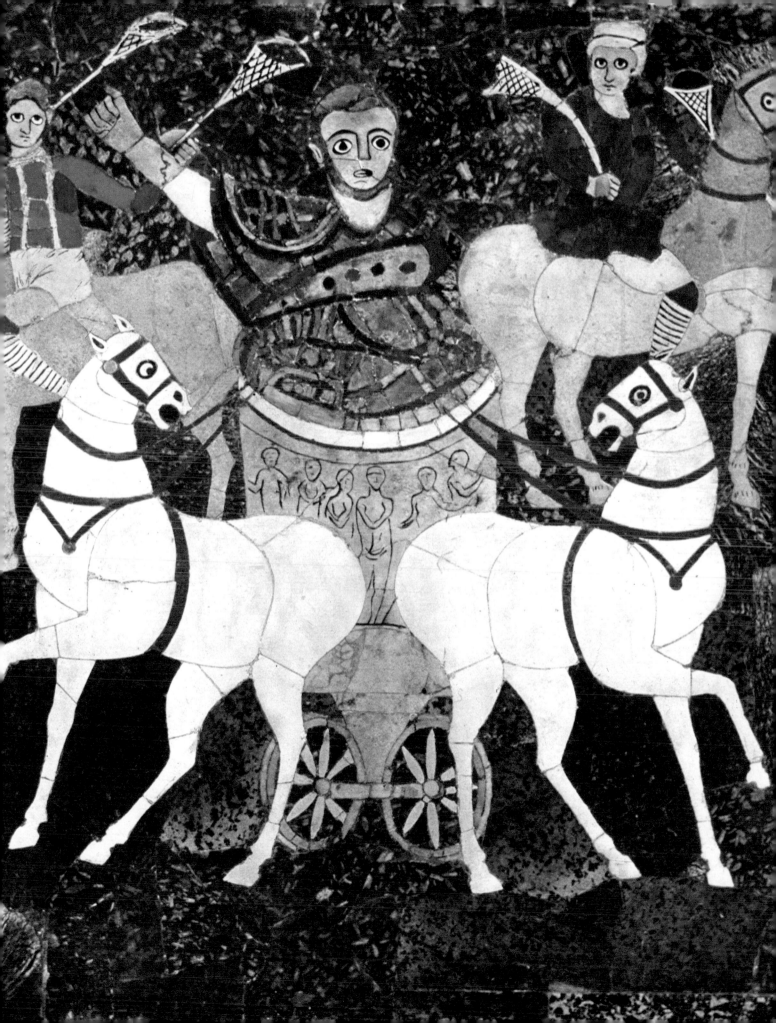

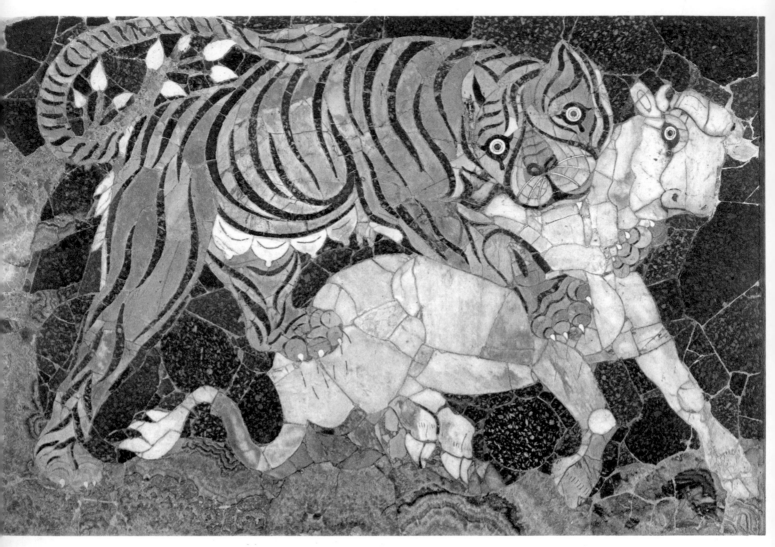

90 ROME, BASILICA OF JUNIUS BASSUS. CALF BEING ATTACKED BY A TIGRESS. ROME, PALAZZO DEI CONSERVATORI

One last splendid example of marble facing was recently discovered at Ostia, in tiny fragments, and reconstructed (1969) by Becatti, with infinite patience and scientific precision. In this case, too, we find typically Roman features side by side with elements suggestive of Egypt. Among the former, we may note the odd imitation, in coloured marble pieces, of a typical local-style brick wall. The latter include certain sections of a very attractive leaf-and-branch frieze, swarming with birds and other small creatures. The overall impression echoes traditional Hellenistic motifs, but the detailed workmanship reveals a schematization of naturalistic form, while the border which frames the whole exactly matches the borders of pieces of material preserved in Egypt.

The development of formal protocol both at Court and in the Emperor's household was, naturally, accompanied by an upsurge of artistic activity aimed at the aristocratic elite. Henceforward art was to concentrate exclusively on two things: luxury craftsmanship, and 'official' works glorifying Imperial power. The bourgeoisie and the working

91 OSTIA, CHRISTIAN EDIFICE BY THE PORTA MARINA. FRIEZE OF COLOURED MARBLE. OSTIA, MUSEO OSTIENSE

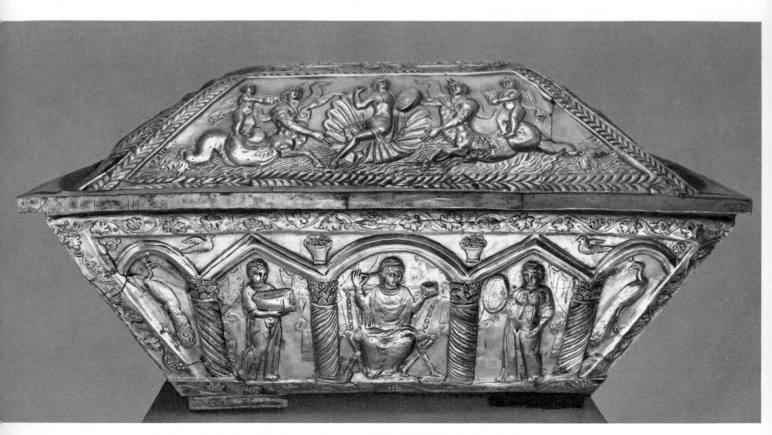

classes alike ceased to take an interest in art as such. Formal beauty no longer played a part, as hitherto, in the ordinary daily life of the period. The only products which maintained their high quality were *objets d'art* such as cameos, jewellery, embossed silver, or ivory-work; and these for long retained Hellenistic-type, neo-classical iconographies. An excellent example of the refinement of luxury craftsmanship in the fourth century is the silver toilet-set acquired as a wedding-present by one Secundus and his bride Projecta, and rediscovered in a house on the Esquiline, in Rome, at the end of the eighteenth century. This set, comprising numerous pieces, holds particular interest for us, since we can date it between 379 and 382: Projecta met an untimely death in 384, and Pope Damasus I composed her epitaph. The lid of the bridal casket – decorated with repoussé work in sheet silver – contains portrait-busts of husband and wife, set in a wreath of leaves supported by two cupids. On the front of it we find Venus, seated in a shell and combing her hair. The shell is supported by youthful tritons, on whose backs there stand small Amorini, holding out offerings. At either end we have nereids and tritons riding on sea-monsters. The far side portrays the bride's entry into her palace, accompanied by people carrying presents. There is an inscription on the lower edge. The body of the casket is decorated with tendrils. Its sides are broken up by a series of arches. In front, under the central arch, the bride sits at her toilet, flanked by two maids who are holding a casket and a mirror respectively. Behind them stand two peacocks. Under the arches at either end and at the back, there are nine more maids, carrying lamps and other objects. This iconographic pattern is a common one in the Eastern provinces.

100

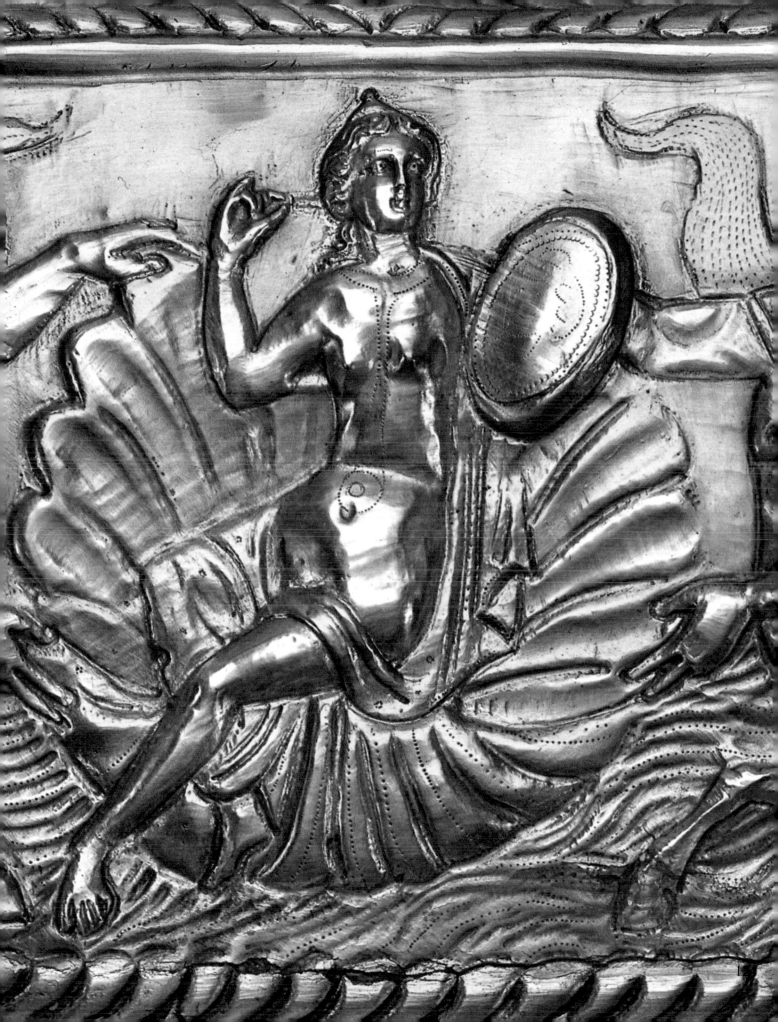

94 BONDONNEAU. TRAY-HANDLE: VENUS IN A SHELL, BORNE BY TRITONS. PARIS, LOUVRE

It seems very likely that this casket was the work of Oriental craftsmen, perhaps from Antioch or Constantinople, who, we may assume, carried on their trade in Rome itself. The addition of Christian features (the inscription reads 'Secundus and Projecta, may you live in Christ') to a pagan figurative design – though the latter was, beyond any doubt, regarded as having purely ornamental significance – is typical of upper-class Roman society. (On the other hand, it is in contrast with the more exclusively Christian allegiance of other centres, such as Milan and, later, Ravenna.) We have numerous examples of this coexistence between pagan and Christian formulae in Rome, such as those of the 354 Calendar, and the new catacomb on the Via Latina.

The motif of Venus in her Triton-borne shell turns up on many other pieces of silver-ware that were exported from Rome to the provinces of Europe (e.g. the tray-handle found at Bondonneau, in the Drôme). It is frequently repeated, with a number of variants, on fourth-century mosaics in Tunisia and Algeria.

The most significant surviving example of the artistic culture which evolved at Rome during Constantine's period is the edifice known today as S. Costanza, but originally designed to serve as a mausoleum for Constantina, the Emperor's eldest daughter, and probably built between 337 and 354 (or 361). This building makes it clear that the pre-valent architectural fashion was based on models designed by architects from the Eastern provinces of the Empire – even when, as here, the type of masonry reveals Roman work-manship. Indeed, it was above all in the sphere of architecture that the new patterns evolved in the Oriental provinces spread to the West. The mausoleum of Constantina is the oldest surviving example of a circular edifice: that is, one with a centralized ground-

102

plan and an internal ambulatory, a type of building which has since become extremely widespread. The inner surface of the dome and vaulting was entirely covered with mosaics. All that survive of them today are those in the large niches and the vaulting of the ambulatory. The walls were covered with marble marquetry-work (destroyed when the building was repaired in 1620). The mosaics in the niches have Christian themes, while those of the ambulatory, executed on a white ground, present scenes of grape-harvesting, together with sparse floral and other ornamental motifs, wholly lacking in perspective, relief or programmatic cohesion, but with a wealth of decorative effect (see André Grabar, *The Beginnings of Christian Art*, frontispiece, *pl. 202, 204–7*).

This type of decoration, with its sparse and irregular component features, had existed ever since Hellenistic times. The famous 'crumb-strewn' (*asaroton*) flooring of the painter and mosaicist Sosos falls into this category, and the ceiling of S. Costanza presents figurative elements which may recall his work. Subsequent examples of similar decorative patterns (mostly funerary) are to be found in Egyptian tombs of the late Hellenistic period. The same *genre* also turns up in Lebanon at the beginning of the third century (tomb of Djel el-Amad near Tyre) and – primarily during this period, but also at the end of the second century – in North African mosaics: the 'House of the Aviary' in Carthage shows a taste closely akin to that of S. Costanza. From here, in the fourth century, it spread to Spain (e.g. the Villa of Saragossa); and, as certain African tomb-mosaics show, it was still going strong a century later. With the mausoleum of Constantina, then, we have an instance of a theme spreading throughout the Mediterranean basin.

At the base of the cupola, as we can see from Renaissance sketches, there was a marine landscape, with *putti* in a boat, or fishing – another old Hellenistic motif. Higher up, however, scenes from the Old and New Testaments unfolded in twelve panels divided by female figures and acanthus leaves. Here we see a typical new-style edifice – typical as regards both its architecture and its decoration. Any harking back to Hellenistic antiquity which it may still reveal is secondary, ornamental. The basic attitude has changed.

On the other hand, the mausoleum of Constantine's mother Helena – built, it would seem, as a family vault before the transfer of the capital to Constantinople – still remains wholly within the Roman tradition. It stood on the Imperial property *ad duos lauros* (the two laurel-trees) on the Via Labicana (now the Via Casilina), and consisted of a large rotunda *en blocage* (internal diameter 20.18 m., external diameter 27.74 m.). Inside there were a number of niches, alternately circular and rectangular. The largest, opposite the entry, was clearly designed to accommodate Helena's porphyry sarcophagus (now in the Vatican, Museo Pio Clementino). The walls must have been covered with marble inlay-work, and the dome with mosaics. Access to the rotunda was through the narthex of an adjacent basilica, the ground-plan of which has recently been laid bare by excavation. During the Middle Ages the mausoleum was converted into a fortress, and popularly known as Tor Pignattara. Today it is a miserable ruin, surrounded by huge suburban apartment blocks.

2 The European Art of Rome

HAVING, in the Introduction, examined the historical background against which the art of these centuries developed, I now propose to trace its special manifestations in the various cultural areas which one can isolate throughout the Empire. Each of them presents its own features and problems; all play a part in that transitional process which marks the end of antiquity and of a primarily Mediterranean-based culture. In this chapter, I shall deal with the artistic production of those Roman provinces which subsequently became what we know as Europe.

The idea of Europe as an entity was not unknown to the ancients. Pliny the Elder (*NH* 3.1), echoing Strabo, declares that Europe is by far the most beautiful region of the known world. What he really has in mind, however, are the territories lying on the Atlantic and Mediterranean seaboard. What we mean by Europe is something different, essentially identical with the territories of Charlemagne's Empire. In fact one cannot speak of European art until the Carolingian period – which means, later, Romanesque and Gothic. There are special reasons for studying the art of these European provinces of the Roman Empire. Not only do certain Carolingian art-forms, in their aulic mode of expression, consciously imitate the art of antiquity; antique art would also seem to foreshadow, and provide a foundation for, some aspects of Romanesque and Gothic.

We have to ask ourselves, in the first place, both who produced the art of the Roman provinces, and for whom it was intended. Its main market seems to have lain among the Roman occupants of these provinces: administrators, Treasury officials, soldiers stationed on garrison duty or in the big, permanent camps. However, in certain Western provinces that had undergone a lengthy spell of Romanization – e.g. Spain (partially occupied since 218 BC and organized into two provinces from 197 onwards), or Southern Gaul (Gallia Narbonensis, incorporated in 118 BC), or the left bank of the Rhine, pacified at the beginning of the first century AD – the native upper classes, with one or two exceptions (Vercingetorix, Arminius), had allied themselves with the conqueror for economic reasons: something that always happens in such circumstances. The result was a social group that 'went Roman', and hence tended to use contemporary Romano-Hellenistic art as a means of expressing its own special interests, particularly in the spheres of religion and commerce. The Iberians of Baetica, the Gauls of Narbonensis

◀ 95 ODERZO, MOSAIC: BIRD-HUNT, WITH OWL. ODERZO, MUSEO CIVICO

and Lugdunum (Lyons), and – from AD 48 onwards – even those of Gallia Comata ('long-haired', i.e. Transalpine Gaul) were Roman citizens, and eligible for advancement to senatorial rank. For two hundred years the barbarian tribes – previously always at loggerheads – experienced, under Roman administration, not only peace and unity, but a substantial increase of material prosperity. Those territories stretching from the middle reaches of the Danube (the provinces of Noricum and Pannonia) to the Rhine, to the British Isles, and to the Atlantic coast of Gaul and Spain experienced some troubles after the second decade of the first century AD. But these few manifestations of revolt had no serious consequences.

In 167 the Danube frontier was breached by the Quadi and the Marcomanni, who penetrated as far as Venetia: but this, the first real danger-signal, remained for the time being an isolated incident. Later, the in-fighting over the succession which followed the death of Commodus (192) led directly to the devastation of Lyons, which in 197 was half-destroyed; but it was not until 234 that the Germanic tribes showed signs of taking the offensive again. In 252 this long period of peace was finally broken by the invasions of the Franks and the Alamanni, who reached the Pyrenees and Auvergne. Between 258 and 273, several military commanders of the Rhine *limes* (Postumus, Victorinus, Laelianus, Tetricus and his son) proclaimed themselves independent rulers of a Roman State of Gaul; during this period the country remained cut off from Rome, and virtually isolated. The re-establishment of unity did not, however, bring life back to normal; and, even during the period of peace which lasted from 285 to the mid-fourth century, conditions underwent a profound change. Local artistic output dwindles away to nothing; all we find are official monuments, directly derived from Imperial art, in places – such as Trèves – where the Emperor had long had a residence. The artistic production of these regions, during the Roman period, is traditionally referred to as 'provincial art'. This is an unsatisfactory term; but to replace it, at this stage, by the more accurate label 'European art of Rome' would be an awkward undertaking.

Various theories have been advanced to explain the formal idiosyncrasies of artistic production in this area. The first, put forward at the turn of the century by Furtwängler, was that it should be regarded as a specifically *military* art-form, something created for the benefit of the Roman legions. The inadequacies of this explanation have long since become apparent. Subsequently, scholars such as Schober attempted to explain the entire phenomenon in terms of the various substrata of local, indigenous culture. But this theory, though flattering to the nationalist sentiments of each country involved (implicit, e.g., in the accepted term 'Romano-Gallic' art), is not wholly satisfactory either. These cultural substrata – among which that of the vast area embraced by Celtic civilization, with its own artistic pattern already embodied in a stock repertoire of formal variants, was undoubtedly the most influential – may have explicitly broken through to the surface, like an outcrop, in certain instances; but they do not constitute the basic ingredient of Roman art in Europe. When we later come to discuss such phenomena, it will be in terms of, say, Celtic or Thracian art *during the Roman era.*

More recently Schoppa has attempted, at least for the early period, to link the works of each province (whether executed in Gaul, the Rhineland, Spain, Britain, or the Danube area) with the artistic culture of those regions – either Roman or long since

Romanized – from which the members of the legions stationed in each province came. One can often identify their province of origin from inscriptions on tombstones, which form the larger part of our surviving artistic evidence. This criterion seems admissible from the methodological viewpoint; but we must bear in mind that, at a later stage, the provinces developed their own local artistic production-centres, each with individual characteristics and methods. Moreover, side by side with this 'provincial' art, there still existed in the Roman cities numerous imported works (which represented official, i.e. State-sponsored, art) and other pieces influenced by the art-centres of the Hellenistic East. At Aquileia, for instance, we find one altar decorated with heads of Pan and Silenus, another portraying a sacrifice to Priapus and the unveiling of the *lychnos* in the Dionysiac mysteries, both dedicated by freedmen of Greek origin: these may well have exercised a constant influence over local production. We should also remember that the Emperor's official portrait, even in the provinces (except for one or two isolated cases), always faithfully reflects physiognomical characteristics and varieties of style that have previously been established in the capital.

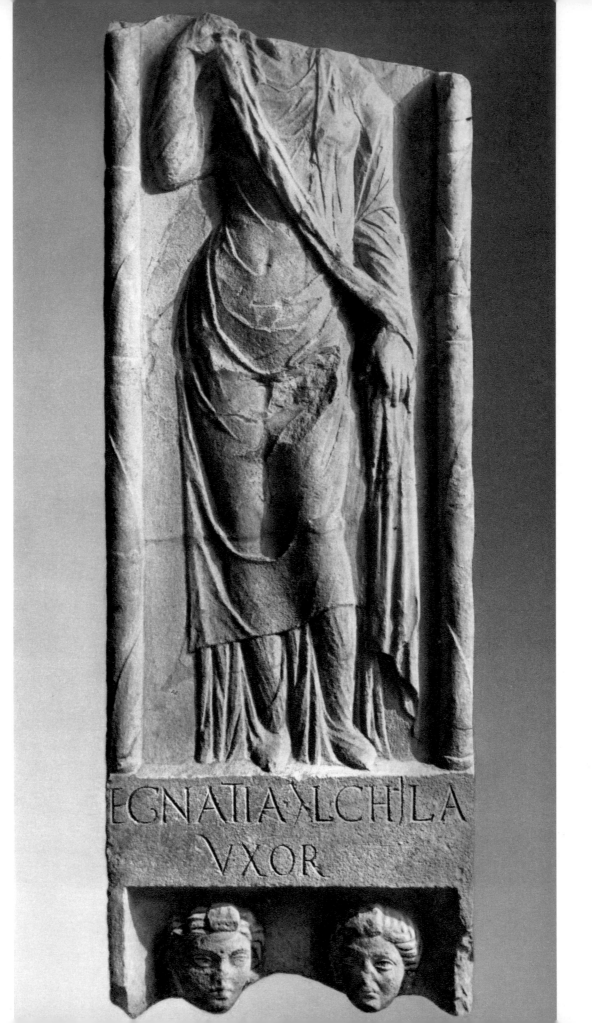

NORTHERN ITALY, ILLYRIA, NORICUM, PANNONIA AND DACIA

In any study of art in this period, it should be borne in mind that the problem of 'provincial art' begins, in Italy, with the Tusco-Emilian Apennines, and is applicable everywhere north of that line. This fact has often been neglected. One could, indeed, say that it was only brought fully to light by the exhibition organized at Bologna in 1964 under the title 'Roman Art and Civilization in Northern Italy from the Republic to the Tetrarchy'. This led to a re-examination of the evidence and the problems, and was all the more effective in that it formed a natural sequel to the preceding year's exhibition, on the theme of 'Art in the Roman West', which had been held in Paris.

It became clear that research into any particular 'provincial' form had to start, geographically and historically, from Northern Italy, where the phenomenon appears earlier than in any other area. But here, too, there arises the question of the cultural substratum prior to Romanization, with its Etruscan, Gaulish, Venetian, Raeto-Alpine and Ligurian elements. Studies have shown that almost nothing of this substratum survived the Romanizing process – at least, nothing of the Etruscan layer (wrongly invoked to explain certain features of Romano-Gallic production). Even in the Republican era, and still more so after Augustus's reforms, Roman organization obliterated all traces of what had been there before its coming. Nothing survived save a few religious elements, embedded in a syncretic pattern that was wholly Roman in spirit.

The truth is that Northern Italy was far more thoroughly Romanized than the Mediterranean regions of Central and Southern Italy, where socio-cultural conditions of greater complexity had been established at a much earlier date. In the north (except that colonization there began sooner, and was carried out more intensively) the situation resembled that of Gaul or the Danubian provinces. There were two different types of colony, 'Roman' and 'Latin'. The former was specifically military in character. It consisted of Roman citizens, organized on a community basis, and with a certain degree of autonomy, including their own magistrates. In return for these privileges, they took responsibility for guarding some strategic key-point (under the Republic, the Roman State had no standing army). The citizens, usually three hundred in number, and accompanied by their families, were assigned small grants of land, freehold. The 'Latin'

109

colonies, on the other hand, were (at least to begin with) recruited from a wide range of peoples, none of whom enjoyed Roman citizenship. These colonies mopped up several thousands of families. They became autonomous communities, established in conquered territory, and bound by alliance to Rome – though all they had to do was to supply a contingent of troops, and toe the line in matters of foreign policy.

It was these colonies which became the true instrument of Romanization. The first of them in Northern Italy was Rimini (Ariminum), founded in 268 BC, and located at the extreme tip of that defensive arc which was always to divide peninsular from continental Italy. Placentia (Piacenza) and Cremona were founded half a century later, both of them well-chosen strategic outposts in the middle of as yet unconquered terrain, and each garrisoned with a force equivalent to a legion (about 4,200 men). That same year, Hannibal crossed the Alps, swept down into Italy, and halted further Roman expansion for a whole generation: the next colony, Bologna, was not established until 189 BC. The territory of Emilia, through which, from Rimini to Piacenza, ran the new Via Aemilia (built in 187), was parcelled out in large lots, and systematically developed. The foundation of a colony at Aquileia, the colonists being Latin and Italiot allies (181 BC; see Livy 40.34.2), takes on particular importance. Aquileia actually lay inside Celtic territory, in an excellent position for controlling the trunk-roads to Noricum and Illyria. The colony itself was a large one, comprising some 3,000 families, to which a further 1,500 were added in 160. Also, because of the many artefacts surviving from it, Aquileia can be studied as a typical example of the form which this so-called 'provincial' artistic problem took in a frontier region. The art of Aquileia, in fact, sets the trend for artistic fashions in Noricum, Illyria, Pannonia and Dacia. Thrace and Moesia form a separate artistic unit, linked directly with Macedonia, indirectly with Greece (Achaea) and, to some extent, with the coastal centres of Asia Minor.

The changes that took place after the Social Wars (91–88) culminated in the transformation of the old Latin colonies into *municipia*, and the establishment of numerous new ones. This in turn led to large-scale land-distribution, and widespread town-planning on the axial-grid system – a feature which still survives in almost every North Italian town. In 49 BC these colonies, too, became *municipia* of the Roman Republic. By 42 the last military garrison had been removed, and with its disappearance the Cisalpine region lost its 'provincial' character. After the Civil Wars, this process was completed by settling veterans on the last few tracts of land still occupied by their original inhabitants. The extent of Romanization is further attested by the number of Latin poets and writers who came from this region, among them Virgil, Livy and Catullus.

All this goes to explain why so little of the cultural substratum had strength enough left to influence the form which art took in the Romanized areas. Because of its opposition to the Gauls, Venetia had always been favourably disposed towards the Romans, and as a result there was no need to found colonies there. Yet even Venetia presents no features that can be clearly traced back to the previous civilization (in this case Palaeo-Venetian and Atestine).

The formal canons of Hellenistic art had been strong enough to impose themselves on some very ancient and complex civilizations, including those of Egypt and Achaemenid Persia. It is therefore hardly surprising that Graeco-Roman artistic canons – as

98 AQUILEIA. MONUMENT OF LUCIUS ALFIUS (DETAIL): A MASTER-MASON'S INSTRUMENTS. AQUILEIA, MUSEO NAZIONALE

long as they held firm – obliterated any forms of art which the barbarian civilizations of Europe had evolved. It is only when these canons lose their authority that what we may term 'nationalist' trends in art begin to reappear in peripheral areas of the Empire – which shows that at least some elements in the substratum had been kept alive.

At Aquileia, a large proportion of the early immigrants came from what is now the Abruzzi region; and the oldest sculptures of this colony do, in point of fact, suggest a stylistic similarity with the civic monuments of Teate and Amiternum (see *Rome: The Centre of Power, pl. 62–64*). We should, therefore, accept as our point of departure for provincial art that plebeian movement which, as we have seen, formed a permanent, characteristic element in the genesis and development of Roman art. By adopting the formal canons of Hellenism, plebeian art became linked with Hellenistic culture; yet of this culture's complex formal significance, the plebeian movement grasped nothing whatsoever. A clear example of this blank incomprehension is the way in which formal architectural patterns degenerate from the structural to the merely decorative. Individual architectural conventions – cornices, friezes, columns and pilasters, capitals and bases – always preserve the memory, in Hellenistic art, of their functional, architectonic origin; the bearing element is actually subjected to stress, ornamentation always reveals its naturalistic origin. The egg-and-dart pattern on a cornice, even when transformed into pure abstract design, still retains the memory of its vegetable origin as a down-turned

111

99 AQUILEIA. FUNERARY MONUMENT (DETAIL): BLACKSMITH'S SHOP. AQUILEIA, MUSEO NAZIONALE

leaf, with the result that it can never be reproduced upside-down. Similarly, the triglyphs of a Doric frieze are always treated as bearing elements (having started life as beam-ends), and not merely as part of the chiaroscuro. All this goes by the board in Roman provincial art: isolated architectural elements can here assume a merely ornamental role, unrelated to their structural function. The same is true of human anatomy, and of draperies. Once anatomical structure has lost its organic meaning, it can be treated just as the artist pleases. A rough approximation (or mere decorativeness) will suffice, and any distortion is permissible in the interests of heightening the effect.

This is true of all European art under Rome's aegis, and, very early in the day, of Northern Italy as a province. Loss of organic structure and a tendency towards 'expressionism', which appear in Roman 'official' art only after the death of Commodus, appear in provincial art as early as the first century. However, this does not imply any kind of provincial influence on the capital; it indicates, rather, a general reaction against that naturalistic rationalism which had been so unusual a feature of Hellenistic art, and which tended to survive longer in the more cultivated centres.

The funerary monument of Lucius Alfius, a master mason from Aquileia, is decorated with a Doric frieze, and adopts a typological pattern very common in the first century BC. This derives from the more grandiose sort of Hellenistic model, and is regularly to be found in the Campano-Samnite *municipia*: it extends as far afield as the Po Valley, Istria and Gallia Narbonensis, but not to old Magna Graecia or Etruria. Such a monument is characteristic of areas where late-Hellenistic culture has been disseminated. From Greek trading-centres (Delos in particular) this phenomenon reached the so-called 'Italiots', penetrating not only the provinces to which they had emigrated, but also the areas from which they had come. By following the routes that the colonists and merchants had travelled, it got a foothold in Gallia Narbonensis, where Hellenistic culture had already penetrated long before. Another feature typical, not merely of the art of Aquileia, but of plebeian art, and eventually of all 'provincial' art, is the prominence given to representations of the working tools used in life by the tomb's occupant. Similarly, another tomb shows us a blacksmith's forge: both cases anticipate that medieval practice of illustrating crafts and professions. We are still very much in the world of plebeian art. Reduction of those Hellenistic elements which infiltrated Italic culture at

112

an early stage of its development, a popularity with the class that includes local magistrates, contractors and wealthy freedmen – such features are typical.

The funerary stele of the quadrumvir Cnaeus Octavius Cornicla (originally from Aquileia and now in the Museo Maffeiano at Verona) was commissioned by the deceased himself, during his lifetime: *v[ivus] f[ecit]*. We assume, then, that it accurately expresses the wishes of its purchaser. Its date has been in dispute. For a long time it was regarded as 'late and barbarous'; but the type of inscription it carries places it in about AD 50–80. Such a date, moreover, agrees with the fine and careful execution of the pilasters, and of the figures surmounting them. The bust of the deceased is designed, primarily, to express energy and authority: his head is merely sketched in, and his chest is as rigid as a cuirass. This impression of forcefulness is augmented by the big, coarse fingers. The toga is rendered with a series of harsh parallel lines, like the strands in a hank of yarn; and – again like a hank of yarn – it bunches up in a quite unjustified fashion above the right hand. Unjustified, that is, from the naturalistic viewpoint, but not from that of ornamentation. These parallel folds, bunched up to suggest an ornamental knot, reappear, right in the middle of the Romanesque period, on the sculptures of Modena

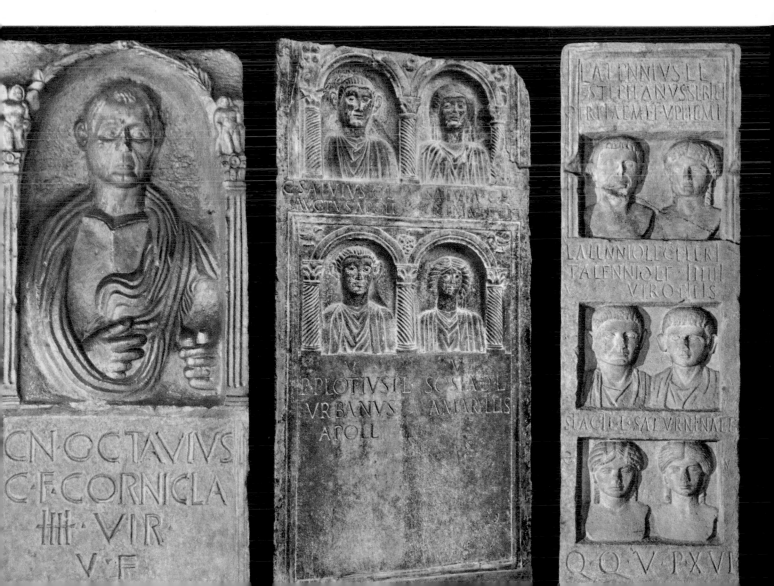

Cathedral, and also on the tympanum of the Madeleine at Vézelay. We have here an instance of that 'foreshadowing of the Middle Ages' which will haunt us throughout our study of Roman sculpture in Europe. If we wanted to find some underlying Veneto-Alpine influence in this example from Aquileia, we could point merely to a general taste for formal decorativeness; or if, *per contra*, we posited a Celtic substratum, then we could place emphasis on those undulating, quasi-geometrical lines.

At precisely the same time, however, it was also possible, in the provinces, to sculpt a funeral stele such as that of Ignatia Chila (from the neighbourhood of Forli, now in the Rimini Museum) which repeats a very widespread Hellenistic motif. The deceased woman is shown between two papyrus stems; while these may be no more than an approximation, the effect of transparent material – so characteristic a feature of Hellenistic sculpture – is very well conveyed. Direct contacts between the Adriatic coast and centres of Hellenism such as Rhodes have never been studied in detail; but the port of Ancona has yielded some evidence on the subject (Ancona, Museo Archeologico). Despite such refinements, this fragmentary piece belongs to a very common type of stele, divided into several sections, one above the other. The hair-styles of the women (of the Octavia-Livia-Agrippina type) place them in the first century A D. A good example is the stele from Bologna, commemorating the freedmen of the Alennia family (*pl. 102*). This presents a series of commonplace portraits, numerous parallels to which can be found in Roman monuments. But the stele, from Modena, of Caius Salvius and others (*pl. 101*), though it repeats this pattern, introduces formal variations which have led some to suppose it a medieval imitation (the stone was built into the Romanesque tower of the Cathedral). Thus decorative schematization and the rejection of naturalism are characteristic features of this production. Here, again, we need not look for a formal recollection of earlier, pre-Roman cultures. One should never forget, in Europe, that Hellenistic naturalism, with its formal correctness, plastic sensibility and sophisticated elegance, was the product of Greek artistic civilization – which remained, throughout antiquity, a unique and exceptional phenomenon. In all the less cultivated peripheral civilizations, these qualities were soon lost. As its indigenous civilizations make clear, continental Europe, as a whole, preferred a non-plastic, linear mode of artistic expression, which worked itself out in abstract, quasi-geometric motifs. From the time that the upper classes' interest in culture declined, that naturalistic feeling for plastic form which was Hellenism's hallmark began to dwindle away.

A further problem arises here, this time a chronological one. The stelae just discussed (at least, those from North Italy) are generally, on the basis of the hair-styles, attributed to the first half of the first century. But in many cases, I feel, one should not rule out the possibility of a time-lag in the iconographic sequence. Some patterns may have been introduced during the Augustan age, at the same time as the great regional reorganization of Italy, and may have survived much longer in the stone-carvers' workshops. If we were to admit the possibility of such a survival of iconographic patterns, the result would be to diminish (in some cases, even to destroy) the value, as a portrait, of many of the representations on the stelae. This is not a conclusion to be rejected, when one considers how much all these faces (whether male or female) look alike. Roman portraits of a high artistic quality, which do achieve a true likeness, are to be found only among

the socially and economically privileged classes. Even with them, the desire to immortalize the appearance of the deceased wears thin as time goes on. As we have seen, there was a trade at Rome in ready-made sarcophagi, on which the head of the main figure was left blank – to be filled in, on purchase, with the occupant's own likeness. From the end of the second century and throughout the third, we find numerous sarcophagi being put into use without any attempt to execute this portrait. Here, I suspect, we have the reason why stelae increased in popularity. They could be used to commemorate several generations at once, and bore no relation to reality except as regards the respective number of male and female heads portrayed. The heads themselves were not real likenesses (which would often have been difficult to achieve). Clearly, however, this was not the case when the stele or other funerary monument had been prepared during the purchaser's lifetime, as was the case with Cornicla, the quadrumvir from Aquileia.

The sculpture of Aquileia possesses other noteworthy features, of which the most interesting is also the hardest to trace back to its historical source. No 'official' or Hellenistically inspired sculpture can match this provincial work for sheer intensity of expression: and while the expression conveyed is, more often than not, one of suffering, it can also, on occasion, suggest deep pride or subtle tenderness. In the Introduction we saw how, and why, an expression of anguish became so frequent in sculpture from the close of the second and, particularly, during the third century AD. In 'provincial' culture, the search for intensity of expression begins almost a hundred years earlier. The only possible explanation for this phenomenon is the adaptation of art to harsh colonial realities, coupled with a minimal spread of Hellenistic exemplars. Such a process of adaptation is confirmed by the clear way in which ethnic characteristics manifest themselves. At Aquileia these are Dinarico-Illyrian or Norican; they have survived until modern times, as have the traditional varieties of local costume. Here, again, we have a typical foreshadowing of the Middle Ages, when religious art loses its aulic, mandarin quality and develops in contact with the people as a 'Bible of the poor' – i.e. of the illiterate.

The stele of Cornicla has already provided us with one instance of deliberate severity in monumental sculpture, but there are many others: female statues which already display a positively medieval stiffness; masculine heads of quite terrifying intensity, carved from hard Istrian stone, and obtaining their effects by a very simple plastic technique. All this suggests a perfect adjustment to the human audience portrayed: emotional intensity on a popular level, wholly lacking in mannerisms. It is, moreover, a characteristic shared by the art of every province of Western Europe.

With the hunting mosaic from Oderzo we are already in the third century. What we have here is not a lion-hunt or a stag-hunt, both of which had their own iconographic patterns, derived from the Hellenistic centres of the Near East, and known all round the Mediterranean littoral. This is a simpler and more popular sport: hunting by lure, with the owl being used to tempt small birds on to limed branches. Venetian peasants still practised it until very recent times: a cruel sport, perhaps, but it enabled them to give some relish to their staple diet of maize-flour *polenta*.

Sometimes, too, Venetian reliefs reveal characteristics which seem to have been derived from the repoussé technique used on bronze: note, for instance, those stiff

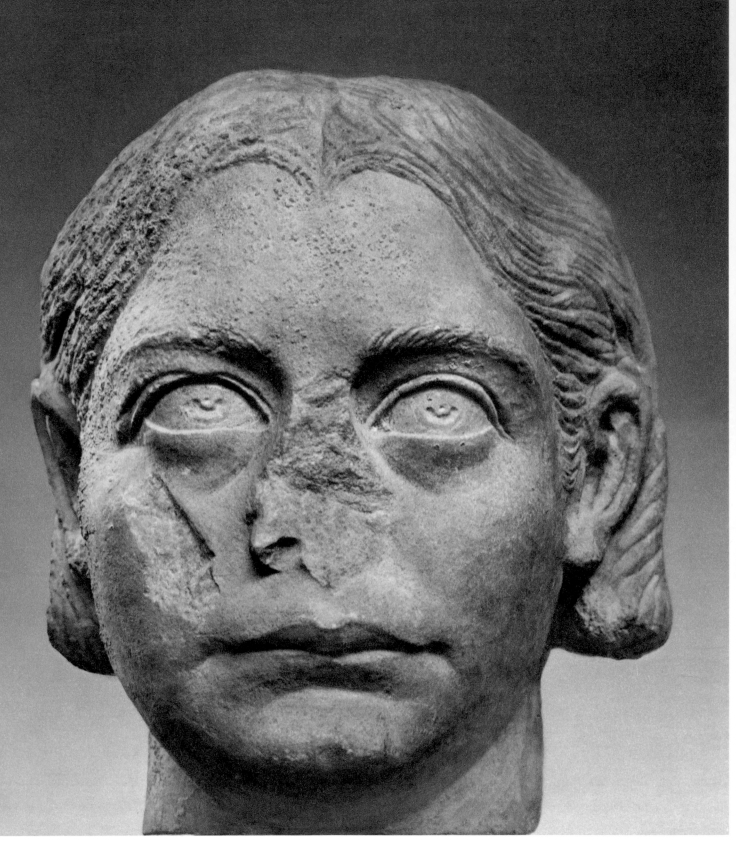

103 AQUILEIA. PORTRAIT OF A WOMAN. AQUILEIA, MUSEO NAZIONALE

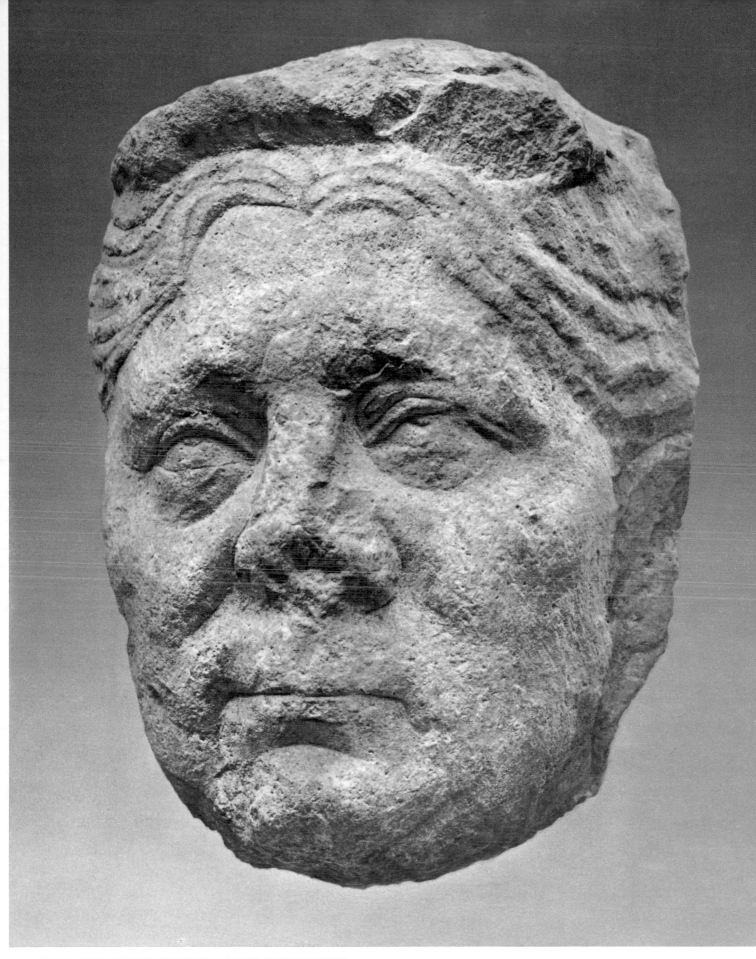

104 AQUILEIA. PORTRAIT OF AN OLD WOMAN. AQUILEIA, MUSEO NAZIONALE

105 AQUILEIA. FUNERARY STELE OF A MERCHANT. AQUILEIA, MUSEO NAZIONALE

118

106 AQUILEIA. FUNERARY STATUE OF A DRAPED WOMAN. AQUILEIA, MUSEO NAZIONALE ▶

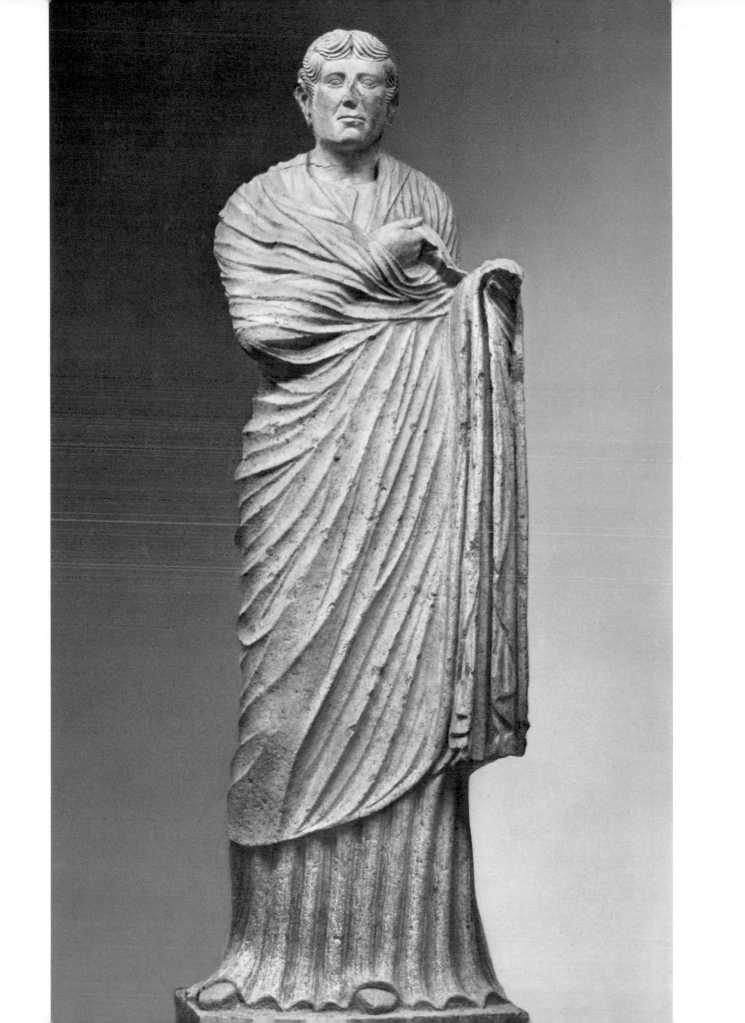

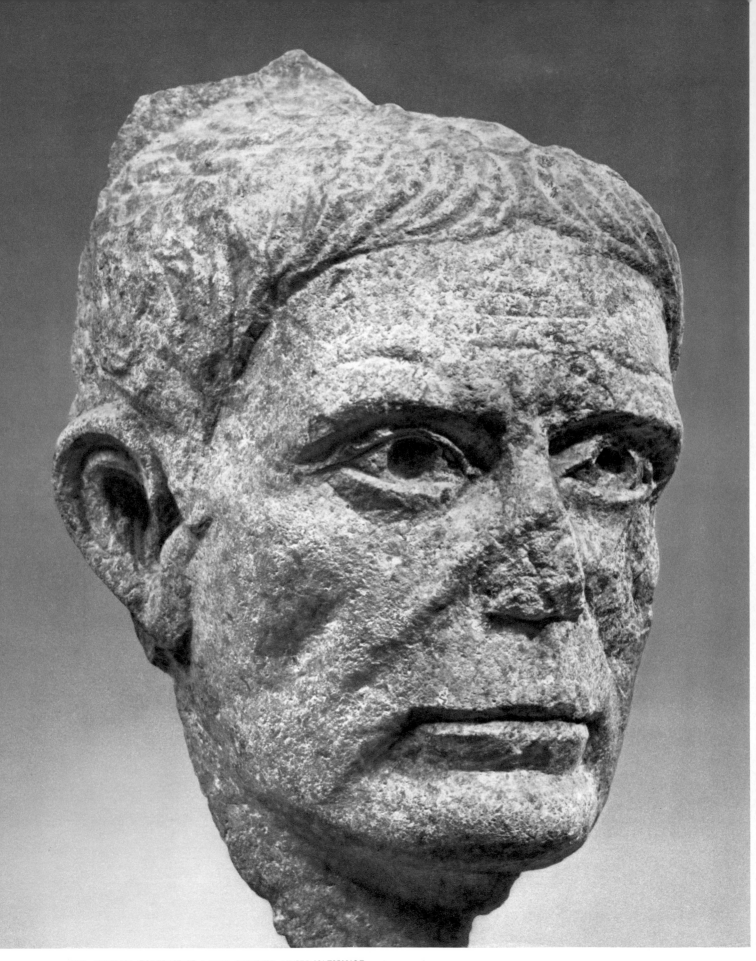

107 AQUILEIA. PORTRAIT OF A MAN. AQUILEIA, MUSEO NAZIONALE

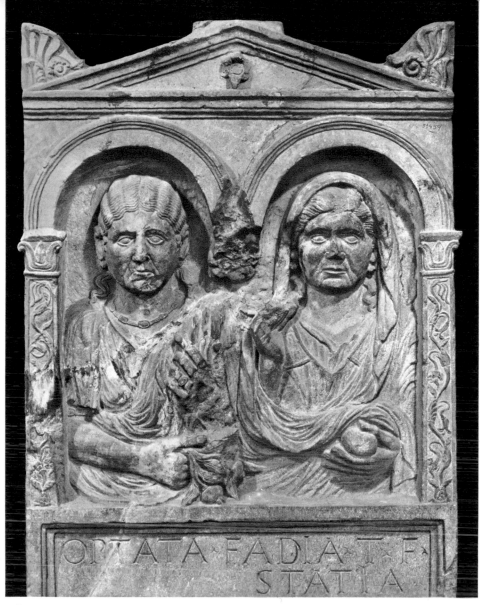

108 AQUILEIA. FUNERAL STELE OF TWO WOMEN. AQUILEIA, MUSEO NAZIONALE

locks of hair (borrowed from the athletes of classical art) which turn up in reliefs and statue-groups. These forms, as well, were picked up by medieval art.

The small bronzes merit particular attention. Large numbers of them must have been disseminated by travelling craftsmen, for it has proved impossible to assign them to local workshops according to provenance. The Hellenistic art-industry had evolved clever techniques for fixing decorations on furniture or plate. Even statuettes could be manufactured in several pieces: the same torso – depending on how the head and arms were attached – could be used for various different figures. These statuettes, copies of classical and Hellenistic stock types, were turned out by the thousand and sold all over Europe, even beyond the Imperial frontiers; so were metal vases with appliqué ornamentation. Decorated parade-harness is often found, as well as special pieces perhaps presented as prizes (*baltei*), on which we find battle-scenes composed according to Hellenistic canons. These recur from Trajan's day onwards, and are particularly common on

121

109 BOLOGNA. FRAGMENT OF A HARNESS-ORNAMENT: BARBARIAN IN FLIGHT. BOLOGNA, MUSEO COMUNALE

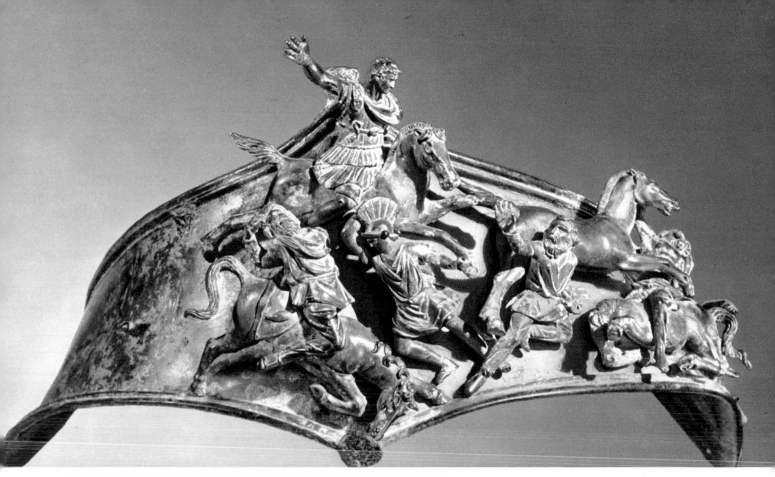

III PIEDMONT. HARNESS-ORNAMENT: BATTLE-SCENE. AOSTA, MUSEO ARCHEOLOGICO

third-century sarcophagi. The specimen from Aosta is, formally, very correct, while that from Brescia is more 'provincial'. But detached figures from similar pieces turn up over a wide area: at Velia (Southern Italy), in the Balkans, and throughout the Western provinces. Their main theme – a richly expressive one – was that of barbarians in flight, whether on foot or on horseback. From the midst of this mass-produced output certain works stand out as original creations. These make it clear that the artists conceived their creations on this small scale to begin with, rather than trying to produce miniature versions of existing full-scale works.

Not enough research has been done to enable us to isolate the centres where such things were produced. In Northern Italy, we can be fairly confident that Brescia Aquileia and Velleia in Emilia had workshops which turned out small bronzes. Undoubtedly, however, connoisseurs of the period also purchased antique pieces which originated in some Hellenistic studio; and on top of this there must have been numerous imports. The two figures of water-carriers in the Vienna Museum (from Montorio Veronese) reveal a sculptural style quite out of key with the provincial Italic tradition: one of them at least is a second-century BC original. The figure of the prisoner from Brescia Museum (there must once have been two of these pieces, designed to go on either side of a trophy) seems to be a simplified version of some lost urban original.

Aquileia, as one such centre, must have exerted a powerful influence over the production of the adjacent Eastern provinces. At the same time it must itself have been stimulated by artistic developments in Macedonia, which would have reached it by way

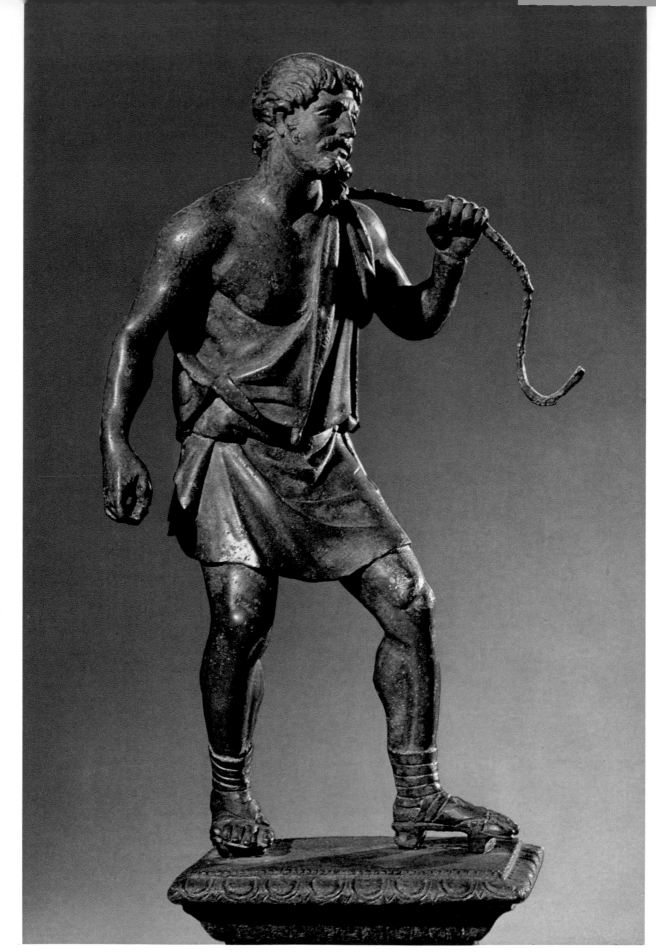

112 MONTORIO VERONESE. WATER-CARRIER. VIENNA, KUNSTHISTORISCHES MUSEUM

113 BRESCIA. ORNAMENT FROM A TROPHY: PRISONER. BRESCIA, MUSEO ROMANO

115 WAGNA. FUNERARY STELE. GRAZ, LANDESMUSEUM JOANNEUM

114 ALBA JULIA. FUNERARY STELE. ALBA JULIA, REGIONAL MUSEUM 116 AU (VORARLBERG). STELE OF UMMA. VIENNA, LANDESMUSEUM

117 KOSTOLAC. FRAGMENT OF A STELE: SCENE SHOWING PAYMENT OF TAXES. BELGRADE, NARODNI MUZEJ

of Illyria. From the fourth century on, Macedonian art seems to have played a more important role than is apparent today. Run-of-the-mill stelae, surmounted by a pair of lions or sphinxes; families of deceased persons portrayed inside a heavy wreath-garland; tombs with pyramids over them – all these recur, in identical form, over an area extending from Pannonia and Dacia to Illyria and Noricum. Here, in Carinthia (Carnuntum, Petronell), a region peopled by Celts, the ancient Iron Age culture had given way to one of intensive metallurgical productivity. The stelae of local women reveal typical clothes and wide, two-pointed hats. Traditional Graeco-Roman funerary scenes (e.g. Eros and Psyche on a sarcophagus from Sirmium) are enclosed in a characteristic framework of curving lines (the 'Norican cornice') which suggests Celtic influence, and is regularly found from the first to the fourth century even on sarcophagi portraying Christian scenes. Another widespread motif is the anthropophagous sphinx, with a human head between its paws, or sometimes (Alba Julia) holding a mask of Medusa: at once a death demon and a tomb-guardian. From Northern Italy (first century) it spread to the British Isles (second century), to the Rhine provinces and the Danube (second to third centuries), penetrating as far as Dacia, but not reaching Pannonia or Upper Moesia.

Throughout this area, military stelae display portraits of armed soldiers, either on foot or horseback, while civilian stelae have representations of individuals or family groups, or of crafts and professions. Alongside these, we find reliefs that are clearly cult-orientated; but there is much overlapping between secular and religious spheres. In Macedonia, Thrace and Moesia, however, we do not find representations of the deceased's profession or craft, and military stelae are rare. Stelae adorned with family

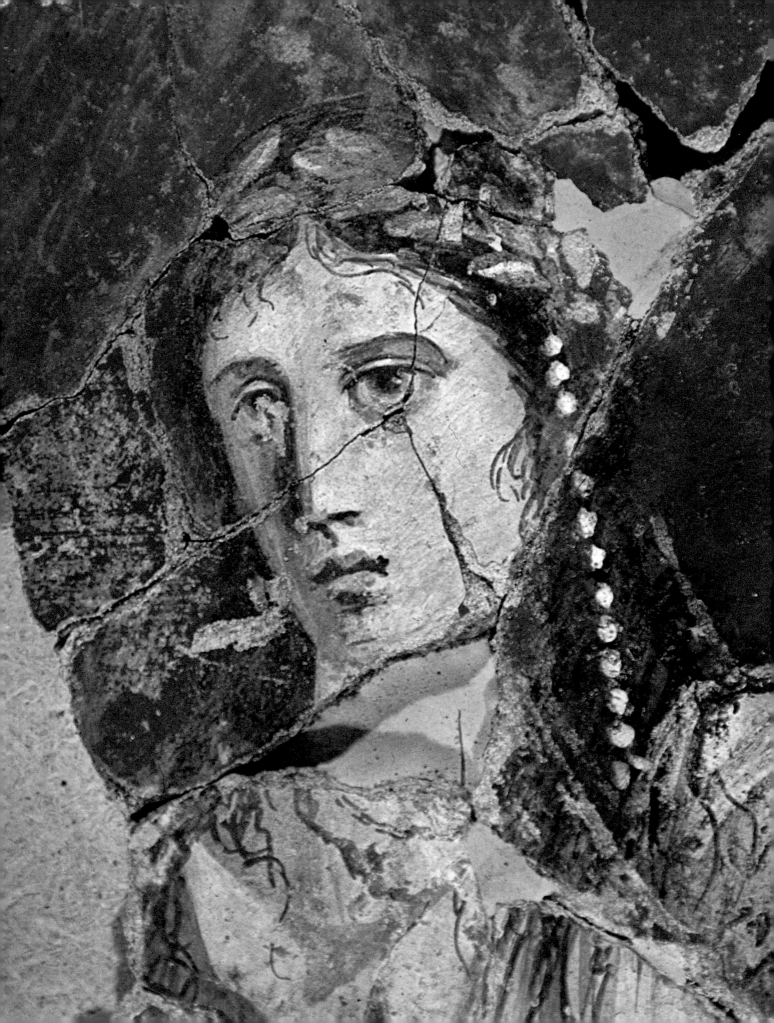

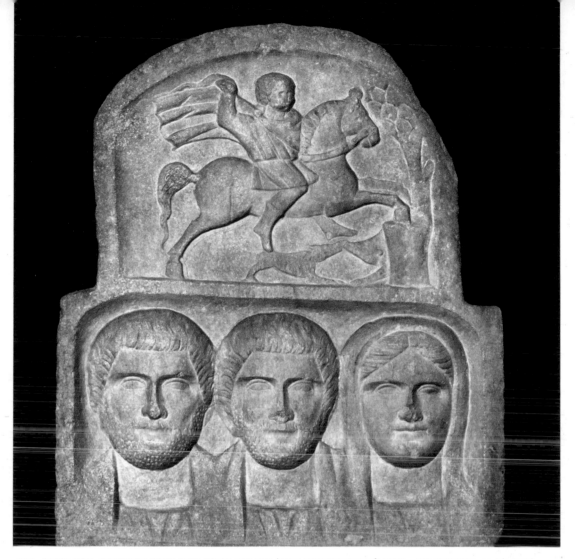

119 SANDANSKI. FUNERARY STELE WITH PORTRAITS AND 'THRACIAN HORSEMAN'. SOFIA, ARCHAEOLOGICAL MUSEUM

portraits also display the sacred image of the 'Thracian horseman': this cult-representation dominates a good number of stelae, while the deceased is always given heroic status, and shown taking part in the funeral banquet.

Imported sculptures are in sharp contrast to the products of local art. These pieces, destined for official buildings and the homes of high officials or big landowners, bring with them an echo of the art of the capital, and reveal a certain persistence of classical motifs. Painters from the main artistic centres (Macedonia or Alexandria?) have left traces of their passage in works that are clearly superior to the general run of Campanian paintings. We may note, for instance, those in a building at Petronell, of which one reception-room was decorated with characters from Greek mythology (*pl. 118*). The basic patterns of cultivated art (kept in circulation by illustrations to literary texts) are to be found on certain sepulchral mosaics, such as that of a child, Aurelius Aurelianus (now in the Split Museum).

Pannonia and Illyria assume a special importance in Roman political life from the time of Septimius Severus to that of Diocletian, who, like the other Tetrarchs, was of Illyrian origin. A statement of Alföldi's needs to be repeated here: that the strong Illyrico-Pannonian element infused into Imperial government in the third century does

129

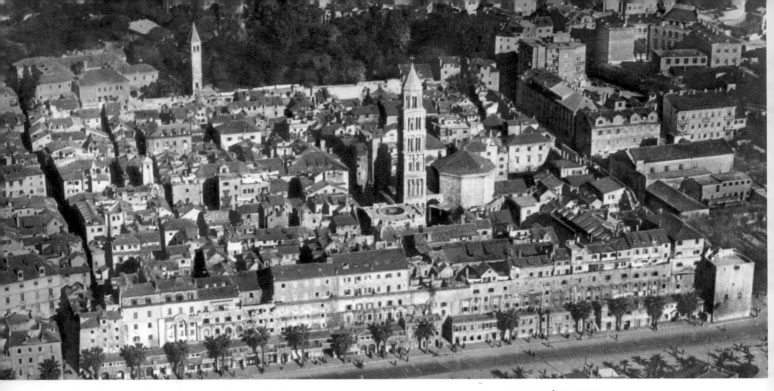

120 SPLIT. AERIAL VIEW OF THE PART OF THE TOWN WHICH CONSTITUTED DIOCLETIAN'S PALACE

not represent an 'Oriental' influence, but operates in a perspective which keeps Rome as the centre of the West. The thoroughgoing Romanization of these regions is apparent in the special characteristics of local art in each province.

A surviving symbol of the leading role played by these Illyrian emperors is the enormous palace which Diocletian began to build in 293 for his retirement. He did not abdicate until 305; but he believed in planning ahead. The site chosen was near Salonae, and its modern name, Split, perhaps derives from the palace itself (*Spalatum* = 's' + *palatium*). The entire historical centre is plainly included within the perimeter of the palace, which became a place of refuge for the inhabitants of Salonae when this city was destroyed in 639.

The ground-plan of the palace is roughly trapezoidal. Its façade, overlooking the sea, extends for 157.50 m. between the corner-towers. The longer walls, on the east and west sides, are respectively 191.25 m. and 192.10 m. The fourth wall (150.95 m.) rests on the upper slope, in such a way that its front section has an ample underlying foundation. There is a modest gateway opening on the sea, and grander ones, framed with octagonal towers, in the middle of the other three sides. The road from north to south has, in its second section, a peristyle with access on one side to a temple, and on the other to the Emperor's octagonal mausoleum (afterwards converted into a cathedral). Finally, there is a subterranean stairway that leads down to the gate above the sea. The doubling of sanctuary and place of residence has a parallel in the sacralization of the Emperor's person. From the architectural viewpoint, the motif of the archivolted colonnade in the peristyle has a precedent in the temple of the Divine Hadrian at Ephesus. The façade facing the sea is occupied by State reception-rooms and private apartments. Throughout its length there ran a windowed corridor, pierced at the centre and at either end by tripartite loggias. The overall plan of the palace derives from that of

130

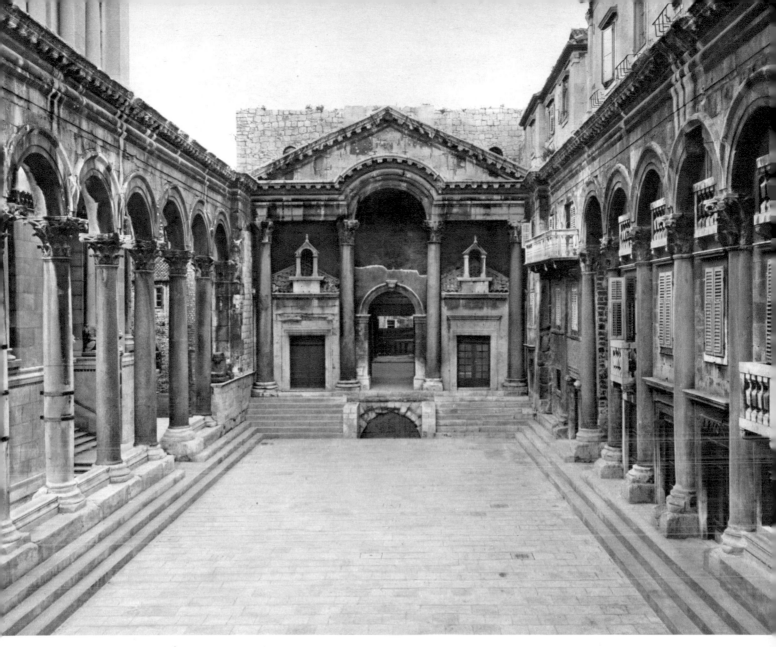

121 SPLIT, DIOCLETIAN'S PALACE. GENERAL VIEW OF THE PERISTYLE

a Roman legionary camp, perhaps in particular from those fortified encampments found on the Syrian frontiers. Yet it also reveals features of a country-house in the Western provinces (e.g. the façade with a loggia, enclosed by two corner-towers).

The architect probably came from the East. In its formal details, in its distribution of spatial mass and the relationship between solid and hollow surfaces, Diocletian's palace – the only Imperial residence dating from the Late Empire which has been recognizably preserved – presents many features which still survive in the architecture of medieval palaces and castles.

Medieval iconography (the 'Virgin of the people' or the 'Virgin in a robe') is brought to mind, too, by the decorations on a Christian sarcophagus datable to about 320. The central niche is occupied by the Good Shepherd, flanked by symbolic peacocks. On

131

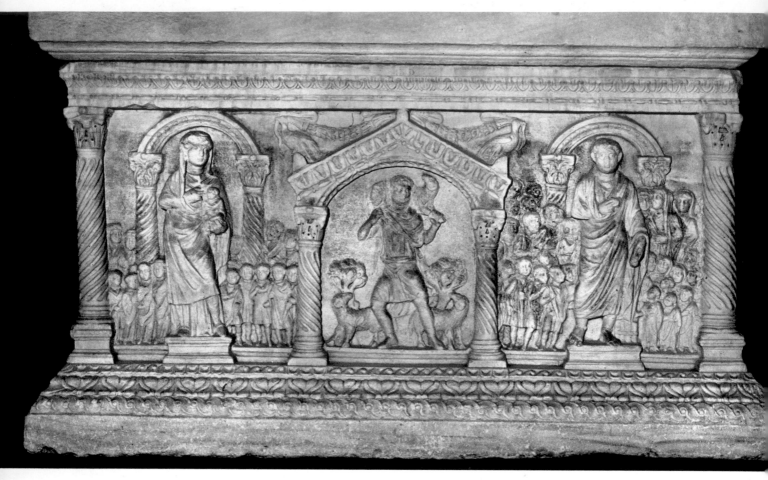

either side are the portraits of the husband and wife whose tomb this is, each of them surrounded by small figures, clients or protégés. Here is an eloquent instance of how the idea of realistic proportions could be replaced by a more hierarchical and symbolic attitude: a trend which hit plebeian art in the first century, and finally imposed itself also on cultivated art, in such sumptuous works as this.

Throughout the Danube region, from Illyria to Dacia and Pannonia, we find similar characteristics – not only from the stylistic viewpoint, but also in the iconographic repertory. The latter reveals an adaptation of Graeco-Roman and 'Roman-plebeian' formal canons which, by progressively sloughing off many elegant cultural traits, eventually achieves features that may properly be termed pre-medieval. Another typical case is provided by the votive images of the goddess Nemesis (then venerated under the name of Regina), which are frequently found in Dacia (Museum of Alba Julia, the ancient Apulum). The gesture of pulling one's robe away from the breast, in order to spit inside as an apotropaic, comes out very clearly with the more classically inspired examples, and is remarkably close to the position which was adopted, iconographically, to indicate someone talking (or later, in Christian art, the bestowal of a blessing): right hand raised, with the middle and index fingers outstretched. An example such as that from Apulum (which in 158 became the capital of the three Dacian provinces, and after 167, when these provinces were united, the seat of a *procurator*) can be placed between

132

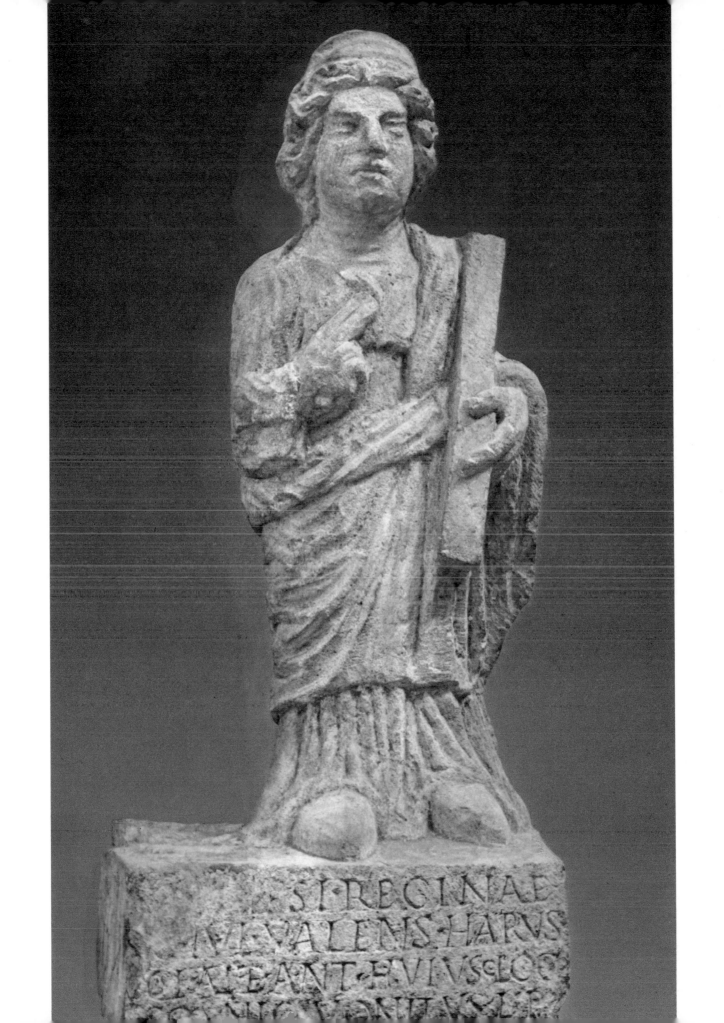

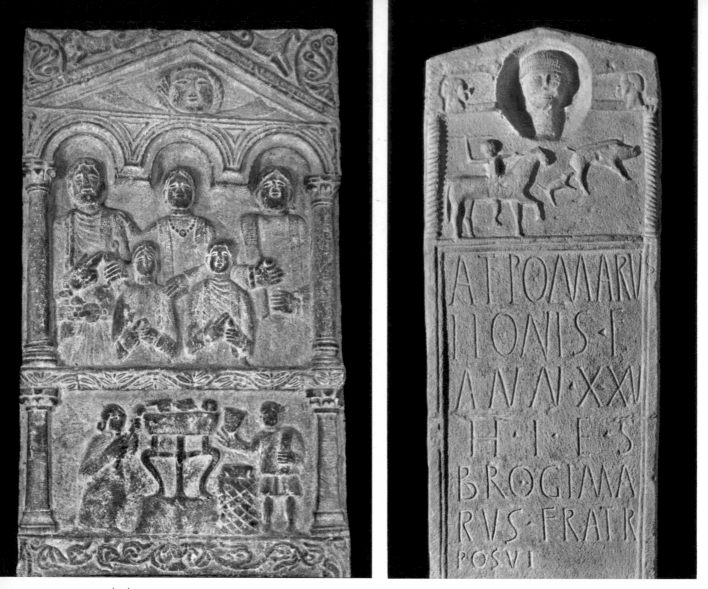

124 CSÁSZÁR. STELE OF AURELIUS JANUARIUS. BUDAPEST 125 BAD DEUTSCH ALTENBURG. STELE OF APTOMARUS AND BRIGIMARUS

the second half of the second century and the first half of the third. The inscription attached to this image, recording a vow made in consequence of a dream, typifies the superstitious aspect of the cult of Nemesis – the goddess who fixes a soldier's doubtful destiny.

The Nemesis of Apulum shows us how a Graeco-Roman formula could be thoroughly transformed to suit local conditions. In other examples, from Noricum and Upper Pannonia (which lay within the Celtic zone) we can again, in all likelihood, see the older local substratum reassert itself. Here it tended towards somewhat primitive and schematized formal patterns, which were widespread throughout the La Tène civilization (see, e.g., the stele of Aurelius Januarius in Budapest, as well as that of Aptomarus, which came from Carinthia and is now in Bad Deutsch Altenburg). Also from Carinthia comes one piece which exemplifies, better than any other, this grafting of a Roman concept on to a format in the Celtic tradition: the remarkable stele of Popaeius

134

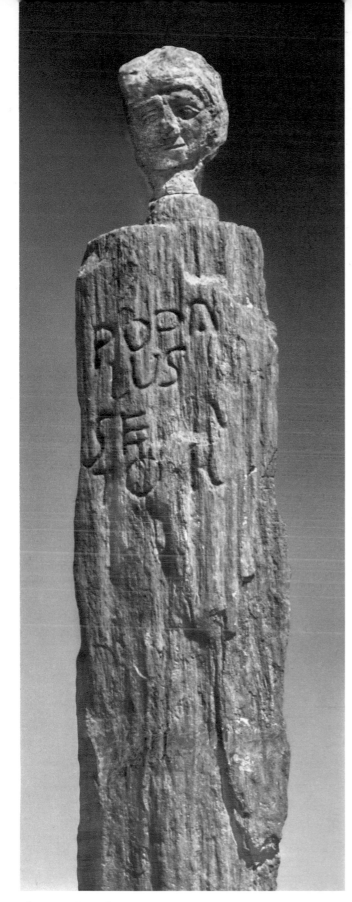

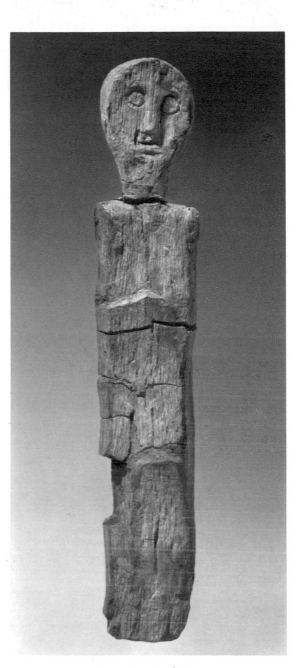

127 MONTBOUY. VOTIVE IMAGE. ORLÉANS

126 MATREI (TYROL). STELE OF POPAEIUS SENATOR

135

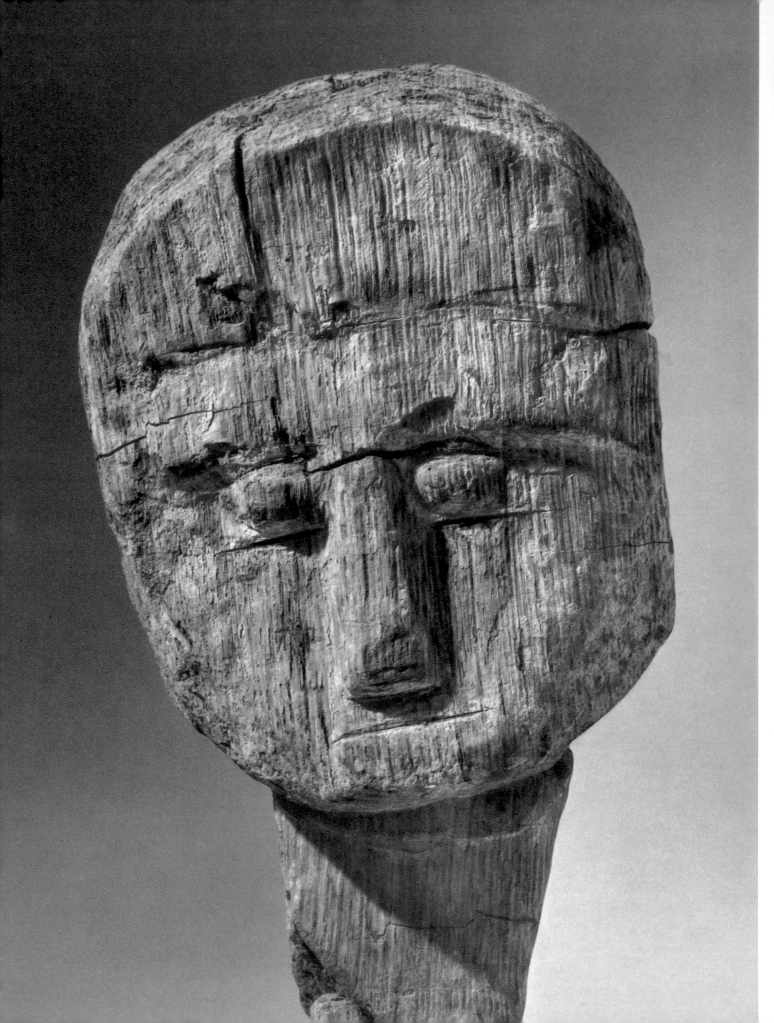

Senator (*pl. 126*), still at Matrei, where it was found. The nearest parallel to this is provided by certain wooden votive images, found at Montbouy, in a sacred well (*pl. 127, 128*), and in the sanctuary close to the sources of the Seine. Popaieus's stele should probably be assigned to a period not long after the Roman conquest in 15 BC (some scholars used to place it, without caveat, in the second century as evidence for the first opening up of Carinthia's mineral resources to Roman businessmen). However, in evaluating its formal significance, we should not forget that this concept of a head, symbolically represented (though also intended as a portrait) on the summit of an inert, lifeless, geometrical plinth – something the Greeks could not help enlivening, at least as regards their stelae, with explicitly sexual signs – was already familiar to Italic art, and picked up by the Romans even in areas that had no previous contact with Celtic elements. It was still current in the Imperial period, as is shown by the cippi in the Tarentum (Taranto) necropolis (see *Rome: The Centre of Power, pl. 82*). A comparison of these cippi with the stone ex-voto offerings – so exactly parallel in structure, yet so different from the viewpoint of formal plastic technique – that were found in a shrine in Halatte Forest (Senlis Museum), gives one some idea both of the differences in development, and of the profound affinities that exist between the Celtic and the Italic peoples. (Comparison of their linguistic patterns gives a similar result.) These affinities may well go back to their common, if distant, Lusatian origins, and to an at least partial connection with the wave of *Urnfeld* immigrants who, in the prehistoric and protohistoric periods, laid down a common ancestry for Western European man.

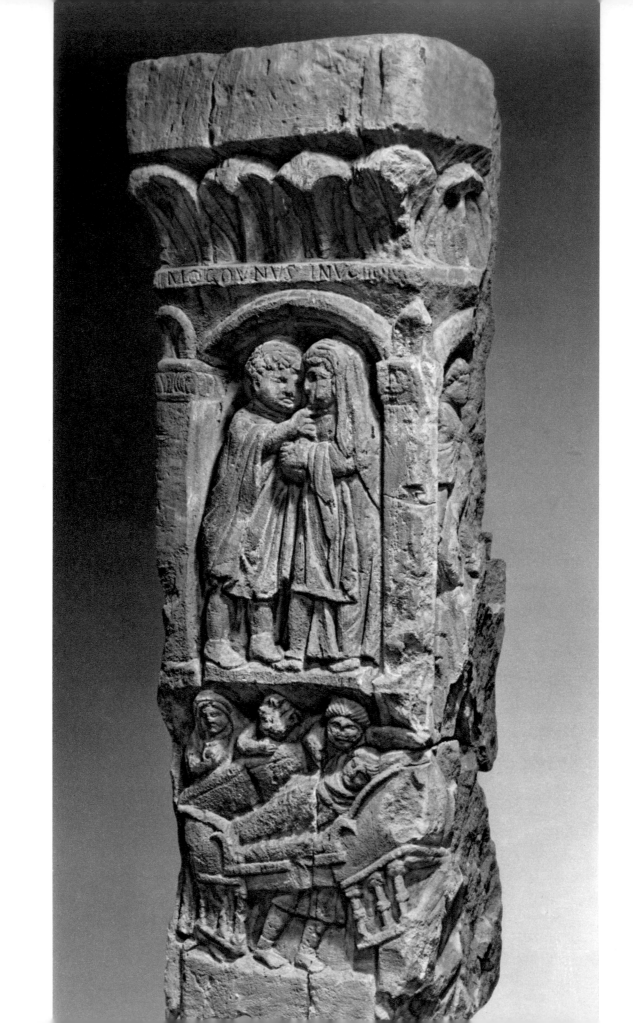

GAUL AND THE RHINE

Within the general compass of Roman provincial art, Gallia Narbonensis occupies a special place. It corresponds, roughly, to modern Provence – a name which preserves the memory of its having once belonged to the Roman 'Province' *par excellence*. Its capital, Narbo Martius (Narbonne) was the first colony of Roman citizens beyond the Alps. Founded in 118 BC, by Tiberius's day it had the largest population of any city in Gaul.

The first occasion on which Massalia (Marseilles) invoked Roman aid was in 154, against the Ligurians; later the Romans withdrew, retroceding the area to the old Phocaean colony. However, they were summoned back in 125 against the Vocontii and the Salyes. In 124–123, the consul Sextius Calvinus captured the Salyes' chief citadel, Entremont, a town whose fortifications and regular ground-plan testify to Greek influence. Not far off he founded the Roman fort of Aquae Sextiae (Aix-en-Provence). Next year the Romans were called in again by the Aedui against the Salyes and the Allobroges; the latter also had the support of a powerful tribe known as the Arverni. After their defeat, the conquered territories were reorganized as a single Roman province, Gallia Narbonensis.

For centuries this area had been exposed to penetration by Greek culture, which spread out from the ancient Greek commercial centre of Massalia (Marseilles). Marseilles was also in close contact with Rome at least as early as the mid-third century, i.e. ever since the outbreak of the Second Punic War. The diffusion of Hellenistic art (recognizable even in the forms taken by Narbonensian sculpture during the Roman period) has become better understood as a result of recent excavations. At Glanum (Saint-Rémy-de-Provence), archaeologists have succeeded in isolating three distinct phases.

The Hellenistic phase, with Marseilles as its controlling centre, continued to develop until about 100 BC. After this the process of Romanization began; it lasted for half a century, reaching its climax with Caesar's capture of Marseilles in 49 BC. The result was a total transformation of civic planning and monumental architecture. The final reduction of the Marseilles area came after the conquest of all Gaul, from the Atlantic to the

139

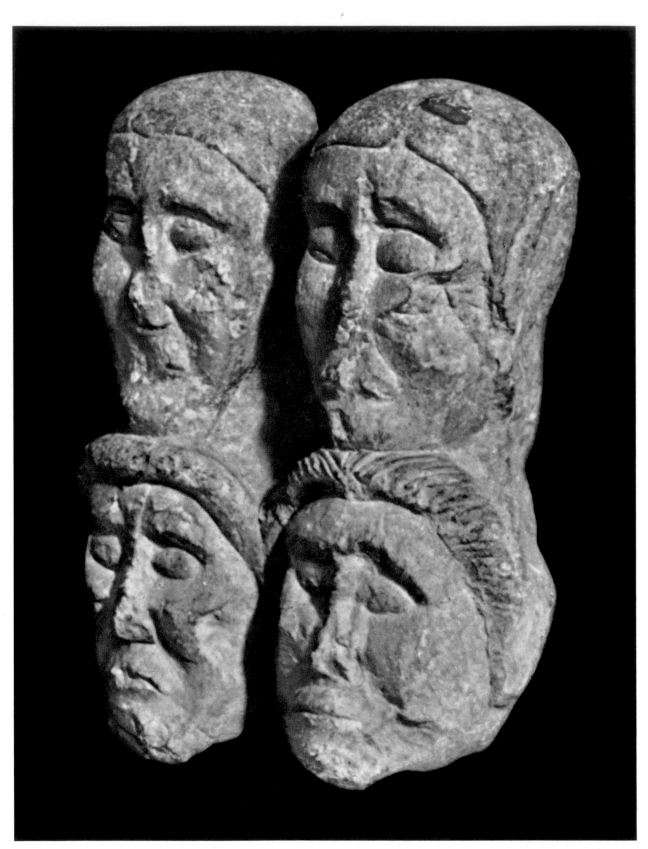

130 ENTREMONT. PILLAR FROM A PORTICO, DECORATED WITH SEVERED HEADS. AIX-EN-PROVENCE, MUSÉE GRANET

131 SAINT-RÉMY-DE-PROVENCE. MAUSOLEUM OF THE JULII ▶

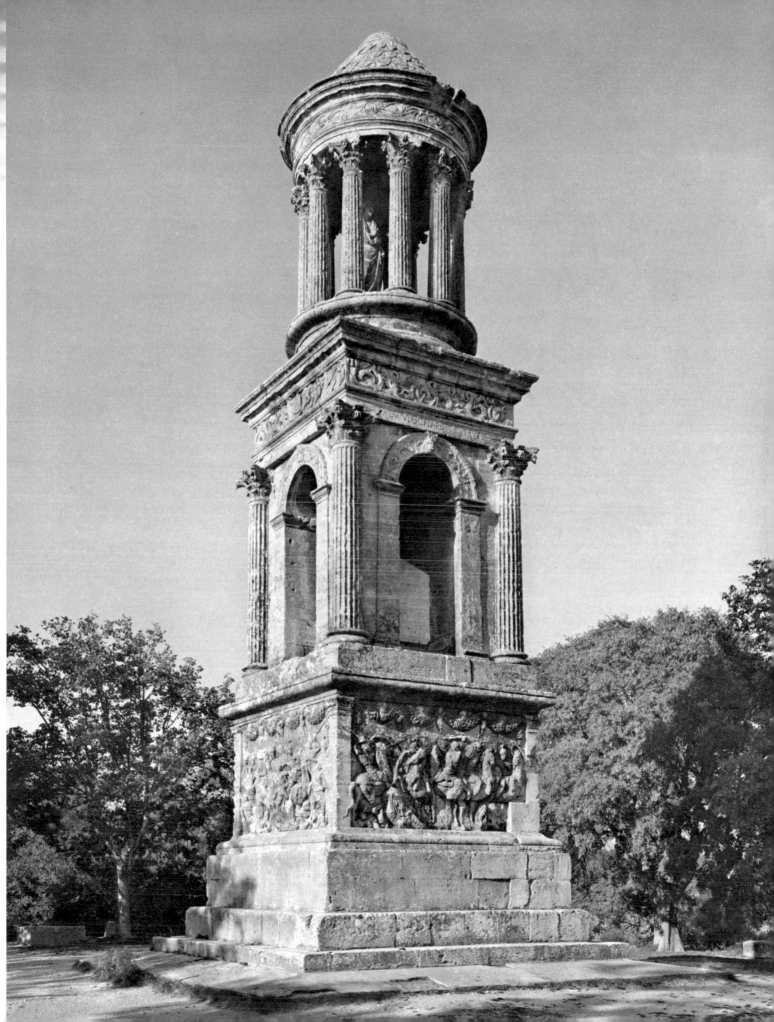

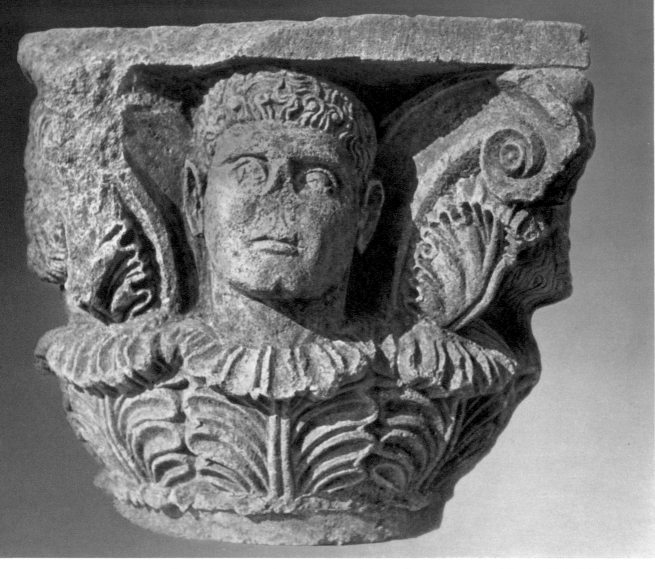

Rhine (58–51), and at the same time as the struggle against Pompey, whose bases lay in Spain. Marseilles preserved no more than the semblance of municipal autonomy, with the title 'free and federated city'. The capital of the Roman province was Lugdunum (Lyons), a colony of Italians (who since 43 BC had enjoyed full citizenship), and the site of both a permanent garrison and a flourishing Mint. In Lugdunum, too, Augustus held the first census of Gaul, and organized the country's administration on a permanent basis.

The studies of Rolland and Picard on the monuments of Glanum have helped to fix 39–38 BC as the date for the temple of the god Glan, the *Matres Glanicae,* and *Valetudo.* This temple was dedicated by Agrippa when he took possession of Gaul after the treaty of Brindisi between Octavian and Antony. The construction of the Mausoleum of the Julii falls between 35 and 25. The capitals of this monument's central tetrapyle belong to the Italo-Hellenistic type; those of the circular upper portion, which resembles a *tholos,* are more purely Hellenistic, but not later. The Mausoleum demonstrates, once again, that the Augustan neo-Attic style was an artistic phenomenon limited to the

142

133 SAINT-RÉMY-DE-PROVENCE, MAUSOLEUM OF THE JULII. A RELIEF FROM THE BASE (DETAIL)

capital, Rome, and to the Court art produced there. At Glanum, as elsewhere in Gallia Narbonensis, both a Hellenistic and an Italo-Hellenistic tradition survived, which had established itself there before the Roman occupation. This is confirmed by the discovery of several capitals (decorated with male and female heads between volutes, the latter set obliquely above limp foliage) which had been re-used as building material for constructions of the Roman period. This type of capital was known to Magna Graecia, and also spread throughout Etruria during the third and second centuries (cf. the Forum of Paestum, and tombs in Vulci and Sovana). The capitals of Glanum can probably be dated to the mid-second century BC. Some of the heads are adorned with *torques*, the typically Gaulish neck-collar. They all reveal a harsh, quasi-geometrical technique which – taken with the transmutation of leaf-veins into mere stiff grooves – betrays the work of local artists. In fact they already possess the characteristics which later distinguish Romano-Gallic art. One capital with heads and volutes from Argentoratum (Strasbourg) is probably to be dated as late as the third century AD.

The sculptor who executed the great panels for the monument of the Julii belongs to this same artistic trend, though he reveals a closer alignment with Hellenistic taste. It is now thirty years since I pointed out that his compositions derived from paintings (a view since generally accepted), and also that the pictorial exemplars on which he drew

143

134 ORANGE, COMMEMORATIVE ARCH. NORTH FAÇADE

135 TARQUINIA. ETRUSCAN SARCOPHAGUS (DETAIL). TARQUINIA, MUSEO NAZIONALE

were Hellenistic. As Picard suggested in 1964, these models may have reached him by way of Central Italy. The problem of just how such Hellenistic pictorial compositions came to be disseminated among the craftsmen of Central Italy and Etruria is still unsolved. That there *is* a problem we know from a number of monuments, amongst them certain sarcophagi with battle-scenes, and the representations on some funerary urns (in particular those of Tarquinia, Volterra and Chiusi). At all events, it is interesting to observe how the Maestro of Glanum can draw, at one and the same time, on both the provincial and the Hellenistic traditions in art. In this respect his art established a precedent, to be picked up and confirmed in the second century by that Hellenistic revival which succeeded the interlude of Augustan classicism. This is revealed not only in the style, but in the choice of subject-matter: mythical, rather than secular. It was, however, the *Maestro della gesta di Traiano* who later gave this stylistic tradition its loftiest expression by using it to portray historical themes.

To translate his pictorial models into terms of sculpture, the Maestro of Glanum used a shallow, bas-relief technique, which was both accentuated and delimited by the use of an incised line corresponding to the preliminary outline for his figures. The latter nevertheless achieve remarkable fluidity of movement and great spatial freedom, despite the fact that they are rendered by linear, pictorial methods.

This technique, which amounts to a private formal language, reappears in less ambitious works from Gallia Narbonensis; and the arches at Carpentras and Orange, for example, demonstrate the emergence of a special local tradition. On historical and epigraphical grounds, the Arch of Orange is generally dated to Tiberius's reign (AD 14–37); and stylistic criteria suggest that it could be earlier. However, one interesting reaction may help us to define this artistic trend more closely. So considerable a scholar as Mingazzini, basing his case on stylistic comparisons, would prefer to assign it to the Severan period, in the early third century. (Since the epigraphical evidence is largely

145

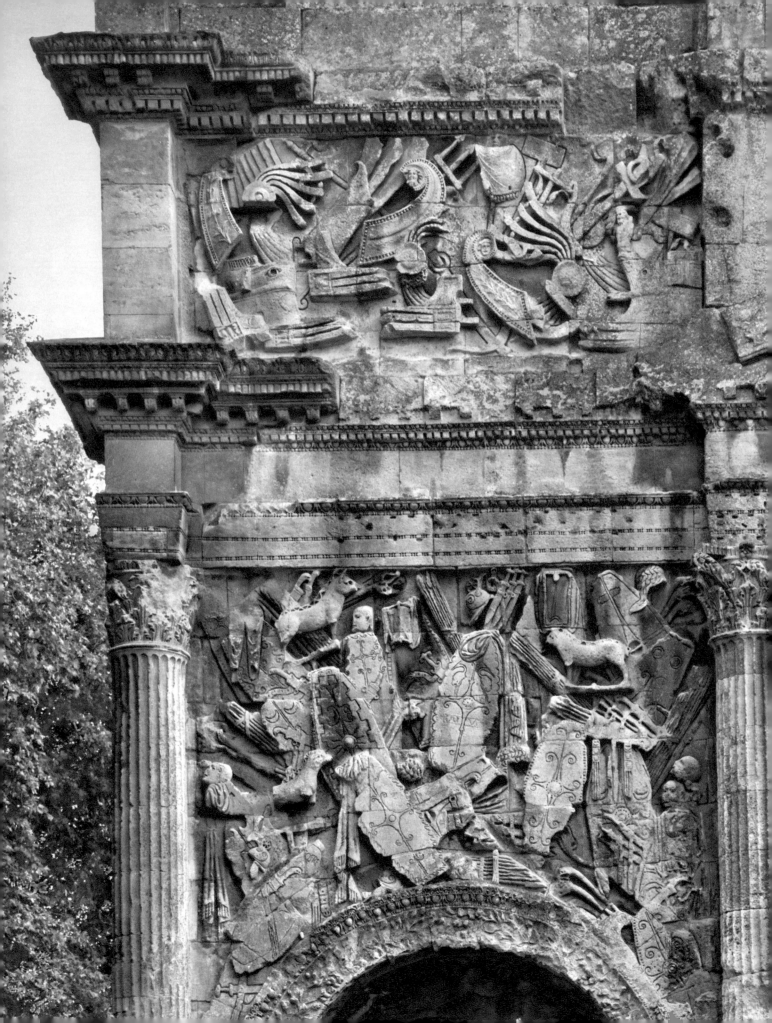

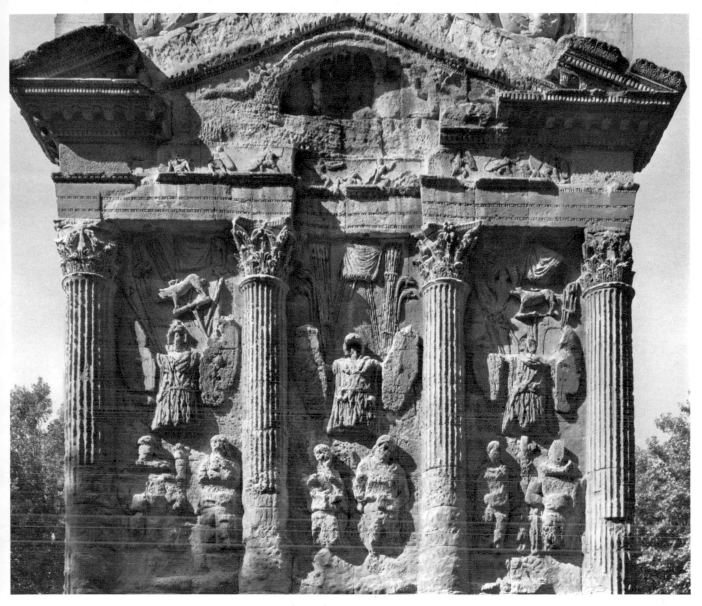

137 ORANGE, COMMEMORATIVE ARCH. EAST SIDE (DETAIL): TROPHIES

dependent on restorations, he proposes to ignore it.) Nevertheless, the general historical background still militates in favour of a date in Tiberius's reign; and – the strongest argument of all – these reliefs can be fitted, without any difficulty, into the general pattern of Narbonensian art during the first half of the first century. On the other hand, we must avoid the converse error: there was no 'prefiguring' of art in the capital by its 'provincial' counterpart. Gallia Narbonensis had an art that was influenced primarily by Hellenism; it cannot, in this respect, be put into the same category as the other Western provinces. We may note that the reliefs on the monument of the Julii at Saint-Rémy appear to 'anticipate' those of Trajan's Column. In fact, this is not prefiguration, but that constant Hellenistic element which turns up in sculpture from the Flavians' day to that of Trajan, independently of any direct influence by Gallia Narbonensis. Moreover,

147

136 ORANGE, COMMEMORATIVE ARCH. NORTH FAÇADE (DETAIL)

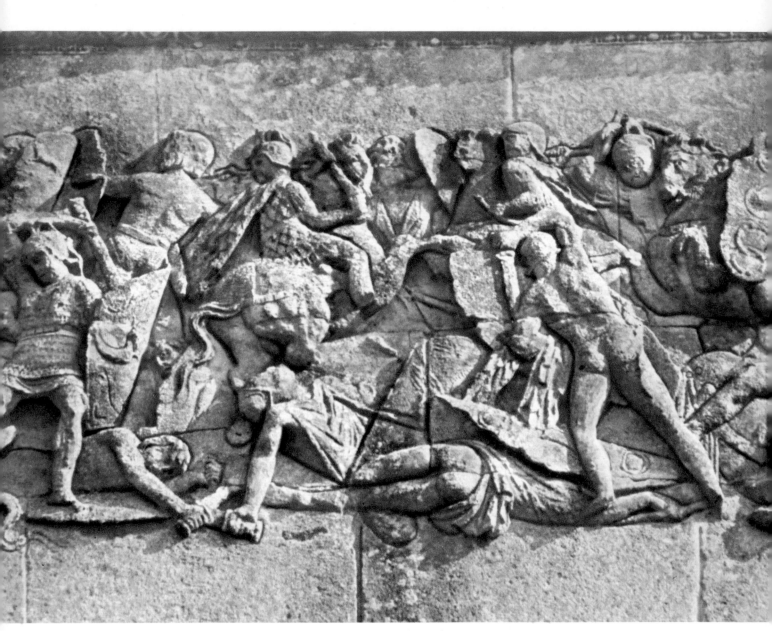

138 ORANGE, COMMEMORATIVE ARCH. NORTH FAÇADE (DETAIL): BATTLE-SCENE

the material assembled in this book should serve to demonstrate that the general trend
is away from traditional naturalism in individual form – even if the patterns of com-
position are still Hellenistic. It is this that 'prefigures' the Late Empire in the sculpture
of the Western provinces, just as it was 'plebeian' art that prefigured it in Latium. So
far as I know, no one discussing the Arch of Orange has ever remarked on the extra-
ordinary composition of the attic storey, where the reliefs stand out clearly against their
background without being framed in a cornice: a technique which has no parallel in
either Greek or Roman sculpture. On the other hand, similar examples are provided by
reliefs on the Graeco-Etruscan sarcophagi of Tarquinia, where this technique stems
from the application of reliefs in moulded (and generally gilded) terracotta to wooden

coffers. The same thing is to be found on the sarcophagi of the Hellenistic necropolis at Tarentum (Taranto), and those of Southern Russia.

All this goes to confirm that, as soon as the Hellenistic tradition weakens, and begins to assimilate 'uncivilized' tendencies, we find formal patterns much akin to those which characterize the Late Empire. The latter, in fact, are not derived from any external formal influence, but evolve from the very matrix of Imperial civilization.

Among those products of the Narbonensian workshops which reveal a particularly strong Hellenistic influence, we must include the funerary statue of Medea preparing to kill her children (*pl. 139*). If any other instance of this iconography exists in a statue, I do not know of it. Nevertheless, the passionate stance and the expression of tragic fury suggest that what we have here is a good copy of a Hellenistic original, which the artist rendered still more dramatic by simplification. The spread of this type-figure in the area is attested by a coffin-lid, carved from local stone (*pl. 140*), which has Medea on the tympanum, while two other episodes from Greek myth – Odysseus and Eurycleia, Oedipus and the Sphinx – adorn the acroteria.

Apart from Gallia Narbonensis (which occupies a special position in the context of Gaul and the German provinces, from the Atlantic to the Rhine and the Upper Danube), we can isolate a number of artistic production-centres that flourished during the Imperial period, each with its own characteristics. However, it would probably be wrong to try and explain such variants in terms of the differences between Gaulish and Germanic tribes, since these represented a mere physical juxtaposition of peoples who differed in language and customs. During the two centuries when Rome managed to keep the peace by putting an end to tribal quarrels, progressive Romanization tended to unify local cultures. This period of peace was the longest-enduring in the whole history of ancient Western civilization. One can imagine what such a span of security achieved if one thinks of the benefits which accrued to modern Europe from the forty-four years of peace between 1870 and 1914. One of the most immediate results of such a period is economic and cultural unification. We can see this happening in the Roman provinces of the West, where a high degree of unity was attained. Consequently, although a number of sculptors' workshops can be isolated within the general context of provincial life, the provinces themselves (except for Gallia Narbonensis) possessed an overall cultural unity. I shall restrict myself here to such aspects of that unity as pertain to the sphere of art.

The period of security came to an end, in Italy, with the invasion by the Quadi and Marcomanni in 167. Gaul was not disturbed until 253. This first alarm was followed by a devastating second invasion (275–6), which left the province's urban life in chaos.

The art of Gaul and the Rhineland during the Roman period is undoubtedly of considerable interest, on more than one count. To begin with, it developed in a barbarous backwater which (apart from Gallia Narbonensis) had had only rare and isolated contacts with Greek artistic products, though these had otherwise penetrated the entire Mediterranean area. This occurs nowhere else: in Spain, Africa and the Balkans, contact with Greek art was of long standing. Thus we have, in the Western European provinces and the British Isles, the superimposition of Roman art on an environment where the existing tradition was strictly limited (even though in some of its aspects exceptionally refined). Above all, we can observe the predilection which this indigenous art shows for

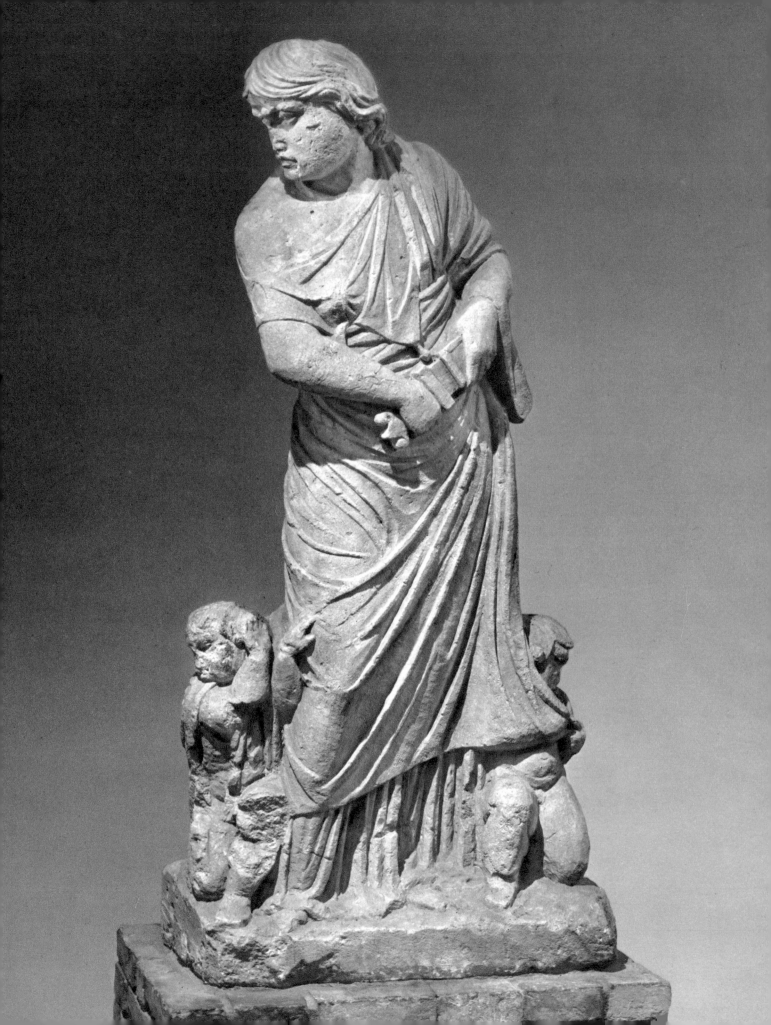

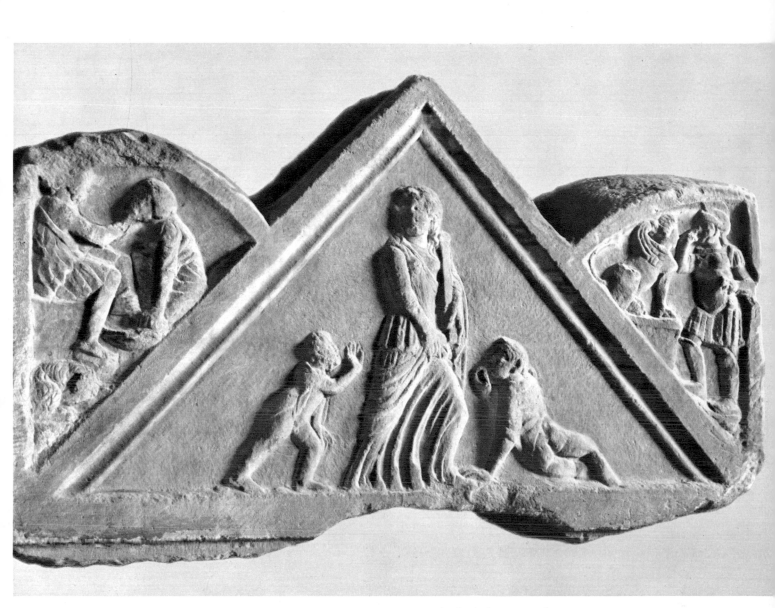

140 MARSEILLES. SARCOPHAGUS-LID: MEDEA AND OTHER MYTHS. MARSEILLES, MUSÉE D'ARCHÉOLOGIE BORÉLY

ornamentation (in metal-working especially), and, formally, for abstraction rather than naturalism, with an absolute preference – as certain artefacts from the British Isles make clear even during the most fully Romanized period – for the curving line. These lines describe winding, serpentine curves, moving away from each other and then coming together again (swelling almost like fish-bladders in the process). The then well-developed taste for ornamentation had started out from a basically non-figurative concept, which itself originated (and was widely diffused) in the Neolithic period: one is reminded of the ceramics from Cucuteni and Tripolje in the Moravo-Ukrainian zone. This art, characteristic of the Celtic area, got a foothold in the West via the La Tène civilization, which on the very eve of the Roman conquest was still in the Iron Age. Apart from the products of the metal-worker's craft, which were rendered precious by inlay-work in coloured enamel, there must have existed a tradition of carving in wood. However, only

151

some near-shapeless fragments survive in this field, all from the Roman period – such as the figurines, heads, animals and various broken anatomical bits which were found in 1963 near the sources of the Seine, and date from the reigns of Caligula and Claudius (Roland Martin, 1964).

Such Celtic sculpture in stone as we know is for the most part late, from the first phase of the Roman conquest. The only earlier sculptures are those of Entremont, the fortress that was captured and destroyed by the Romans in 123. What we have here, translated into the medium of stone, is the practice of decapitating one's defeated foes, and exposing their severed heads in hollow niches along the walls. These 'severed heads' on the Entremont portico, though purely Celtic in concept, already reveal, as regards form, a Hellenistic influence from Gallia Narbonensis. During the preceding period, however, the human figure has a schematic appearance, structurally descended from a type of representation common in Neolithic times.

On to this indigenous and so-called 'primitive' culture there were now superimposed both main branches of Roman art: the 'cultivated', Hellenistic variety, and the 'plebeian' movement. It is safe to assert, when considering this process of superimposition during the Imperial epoch, that the 'cultivated' strain produced no vital artistic impulse whatsoever. All it achieved were coarse imitations (*really* provincial in this case) of sculptures imported either from Rome, or else from Greece and the coastal centres of Asia Minor. Plebeian art, by contrast, the trend which glorified middle-class *mores*, found this environment highly congenial for free development. Born in the artistic context of Central Italy, nurtured on a never fully assimilated Hellenistic tradition – this being flatly opposed to the non-figurative background of primitive Italian art (itself not unlike that of the Celts) – the 'plebeian' trend, more than any other, seems to have been behind the development of Western 'provincial' art, or, as I prefer to call it, the 'Roman art of Europe'.

This is quite natural, in that provincial art was designed for the same social categories as plebeian art served in Rome and the *municipia* of Central Italy. Local magistrates, freedmen, merchants, all had their provincial counterparts – military or administrative officials, traders (either Romans or semi-Romanized natives), and soldiers. That is why, on the funeral stelae, we find representations not only of military, commercial and working-class activities, or the collection of taxes, but also of private life.

It goes without saying that when 'plebeian' art moves out from Rome to the provinces, it undergoes various modifications in the provincial workshops. The stele of Marcus Caelius, who fell in the Teutoburg Forest in AD 9 (Bonn, Rheinisches Landesmuseum), is still much akin to the art of Northern Italy. But latterly this art acquires, *in situ,* elements derived from the Hellenistic studios of the East. Any monumental masons who followed the troops enrolled in the Eastern legions were from this part of the world. Their influence tended (though seldom explicitly) to contaminate existing elements of the indigenous artistic tradition, whether these were Celtic, as here and in the British Isles, or Iberian, as in Spain, or Thracian, as in Thrace and Moesia. But from now on, the provincial workshops began to elaborate their own methods and traditions, which formed variants on a common basis of technical knowledge. More often than not they took their cue from some master-sculptor with an outstanding artistic personality.

153

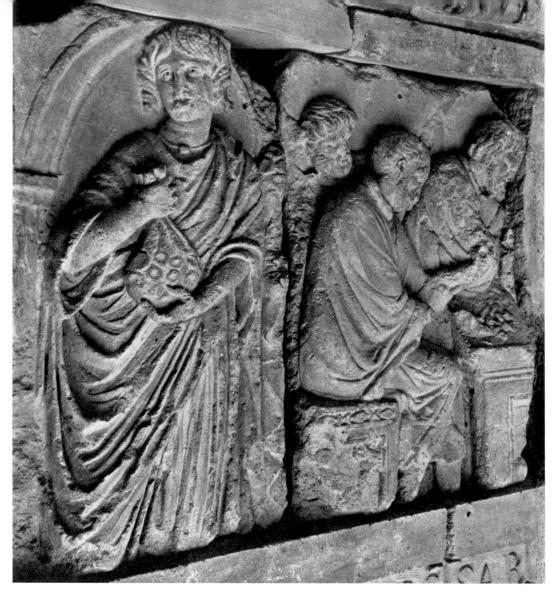

142 SAINTES. FRAGMENT OF RELIEF: SCENE OF TAX-PAYMENT. SAINTES, MUSÉE ARCHÉOLOGIQUE

By treating the sculpture of the Western provinces as a development – and effloresc-
ence – of the plebeian trend in art, which was clearly evident in Rome by the end of the
Republic and in the early years of the Empire, we find a simple and satisfying answer to a
problem that has hitherto elicited some very complicated solutions. Above all, we
eliminate the highly equivocal supposition that 'Etruscan' workers were somehow
involved in the development of provincial art. What used to be interpreted as 'Etruscan'
is, in fact, a streak of Italic Hellenism making itself felt in the plebeian tradition at
Rome. Some scholars have argued that to call this art 'Roman' is a misnomer, because of
the foreign influences it has assimilated, and propose the more generalized description
'art of the Empire'. There are two faults here. The first is that of applying a single title to
something with no overall unity. Each province – whether in Western Europe, Asia
Minor or North Africa – has its own original character, and develops in a different way
from the rest. Each environment, while relatively coherent in itself, must be studied
separately. The only feature they have in common (and not always then) is one that

154

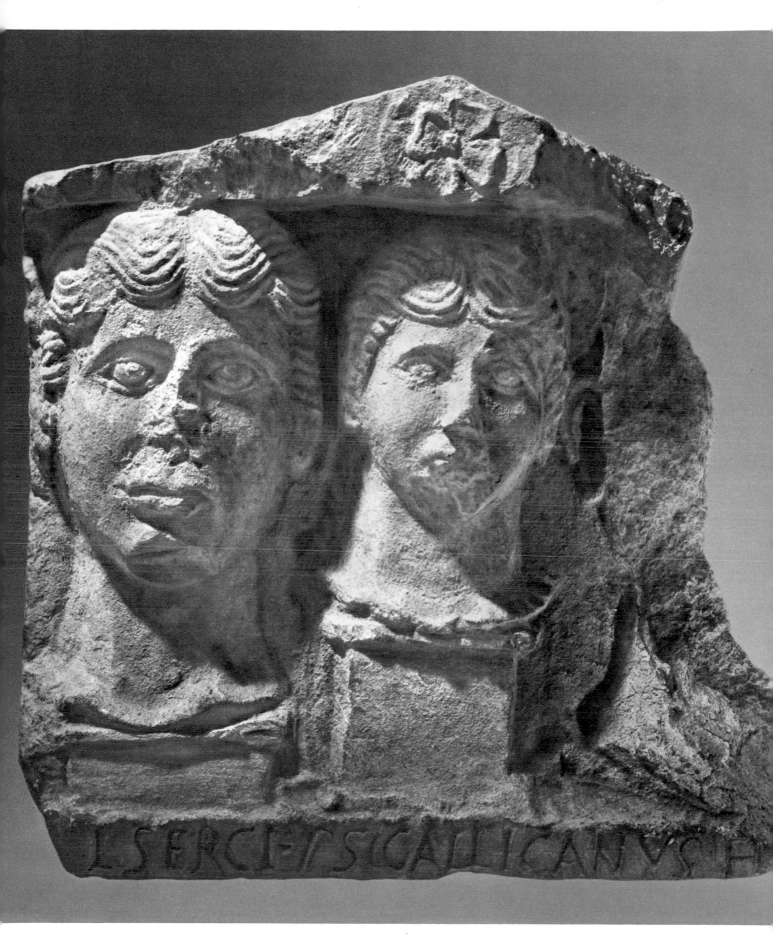

143 NARBONNE. FUNERARY STELE OF SERGIUS GALLICANUS. NARBONNE, MUSÉE LAPIDAIRE

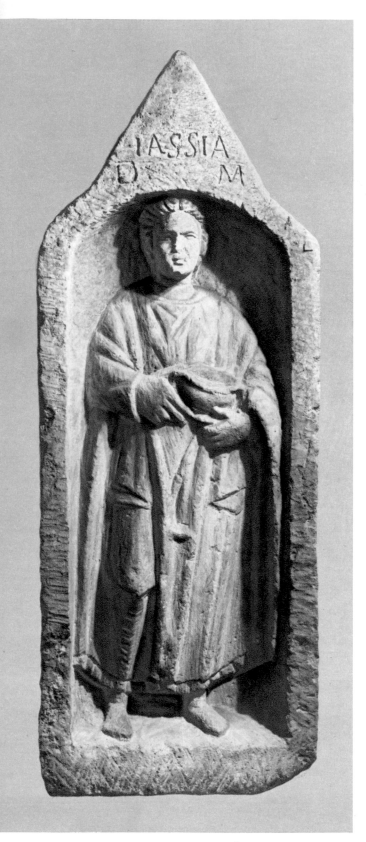

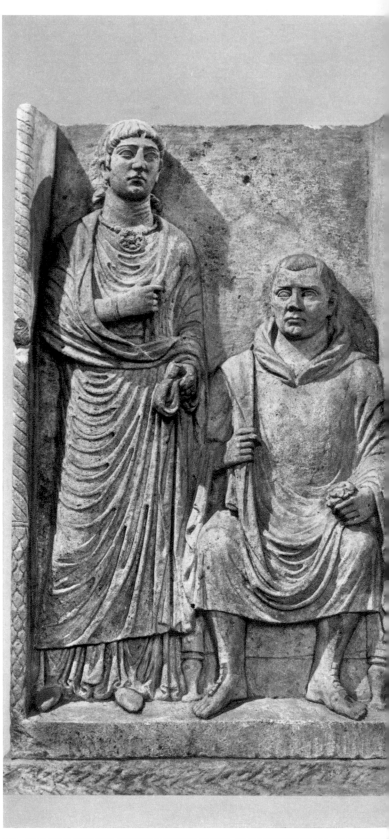

144 SOULOSSE. STELE OF IASSIA. METZ, MUSÉE CENTRAL

145 WEISENAU. STELE OF MARRIED COUPLE. MAINZ, MITTELRHEINISCHES LANDESMUSEU

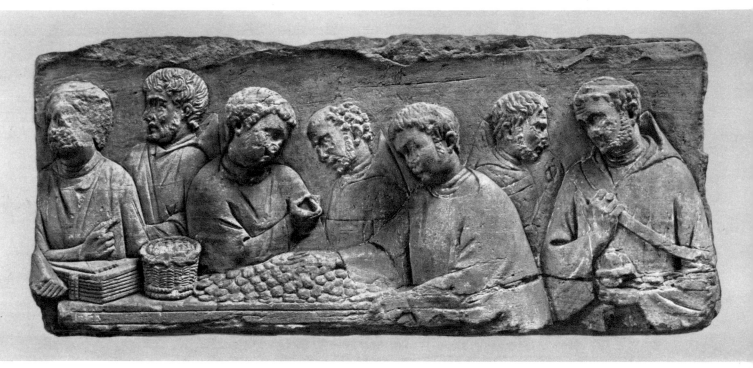

146 NEUMAGEN. FRAGMENT OF RELIEF: SCENE OF TAX-PAYMENT. TRÉVES, RHEINISCHES LANDESMUSEUM

characterizes all the peripheral cultures of classical antiquity that have been exposed, at an elementary level, to Hellenistic concepts of form. The second mistake is failing to recognize in the art of the West European provinces that basic Roman element which outweighs all other influences. True, there is not a 'provincial' art that embraces the whole Empire; but there is, in the Western provinces, a 'Romano-European' art, which covers Northern Italy and the Pyrenees, Illyria and Dacia, Spain and the British Isles, besides having several active centres of production in Gaul, Belgica, Aquitania and Lugdunesis, as well as in Upper and Lower Germany.

This Roman art of Europe demands our attention not only because of its development and position *vis-à-vis* Rome, but also because of its language and thematic scope. Looking ahead, we find that these reappear as an integral element of medieval art, as it evolved in the same areas. And (one might add) a basic, perennial, popular element, to which latterday Byzantine influence was to add cultural facets, each linked with some special aspect of the Christian cult and its hierarchy. In one sense this Byzantine influence did for medieval art and culture what Hellenistic influence had done for that of Rome; and Byzantine culture was, besides, directly rooted in Hellenistic soil. The fragment of a scene depicting the payment of taxes (*pl. 142*) from Saintes, with figures in long robes, seems distantly to foreshadow the sculptures in French Gothic cathedrals. Thus the art of these European provinces represents an important element in the transition between Antiquity and the Middle Ages. It offers clear evidence in support of my view that such a transition is due, not to external influence, but to the inner transformation of the Roman and the Romanized world.

The division of Gaul into three provinces was as follows. The first province, Aquitania, covered an area including Cher, Gers, Périgueux and the Bordeaux region. The second, Lugdunensis (Lyonnaise), included Lyons itself, Chalon-sur-Saône, Autun,

157

Orléans and Paris (Lutetia). The third, Belgica, embraced Rheims, Metz, Epinal, Bar-le-Duc, Arlon, and also Trèves, which in the fourth century acquired a special character in its capacity as an Imperial residence, and hence as a centre of Court art. Upper Germany included Switzerland and Alsace, with Argentoratum (Strasbourg) and Mogontiacum (Mainz) as their principal cities, both located near large military camps. The important centres of Lower Germany were Bonn and Cologne.

The survival of evidence for provincial art has been due to chance, and very little to systematic investigations which might provide reliable dating. Because of this lack of specialist research, it is still impossible to characterize the various regions, much less to place the material in its line of development – if, indeed, such a line exists. All one can say is that from the first century of the Empire the characteristics of this art appear to be fixed – which confirms that it was simply prolonging a trend already well-established in Rome and Italy. Yet there is no sign of any emergent awareness of formal problems as such, no attempt to grapple with difficulties and resolve them: it is wrong, in fact, to talk of a deliberate opposition to classical form. This is production at workshop level, which changes from age to age and place to place, while preserving a common denominator throughout.

This is why the characteristics we find in the first century do not vary substantially until the end of the third, when the Germanic invasions put a stop to the activities of those workshops producing 'cultivated' art. From now on such local centres cease to exert any sort of influence: the little which they still produce reveals a rapid decline into barbarism. This barbarism occasionally corresponds to a reappearance of formal elements from the Celtic substratum, but more often it is a descent into pure primitivism – as we can see, towards the end of the seventh century, from the funeral stelae of the Rhine area (e.g. that from Niederdollendorf, now in the Bonn Museum).

Of the three Gallic provinces, Aquitania (which had experienced a period of great vigour before the Roman conquest) seems to have produced the most original work, and most often provides forms which can be termed 'pre-medieval' ('pre-Romanesque'). Two examples are the stele with pilasters of Mansuetus the carpenter from Saint-Ambroix, and the statuette of a hunting-god from Touget (found in the Gers region), which has almost entirely broken away from Hellenistic traditions (*pl. 147, 149*).

The ways in which the iconographic formulae of the Graeco-Roman pantheon are adapted for local use provide us with a genuine glimpse into 'cultivated' provincial art. (The most popular god is Mercury, a fact which confirms the importance attached to commerce.) Thus, Diana and Apollo preserve their Hellenistic iconography intact, as does Venus, who is portrayed nude – something most unusual for a barbarian artist. This is why, even with local divinities who have been assimilated to their Graeco-Roman counterparts, we find a reflection of 'cultivated' typological patterns – except for certain details, e.g. the cross-legged posture (known as the 'tailor' or 'Buddha' position) assumed by some masculine Celtic deities. Minor divinities, however, with no niche in the classical pantheon, tended to be portrayed in a more original manner, and it is here that we are likelier to find a new stylistic formula: take, for instance, the woodland hunter-god (originally horned) from Mont-Saint-Jean, in the Sarthe region, with his bow and bill-hook (*pl. 150*).

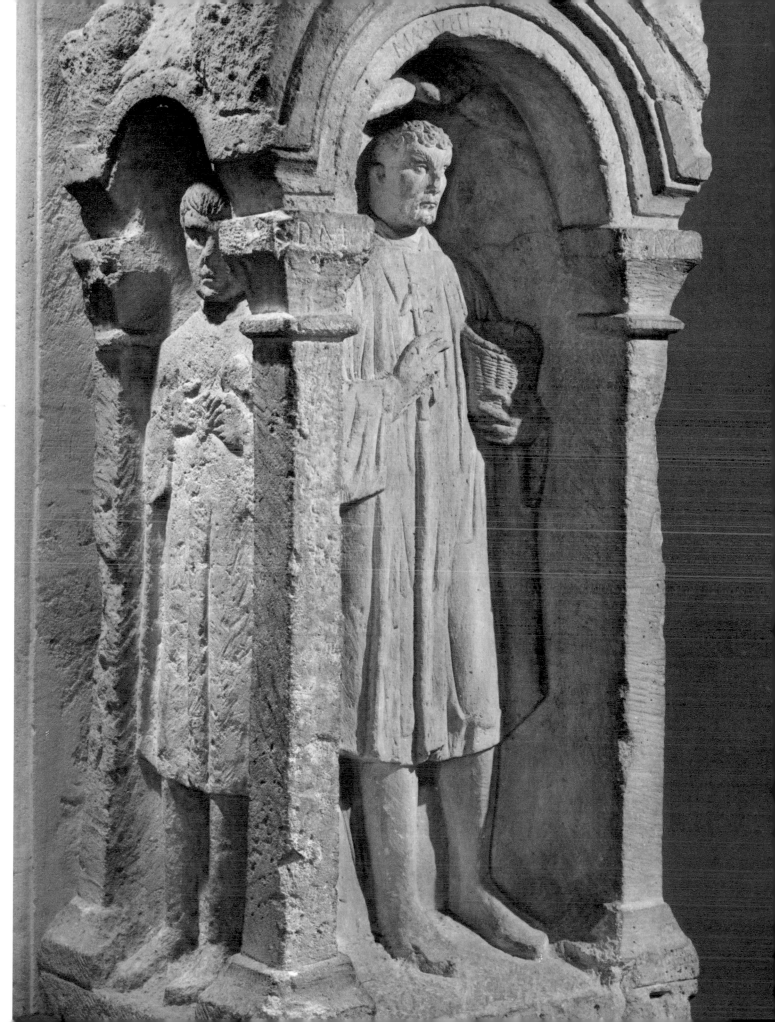

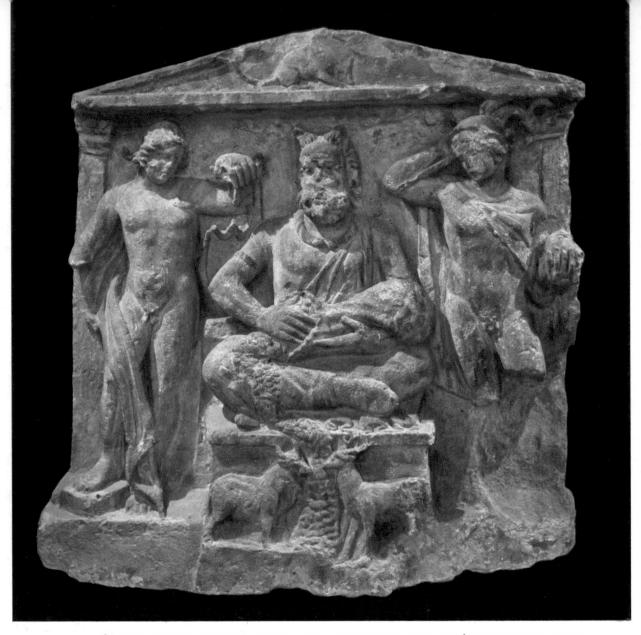

148 RHEIMS. THE GOD CERNUNNOS BETWEEN APOLLO AND MERCURY. RHEIMS, MUSÉE HISTORIQUE ET LAPIDAIRE

The Bonn production-centre turned out various monuments dedicated to the *Matronae Aufaniae*, local divinities whose nature is somewhat obscure. These monuments were re-used as building material for a chapel, the chapel itself being a separate resting-place for several sarcophagi from the Romano-Frankish necropolis, which were thought to contain the remains of Christian martyrs. The Cathedral was later built on the same site (excavated in 1928–30). Some of the monuments can be firmly dated, on epigraphical grounds, to 138–61: they were dedicated by high-ranking officers, centurions, and soldiers of the Roman First Legion (*Minervia*), together with their wives. Some of these troops had served in the East, others (as their names testify) came from Greek- or Italic-speaking areas. Their birthplace does not affect the style of the sculptures dedicated by them, which remains uniform in every case. Inscriptions added by Government civil servants show that the cult was still flourishing as late as 235.

160

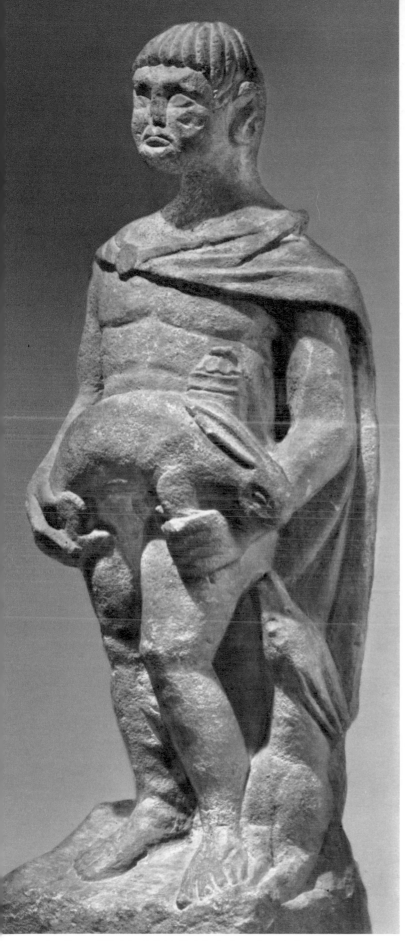

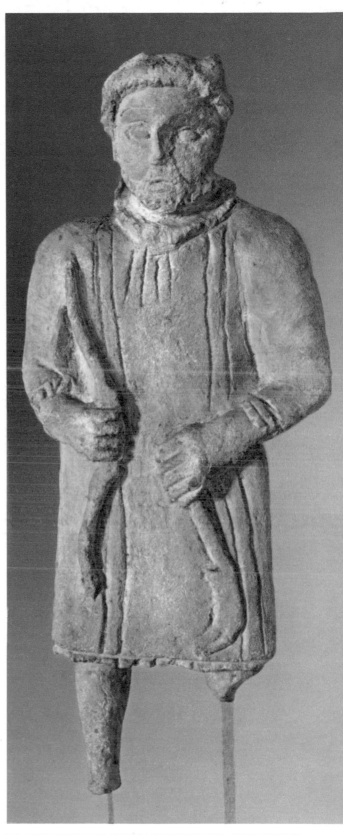

150 MONT-SAINT-JEAN. WOODLAND HUNTER-GOD. SAINT-GERMAIN

149 TOUGET. HUNTER-GOD. SAINT-GERMAIN-EN-LAYE (MUSEUM)

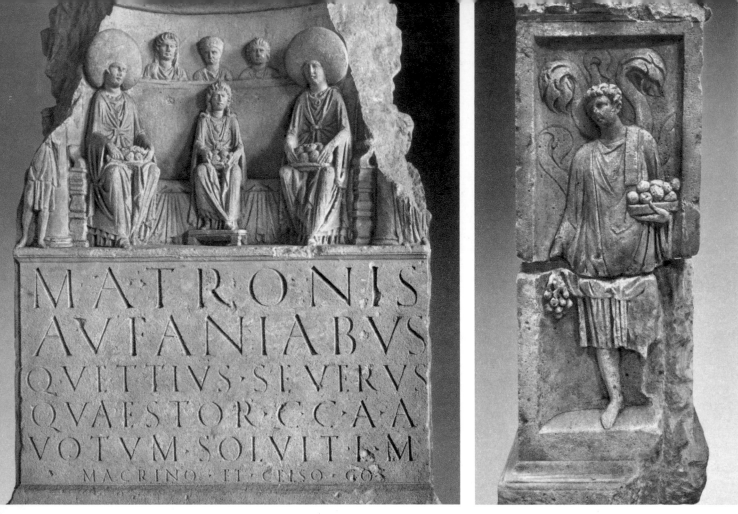

151 BONN. MONUMENT DEDICATED TO THE MATRONAE AUFANIAE. BONN, RHEINISCHES LANDESMUSEUM 152 BONN. OFFERING TO THE MATRONAE AUFANIAE

What we have here is an exceptional case. Though the workshop is local, its products are of high quality, and belong to a cultivated art, which has contrived to assimilate the magnificent lettering of Roman inscriptions and to create an original typology for these indigenous deities, worshipped (perhaps solely out of convenience) even by high-ranking Roman officials. These long robes with their severe folds, not to mention the decorative plant-motifs, could almost be a prefiguring of the medieval 'flamboyant' pattern. The same might be said of the somewhat less elegant sculptures from Upper Germany (e.g. the Nancy torso, now in Strasbourg). Still further removed from classic taste are certain other Gaulish cult-sculptures, such as the massive statue of a matron, flanked by two smaller figures, and resembling a medieval 'Caritas' (preserved in Caen). Full-sized replicas of this have been found at Naix-aux-Forges and Bar-le-Duc, while small ones turn up all over the place.

The regular participation of Roman officials in the cults of local divinities, every-where and in all periods, is worth noting. In the Cologne Museum (to cite another example) we find an altar with a relief, representing a scene of sacrifice, and dedicated to the goddess Vagdavercustis by Titus Flavius Constans, Praetorian Prefect between 165 and 167. In Dacia, too, we regularly find dedications to the divinities of esoteric cults – even to the serpent Glycon, a notorious fraud. One of the most characteristic is that

162

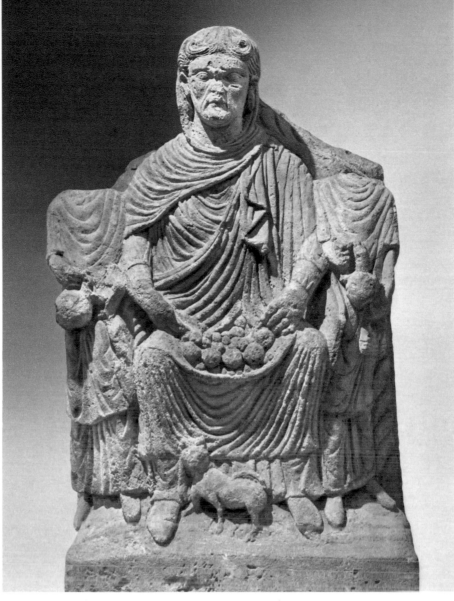

153 BAR-LE-DUC. GODDESS ON A THRONE. BAR-LE-DUC, MUSÉE BARROIS

dedicated by a quadrumvir of Colonia Ulpia Traiana (Sarmizegetusa), to the *diis patriis* Malagbel and Bebellahamon, Benefal and Manavat, for whom he had built an apsidal temple (Museum of Deva in Transylvania).

In the general picture of Gaulish cult-representation, one divinity assumes special importance, iconographic no less than artistic. This is a god (assimilated to Jupiter) who is shown on horseback, trampling down a serpent-footed giant. His image was generally placed on top of a column, which might be either decorated or plain. Here, beyond a doubt, we have a compromise between indigenous and Roman religion, just as there is also a clear borrowing from Graeco-Roman iconography. Numerous fragments of such groups survive, and turn up over a wide area. Major variants noted concern the serpent-footed giant (anguipede), over whom the native passion for anything grotesque, fabulous or monstrous could give itself free rein. It is still discernible behind the legacy of fable and fantasy which Central Europe inherited during the Middle Ages.

163

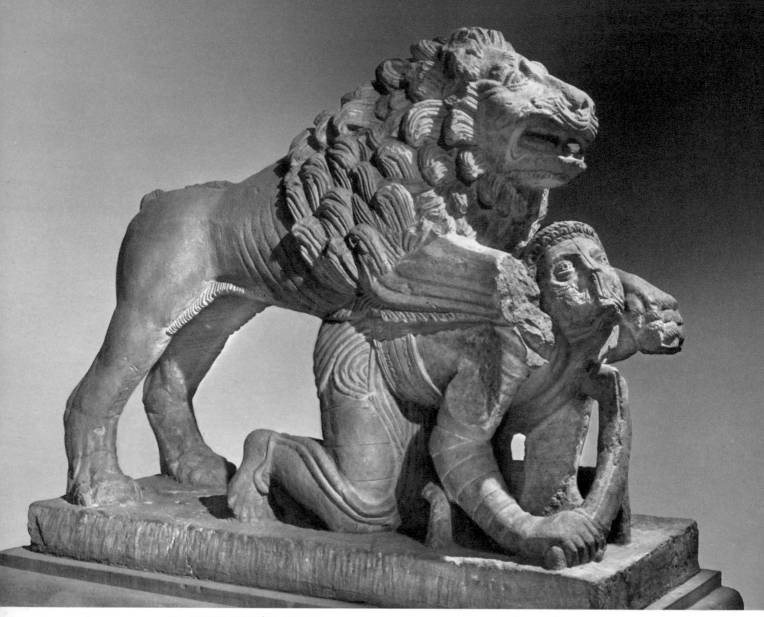

154 CHALON-SUR-SAÔNE. LION SPRINGING ON A GLADIATOR. CHALON-SUR-SAÔNE, MUSÉE DENON

The same taste finds expression in the impressive group of a lion springing on a gladiator, from Chalon-sur-Saône (later an active production-centre for medieval sculpture). Here, the gladiator's helmet serves to transform a human head into something purely monstrous, while the lion directly foreshadows the numerous lions that figure on the doors and pulpits of medieval churches. This taste for portraying ferocity and suffering recurs in the 'severed heads' of Celtic tradition, and in those anthropophagous monsters (e.g. the 'Tarasque', a mythical monster that supposedly haunted the Rhône near Tarascon) which the sculpture of the Roman period has preserved for us in Gaul and Spain. Cult-art, then, covers a wide field: at one extremity, provincialized versions of Graeco-Roman divinities; at the other, modes linked to the indigenous substratum. The latter, enriched by Roman forms of expression, gave rise to totally new types of representation which were later reflected in the sculptures on medieval monuments.

155 AVIGNON. THE 'TARASQUE'. AVIGNON, MUSÉE LAPIDAIRE

156, 157 AVIGNON. THE 'TARASQUE' (DETAILS): THE TWO MALE FACES

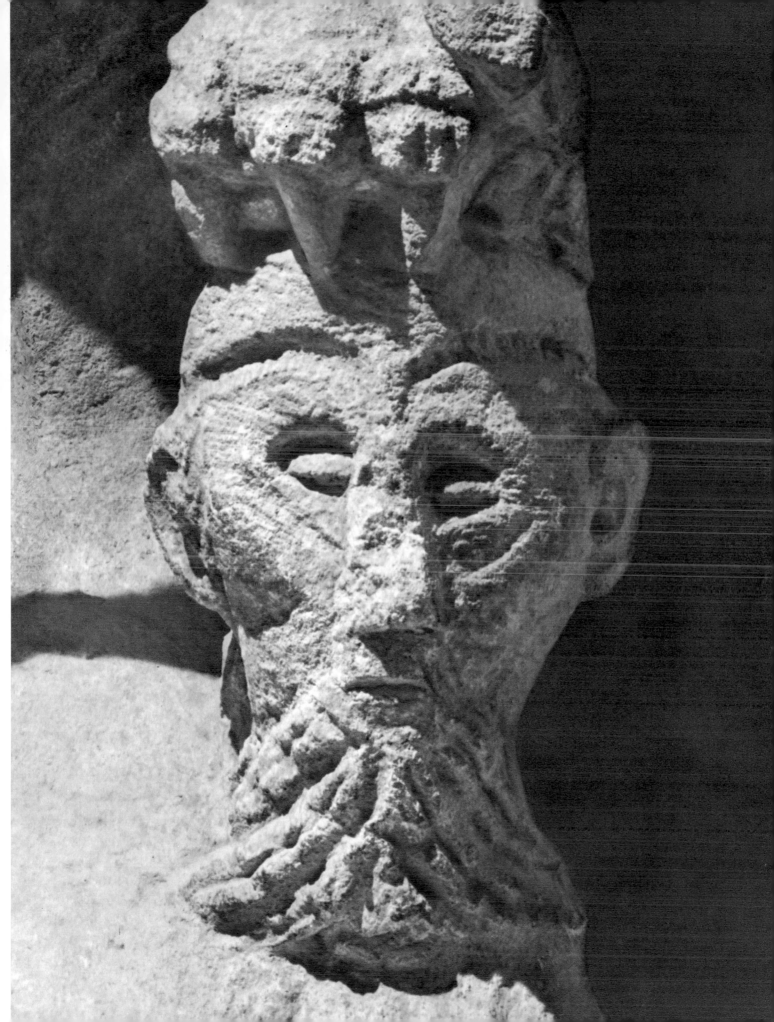

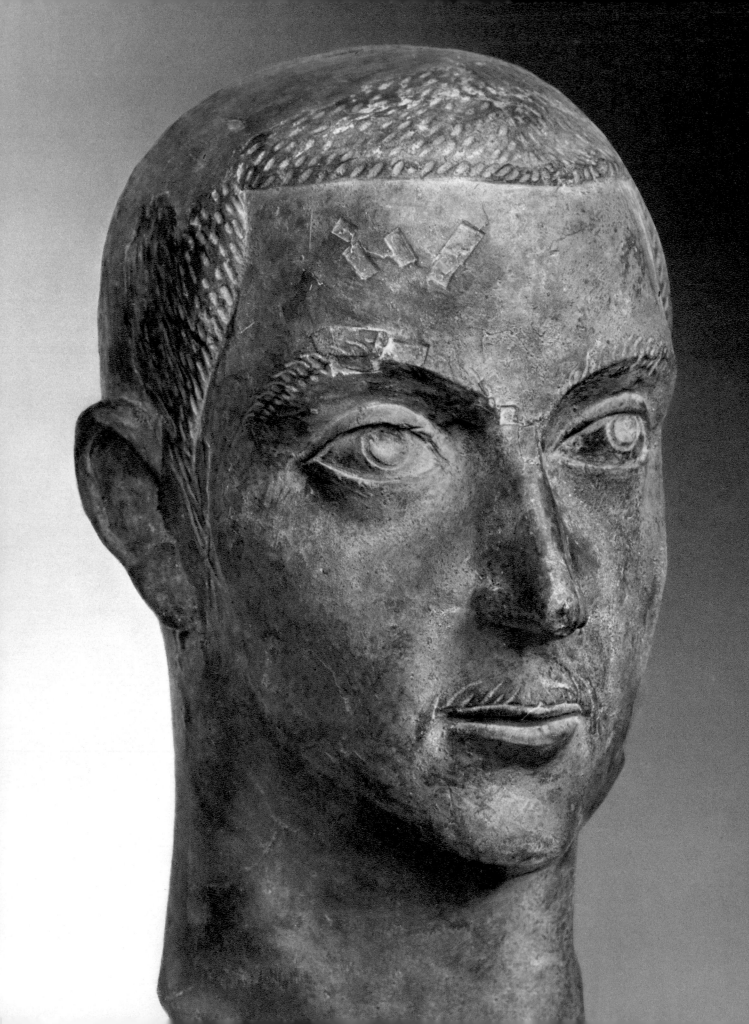

Official art relating to Imperial portraiture is normally represented in the provinces by imported works, or servile imitations. But at the end of the second and the beginning of the third century we find certain exceptions. A head almost twice life-size, and on that account identified as the portrait of some emperor, has been found in the neighbourhood of Argentoratum (Strasbourg). This town suffered severe damage in 235 during the struggles for the succession; the result was an easily recognizable stratigraphical layer, with traces of burning and the destruction of monuments. Thus inside the town we can work out a chronological sequence for the sculptures. Unfortunately this does not enable us to date the head in question, since it was found outside the walls, at Eckbolsheim. Such deductions as can be made on stylistic grounds are – as regards this example and this context – both extremely flimsy *per se* and based on far from certain dates. The official iconography has been altered by the local artist, to such an extent that no firm conclusion is possible. The attribution of this portrait to one of the ephemeral emperors of 238, Pupienus, is not very satisfactory, even if, with Hatt, we assume that it was executed only several years later; the differences between it and our authenticated portraits are too great. Forrer's earlier suggestion, Antoninus Pius, would be more acceptable on iconographic grounds. In any case, as a piece of sculpture it has interesting features: the simplification of plane surfaces, the method of suggesting lines and wrinkles (though it is hardly necessary, in this instance, to invoke either traditional Celtic methods of metal-working, or Italic terracotta techniques). Similar observations can be made about the bronze portrait, now in the Bonn Museum, which has been identified as that of Gordian III (238–44).

We must, then, distinguish between the funerary sculptures turned out for the private benefit of soldiers, merchants or civil servants, and works of a religious or official nature. The former were grafted on to the Roman 'plebeian' trend; the latter – when they were not mere servile imitations of some Graeco-Roman model – tended to be original in character, though their relief-work was often uneven.

It nevertheless remains true that even those scenes which draw their inspiration from ancient mythology take on qualities which bring them far closer to the sculptures of medieval Europe than to those of antiquity. One has only to glance at the stele from the Briançon Museum (*pl. 161*), with its Hellenistic frieze portraying Eros as charioteer; the upper section, in which Andromeda is shown between the monster and her liberator, irresistibly suggests a Renaissance lunette. Another relief portrays the Labours of Hercules (*pl. 160*), which are narrated with a childlike and expressive simplicity.

When we turn to the bronzes, we find further examples of a more complex and less instinctive art than that of the funerary monuments in stone. The workshops that produced such pieces were clearly run by master-craftsmen of superior skill and experience: it seems likely that the casting was done by experts from Northern Italy, since as far as formal technique is concerned, the two areas have a great deal in common.

The portrait of a young man – probably some local chieftain – in the Berne Museum is a good case in point (*pl. 162*). The portrait of the national hero Vercingetorix, as represented on coins, falls into the same category. But the female head from Avenches, in gilded bronze (originally, perhaps, part of a trophy), is characterized by a markedly greater intensity of expression (*pl. 163*). It belongs, together with one particular relief,

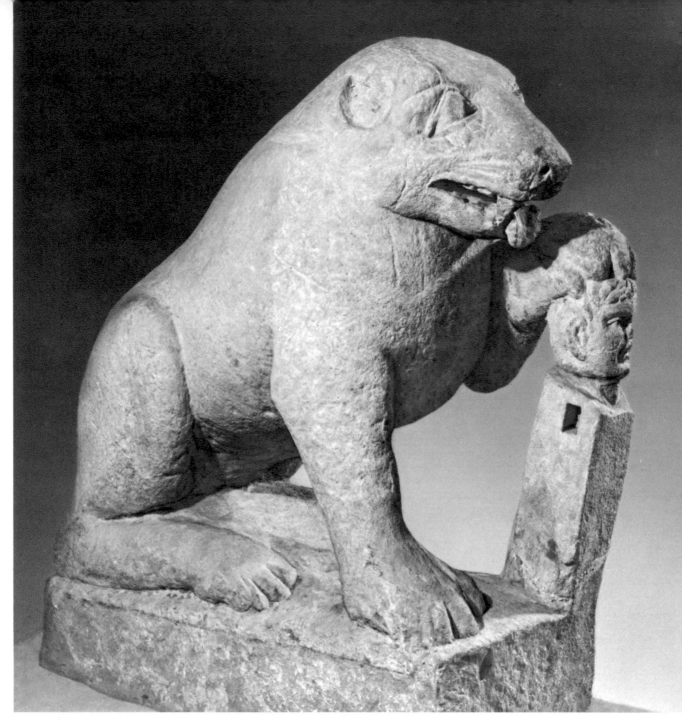

159 PORCUNA. BEAR WITH ITS PAW ON A PORTRAIT-HERM. MADRID, MUSEO ARQUEOLÓGICO NACIONAL

to a tradition mentioned in the Introduction, that of portraying barbarian prisoners in pain or despair.

A number of small bronzes have been found near Orléans: these are somewhat primitive in design, and have affinities with local wood-carving.

There are, however, also instances of a formal Hellenistic design being reduced and simplified to mere robust geometry: this technique recalls the heads on the capital at Glanum, and crops up as late as the Imperial era.

170

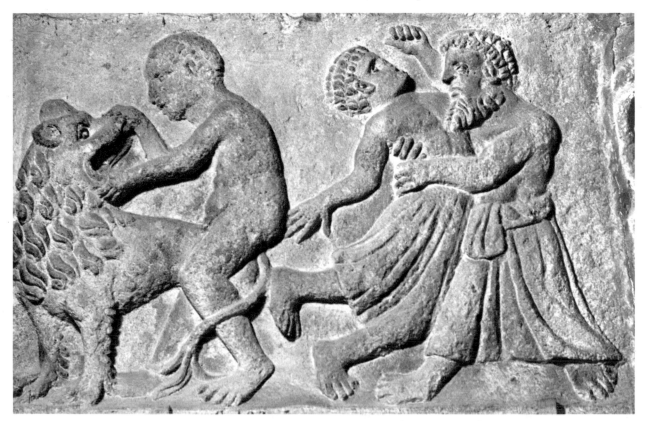

160 VAISON-LA-ROMAINE. FRAGMENT OF A FRIEZE: THE EXPLOITS OF HERCULES (DETAIL). AVIGNON, MUSÉE LAPIDAIRE

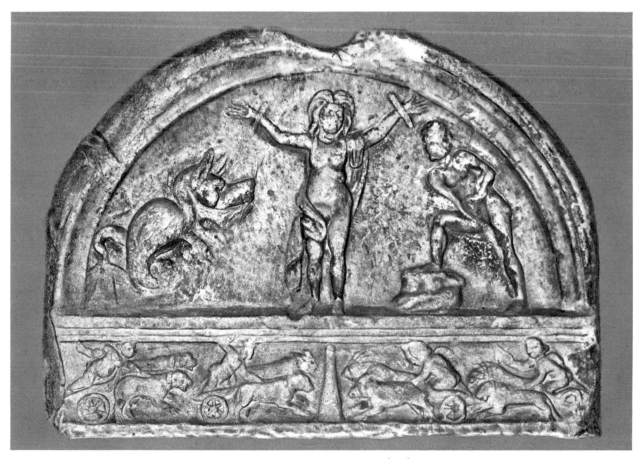

161 BRIANÇON. STELE: MYTH OF ANDROMEDA, AND EROS AS CHARIOTEER. GAP, MUSÉE DÉPARTMENTAL DES HAUTES-ALPES

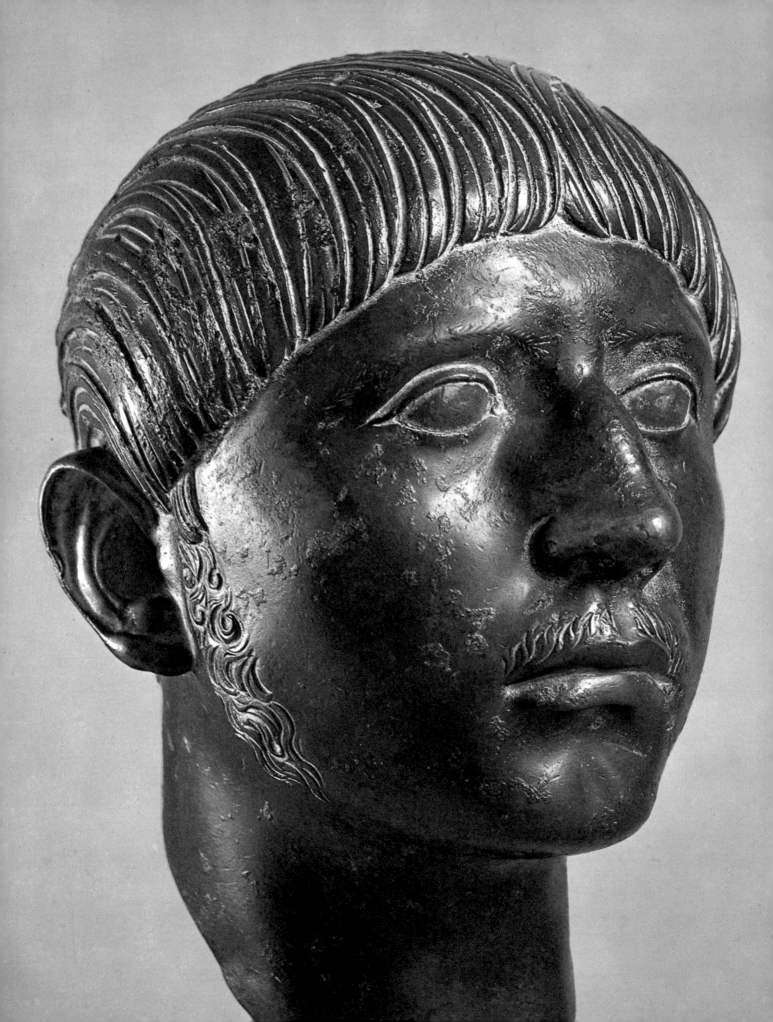

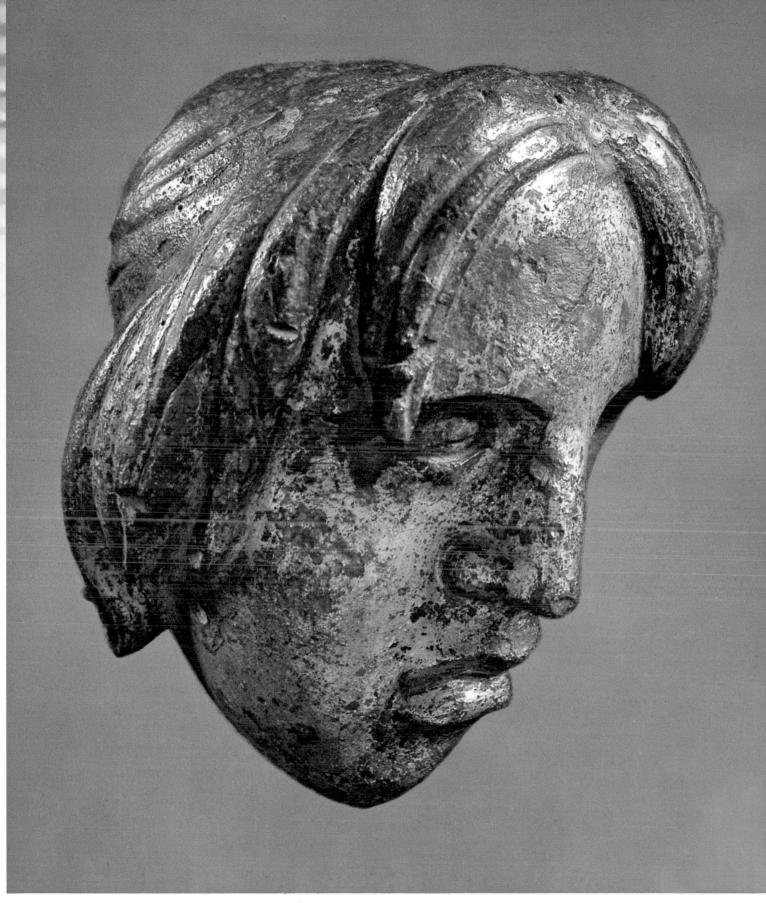

163 AVENCHES. HEAD OF A BARBARIAN WOMAN. AVENCHES, MUSÉE ROMAIN

162 PORTRAIT OF A CELTIC CHIEFTAIN. BERNE, BERNISCHES HISTORISCHES MUSEUM

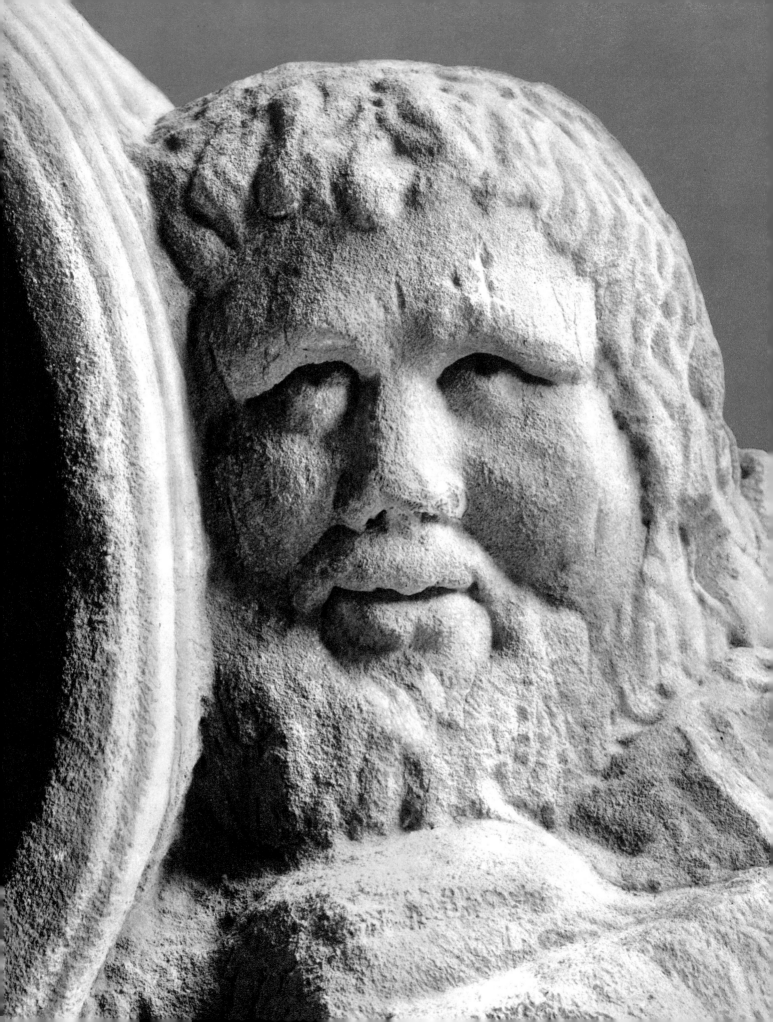

TRÈVES: IMPERIAL RESIDENCE

Trèves, situated in the Moselle Valley – then part of Gallia Belgica – acquired importance at the end of the second century as a defence-point against incursions by Germanic tribes. The Gallic emperors of the third century (Postumus, 258–67, Laelianus, 267, Victorinus, 268–70, Marius, 270, Tetricus, 270–3) chose it as their residential seat, until Claudius Gothicus persuaded the Western provinces to reacknowledge their dependence on Rome. In 275–6 Trèves was captured by the Franks and the Alamanni; but in 287 it was selected by Diocletian as the capital for the Western part of a now quadripartite Empire. It was the Imperial residence during the struggles between Constantine and Maxentius, and it was here, in all likelihood, that Constantine married Fausta, the daughter of Maximian, who had sought refuge with him and on whom he had bestowed the title of Augustus. The panegyric pronounced on this occasion (in 307, probably on 31 March), which also, as it happens, refers to a commemorative painting in the palace at Aquileia, emphasizes the city's magnificent urban development.

This magnificence increased still further under Valentinian I and Gratian. Ausonius, professor of ancient rhetoric at Bordeaux, was summoned to Trèves to undertake the education of the young Gratian, who kept him on at Court after becoming Emperor. Important offices were bestowed on him: by 378 he had risen to be *praefectus Galliarum,* and in 379 he was made consul. As a poet he was elegant rather than profound; his Christianity sprang from conformism, not from any lofty spiritual conviction – although among his pupils at Bordeaux was that fervent character Paulinus of Nola. He struck a sincere note, however, when he sang the praises of a young slave, Bissula, who had been assigned to him as a prize of war; and his little poem 'The Moselle' reflects the kind of life led by people in official circles. We also get a glimpse from it of that intense river-traffic which a funerary monument from Neumagen confirms: this is in the form of a boat, laden with barrels, and crewed by bearded men whose dreamy placidity would seem to have been occasioned by the wine they are carrying. After the arrival of the usurper Maximus in 383, Gratian sought refuge at Lyons; then in 402 Stilicho removed the Court to Ravenna, and the *praefectura Galliarum* to Arles. Trèves went into a decline.

175

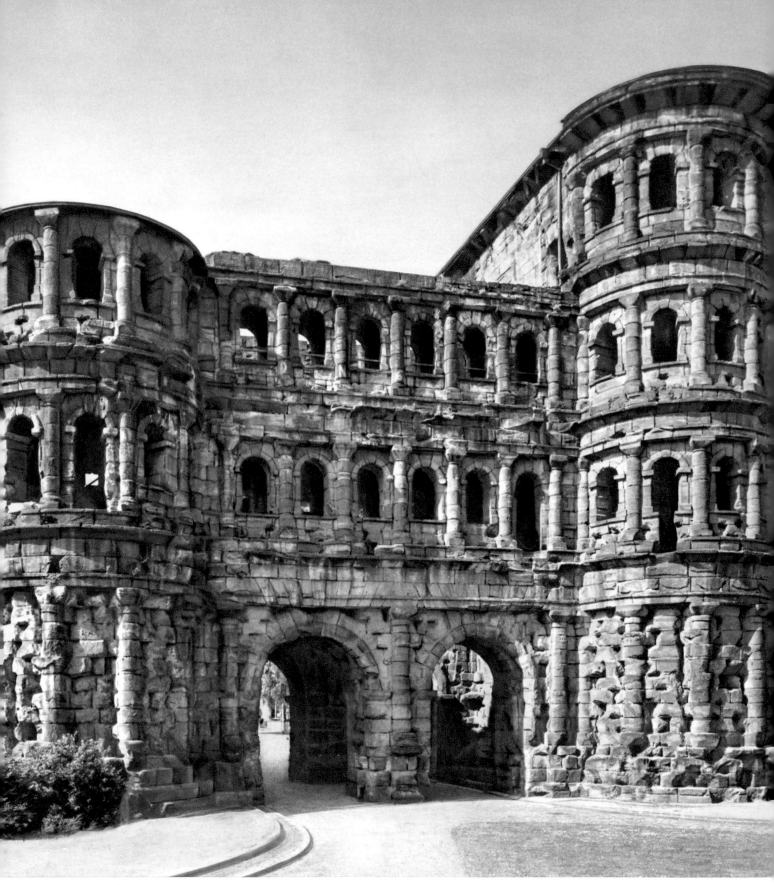

165 TRÈVES, THE PORTA NIGRA, INSIDE THE RESIDENTIAL QUARTER OF THE TOWN

176

166 TRÈVES THE COFFERED CEILING (DETAIL): ALLEGORICAL FIGURE WITH HALO

In the environment of the Court, naturally enough, there was not so much as an echo of provincial art. Monuments such as the Porta Nigra, the Aula Palatina (the Basilica), the twin churches built by Constantine, and the remains of Gratian's various edifices are all grandiose undertakings which aimed at rivalling those of Rome. Excavations carried out under one of Constantine's churches, erected in 326 on the ruins of an earlier building, revealed the remains of paintings; these made it possible to restore the coffered ceiling of a large reception-hall, and they provide valuable evidence for decorative painting during Constantine's era. Busts of allegorical and haloed figures alternate with rectangles on which winged *putti* are holding garlands of flowers.

We may get some idea of the significance of this decoration (as Alföldi showed in 1955, it was designed to promote joy and happiness) by comparing it with a gold medallion issued by Constantine, in which very similar *putti,* also with garlands, are accompanied by the legend *Gaudium Augusti nostri.* It is important, if we are attempting to define the Constantinian style, to observe these clear, sharp outlines. They no longer dissolve in juxtaposed masses of chiaroscuro; their execution offers us solid relief-work, compact bodies framed in precise, clear-cut cornices against a background of infinite azure blue. Though few fragments of the mural decorations have survived, they suffice to show that the walls were adorned with *trompe-l'oeil* pilasters, resting on an imitation

177

marble plinth. Between the pilasters were panels carrying lifesize figures. We have here, then, a reversion to the manner of the first phase in the Second Pompeian Style; in other words, a classicizing tendency. The female heads on the ceiling likewise have a classic breadth and solidity. I shall attempt to define this Constantinian classicism later; but I may say here and now that it provides a link with Carolingian classicism, which developed some five centuries later in the Imperial residence of Aix-la-Chapelle, not far from Trèves.

Among various other forms of expression available to the highly skilled craftsmen of this era (whose work enjoyed widespread popularity in the second to fourth centuries) we must not forget glass-manufacture, in particular that of Cologne. When it became known that crude glass could be fashioned and shaped by blowing air into it through a tube – a discovery which probably occurred in Phoenicia, at the end of the first century BC – glass-working moved into the mass-production stage. From Phoenicia and Egypt it spread to Italy (Aquileia in particular) and to Gaul; from Augustus's day on, a particularly flourishing centre was Cologne. The factory there turned out plates, cups, drinking-glasses, bottles and amphoras, in plain or coloured glass, often by blowing them into a mould. Receptacles decorated with filaments of glass paste in various colours, superimposed on the outer surface (the so-called 'serpentine decoration'), and certain other *appliqué* motifs (birds, fishes, 'proboscidea'), are characteristic products of the Cologne factory. This type of decoration first appears in the second century, but really develops during the third. The peak of virtuosity is reached a hundred years later, when we find cups fashioned in such a way that the receptacle appears to be encircled by a filigree band several millimetres distant from the body of the vessel. Such glasses, known as *diatreti*, were specially prized in antiquity. During the fourth century, too, apart from ordinary products, the glass industry turned out luxury items for a small, high-class clientele.

178

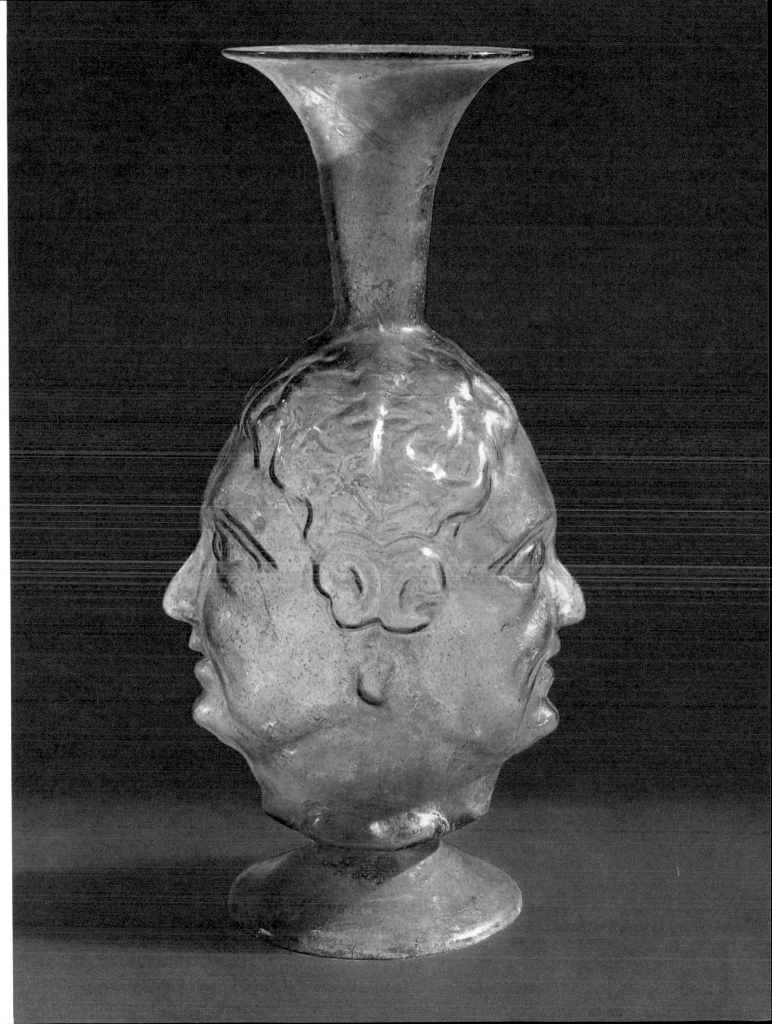

170–3 COLOGNE. EXAMPLES OF GLASSWARE. COLOGNE, RÖMISCH-GERMANISCHES MUSEUM

181

169 COLOGNE. VASE SHAPED LIKE A BUNCH OF GRAPES. COLOGNE, RÖMISCH-GERMANISCHES MUSEUM

THE IBERIAN PENINSULA

The art of the Roman period in the Iberian peninsula is noticeably different from that of the other Western continental provinces. The reasons for this difference are not hard to find. Whereas the other provinces, at the time of their occupation by Rome, were populated by barbarian tribes who were still very much isolated from the rest of the world, the peoples of the Iberian peninsula had already, from an early period, had widespread contacts both with the Greeks and with the Western Phoenicians (Carthaginians). They had developed their own artistic culture, which attained a high level of excellence; its formative impulse, nevertheless, was provided by Hellenism.

The creators of this Iberian art had been the inhabitants of Andalusia and south-east Spain: those dwelling in the north had remained more countrified, and were still within the sphere of Celtic influence. On the general cultural level, there had been another intrusive element, brought back by those Iberians who had seen mercenary service with the Carthaginians in Sicily and Greece. Finally, the Romans lost no time in occupying eastern Spain: Hispania Citerior was first constituted a province in 197 BC, with a resident praetor whose seat was the southern city of Carthago Nova.

The south-west part of the peninsula (Hispania Ulterior) had been partially Romanized ever since the Second Punic War (218–201). It subsequently served as a base for the conquest of the north-western region (Lusitania), and for the struggle between Caesar and Pompey (valuable silver and copper mines lay in the area). In the reorganization carried out by Augustus between 27 and 19 BC, the south took the name of Baetica and was given provincial status, under a proconsul of senatorial rank, while Lusitania was detached from Hispania Ulterior and became an Imperial province, governed by a legate, whose seat was at Emerita Augusta (Merida). The west, Hispania Citerior, retained its old status virtually unchanged until the end of the third century, when Diocletian detached the Asturias and other territories and changed its name to Tarraconensis, with Tarragon – a city that had suffered badly from the attack by the Franks and Alamanni in 260 – as its capital.

For all these reasons, Iberia's ruling class had assimilated the formal patterns of Roman official art rather more thoroughly than was the case elsewhere, though without leaving scope for the development of a real provincial art. They had behind them, however, a genuine artistic culture of their own, widely penetrated by Hellenistic influence. We can detect echoes of this Iberian artistic culture in the sculpture produced during the Roman period, not as a mere back-cloth, but rather as a free and original interpretation of Roman official art.

Among the most ancient examples of the latter we may note the fragments from Osuna, in the Seville province, which perhaps originally formed part of a monument commemorating Caesar's victories over the Pompeians, set up in Colonia Julia Genetiva Urbanorum Urso. They would, then, be assignable to a date about 45 BC. Of these fragments the most characteristic is a relief showing a soldier blowing a horn (*pl. 174*). It can be regarded as a typical product of this Romano-Iberian art. Hellenistic features include the positioning of the figure and the fluid quality of the drapery; other elements derive from the commemorative tradition of Roman plebeian-municipal art; while the flattened relief-work and incised detail reveal a typically local interest in design.

Conceptually akin to this are various funerary stelae with scenes of the deceased's trade or profession on them – though the motif occurs less often here than it does in the provinces of Central Europe. Fragments of one stele in this category, from near Cordova, show a man emptying a sack of olives into a receptacle which resembles a *modius,* and confirm the abundance of olive trees in Baetica (see Pliny, *NH* 15.8; Martial 12.63.1f.).

There are also numerous portraits. When these are not straight imitations of work turned out by Roman studios (e.g. the very beautiful female bust, late second century, now in the Boston Museum), they have a quality which matches that of the best products of Italian municipal art. What marks them out as local work is the treatment of the body, and the form of hair-style. For Baetica, we have a female terracotta head now in the Seville Museum; for Lusitania, a portrait in Merida Museum; and for Tarraconensis, one in the Museum of Barcelona. These three sculptures, one in bronze, one in terracotta, and one in marble, can all be dated to the second half of the first century (the Merida one, known as 'the gypsy-girl', may be from Nero's reign; the other two are Flavian), and all three are particularly successful in rendering a specific physical type by means of a simplified, not to say perfunctory, plastic technique.

The small bronze reliefs used to decorate objects in daily use (e.g. dishes or horse-harness) also display characteristics, in Spain, which mark them off from similar products in other provinces. The copper mines, exploited since remote antiquity, must have encouraged the emergence of local workshops, or of itinerant craftsmen. All these small bronzes are characterized by liveliness of composition and simplicity of detail. The important thing is always the overall impression, never any individual feature. See, for instance, the rein-guide decorated with an Amazonomachy; here the traditional iconographic motif of an Amazon thrown from her horse (which goes back to Greek art of the fifth century BC) is reinterpreted with great freedom. Another example is a fragmentary hunting scene, which shows a rider followed by another man, on foot, and a dog: the naturalism of this composition is quite extraordinary. Both pieces may be dated to the end of the second or the first half of the third century.

175 CORDOVA. FRAGMENT OF A STELE: OLIVE-HARVESTING. CORDOVA, MUSEO ARQUEOLÓGICO PROVINCIAL

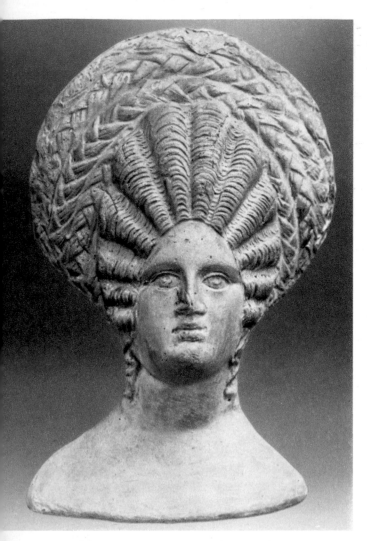

176 SEVILLE. BUST OF A WOMAN (FULL-FACE): SEVILLE MUSEUM

177 SEVILLE. BUST OF A WOMAN (BACK VIEW). SEVILLE MUSEUM

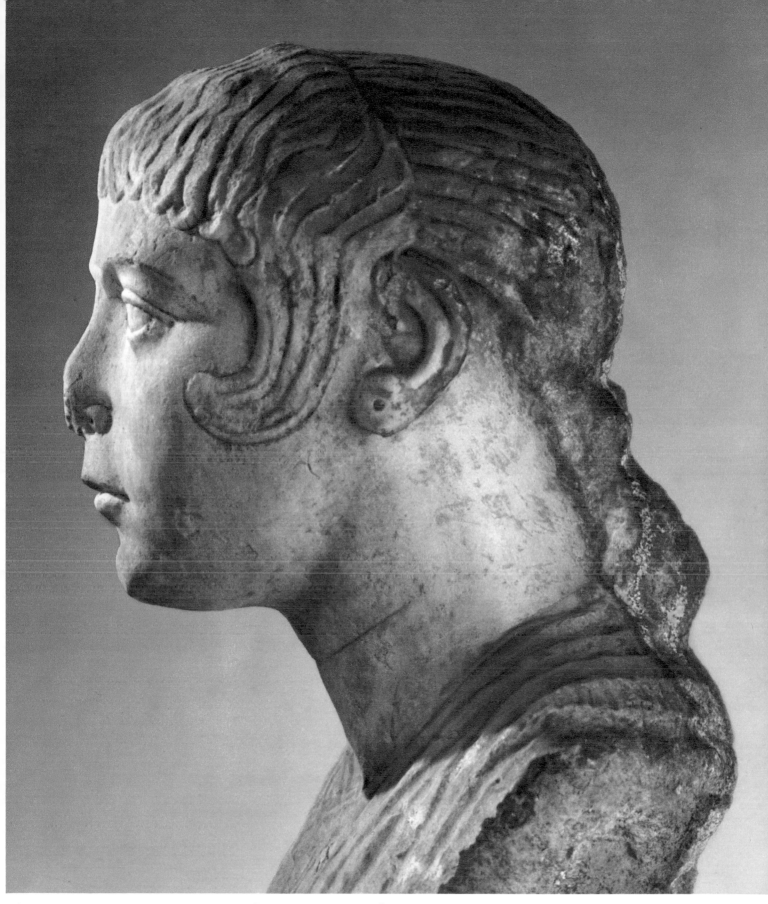

178 MERIDA. PORTRAIT OF A WOMAN (THE 'GIPSY-GIRL'). MERIDA, MUSEO ARQUEOLÓGICO

187

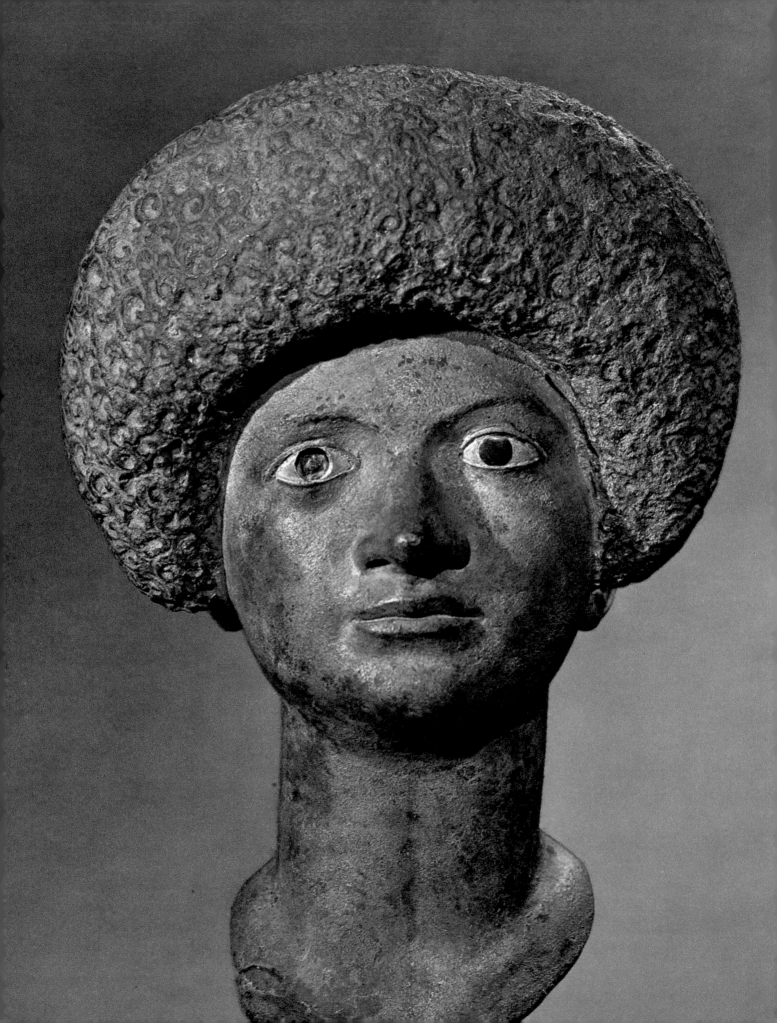

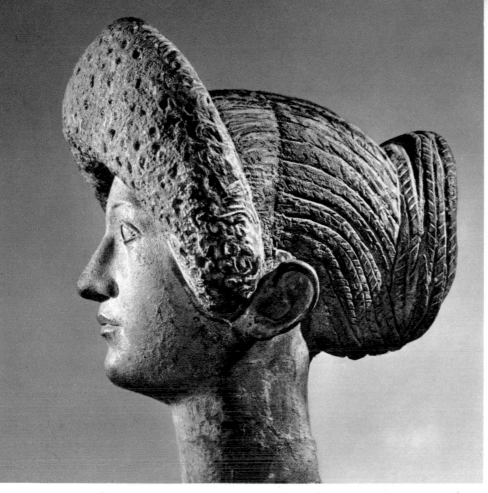

180 AMPURIAS. PORTRAIT OF A WOMAN (PROFILE). BARCELONA, MUSEO ARQUEOLÓGICO

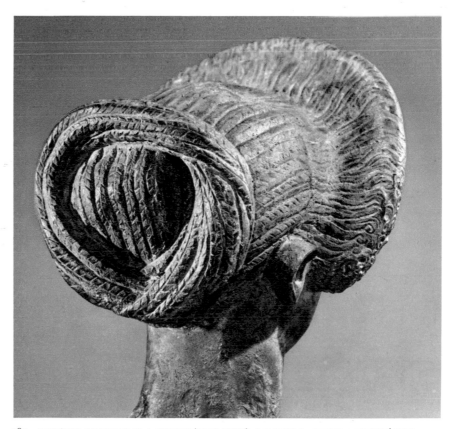

181 AMPURIAS. PORTRAIT OF A WOMAN (BACK VIEW). BARCELONA, MUSEO ARQUEOLÓGICO

179 AMPURIAS. PORTRAIT OF A WOMAN (FULL-FACE). BARCELONA, MUSEO ARQUEOLÓGICO

182 MARCHENA. REIN-GUIDE: BATTLE AGAINST AN AMAZON. PARIS, LOUVRE

183 SPAIN. ORNAMENT FOR A RECEPTACLE: GOING HUNTING. MADRID, MUSEO ARQUEOLÓGICO NACIONAL

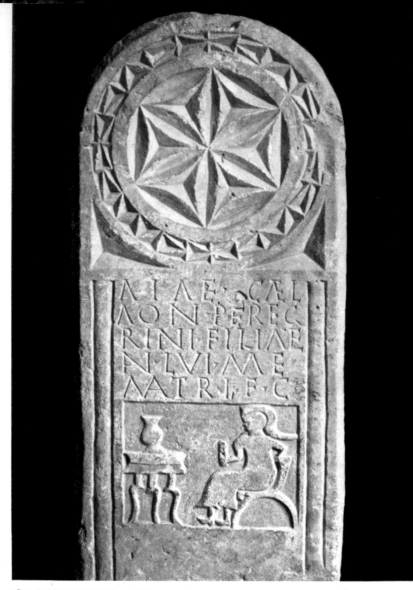

184 SALAS DE LOS INFANTES. FUNERARY STELE. BURGOS, MUSEO ARQUEOLÓGICO

In the northern part of the peninsula, towards the Pyrenees and the Bay of Biscay, we more often find traces of that ethnological substratum – here partly Celtic – which had been less exposed (or not exposed at all) to contact with the Greeks and Carthaginians. In the neighbourhood of Burgos, the stelae preserve an incised type of decoration with a predilection for a disc-shaped motif at the top, which stems directly from the local wood-carving tradition. The same formal and technical approach is applied to the figures on reliefs, which, again, are incised rather than sculpted; their flat chiselling and linear contours are more closely related to the Celtic tradition of La Tène than to Roman sculpture. Even the subject-matter (hunting, warfare, the deceased as hero participating in a mystical banquet) fits in with this same area of culture. Such stelae continue to turn up, without substantial variation, between the second and fourth centuries. It comes as something of a surprise when, amid this primitive range of decoration, one finds a Latin inscription in fine Roman lettering.

No equivalent examples of painting during the Roman period have survived in the

192

Iberian peninsula; but painting must undoubtedly have existed. Such mosaics as we possess date from the first, second or third centuries, and present no original features. They are standardized products, employing iconographic designs ('cartoons') that recur throughout the Empire. There is sufficient characterization to identify the provenance of the model in each case, whether Roman or from one of the centres on the North African coast. One can also perhaps detect a preference for Roman models up to the end of the second century, whereas from then on African ones become the favourites. At Merida and Italica in particular, we find black-and-white mosaics that are the counterpart of contemporary work from Ostia, whereas in the Central European provinces black-and-white mosaics are virtually unknown. In this sphere, too, artistic craftsmanship reveals direct contact with Rome. During the same period, two of the best Roman emperors to emerge from the Senate, Trajan and Hadrian, were both Spaniards by origin.

In the fourth century, however, we find funerary mosaics with direct parallels in Africa (e.g. the Tabarka necropolis in Tunisia). By the end of the century we also witness the onset of that process of disintegration which is a common feature of all peripheral territories in the Roman world. Iconographic features taken over (sometimes accidentally) from different regions mingled with spontaneous forms of popular art, so much so that the products of different localities came, in the end, to resemble one another. But in the Iberian peninsula this break-up of traditional iconographic motifs assumes its own pattern. In this connection we may recall the mosaic of 'Dominus Dulcitius' from Tarraconensis (*pl. 185*), and another one, signed *ex officina Anniponi*, from Lusitania (*pl. 186*). Both were found in country-houses belonging to big landowners. That of 'Dominus Dulcitius', which turned up near Tudela, shows the master himself, as named in the inscription, out hunting, and framed in a schematic leaf-and-branch border. It seems likely that the iconography was taken from one of those silver dishes, portraying a sovereign on horseback frenziedly galloping after game, which were typical of Sassanid art in the fourth to sixth centuries. The Tudela district is close to the Bay of Biscay, and Iranian tapestries or silverware could well have reached Spain by this route.

On the other hand, the mosaic found near Merida, which was produced in the workshop of one Anniponus (or Annius Ponus?) reveals a distortion of the Graeco-Roman models characteristic of the frontier provinces, together with an uncritical tendency to blend traditional iconographic material into decorative motifs of a purely local variety. Isolated figures are imitated from the stock scenes that appear on sarcophagi: Dionysus, Ariadne sleeping, the Bacchic rout. But such figures have no mutual cohesion of any sort; they are separated by rosettes similar to those which we find on the Burgos stele. By contrast, the original plant-life motifs are reduced to a mere threadlike consistency, while Dionysus has assumed the dress and appearance of a city-dweller. Yet the author must have taken a pride in his achievement, since he went to the trouble of signing it. This is a typical feature of very late work from the periphery of the Empire: another example which much resembled it – in its artist's honest pride as well as in the distorted quality of its composition – was a mosaic from Sheik Zoueda in Egypt. This work, which consisted of two scenes, Dionysus on one side, Phaedra and Hippolytus on the other, is now unfortunately lost.

DVL...CITIVS

186 MERIDA. MOSAIC: DIONYSUS AND ARIADNE. MERIDA, MUSEO ARQUEOLÓGICO

The Anniponus mosaic (like certain pieces from the British Isles) shows how, towards the westernmost boundaries of the Empire, ancient formal tradition could be totally lost, even when the memory of Hellenistic iconography still survived. In contrast to developments in the provinces of the Eastern Mediterranean, all discipline vanished from the style – even when this was different from, or indeed actively opposed to, that laid down by Hellenistic tradition. In the immediately adjacent provinces, at the turn of the fourth century, there is little artistic production, and it never rises above the level of popular craftsmanship. While the latter preserves no formal link with antiquity (assuming that iconographic motifs do not, *per se*, possess any formal value), neither does it evolve a new tradition of its own. The same anomaly, as regards tradition, appears in the Christian sarcophagi of Ecija, or those from the Quintana of Bureba and Alcaudete in the province of Burgos. Here, features borrowed from the Orient have been distorted by local artists, who seem suddenly to have reacquired a taste for old Iberian formal motifs (H. Schlunk, 1962, 1965). The ancient tradition was lost, and no new formal vision took its place. This happened only under the impact of Merovingian art and, later, with the great efflorescence of Catalan painting in the tenth century.

THE BRITISH ISLES

The art of the Roman period in Britain produced some works of an official character (more or less marked by provincialism), and others that were typical of all Rome's peripheral cultures: in these, the ancient iconographic patterns were preserved, but underwent a disintegrating process that left them without any stylistic cohesion. There was also a flourishing tradition of local craftsmanship. Although the latter was enriched by Roman techniques, the local Celtic legacy – both formal and decorative – on which it relied was left virtually intact: so much so, indeed, that at a later date both the form and the thematic repertoire of the miniatures in the Irish monasteries stemmed directly from it. In this case, the degeneration of classical form was brought about by an internal process, without any influence from outside – or, at most, only a few intermittent contacts with Lusitania and Tarraconensis. On the other hand, official art, which was aimed at top-ranking administrators, followed the same evolutionary pattern as such Continental centres as Trèves or Rome itself.

The British Isles were not easy to govern. Their oligarchic, tribal form of society resisted all encroachments on its independence. Though local kings and chieftains might put Latin inscriptions on their coinage, and call themselves the protégés of Augustus and Jupiter Capitolinus, they preserved their autonomy wherever possible. The Romans were always obliged to maintain large troop-concentrations on the island. Caesar's landing (55 BC) was regarded as an extraordinary undertaking, carried out against a distant and savage country around which legends clustered. It served to protect the frontiers of Gaul, and to open up new trade-routes, but it went no further than the south-east corner of the country. The conquest was completed in AD 43, on Claudius's initiative; after which four legions were transferred there from Pannonia and the Rhine, reinforced by Gaulish and Thracian auxiliaries. Under Vespasian, the occupying forces pushed up as far as the Firths of Clyde and Forth. Later, in the time of Antoninus Pius, this line was established as the frontier, and a wall built along it to hold off the marauding northern tribes. In Hadrian's day it had proved necessary to shorten this defence

197

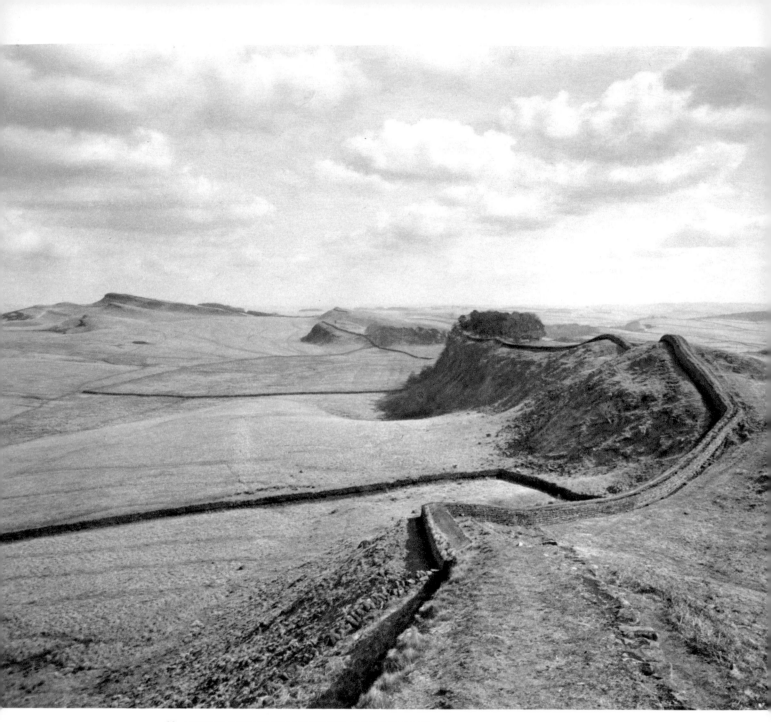

188 BETWEEN CARLISLE AND NEWCASTLE. HADRIAN'S DEFENCE WALL

line, and build another wall further south, on the Solway Firth – which had been in Roman hands since the time of Claudius. Between 287 and 296 the island enjoyed ten years of independence – though Carausius and Allectus, who declared themselves 'Augusti of Britain', were sovereigns in the true Roman tradition. One of the Tetrarchs, Constantius Chlorus (Constantine's father), put an end to this secession, and brought the island back under the authority of the central government: after this Britain was divided up, first into four, then five, minor provinces. A medallion struck in Trèves

shows us the city of London – personified as a woman with one knee bent and arms out-stretched – welcoming the Emperor Constantius (shown on horseback) outside the fortified city-gate, while a great vessel rides off-shore in the Thames.

Provincial-type sculpture in Britain is closely linked with that of Gaul (Belgica in particular), as regards both form and stock themes. The statue of a seated matron (*pl. 189*), found in the Solway Firth area (at Birdoswald, the ancient Amboglanna), has the same massive, monumental posture, the same almost pre-medieval character which we find in Gallic statues such as that of Naix-aux-Forges at Bar-le-Duc. A capital of the classic type, with busts of Romano-Gallic deities inserted in it, also corresponds stylistically to the material we find in central and northern Gaul.

Some particularly interesting statues come from the neighbourhood of Colchester, in Essex, the ancient Colonia Camulodunum (from Camulos, the Gaulish war-god). This town had been the capital of the chief dynast in south-east Britain, Cunobellinus (Cym-beline), who succeeded Caesar's adversary King Cassivellanus. On his coins, struck about AD 40, we find, *inter alia,* the emblem of the sphinx; and anthropophagous sphinxes (holding a human head between their fore-paws) figure also on the funerary monuments of this area (*pl. 191*). Thus the sphinxes and lions which form iconographic motifs on ancient Greek funerary monuments spread first to Aquileia, and from there to this remote northern fastness – just as they also penetrated Gaul and Dacia, and with scarcely any distortion *en route.* In this way there began to develop a genuinely European art, the European art of Rome, which had its roots far back in classical antiquity.

Another stele (also from Colchester), surmounted by a sphinx and two small lions, one crouching in each corner, shows us a Roman soldier on horseback, trampling down a naked, bearded barbarian (*pl. 192*). The inscription tells us the name of the horseman – Longinus. The iconographic pattern follows the traditional iconography adopted by stelae in Gaul and the Rhineland, the sole difference being a certain roughness in the imitation of what was, originally, a classical format. This roughness is the product of incompetence, not a stylistic device (as is the case, later, with the famous seventh-century German stele of a horseman from Hornhausen in the Halle Landesmuseum).

Roughness, together with a certain unimaginative quality which marks the repetition of stock designs from the Roman commemorative repertoire, turns up again in a particularly interesting series of pieces: the reliefs accompanying the inscriptions on Antoninus Pius's *vallum* in Scotland (*pl. 193, 194*). These inscriptions commemorate the sections of wall built by each separate legionary contingent: English scholars refer to them as 'distance slabs'. The first of them, as we move from east to west, was found near Bridgeness, and tells us that the Second Legion (II Augusta) built 4,652 feet of the *vallum* (slightly over one mile), between Bridgeness and the Avon. Seventeen such inscriptions have been recovered, belonging to the following legions: VI Victrix, XX, XXV Victrix, as well as the II Augusta. Only some of them are decorated with reliefs. In that from Bridgeness, the left-hand relief – set under a cornice between pilasters – shows a horseman, wearing breastplate and helmet, shield in one hand, spear in the other, overcoming four naked Caledonian barbarians, of whom one has already been decapit-ated, and only two are armed, with buckler and javelin. This relief recalls the stele of Longinus. Next comes the inscription, under a cornice decorated with two Amazons'

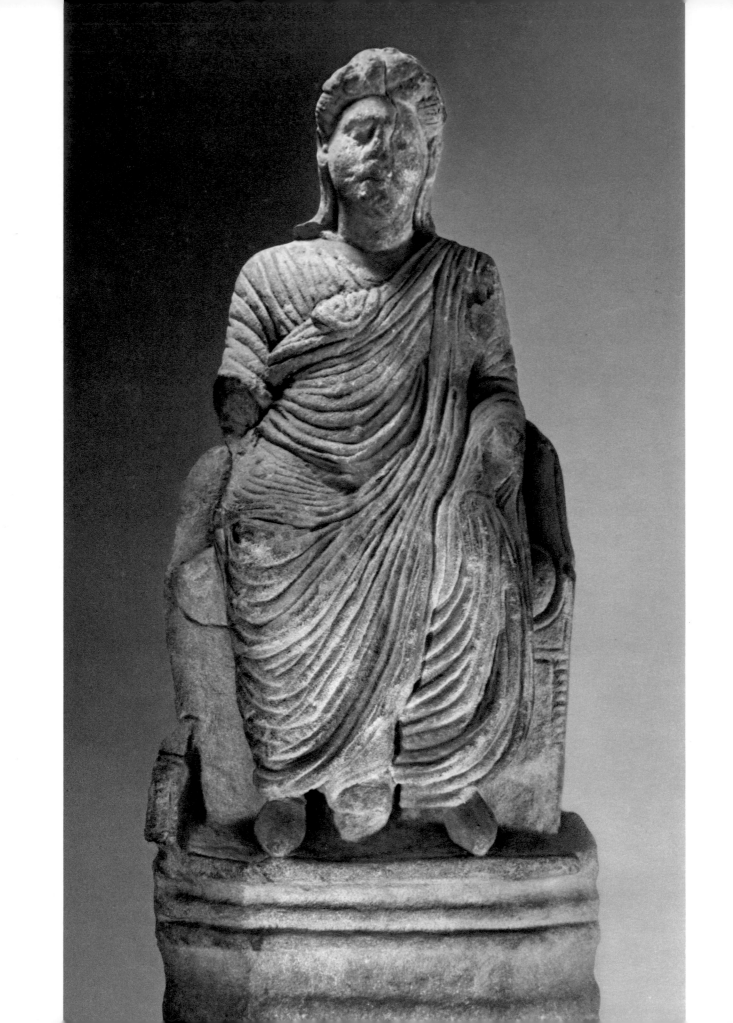

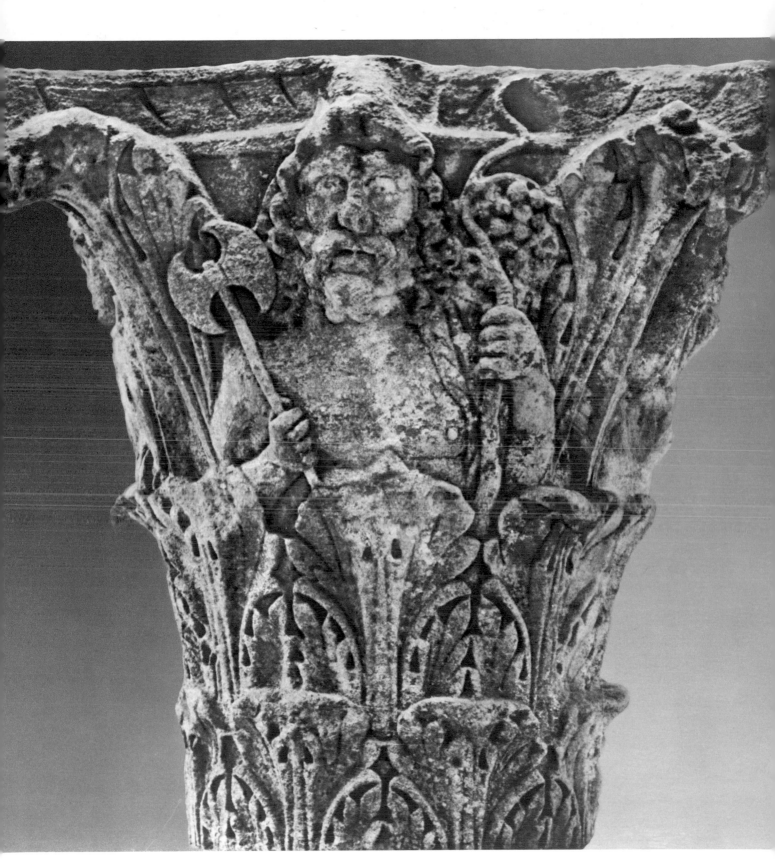

190 CIRENCESTER. CAPITAL WITH BUSTS OF DIVINITIES. CIRENCESTER, CORINIUM MUSEUM

◄ 189 BIRDOSWALD. STATUE OF SEATED WOMAN. CARLISLE, MUSEUM AND ART GALLERY

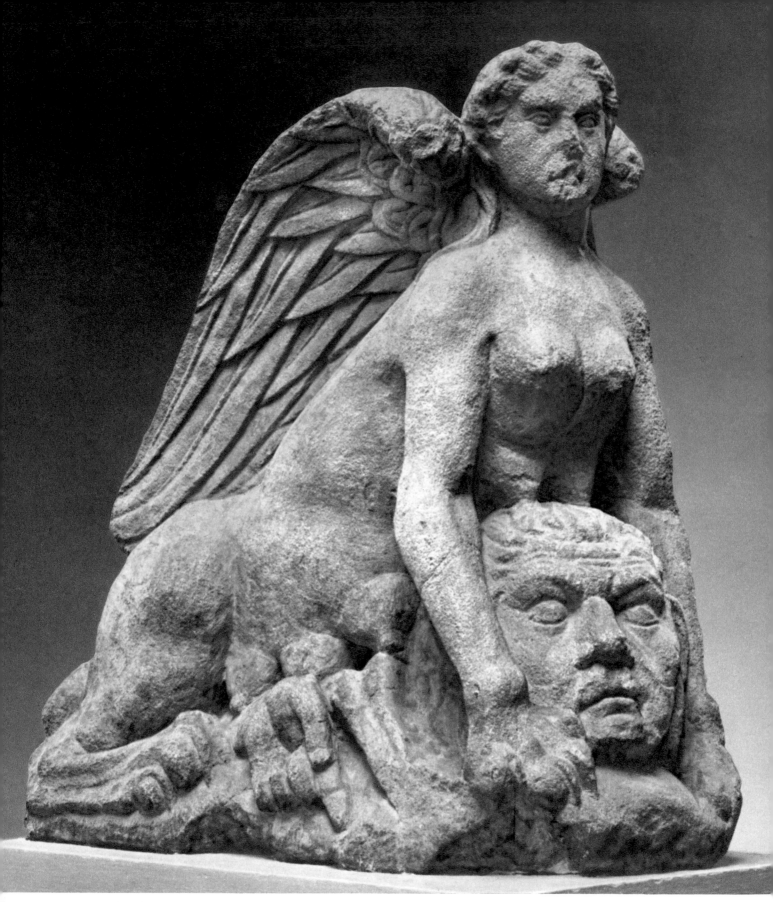

191 COLCHESTER. FUNERARY MONUMENT: ANTHROPOPHAGOUS SPHINX. COLCHESTER, COLCHESTER AND ESSEX MUSEUM

202

192 COLCHESTER. FUNERARY STELE OF LONGINUS. COLCHESTER, COLCHESTER AND ESSEX MUSEUM

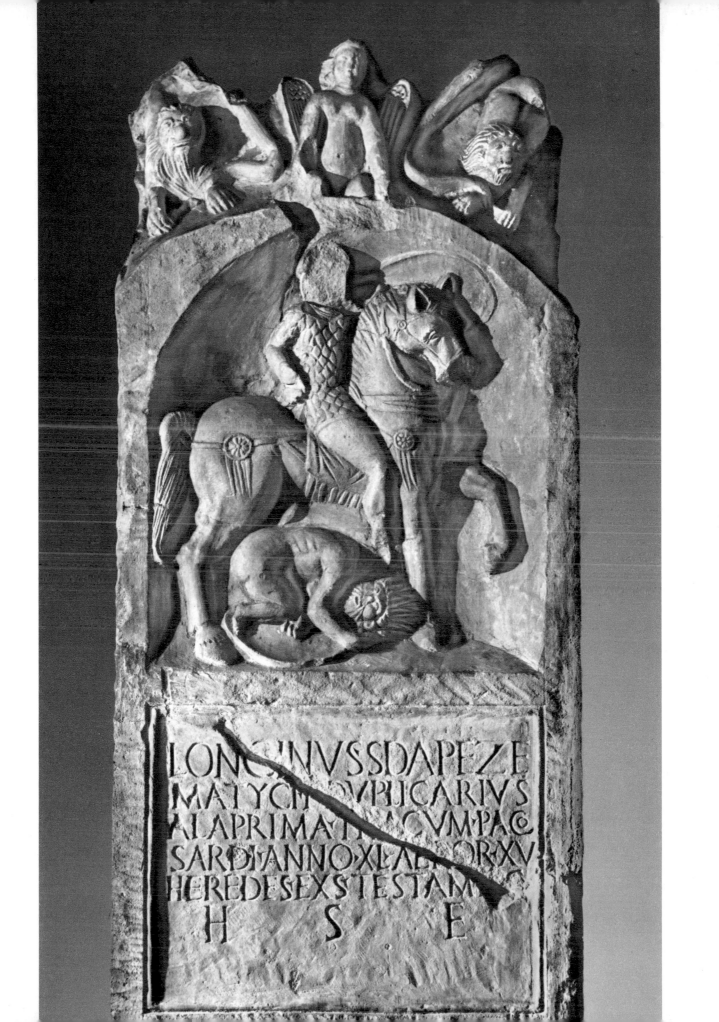

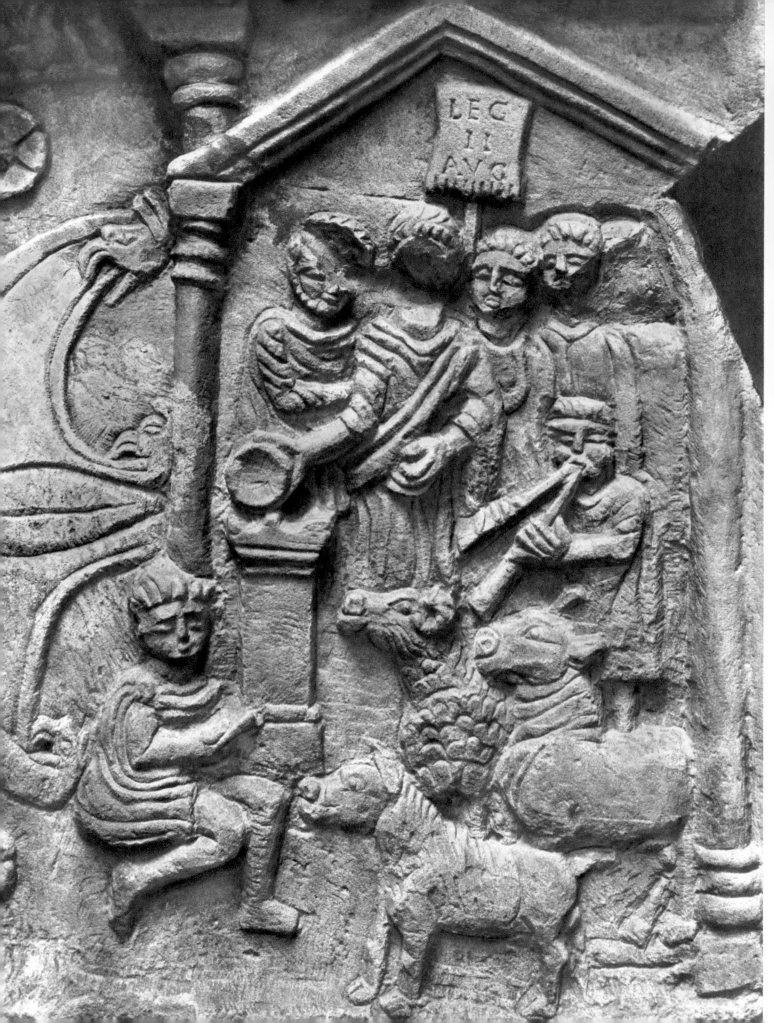

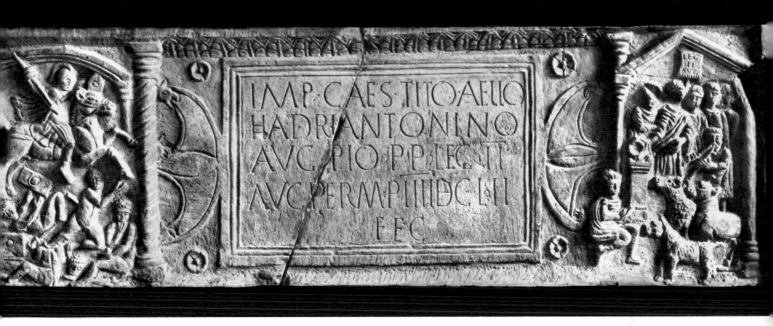

194 BRIDGENESS. INSCRIPTION FROM THE WALL OF ANTONINUS PIUS. EDINBURGH, NATIONAL MUSEUM OF ANTIQUITIES OF SCOTLAND

shields in the half-moon position, terminating in eagles' or griffons' heads – an ornament which is typical of many sculptures along the Scottish *limes*. On the right of the inscription is another relief, which portrays a sacrificial scene (a *suovetaurilia*, the sacrificial animals being a pig, a sheep and a bull). This sacrifice is taking place in front of a building with a portico, and the celebrant is pouring the contents of a bowl on to the altar. This scene is a very popular one in the Roman repertoire; here its composition involves stiffly frontal protagonists, and a conventional reduction in size of the animals. These are precisely the conventions I attempted to interpret earlier, in the 'plebeian' reliefs of the first century. Thus this scene of *lustratio* from the Antonine *vallum* (built between 142 and 145) offers proof of my thesis that the art of the Western provinces is linked with the 'plebeian' trend in Rome, and that this trend embodies – at a much earlier period – the formal language of the Late Empire.

The sculptors of the *vallum* were capable of thoroughly barbarizing their models, as we can see from another of these inscriptions, apparently found near Castlehill (*pl. 195*). This mentions 3,666½ feet of fortification built, again, by the II Augusta. Here, on the left, we see a winged Victory, holding out a crown to a helmeted horseman (who is very small, and of linear design); below them are two prisoners, somewhat shapeless figures. In the right-hand relief an eagle (shown full-face, and very crudely blocked in) is shown above the Zodiacal sign of Capricorn, which was the Second Legion's badge. Below, we see a naked prisoner sitting. Even the cornices here have lost all grace and structural feeling. It is, indeed, art by and for soldiers.

A special feature of the Romans' presence in Britain is the development of the rural farmhouse. This may sometimes be a gentleman's country retreat, designed for pleasure;

205

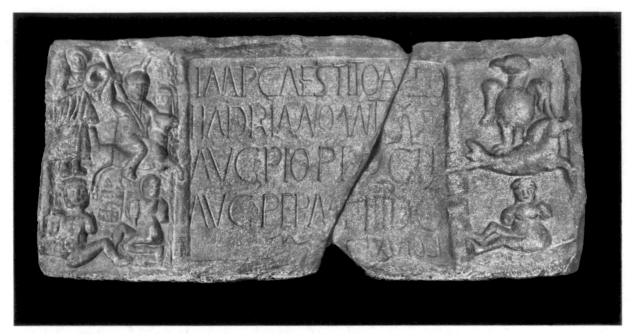

195 CASTLEHILL (?). INSCRIPTION FROM THE WALL OF ANTONINUS PIUS. GLASGOW, THE UNIVERSITY, THE HUNTERIAN MUSEUM

yet even the most luxurious specimens never lose sight of their basic agricultural function. Thanks to diligent archaeological research, and the careful preservation of those monuments which have been uncovered, we can follow the progressive enlargement of several of these country 'villas' over a period of time. Some of these country houses belonged to soldiers or administrators who had stayed on in Britain after retirement: but the greater number must have been owned by Britons, or those clever enough to make a good thing out of the occupation. It took no more than a generation after the conquest for Roman building techniques to become generally adopted.

Strabo, the geographer, tells us that Britain's exports were grain, cattle, gold and silver, iron, slaves, and hunting dogs. High-ranking Britons in turn bought a number of things from the Romans: wine, vessels of silver and bronze, worked ivory, glassware, jewellery. The import trade, in short, dealt almost entirely in luxury goods. The quantity – and beauty – of Roman-period silverware found in Britain is quite remarkable. Most impressive of all is the Mildenhall Treasure, discovered by accident, in 1942, close to a small Roman villa. It comprises thirty-four pieces of silver: a large round dish, its centrepiece bearing a representation of Ocean; two smaller dishes, decorated with nymphs and satyrs; four basins, their broad rims embossed with a pattern of animals and non-individualized human heads; and various other small basins, plus two chalices and five spoons bearing Christian inscriptions. One basin, in particular, merits study (*pl. 197*). It is somewhat deeper than the others, and its rim carries a formalized leaf-and-branch design. The lid displays a sequence of centaurs, boars, lions and human heads; surmounting everything is a small silver figure (perhaps once gilded) portraying a triton. Admittedly, the lid carries a pattern of sea-shells; but the triton, which serves as a handle, does not look as though it were originally designed to perform this function.

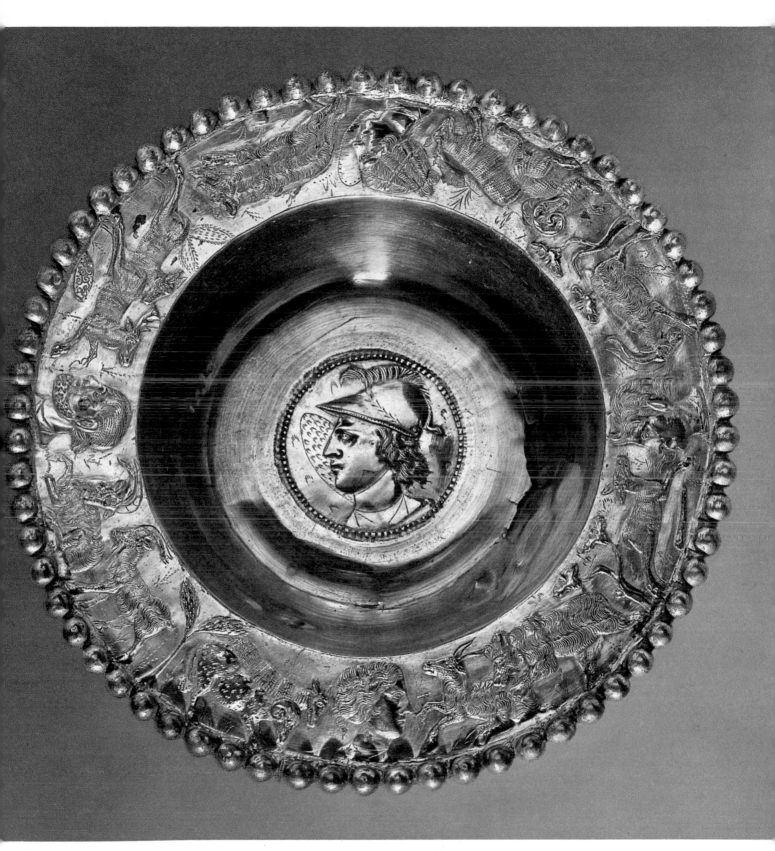

196 MILDENHALL. BASIN WITH ANIMAL FRIEZE AND HELMETED HEAD. LONDON, BRITISH MUSEUM

Perhaps it was substituted for something else at an early date; it is not even certain whether the lid originally belonged to this particular basin. The geometric decorations around the rim were designed to carry a niello inlay.

Formal analysis, and comparison with other hoards of silverware found in the Western provinces and the Mediterranean countries, enable us to date the Mildenhall Treasure to between 350 and the reign of Valentinian I (364–75). The Romans abandoned Britain in 407, after the occupation of Flanders and the Lower Rhine by Franks and Burgundians. It must have been in this period that the treasure was buried by its owner (perhaps some Roman official), who probably hoped to recover it when things took a turn for the better – which they never did. Except for the platter with a geometric design and niello inlay, all these pieces are of Western, probably Roman, manufacture; iconographically, and perhaps also as regards their workmanship, they suggest a connection with Greek-speaking craftsmen.

Unless silverware carries a signature or hallmark (which is seldom the case), to establish its place of manufacture presents insuperable difficulties. It could equally well be Rome, Milan or Trèves – or, indeed, Constantinople, Antioch or Alexandria. The general design of the two basins with an animal-border decoration seems to stem from Hellenistic art: the realistic presentation of the animals, and the beauty of the trees separating the groups, both confirm such a view. But the four large human heads, two male and two female, which are inserted in the decoration have no relationship whatsoever with the rest, whether compositional or thematic. Except for that portraying a bearded man, with a fringe over his forehead and long hair down his neck, these heads are neo-classical, idealized – as are the somewhat larger heads which adorn the bottom of the basin, inside: one veiled (perhaps Ceres), and the other (undoubtedly Virtus) wearing a helmet. The bearded head recalls those Athenian portraits which turn up regularly from the time of Gallienus well into Constantine's reign. It is in just such an environment of classically oriented taste that we must seek the origin of the models employed here. (Despite the time-lag between their creation and their borrowing, they have not suffered any gross distortion.) The relief-work must have been carried out by hammering sheet silver on to wooden moulds. The outlines were then given a final touching-up by hand; this delicate process involved laying the sheet-silver on a supporting base of pitch or resin, which filled out the relief-work but still allowed minor modifications to be carried out. Thematically speaking, the lid of the other basin is akin to this one; the difference lies in the process of distortion which its models have undergone. This is particularly noticeable in the large heads (of Pan and a Satyr) inserted in the animal frieze – though the animals, too, have lost much of their elegance and formal pliancy. Furthermore, it looks as though the animal figures are drawn from a number of different repertoires, since their relative proportions tend to be ignored. However, what would be a fault for an artist still imbued with naturalism is not regarded as such by the craftsman of Late Antiquity, whose sole object is to cover a surface with varied elements so as to create a play of light and shadow on it. The figurative side of things loses importance in comparison with the geometrical, which later, in barbarian jewellery and goldsmith's work, holds the field to the exclusion of all else. Not much later, again in Britain, we find other treasures (such as that of Taprain Low, from the early fifth century) which

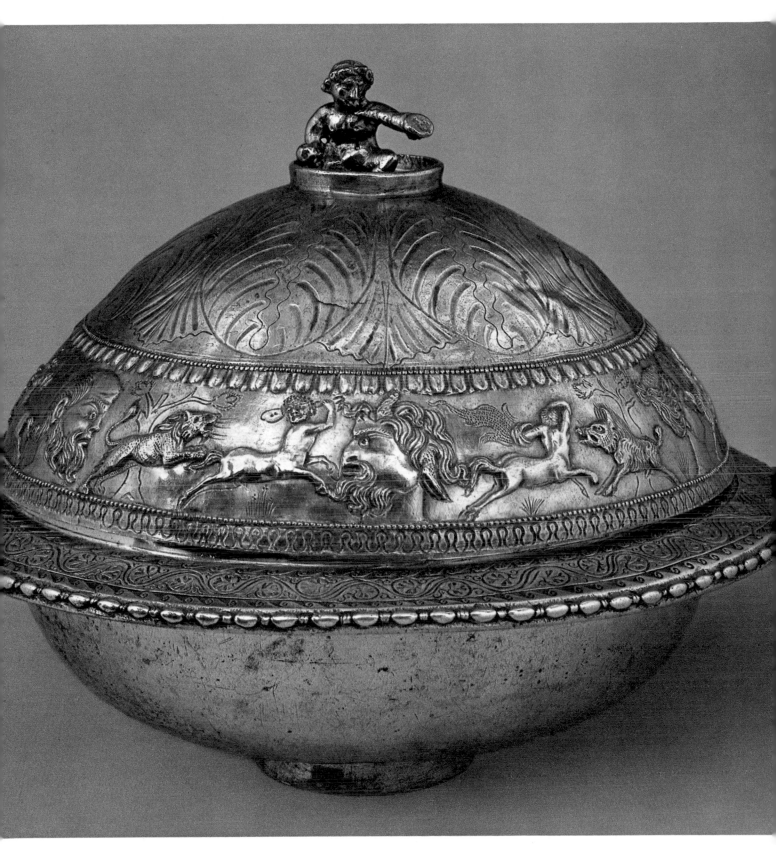

197 MILDENHALL. BASIN WITH LID SURMOUNTED BY A TRITON. LONDON, BRITISH MUSEUM

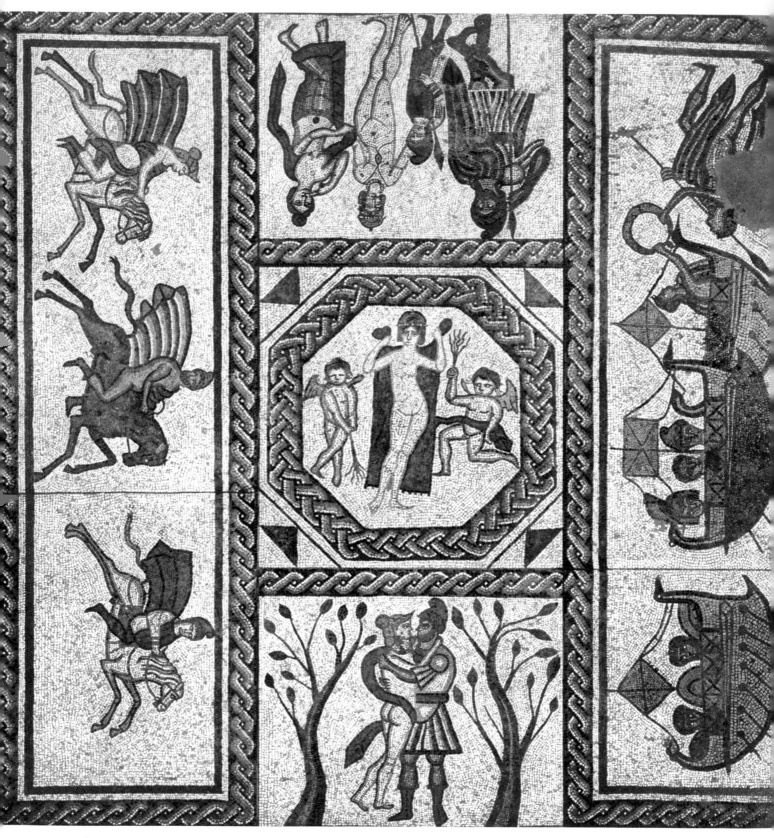

198 TAUNTON, LOW HAM VILLA. MOSAIC: THE STORY OF DIDO AND AENEAS. TAUNTON, CASTLE MUSEUM

contain a similar collection of equally fine bowls and vases – but in pieces, ready to be melted down.

The survival of classical themes and iconographic models (their form more or less modified according to circumstances) is equally notable in the mosaics of Britain's most luxurious country houses from the mid-fourth century on. In 1963, D. J. Smith attempted to establish the existence of three mosaic-workshops in the British Isles during the fourth century: the first at Petuaria (Brough on Humber, East Yorkshire), another at Durnovaria (Dorchester, in Dorset), and the third at Corinium (Cirencester, Gloucestershire). The most typical example is provided by the mosaics from a villa at Low Ham, near Taunton in Somerset, which tell the story of Dido and Aeneas. The composition of the central octagon, showing Venus and the Amorini, seems to have a close connection with the mosaics of Tunis and Algeria. The composition of the scene in which Venus is surrounded by Dido, Ascanius and Aeneas himself would seem to confirm such a supposition. Nevertheless, the model has undergone numerous modifications, especially in the panel with the ships, which are decidedly Nordic rather than Mediterranean. A connection with the workshops of Trèves has also been suggested, and this is more plausible. There are certain distortions in the Low Ham design which come fairly close to those of the Kornmarkt mosaics from Trèves; whereas the African mosaics invariably reveal a quite different style. It has also been argued that the spread of this iconography was due to book-illustrations; but the difference of format between the various scenes, and the connections with the African mosaics, render this a somewhat less acceptable hypothesis. At all events, this echo of Virgil – coming so late in time, and at the most distant frontiers of the Empire – remains an interesting phenomenon: though we are not obliged to infer from it that the owner of the villa was a great reader of books, or even particularly cultivated. The preference given to literary, above all to Homeric, subjects is characteristic of this period; mythological topics might seem a little out of place in a society whose hierarchical chieftains called themselves Christians Rome (391) and Constantinople (392) both issued edicts outlawing the pagan cults, and increasing the penalities for anyone who continued to burn incense on the gods' altars (*Cod. Theodos.* 16.10.19). It was only in 435 (*Cod. Theodos.* 16.10.25) that the decree renewing this ban on sacrifice in the pagan temples added: 'if any of them still survive' (*si qua etiam nunc restant integra*).

PART TWO

The Mediterranean and the Orient

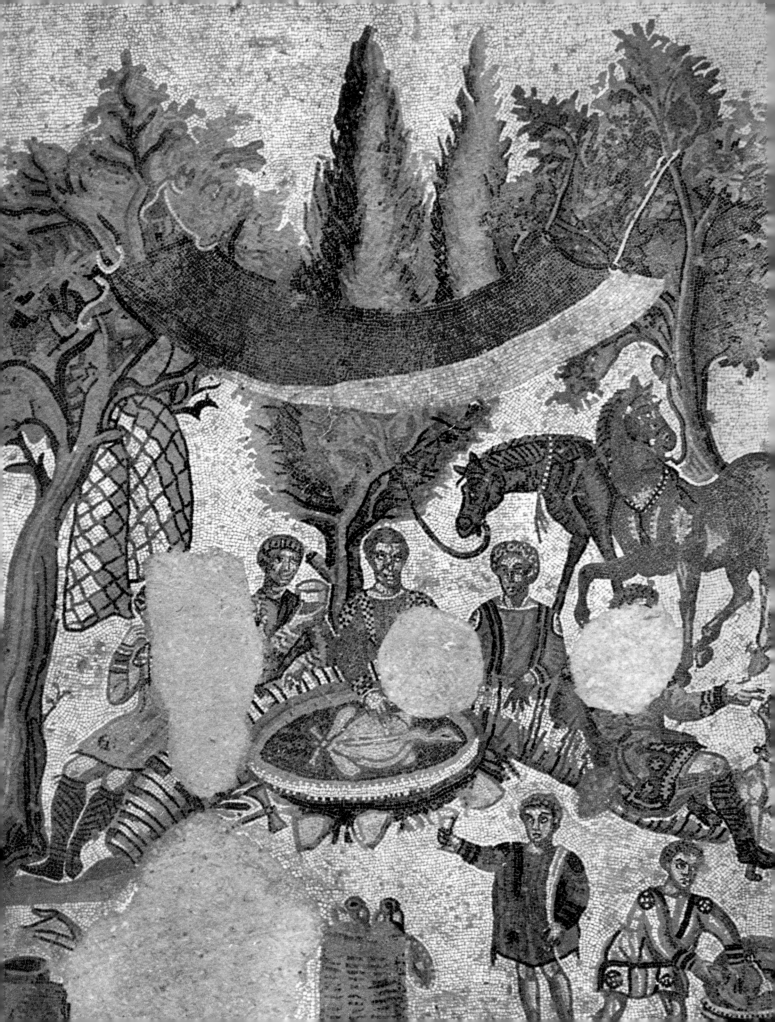

3 Africa

AFRICA PROCONSULARIS

THE Mediterranean had been the centre of ancient classical and Hellenistic civilization, which ran its entire course in the countries that border it. In the third and fourth centuries AD, the Continental centres of Europe gained importance; others, in the Middle East, still retained it. But it was, as always, in the Mediterranean that artistic production found its most fertile soil; and there, too, that the vast heritage of Hellenistic civilization so long continued as a basic and determining factor in figurative art.

We can isolate three major cultural areas, distinguishable by the specific characteristics of their art: the provinces of North Africa, Mauretania and Africa Proconsularis (in modern terms, part of Morocco, Algeria, Tunisia and Tripolitania); Cyrenaica, linked administratively with Crete, and culturally with Greece and Alexandria; and, finally, Egypt. Each area could provide enough material for a separate chapter, especially since many of the chronological problems are still in debate; but, for reasons of space, we can examine only those features which were most typical of the various areas during the period of transition immediately before the Late Empire.

The provinces which Rome properly regarded as 'African' lay in those territories where for centuries Carthaginian civilization had developed: that is, to the west of Cyrenaica. They included Mauretania Caesariensis, Sitifensis and Byzacium (modern Algeria and Tunisia), where an original artistic culture evolved. The same area was marked by an intense spiritual life, the Christian communities here producing such men as Tertullian, Cyprian, Arnobius, Lactantius and Augustine. What distinguishes the writings of these men from those of the Alexandrian Christians (e.g. Clement, Origen, Dionysius or Athanasius) is a clearer understanding of the concrete problems faced by any Christian community, struggling to survive in provincial Imperial society.

African Christianity was popular and impassioned by nature; this quality is still discernible in the Acts of the Martyrs of Carthage (August 180), and the Passion of Perpetua and her companions (202–3). The African Church was probably founded from Rome (see Tertullian, *De Praescr.* 36), but its popular character saved it from those intellectual deviations which beset Marcion's gnosticism. In those provinces where the spiritual life went deepest, Christianity must have seemed a liberation from moral inferiority. Even Tertullian's adherence to Montanism is free from that quality of

215

prophetic exaltation with which the creed's founder, and his two prophetesses, had surrounded it in Phrygia. The announcement of the world's imminent end was accepted as a justification for rigorous austerity, for a polemic rejecting the whole idea of hierarchy (even if this meant attacking Rome), and a return to the primitive Church. Such characteristics (which were in complete accord with the innate seriousness and austerity of the North African peoples) find clear expression in both local portraiture and sculpture, where the pre-Roman, even pre-Punic, stratum of African civilization comes to the surface.

These territories formed a world apart, which had attained its unity through that network of fraternities on which the old Punic religion depended. Such a unity survived for a long time; it even outlasted the Roman occupation, which was inaugurated by the fall of Carthage (146 BC), and extended further westward under Augustus. It is not until Marcus Aurelius's reign, in the second half of the second century, that Latin replaces Punic as the language on ex-voto offerings, and that Graeco-Roman-type temples oust the old Punic sanctuaries. These temples added fresh glory to the often already splendid urban development of Roman cities such as Hadrumetum, Thugga, Timgad, Hippo Regius, Cuicul and Caesarea. The emergence of so many Christian communities, from the end of the second century on, may be regarded as a natural consequence of that moral opposition to the Empire which had previously flourished, over a long period, in *Punic* religious circles.

From the artistic viewpoint, the Punic substratum – and, even more, the purely indigenous Berber element – appears in the most modest works of sculpture (stelae and ex-voto offerings), and even influences certain details of this province's statuary. We see this clearly in the famous stele found at Siliana, and dedicated, by one Cuttinus, to Saturn – this being the name under which the Punic cult of Baal Hammon was pursued during the Roman period. At the top of the stele is an eagle, perched on a cartouche. The cartouche is supported by two Victories, each of whom holds a palm in her free hand; on it is inscribed the dedication to Saturn. In the lunette sits Saturn himself, on a bull, flanked by the Dioscuri, who are wearing Roman body-armour; underneath, on the dividing band, we have Cuttinus's dedication. The next strip down portrays Cuttinus himself, his wife, and his two daughters (?), who are carrying baskets; in the middle stands an altar, flanked by the two sacrificial animals, a large sheep and a bull. Two narrower strips at the bottom give a lively picture of work in the fields on the donor's estate (referred to in the dedication): ploughing, harvesting, and the removal of the garnered sheaves on three two-horse waggons. This stele, in view of its style, is generally dated to the Tetrarchy (late third century); but it is questionable whether stylistic criteria extrapolated from the development of official Roman art can be applied. What we have here is a special type of formal expression, which distorts all the traditional iconographic elements in order to achieve a cohesive artistic symmetry of its own. Heavy, squarish shapes are simplified in such a way that their subject-matter is self-evident, and rendered clearer still by symmetrical repetition, whether in the detail (folds in the drapery, corn-ears in the sheaves), or in the composition of the figures, and their gestures. Thus the artist achieves a decorative effect which is at least comparable to that of many primitive works of art.

216

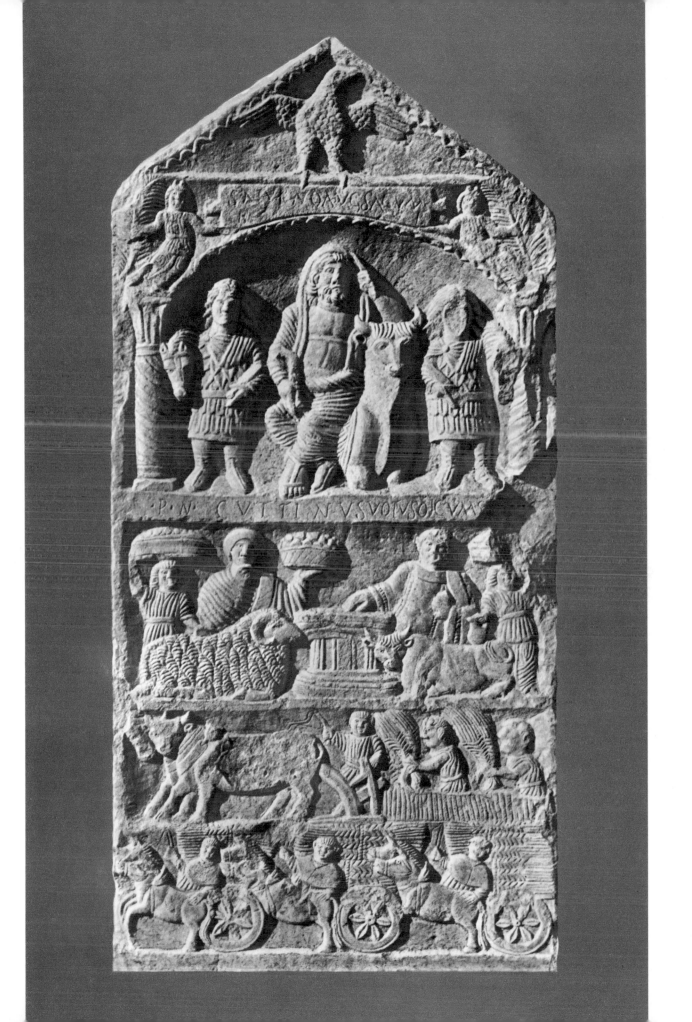

201 GHIRZA. FRIEZE ON A TOMB: HARVESTING SCENE (DETAIL). TRIPOLI MUSEUM

The clearest traces of the local substratum occur in the Tripolitanian hinterland, at Ghirza, the modern name for an important Roman military settlement, established – probably in the second half of the third century – some 150 miles south-east of Tripoli. Like other such posts, created as a defence against nomads, Ghirza was defended, not by Roman legionaries, but by levies raised in the frontier areas: the inscriptions bear purely local, Punico-Berber names. Outside the actual settlement, two extensive cemeteries have been found. The architectural-type funerary monuments (sometimes with a spire-pattern on top) are akin to similar constructions in the African provinces, where Graeco-Roman features blend with Punic ones, and formal patterns much like those' found in the Central European provinces. The originality of the Ghirza monuments lies in the decorated friezes with which some of them are adorned. These are framed in classical-style (though somewhat simplified) cornices; they show scenes of life in the fields, dromedary-caravans and hunting-expeditions, all vividly executed in flat, harsh relief-work. The figures have that immediately representative quality which characterizes all primitive art untouched by Hellenism. Though more coarsely executed, they reveal the same governing principles as emerge from the Siliana stele.

Even Ghirza's figurative sculptures (which come closer to Roman convention), and in particular the portraits – generally of great liveliness – are characterized by this tendency towards immediate, not to say brutal, expressiveness. Let us take the example of a certain citizen of Thugga (today Dougga in Tunisia), honoured with a statue in one of the three *cellae* of the temple of Saturn. (This temple was built in 195, in the lifetime of the Emperor Clodius Albinus, himself born at Hadrumetum, a coastal city in the same region.) The citizen thus singled out is clad in a toga, and must be performing a sacrificial libation. His turreted crown denotes his elevation – despite that rustic mien – to the rank of Genius and Protector of the town. What we have here is not – as in Europe

218

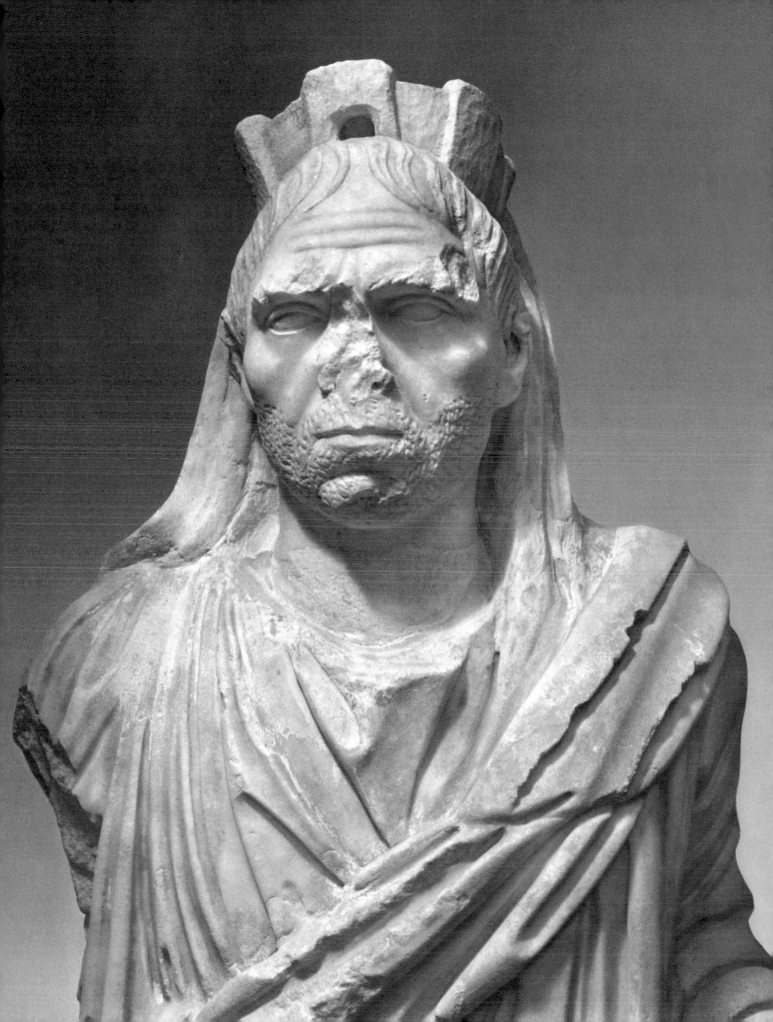

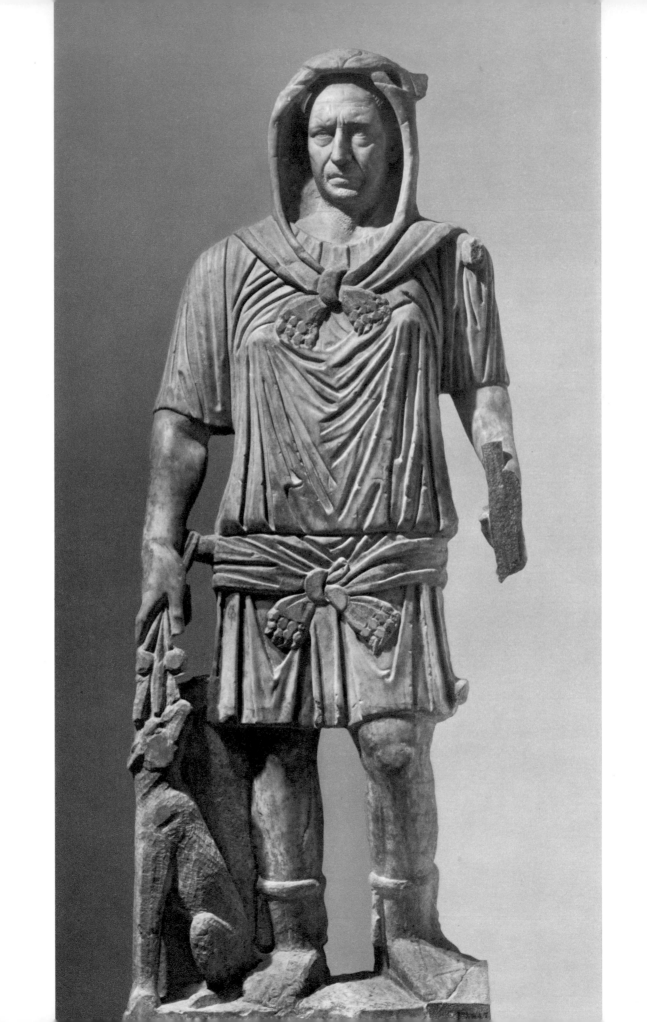

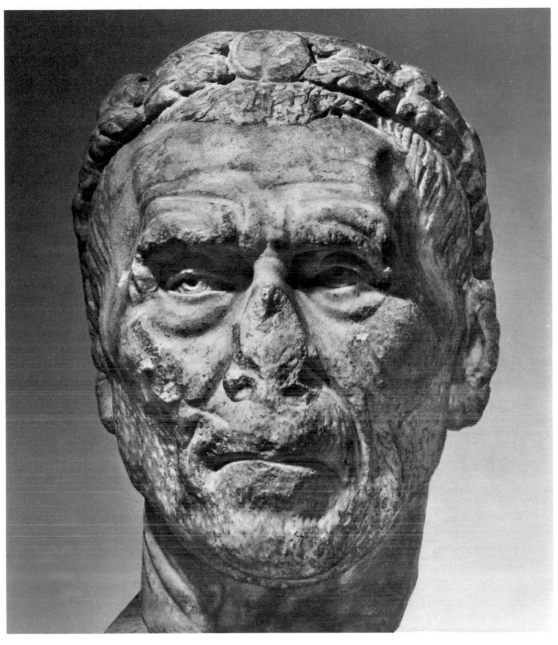

204 TUNIS. PORTRAIT OF A PRIEST. TUNIS, BARDO NATIONAL MUSEUM

– provincial art, bound up with Roman 'plebeian' art. This is artistic production on a high level, which has evolved its own style by utilizing iconographic elements from Roman official art: above all, those Hellenistic elements which circulated freely throughout the Mediterranean area. This style, wholly lacking in artifice or delicacy, concerns itself more with design than with tone, and tends to flatten out natural contours. These tendencies emerge clearly in the funerary statue of a man who is wearing a lion-skin (like Hercules), and holding some poppies in his right hand (sign of an initiate of the Mysteries). His body is no thicker than one on a bas-relief stele; only his head is carved fully in the round.

221

205 CARTHAGE. SARCOPHAGUS OF THE FOUR SEASONS. TUNIS, BARDO NATIONAL MUSEUM

The second portrait reproduced from this source (*pl. 204*) is a most remarkable one, which blends both Roman and Hellenistic features. It portrays a rough-looking man, with an unkempt beard: on his head he wears a priest's fillet, and his features are scored by age and experience. These portraits alone raise Africa Proconsularis to the first rank of Imperial Roman art, and reveal the degree of originality her artists attained during the third century (to which all examples shown may be assigned).

Later, nevertheless, echoes of Constantinian classicism very soon made themselves felt in Africa – as we can see from one sarcophagus in the Carthage necropolis. This shows the deceased, a woman, standing in front of an arras, with writing-scrolls beside her. Flanking this central figure are four youthful 'Spirits of the Seasons', ostensibly presenting their symbolic first-fruits, as in one of those harvesting scenes of which African art was so fond. The symbolism of the seasons is picked up by the baskets and garlands on the tall gabled lid – and is what makes this sarcophagus an original local variant on the stock types most commonly exported by Roman or Asiatic workshops.

It was with mosaic flooring that the artistic culture of Africa Proconsularis reached its height. A special mode of formal expression emerged, closely bound up with the mosaic-worker's technique. This was reinforced by an acute sense of colour, which found in the local varieties of marble and glass-paste a fine medium to express itself. In the third and fourth centuries, it seems, the entire Mediterranean basin witnessed a special efflorescence of painting, which virtually marks the beginning of the great pictorial civilization of Byzantium. Unfortunately the works themselves are lost, and the literary *testimonia* are vague and contradictory. One regrets the absence, for this period, of something like Pliny's encyclopedic notes (confusions and all), which at least made abundant use of Hellenistic art-criticism. Even so, there is sufficient literary evidence to confirm that pictorial art was now in a specially flourishing state.

As regards the mosaics, we have to make a sharp distinction between those produced in Byzacium or Mauretania (*Caesariensis* and *Sitifensis*), and those from Tripolitania. The latter centre remained more closely attached to Hellenistic exemplars, which probably came from Alexandria. In the other regions, however, especially in the third and fourth centuries, and even as late as the sixth, the mosaic takes on local characteristics both of style and of theme, often connected with the region's economic and social structure. The typical pattern is one of big agricultural estates (whether private or Imperial), with a few groups of smallholders, often time-expired legionaries, surviving among them. A document such as the inscription (*CIL* 8.18587) regulating irrigation in the Lamasba district, datable to the reign of Elagabalus, sheds light on the existence of this smallholding minority. But for the most part it was the large, or very large, estate that played a decisive role. As early as the first century, according to the Elder Pliny (*NH* 18.35), half the province of Africa was owned by no more than six landowners, whom Nero had executed for the sole purpose of acquiring their estates. A rescript of 422 reveals that a fifth of the entire territory was by then Imperial land. From our literary sources, it would appear that Egypt supplied Rome with grain for four months of the year, and Africa for the other eight. It has also been calculated that of Africa's total crop – well over 12,000,000 quintals – about one-quarter was sent to Rome. Other important products were sorghum and millet, and, above all, wine and olive-oil. The great estates developed their own pottery-works, specializing in lamps and crockery, mostly for export. Recent studies have shown that a large proportion of the ordinary earthenware crockery found in Rome and the Western Mediterranean, from the late first to the sixth centuries, came from African workshops.

One motif that regularly recurs on mosaic flooring in Africa, at every stage of its development, is that of the country-house itself. We begin with a view, in perspective, of some villa, and its surroundings, beside the sea (*pl. 206*): this is still very much akin to the Hellenistic-type landscape. We end with a quasi-didactic portrayal of life among the nobility in a château-like manor of the Late Empire (*pl. 208*). Here, on separate 'strips', we see husbandmen bringing offerings to the Big House, the hunter who supplies their lordships with game, and, at the bottom, the Lord and Lady in person: she has just risen from her basket-chair to attend to her toilet, while he is sitting down, and being presented with a document. In the second half of the fourth century, or soon after, we

206 VILLAS BY THE SEASIDE (DETAIL). TUNIS, BARDO NATIONAL MUSEUM

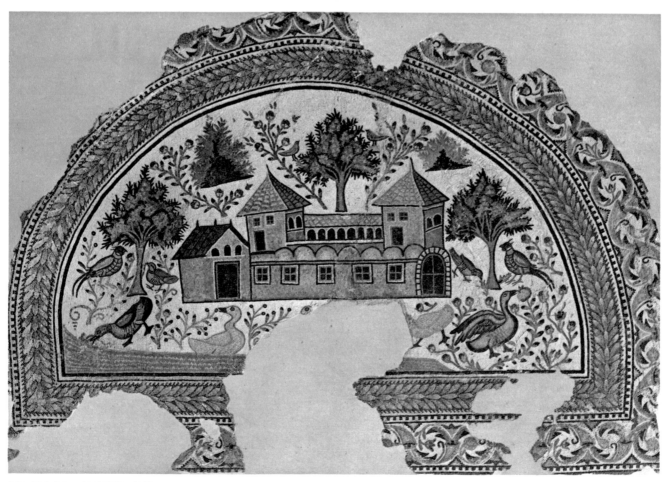

207 TABARKA. COUNTRY-HOUSE WITH TOWERS AND COLONNADE. TUNIS, BARDO NATIONAL MUSEUM

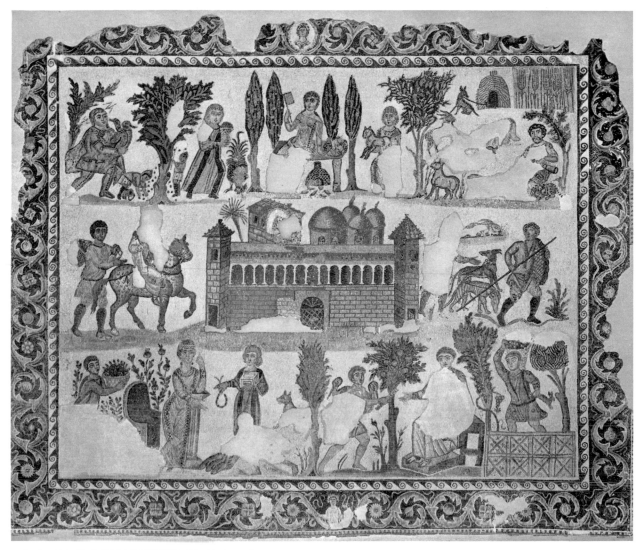

208 CARTHAGE. SCENES OF COUNTRY LIFE ROUND A LARGE VILLA. TUNIS, BARDO NATIONAL MUSEUM

have the representation of a big estate at Tabarka, with its colonnaded villa and twin towers. (Other mosaics in this group show the husbandmen's dwellings and the fields; these look almost like illustrations for a census-return.) Here, the garden has abandoned all semblance of naturalism. The trees and flowers, the pheasants, geese and quail are purely ornamental; and the composition as a whole is two-dimensional, like a tapestry.

Those mosaics which portray agricultural activities, hunting, or the breeding of horses (each called by its own name, names suggestive of ambition or love) are similarly influenced by their local environment. Here we need only recall the famous mosaic from a villa in Carthage (the villa, in fact, was named after it) on which are portrayed over eighty race-horses, each of them with its name, belonging to a variety of owners; and that other one from a house in Hadrumetum (Sousse), with four horses decked out in the colours of the Circus factions (*pl. 209*).

Mythological scenes, elsewhere the most prominent of all, are by no means entirely absent. Since the coastal towns of Africa lived off the sea, the preference shown is for processional scenes involving Amphitrite or the Marine Venus. One mosaic portraying

225

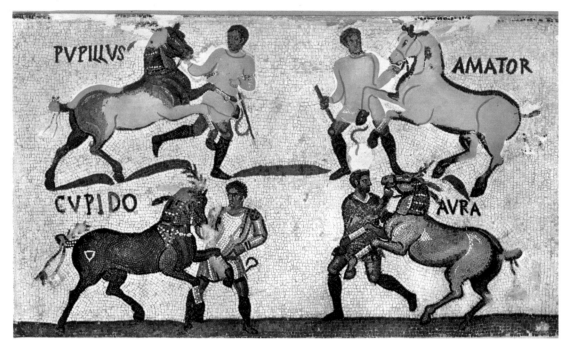

209 SOUSSE. HORSES AND GROOMS. SOUSSE MUSEUM

a marine *thiasos* is signed, in Greek, by a certain Aspasios – which indicates the presence (in the first and second centuries) of craftsmen working in the Greek tradition. The numerous versions of the Marine Venus enable us to trace their evolution from Hadrian's day. At this early stage they have bright, clear colouring, a sense of perspective, a leaning towards grace and elegance – all based on Graeco-Roman prototypes. But after a while the patterns become frozen in a kind of heraldic symmetry.

More often local taste expresses itself in a passion for baroque (or sometimes merely brutalized) varieties of form, exaggerating the deformities of the sea-monsters that are holding the goddess or raising waves about her: such occasions are an excuse for the boldest polychromatic experiments. Oddly, and despite African strictness in religious matters, these representations of Venus do not cease with the advent of Christianity (cf. the central hall of the baths at Setif, probably datable to the late fourth century). Similar representations, again from the Christian era, occur on silverware.

These late works do not give the impression of being fully rounded compositions, the product of one artist's single and coherent vision. Rather they resemble 'cartoons', put together from a number of separate stock figures, often with the minimum of adaptation. Technically, the teams that produced them were highly skilled. They show signs of personal interpretation in both their design and their colouring – an extraordinary richness, a variety of ornamental motifs, some geometrical, others inspired by plant-life. The emergence of an individual 'African' style, however, must be sought in those mosaics which deal with local subjects. From here it spread to those with mythological themes (mostly of a marine nature), thus giving them a character of their own.

These 'cartoons' of mythological scenes could, in the first instance, have come from other artistic centres. There are certain cases, indeed, where we can legitimately deduce that they originated in one of the centres of Eastern Hellenism (or, more rarely, in Rome); the local craftsmen would then need only to adapt them to the buildings they

226

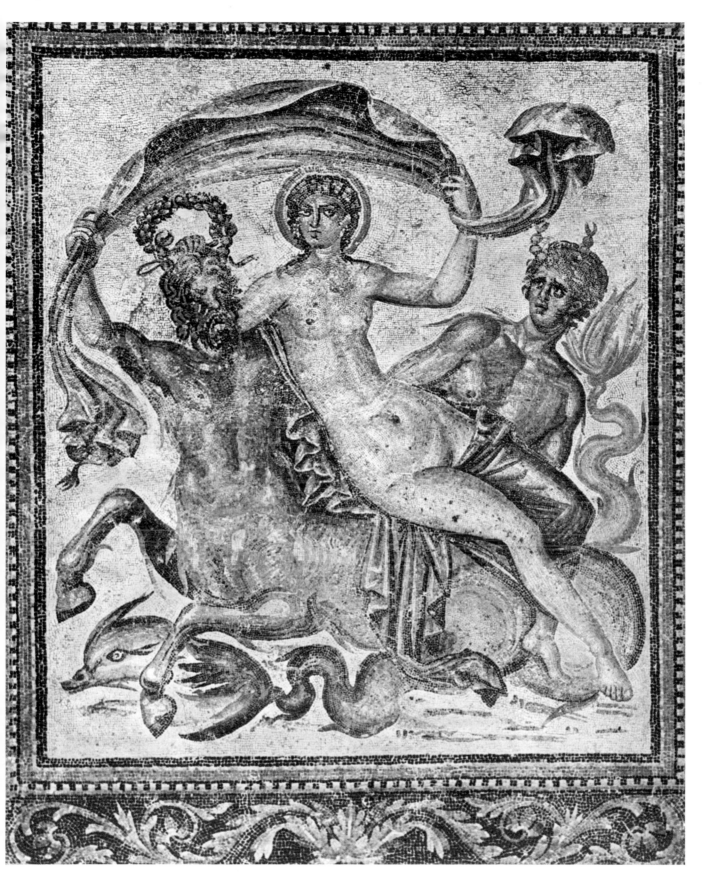

210 TIMGAD. MARINE VENUS. TIMGAD MUSEUM

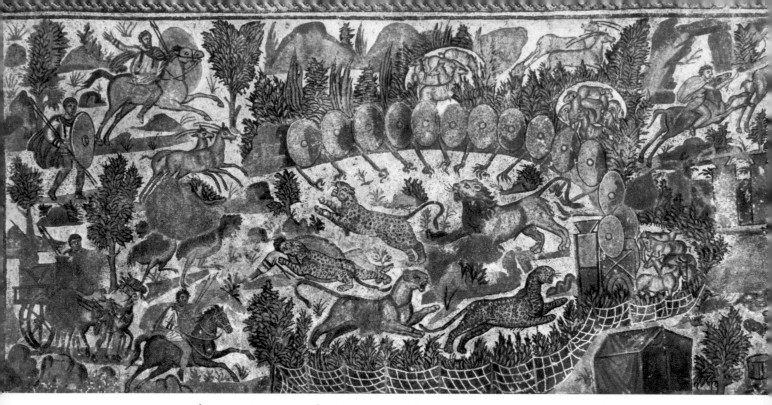

211 BÔNE. WILD-BEAST HUNT. BÔNE MUSEUM

were decorating, and otherwise execute them as they stood. But as regards those scenes
that are more closely linked to their African environment, we must undoubtedly posit
the creation of original cartoons, by artists working on the spot – and in direct contact
with the mosaic-workers, who were highly skilled craftsmen. One need only cite such
compositions as the antelope and ostrich hunt from Kef, the lion and panther hunt from
Hippo Regius, the scenes of country-house life (Tabarka), or the cliff-landscape – in
a mosaic also decorated with medallions of racehorses – from Sorothus, near Sousse
(destroyed in 1943 during a bombardment). Furthermore, there are definite differences
between the various African workshops: the vigorous representationalism of the coastal
centres, for instance, sets them apart from those of the interior. These African work-
shops undoubtedly form a single stylistic entity, with its own variants and ramifications
even beyond the frontiers of Africa: in Sicily, Spain, southern Gaul, as far afield as
Aquileia, perhaps in the Eastern Mediterranean.

This chapter in the history of Roman art has only recently been recognized as an
autonomous unit. The detailed studies necessary to treat it fully are not yet available;
but I can at least note down its more specific characteristics. The most important is the
conception and execution of large mosaic floors decorated with unitary compositions.
As we shall see, the centres of the Eastern Mediterranean long retained (at least up to
Constantine's day) the practice of imitating small painted pictures in mosaic, and of
inserting these, as independent compositions, into an overall decorative pattern based
on geometrical motifs. In African mosaics, however, we can observe the development of
compositions that fill an entire section of flooring with one single scene – which pre-
supposes the existence of original cartoons. From now on mosaic art develops in its
own right, not as a variant of painting. Until the mid-third century, it is true, we still
find a subtlety of chromatic gradation and a use of chiaroscuro which both derive from

228

painting; but nevertheless, a new language is being worked out, more in keeping with the actual technique of mosaic composition.

These features, unitary composition in flooring decoration and independence of painted models, had already appeared at Rome in the black-on-white-ground mosaics that enjoyed their greatest success during the second century, in those areas most directly influenced by Roman craftsmanship. Ostia provides magnificent examples: the flooring of the great domed hall in the Baths of the Seven Sages (*c.* 130), and that in the House of Bacchus and Ariadne (also datable to Hadrian's reign). In the third century, black-and-white mosaics give way to coloured ones. In Africa, black-and-white flooring in the Roman manner was used as early as the second century, and brought with it a taste for unitary compositions; but it did not really catch on, and was soon ousted by the unitary polychrome mosaic. At Rome, meanwhile, mosaic art marked time, and simply went on repeating itself.

From the present state of our knowledge, it would seem that the unitary composition in mosaic flooring (which enjoyed a marvellous efflorescence in the Byzantine era) first appeared – certainly in its most typical form, that of a large coloured carpet – in Africa: Antioch has no examples before the reign of Constantine. Recent studies use these facts to support the theory that the evolution of the Late Empire style, and hence of early Byzantium, was modified by the influence which the West – in particular the African provinces – supposedly exercised over the Eastern half of the Empire. This thesis runs flat counter to the traditional view, which sees the preponderant influence in Late Antiquity as being that of the East. That this traditional view must now be abandoned I would agree; one of my aims in this book is to demonstrate that Rome, and the Western provinces, detached themselves from the old classico-Hellenistic tradition rather more quickly than did the Eastern provinces. On the other hand, I do not believe we should allow any influence by the Western on the Eastern half of the Empire as regards formal development. To do so would be, from the historical viewpoint, to oversimplify. What we have to realize is that classico-Hellenistic form, in all its cohesive and elegant naturalism, was something bound up with the minority elite of one particular society, and its quite exceptional rationalist culture. The formal expression embodying this attitude inevitably underwent a radical transformation as soon as the cultural assumptions of the civilization which had given rise to it were overthrown. Each cultural area was then obliged to seek its own solutions to the problem. In this quest, Africa (within the geographical limitations here laid down, and working from what was still an essentially Hellenistic basis) showed more freedom and originality over the solutions it proposed than did any other Mediterranean province. One cannot exclude the possibility that the discovery of 'unitary design' for mosaic flooring (applied with such splendid results in the homes of the African nobility) was responsible for the centres of the Eastern Mediterranean, such as Antioch, adopting the same idea. But I do not think one can go beyond that, and I have found no instances of African cartoons being employed in the Eastern half of the Empire – let us say anywhere east of Leptis Magna.

At the beginning of the second century, African mosaic floorings are still conceived in terms of a decorative geometrical pattern, within which are set small pictures of various sizes, imitations of Hellenistic paintings on mythological themes. The central

213 DOUGGA. PIRATES METAMORPHOSED INTO DOLPHINS BY DIONYSUS. TUNIS, BARDO NATIONAL MUSEUM

scene in one such mosaic, from Hadrumetum (Sousse), composed of large medallions ringed with interwoven lines and separated by lozenges, represents Achilles at the court of King Lycomedes. Hearing the trumpet sounded by one of Odysseus's companions, Achilles springs to arms, thus spreading panic among the King's daughters. Although this composition has no specific features in common with one that appears in Nero's Golden House at Rome (*Rome: The Centre of Power, pl. 145*), it belongs to the same type, with the figure of the hero in the middle, and the other characters ranged symmetrically around him. In Pompeii, before the year 79, the same subject had been tackled at least twice in direct imitation of classical Greek painting, and over a dozen times with variations, but still sticking to Hellenistic taste. This African version is not much different.

During Gallienus's reign, i.e. about 250–65, the town of Thugga was elevated to colonial status, and underwent considerable urban development. There is one house there whose fittings can, fairly certainly, be dated to this period: it is laid out about a colonnaded courtyard, with fountain-basins in the middle, and round them mosaic paving, with scenes of maritime adventure. Here we see an episode from the legend of Odysseus and the Sirens, and another Homeric myth: Dionysus and the Tyrrhenian pirates who were changed into dolphins. Dionysus (whose head has been restored) brandishes his lance at a pirate who has just jumped from the vessel; the upper part of the pirate's body has already assumed dolphin form, while his still-human legs are being attacked by a leopard. This detail recalls the description of a painting on the same theme which we find in Philostratus the Elder's *Imagines* (1.18). This third-century writer, as an exercise in rhetorical style, describes a series of paintings which, he tells us, he saw in Naples. Despite the literary *genre* employed, we can take it that actual paintings provided a basis for his descriptions. We may, further, imagine them as being very like this representation in mosaic – which, indeed, is more literary than realistic in feeling. The isolated figures still have a Hellenistic quality, but the utilization of space is perfectly conventional and non-realistic: the various fish which fill up the background have no organic connection with the scene. Even if the mosaic still betrays a pictorial origin, and even though it was fitted (as an independent panel) into the general scheme of the paving, it represents that *dissociated* type of composition which comes to characterize third-century art. A few comments will suffice to clarify the way in which this process evolved.

231

214 SOUSSE, HOUSE OF THE TRIUMPH OF DIONYSUS. COMPOSITION: ANIMALS, FLOWERS AND STILL-LIFES. SOUSSE MUSEUM

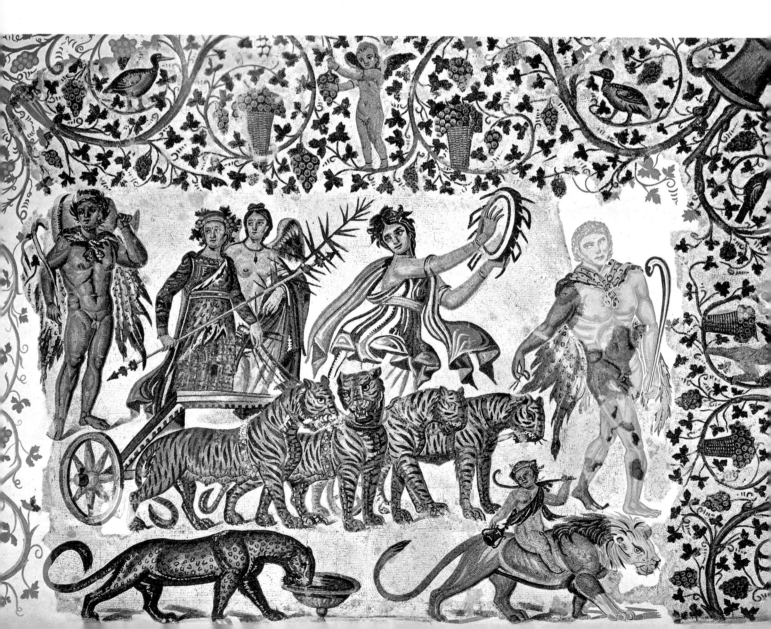

In the mosaic flooring of the House of Bacchus and Ariadne (Ostia) already mentioned, there is a small picture portraying the struggle between Eros and Pan. This was originally designed to stand on its own; here it has been framed in an elaborate leaf-and-branch border. The result is a piece of flooring with unitary composition. The same is true of the mosaic in a house at Hadrumetum (Sousse) portraying the triumph of Dionysus; but here, since the inset-picture is in colour, its transformation – from an individual work of art to one element in a unitary design – becomes more noticeable. The original model was a picture, and traces of its spatial perspective still survive in the figures of the two satyrs. One of them (the badly damaged restoration) is walking ahead of the chariot and its team of four tigers, while the other follows behind – at a slightly higher level, to give a truer sense of perspective. The perspective diagonal, in fact, passes through them. Another indication of perspective is the trace of projected shadow sketched in at the feet of the satyr and the tigers. But in the process of transition between an older cartoon and this mosaic, the sense of perspective was lost; it no longer formed part of the mosaic-worker's heritage. This is even more evident in the cymbal-clashing Maenad, who should have been placed in front of the chariot, and now looks too big because she has simply been transferred to a less suitable position. On the other hand, the mosaic artist is very much at ease with his leaf-and-branch border, which is full of birds and grape-harvesting Amorini. This border, with its wealth of colour and delicate detail, is in perfect harmony, because it does not run counter to the artist's natural taste – which from now on jibs at naturalistic perspective. The frieze, in fact, is completely successful on its own terms, as a two-dimensional essay in abstract-style decoration.

In trying to date this mosaic, scholars have compared its Triumph of Dionysus with that of Septimius Severus on the Leptis arch. But at Leptis we find no contradictory tendencies in the overall concept, which is a coherent whole, created by an artist of quality. In the mosaic, however, we have an adaptation of some earlier model, made to suit a quite different type of artistic sensibility. Since we are concerned with a joint workshop project, this use of an older, well-known model should perhaps be assigned to a period somewhat after the very beginning of the third century (the Leptis arch date).

If we accept this slightly later dating, then we can also provide a more convincing context for another work in the same house. This is the mosaic from the semi-circular exedra in the hall of columns (*oecus*), which constitutes a typical example of 'scattered-element' composition, the objects portrayed being spread in apparent disorder over a blank background. Here we have a remote descendant of that 'unswept floor' motif (*asarotos oikos*) which was a speciality of Sosos, the Hellenistic painter from Pergamum. But in this case the syntax of composition is different. What we have here is the type of decoration that will lead, a hundred years later, in the mid-fourth century, to the mosaics on the vaulting of S. Costanza in Rome. The figures scattered about this composition all still preserve a trace of projected shadow – something which thereafter disappears. The millet-stems framing the composition, the gazelle in the middle, and the baskets of raisins and figs give the material a local character; but the overall concept is undoubtedly linked with those compositions portraying still-life subjects (or gifts to guests, *xenia*), which were so characteristic of Hellenistic and Graeco-Roman painting. We see, then,

233

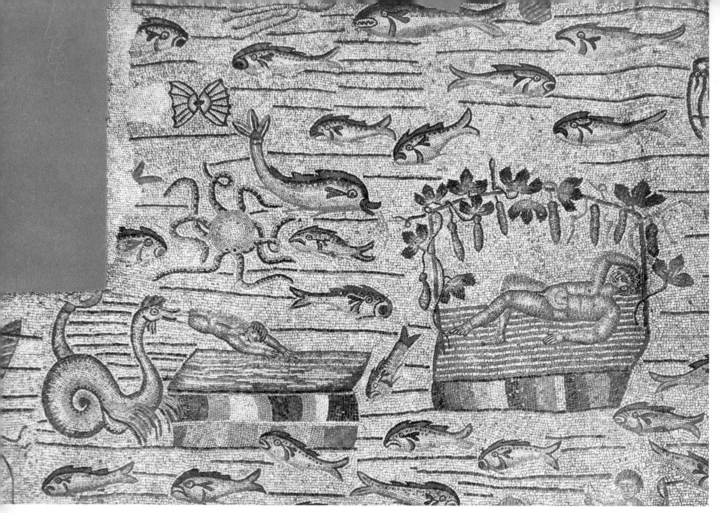

216 AQUILEIA, BASILICA OF BISHOP THEODORUS. THE STORY OF JONAH (DETAIL)

how African mosaics assimilated earlier pictorial models: the latter circulated, in the guise of cartoons for mosaics, to every art-centre of the Mediterranean. The result was a firm basis, common to the entire Empire, for figurative processes in art.

In the lobby of the same building which contained the exedra with the gazelle, there was another mosaic, similarly bordered with millet-stalks. This shows two fishing-boats, and their occupants, sailing across a fish-filled sea; it is not so much a fishing scene as a catalogue of fishes, for which parallels can be found in didactic literature. This type of picture is widespread in Africa, and the catalogue of fishes is a theme which goes back to the Hellenistic era. Here, however, we have a special form of stylization for the sea, which is rendered by a number of small, undulating, horizontal lines, set parallel to one another – a typical feature of African mosaics from the beginning of the third century. This sea constitutes a uniform surface, upon which the fishes are super-imposed without any attempt to achieve an effect of transparency. The Hellenistic pursuit of pictorial impressionism (with a tendency towards the realistic) has been abandoned in favour of a convention which gives figures an almost heraldic (or didactic) quality. We find a similar convention employed at Aquileia, on the flooring of Bishop Theodorus's basilica (308–19), which includes an illustration of Jonah reclining beneath his gourd.

234

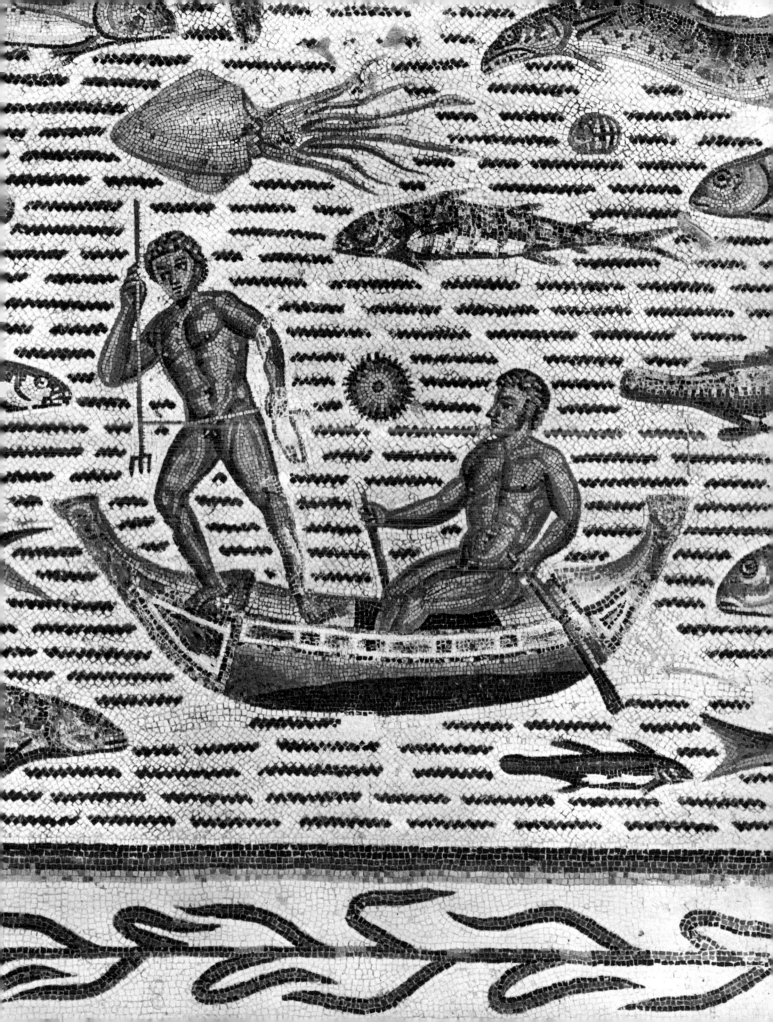

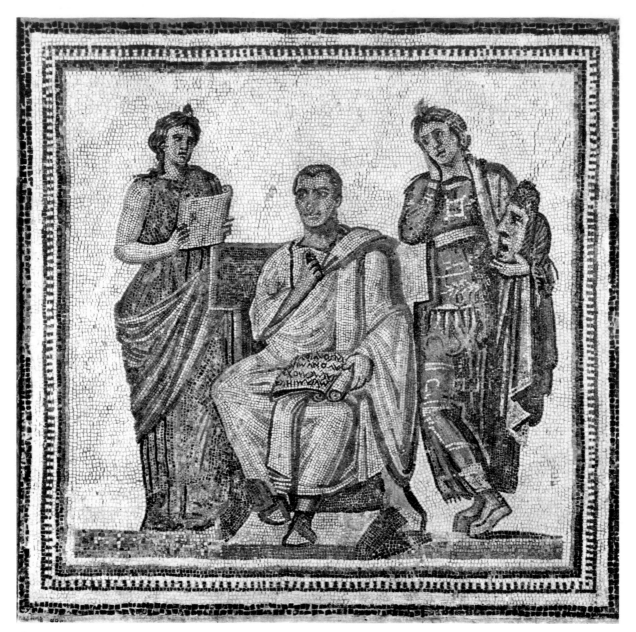

218 SOUSSE, HOUSE OF VIRGIL. THE POET VIRGIL BETWEEN CLIO AND MELPOMENE. TUNIS, BARDO NATIONAL MUSEUM

Also from Hadrumetum (but in a group of rooms lying a little south of the others, and separated from them by an unbroken wall such as normally runs between two different houses) there comes that famous panel with a portrait of Virgil between the Muses of History and Tragedy. The poet can be identified by the words written on the roll he holds in his lap – *Musa mihi causas memora quo numine laeso,* the eighth line of the *Aeneid.* This gives us some hint as to the lively cultural interests of third-century African society. Scholars have assigned this work to the end of the Severan era; but in view of the surrounding border (very like the blue-and-red type of border which encloses the illustrations in our oldest *codices*), I would favour a date nearer the middle of the century (some people even propose the *fourth* century). The transition from roll to *codex* – that is, to the book as we know it – took place just about the middle of the third century.

236

The presence of talented local artists in the African mosaic-workshops is well attested, for the third and fourth centuries, even without reference to our major surviving compositions. Among the latter we may cite a mosaic floor from Tipasa, a coastal town to the east of Caesarea (*pl. 219, 220*). This displays geometrical motifs (*peltae*, or Thracian half-moon shields, arranged in a cruciform pattern, and vertically aligned squares); at the centre there is a picture of a group of prisoners, while smaller pictures show us a number of heads – again, no doubt, portraits of prisoners. This type of geometrical-design flooring is very common in Rome during the period 250–350 (Ostia, 'Casa del Protiron', and house in Reg. IV, *Ins.* 3, 4). In the European provinces, barbarian prisoners are conventionally portrayed, after the manner of the Pergamum school: there is seldom any attempt at ethnic realism, except perhaps in high-quality works such as those of Trajan's Column. Yet here – and not only in the central group, but in each of the smaller heads – we have a magnificent series of Berber portraits, all executed with the same vigorous characterization that we find in commemorative marble busts of the third century (to which period this flooring, too, must be assigned).

Another specimen of geometrical-design mosaic flooring with portrait-insets (datable, in view of the building's internal development, to the end of the Constantinian era) comes from Djebel Oust, a watering-place between Uthina and Thuburbo Maius in Tunisia (*pl. 221, 222*). The portrait-insets show the busts of the four Seasons: these diverge considerably from the iconographic formulae in use at Rome, and in regions with a Hellenistic tradition. These Seasons possess physical characteristics of an unmistakably indigenous type, and in fact look like local society ladies. Despite the influx of Italian veterans, and the presence of a top-level Imperial bureaucracy which had nothing African about it, the vast bulk of the population was either Punic or Berber.

One particularly important type of motif is that in which the flooring is decorated with a series of medallions formed from wreaths or garlands, each containing a human portrait-bust or animal head, with leaf-and-branch patterns filling up the spaces in between. This type of mosaic is highly practical for covering vast surfaces, of any shape whatsoever; which is why it was so popular with ancient craftsmen. A very simple version of it, where the leaf pattern contains one row of leaves only, can be seen in a floor area at Chott Maria (Sousse), probably of the late third century. A more complex fourth-century example (*pl. 223*) is that of Henchir el-Kasbat (Thuburbo Maius).

The great peristyle of the villa at Piazza Armerina in Sicily (*pl. 224f*) has its flooring decorated according to the same scheme; but the wreaths of foliage get rather heavier treatment, and the heads – all of animals – are distorted in a quasi-heraldic manner. Scholars now agree that the mosaics in this magnificent villa were executed by African workshops, and in particular by those associated with the great sea-ports of Carthage, Hippo Regius and Caesarea. The date of these mosaics, however (like the identity of the villa's owner), is still very much in debate. Of the various hypotheses advanced, I still favour that which assigns the mosaics – apart from a few small and obviously late bits – to a period between 320 and 360, with the flooring being gradually laid down over about forty years. With its more than 3,500 square yards of mosaics, the villa at Piazza Armerina constitutes the most remarkable and comprehensive piece of evidence in existence for African mosaic art during the Late Empire.

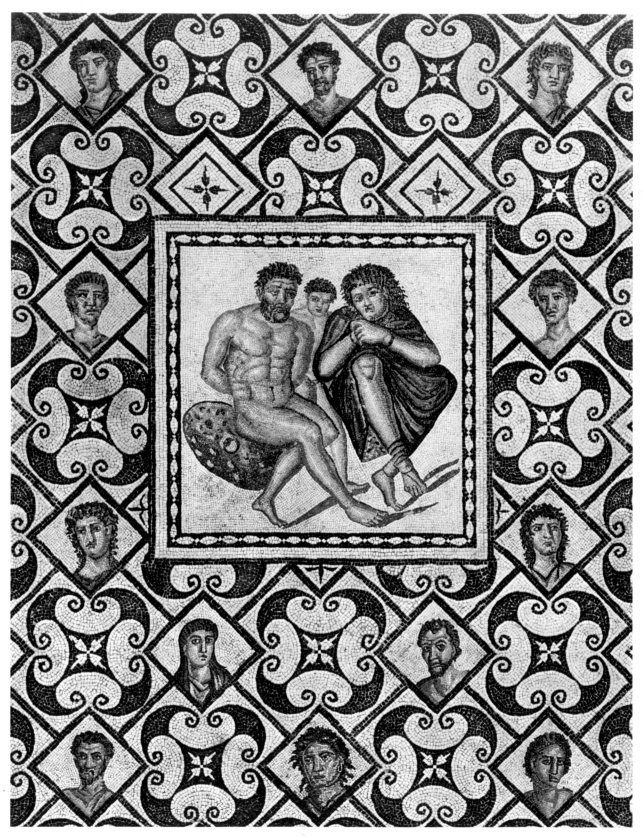

219 TIPASA. BERBER PRISONERS: OTHER PORTRAITS IN THE BORDER. TIPASA MUSEUM

238

220 TIPASA. HEAD OF A PRISONER (DETAIL). TIPASA MUSEUM ▶

221 DJEBEL OUST, ROMAN BATHS. THE FOUR SEASONS

240

223 HENCHIR EL-KASBAT, HOUSE OF THE ANIMALS. ANIMALS IN FOLIAGE-BORDERED MEDALLIONS (DETAIL) ▶

222 DJEBEL OUST, ROMAN BATHS. PORTRAIT-BUST OF A SEASON: SUMMER

224 PIAZZA ARMERINA, ROMAN VILLA. THE GREAT COURT (DETAIL)

225 PIAZZA ARMERINA, ROMAN VILLA. THE GREAT COURT (DETAIL): LION'S HEAD

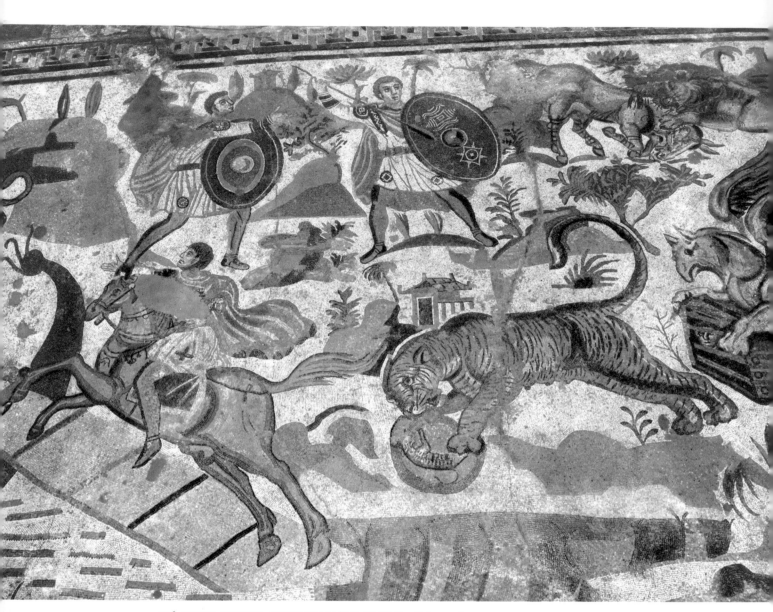

226 PIAZZA ARMERINA, ROMAN VILLA: 'THE GREAT HUNT' (DETAIL)

The Great Hunt, which adorns a long, narrow room terminating in two exedrae, forms a kind of narthex in front of the main basilical hall. This mosaic is loaded with purely African motifs; its dimensions (58.30 m. by 3.90 m.) make it a spectacular example of the advantages to be gained from vertical composition with juxtaposed elements. Its narrative possibilities are limitless, since they permit the constant insertion of different representations in varying formats, without disturbing the overall effects.

The Little Hunt (*pl. 199*) is of higher quality, and more picturesque and coherent as a composition. It offers a realistic picture of life as led by the nobility, and has an extraordinary sense of landscape (despite that division into 'strips' which is typical of fourth-century African mosaics dealing with this kind of scene). The most exact counter-

244

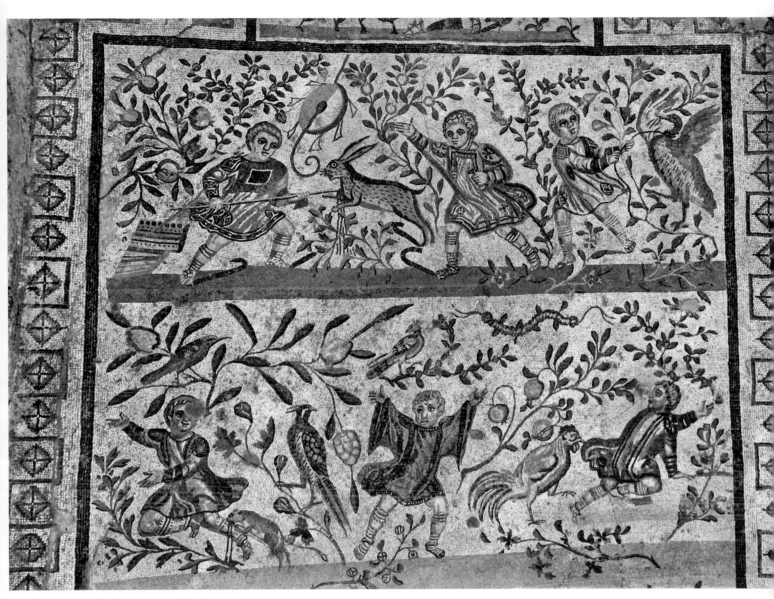

227 PIAZZA ARMERINA, ROMAN VILLA. CHILDREN HUNTING (DETAIL)

part which Africa can provide to Piazza Armerina is that of the mosaics from the House of the Horses in Carthage. The resemblance applies not only to the parts decorated with medallions (once again with the Four Seasons inserted), but to much less common motifs as well. Among the latter is a frieze of children running along, chasing birds and small quadrupeds through a mass of leaf-and-branch decoration, irregularly arranged so as to fill up the blank spaces in the white background. Identical versions are known from Carthage and Piazza Armerina. The motif looks as if it might have been copied from one stencilled on material: examples of this technique have been preserved in Egypt. Furthermore, the medallion motif also turns up on material, and one cannot tell, in this case, whether material or mosaic should have the credit for employing it first.

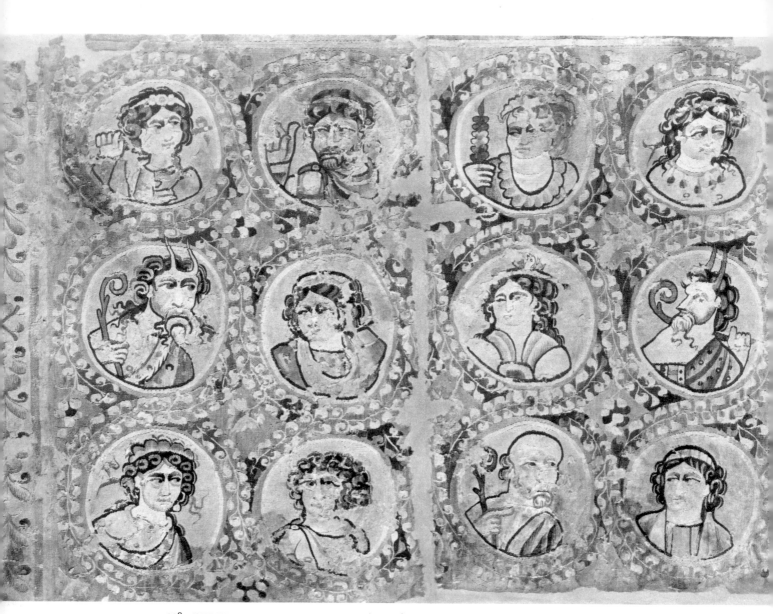

228 ANTINOE. TAPESTRY WITH MEDALLIONS (DETAIL). NEW YORK, METROPOLITAN MUSEUM OF ART

It is less easy to classify the compositions which decorate another room in the Piazza Armerina villa – a three-apsed chamber with a large oval courtyard outside it, undoubtedly designed for formal receptions. Some scenes represent the exploits of Hercules: these are executed in a grandiose baroque style, violent almost to the point of barbarity. The most plausible theory so far advanced is that of Carandini (1964), who suggested that the actual motifs derived from Pergamum, but had reached their final form by way of an African cartoon. Here, as so often, it is pointless to posit the existence of a 'maestro' when there are no comparable works to assign to the same hand. We must also take into account the way in which such works were actually produced: that is, by the transmission of models (often very ancient), which circulated among a large number of flourishing workshop-studios. What we can, once again, deduce is that during the third and fourth centuries the schools of painting in the Mediterranean went through a

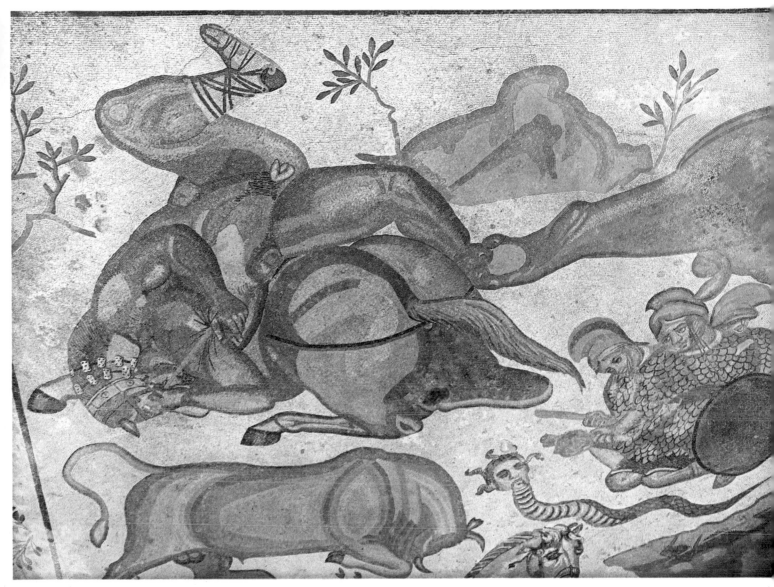

229 PIAZZA ARMERINA, ROMAN VILLA: THREE-APSED CHAMBER. THE EXPLOITS OF HERCULES (DETAIL)

period of intense activity. The old-style Hellenistic models, which no longer satisfied the new formal sensibility emerging throughout the Empire, were thoroughly rejuvenated. The resultant paintings were used to provide cartoons for numerous mosaics. The latter (with very few exceptions), though the product of high-quality craftsmanship, are not original works created by noteworthy artists. Only later, from the end of the fourth century, when wall-mosaics begin to replace paintings, do we find mosaics that are attributable to an individual artist. The flooring which adorned the villas of the nobility was executed by craftsmen hired on a day-to-day basis, and working to the pattern chosen by their employer. Skilled though they were, their vision remained limited. It is an entirely different matter when we turn to the works created for Byzantine churches. These were designed to last a long time, and greater resources went into their execution. The artists who obtained such commissions had much stronger personalities; their

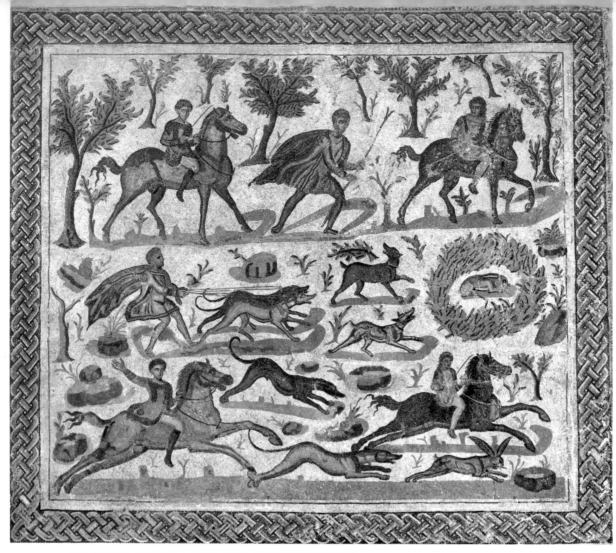

230 EL-DJEM. COURSING A HARE. TUNIS, BARDO NATIONAL MUSEUM

employer would indicate a theme to them, which they would then work out in elaborate detail.

There are one or two further mosaics in Tunisia and Algeria to which we must now turn. The first comes from Thysdrus (El-Djem), in the hinterland of the east coast. It shows huntsmen coursing a hare, and is structurally very close to the *Great Hunt* at Piazza Armerina, though perhaps earlier in date (mid-third century rather than the close of the Severan era). The division into three strips is already there, though the line of the ground and the projected shadows are more strongly marked than at Piazza Armerina. The scene has an airy quality, and retains more than a touch of naturalism.

If we are looking for vertical composition – from now on wholly freed from naturalistic axioms, and governed by altogether new canons of style – we find an example of it in a hunting mosaic from Cuicul (Djemila, in Algeria), which Lavin dated to between 315 and 330. The taste which this composition reveals is precisely that which we find on ivory diptychs of the late fourth and early fifth centuries (manufactured in the West as well as at Constantinople). A date nearly a century earlier would be very remarkable: its implication being that the African West had played a decisive part in forming the

248

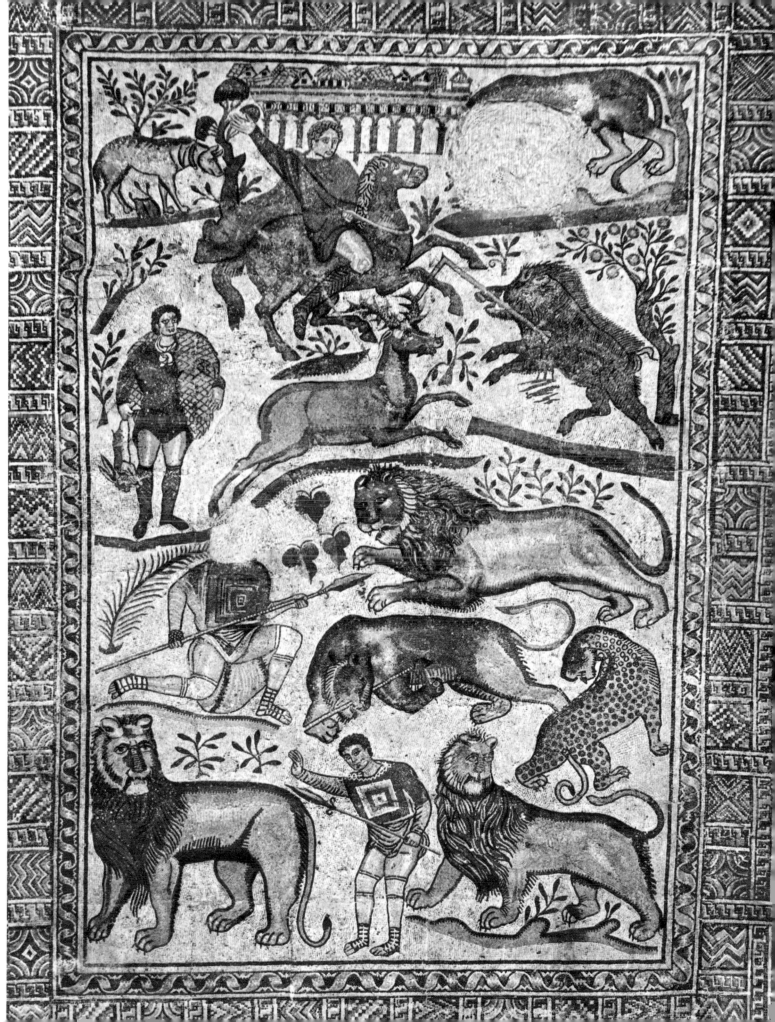

232 CARTHAGE. COUNTRY SANCTUARY OF DIANA AND APOLLO (DETAIL). TUNIS, BARDO NATIONAL MUSEUM

post-antique style. In the Cuicul mosaic, the horseman at the top is still foreshortened – the habit of observing perspective dies hard – and still falls into the classic pattern of the victorious warrior. But all the rest is composed according to a new decorative rhythm. It looks as though the cartoon were an original piece for which the African mosaic-workers were responsible. However, research carried out by Février (1965), based on the stages of the building's construction, makes it clear that this mosaic could not have been installed before the end of the fourth or the beginning of the fifth century; a still later date is also possible. In this case, the African *ateliers* would no longer have any priority.

For contrast, we should look at a hunting scene with a small temple of Diana and Apollo in the middle, which comes from Carthage, can be dated to the mid-fourth century, and is constructed with an absolute rigour of line. Here we have a reflection of the new style evolving at Constantinople. Its roots lay in Constantinian classicism, and in that (initially decorative) taste which reduced every shape to an abstract, indefinitely repeatable formula, with all figures shown full-face against a neutral background. In the central section of this mosaic, the hunting scenes still preserve echoes of earlier compositions, but are frozen into stylized gestures – which make up in decorative value for what they have lost in realism. In the upper level the huntsmen are lined up as for some ceremony. They have deposited their offering, a crane, outside the little shrine; the abstract manner in which they are portrayed renders them indistinguishable from the images of the gods shown inside the sanctuary. The figures lined up in front of a cypress-hedge already possess the same formal value as we find in the early-sixth-century figures of the Apostles (separated by palm-trees) in the Arian baptistry at Ravenna. It is clear, then, that the original, independent African mosaic was at its height between the beginning of the third and the middle of the fourth century. Before this period, the influence of

250

233 GAFSA. CIRCUS-SCENE AND SPECTATORS (DETAIL). TUNIS, BARDO NATIONAL MUSEUM

Hellenistic motifs can still be detected; after it, the West is invaded by motifs from Constantinople that herald the advent of Byzantine art.

The Imperial *vicarius* L. Domitius Alexander revolted against Maxentius, and set up an independent African kingdom; this, however, came to an end with Alexander's defeat in 310 or 311. There followed a pitiless wave of murder and destruction, of which the main victims were those great landowners who had supported the usurper – and, in particular, the city of Carthage. As a result, the country's resentment against Maxentius was such that after the battle of the Milvian Bridge Constantine sent his defeated rival's head to Africa. In any case, there must have been a hiatus in the construction of great country houses for the African nobility. Further disturbances broke out with the rebellion of a local prince, Firmus, in 370 (quelled two years later by the father of the Emperor Theodosius), and again in 397–8 under Firmus's brother Gildon. Finally, Boniface, *comes* of Africa, not only seceded from the central government (probably in 429), but also sought aid from the Vandals. The latter emigrated *en masse* and occupied the entire province, bringing about the permanent separation of these territories from Rome, but not their general decline. After the Vandals had been driven out, Africa's artistic culture came under the domination of Byzantium: yet it displayed an extraordinary vitality right up to the end of the sixth century.

One of the last large-scale mosaics is that from Gafsa, in Tunisia, which portrays a circus-scene. By now the medallion-border motif has completed its evolution, and clearly belongs to a different artistic civilization. The scene portraying a chariot-race round the *spina* has rediscovered the artlessness of primitive narration. Particularly revealing is the technique employed to represent the spectators, crowded under the arches which enclose the tiers of the amphitheatre. The effect is obtained by aligning their heads in an

endlessly repeated frontal pattern, with only minor variations of beard, hair-style and facial angle, and scarcely any recourse to polychromy.

After this period, mosaics are no longer employed except as decorations for tombs and basilicas (the Christian necropolis of Tabarka, the basilica of Sidi Abich near Enfidaville, with an inscription of Bishop Paul of Mauretania, etc.), and are invariably of small dimensions.

To conclude this chapter on African art, let us consider a series of mosaics which must be reckoned among the finest works of art produced during the period under discussion, and not merely in Africa: the mosaics of agricultural life found at Caesarea (Cherchell), former capital of the kingdom of Numidia. When Juba II was set up as ruler over this region by Augustus, he transformed Caesarea into a museum of classical art.

These mosaics were discovered in 1925, and are only fragments of a larger whole. The largest is 5.50 m. high by 3.60 m. wide. It is framed in a plant-life border of unusual design, made out of thick, twining stems with a bright-coloured flower in each loop, and highlighted by touches of white. The mosaic itself is divided into four scenes, which, unusually, have no borders between them, but are set in direct juxtaposition. The two upper scenes, of ploughing and sowing respectively, are separated only by an irregular demarcation-line; they run in a winding, or *boustrophedon,* sequence from the lower to the upper. These external features not only at once place this work in a different category from any other group of African mosaics, but have no counterpart anywhere else in the Empire. Furthermore, its very stylistic excellence makes it an exceptional work, artistically the finest of its *genre* and period. This is no second-hand workshop product; it displays that unity of form and expression which enhances every detail, and is to be found in only major original works. A similar spirit animates all the figures, even the oxen pulling the plough. It can be seen, too, in the wind blowing through the olive-trees, stirring the old stocks and branches of the vines. The shaggy-locked labourers are all conceived in terms of the same physical type – there is no attempt at anecdotal distinctions – endowed with virile, but sorely tested, strength. The only one who stands out is the bearded foreman at the bottom left-hand corner, his face marked by experience rather than the years. The dress and footwear, though of a very widespread type (especially in scenes of hunting or agricultural life), are nevertheless unique for their easy, realistic accuracy.

Apart from this scene of ploughing and sowing, and another showing the weeding of the vines, we have a third fragment which would seem to belong to the same building. This is a grape-harvesting scene, with a vintager coming down (*not* climbing) a ladder beneath an already well-stripped vine-arbour. In this fragment, the figure is twice as large as the characters in the preceding group: almost lifesize, in fact, which makes one wonder whether the piece belongs to the same composition, or even comes from the same room. This doubt is strengthened by the fact that, in the regular sequence of the farming year, vintaging comes before the autumn sowing; while the weeding of the vines, already bare of leaves, takes place early the following spring. (That what we have here is autumn rather than spring sowing is proved by the fact that there are still olives on the trees.) These scenes, then, form a kind of anthology, and must come from a much larger overall sequence.

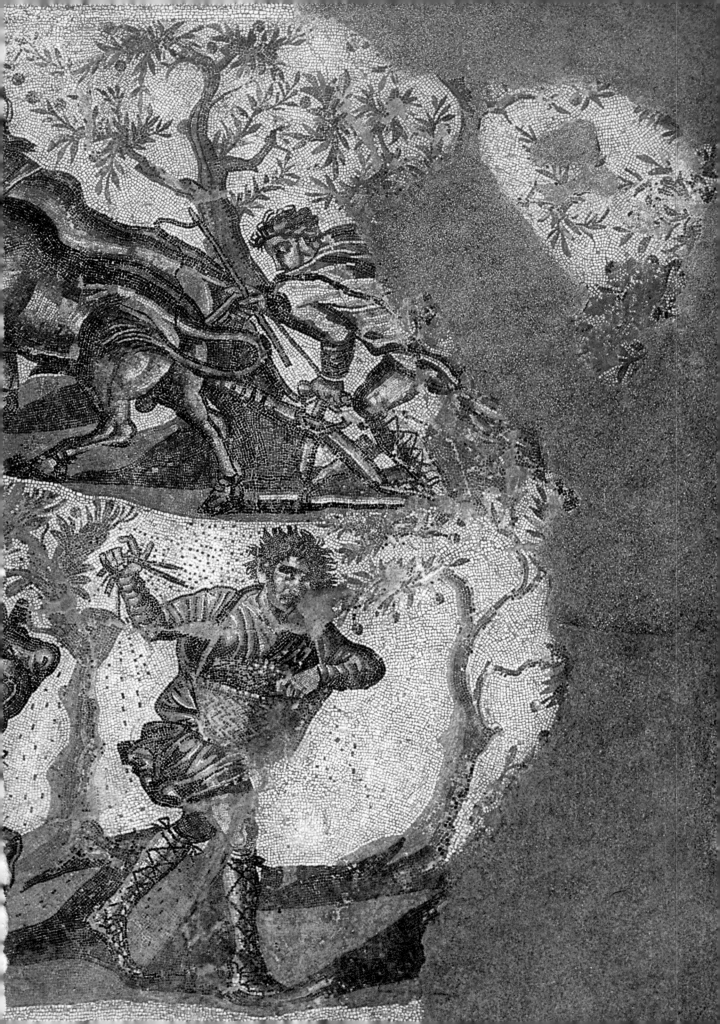

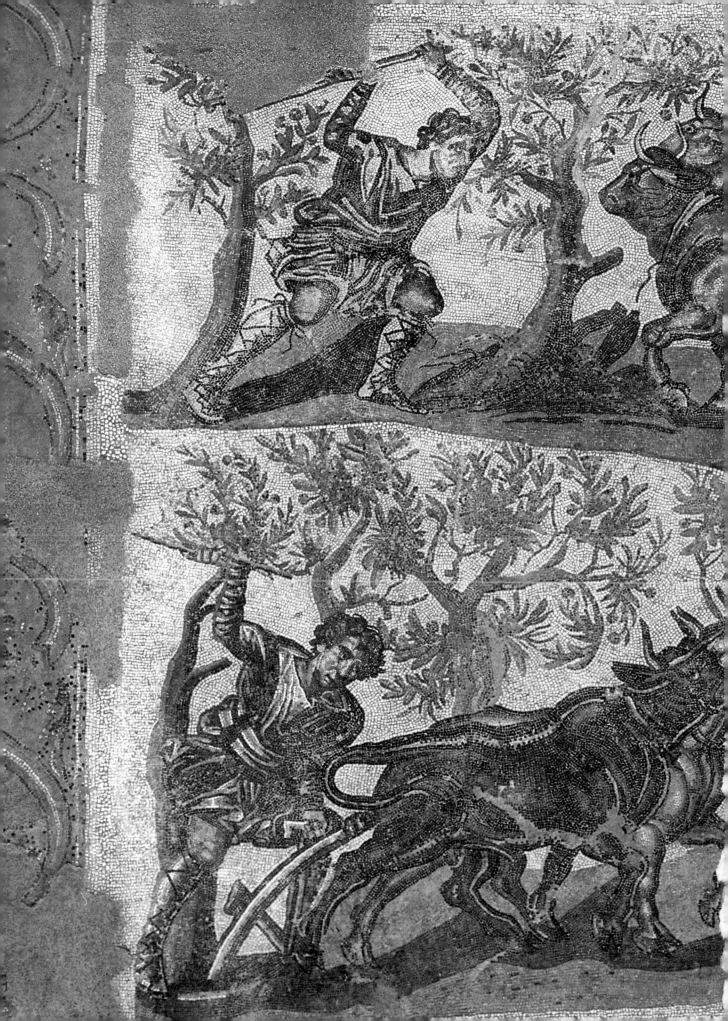

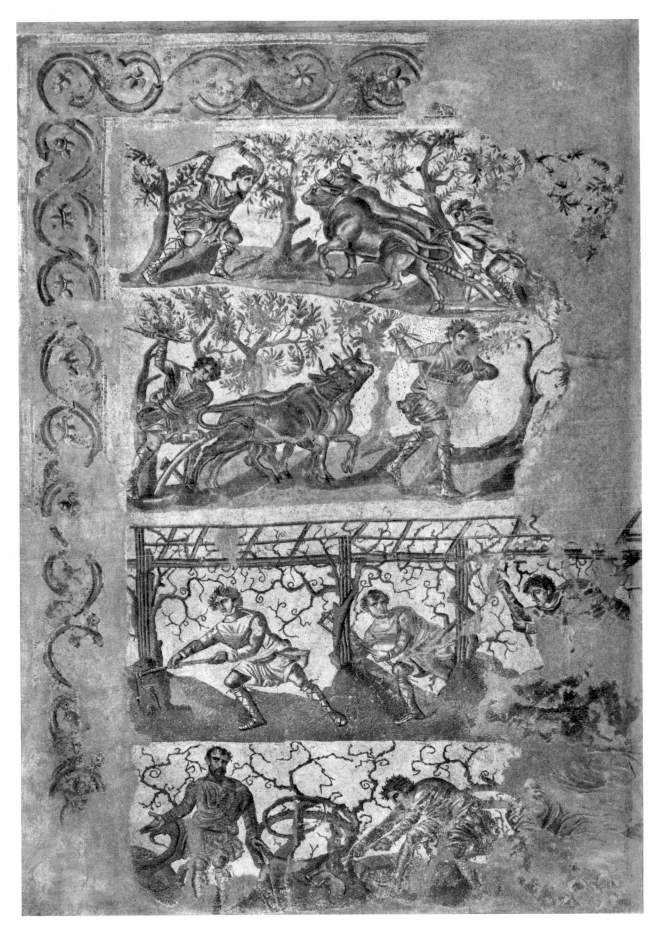

236 CHERCHELL. AGRICULTURAL PURSUITS. CHERCHELL ARCHAEOLOGICAL MUSEUM

235 CHERCHELL. AGRICULTURAL PURSUITS (DETAIL): DIGGING. CHERCHELL ARCHAEOLOGICAL MUSEUM

237, 238 CHERCHELL. LEFT, VINTAGING; RIGHT, TREADING OUT THE GRAPES. CHERCHELL ARCHAEOLOGICAL MUSEUM

Little was left of the walls of the building which housed these mosaics; but the discovery *in situ* of fine capitals and classical-type sculptures, as well as an inscription in honour of a procurator, Aurelius Heraclida, suggests a place of importance, and public rather than private. This would explain the singular and quite outstanding quality of its mosaics.

The same studio-workshop was undoubtedly responsible for another fragment from Cherchell: its subject forms part of the same cycle, but probably came from a different building, even though its mode of composition is markedly classical. It portrays the treading-out of grapes. The workers are girt about with material that resembles panther-skin – the panther being a Dionysiac animal – and have a satyr-like appearance. The way they are treading out the grapes, hand in hand, almost makes it look as though they are dancing. The left-hand vine-dresser – the only one whose head survives intact – is undoubtedly by the same hand that created the field-labourers.

The figures of the main fragment are drawn in violent chiaroscuro and accompanied by large projected shadows; yet they lack true spatial depth and perspective, and the effect they create is that of a cut-out. Here we have a typical feature of the Late Empire, which continues into the Middle Ages. We find striking examples of it in those large figures set against a background of fantastic architecture on the dome of Haghios Georgios at Salonika (executed some time after 390, under Theodosius), the heads of which – allowing for variations due to their hieratic nature – show affinities with the general pattern of the Cherchell mosaics (*pl. 354*). Further parallels are to be found, not so much in third- or fourth-century African mosaics, as in those from the East. A good example is that of the Apamea *triclinium* (datable, by its inscription, to 539), in which the

figures display an identical spirit, and very similar connections with the land. Further resemblances can be found in some illustrations from the Paris *Nicander* (Bibliothèque Nationale, Suppl. gr. 247, f° 47 v.), executed in the tenth century, probably at Constantinople, and based on models which still kept alive some part of the old Hellenistic tradition. One last echo – no longer in the style, but solely in the iconography – is provided by the miniature of the 'vine-digging' in a manuscript of the Gospels, also in Paris (Bibliothèque Nationale, gr. 74, f° 39 v.). This manuscript, it is thought, was written by a Greek monk from Constantinople in the mid-eleventh century. As regards the Cherchell agricultural mosaic, several factors combine to suggest a date in the second half of the third century at the very latest. There is the survival of a tendency towards spatial depth (linked with a preference for cut-out figures against an abstract background), and, above all, the lively and expressive realism of the whole. This date, however, is at variance both with the generally accepted one (early third century), and with that of a period between 340 and 360, proposed by Andreas Rumpf. But there is a still more important point to be made here. The affinities I have noted – all with very late works, and all from the Eastern part of the Empire – suggest that these mosaics should be related to a major painting done in the second half of the third century. Set up in some public edifice in an Eastern city of the Empire, such a painting could well have gone on exercising an iconographic influence right into the fifth and sixth centuries, perhaps even longer. The wine-press fragment strengthens this theory; and the cultural traditions of Caesarea all pointed the same way.

The centre that contrived to produce such a painting must have been the same one which, a century later, threw up the maestro responsible for the mosaics of Haghios Georgios in Salonika. Bérard has pointed out that the action of the sower – who, rather than flinging his arm out in a circular gesture, moves it vertically, letting the seed fall straight down from his fist – is still to be seen in Algeria today. Despite this, I believe that these Cherchell mosaics do not fall in the category of genuinely African art, but constitute a reflection of some large scale pictorial work located elsewhere.

By way of contrast, another Cherchell mosaic showing scenes of vintaging – only recently brought to light (J. Lassus, 1959) – fits perfectly into the context of African mosaic-work, and must date from the end of the fourth century. The unique quality of this mosaic lies in the fact that the figures are disposed like a border round a central square, the latter being formed by the vine-arbour that the workers are stripping. With its regular wooden vine-props, this climbing vine forms a motif at once geometrical and perfectly naturalistic. Such a treatment is only suitable for flooring; one could hardly imagine it on a wall. It must, then, have been specially designed for flooring, and is one of those rare cases of a pattern formulated outside the stock repertoire – evidence of the originality which the art of these African provinces could display.

One very recent discovery (F. Magi, 1969) is that of some large-scale painted landscapes showing work in the fields, found under the basilica of S. Maria Maggiore in Rome. These are divided by vertical panels, on which a month-by-month calendar is inscribed. The models for the tasks proper to each season must come from a centre on the southern shore of the Mediterranean; and the discovery confirms the existence, late in the sixth century, of large-scale paintings on agricultural themes.

239 LEPTIS MAGNA, THE HOUSE OF ORPHEUS. COMPOSITE MOSAIC. TRIPOLI MUSEUM

TRIPOLITANIA AND CYRENAICA

Tripolitania's contribution to the development of Late Empire art is different from that of Roman Africa's western regions. The towns which gave the country its name are three: Oea (Tripoli), Sabratha and Leptis Magna. There was none of that great development, both urban and cultural, which we find in Byzacium and the territories of Numidia and Mauretania. The inhospitable nature of the coast limited commerce; not even the major harbour-improvements which Septimius Severus carried out in Leptis, the city of his birth, would seem to have stimulated trade to any great extent. While the quays of the old port have that worn appearance which only comes from long and frequent use, those of the Severan harbour give the impression of never having been used at all, right through the long period between the port's enlargement (210–16) and the occupation of Tripolitania by the Vandals (455), which marks the decline of Leptis as a city, and the point at which its harbour began to silt up.

Tripolitania plays no part in the original development of the African mosaic. One phenomenon which long survived there was the Hellenistic pictorial-type mosaic, in the form most popular with artisan-craftsmen: this involved the use of small prefabricated mosaics, set in a terracotta backing, which could be inserted (*emblema*) directly into the flooring, within a border of geometrical design. Such was the method employed to create the mosaic pavement for that house in Leptis which got its modern name – the 'House of Orpheus' – from one particular scene discovered there. Orpheus charming the beasts with his song forms one panel extending from side to side of the mosaic. The arrangement in 'strips', and the neutral background, with ground-lines barely sketched in, combine to place this composition in the third century. The rest of the flooring consists of six small pictures. Two contain scenes of country life, and one of fishing. The remaining three are typically Hellenistic compositions, with birds, fruit and fish. These last have parallels in the Graeco-Roman mosaics of Rome and Pompeii, where they are known, generally, as *xenia*, i.e. 'guest-gifts'. Being ready-made mosaics set in a terracotta base, these could well be older pieces that were re-employed in a new section of flooring.

261

240 LEPTIS MAGNA, THE NILE VILLA. FISHING SCENE (DETAIL). TRIPOLI MUSEUM

Also assignable to the early third century are the mosaics from the 'Nile Villa'. Their subject-matter is patently all of Hellenistic origin: maritime scenes including fishermen, boat-races between Amorini, a personified representation of Nile stretched out on a hippopotamus, and Pegasus being watered by the Nymphs (this last has parallels in scenes of Pegasus being fed by the Muses, on terracotta pots at Djemila and in Cairo). But the general label 'Hellenistic' is not good enough. Everything suggests that we should specify an 'Alexandrian' origin: the mosaic's pictorial conception (still in the first flush of naturalistic impressionism), depth-perspective, and illusionist technique.

262

241 DAR BUC AMMERA, ROMAN VILLA. DECORATION ON VAULT OF A CRYPTOPORTICUS (DETAIL). TRIPOLI MUSEUM

Such general features of Tripolitania's artistic culture help to decide the source of the landscapes. These, too, are clearly Alexandrian; the small buildings and swiftly-outlined figures that fill them are both typical of the early Augustan period in Rome. Here, however, we still find them at the end of the second (or the beginning of the third) century, in a small picture which forms part of some vaulting-decoration (the central motif being Dionysus on a panther). This vaulting belonged to a seaside villa at Dar Buc Ammera, near Zliten, east of Leptis; other mosaics and paintings have been found there, but archaeologists are not yet agreed on their dating.

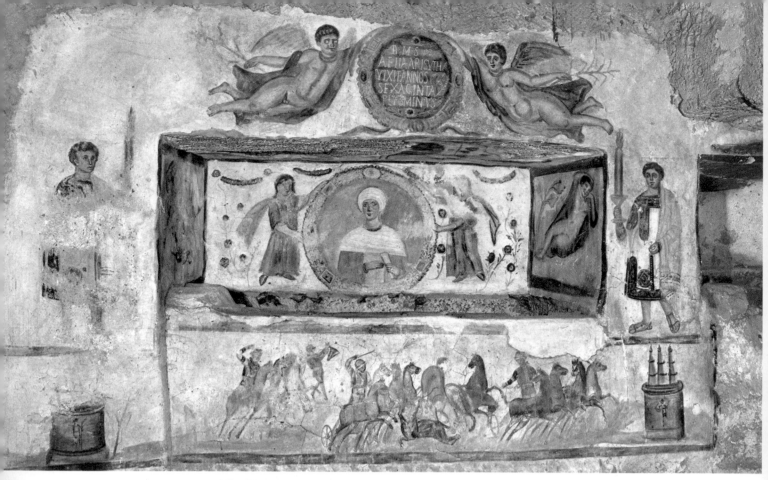

242 GARGARESH, TOMB OF AELIA ARISUTH. MURAL DECORATION

Still later, in the second half of the fourth century, we find some paintings from the neighbourhood of Tripoli which come closer to the culture of Rome and the Hellenistic East than to that of Carthage – e.g. those on the tomb of Aelia Arisuth at Gargaresh. The name of the deceased, a lady who 'lived to the age of about sixty', is inscribed on a plaque ringed with a wreath, the whole being held up by two genii fluttering above the tomb (a *loculus* hollowed out of the wall). The dead woman's portrait is painted on the back wall of the *loculus* itself, and framed in another wreath, studded with precious stones, which two children are supporting against a background of garlands and roses. It is an austere, linear, genuinely pre-Byzantine portrait. The remaining decorations are done by another hand, that of a somewhat careless decorator: for his circus scene he sticks to the old patterns of popular art, while at the same time observing perspective. As a result, it is not clear whether the scene has a symbolic significance, or a realistic and commemorative one, though the former seems more likely. On the ceiling of the *loculus* there is a peacock spreading his tail; and on the side-walls we see two allegorical figures, each resting one arm on a reversed torch – the extinct flame of life. On either side of the *loculus* stand two servants, sumptuously dressed and holding lighted candles. We have seen an identical fresco in Rome (*pl. 86*). The tomb was fitted with a basin, its bottom pierced so that libations could run through on to the wooden coffin at a point directly above the corpse's head. The figure of a lioness was painted on the tomb itself, with the inscription *quae lea jacet*. A corresponding inscription, *qui leo jacet,* was found in the *loculus* of a tomb dug in the wall that abutted on the sepulchral chamber. This second

264

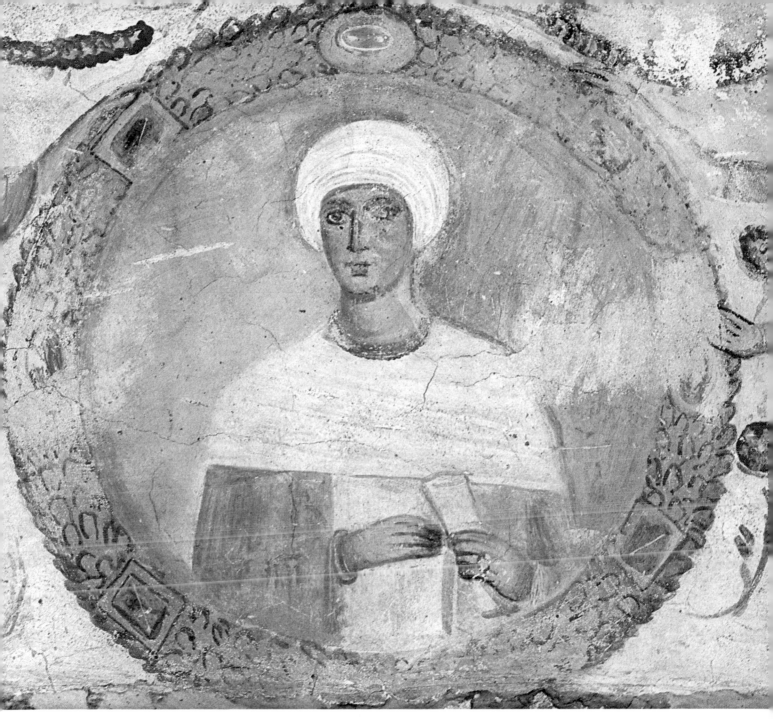

243 GARGARESH, TOMB OF AELIA ARISUTH. LOCULUS (DETAIL): PORTRAIT OF AELIA ARISUTH

tomb was decorated with very inferior paintings, now much defaced. An inscription mentions a masculine name. The use of the words 'lioness' for the woman, and 'lion' for the man, shows that the dead couple had attained the fourth grade of initiation in the mysteries of Mithras. Yet no Mithraic symbols can be identified in the painted decoration. This looks like a case of religious polyvalence – another example, in the same period, being the coexistence of pagan and Christian elements in the same decorative painting (e.g., in Rome, the new catacombs on the Via Latina).

265

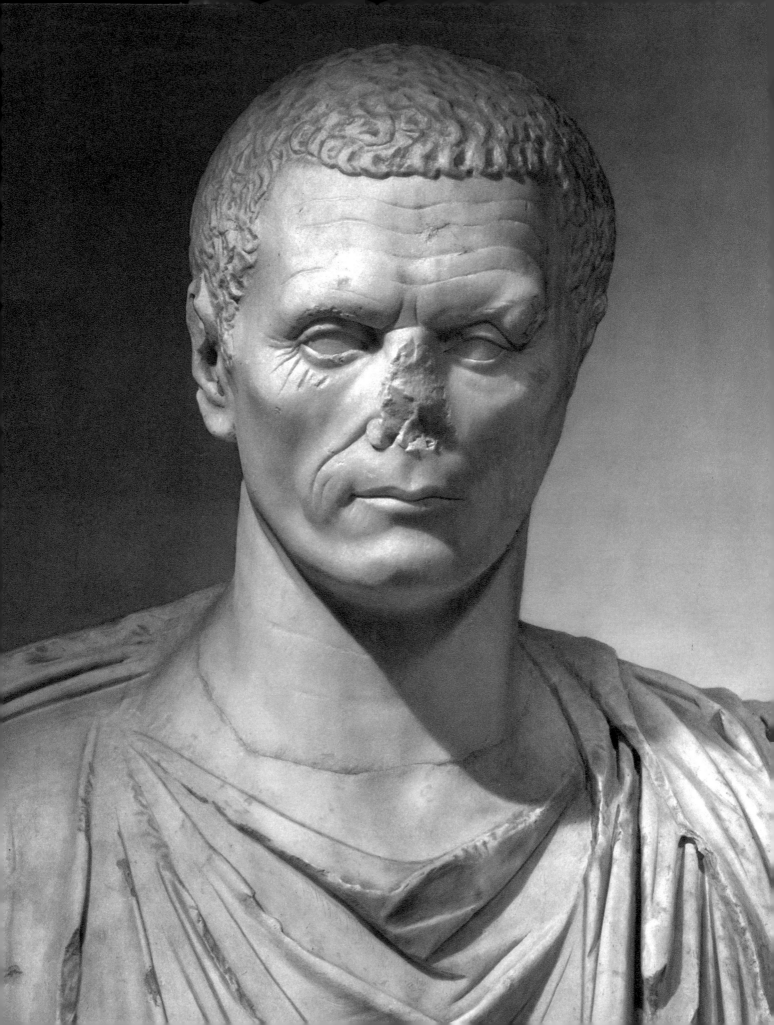

Portrait-sculpture here lacks those local idiosyncrasies which so strongly mark works found in Tunisia, Algeria and Morocco. Some pieces present indigenous physical characteristics, such as the toga-clad statue of Iddibal Caphada Aemilius, citizen of Leptis, devotee of the Imperial cult, and a munificent benefactor of his town; but the basic formal patterns remain an offshoot of Roman urban art. If we look at the majority of inscriptions from Leptis Magna, we see that, in the first and second centuries, the town grew, and acquired numerous fine monuments, thanks to the generosity of its Romanized Punic citizens. However, the Greek inscriptions from the temple of Isis and Serapis attest to the existence of various Hellenized groups as well; their presence is further confirmed by some highly sophisticated statues and portraits, which show closer affinities with Alexandria than with Rome. Nevertheless, in the sculptures from the Severan monuments of Leptis Magna, Tripolitania has preserved a range of vitally important evidence for the history of Late Empire art.

The enlargement of the town decided on by Septimius Severus was carried out under the direction of C. Fulvius Platianus, an extremely wealthy citizen of Leptis, who was Severus's childhood friend, Praetorian Prefect, and later Caracalla's father-in-law. The project was executed by an architect of genius. The old town of the Punic era had occupied the tip of the promontory which sheltered the harbour. Next, the commercial quarter had developed, along an east-west axis. However, at least as early as this we find the theatre (begun in AD 1 or 2 and completed under Tiberius) being oriented on a southeast-northwest line, parallel to the new network of streets that was being laid down. This became the town's central axis. At its principal crossroads was built a *quadrifrons* arch, dedicated to Septimius Severus and his sons Caracalla and Geta. The architect of the Severan city extended its main agglomeration eastward and towards the port. He laid down a broad boulevard lined with colonnaded porticoes; the latter were built facing north and south, and thus parallel to the public baths, which dated from Hadrian's reign. Immediately behind the baths he created a large exedra and a nymphaeum, which served as a link between baths and boulevard. From this point the road, which ran east and west, was aligned with a lighthouse built on the tip of the promontory. This colonnaded boulevard recalls the lay-out of Roman towns in Syria. Between it and the first-century town were placed the Severan Forum and the basilica. These buildings were of unprecedented size and splendour (the Forum covered nearly two and a half acres, and was closed to wheeled traffic). They were also adapted to fit in with the divergent directions taken by previously existing streets: between the Forum and the basilica we find a narrowing wedge of shops, which completely mask the change in orientation.

The name of this brilliant architect, like his nationality, remains unknown. He may have been a Roman or a Syrian: in view of Septimius Severus's close links with Syria, and certain features of the architecture, the latter seems more likely. The work was carried out by sector, according to a strict timetable that made little allowance for hold-ups: some parts were actually put into place minus their ornamental finishing. The entire project was completed in about fifteen years.

Before we leave this great joint enterprise of city-planning and art, it may be of interest to try and work out the relationship between sponsor, designer, and working craftsmen. The Pergamum-type capitals in the portico of the Severan Forum, as well as

267

245 LEPTIS MAGNA, SEVERAN FORUM. THE STRUCTURE AND ARCHES OF THE PORTICO

their bases, bear the signatures of some thirty Greek artisans; the column-bases of the temple in the Forum rest on sculptured plinths which form an exact counterpart to the contemporary reliefs of Aphrodisias. Similarly, the masks representing Medusa and some marine divinity, which decorate the medallions set between the arches of the portico, recall (at least the best among them do) the Aphrodisias sculptures. These medallions may perhaps give us some clue as to how the work was carried out. The marble, undoubtedly, is from Asia Minor. However, the great difference, in quality as in style, among these heads suggests that only a few came from Asia Minor, as models, and that the rest were turned out in Leptis, by local workshops. The presence of a team of sculptors, or even one master-sculptor, from Asia Minor would, I am convinced, have eliminated their more barbarous features. It seems likely, too, that the capitals signed by Greek artists were imported ready-made, as we know to have been done in Cyrenaica, in Justinian's reign. And perhaps the facings on the pilasters of the great Severan basilica (built between 210 and 216) were also sculptured beforehand, abroad? They constitute the main evidence here for a style alien to the Roman West, and for which certain indications suggest an original home in the studio-workshops of Aphrodisias. These sculptured elements form a splendid and decorative extra; they are not an organic part of the wall-structure. The pilasters of the basilica are masterly achievements, neverthe-

268

246 LEPTIS MAGNA, THE SEVERAN BASILICA. DECORATION OF THE PILASTERS (DETAIL)

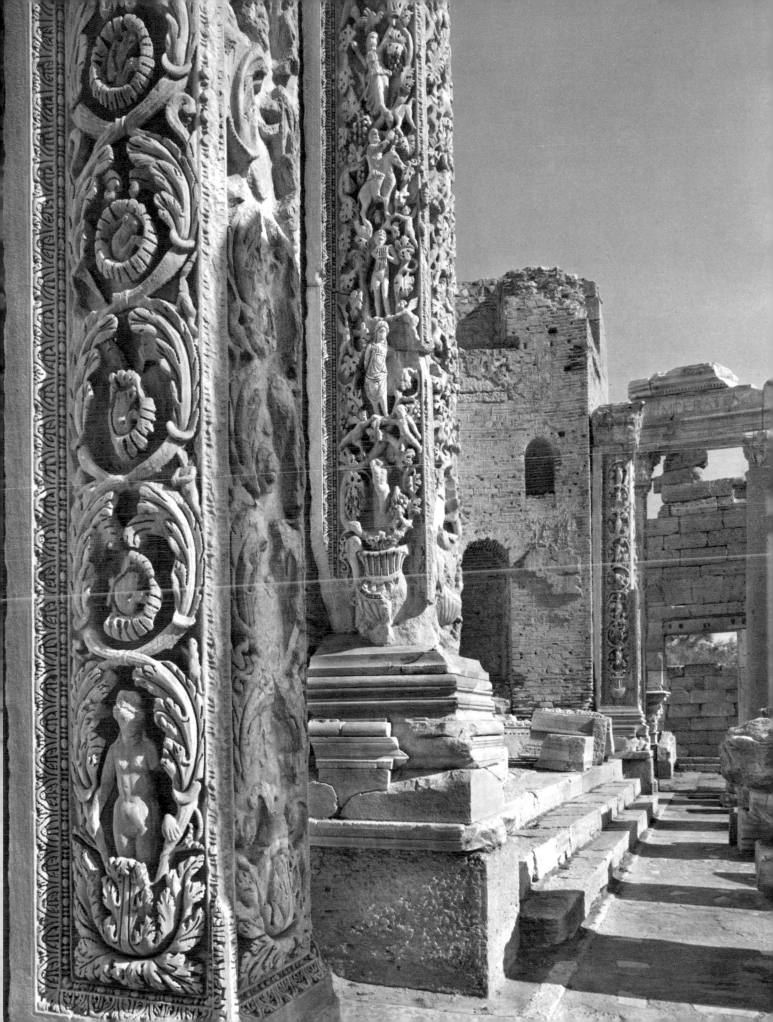

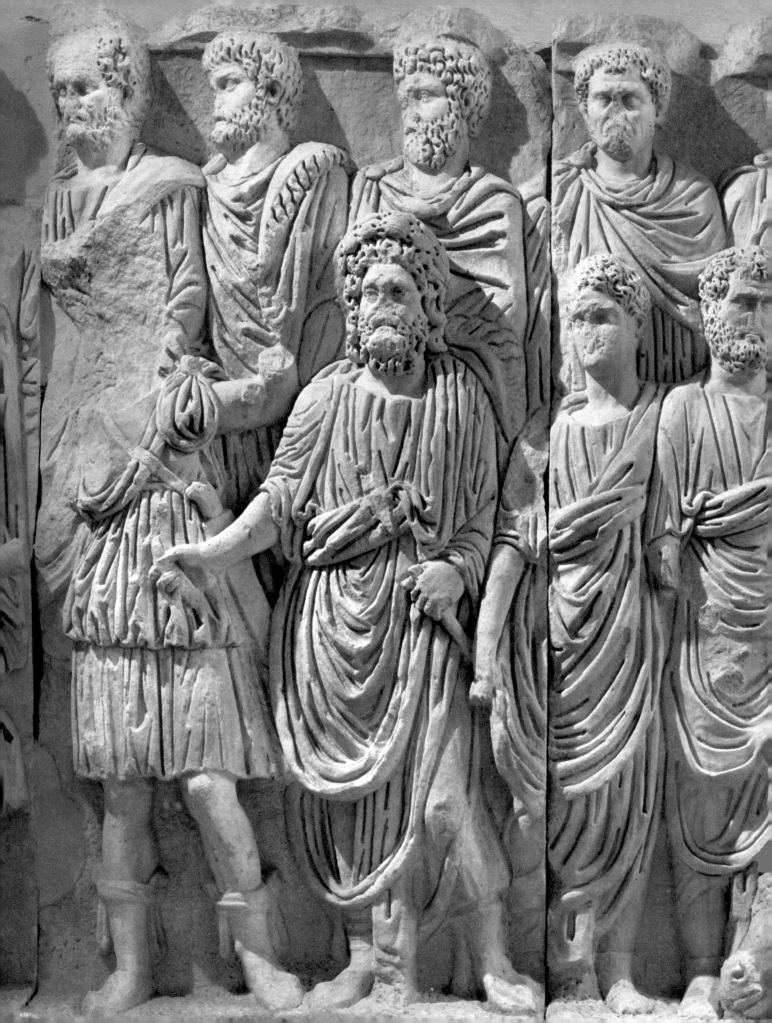

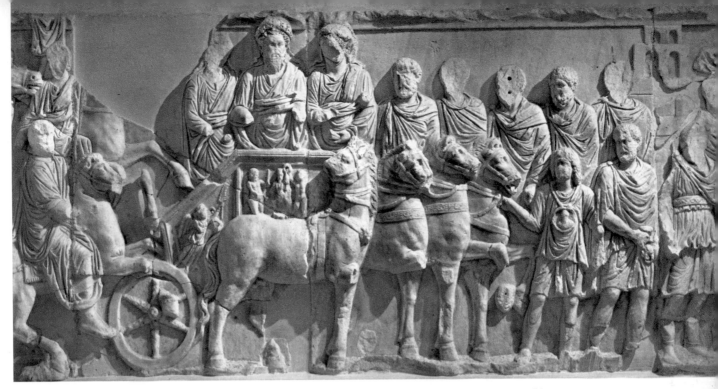

248 LEPTIS MAGNA, ARCH OF THE SEVERI. THE EMPEROR AND HIS SONS ON THE TRIUMPHAL CHARIOT. TRIPOLI MUSEUM

less: both in their ground-augur relief technique, and in the formal inventiveness of their motifs.

They display, in fact, a figurative inventiveness which, in its elegance, its effective use of relief, and the coherent evolution of its grouping leans heavily on Hellenistic tradition; but to this is added a taste which discards tradition altogether. The figures stand out against a neutral background, according to a concept later carried to its logical conclusion in Byzantine paintings and bas-reliefs. A good example of this taste at its most extreme is the ivory-work on the tenth-century Veroli casket (London, Victoria and Albert Museum). The borders have lost all connection with their naturalistic origins, and are now a delicate lace-work which, similarly, foreshadows the ornamental forms of the Byzantine capitals of Constantinople and Ravenna. At all events, whether imported ready-made or executed on the spot, these pilasters belong neither to African art nor to that of the Western provinces; they are a product of the provinces in the East – which is, precisely, the area from which Byzantine art emerged.

Four great friezes adorn the Severan Arch. One of them shows the Imperial family lined up before images of the town's, and the Severan House's, tutelary divinities: the Emperor stands between his two sons, holding the augurial staff of the Pontifex Maximus. Another shows two bulls being sacrificed while the Imperial family look on. On the third, we see a procession of distinguished personages on horseback, as well as a number of Parthian prisoners, both male and female. The men are standing beside a trophy, while the women (who wear the Phrygian bonnet) are being carried on litters. In the centre stands Julia Domna, and beside her another figure (now incomplete, possibly Caracalla or Severus), crowned as Hercules. The fourth relief seems to be a continuation of the preceding one: it portrays the ceremonial *quadriga* (four-horse chariot) ridden by Septimius Severus and his sons; the *quadriga* is decorated with images of Cybele, Hercules-Melqart and Venus-Astarte, all Oriental divinities.

271

◀ 247 LEPTIS MAGNA, ARCH OF THE SEVERI. SEPTIMIUS SEVERUS TAKING PART IN A SACRIFICE (DETAIL). TRIPOLI MUSEUM

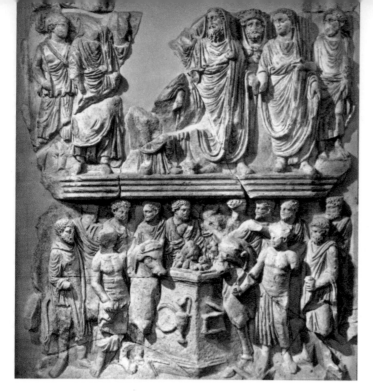

249 LEPTIS MAGNA. SACRIFICE BEFORE A TEMPLE. TRIPOLI MUSEUM

The most striking feature of this relief is the way in which the triumphal chariot has been fitted into it, with a different rhythm from that of the lined-up figures. The latter, in accordance with narrative convention, move from left to right. The chariot, too, is moving towards the right, but its perspective has been modified so as to present the members of the Imperial family full-face. We have met this 'frontality' before, in Rome, on the door of the Argentarii: here it is still more explicit, since it violates the natural movement of the figures in their narrative context. The reason, I believe, is ideological: the image of the Emperor must not be made part of any narrative sequence, but must be elevated to the rank of a ceremonial emblem, an *image d'apparat*. This distinction is readily comprehensible: we need only think of a Byzantine icon, with its deeply religious content, and remember how that content dwindled away to vanishing-point when the Renaissance represented the Catholic Mother of God as an ordinary human mother playing with her baby. This *image d'apparat,* which the emergent ideology of absolute sovereignty now demanded, would nevertheless have remained artistically unacceptable had it not been also for an increase in that reaction against Hellenistic naturalism first noted under Commodus. The objective image of reality fell out of favour: people preferred an image which formed a substitute for reality (while making use of optical illusion to keep reality in mind), and left the artist free to give his work a decorative and symbolic quality – even if that meant violating aspects of reality itself. When the *maestro* responsible for the reliefs on the Leptis arch used a helicoidal or running ground-auger to deepen the shadow-work in drapery-folds, or to drill out hair and beards as ornamental counterparts to the border-decoration of the pilasters on the basilica, this was the effect he achieved. Those deep, furrow-like lines (which give a mere illusion of plastic form) are executed with such formal sensibility that the master-artist supervising the work must surely have been responsible for them himself. His hand is unmistakably present here. Perhaps he went round the rough-hewn figures with a brush and a pot of

272

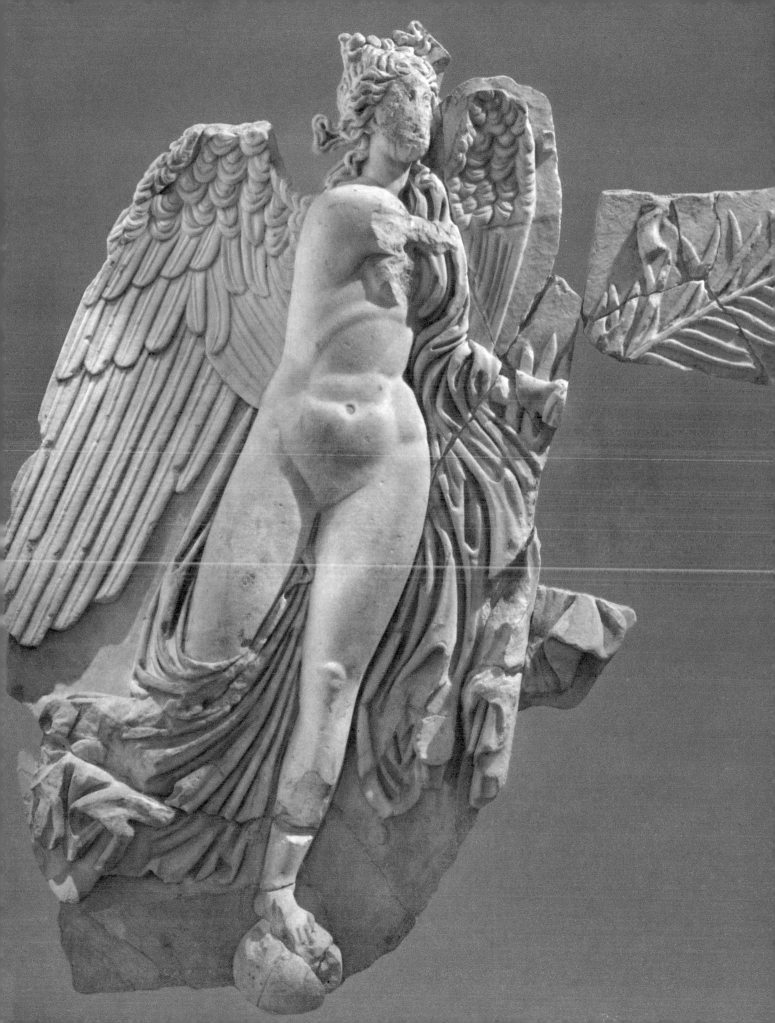

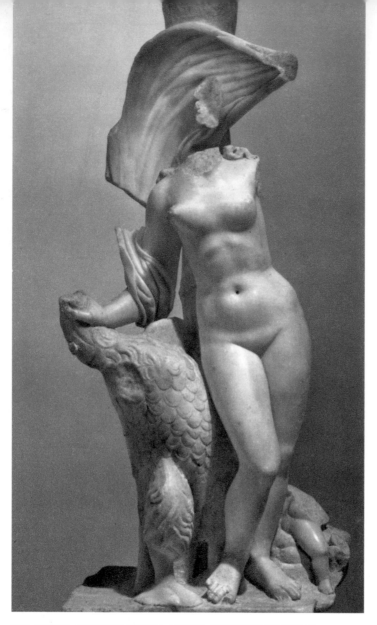

251 CYRENE. STATUETTE OF LEDA. CYRENE, MUSEUM OF SCULPTURE

paint, marking in shadows and lines – which, alone, would have sufficed to bring them alive. This is, in fact, pictorial sculpture, which utilizes a technique very like that employed by contemporary *tachiste* painting – itself equally destructive of naturalistic form. We are witnessing a profound revolution in the visual concept of form. At the same time, it is worth noting that, in an era of economic crisis, this technique represented a considerable saving of time, and an appreciable degree of progress. In my view, these four large reliefs were executed on the basis of themes (and perhaps also of designs) that came from Rome, and were then realized by the team of sculptors working at Leptis, directed by a master-artist from one of the major workshops in Lycia or Caria.

The reaction against perspective, and the new mode of composition in general, are even more noticeable in another relief, designed in two 'strips', which shows the Imperial family looking on at a sacrifice from the *podium* of a temple (*pl. 249*). Here the

274

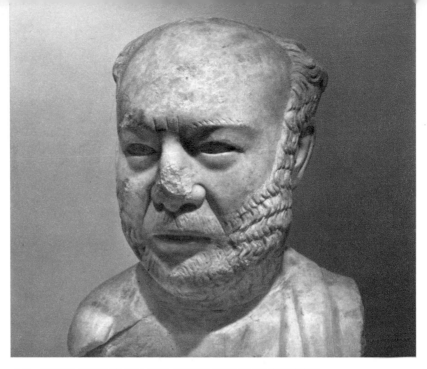

composition is novel, whereas in the relief just discussed there is still a reflection of tradition. The double-level composition is in fact unitary, since the steps of the temple serve as a dividing-line, while its columns form a background for the Imperial group. The only trace of perspective is in the altar, which is placed in the centre, but seen from a three-quarters angle. Here, too, it was not initially artistic motives which led to this complex scene being composed on a unitary basis. If a three-dimensional perspective vision had been adopted, it would have meant making the Imperial family smaller than the minor characters in the foreground. This was no longer permissible: the Imperial family was now (as an inscription from Leptis reminds us) the *divina domus*

The Leptis Arch was rich also in decorative elements: columns with trophies and prisoners, figured scrollwork, a frieze of Amorini holding festoons of flowers (this motif spread as far as Gandhara, on the borders of India), and the usual Victories, who occupy the extrados at each of the arch's four openings. These Victories are in a style very different from that of the major reliefs, or the fashionable style of the capital. Their rounded fullness, so rich in delicate variations of chiaroscuro, is wholly Hellenistic; and this is matched by the almost baroque treatment of the drapery, with parts (e.g. the lost arm) done fully in the round. This is the style to be found in the decorative sculpture on Attic sarcophagi, and in all sculpture from Asia Minor, where the Hellenistic tradition still prevailed. With these Victories on the Leptis Arch we are back in the line of development from Hellenistic art, which remained dominant in nearby Cyrenaica as late as the first or second century. One glance at the statuette of Leda and the swan should suffice to confirm this. Though portraits from Cyrenaica tend towards over-expressive notation and structural stiffness, they still – even in the mid-third century – preserve a feeling for plastic relief and a fineness of detail which betray Hellenistic influence. The eyes of the head reproduced above were probably filled with glass paste, as is so often the case with third-century Egyptian portraits.

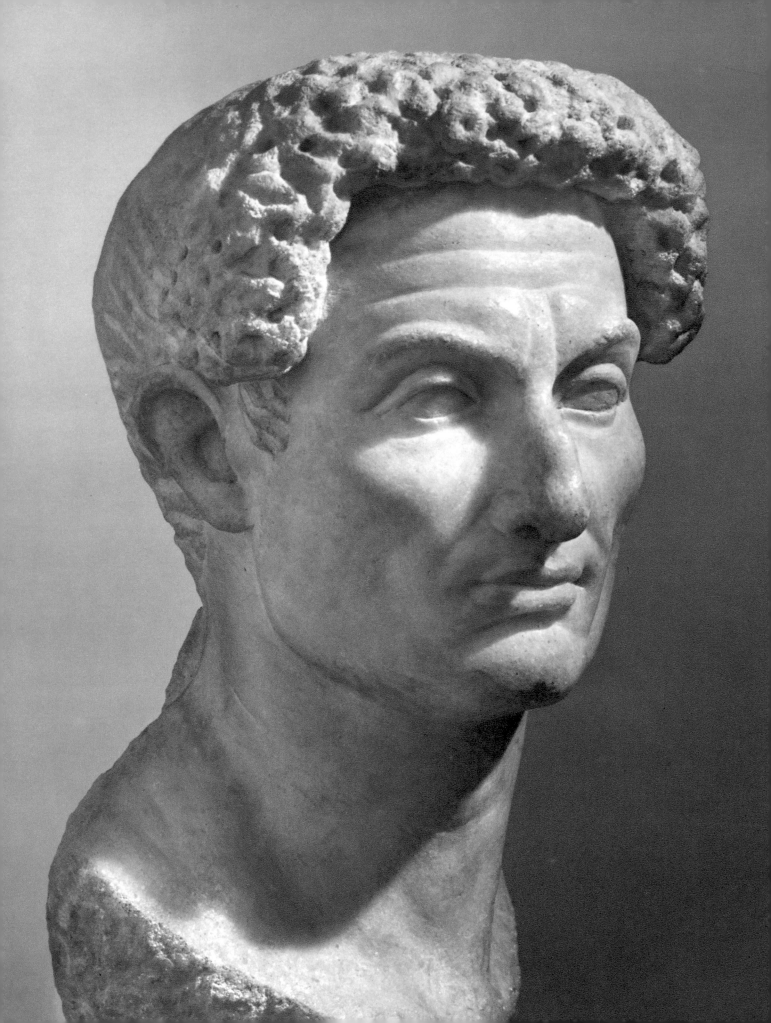

EGYPT

The history of art in Roman Egypt has yet to be written, even though – thanks to written documents, on papyrus or ostraka – there is no Imperial province about which we know more. One reason for this, no doubt, is the controversy that has surrounded Alexandria's role as a centre of artistic culture, from its foundation in 331 BC right through the Hellenistic period. For some, Alexandria was the great innovator, the home of all new ideas; others saw no individual quality in her art at all. The truth probably lies somewhere in between. Clearly, except as regards architecture and official Imperial statuary, Roman Egypt was not in any particular way influenced by Rome. Her sculpture, and especially her portraiture, are typical of the Eastern half of the Mediterranean. Sometimes they reflect the practices of Asia Minor, more often – though in a more solid and restrained fashion – those of Attica. A good example is provided by the woman's head opposite, datable to the late first century (her hairstyle, indicated by a perfunctory use of the ground-auger, recalls that in fashion in Rome under Titus and Domitian). The back of her head was probably covered by a veil made out of stucco, this being a favourite technique among the Hellenistic sculptors of Alexandria.

The funerary portrait of an elderly man, shown overleaf (*not* a sarcophagus-lid: the short, stubbly beard suggests a date in the mid-third century), makes it clear that sculpture still retained a certain compactness of form, and a preference for drapery with clear-cut linear folds – a very different taste from that revealed by the Severan Arch, with its illusionist sculpture. One senses behind such work a body of craftsmen who still kept up the great tradition of Hellenistic refinement. However, this predilection for formal elegance and clarity must have been due also to that still-flourishing artistic trend associated with the most ancient traditions of native Egyptian art. We possess numerous statues executed in diorite or basalt – hard stone, already long exploited as a medium – which combine a traditionally Hellenistic form with those massive linear qualities typical of Egyptian art. One example must suffice here: the statue of a priest of the god Thoth – Hor son of Hor, as we learn from a hieroglyphic inscription on the pillar behind him. This statue is only slightly smaller than lifesize; the bottom part of it has been lost. Pillar, inscription, function and material (basalt) all belong to the tradition of ancient Egypt: so do the subject's stance and costume. All such sculpture

277

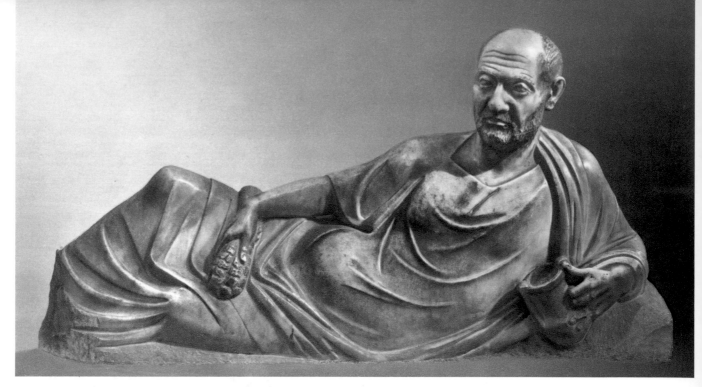

reveals a successful fusion between the two great artistic cultures, Egyptian and Hellen-
istic, which followed one another in this area. The result, here, is a high-relief portrait,
the stylistic coherence of which reaches its apogee with the head: that stiffly frontal
pose, those drawn features, the huge eyes, all combine to produce an impression of
religious asceticism. The date of this work, possibly early second century, is still in
debate.

If we take the existence of this particular artistic trend as our starting-point, we may
perhaps achieve a more satisfactory definition for a series of works which historians
have found difficult to place in the artistic context of their day. The best-known and
most typical piece in this series is a group of two embracing couples, executed in por-
phyry, which stands at the corner of St Mark's in Venice, looking towards the Doges'
Palace (*pl. 256*). The recent discovery, in Istanbul, of a foot missing from one of these
statues makes it clear that the group came from Constantinople – though this is not to
imply that it was actually made there. It was originally backed by a column; this suggests
a parallel with those figures on corbels which similarly decorated the colonnaded
boulevard of Palmyra. Their Pannonian-type hats – the gems adorning them were an
innovation of Diocletian's (Eutropius 9.26) – and their reciprocal salutations place
these characters in the context of the Tetrarchy. They are Augusti and Caesars who, in
their fore-ordained succession, symbolize union through shared power – and, thus, the
everlasting nature of the Empire (also extolled on coins). Just *which* Tetrarchy is
referred to we do not know. It may be the first, which united Diocletian and Maximian,
as Augusti (the one taking the title of 'Jovius', the other of 'Herculius'), with the two
Caesars, Galerius and Constantius Chlorus (who in 303 celebrated his own *decennalia*,
as well as the *vicennalia* of Diocletian). Or it may be the third, that of Galerius, Licinius,
Constantine and Maximin Daia, established at the Carnuntum Conference (308). In
my view the first is the more probable.

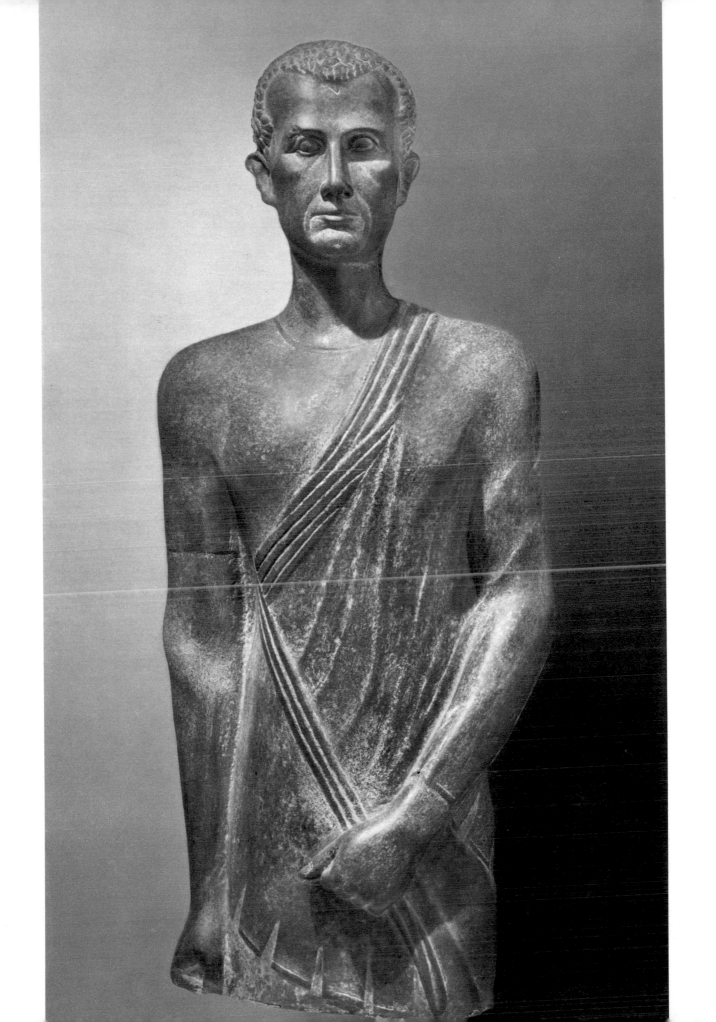

256 CONSTANTINOPLE. GROUP OF TETRARCHS. VENICE, ST MARK'S

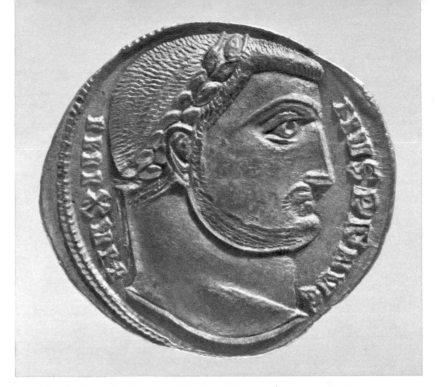

257 ALEXANDRIA. COIN OF MAXIMIN DAIA. PARIS, BIBLIOTHÈQUE NATIONALE

From the formal viewpoint, this group, together with the other pieces in the same series (e.g. a fragment from Nis, Constantine's birthplace in Yugoslavia), constitute a violent, and irreversible, stylistic advance. It is always cited as evidence of the Late Empire's final break with Hellenistic form, and its prefiguration of that current in the Middle Ages. The type of sword, with its Persian hilt-guard, reinforces this impression. The heads, on the other hand, present a style which matches that adopted for the coinage of the First Tetrarchy. In the latter, this new, massively geometrical style (which at the same time reveals certain linear features) appears first on some coins of Maximin's, struck in Alexandria. The same type was subsequently adopted by the other Eastern mints (Antioch, Cyzicus, Nicomedea), and later even by those of Rome and Siscia. In all these mints, up to the issues of 290–2, the type of head struck preserves traditional relief techniques. Its original model, then, must be sought in Egypt.

Another clue leading us back to Egypt is the material used for the sculptures: red porphyry. The quarries lay close to the Isthmus of Suez, on the Mons Porphyrites (now Gebel Dukhan, near Klysma) by the Red Sea. We know that porphyry, an extremely hard, reddish-purple stone, was used in the Imperial Roman period (perhaps as a revival of earlier Ptolemaic practice) only for the images of the gods and the Emperor, and for the building and decoration of Imperial palaces. It was particularly popular from the time of the Tetrarchy, and under Constantine. From these workshops came the sarcophagi in which were deposited the remains of Constantine's mother Helena, and of his daughter Constantia (Vatican Museum); similar fragments, preserved in Constantinople, may perhaps have belonged to the sarcophagus of Constantine himself. The only other porphyry statue comparable to the group in question is the famous bust, slightly smaller than lifesize, from Athribis (an ancient Delta town of some importance) which has been variously identified as a portrait of Licinius, Maximin Daia, or even

281

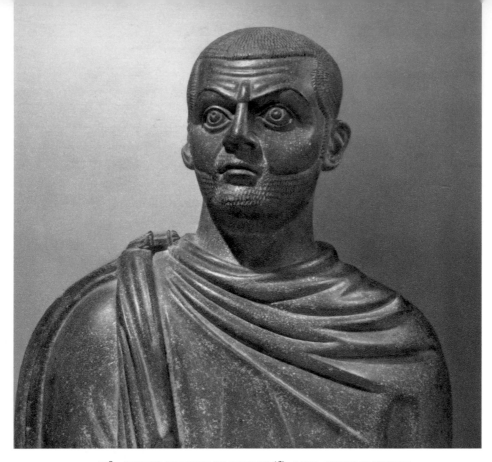

258 ATHRIBIS. PORTRAIT OF GALERIUS (?). CAIRO, EGYPTIAN MUSEUM

Diocletian. But the likeness it bears to Galerius, as revealed by a small marble arch in his honour now in the Salonika Museum, suggests rather that he is the emperor portrayed here.

This group of sculptures can no longer, in my opinion, be regarded as evidence for the decisive and irreversible infiltration of Eastern formal elements into the artistic culture of the Late Empire. What we have here, I would suggest, are works produced, at a given moment, in some Egyptian studio where the artist responsible for their realization had preserved the legacy of 'Egyptian-style' sculpture. (The latter represented a still-vigorous trend, as the portrait of the priest Hor demonstrates.) In point of fact this style, long considered typical of the Tetrarchy, never really caught on; it remained limited to a small group of works in porphyry, and lasted only about a dozen years. It is certainly significant that people were willing to accept such a style for what were surely 'official' works, at a time when Egypt itself was still permeated with the Hellenistic Graeco-Roman tradition. An Egyptian origin for these sculptures had, in fact, already been proposed by Strzygowski; but his theory was abandoned in favour of one which suggested the sculptures of Palmyra as their source. Far too great an importance has been attached to Palmyran art, which remains a local, peripheral phenomenon, in no way comparable to Egypt's great cultural heritage – nor, indeed, to the key role she played in the politics and economy of the Roman Empire.

The most famous works of art from Roman Egypt are portraits painted on wood, or sometimes on canvas, using distemper and the encaustic process. These were kept at

282

259 EGYPT. WINDING-SHEET: ANUBIS ACCOMPANYING THE DECEASED. MOSCOW, PUSHKIN MUSEUM

home during their subject's lifetime, and placed upon his mummy when he was dead. We find similar portraits on the linen used for shrouds: these show the dead person accompanied by Anubis, the ancient Egyptian god of the dead. Apart from their ritual function, these portraits are not, in the majority of cases, an art-form peculiar to Roman Egypt. Similar ones must have existed in all the more prosperous provinces of the Empire. What little we know of portraiture in Pompeii, from the random specimens that have survived, supports such a view. It should be remembered that those in Egypt, too, were preserved

260 THE FAYUM. PORTRAITS OF TWO BROTHERS. CAIRO, EGYPTIAN MUSEUM

only by accident, as a result of the exceptionally dry climate. Most of them come from the Fayum, the nearest oasis to the Nile Valley, and are often so labelled in textbooks, though in fact they have been found in at least a dozen other localities. Scholars have questioned whether some of them date from the Augustan era, or merely from that of the Flavians. It is only from Hadrian's reign that we have any external cross-checks on their chronology. Throughout this period, the taste which such portraits reveal is typically Graeco-Roman. The second-century medallion with a double portrait (*The Two Brothers*) differs hardly at all, except perhaps in its greater fluency of execution, from the supposed portrait of Pacuvius Proculus in Pompeii (*Rome: The Centre of Power, pl. 108*). At the same time the linear sobriety, almost austerity, of these pictures is close to that revealed by the statue of Hor in the field of sculpture. Some portraits, however, belong

284

261 EGYPT. PORTRAIT OF A YOUNG GIRL, WITH OFFERINGS. CAIRO, EGYPTIAN MUSEUM

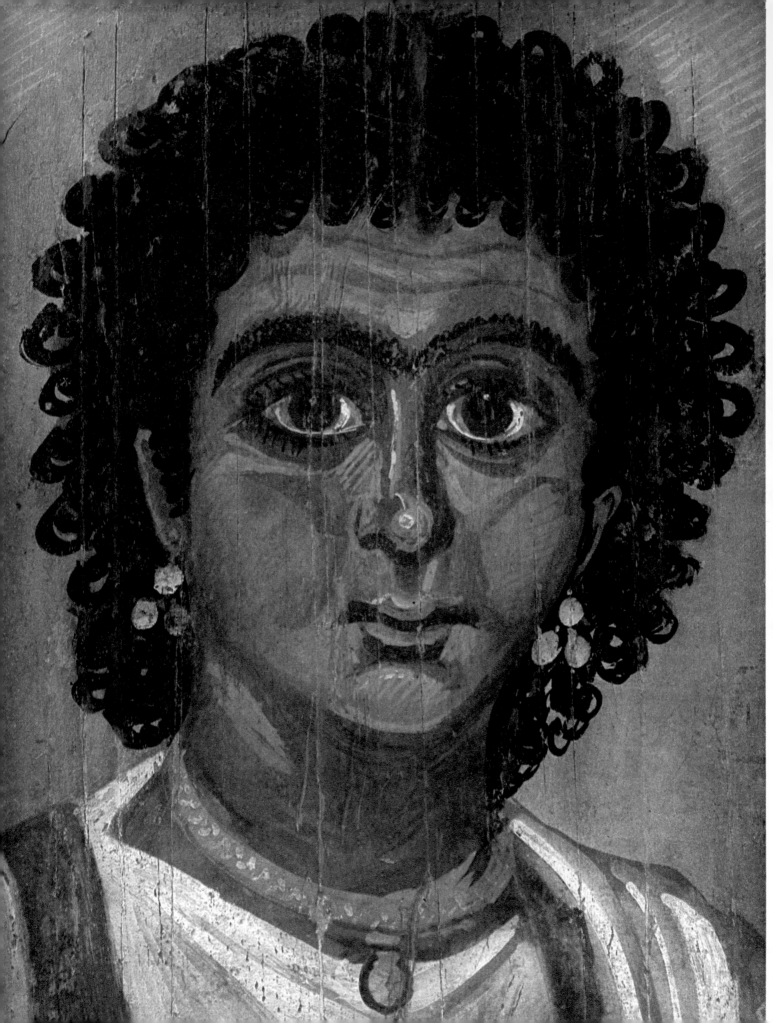

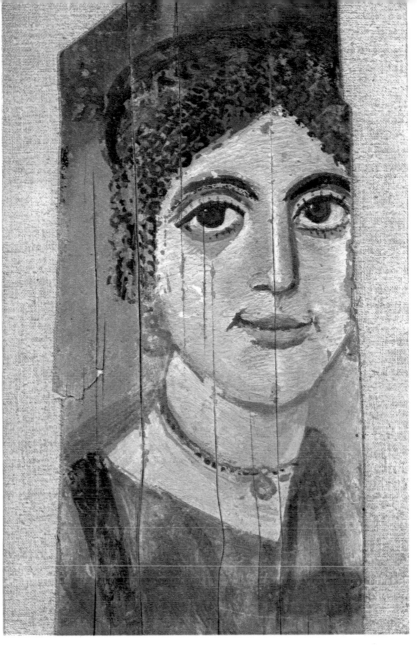

263 THE FAYUM. PORTRAIT OF A LADY. CAIRO, EGYPTIAN MUSEUM

to a more popular, local trend, and reveal different characteristics. One such example –
also, it is thought, of the second century – shows a young girl in a niche, before which
offerings of fruit, drink and flowers have been placed. Another (in the Louvre, formerly
assigned to the third century) reveals a more perfunctory technique, notable for its
strong contrasts – which at once puts it in line with contemporary illusionist painting.
In the second half of the third century, and throughout the fourth (after which they pass
out of fashion), such paintings are always in complete harmony with other artistic
manifestations of the day, even those in other parts of the Empire. They show the same
flattening of mass, the same tendency to formal abstraction, the same emphasis on
expression, with huge, staring eyes. Art-historians generally regard them as the direct
forerunners of Byzantine icons, those of Sinai in particular, and of the Ravenna mosaics.

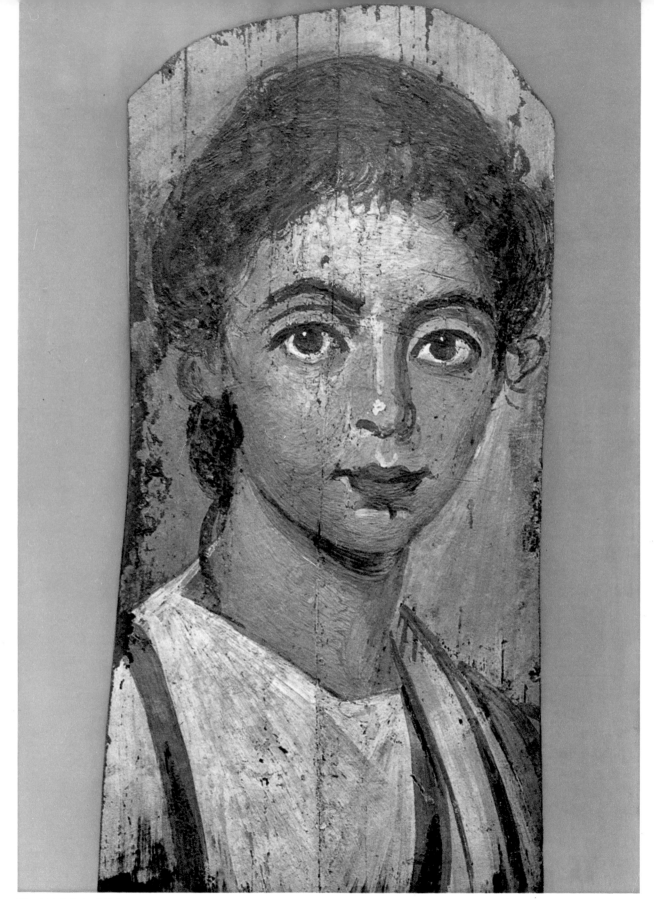

264 THE FAYUM. PORTRAIT OF A YOUNG GIRL. BERLIN, STAATLICHE MUSEEN

288

265 ANTINOE. PORTRAIT OF AMMONIUS, WITH A BOUQUET OF FLOWERS. PARIS, LOUVRE ▶

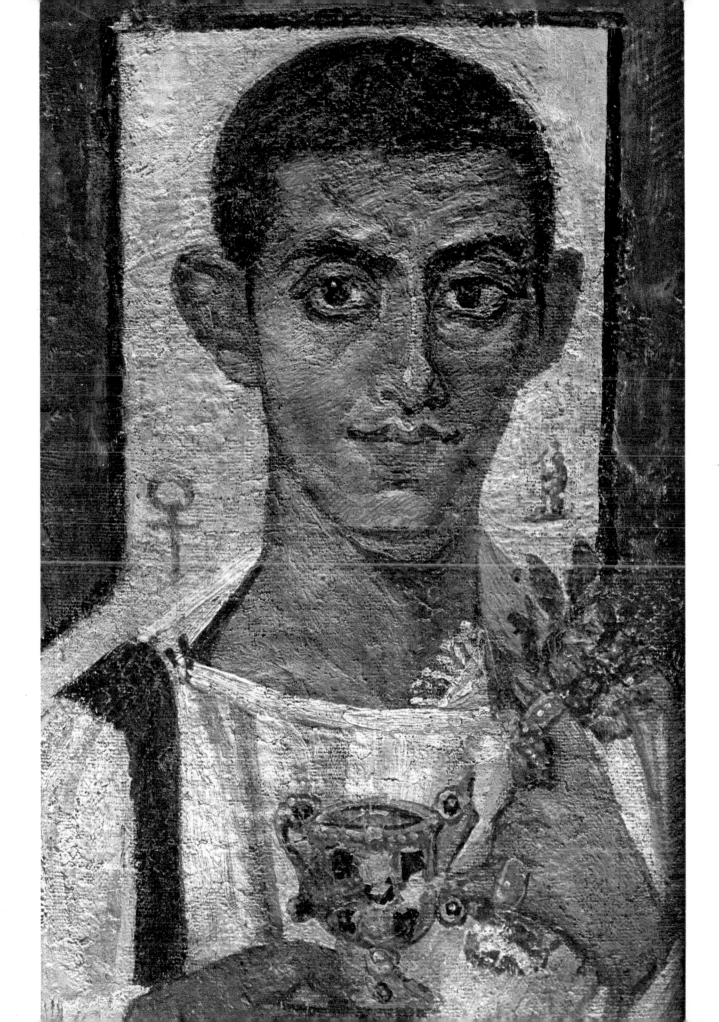

266 LUXOR, TEMPLE OF THE IMPERIAL CULT. WATERCOLOUR AFTER THE ORIGINAL PAINTINGS. OXFORD, GRIFFITH INSTITUTE, ASHMOLEAN MUSEUM

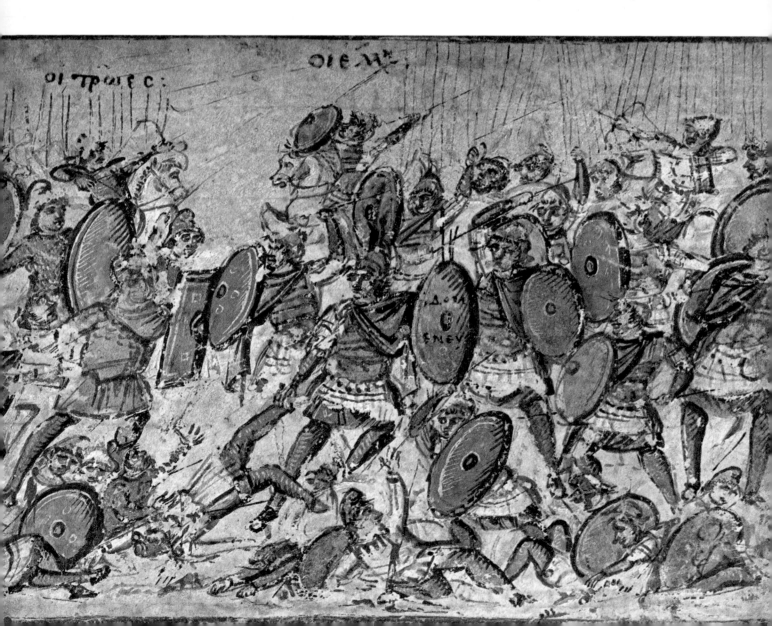

This is fair enough, if one sees these portraits simply as one stage along a general line of development; but it is wrong if one places the origin of this evolutionary process exclusively, or even chiefly, in Egypt. The few works that have survived in the other provinces show, rather, that there was great unity of style in painting, which does not lapse into formal incompetence, even from the fourth century onwards, except in the Western provinces.

It is from Egypt, too (though only indirectly, in the shape of watercolour sketches provided in the nineteenth century by Wilkinson), that we have evidence for commemorative and narrative mural painting: the paintings in the temple of the Imperial cult at Luxor. This cult, connected with a military camp established there under Diocletian, was installed in a former Egyptian temple. The plaster surfacing was removed, and the paintings destroyed, so that scholars could see the reliefs and read the hieroglyphs that lay beneath. Nothing now survives except for Wilkinson's watercolours; but these suffice to show that the compositions were rich in human figures, moving through a spatial dimension which as yet showed no signs of 'frontality' in the main arrangement, but still belonged to the Graeco-Roman tradition.

Further indirect testimony is provided by a group of miniatures used to illustrate a codex of the *Iliad*, and of which the fragments are preserved in Milan (*Ilias Ambrosiana*). The codex was probably written out in Constantinople, at the beginning of the sixth century: this date, which I proposed some time ago, has now been upheld, on palaeographical grounds, by Cavallo. But the miniatures themselves, or at least the greater part of those still surviving, were copied from older models. It is possible to isolate one group based on originals of about 250 (the date at which illustrations in parchment codices first begin), probably from Alexandria. The miniature in Book XIII (Idomeneus with the body of Othryoneus) exemplifies this style of painting admirably: rich in movement, with a clear differentiation between individuals. The existence of such a pictorial tradition is confirmed by certain other paintings, from the Tunah el-Gebel necropolis near Hermopolis (capital of the thirteenth administrative district). Though their subject-matter is ritual and Egyptian, they are Graeco-Roman in form, with mythological features.

The name Alexandria was synonymous with the world's wealthiest and most variegated source of *objets d'art*. From here both patterns and products continued to circulate throughout the Empire until the Byzantine era. At times, 'Alexandrian' is used to denote the output of Eastern Mediterranean centres in general (they remained productive for a long time); at others, it is an object's own characteristics which reveal its Alexandrian provenance. Such is the case with the glassware, and the plaster models designed for toreutic work, which Hackin's French expedition found in the royal palace of Begram, in Afghanistan (late second or early third century). One of these glasses carries a relief representation of the lighthouse at Alexandria (*pl. 268*), while others are painted with figures which are analogous to those in the miniatures of the *Iliad* just discussed. Identical pieces have turned up in Pomerania – which hints at the wide-ranging export markets Alexandria found for her wares. Similarly, it would be possible to cite a measure intended to prevent the abandonment of the Egyptian home market in favour of trade with countries bordering on the Indian Ocean. On the other

267 CONSTANTINOPLE (?). MINIATURE FROM THE ILIAD: IDOMENEUS DRAGGING OFF THE CORPSE OF OTHRYONEUS. MILAN

268 BEGRAM. GLASS DECORATED WITH THE LIGHTHOUSE OF ALEXANDRIA. KABUL MUSEUM 269 THE GLASS OF LYCURGUS. LONDON, BRITISH MUSEUM

hand, the 'Glass of Lycurgus' (once owned by the Rothschilds), a quite exceptional piece decorated with figures in high relief, could come from either Alexandria or Antioch: both are merely conjectures, and both equally possible for such a work. I have observed, when studying the coloured marble inlay-work of Junius Bassus's basilica in Rome, certain Egyptian-type motifs – used to decorate a mythological scene (Hylas carried off by the Nymphs) – which for sheer animation come very close to the figures on the Glass of Lycurgus. This being so, we might attribute both to Alexandrian craftsmen, and perhaps give the vase roughly the same date as the inlay-work, 330–50.

At the beginning of the fourth century, the Egyptian practice of decorating garments with circular appliqués became widespread; examples include a medallion showing a personification of the Nile, with its name in Greek and the symbol of its fertility, the horn of plenty (pl. 271). The work is done in coloured wool, on linen. This piece resembles another, showing a bust of Ge, the Earth, which was found by V. G. Bock during his excavations for the Hermitage (Leningrad), and doubtless formed part of the same garment. Both still preserve the essential features of the Hellenistic pictorial tradition – above all, in their rich texture and cross-hatched colouring.

Yet it is precisely in textile art that, from about this time, there appears also a quite different formal vision, which later developed among the Christian communities of the interior under the name of 'Coptic art'. A characteristic example is the fragment of a

292

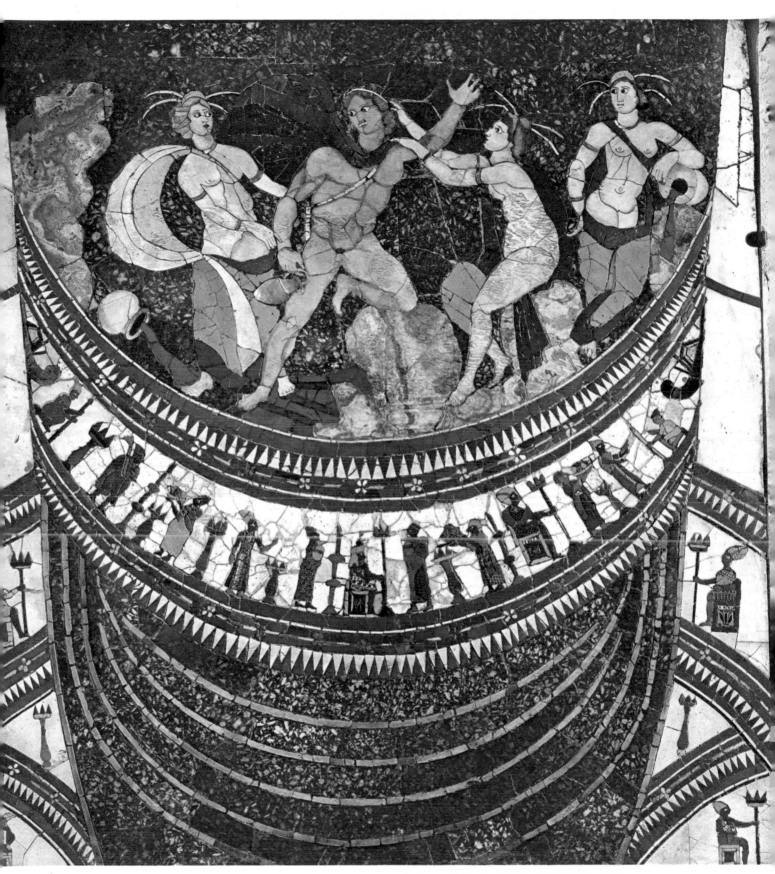

270 ROME, BASILICA OF JUNIUS BASSUS. HYLAS CARRIED OFF BY THE NYMPHS. FORMERLY IN THE PALAZZO DEL DRAGO, ROME

271 EGYPT. CLOTH MEDALLION: THE NILE. MOSCOW, PUSHKIN MUSEUM

woollen wall-tapestry, showing Pan and Dionysus enclosed in a rectangular frame
(*pl. 272*). The halo which both of them wear testifies to what was by now a widespread
convention (in Pompeii, it was still reserved for divinities associated with light). The
features which render this composition so un-Hellenistic in the formal sense are its
'frontality', the exaggerated importance attached to the head, a lack of ease in the design,
and that quasi-ornamental display of characteristic attributes against a plain back-
ground – castanets, Pan-pipes, a jar with handles (*kantharos*). Scholars still disagree
over the genesis of this style, which preserved its own formal canons in painting and
architecture until the Arab Conquest (which began in 640; 646 for Alexandria). Quite
certainly, what we have here is a 'nationalist' Egyptian reaction against Hellenism, with
Sassanid and even Indian elements (brought in along the silk-route) mixed up with it.
This reaction, which had strong support in the rest of the country, outside Alexandria,
was fiercely hostile, not only to Graeco-Roman culture, but to the Mother Church of
Christian Egypt, which seemed too Greek, too speculative. Meanwhile, in the interior,
the masses were rediscovering, in a naive and passionate version of Christianity, that
religious *élan* which had nurtured all the art of ancient Egypt. 'Coptic art' is merely one
element in a more general phenomenon, the rejection by frontier regions of Graeco-
Roman culture, which becomes more apparent when Roman domination begins to
crumble. Everywhere we see aspects of ancient indigenous cultures reappearing –
though naturally much changed by their long experience of Roman Hellenism. 'Coptic

294

272 EGYPT. FRAGMENT OF WALL-TAPESTRY: PAN AND BACCHUS. BOSTON, MUSEUM OF FINE ARTS

art' is restricted to Egypt, and thus cannot be considered one of the factors that transformed Late Empire art, even though it may represent an important element in early Christian art. Scholars have not yet fully elucidated the socio-historical phenomenon which this art constitutes; to do so, they would need to distinguish the various production-centres according to their social composition and economic level. Such a task is rendered difficult by the plundering of cemeteries in antiquity, and that demolition of Roman remains which continued – in a country short of building-stone – right into the nineteenth century.

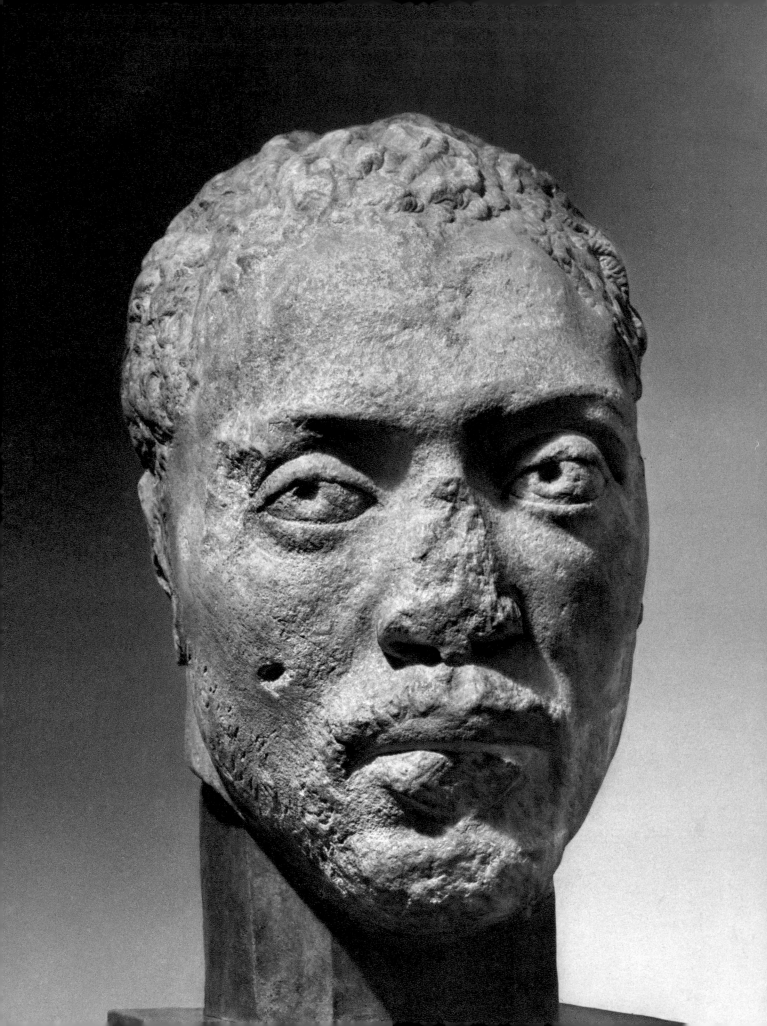

4 Greece, Thrace and Moesia

Throughout the centuries of Roman domination, Athens remained a cultural centre; but she was living on her past, and produced nothing new. In sculpture, the tendency towards heightened expression and baroque colouring was held in check by a fundamentally classical sense of form. In portraiture, the cultural influence of Herodes Atticus is to be noted, a millionaire who taught Marcus Aurelius, founded a school in Athens, and not only built but restored public edifices all over Greece. Any works which represent members of his intellectual circle – the young Polydeuces, say, or Memnon the African – rate among the finest examples of this period's output (*pl. 273, 275*). Both attributions are reasonably secure. Polydeuces, his master's favourite disciple, died young, and Herodes had numerous portraits done of him (several replicas of these still survive). The sculptor has adopted a formal technique calculated to bring out his aristocratic elegance, with its underlying tinge of melancholy. More striking still is the remarkably fine head of the Ethiopian, found on one of Herodes' estates (where he had set up portrait-busts of his best disciples). Herodes Atticus's own portrait, firmly identified by a herm inscribed with his name (in Athens alone there were seventeen statues representing him), has survived in several versions. The best of these (*pl. 274*) suggests a delicate, pensive personality. It is clearly inspired by statues of the fourth century BC, even though the inner spirit transforms it into something quite different.

In the mid-third century, even Athenian statues acquire greater animation, due to heavier chiaroscuro and greater emphasis on expression. We can see this in a series of portraits representing *kosmetai*, officials charged with the education of the young (*pl. 276*). But the finest sculptural works to come out of Greece during this period are the sarcophagi. Monumental, crowded with figures, and in high relief, the best examples faithfully stick to classical iconographic patterns, while at the same time managing to imbue them with fresh life through their incisive technique. Here, too, the running ground-auger is in evidence, though only as a means to detach figures from one another (see, e.g., the arm of the Amazon holding a sword on the Salonika sarcophagus, *pl. 277, 278*), or, restrainedly, in the treatment of hair; the techniques employed by the artists of the Severan reliefs at Leptis Magna would have struck these Greek sculptors as downright barbarous.

297

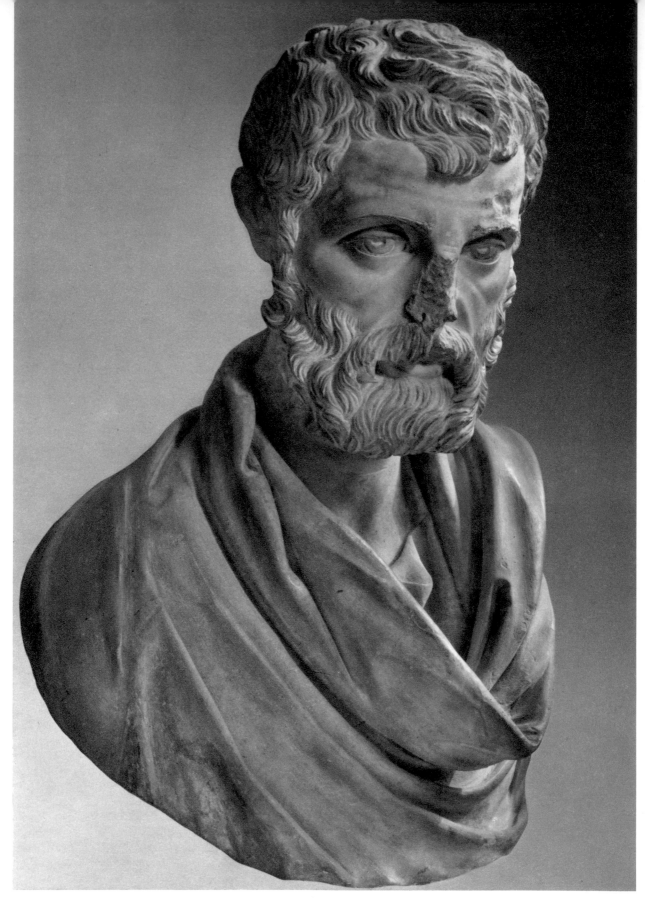

274 PROBALINTHOS (ATTICA). PORTRAIT OF HERODES ATTICUS. PARIS, LOUVRE

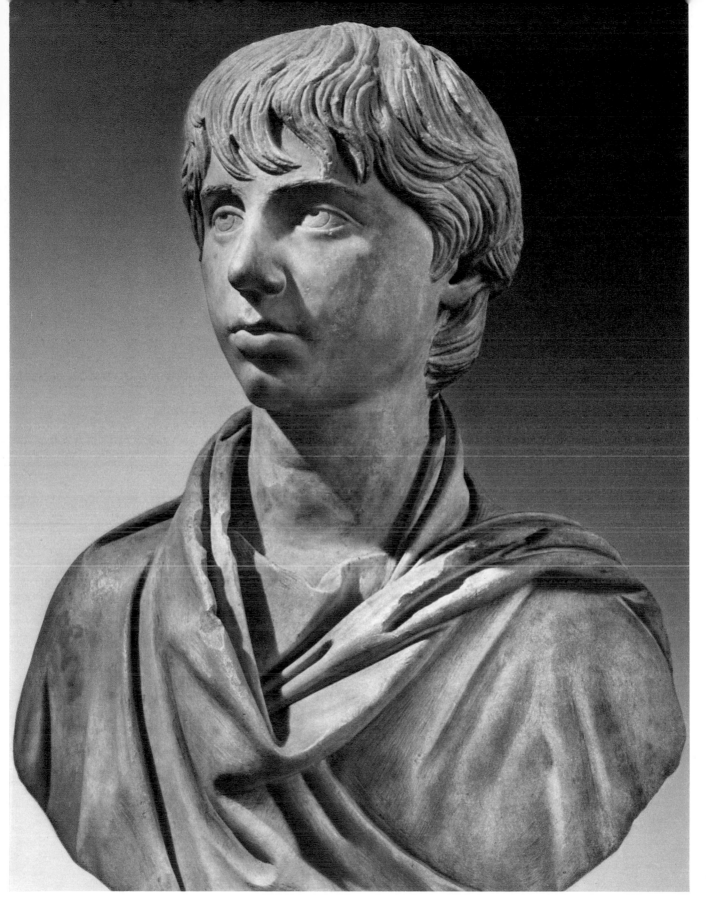

275 ATHENS. PORTRAIT OF POLYDEUCES. BERLIN, STAATLICHE MUSEEN

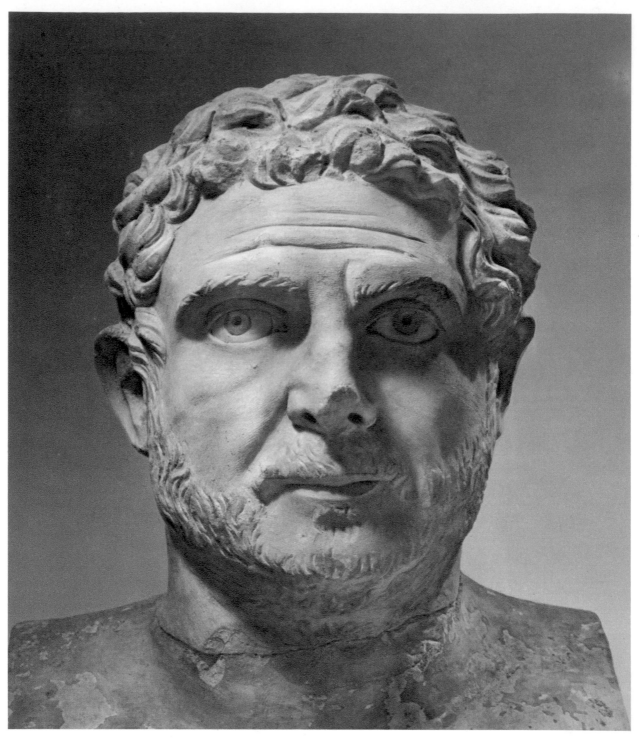

276 ATHENS. PORTRAIT OF A KOSMETES. ATHENS, NATIONAL MUSEUM

These sarcophagi (as noted in Chapter I) were exported to Rome and all the Western provinces. One of the finest is an early-third-century specimen preserved in the Church of S. Nicola at Agrigento, which relates the story of Phaedra and Hippolytus. Here, too, we can postulate the existence, as a model, of some painting that was imitated, with little variation, in every replica. The episode of Hippolytus's death, relegated – as usual –

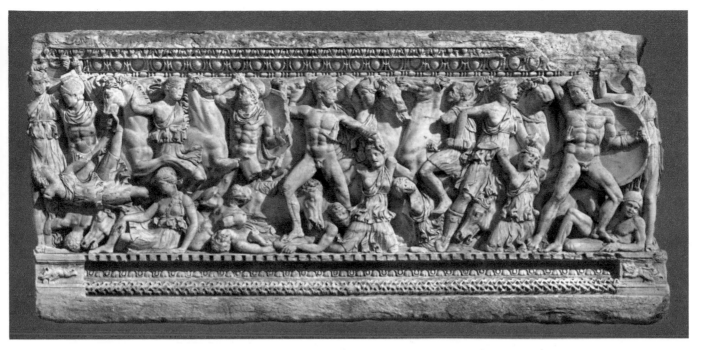

277 SALONIKA. SARCOPHAGUS: BATTLE OF AMAZONS. SALONIKA, ARCHAEOLOGICAL MUSEUM (OLD MUSEUM)

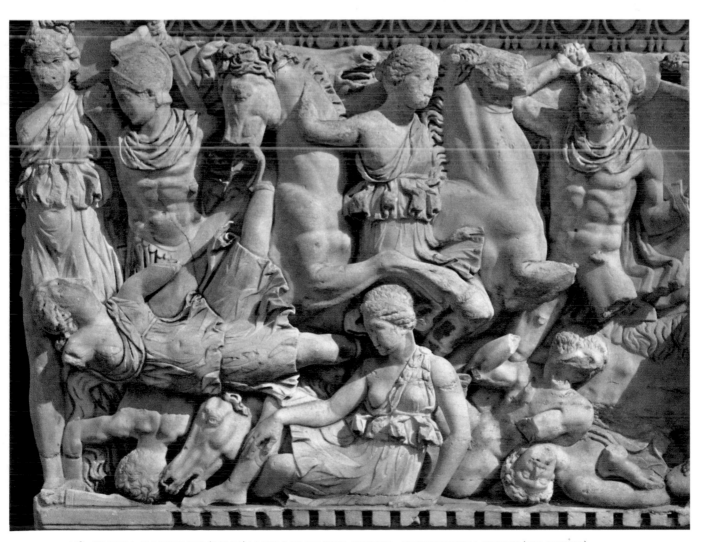

278 SALONIKA. SARCOPHAGUS (DETAIL): BATTLE OF AMAZONS. SALONIKA, ARCHAEOLOGICAL MUSEUM (OLD MUSEUM)

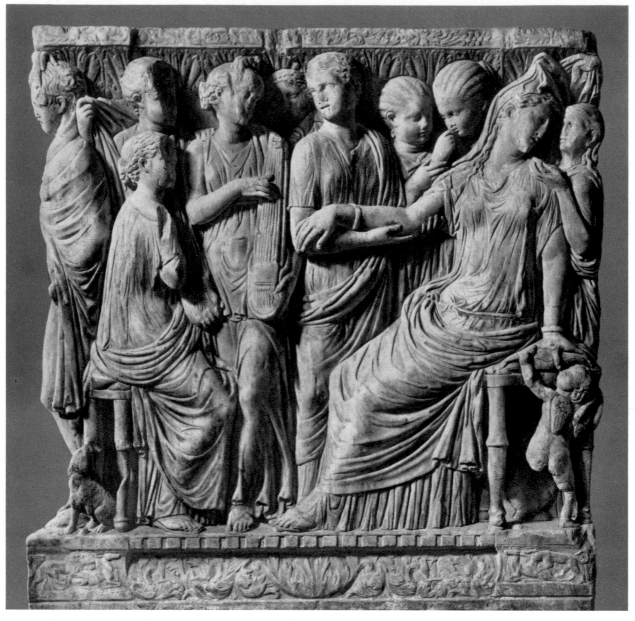

279 ATHENS (?). SARCOPHAGUS (SHORT END): PHAEDRA SICK WITH LOVE. AGRIGENTO, S. NICOLA

to the back, is a particularly obvious piece of pictorial invention. The outline of the figures, like their setting in pictorially conceived space, still observes Hellenistic conventions. The only sign of the times is the intense feeling for human involvement. An ability to comprehend moral anguish is, beyond a doubt, one element in that new artistic trend which emerged at the close of the second century.

But the genuine art of the Late Empire, that which breaks with Hellenistic tradition, does not appear in Greece before the Tetrarchy, and even then only on the periphery of Greece proper, at Salonika. Here there survive the remains of one of the principal monuments from this era: the four-fronted arch set up by Galerius, in the town which he had made his residence, to commemorate his victories over the Persians. Galerius

281 SALONIKA, ARCH OF GALERIUS. CYMA OF A PILLAR (DETAIL)

282 SALONIKA, ARCH OF GALERIUS. RELIEF OF A PILLAR (DETAIL)

283 SALONIKA. FRAGMENT OF A SMALL ARCH OF GALERIUS DECORATED WITH MEDALLIONS. SALONIKA, ARCHAEOLOGICAL MUSEUM (NEW MUSEUM)

was Caesar in the first Tetrarchy (293–305), Augustus in the second (305–7) and the third (308 until his death in 311). The arch, which was unusually high and built with smaller arches, in masonry, probably stood on the Via Egnatia, the trunk-road linking the Adriatic and the Bosphorus. The space in the middle was covered over with a dome. On one of its shorter sides the arch was attached to a colonnaded street, which led up to a rotunda, a Palatine (or Mausolean) chamber, surmounted by a dome. This rotunda, which later became the Church of Haghios Georgios, was converted, at the end of the fourth century, into a Palatine chapel by the addition of an ambulatory, an apse and a vestibule (p. 398). The interior was adorned with marbles and mosaics, still partially preserved. At the lower level these mosaics imitate Persian tapestry-work, with birds and palmettes. Up above, they portray large-scale figures of Apostles, Martyrs and Patriarchs, shown standing in front of fantastic architectural designs against a gold background – a motif deriving from the *frons scenae,* or theatrical façade. This, then, is already a work in the Byzantine manner, something wholly alien to ancient art.

The sculptures on the two surviving pilasters of the Arch of Galerius describe his campaigns in Mesopotamia and Armenia. These pilasters are characterized by an absence of architectural framing at the corners, perhaps a harking-back to the spiral columns in Rome: above all, in view of the deep relief-work, that of Marcus Aurelius. Furthermore, a new element now appears in the composition: those wide transverse cornices, with their strips of vegetal motifs, strongly moulded and rich in chiaroscuro,

305

which divide up the figured scenes and correspond to the great terminal cornice above the pilasters. The emphasis with which these architectural elements intervene to articulate the overall pattern is something unknown in classical art, though it was to become a commonplace in the Middle Ages.

The reliefs are crowded with figures, all standing out sharply from the background; yet for want of any compositional formula to clarify their narrative significance, they lack real density. Characters of varying sizes meet and mingle, not according to any hierarchical criteria, but solely (it would seem) as space-fillers. Traditional iconographic motifs (especially with battle-scenes involving the Emperor) jostle scenes which must derive from travel-notes taken during the actual campaigns (groups of exotic animals). On the cornices we find echoes of the architecture of Diocletian's palace at Split, and, even more, of the fragmentary frieze from the five-columned monument set up in the Forum Romanum in honour of the Tetrarchs. These sculptures suggest an artist brought up in the provincial environment of the Adriatic, but also in direct contact with Rome – which would be in keeping with the Illyrian background of Galerius himself.

On the side opposite to that which opened on the colonnaded street, the Arch was connected with the Palace of Residence (the remains of which have been identified). Nearby have been found the fragments of a smaller arch, in marble, decorated with medallions, which are being held up by human figures as if they were *imagines clipeatae,* or shield-portraits. One of these medallions presents a portrait of Galerius (important as an iconographic document), while the other contains the head of Tyche, the town's divine protectress.

All these monuments are official. But side by side with them there existed a local tradition, turning out typically Macedonian funeral stelae, adorned with numerous portrait-heads (up to seven, on occasion), all joined together. Some, slightly more correct in style, recall the stelae of Thrace. During this period, Macedonia, Thrace and Moesia formed, artistically speaking, a single province, distinguished not so much by its formal characteristics as by its typology, and this derived from Greece; whereas the typology of Illyria, Dacia and Pannonia was linked with Aquileia. Here the funeral stelae revert to traditional patterns of composition: the deceased person, in heroic guise, reclines at the feast, surrounded by his family and servants, the latter shown very small. Formally, these stelae sometimes preserve a correct, if frigid, neo-classical manner (see the Varna stele), but more often they descend to a crude 'provincial' design. What we have here is a repetition (see the Vranja stele) of the phenomenon observable in all 'plebeian' art: the desire to emphasize and honour the principal characters leads the artist to ignore true proportions. What matters in these small, close-packed figures is the head – a deliberate, if no more than approximate, attempt at a likeness. The small bust in the background provides a link between this stele (now in the Sofia Museum) and the multiple-portrait ones from Macedonia.

A special feature of this region (Northern Greece, Macedonia and Bulgaria) is the repetition of a figure known as the 'Thracian horseman', in thousands of little votive reliefs and, less often, in funeral stelae, from the second century onwards. Its iconography is undoubtedly Hellenistic; but we do not know whether this divinity was previously represented in a different form, or whether his cult actually originated at this

306

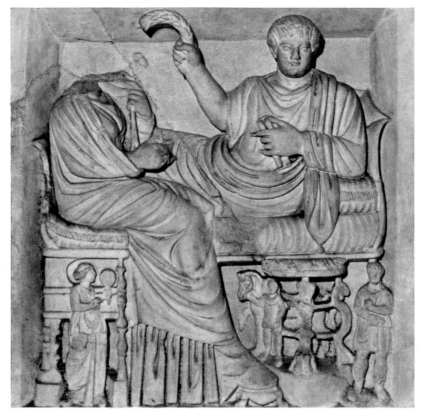

284 VARNA, FUNERARY STELE OF DIONYSOGENOS. VARNA ARCHAEOLOGICAL MUSEUM

285 VRANJA. STELE WITH FUNERAL BANQUET. SOFIA, NATIONAL ARCHAEOLOGICAL MUSEUM

286 VARVARA. CULT-RELIEF OF THE THRACIAN HERO. SOFIA, NATIONAL ARCHAEOLOGICAL MUSEUM

288 KRITCHIM. CULT-RELIEF OF THE THRACIAN 'HEROS'. PLOVDIV ARCHAEOLOGICAL MUSEUM

time. In the inscriptions, he is designated by the name *Heros,* or *Heron.* We find occasional variations on the Hellenistic type: sometimes (see the Kritchim relief) it verges on the grotesque, with the usual distortions that this implies. Side by side with these representations we find others, very similar from the artistic viewpoint – those of the so-called 'Danubian' horseman, or three-headed hero. Formally, we are still in the same context: that of poor craftsmen, sensitive enough, but without any capacity for personal innovation.

Yet it was in this context of humble craftsmanship that there came into being one of the most impressive monumental ensembles that Roman rule over these provinces ever produced: the trophy of Adamklissi in the Dobrudja (Rumania). If we compare the horse on a relief from Erzerovo, portraying a Thracian cult-hero, and that from metope

289 EZEROVO. CULT-RELIEF WITH A HORSEMAN. SOFIA, NATIONAL ARCHAEOLOGICAL MUSEUM

291 ADAMKLISSI, MONUMENT OF TRAJAN. METOPE: TRAJAN AND A LIEUTENANT. ADAMKLISSI MUSEUM

no. I on the Adamklissi frieze, we find that they share a common matrix. This, it seems to me, is the most plausible explanation for the genesis of the reliefs decorating this monument, over which there has been so much dispute. What now seems certain is that the monument dates from Trajan's reign; at least one of its reliefs (metope no. XLIV) portrays Trajan himself, though in a highly distorted form.

Radu Vulpe (1964) offers an ingenious explanation of why the monument was set up in the Dobrudja plain, rather than on the mountain heights of Dacia. He assumes that Xiphilinus's brief account of Dio Cassius ran together two originally separate passages, and that the suppressed section contained the description of a decisive battle which

311

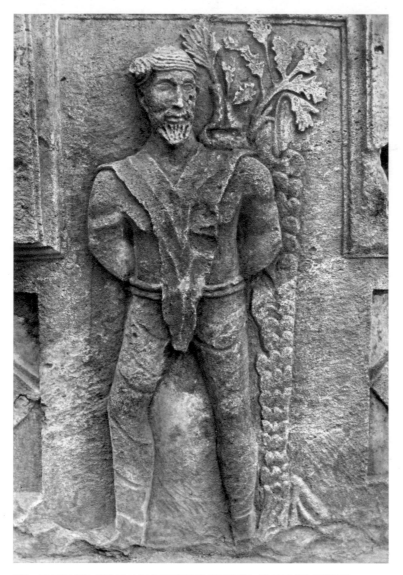

292 ADAMKLISSI, THE TRAJAN MONUMENT. PRISONER. ADAMKLISSI MUSEUM

took place in the Dobrudja, and for the reality of which there is considerable evidence. Further, this great triumphal monument was very close to the altar-cum-cenotaph on which were inscribed the names of the fallen (3,800 in all, to judge by the spacing), and which perhaps also commemorated the defeat incurred in this area in Domitian's reign.

The monument itself, a vast circular construction, stood overlooking the crossing-point on the main roads from the Black Sea to the Balkans, on the right bank of the Danube. Set on the edge of a vast plateau, it dominated the entire valley below (in which a fortified Roman settlement lay) and was visible from a long way off. The core of the structure was 31 m. in diameter – only half as wide as Hadrian's mausoleum, which it somewhat resembles – and covered with dressed stones. Above the tambour it was decorated with merlons, each carrying the figure of a prisoner carved in relief. The ethnic characteristics revealed by these figures give us a good idea of the combatants taking part in the battle. Typologically, these reliefs recall the figures of prisoners from

293 ADAMKLISSI, THE TRAJAN MONUMENT. METOPE: BARBARIAN FAMILY ON A CART. ADAMKLISSI MUSEUM

Gallia Narbonensis: they are therefore traditional, except as regards their artistic character. The metopes formed a sequence of forty-four reliefs, each framed by little pilasters that were either fluted, or picked out with vegetal motifs. The composition of the reliefs varied a good deal, and was sometimes very remarkable. For instance, side by side with some ordinary soldiers (both infantry and cavalry) shown on the march, we have battle-scenes composed in a highly original manner. Among the latter is metope no. XXXI, in which the naked and headless body of a barbarian is shown in the foreground, while behind it a Roman soldier, wearing a cuirass and armed with shield and spear, attacks another barbarian who has sought refuge up a tree (*pl. 295*). In another (no. XXIV) the pile of barbarian corpses, thrown down on shields, recalls scenes from Trajan's Column. It is similarities such as this which enable us to trace these reliefs back to source. In my view, the designs were made in Rome, by some member of that highly creative artistic circle which grew up round the *Maestro della gesta di Traiano*.

313

294 ADAMKLISSI, THE TRAJAN MONUMENT. METOPE: DACIANS KILLED IN BATTLE. ADAMKLISSI

They were then sent out to the site, and executed by local craftsmen. The reliefs on Trajan's Column must, similarly, have been based on a design worked out by the master-artist, rather than on a relief maquette. Metope no. IX, which portrays a barbarian family riding on a two-wheeled ox-cart, tends to confirm this theory (*pl. 293*). Despite considerable formal simplification, the scene preserves a sense of perspective. The cart moves obliquely from background to foreground, its wheels are seen from an angle and therefore made oval, while the back wheel's spokes are foreshortened. No local stonemason could ever have conceived such a composition unless he had a really intelligent design from which to work. The metope showing Trajan with one of his officers (*pl. 291*) is likewise composed in perspective; whereas not only Roman plebeian art, but also the 'non-cultivated' art of the provinces, invariably used the full-face pose for such a representation – a practice which heralds the *représentations d'apparat* of the Late Empire.

If this is true, then everything that has ever been said about the importance of the Adamklissi reliefs for the evolution of ancient art into that of the Late Empire and the Middle Ages will have to be reassessed in terms which restore the sculptures to their true position, that of a local, episodic phenomenon. And the phenomenon is revealing. It

314

295 ADAMKLISSI, MONUMENT CELEBRATING TRAJAN'S VICTORIES. METOPE: SOLDIER IN COMBAT AGAINST THE DACIANS.

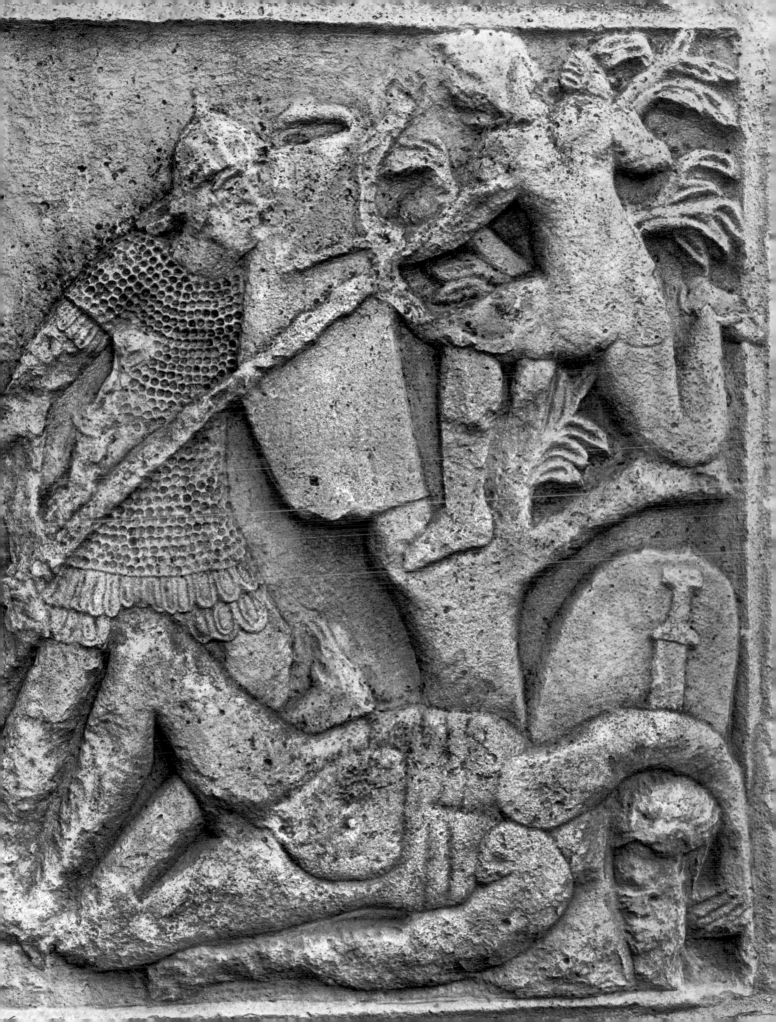

297 ADAMKLISSI, MONUMENT CELEBRATING TRAJAN'S VICTORIES. THE RUINS

shows us how easily, how spontaneously, a model could be transformed, without any conscious resort to the 'influences' of other artistic civilizations. When this 'translation' took place in an environment where Hellenistic figurative culture did not exist, it made no difference if the model was still fully aligned with Hellenistic tradition (even that special Roman variety which it assumed under the Empire): the result, formally speaking, was something which seemed at first sight far later, if not wholly medieval.

The same simplification of classical elements appears in the ornamental part of the monument. On the other hand, the remains of the gigantic trophy which once surmounted it are perfectly in line with the usual pattern for such compositions: the inspiration could only have come from a Roman model. At the top we have a cuirass surrounded by shields (there was probably a helmet above it, too, though of this only a few fragments survive); the *cingulum militiae,* with its rows of lappets, hangs down beneath. At the base there are some seated prisoners. The overall height is considerable: over nine metres.

Despite its incidental crudities, this monument is clearly stamped with the Roman imprint, both generally and in detail. The provincial culture of Moesia, by contrast,

317

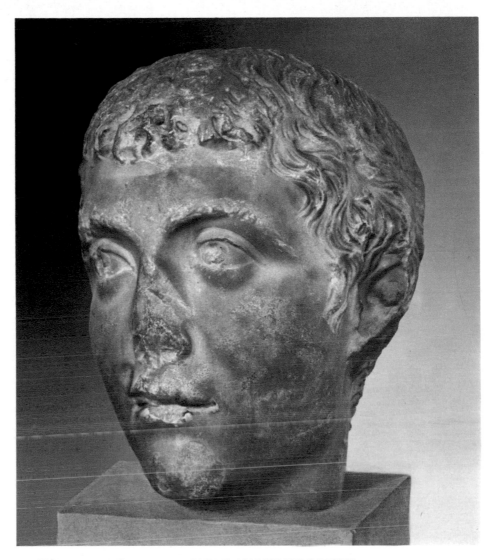

like that of Thrace, was either based on Hellenistic patterns, or else reverted to a purely primitive or Celtic-type schematism (see *pl. 298*, from Varna Muscum).

The larger centres of Thrace, however, reveal not only echoes of Western Roman art, but signs that schools of marble-workers from Asia Minor were once active in these parts. Various portraits recall the presence of Rome. We recognize the style of the Antonine period in a head from Pastoucha (*pl. 299*); that of the early third century in a bronze portrait of Gordian III (*pl. 300*); and that of the Tetrarchy, when Serdica (Sofia) was for a time an Imperial residence, in the head from the Sofia Museum (*pl. 301*). The presence of teams of masons from Asia Minor, probably from Aphrodisias, is proved by the ornamental facings of a large villa near Isvailovgrad (still being excavated), and by a beautiful fragment (*pl. 302*) from ancient Oescus (Gigen), which can be linked up with some of the detailed work on the pilasters of the Leptis basilica (*pl. 303*). The Asia Minor workshops were also undoubtedly responsible for a fine statue from

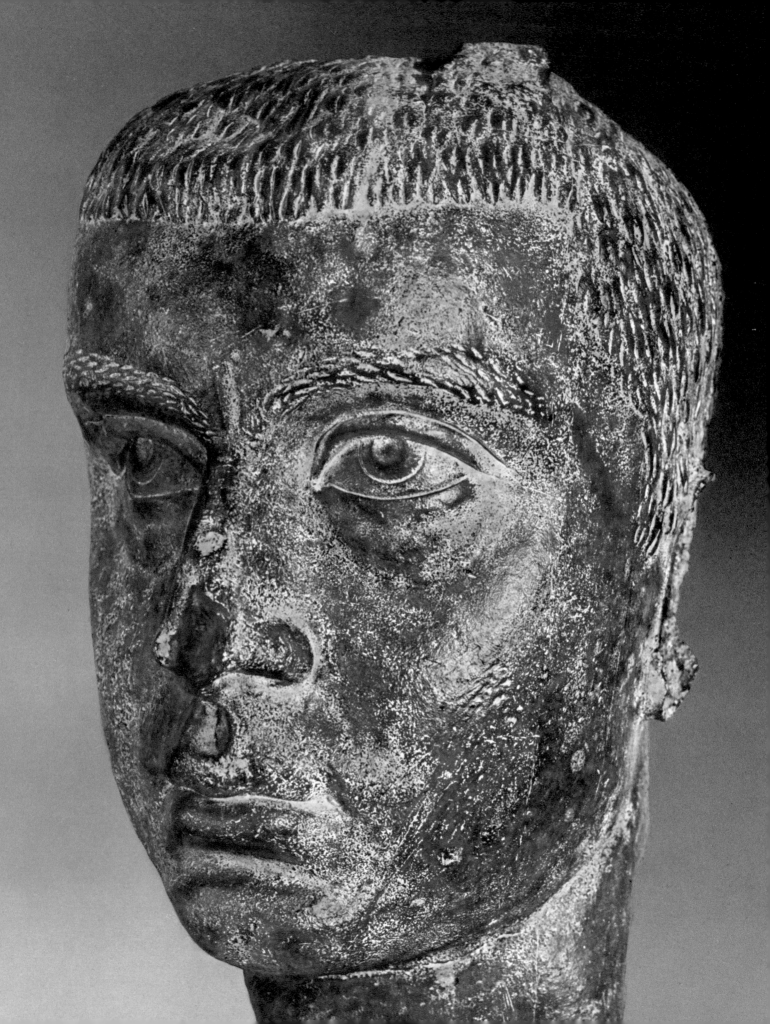

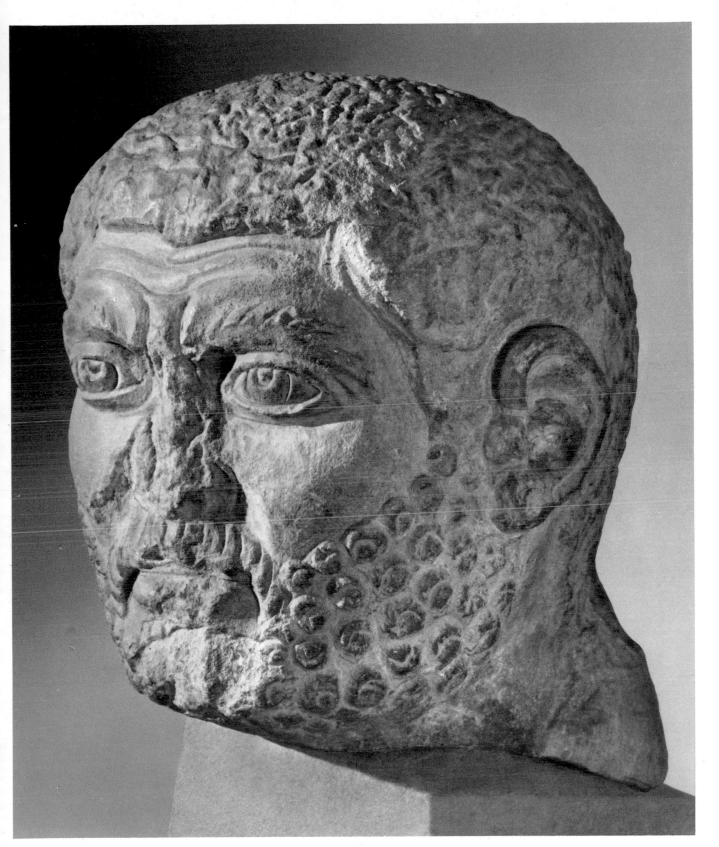

301 BREST (PLEVEN). PORTRAIT OF A MAN. SOFIA, NATIONAL ARCHAEOLOGICAL MUSEUM

◄ 300 NIKUP. PORTRAIT OF GORDIAN III. SOFIA, NATIONAL ARCHAEOLOGICAL MUSEUM

302 GIGEN. FRAGMENT OF ARCHITECTURAL ORNAMENTATION. SOFIA, NATIONAL ARCHAEOLOGICAL MUSEUM

Constantza, representing a goddess carrying a cornucopia (*pl. 304*). This deity can be identified as Tyche, protectress of the town of Tomis and its port (symbolized by the small figure at Tyche's feet). From the beginning of the third century (the date of the sculpture) Tomis, as is shown by the impressive civic amenities lately brought to light, went through a great boom period. From personal examination of this material, I would suggest that it should be dated to the Severan period.

322

303 LEPTIS MAGNA, SEVERAN BASILICA. DECORATION ON A PILASTER (DETAIL) ▶

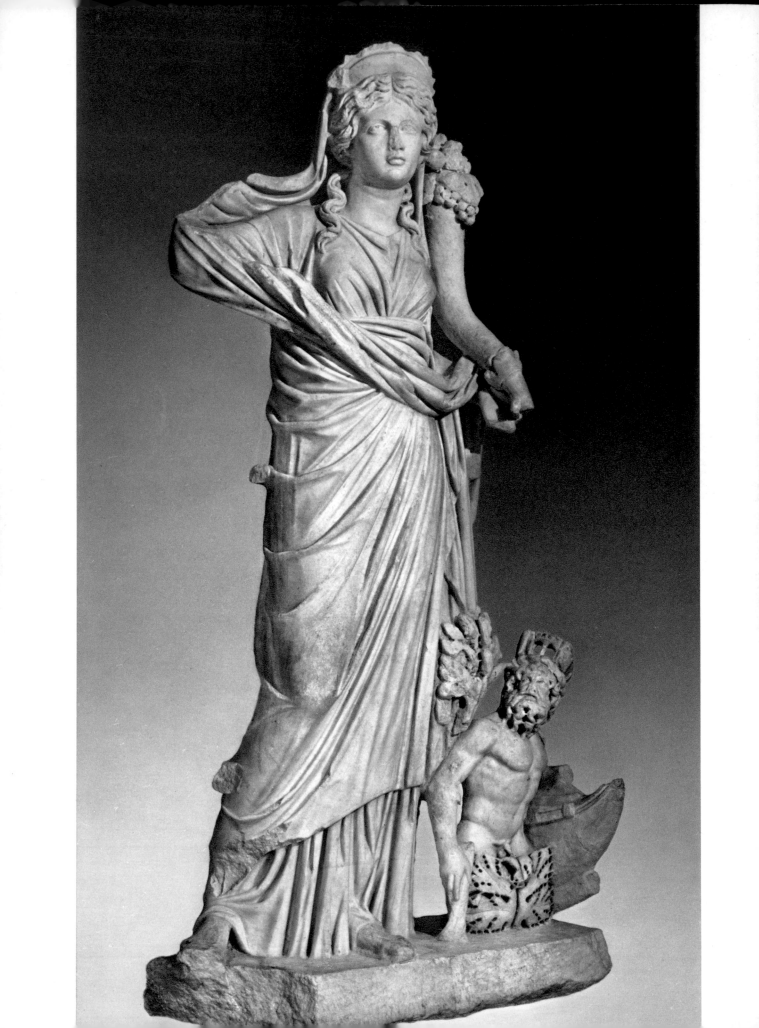

305 STARA ZAGORA. MOSAIC WITH FISHING AND HUNTING THEMES (DETAIL)

On the other hand, the mosaic floorings from the Isvailovgrad villa already mentioned, as well as the other remains preserved *in situ* at Stara Zagora, show the clear influence, in Thrace, of Western models and workmanship. The same, I believe, can be said of the paintings in a small tomb-chamber at Silistra (Lower Moesia), on the right bank of the Danube (*pl. 306, 307*). Stylistic considerations, together with certain local historical events, enable us to date these paintings to the second half of the fourth century. Any parallels that spring to mind are Western rather than Eastern, whether it is the main figures or the vaulting-decoration. The little animals and hunters which occupy the panels on the ceiling are sketched with a light hand, and the *trompe-l'oeil* beams, though structurally meaningless, do preserve, by way of ornamentation, a spatial element which originated very far away from here.

307, 308 SILISTRA, TOMB. CEILING PANELS (DETAILS)

306 SILISTRA, TOMB. WALL- AND VAULT-PAINTINGS

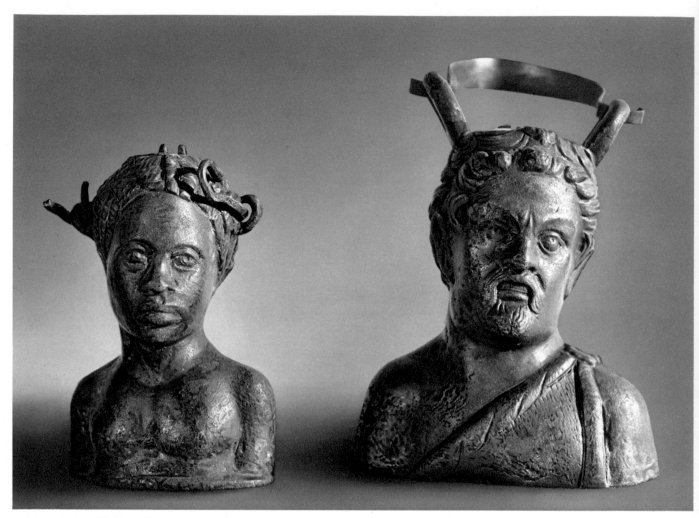

309, 310 VARNA. SMALL JARS IN THE FORM OF PORTRAIT-BUSTS. VARNA, ARCHAEOLOGICAL MUSEUM

This area, like the Western provinces and the northern shores of the Black Sea, imported small bronze pots in the form of portrait-busts, doubtless for use as perfume-braziers. They came from Egypt, produced, it seems, by Nubian workshops.

Evidence for the foreign, probably Alexandrian, provenance of inlaid marble-work panels is furnished by some panels of glass paste (still partly packed in boxes) that have recently been discovered at Cenchreae, the southern port of Corinth (*pl. 311, 312*). They can be dated to about 350, and are decorated with Nilotic scenery and figures representing Plato and Homer – a significant choice in both cases. This was the period when mystical Neo-Platonism, especially in Alexandria, had begun to attract even Christian thinkers; while the upper classes, anxious to prove themselves in touch with the great days of classical culture, practically worshipped Homer. One particularly significant piece of evidence, from Argos in Greece, is a late-fifth-century mosaic portraying the months (*pl. 313*). Their iconography, in this mosaic, includes features from both Eastern-cycle and Western-cycle calendars (e.g., in the representation of March, Mars is portrayed as an Oriental-type warrior, but we also find a pot of milk and a swallow – both items from the Western repertory). Themes connected with the cycle of the seasons

328

311 CENCHREAE. GLASS PASTE PANEL: LANDSCAPE (DETAIL). CORINTH MUSEUM

are very much to the fore, but as symbols rather than representations of the work appropriate to each month. January is shown as a consul in a toga, just raising the *mappa* as a signal for the Games to begin, and largesse to be scattered. These motifs recur on a mosaic from Tegea, which is already rather more Byzantine in tone. This shows that, in fifth- and sixth-century Greece, there evolved certain stock patterns built up from disparate, though in one sense autonomous, elements. The stones used in the Argos mosaic are all of local origin. This mosaic occupied an L-shaped portico, looking out on the inner courtyard of a rich private house. Other sections of flooring had Dionysiac subjects (perhaps motivated, like the months, by a symbolism that still had links with Hermetic philosophy), or scenes of falconry and big-game hunting.

This mosaic consists of panels framed in animal and vegetable motifs: it is in the Syrian tradition, and still classical, though its figures no longer show any trace of ancient classicism. Yet they remain unaffected by the new Byzantine style. Provincial-type models are still circulating round the shores of the Mediterranean, like a new *koine*, or common language, employed by all craftsmen, which Greece, too – from now on part of a peripheral culture – shared with everyone else.

329

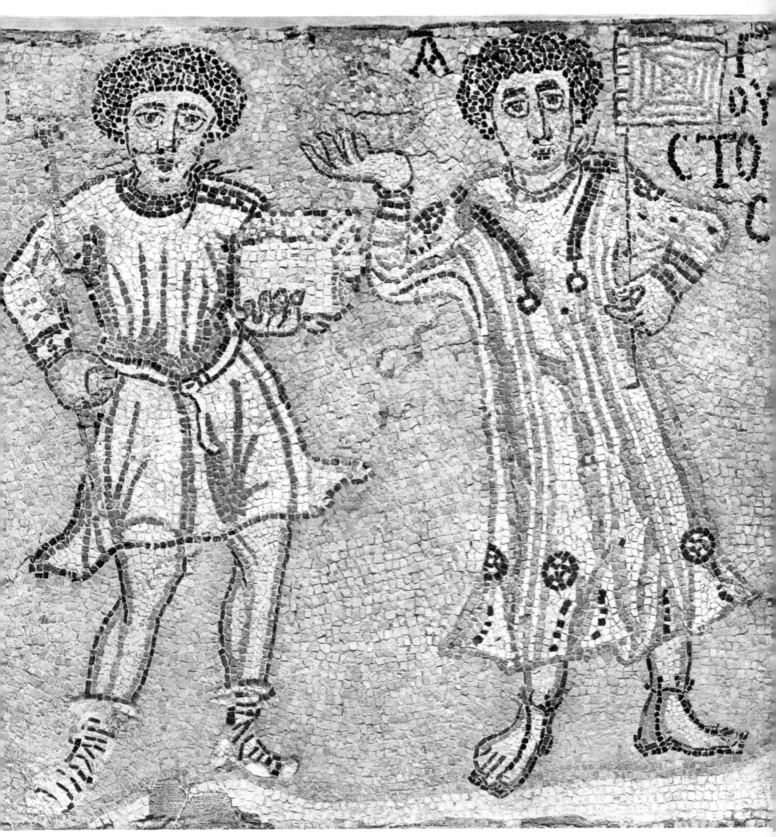

313 ARGOS. MOSAIC OF THE MONTHS (DETAIL): JULY AND AUGUST. ARGOS MUSEUM

◀ 312 CENCHREAE. GLASS PASTE PANEL: HOMER. CORINTH MUSEUM

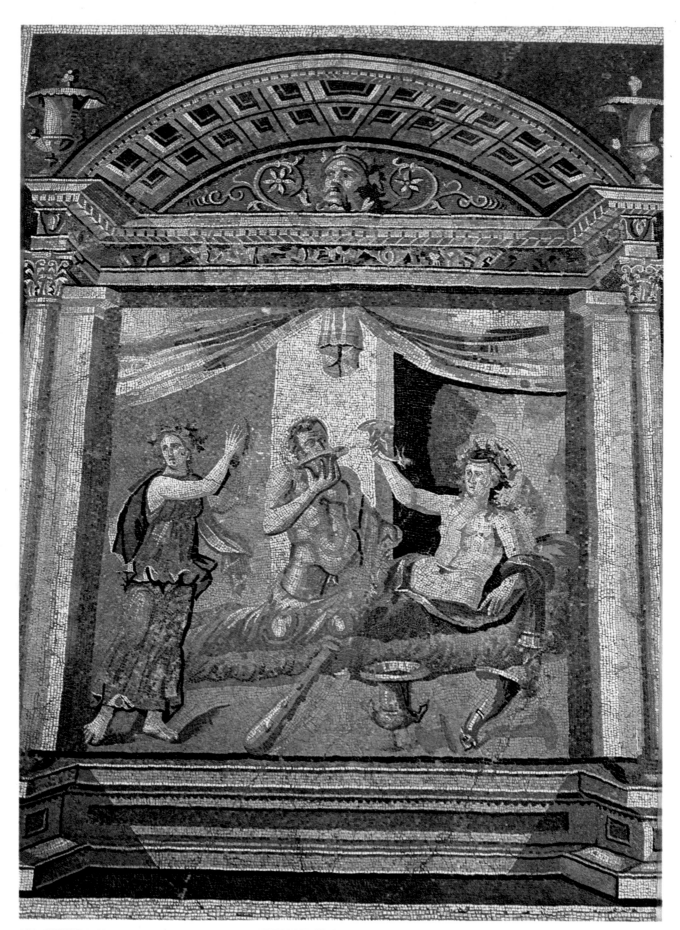

314 ANTIOCH, VILLA. MOSAIC: DRINKING CONTEST BETWEEN DIONYSUS AND HERACLES. PRINCETON UNIVERSITY ART MUSEUM

5 Syria and Asia Minor

M Y survey of the provinces up to this point has been more cursory than I could have wished; and even less space is left me to deal with the transition, in the Eastern provinces, from Hellenistic form to that of the Late Empire. This constraint, however, is partly offset by the fact that the Eastern provinces have been more thoroughly studied, as regards their artistic development, than most of the other provinces. My own treatment, then, can limit itself to presenting the conclusions of the many scholars who have already written on the subject, and will be based largely on evidence which has already been published.

In order to grasp the sequence of events, we must go back to the works of Josef Strzygowski, from his earliest researches in 1893 to the famous *Orient oder Rom* of 1901, and the various other studies he published between then and 1920. His constant efforts to shift the origins of Early Christian and Late Empire art ever further eastward had the effect of introducing to European culture many hitherto unknown works from Iran and Central Asia. This achievement will make posterity forgive his violent attacks on other scholars, one symptom of the distressing psychological condition from which he suffered at the end of his life. Some of those who opposed Strzygowski's thesis were highly reputable scholars (Riegl, Wickhoff, Wölfflin, Von Schmarsow), but all were adherents, or rather precursors, of the idealistic method in art-history. This saw art as a wholly self-contained phenomenon, which evolved, at a formal level, according to its own internal principles, without regard to other historical factors. Indeed, so thoroughgoing were its exponents that they had nothing but theories and words with which to counter the facts and documents presented by Strzygowski. His other opponents – mostly scholars of dubious scientific standing – set up a kind of *parti-pris* 'Mediterranean' nationalism against the Asiatic civilization that he posited, and for a long time all studies were bedevilled by the red-herring dilemma of 'Rome versus the Orient'.

Only recently have scholars realized that the problem, as stated, was nonsensical, and bore no relation to historical reality. Corrections, too, were made to a number of erroneous facts and dates on which Strzygowski and his school had based more than one argument. (For instance, they assigned the fortress of Mushatta, in the Jordanian desert, to the second or third century, whereas we now know that it was built by the Umayyads,

about 740.) Furthermore, while the validity of certain formal contributions was recognized, it became clear that such influences had to be relegated to a somewhat later period. One instance of this is the relationship between Armenian and Western church-architecture, a relationship which really existed only in the context of the Middle Ages. Even in Armenia itself, those few edifices for which a date in the first half of the fourth century seems indisputable (the cathedrals of Dvin and Echmiadzin, the churches of Kasakh and, possibly, Diraklar) can be seen as local creations, borrowing elements from the Eastern tradition (Hatra in Mesopotamia, Sarvistan in Sassanid Persia), but exclusively in the technical sphere: their formal structure and proportional relationships are still fundamentally Hellenistic. Above all, they appear very different from anything we find in Constantinople, in the great Byzantine architecture of Justinian's era.

The discoveries made at Dura-Europos between 1921 and 1936 – first by Breasted and Cumont, then by an expedition from Yale University – seemed to have solved the problem of how the formal canons which characterize the Late Empire and Byzantium first came into being. Originally, during the Hellenistic period, this town was a Greek colony. Later it was taken over by the Parthians, and became an important fortress and caravan-station. In 165 Trajan conquered it. After this it was transformed into a Roman garrison town on the Syrian frontier, and served as a base for campaigns against the Parthians. Finally, soon after 256, it was reconquered and destroyed by the Persian Sassanids. Its monuments, therefore, are all datable before the middle of the third century. The paintings are particularly important, since they reveal – in a far more developed form than do the representations on the Arch of Constantine – such features as full-face portraiture, hierarchical rather than naturalistic proportions for human figures, and the abandonment of perspective. Similar conclusions had already been drawn from the architectural and sculptural monuments of Palmyra (a town in the Syrian desert, vassal to Rome – though enjoying a certain degree of independence – and destroyed, by way of reprisal, in 272, after Aurelian's campaign against Queen Zenobia). The discoveries at Dura-Europos meant, it was felt, that Palmyran art could not be treated as something merely local or marginal; it implied, rather, the existence of a Partho-Syrian artistic civilization which exercised a decisive influence on the evolution of art in antiquity, provoking that formal mutation known to us as the Late Empire style (which in its turn – after a further influx of Eastern influences – gave rise to Byzantine art), and thus marking the end of the ancient world.

This evolutionary pattern appeared to win general acceptance, and confirmation for it was sought in the excavations conducted by Princeton University and the Louvre at Antioch (1932–9). Antioch was not merely the seat of the Roman governor in Syria, and of other top-ranking civil or military officials; it had also been a brilliant centre of Hellenistic culture, and from the Imperial period onwards became the *de facto* metropolis of the East, only later equalled by Alexandria and Constantinople. In the Esquiline Treasure (mentioned earlier apropos Projecta's bridal casket) there were four silver statuettes, personifying Rome and three other equally important cities: Alexandria, Antioch and Constantinople. In 526 Antioch was severely damaged by an earthquake; and in 540 the Persians sacked the city, an event from which it never recovered. We have a vivid description of its culture, beauty and luxury during the fourth century in a minor

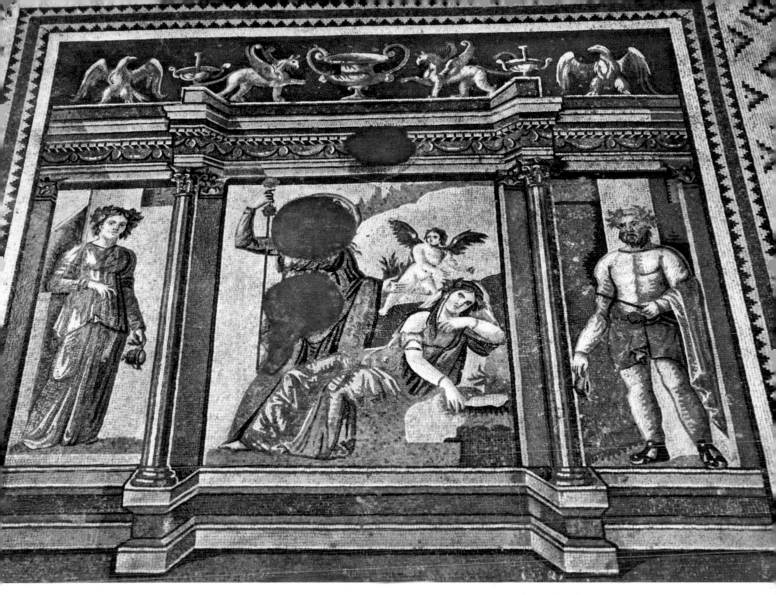

315 ANTIOCH, VILLA AT THE FOOT OF MOUSSA DAGH. MOSAIC: DIONYSUS AND ARIADNE. ANTIOCH, MUSEUM OF MOSAICS

work by Libanius, written after 350. For forty years Libanius had taught and moulded the upper-class youth of Antioch, both pagan and Christian; one of these Christians, who later achieved great eminence as St John Chrysostom (b. 349), gives us further descriptions of his native city. Other details, again, are to be found in a work by the Emperor Julian (the *Misopogon*, notable for its bitter autobiographical references), composed during his visit to Antioch in 363. It was here that Julian's austerely fanatical dream of revivifying paganism lost all chance of success. Its substance dissolved into that brand of intellectual formalism affected by Libanius and the other rhetoricians he had gathered round him; and the worldly frivolity of Antioch's ruling classes (most of whom, anyway, called themselves Christians) was an insuperable obstacle to its development.

It was confidently expected that excavations in this lively, wealthy, fashionable Syrian capital would confirm the predominance of Eastern artistic influences during the third and fourth centuries. In fact they revealed exactly the opposite. The ample harvest of magnificent mosaic flooring, both from wealthy town-houses in Antioch itself, and from various villas in the elegant garden-suburb of Daphne, shows that the Hellenistic

335

tradition went on uninterrupted until the end of the fourth century. (We may note, further, that it is the coins struck at Nicomedeia and Antioch by Constantius II, in 355, and carrying the personified figure of Constantinople, which best preserve a formal reminiscence of classical art.)

History cannot be reduced to preconceived patterns or ready-made formulae. We must, therefore, continue to examine such evidence as we can assemble, and draw our conclusions later. At Antioch, early third-century mosaics such as that of the drinking contest between Heracles and Dionysus, or that portraying Dionysus with Ariadne, are still clearly based on paintings conceived in terms of neo-classical Hellenism (*pl. 314, 315*). The urge to imitate painting brought mosaic technique to an extreme pitch of refinement (up to 523 pieces in a square decimetre); there is no hint here of formal disintegration, as in the *tachiste* painting at Rome, and (with the adoption of a different technique) in African mosaic-work.

For a true change of style, for the abandonment of the inset 'picture' and the use of unitary composition, we have to wait until the Constantinian period is well under way. To this date we can assign the large mosaic built round an octagonal fountain. From the fountain there radiated four broad vertical strips, each containing a personified Season, very solemn and classical in appearance, and surrounded by appropriate vegetation. The latter grew out of large clumps set at each of the border's four corners: the border itself consisted of leaf-and-branch volutes (*pl. 316, 317*). The divisions thus created contain a number of hunting scenes, with various animals. It is these hunting scenes which give us our first glimpse of Late Empire style in this mosaic, or indeed in the mosaics of Antioch generally. Although the landscapes in which they are set are characterized by a wealth of vegetation, the figures appear two-dimensional, lacking in depth; while their physical proportions are simplified, and bear no trace of that easy elegance which characterizes the Hellenistic tradition. The scene in which several hunters are shown resting round a pillar, with a small statue of Diana on top, recalls the composition of *The Little Hunt* at Piazza Armerina (see p. 244). Because of this, at least one scholar (Lavin) has suggested that the influence of African mosaics can be detected here. Finally, the whole ensemble is framed by an architectural-type cornice executed in gilded mosaic-work; outside this is another strip, consisting of symmetrical motifs, with little compositions inserted in them, three to a side – scenes from mythology, birds, and, at the four corners, busts of allegorical figures.

When we turn to other centres in Syria and Anatolia, or along the coast, we find artistic production flourishing everywhere, with a wealth of inventiveness that it passed on directly to the West. Yet its formal substance remained in close and faithful association with the great tradition of Hellenistic art, and particularly with that of Pergamum, which seems to have been an inexhaustible source. This type of production lasted from the second to the early fourth century, and shows no abrupt changes or breaks during the course of its development. It is only late in the fourth century and during the fifth that a new formal structure makes its appearance.

The painted decorations of a tomb in the necropolis at Tyre (mythological figures placed above garlands) reveal the pictorial origin of exactly similar compositions found on mid-second-century Roman sarcophagi (*pl. 318*).

336

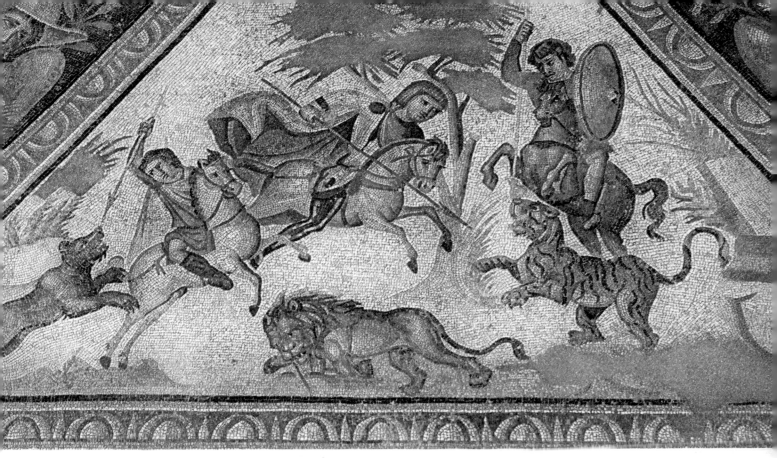

316 ANTIOCH, CONSTANTINIAN VILLA. MOSAIC (DETAIL): WILD-BEAST HUNT. PARIS, LOUVRE

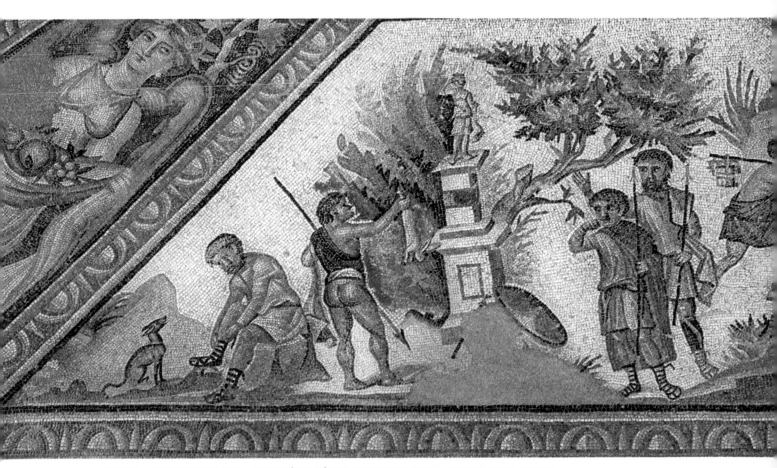

317 ANTIOCH, CONSTANTINIAN VILLA. MOSAIC (DETAIL): AN OFFERING TO DIANA: AUTUMN. PARIS, LOUVRE

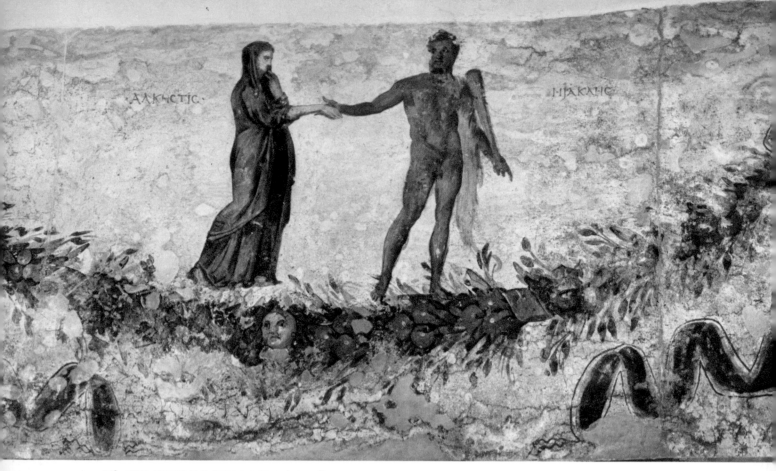

ΑΛΚΗCΤΙC ΗΡΑΚΛΗC

318 TYRE, NECROPOLIS. TOMB-PAINTING (DETAIL): HERACLES AND ALCESTIS. BEIRUT, NATIONAL ARCHAEOLOGICAL MUSEUM

320 EPHESUS, TEMPLE DEDICATED TO HADRIAN. DECORATION OF THE ARCATURE (DETAIL)

At Ephesus, the most splendid and one of the oldest towns on the Ionian coast, one can observe the development, from Hadrian's reign onwards, of what is known in Rome as 'Antonine baroque'. The movement is a crescendo one, extending from the temple built in honour of Trajan to that dedicated to Hadrian; the decoration on the latter already embodies all those innovations displayed by the reliefs (executed under Commodus) which figure on the Arch of Constantine. The cornices are deeply intagliated, but the actual ornamentation – a design combining figures with a leaf-and-branch motif – has been sharply detached from its background by means of the helicoidal ground-auger. The column-bases in the agora, standing on high plinths decorated with figures, emphasize the ostentatious quality of this architecture, and the current taste for sculpture hollowed out in chiaroscuro. The basic formal patterns, however, are still bound up with the tradition of Hellenistic naturalism. With the great frieze honouring Lucius Verus (*Rome: The Centre of Power*, pp. 312–17), we are confronted by a major artistic personality, whose influence marks a turning-point in sculpture of the Roman

319 ROME, TORRE NUOVA. SARCOPHAGUS (DETAIL): THE BATH OF DIANA. PARIS, LOUVRE

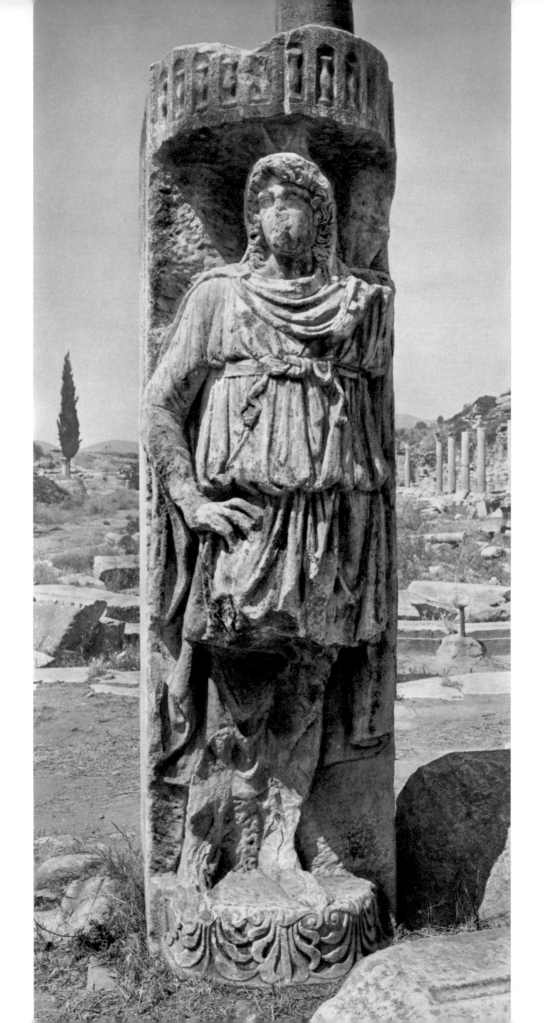

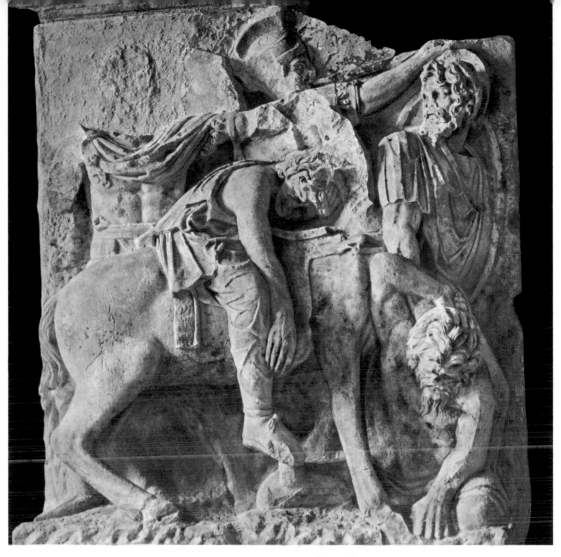

322 EPHESUS. MONUMENT OF MARCUS AURELIUS AND LUCIUS VERUS (DETAIL). VIENNA, KUNSTHISTORISCHES MUSEUM

period. It is my belief that the school built up by this artist was responsible for the change we have observed in the narrative and commemorative relief, at Rome, from Commodus's day onwards, and to which the Antonine Column bears witness. However, in the hands of Roman craftsmen this style becomes more crude, and blends with the heritage of the 'plebeian' tradition. In comparison with the Ephesus reliefs, Late Empire sculpture from Rome is almost provincial. Several master-artists contributed to the Antonine relief of Ephesus. The most brilliant and original was the one responsible for the panels describing Rome's Parthian Wars (nos. 4–7). But the other panels – which portray the adoption of Marcus and Lucius (nos. 1–3) and the latter's apotheosis (nos. 8–11) – are similarly founded on a new spatial dimension. It is as if the relief of the *Maestro della gesta di Traiano* had been reinforced by fresh contact with Pergamum; but the artist uses secondary figures – killed or wounded barbarians – to introduce a wholly new iconography, and to create masses that slant obliquely away into the background, thus producing a pictorial chiaroscuro of unprecedented force and coherence. We may note the use of the ground-auger in those panels that are by the innovating maestro – though only on the hair, nowhere else.

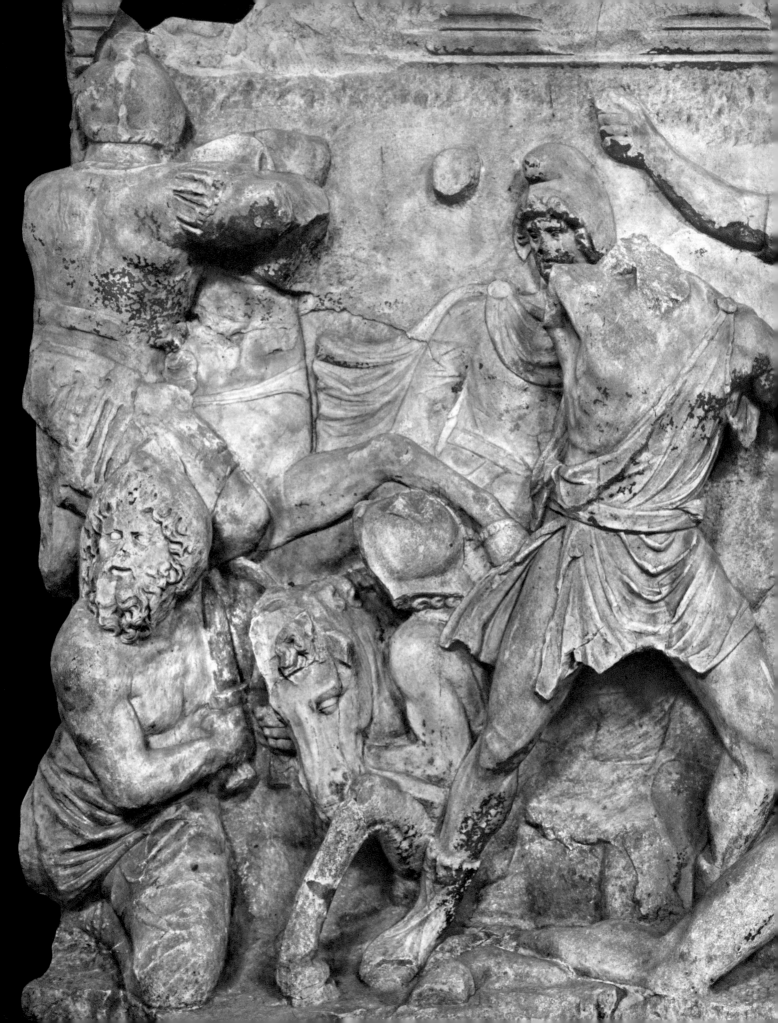

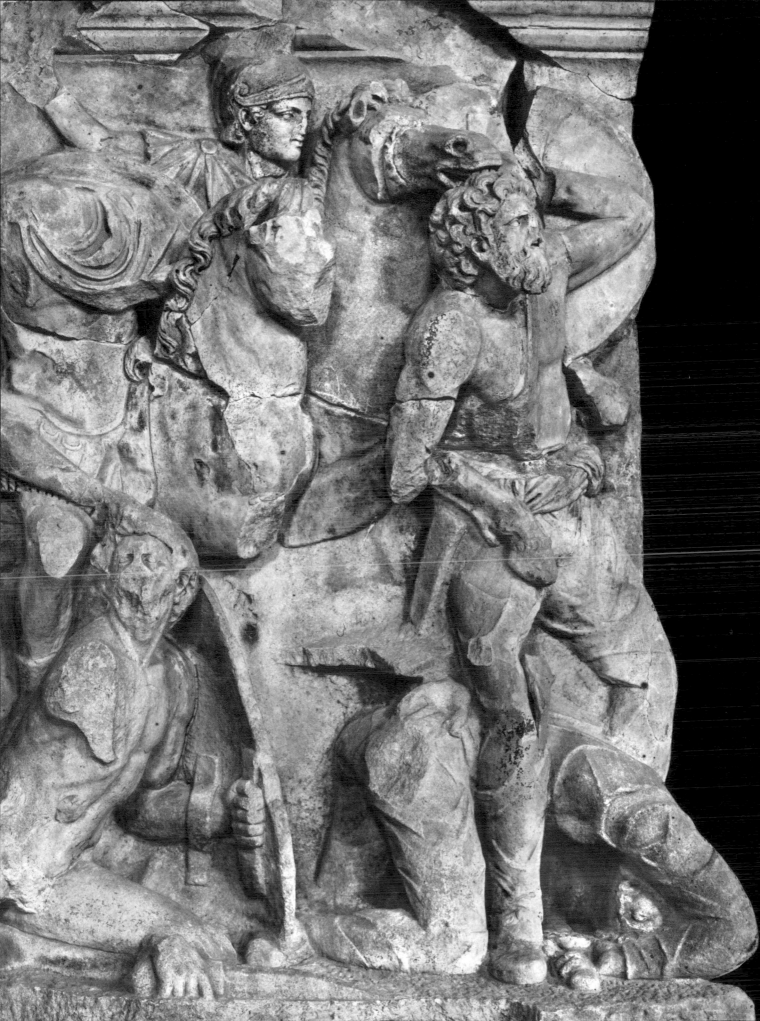

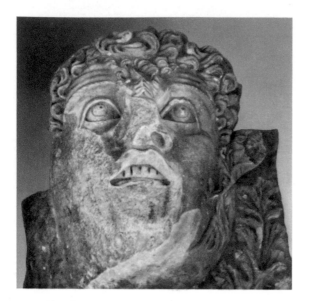

324 APHRODISIAS, PUBLIC BATHS. A CORBEL (DETAIL)

The same tendencies (together with the use of the ground-auger) are to be found in certain third-century works produced by the workshops of Aphrodisias; but although their standard of craftsmanship is very high, they lack the creative originality that marks the Ephesus reliefs. We have already encountered the products of these workshops in Leptis and Thrace. It seems that they specialized in two types of production: on the one hand, decorative and architectural friezes; on the other, copies. The friezes embodied those baroque inventions we have already noted, besides providing great scope for the masons' technical skill. The copies perpetuated a tradition which had formerly been centred on Athens; they were exported to Rome from Hadrian's day until the close of the fourth century and beyond. But it is possible that artists from Aphrodisias were also established, and working, in Rome from an equally early period.

I have already alluded, in my chapter on Rome, to the mass production of monumental sarcophagi which characterizes second-century sculpture in these regions, besides being exported to the West. This ranges from sarcophagi with garlands and bed-shaped lids (quarried on Marmara, and exported to Rome, Greece and Asia Minor) to a brand-new variety known as the 'Sidamara-type' sarcophagus, after the site where one specimen was found. Today we speak rather of 'Asiatic-type' sarcophagi, because they turn out to have been widely employed, not only in Lydia and Phrygia, but also in Bithynia, Lycia, Pamphylia, Galatia, Syria and, above all, Greece, Southern Italy and Rome (where, probably, they were supplemented by imitations made on the spot). We can isolate two different techniques – one being 'Sidamaran', and the other (seemingly older) 'Lydian' – but the general pattern is always the same. The sarcophagi are large, with a heavy, bed-shaped lid, on which the effigy of the deceased reclines. The sides of the shell are adorned with niches and porticoes with pediments, in front of which are placed various figures: sometimes mythological (e.g. *pl. 326*), sometimes philosophers, or the Muses. The architectural features of the porticoes are deeply incised and virtually transformed into filigree-work: here we have the most characteristic formal element of all, which links these products with the ornamental patterns of the Byzantine era. Statues,

344

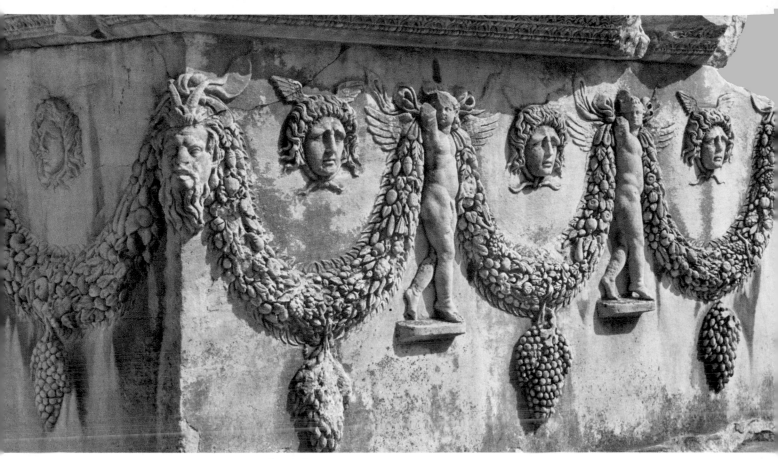

325 IASOS. SARCOPHAGUS WITH GARLANDS (DETAIL). ISTANBUL, ARCHAEOLOGICAL MUSEUM

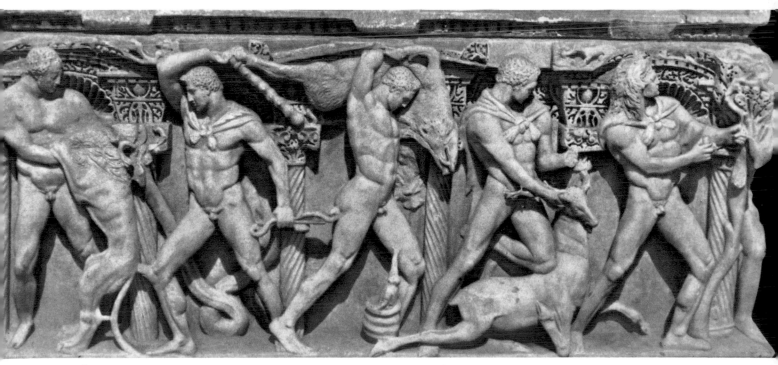

326 YUNUSLAR. SARCOPHAGUS: THE LABOURS OF HERCULES. KONYA, ARCHAEOLOGICAL MUSEUM

345

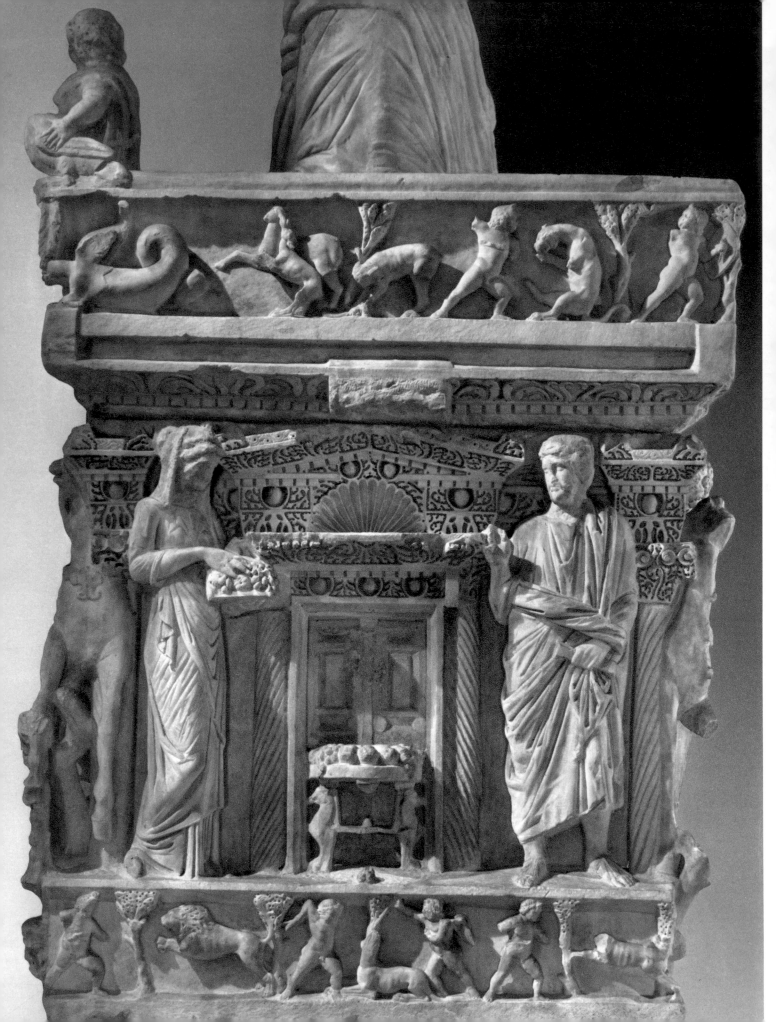

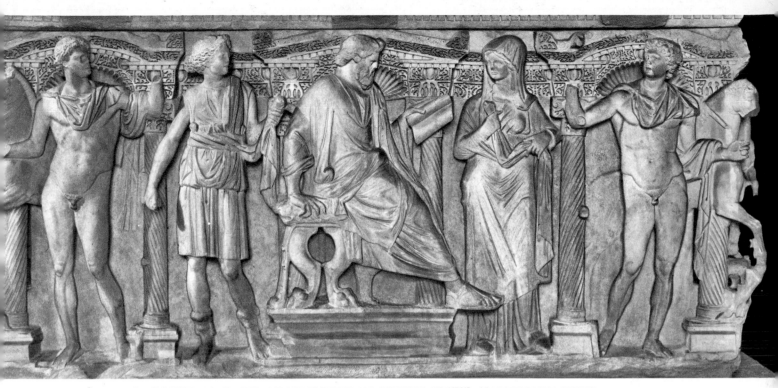

on the other hand, still adhere to the Hellenistic tradition, their only distinguishing feature being a certain rigidity. Against the rich background chiaroscuro provided by the architecture of niches and porticoes, these impersonal, neo-classical figures stand out: in the round, yet oddly two-dimensional, like cut-outs. This quality is typical of a trend which spread right through the Mediterranean area from the second half of the third century – a trend which resulted from loss of contact with the principles of naturalism. Classical forms continued to be repeated – but now as abstract designs, frozen into their existing pattern. What we have here is one of the basic elements in the new style, something that leads on directly to the Byzantine manner.

This type of sarcophagus first appears in the second century; about the beginning of the third, the Lydian technique is replaced by that of Sidamara, which lasts until about 250, and can be distinguished by its heavy use of the ground-auger, which tends to erode architectural elements. These sarcophagi, in their first phase, seem to originate from Ephesus – which would be in accordance with what we have already observed.

Apart from the evidence which these sarcophagi provide for the emergence of a new style about the middle of the third century, we can observe an unmistakable evolution towards the pre-Byzantine manner in a series of statues, for the most part commemorative portraits of consuls, senators and governors in togas (though some affect the Greek chlamys). Numerous statues of this type have been found in Ephesus, Aphrodisias and Constantinople. However, their date and stylistic context link them with works from the age of Theodosius, and the art of the new capital on the Bosphorus. We shall return to this later. All I wish to say at this stage is that the fundamental motifs of the Byzantine style can be traced back, in embryo, to the sculpture of Asia Minor.

347

6 Constantinople

BECAUSE of its geographical position, one of the most advantageous and beautiful in the world, the site of Constantinople attracted Greek colonists at a very early date. This rocky point separating the Sea of Marmara from the Bosphorus somewhat resembles a Phrygian bonnet, on account of the elbow formed by the narrow gulf of the Golden Horn at its outlet. The Greek city of Byzantium grew up with the first colony. In the period with which we are concerned, Byzantium (now incorporated into the Roman Empire) was severely punished by Septimius Severus during his struggle against his rival Pescennius Niger: after the siege of 193 5, the city was sacked, and deprived of all political rights. However, because of its position, Septimius Severus himself rebuilt its walls, and for good measure provided it with a portico-lined boulevard (shorter than that in Antioch, but still a monumental undertaking), a great Hippodrome, a theatre and sumptuous baths. The town was renamed Antonina Sebasta Byzantion.

Later, Byzantium once again backed the losing side, when she supported Licinius against Constantine. And, once again, she was punished by her conqueror, who in 324 ordered the demolition of her walls to begin. Soon afterwards, however, Constantine decided to shift the capital of the Empire to Byzantium, and to make this city his 'New Rome'. It lay closer to the difficult Eastern frontier, and well away from the political meddlesomeness of the senatorial aristocracy. The senators remained obstinately attached to their privileges, even though since Caracalla's day less than half of them were Italian, and less than one-fifth spoke Greek, the rest being provincials. After the surrender of Byzantium, many important citizens had been exiled; but Constantine now decreed that all ground landlords in the dioceses of Asia and Pontus must maintain a residence in the city, which had meanwhile been renamed Constantinople. It was inaugurated as the capital on 11 May 330, after the walls had been rebuilt on a more lavish scale, and various monuments set up within them. It is known (Codinus 52 = Unger 879; Zosimus 2.31 = Unger 307) that numerous statues, earmarked for the beautification of the new capital, were brought in from other towns: Cyzicus, Antioch, Tralles, Nicomedia, not to mention Athens and Rome itself. Classical statuary, by such masters as Pheidias and Lysippus, adorned the main boulevard, the Forum, the baths and the Hippodrome (whose bronze horses still survive on the façade of St Mark's in

349

Venice). The new capital, like Rome, was divided into fourteen regions. Five of these were located within the Severan walls, while five more lay between the latter and the new walls – which indicates the extent of the city's enlargement. Of the four remaining regions, two were suburban, the third extended beyond the Golden Horn (this quarter had been inhabited since the Greek era), and the last formed a little community apart, with its own administration, centring on a church and a second Imperial palace. It lay to the north of the city-walls, in the quarter known as Blachernae, which still today seems like a separate village in the heart of Istanbul.

The celebrations marking the foundation of Constantinople lasted forty days. The city itself was clearly copied from Rome, with its own Capitol, Curia and Forum (the last being placed outside the Severan walls and connected to the Imperial palace by an extension of the great portico-lined boulevard); but it was a Christian Rome. The Forum, too, was built to an original design, being circular in shape; this pattern is known from certain caravan-stations in Asia (Gerasa, Apamea), and may have derived from the circular ground-plan of ancient Iranian cities. A column of porphyry (which still survives, though badly damaged) marked the entry to this round city-square. On top of the column stood a bronze statue of Constantine as Apollo, globe in hand – but with the Cross of Christ surmounting the globe. (However, the silver coins struck for the inauguration of the new capital carry no Christian symbol of any sort.) Seldom does one get so good an example of the way in which official iconography can modify a portrait. Look, first, at a coin issued when Constantine was a Caesar in the Second Tetrarchy, and observe his sly, determined expression. Now turn to the Apollonian sovereign, eyes uplifted in communion with Heaven: this is the 'inspired captain' motif, first introduced on coins by Alexander the Great, and emphasized by Eusebius in his *Life of Constantine* (4.15f). Eusebius also describes Constantine's funerary monument, a mausoleum adjoining the Basilica of the Holy Apostles. Its proximity to a place of worship recalls the lay-out of Helena's monument in Rome. The sarcophagus stood at the centre of this mausoleum, between twelve pillars, each dedicated to an apostle. Thus, says Eusebius (4.60), the deceased would profit by the prayers people made to them; but also, by such an arrangement, the Emperor – who died a neophyte shortly after receiving baptism – would be regarded as the equal of the Apostles (*isapostolos*). This tradition appeared in some respects erroneous. It was therefore suggested that the church had in fact been built by Constantine's son Constantius, who (some held) began it in 356, when the relics of St Paul's disciple Timothy were brought to Constantinople. But the arguments against an interpolation in Eusebius's text seem valid (J. Vogt, 1953), and confirm the tradition which Eusebius reports.

Of the city known to Constantine and his successors almost nothing remains. We are thus deprived of the means whereby to trace the evolution of a new style in works of art produced around the Imperial court. The artistic trend was undoubtedly aulic, and reflected the artificial, closed-shop elements implicit in the foundation of a new capital; but sheer lack of evidence precludes our following its development for at least two generations, such works as we possess belonging to the period of Theodosius (379–95). Their style is already clearly pre-Byzantine, with no trace of Hellenistic formal practices: a style, in fact, which no longer has any part in the ancient world.

330 ROME. COIN OF CONSTANTINE, WITH THE TITLE OF CAESAR. NAPLES, MUSEO NAZIONALE

331 MEDALLION OF CONSTANTINE. PARIS, BIBLIOTHÈQUE NATIONALE

332 ISTANBUL, THE CITY-WALL OF THEODOSIUS II (DETAIL)

Constantine's major projects for the embellishment of the city must have necessitated the formation of numerous working teams, directed by architects, sculptors and painters who were hand-picked from the workshops of Asia Minor and Syria. The point of departure for the art of Constantinople is to be sought in these years. By blending elements of varied origin, Constantinople evolved an eclectic pattern which was still in evidence years later. Another milestone in the city's urban and monumental development was the new look it received under Theodosius.

In 413 Theodosius II built a new, grandiose, and (as things turned out) final city-wall, to the west of Constantine's: it is still standing today. Under Theodosius I, the town had been transformed by the creation of a large forum, the Forum Tauri, set on the great portico-lined boulevard between Constantine's Forum and the Church of the Holy Apostles. The principal monument in this new forum was a column resembling those of Trajan and Marcus Aurelius in Rome, with a narrative relief-sequence carved on it. This column, erected between 386 and 393, survives only in small fragments. Even so, it is clear that the relief-work did not employ that strong chiaroscuro which characterizes Marcus Aurelius's column. What we have here is a straightforward design, lacking in sensitivity, which frequently invokes repetition in order to give the composition some sort of rhythm. A sketch made in the late sixteenth century, almost certainly copied from an older drawing (attributed by some to Gentile Bellini), perhaps preserves for us – in the pictorial style of its day – a record of the scenes that once adorned this column. Becatti's recent study of this sketch (1960) proves, in my view, that this *is* the Theodosian column, and not that of Arcadius. Naturally, we cannot use it to speculate on the *style* of the original; but the prevalence of landscape, with very leafy trees, does seem surprising.

The type of forum which Theodosius built made it clear that he was setting out to eclipse all similar monuments in Rome. To this end he planned to set up, on the *spina* of

334 ISTANBUL, THE COLUMN OF THEODOSIUS I, AFTER A SIXTEENTH-CENTURY DRAWING (DETAIL). PARIS, LOUVRE ▶

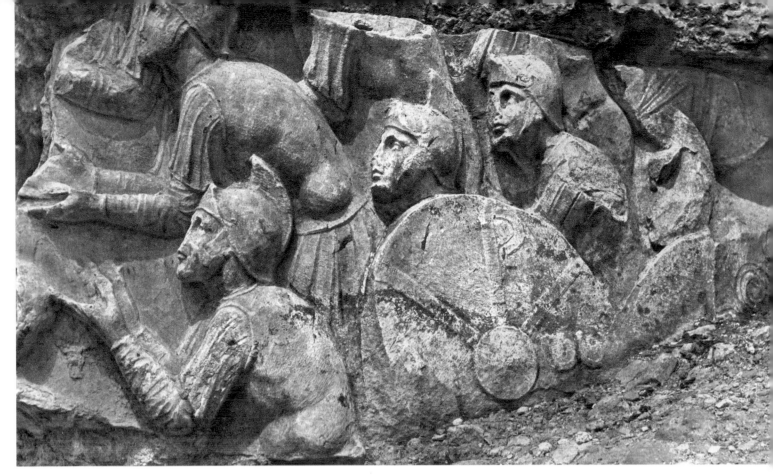

333 ISTANBUL. FRAGMENT OF THE COLUMN OF THEODOSIUS I. ISTANBUL, BATHS OF BAYAZID

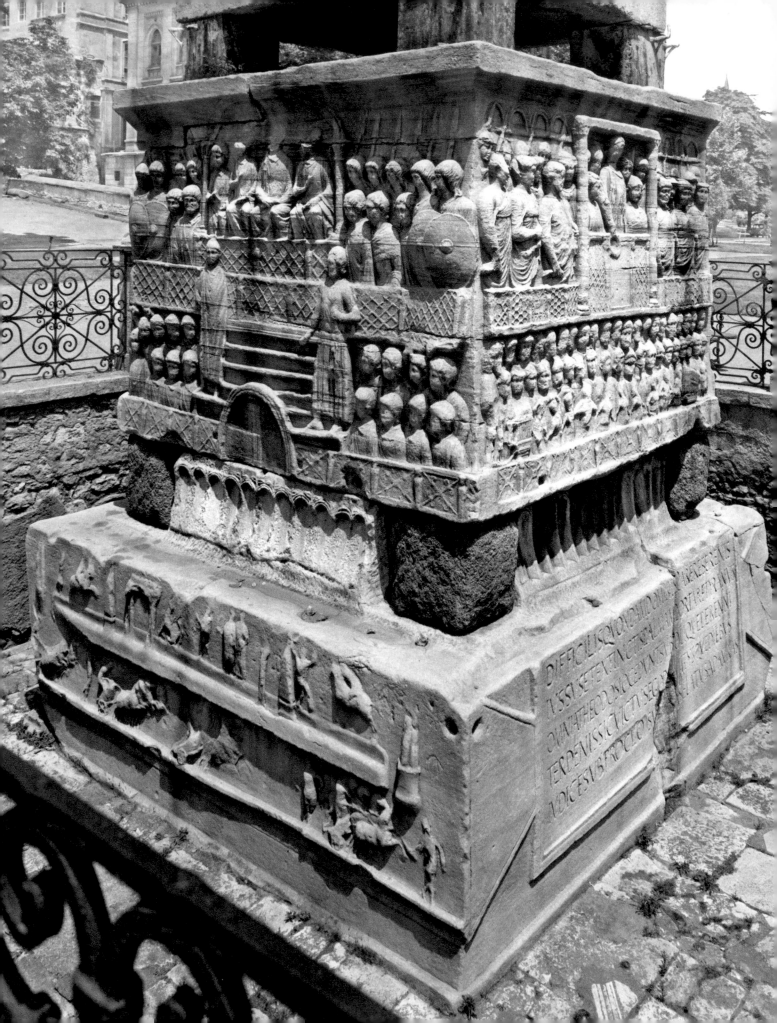

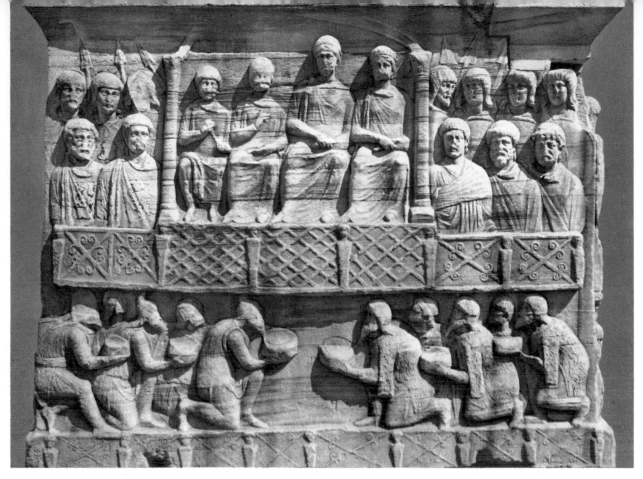

336 ISTANBUL, HIPPODROME. SCULPTOR 'B'. BASE OF THE OBELISK OF THEODOSIUS I (DETAIL.)

the existing racecourse, an obelisk which an earlier emperor, Julian the Apostate, had had brought from Egypt. After many difficulties the obelisk was finally erected, on a base decorated with sculptures. These constitute our only surviving evidence for the art of this period. A chronicler supplies the date of the obelisk's erection, 390; and the inscription, in Greek and Latin, tells us that it took place while Proclus was Prefect. Bruns' detailed analysis of the sculptures on the base (1932) confirmed the accuracy of this information, and invalidated the hitherto accepted hypothesis of a date in Constantine's reign. The reason why scholars got the problem so consistently wrong is that the Constantinian reliefs on the Roman arch and those on the base of the obelisk do, in fact, share the same line of development. Yet this line is not a direct one. The reliefs on the arch (*oratio* and *liberalitas*), like those on the base of the obelisk, adopt the same full-face stance for Imperial personages, and the same symmetrical disposition for the crowds thronging round them. But the plastic form is very different – being popular in Rome, aristocratic in Constantinople. A precedent for the latter should be sought, rather, in the Victories which adorn the column-bases of the Roman arch. Variations of style are also to be found on the base itself of the obelisk. Clearly, two hands have been at work here. On the south-east and south-west sides, the austere composition is interrupted by narrative elements, whereas on the north-east and north-west sides the ceremonial representation is executed with great consistency, all intermediate persons being suppressed in the interests of clarity. The Imperial family, one notes, is shown at two different periods, while the name of Proclus has been first erased, then restored. One

355

337 ISTANBUL. STATUE OF A PERSON IN A TOGA. ISTANBUL, ARCHAEOLOGICAL MUSEUM

attractive theory deduces from these facts that the work (begun in 390, and undoubtedly carried out *in situ*) was abandoned for a time, and resumed in 395–6 under Arcadius, when the base also became a fountain. It has been justly remarked that the second, and more consistent, of the two sculptors is the first Byzantine artist in whom one can recognize an individual style.

356

We lack the evidence to trace any precise line of artistic development here. Yet it seems safe to say that the style of the first artist, 'A', has its roots in Constantinian classicism, which – since the authorities wanted to give their new capital an appearance of nobility and refinement – was now developed as a 'Court art'. For two generations, we may assume, artists came flocking to this new milieu from the various schools of sculpture established in Asia Minor. We have already noted the attachment which such schools display to the Hellenistic tradition, with its correctness and formal elegance. From the close of the second century they abandoned the baroque exuberance of the Ephesus school, and during the third they picked up those new conceptions of the relationship between figures and space which led to the figures themselves being flattened, and charged with symbolic significance. At the request of prospective patrons, 'ceremonial representation' took the place of 'narrative'. The results – frontalism, hierarchical proportions, deployed perspective – were just those that had already developed in Rome in the period between Septimius Severus and Constantine. Here, then, are the stages – coherent enough in historical terms – which, in my opinion, led to the plastic form employed on the base of the Theodosian obelisk. Sculptor 'B' differs from sculptor 'A' simply by virtue of a more radical application of the same basic principles, and the consequent jettisoning of all naturalistic tradition. Nevertheless, the process leading to the establishment of this formal pattern always retains, as its foundation, that classicism which was still the Hellenistic ideal.

A series of statues in honour of various consuls and other high-ranking magistrates, datable to the reigns of Theodosius and Arcadius, help us to place this artistic phenomenon in its context. Unfortunately, almost all the statues have lost their heads; on the other hand, we do still have portraits of the Emperors for this period. These honorific statues, whether they come from Ephesus (as most of them do) or from Aphrodisias or Constantinople, do not differ stylistically. They are distinguishable one from the other only by the degree of application given to the same formal principles, or by a greater finesse in the execution. These principles are summed up by a rigorous frontality of posture, emphasized by the vertical, linear quality given to the main folds in the drapery. This latter characteristic appears also in the oblique folds, with their harsh angles, and the parallelism of the folds in the festooned drapery of the toga. If we imagine such drapery in terms of painting, what we have is, precisely, the technique adopted in Byzantine mosaics and icons. When we study the drapery that lies under the wide cross-swathes made by the toga, we see that the shadowing of the minor folds stops short well above the toga's lower section, to avoid robbing it of its full weight and volume. This procedure becomes a commonplace in Byzantine art.

The same characteristics are displayed by a large silver dish (*missorium*) now in Madrid (*pl. 338*), which shows us the Emperor Theodosius, with Valentinian II (who commanded the *pars Occidentalis* under his direction), and his son Arcadius, who succeeded him in the East when the Empire was divided after his death (395). This dish comes from Almendralejo in Spain; it must have been a present from the Emperor, himself Spanish by birth, to some high dignitary of his country. The occasion, as the inscription tells us, was Theodosius's *decennalia,* which fell on 11 January 388. He spent the period between September 387 and April 388 in Salonika. This dish was certainly not a

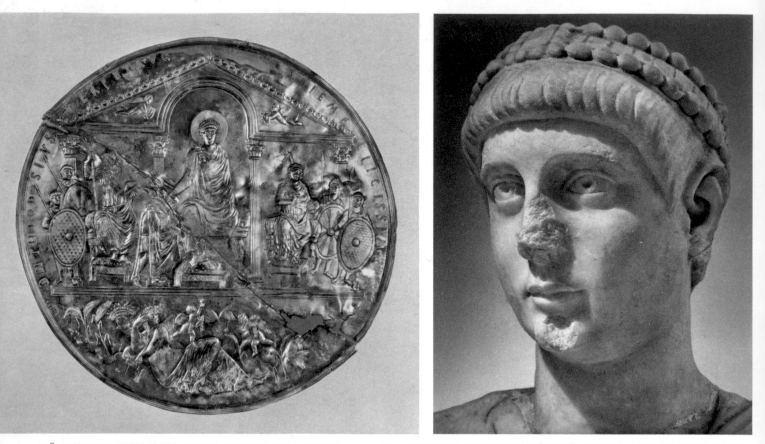

338 MISSORIUM: THEODOSIUS I. MADRID, ACADEMIA DE LA HISTORIA 339 APHRODISIAS. VALENTINIAN II (DETAIL). ISTANBUL, ARCHAEOLOGICAL MUSEUM

unique piece; the fabrication of such gifts on the occasion of the Emperor's jubilee must have been entrusted, well in advance, to the silversmiths of the capital, Constantinople. There is a close resemblance between the drapery of the figures on the dish and that of the honorific statues just discussed; but, in addition, the iconography of the guards on the dish clearly recalls that of the pages (Gothic in origin, with long hair and soft oval faces) on the reliefs which adorn the base of the obelisk. These figures put one in mind of the angels that figured in Byzantine and Western art until the close of the Middle Ages. They also, however, recall the words which the Neo-Platonic philosopher Synesius addressed to Arcadius (*De Regno,* 16–18): 'The guards are chosen for the splendour of their young manhood . . . and take great pride in their fair, curling locks. Their faces and foreheads are bathed in sweet perfume; they carry golden shields and golden spears. Their presence announces the appearance of the prince, just as the first, faint morning light heralds the rising of the sun.' But later on he criticizes the luxurious palace-bound isolation of the emperors, who, 'like lizards', remain unapproachable – 'to prevent men seeing that you are men, as they are.'

The *missorium* of Theodosius slightly antedates the reliefs on the base of the obelisk, and the drapery here is not so stiff as that of the later honorific statues. This indicates the general trend of artistic development. Figures still wholly inspired by Hellenism (e.g. the personification of Earth, surrounded by corn-ears and small winged *putti*) were being put on Constantinople silverware as late as the seventh century, as we can

358

340 ISTANBUL. PORTRAIT OF ARCADIUS. ISTANBUL, ARCHAEOLOGICAL MUSEUM ▶

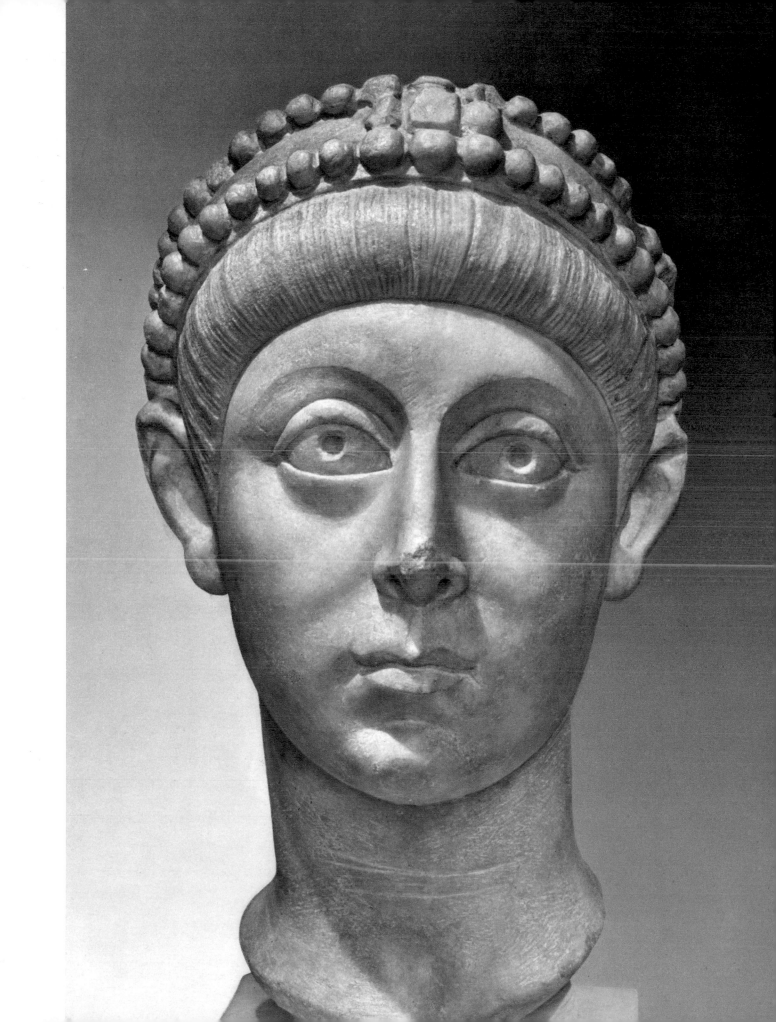

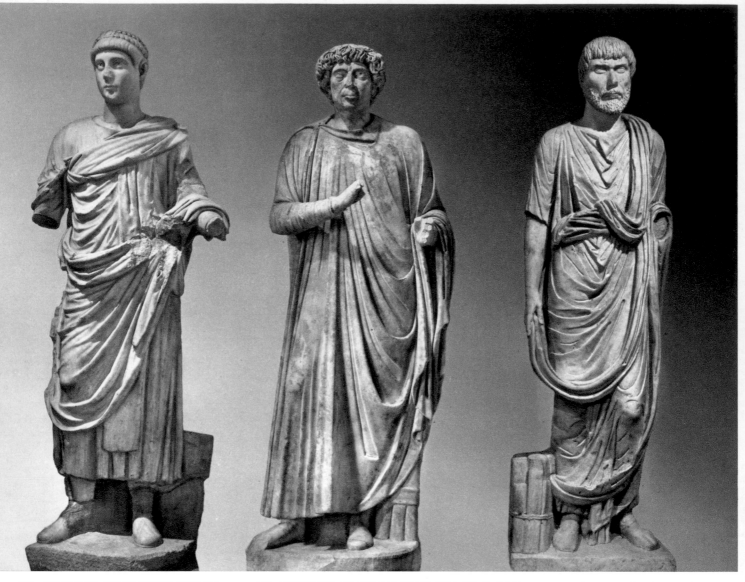

see from numerous pieces, the metal for which was stamped by the Imperial Treasury before their manufacture. These Hellenistic iconographic motifs – taken out of context and set against a neutral background – long continued to be used as symbols or ornaments in this part of the Empire. They are, however, no more than an adjunct to creations that were being conceived in a quite new style. This coexistence of new formal patterns and old stock decorative and symbolic motifs tells us a great deal about the intellectual character of this Court art, which reached its height not only with great monuments of Church and Empire, but with exquisite *objets d'art* designed for an aristocratic elite.

A consular statue from the baths of Aphrodisias (now identified as Valentinian II), and the head of Arcadius as a youth, found near the Forum in Constantinople, are both marked by the same style, which from now on is common to all official art throughout

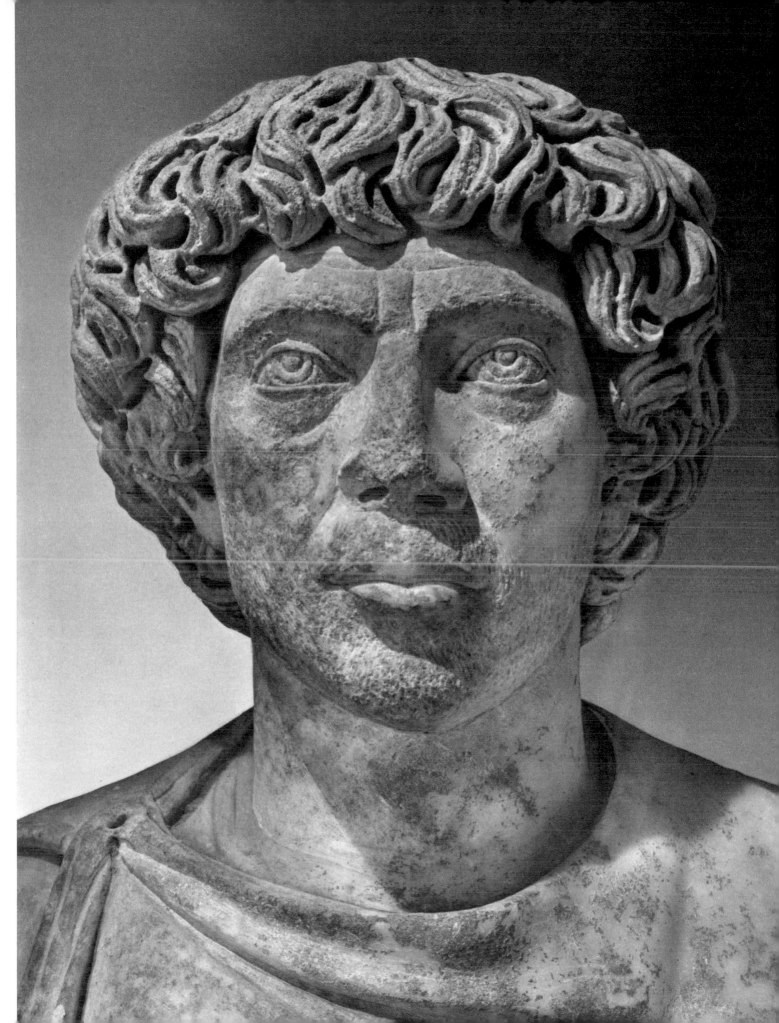

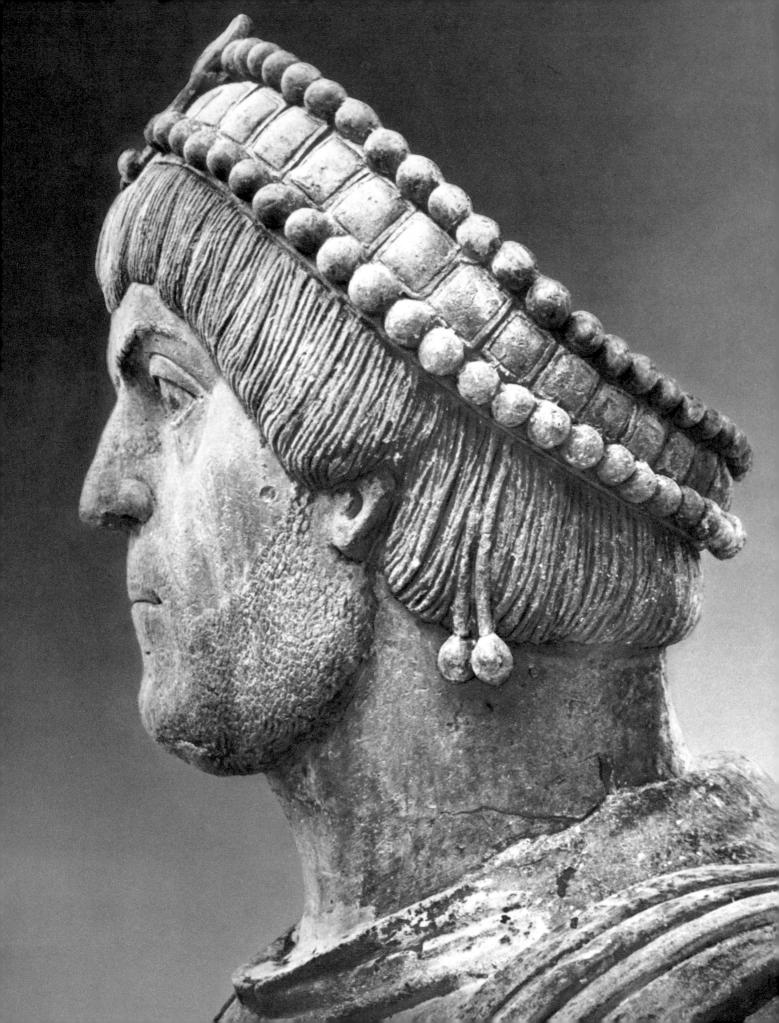

the Eastern provinces. What is more, in these provinces, as opposed to the West, we find no other kind of artistic production, no 'provincial' or 'popular' art. A little later, however, in portraits of people outside the Emperor's immediate circle, both the strictness of line and the formal character of the *représentation d'apparat* were to some extent relaxed. The drapery on the statue of Valentinian II may be pre-Byzantine in its linear emphasis, but it has not yet lost all flexibility. (Since he is dressed as a consul, and his statue was set up at the same time as one of Arcadius, it may date from 387 or 390.) On the other hand, another statue of a magistrate, also from the baths of Aphrodisias, has far stiffer drapery (which achieves high distinction by its unswerving fidelity to its chosen canons of style), and must therefore be somewhat later in date, perhaps early fifth century; but the actual portrait is far livelier and more personal than those of the Emperors. Its hair has been drilled out deeply with the ground-auger to produce a shadowed yet immobile mass. The face is constructed in large planes, expressive yet firm. The chin has a growth of stubble, a characteristic of other portraits in this group. All these features suggest a parallel with the colossal head from Barletta. This head forms part of a bronze statue, fifteen feet high, which the Venetians brought over in the twelfth century from a town – still unidentified – in the Levant. It was certainly the statue of an emperor; but which one is still uncertain. Various candidates have been put forward: Theodosius II (408–50), Valentinian III (425–55), and, more plausibly, Marcian (450–7). Some suggestions can be ruled out on stylistic grounds: Valentinian I (364–75) is too early to fit the style; Heraclius (610–41) is too late. By now, moreover, the iconography of coins has become too impersonal to be any aid towards identification. The style matches that of the portraits of magistrates from Aphrodisias, with perhaps a slight increase in stiffness.

A portrait now in the Vienna Museum (*pl. 346*) leads us back, yet again, to Ephesus, which continued as one of the most important centres of development, and in the sixth century was still turning out some highly characteristic work. This head, found in the theatre, does not correspond to any of the headless statues mentioned. Its style has evolved still further in the search for characterization: this nevertheless remains subordinate to an overall concept, whose chief aim is decorative. Here details serving to type the physiognomy become purely ornamental, like the eyebrows of the Barletta colossus. The alignment of eyes and eyebrows, and the lines on the forehead and round the mouth, certainly suggest individual characteristics; yet they end by forming a sort of ornamental design, in which the two halves of the face balance each other. We would, I think, be justified in dating both the Barletta head and this one to the mid-fifth century.

To conclude this series of examples, we may consider a Victory relief (*pl. 347*), found in the neighbourhood of the Seraglio (where the Great Imperial Palace once stood), and known since the seventeenth century. The marble slab is too thin to have formed part of an arch-decoration; it would be more suitable for the internal decoration of some building. The Victory was probably holding out a crown in her right hand. We may regard her as the last manifestation of that trend in Late Antique art which we saw at its inception in the Victories adorning the column-bases of Constantine's arch in Rome. All the elements that appeared for the first time in the Constantinian column-bases here stand fully revealed. Their strict inner logic is reinforced by a stylistic awareness that has acquired full mastery over its mode of expression. All trace of naturalist improvisation is

◀ 345 CONSTANTINOPLE (?). COLOSSAL STATUE OF AN EMPEROR (DETAIL). BARLETTA, PUBLIC SQUARE

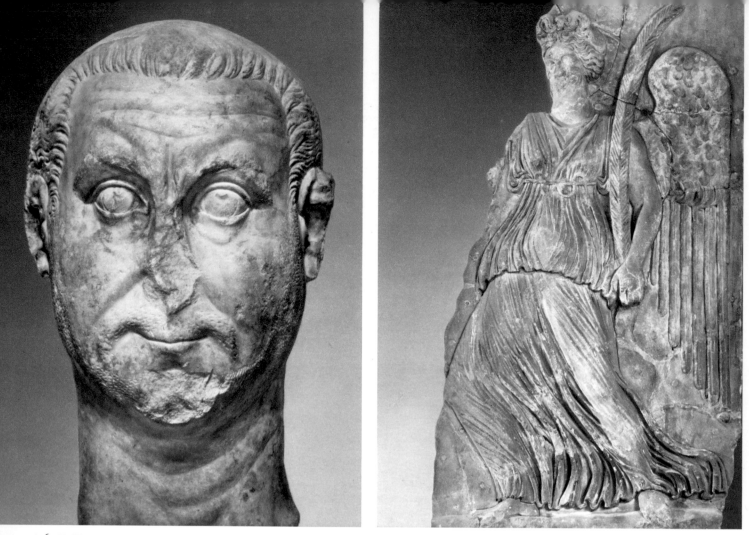

346 EPHESUS. PORTRAIT OF A MAN. VIENNA, KUNSTHISTORISCHES MUSEUM 347 ISTANBUL. A VICTORY. ISTANBUL, ARCHAEOLOGICAL MUSEUM

gone; this is a far cry from the well-fleshed nudity of the Victories on the Leptis Magna arch. The figure obeys a linear rhythm that seems as inexorable as it is impersonal, and culminates in the rigid parallelism of the wings. This is the same stylistic aim as we observed in those official, toga-clad statues. Its accentuation here may be connected with the art of bas-relief, and also with a more advanced phase in the development of Constantinopolitan art, datable to the late fourth or early fifth century.

Arcadius continued his father's policy of embellishing the city. He built a forum much like that of Theodosius, similarly adorned with a column round which ran a spiral narrative relief. Thus the parallel with Rome was complete. However, the planners determined to make this column higher than those of Trajan and Marcus Aurelius. It was set up in 402–3; just when the sculptures were finished is unknown, but there do not seem to have been any delays. We know that the Emperor's statue was set up on top of it in 421, after his death. The column itself was composed of twenty-one marble drums, and stood on a high plinth; the latter, though calcined by successive fires, is still standing *in situ,* together with part of the first spiral from the relief. The actual body of the column was demolished in 1717, by which time – as surviving sketches show – it had become seriously dilapidated. (See, e.g., the sketches made in 1574, formerly part of the Fresh-

364

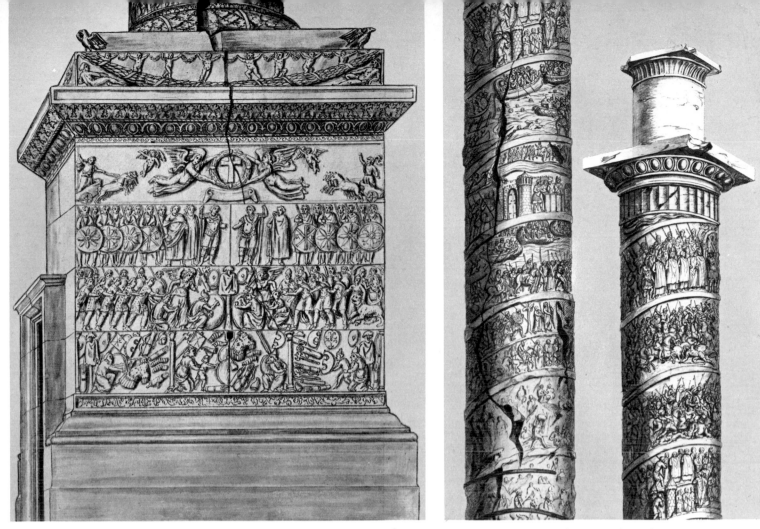

348 ISTANBUL, BASE OF ARCADIUS'S COLUMN. CAMBRIDGE, TRINITY COLLEGE

349 ISTANBUL, ARCADIUS'S COLUMN (DETAIL). PARIS

field Collection and now in Trinity College, Cambridge; that by Mathieu Lorichs (1559), in the Department of Prints and Drawings, Copenhagen; and an anonymous sketch made towards the end of the seventeenth century, no. 6514 in the Bibliothèque Nationale.) These sketches, when compared with written descriptions, both ancient and modern, give us a fairly complete idea of the monument's iconography, but very few indications as to its style.

The great base assumed particular importance: round three of its sides ran reliefs, in four horizontal 'strips', while the fourth, or north, side was taken up by a door leading to the internal staircase. As Becatti observed, when the two twin columns of Theodosius and Arcadius are referred to by contemporary writers as 'wonders', it is because they were accessible from the inside, and offered such a splendid view over the city. On each side, above the sculpture, the Cross or monogram of Christ was prominently displayed; while in the scenes on the column itself, divine intervention was several times indicated by the presence of angels. The reliefs decorating the base were of a ceremonial or triumphal nature; and in those round the column, similarly, the aim is triumphal rather than narrative. At the same time, even if only from the sketches, we can discern an emphasis on landscape. Although, here too, the neo-classical Court style of other works

350 CONSTANTINOPLE. MINIATURE FROM THE 'ILIAD': BATTLE-SCENE (DETAIL). MILAN, BIBLIOTECA AMBROSIANA

from the Theodosian period can be identified, we also have confirmation of how long-lasting Hellenistic motifs could be, whether in landscapes or in battle-scenes.

What little evidence we have for painting, from written sources and miniatures, even those of a later period, reveals a similar persistence of Hellenistic motifs. Writings attributed to Libanius (Foerster edition, VIII, 465–70) provide us with descriptions of fourth-century paintings; these include rustic scenes, and illustrations of episodes in the *Iliad*. Procopius of Gaza (ed. P. Friedländer, 1939) describes the paintings in an early-sixth-century public building as including mythological themes, and once again episodes from the *Iliad*. We have already noted the evidence for third- and fourth-century painting which can be extracted from the miniatures illustrating a manuscript of the *Iliad*, now in the Ambrosian Library at Milan (*pl. 350*). It is my belief that, while some of these miniatures reproduce older compositions, others (e.g. miniature XLV) were first created at the beginning of the sixth century. A comparison between these works, those derived from third-century models, and such information as we can glean from the reliefs on the Arcadian and Theodosian columns, confirms the general trend. Composition becomes increasingly schematized, and figures more uniform, while mass and structure lose their physical substance: persons are drawn with the points of their feet barely brushing the ground, like puppets suspended from a thread. We find this same skipping gait in the religious mosaics at Ravenna (S. Apollinare Nuovo), about 568. After the early sixth century, the last trace of what had given Hellenistic naturalism its force vanishes. But in the area round Constantinople, in Anatolia and Syria, there is still a lingering memory of it, whereas in the West any surviving iconographic motif has been distorted and barbarized.

The famous manuscript of Genesis (*pl. 351*) is now, in the light of recent research, to be dated to the first twenty years of the sixth century rather than to its close. Its miniatures, by various hands, all exemplify a style which, from now on, we may term Byzantine – even if they contain decorative or landscape motifs which are still so close to Hellenistic art that scholars have been misled on their date and possible connections with Pompeian painting and Roman art. But compared with these miniatures, which are products of contemporary art, the three used as headings possess a different, far less narrative character. The third, better preserved than the other two, portrays the Flood; its structure is still tinged with Hellenistic spatiality and expressive pathos. This quality has even survived the successive stages between a full-scale original painting and the manuscript illustration. The oblique position of the Ark, seen in perspective, the waters whirling drowned people away, the variety and pathos of the latter – all this takes us into a world remote not only from Late Empire art, in Rome and the Western provinces alike, but also from the Jewish and secular Roman paintings of a peripheral centre such as Dura-Europos, to which overmuch importance has been attached. I would like to recall here what I said earlier apropos the agricultural mosaics at Cherchell, and repeat my assertion that it was in the specific environment of Anatolia, Syria and Constantinople, between the late third and late fourth centuries, that the transition from ancient to Byzantine art was accomplished; and that the form which the latter took involved an aristrocratic 'freezing' of models which had remained alive in the Eastern part of the Empire, and were transmitted by the Hellenistic spirit.

351 ANTIOCH OR CONSTANTINOPLE (?). MINIATURE FROM BOOK OF GENESIS: THE FLOOD. VIENNA, NATIONALBIBLIOTHEK

352 ANTIOCH. MOSAIC: THE JUDGMENT OF PARIS. PARIS, LOUVRE

368

Conclusion

I SHALL make no summing-up. I refuse to confine a great historical phenomenon within the limits of a few formulae. Living in this age of ours has perhaps taught us something. It is a problem-ridden yet exhilarating era, during which – as during the two centuries covered by this book – men grappled with profound changes in their way of life. It has, I believe, taught us that the direction in which history evolves is determined by concrete factors, driving this or that human community to find itself a better world. But there is no single, direct road to follow. Every event offers numerous possibilities; depending on which one of them is chosen, the course of history will be speeded up, or slowed down and sidetracked. Yet despite everything, this evolutionary process preserves its unity – an internal unity in which politics and economics are bound together, with culture occupying a subordinate role. Culture, *inter alia,* embraces art. To isolate art and treat it as an autonomous unit is an error which has filled large numbers of useless pages. Yet though it is not autonomous, art does have its own continuity, passing through various preparatory phases before attaining some new and quite different form. This is the process I have attempted to illustrate in this book.

Hence my inability to provide any summing-up for a text which is solely designed to accompany a number of illustrations, and to draw the reader's attention to them as evidence. The choice of evidence, too, has been limited by the amount of space at my disposal. So rather than make any formal concluding statement, I intend to explain why I chose some items and eliminated others, and why this material has been presented in a geographical sequence, rather than according to typological or strictly chronological considerations, as is normally the case.

During the three centuries of the Hellenistic period (323–31 B C) there evolved certain formal patterns which, for all their variety, achieved coherent self-expression combined with elegant naturalism and a high degree of decorative sophistication. They were the fruit of cultural selection and maturation over a long period, and all the roots of their development lay in classical Greece. In sculpture and painting this civilization had evolved numerous iconographic designs which were handed down, generation after generation, by the various artistic workshops. This iconography not only embraced

myth and cult, but also covered the erection of monuments commemorating notable achievements. Each artist produced some variation on this iconography: men like repetition, but not monotony. However, only quite outstanding individual artists succeeded in creating their own new iconography, which in turn imposed itself over a long period. The truth of the matter is that throughout antiquity art was regarded primarily as a technique, a craft. In these circumstances production achieved a high cultural standard, together with a quite exceptional sureness and refinement of form. The result was that even a wholly unoriginal artist could create correct and agreeable formal designs, in harmony with contemporary taste. Furthermore, the fundamental stability of all iconographic motifs meant that anyone could easily grasp what a given work of art meant.

These characteristics (together with the vast diffusion of mass-produced craft artefacts, for which industrial techniques were also brought into service) meant that Hellenistic form not only imposed itself throughout the entire civilized Mediterranean littoral, but was accepted as the only valid choice. It was this Hellenistic culture which the Roman Empire inherited. It had caught on very quickly in Southern Italy (Magna Graecia), which became a noted artistic centre. The art of Campania, Etruria and Latium benefited a great deal from it, and these provinces successfully met the demand for artistic products placed on them by that rapidly expanding centre, Rome. However, after the Romans had conquered, first Asia Minor, then Greece, Hellenism was imported to Rome direct, by Greek artists in the service of the Roman ruling classes. Rome in turn spread Hellenistic formal canons more widely still, to areas where they had not hitherto penetrated: to those countries, in fact, which afterwards formed the heart of medieval Europe.

We have been accustomed to regard this spreading of Hellenistic civilization over so vast an area – vast in human no less than geographical terms – as one of Rome's greatest achievements. (The area included peoples whose prior way of life leads us to place them in the 'barbarian' category, and who must have found the basic tenets of Hellenistic art wholly alien, incomprehensible even.) As a result, the practice has been, when studying the art of the provinces that made up Rome's huge empire, to put most emphasis on such material as bore witness to the wide diffusion and persistent survival of Hellenistic form. This attitude, moreover, corresponded to a general conviction that the naturalistic form which Hellenistic art assumed was the sole legitimate form of art whatsoever, or at least stood superior to all others: a conviction which, though shared by many of the specialists in the field, the archaeologists, was based on a poor sense of historical evolution.

If we consider this problem without aesthetic prejudice, we are forced to admit that the facts of the matter are somewhat different. Hellenistic form, with its elegant naturalism, constitutes an exceptional, indeed a unique, phenomenon in the history of ancient civilization. In all other countries, prior to their invasion by Greek artistic culture, art had achieved profoundly different modes of formal expression. The innumerable shapes in nature were generally simplified and reduced to more or less geometrical patterns, following formulae and conventions the purpose of which was primarily decorative. In the ancient civilizations of the East, art was fundamentally bound up with religion, the

direct expression either of a cult, or of a political concept of the sovereign's power *qua* incarnation or image of the god. All religious subject-matter tends towards the irrational, and thus is liable to express itself in visual symbols or abstract signs. Naturalism, on the other hand, was the direct expression of that secular, rational outlook which the Greeks had attained after long study of natural phenomena and logical thought – taken, by them, as the very basis of their institutions. When Xenophanes, in the sixth century, writes that if horses had a god, they would represent it as a horse, he bears witness to the fact that Greek religious art, too, was based on a relationship between men and gods quite different from that of other contemporary civilizations.

In the Hellenistic period, communities of citizens forming a *polis,* or city, were replaced by kingdoms, modelled on the Oriental pattern. It was no longer well-to-do urban citizens who decided on the building of monuments or the erection of commemorative statues, but the sovereign. Art ceased to be a monopoly of religious cults and the community as a whole; it now found its way into wealthy merchants' private houses, adorning them with paintings and sculptures, and giving even objects in everyday use an artistic, decorative quality.

It was at this stage of its development that Hellenistic art was first brought into contact with Rome. But in its adaptation to Roman culture it remained an alien phenomenon, superimposed by the ruling class on a quite different cultural substratum, which did not encourage the direct development of Hellenistic form as such. The latter was founded on naturalism, which gave every element its real proportions: this applied both to individual figures and to the relationship between one figure and another. Naturalism had invented the conventions of chiaroscuro and perspective, their purpose being – in sculpture as in painting – to give each figure the appearance of existing in space, with the same freedom of movement that it would enjoy in real life. Though permeated with Hellenism, Roman artistic culture never reached a point at which it treated these principles as fundamental. It paid no more than lip-service to Greek formal canons, abandoning them whenever they hampered the symbolic expression of what Romans regarded as far more important – the promotion of civic or political ideals, and the extolling of personal achievement in the same sphere.

In some special cases – official art, the statues of the gods, the Imperial cult, and architectural decoration – they continued to copy classical and Hellenistic models. But the most vigorous (and most specifically Roman) branch of art, that which served to glorify the achievements of the Princeps in his defence or enlargement of Rome's Imperial frontiers – and, above all, that which was most closely bound up with individual daily life – inevitably took on a very different formal appearance. The final break with Hellenistic canons of form came from within a society which had changed almost beyond recognition, and in which the way an individual was conditioned to face the world had changed too. The great economic, political and social crisis of the third century produced a profound ideological revolution among men whom the world no longer offered either external security or inner peace of mind.

If we wish to pursue that phenomenon known as the 'end of antiquity' – which in respect of figurative art means the end of Hellenistic form – the generally accepted practice of concentrating on Rome and Constantinople will not suffice. The truth is that

371

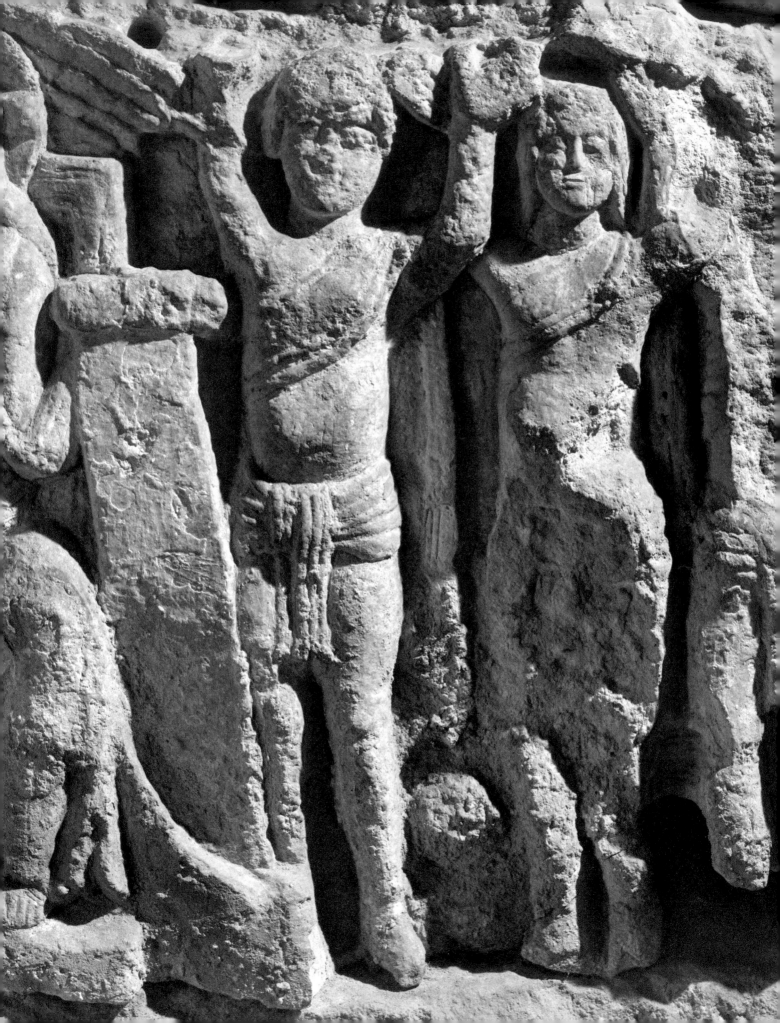

capital cities required a different sort of art from that which suited the provinces. Moreover, each province – or group of provinces governed by a common social pattern – was bound to have its own particular requirements, and the various assimilated populations must have reacted in different ways to the acquisition or production of *objets d'art*. These variations in attitude assumed considerable importance after the collapse of the Empire, when every province (or group of provinces) acquired genuine independence, and worked out a mode of artistic expression that reasserted its old indigenous traditions, modified by the Graeco-Roman experience. Yet, at the same time, these inherited traditions had a common basis, that which underlies the expression of all primitive, spontaneous, 'non-cultivated' art.

In the present volume I have not dealt with this revival of peripheral cultures; I break off at the very end of that period during which the Roman Empire still remained a unity. On the death of Theodosius, the Empire was divided between his two young sons. Arcadius, then aged eighteen, got the East, with the Prefect Rufinus as his adviser; while the eleven-year-old Honorius obtained the West, under the watchful guidance of Stilicho. The latter, a Vandal by origin, was commander-in-chief of the army; shortly afterwards he transferred the capital to Ravenna. I have attempted to demonstrate that, at this point, the formal metamorphosis which figurative art underwent was already a *fait accompli* in all the provinces of the Empire. The early development, on the Empire's eastern fringes – in certain parts of Mesopotamia, like Dura or Hatra, or in the hinterland of Syria, as at Palmyra – of a style, in sculpture and painting, which had acquired no more than a tinge of Hellenistic form remains an isolated phenomenon, without that decisive significance that was formerly attributed to it.

In the Western provinces, which afterwards became Europe as we know it, art that had close links with local daily life threw off all formal Hellenistic attributes very quickly indeed – though official art continued to utilize the stock Graeco-Roman repertoire. What I earlier termed the 'European art of Rome' moved swiftly in the direction of the Middle Ages. Alien as it was to the Hellenistic tradition, in certain respects it represents a prolongation and development of that 'plebeian' trend in Roman art which had existed from the Republican era onwards, and was less concerned with aesthetics than with the commemorative and narrative aspects of the subject. Later it also acquired certain formal characteristics from barbarian art. In this way it not only laid the foundations of Merovingian and, subsequently, of medieval European art, but in some respects can claim credit for the former's earliest achievements (e.g. the seventh-century monuments of Jouarre Abbey; see *pl. 353* opposite, and *Europe in the Dark Ages*, 'Arts of Mankind' series, *pl. 77–91*).

The West was closely linked with Rome; and throughout the third century Rome remained the centre of political power, despite the anarchic condition of the Imperial succession between 235 and 260. At Rome, working alongside local craftsmen, there were, no doubt, Anatolians, Syrians and Alexandrians as well. Yet the principal sculptured monuments retain their own, clearly individual characteristics. Between the turning-point at the end of the Antonine period (which marks the first disenchantment with traditional Hellenistic principles) and the Tetrarchy, Rome experienced one of her greatest periods of artistic independence and expressive force. The sculptures on the

Arch of Septimius Severus pointed the way; but it was, above all, with the frieze on the Arch of Constantine that the most typically 'Roman' trend (what I term 'plebeian' art), adapted to a new ideology and a Court ceremonial which took its inspiration (though not its art forms) from the East, finally won its place on the official monuments. But this conquest lasted only a brief while, and was very soon followed by a return to the old classically-inspired formal patterns. This reflected the wishes of the authorities, who, under Constantine, harked back deliberately to the Augustan era. Under the Tetrarchy, between 294 and 324, Rome witnessed the efflorescence, and final manifestation, of her most characteristically local trend in art; but at precisely the same period we find the Empire just as ready to accept that somewhat different formal pattern which Egypt – a province under the Emperor's direct control – gave to monuments honouring the four sovereigns (cf. the group of porphyry statues, referred to above, which have their counterpart on coins struck in Egypt, and, later, elsewhere as well). This episode in the art of the Tetrarchy is brief and isolated, but significant. It shows what is liable to happen when Hellenistic standards are completely abandoned, not only in Egypt, but in other parts of the Empire as well.

Under the influence of Rome and the Hellenistic East, the western region of the province of Africa developed its own artistic production. The entire culture of this area – literature and religion included – reveals a sharply idiosyncratic character. However, after spreading to Spain, Sicily and Southern Gaul, this art lost its impetus and came to a dead end. It was finally obliterated by the Byzantine reconquest.

Whereas other regions of the African province, such as Tripolitania and Cyrenaica, come in the cultural orbit either of Rome, or else of Greece and Alexandria, Egypt presents two artistic trends which are probably to be linked with the tradition of various groups in the local population. The first is still completely Hellenistic; this will have catered primarily for the men in power, the descendants of the Macedonian or Roman conquerors. It also manifests itself in those craft artefacts which continued to be disseminated, not only along the trade-routes of the Mediterranean and Northern Europe, but also as far afield as the Indian Ocean, the navigation of which had been made much easier from the second century onwards when it became known that the monsoon was a regular seasonal phenomenon. The second artistic trend will have appealed chiefly to native Egyptians, priests of the ancient cults, or those who inhabited the oases of the interior. This trend, which also directly assimilated certain Iranian elements, gave rise to Coptic art – the first of the peripheral arts to discover its own personal style. It was to have a direct influence on local Christian art – simultaneously with the art of Byzantium – and achieved a striking success, during the centuries that followed, in Ethiopia and the Sudan.

Greece during this period had become an artistic province where various trends converged and met, yet which remained incapable of giving its works an individual accent. Its *ateliers* remained faithful to a formally correct, neo-classical tradition, which came back into favour with Constantinian classicism. At a modest artisan level, its influence affected the minor ex-voto and funerary monuments of Macedonia, Thrace and Moesia; any more large-scale undertakings in this region were carried out by teams of masons from Rome or Asia Minor.

The oriental provinces of Asia Minor (Asia, Bithynia, Lydia, Cilicia), being rich in high-quality marble, were the ones in which sculpture – at Ephesus and Aphrodisias in particular – retained its greatest vitality. Copies and adaptations of classical models continued to be turned out; but at the same time artists were creating new commemorative monuments, luxurious architectural decorations, and new types of sarcophagi. Their formal language is still essentially based on Hellenism, especially that of Pergamum; yet here, too, we find a movement away from total and consistent naturalism, which no longer corresponded to the new needs that had arisen. This movement manifests itself in an overabundance of chiaroscuro, which detaches every shape from its background by surrounding it with deep shadow-work. This isolation gives each object an independent decorative value; it no longer observes the rules of balance, or anatomical correctness, but only those of decorative effect and heightened expression. This seems to have happened above all in the workshops of Aphrodisias, where the sculptors were endlessly inventive as regards decoration, but lacked the talent for creating new formal concepts. By following the rhythm and trend of an ornamental design, figures gradually become isolated from their context; they lose their depth, their substance, and with them that sense of perspective which had been classical art's great innovation. During the third century the workshops of the Hellenistic East, too, lose interest in this particular formal device (even though it had given Hellenistic art its originality); by repeating patterns again and again they freeze them into decorative immobility. Here we perceive the link between the great figures of Saints and Patriarchs, and those Theodosian mosaics from the dome of Haghios Georgios in Salonika, with their architectural motifs set against a gold background (*pl. 354*).

The loss of interest in pictorial space is directly bound up with the development of a new relationship between man and reality. Realism, naturalism, pictorial space – these all resulted from the attitude that man had taken, under Greek civilization, to nature and the world: an attitude that was fundamentally rational. The culture of the Western provinces had never, of itself, produced such an attitude. The ruling classes – of Italy in the first instance, and *a fortiori* those of Gaul and Spain – had done no more than accept the outer shell of this Greek culture; at heart they remained faithful to the kind of irrational, superstitious beliefs from which only a few intellectuals, such as Lucretius, had succeeded in breaking away completely. Two contrasting notions of the world, neither of which could understand the other, now met head-on. This explains the early 'disappearance' of formal Hellenistic patterns in the West. Yet even in the East, even in those cities which had grown up with Hellenism, the tendency towards the irrational steadily gains ground during the centuries covered by this book, though here it assumes rather more complex philosophico-religious forms. I have already referred to this in my Introduction, and apropos the symbolism of the sarcophagi. It was, moreover, from the provinces of the Eastern Mediterranean that there first spread, to Rome and then throughout the Empire, those doctrines of salvation on which humanity – faced with a world that seemed, at one and the same time, cruelly oppressive and everywhere collapsing in ruins – had come to pin its hopes. The doctrines in question – Hermetic philosophy, Neo-Platonism, the mysteries of Dionysus, the cults of Sabazius and Mithras (respectively Thraco-Phrygian and Iranian in origin), Christianity (a Palestinian Jewish creed), and various other smaller

local sects – all combined to bring about a profound transformation in the relationship between men and the realities of their world. All, in one way or another, could endorse the pronouncement of St Paul (reaffirmed later by medieval mysticism), concerning the unreality of the visible world, which is no more than a veil placed between men and the invisible, the latter alone having any claim to be considered true and eternal (*Romans* I.19–20).

This new relationship with reality is the decisive factor shaping the new mode of artistic expression, which moves further and further away from naturalism, to take on an increasingly symbolical – and afterwards transcendental – significance. It was now, when the artist's vision had already broken loose from the domination of naturalism, but was still stamped, in the Eastern provinces, by Hellenistic iconography, that a decisive new influence made itself felt. This was the neo-classical inspiration emanating from Constantine's court, in his new capital on the Bosphorus. Pre-Hellenistic classical forms, in which realism was based on abstract rhythms, were revived as models, but interpreted according to the new, irrational, symbolic vision. By the end of the century, under Theodosius, we can already observe in all the Eastern provinces – but most particularly in Anatolia, and at Constantinople and Salonika – the first true manifestations of Byzantine art. It seems apposite, in this context, to quote Ostrogorsky's formulation at the beginning of his *History of the Byzantine State*: 'Roman political concepts, Greek culture and the Christian faith were the main elements which determined Byzantine development.'

Thus a great gulf – not merely political and administrative, but also cultural, artistic – opened up between East and West. By the end of the fourth century, the East was already familiar with the earliest forms of Byzantine art. For the next two hundred years, Constantinople remained the only metropolitan centre of art-production. The West never advanced beyond the standards of popular provincial art. In the East, the importance of Hellenistic art as a constituent element in that of Byzantium has long been recognized; yet the importance of Roman art for the artistic civilization of Western Europe, looked at from this angle, has not always been appreciated at its true value, despite a long-established tradition of research on the subject.

If we consider art as the most direct, spontaneous, and uncontrolled mode of expression available to any society, it is not surprising that the Hellenistic form of art should have come to an end. Yet the change that took place in artistic form has given rise to endless discussions and misunderstandings. One reason is that post-Renaissance European civilization – in particular between the late seventeenth and the nineteenth centuries – regarded the naturalism of Hellenistic art, not as the expression of one particular culture, tied to a specific period and geographical region, but as the sole true form that art could take. The art of Greece was regarded as Art, in an absolute sense; any formal deviation from its canons and practices was written off as mistaken, barbarous, decadent. Hence the endless discussions on how and why this 'perfection' came to be lost. And since, often without realizing it, we tend to make a *moral* condemnation of any formal change in artistic expression, some 'guilty party' had to be found responsible for this 'decadence' – which all goes to show how deeply the formal canons of art are bound up with our human existence, in historical terms.

The question was posed in the very first Renaissance attempt made in Europe to sketch out the history of art from antiquity down to modern times. In his *Commentaries,* written between 1447 and 1455 (the year of his death), Lorenzo Ghiberti, creator of the famous bronze doors for the Baptistry in Florence, having summarized the chapters on art which Pliny the Elder included in the *Natural History,* began his 'Second Commentary' with this statement:

'Thus in the days of Constantine the Emperor and of Pope Sylvester, the Christian faith triumphed. Idolatry underwent such persecution that all the statues and paintings – works of great nobility and antiquity and perfect dignity – were destroyed and torn asunder. Thus there perished, not only statues and paintings, books and commentaries, but with them the rules and principles governing this extraordinary and most noble art. Afterwards, in order to stamp out every last idolatrous custom of antiquity, they built their places of worship plain and unadorned; and in those days they decreed stern penalties against any person who should make a statue or a painting. In this manner the arts of painting and sculpture came to an end, together with all doctrine concerning them.'

It has taken almost a century of research to make people realize that this formal metamorphosis came about *before* the triumph of Christianity, the barbarian invasions, or the Iconoclastic period – and to make modern culture abandon the concept of 'decadence' in its most simple, popular form. We shall come closer to historical reality only when we understand that external forces (which are more easy to put one's finger on) played a far smaller part in the overthrow of this great civilization than did the internal transformation which took place in the social fabric of the Roman Empire itself. The birth of the new civilization was a difficult business; it grew from a less educated and less refined culture. But a greater number of people, ultimately, were drawn to participate in it.

PART THREE

General Documentation

TECHNICAL EDITOR: MADELEINE DANY

Supplementary Illustrations

355 MILETUS: ENTRANCE-GATE OF THE AGORA

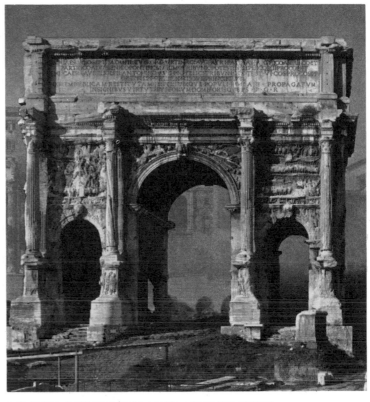

356 ROME: FORUM ROMANUM. ARCH OF SEPTIMIUS SEVERUS

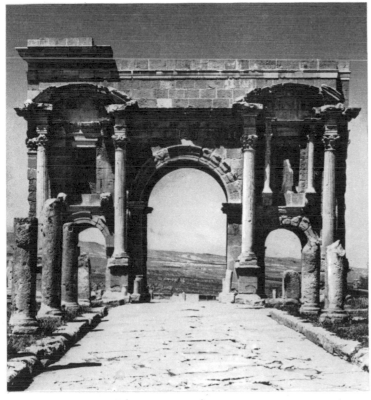

357 TIMGAD: CITY GATE (SEVERAN PERIOD)

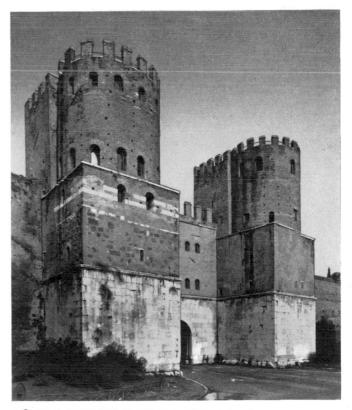

358 ROME: THE WALLS OF AURELIAN. PORTA S. SEBASTIANO

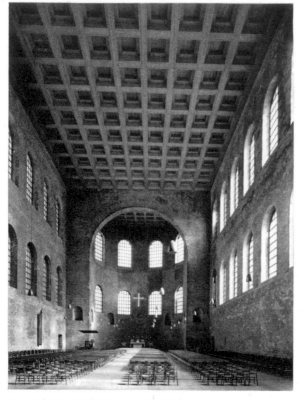

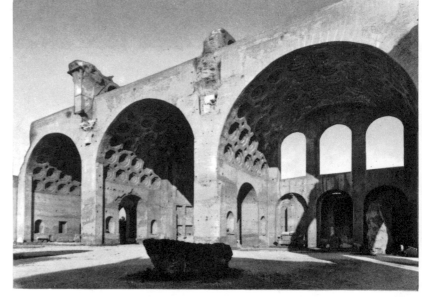

359 TRÈVES: THE BASILICA. VIEW OF THE NAVE

360 ROME: BASILICA OF MAXENTIUS. VIEW OF ONE OF THE SIDE-AISLES

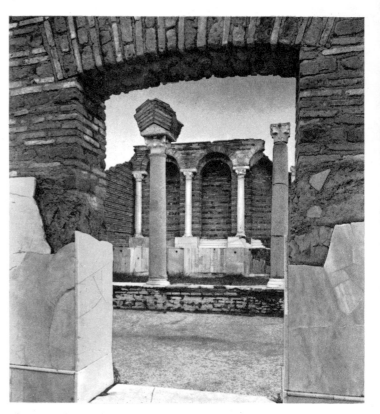

361 ROME: BATHS OF DIOCLETIAN. INTERIOR OF FRIGIDARIUM

362 OSTIA: 'HOUSE OF CUPID AND PSYCHE' (DETAIL)

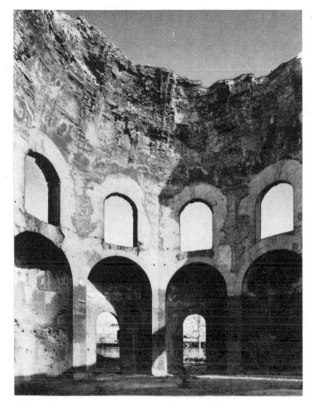

363 ROME: TEMPLE OF MINERVA MEDICA. NYMPHAEUM

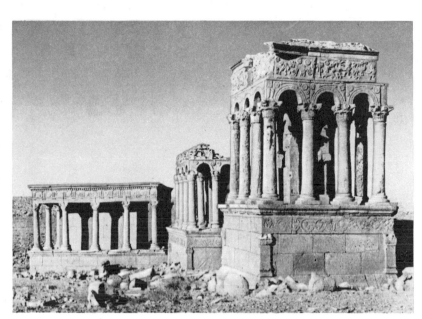

364 GHIRZA: NORTH NECROPOLIS. TOMBS

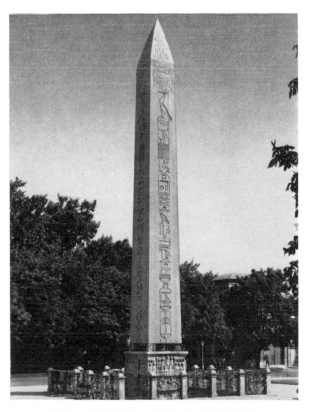

365 ISTANBUL: HIPPODROME. OBELISK OF THEODOSIUS I

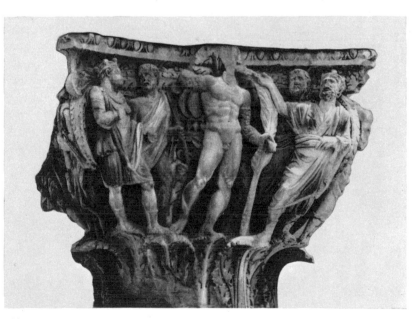

366 ROME: BATHS OF ALEXANDER SEVERUS. FIGURED CAPITAL. THE VATICAN

385

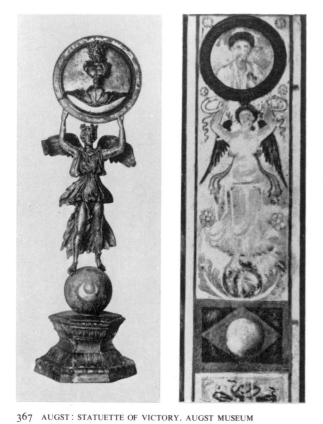

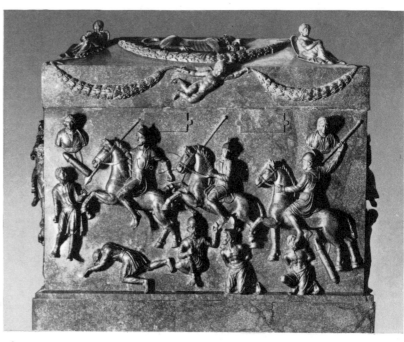

367 AUGST: STATUETTE OF VICTORY. AUGST MUSEUM

369 ROME: SARCOPHAGUS OF HELENA. THE VATICAN, MUSEO PIO CLEMENTINO

368 PALMYRA: PAINTING FROM A TOMB

370 ROME: SARCOPHAGUS OF CONSTANTINA. THE VATICAN, MUSEO PIO CLEMENTINO

386

Coins and Medallions

The coins and medallions are arranged in chronological order

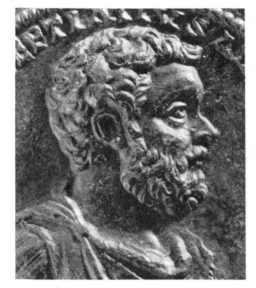

371 CLODIUS ALBINUS

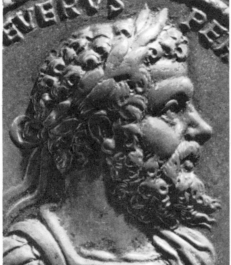

372 SEPTIMIUS SEVERUS

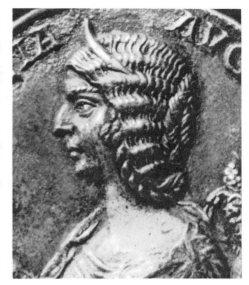

373 JULIA DOMNA

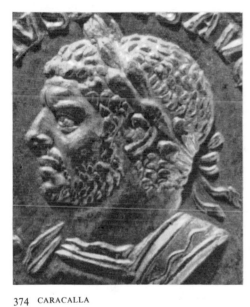

374 CARACALLA

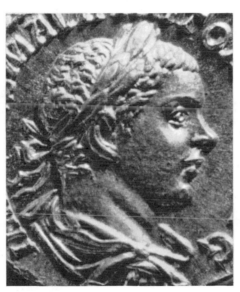

375 ELAGABALUS

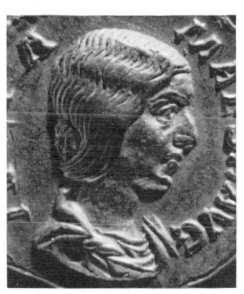

376 JULIA MAESA

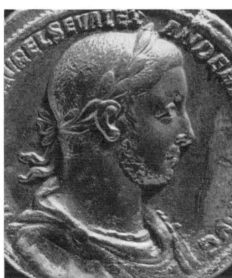

377 ALEXANDER SEVERUS

378 MAXIMINUS THRAX

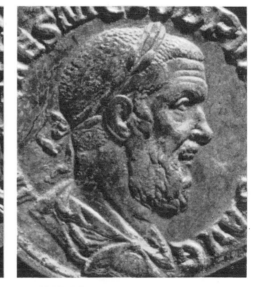

379 PUPIENUS

389

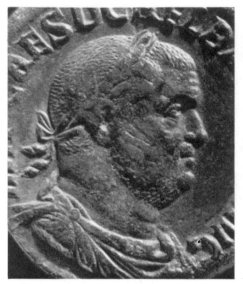

380 BALBINUS

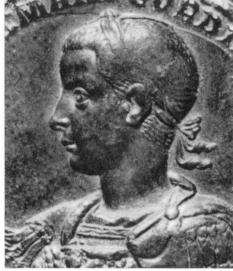

381 GORDIAN III

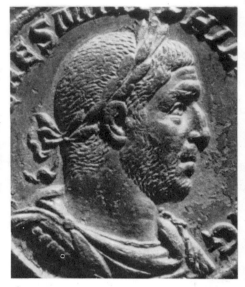

382 PHILIP THE ARAB

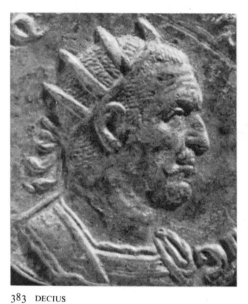

383 DECIUS

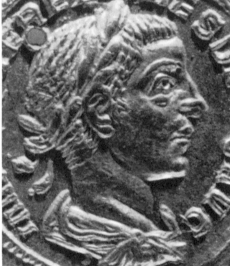

384 HERENNIUS ETRUSCUS

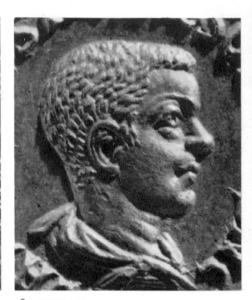

385 HOSTILIAN

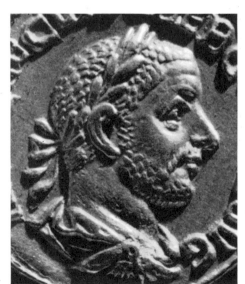

386 TREBONIANUS GALLUS

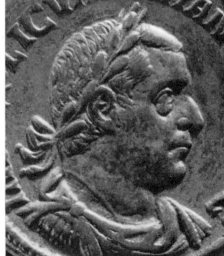

387 VALERIAN

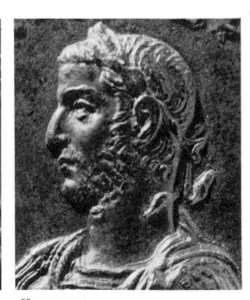

388 GALLIENUS

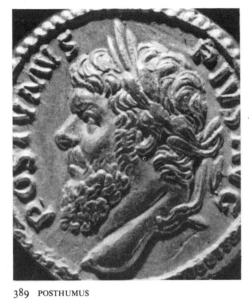

389 POSTHUMUS

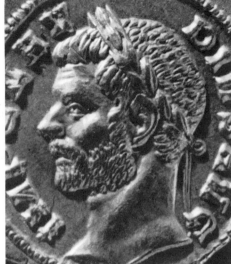

390 CLAUDIUS II GOTHICUS

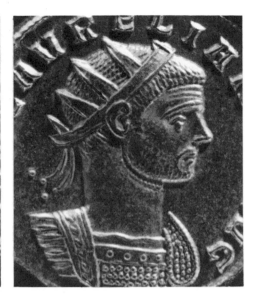

391 AURELIAN

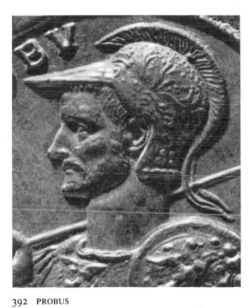

392 PROBUS

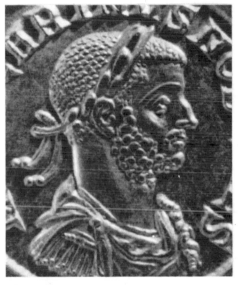

393 CARINUS

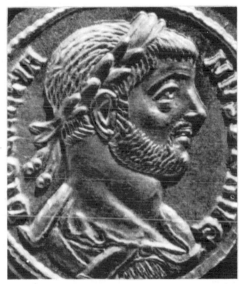

394 DIOCLETIAN

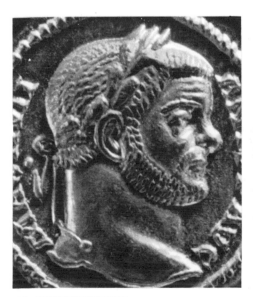

395 MAXIMIAN HERCULES

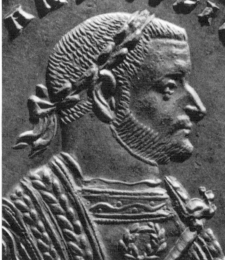

396 CONSTANTIUS CHLORUS

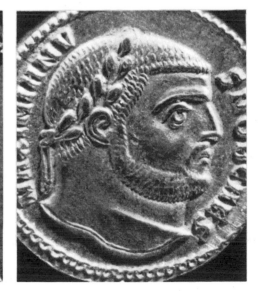

397 GALERIUS

398 MAXIMIN DAIA

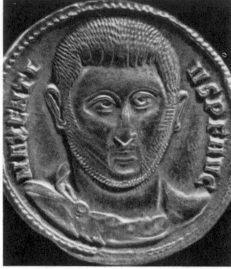

399 MAXENTIUS

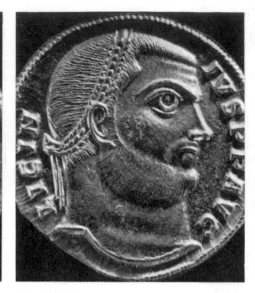

400 LICINIUS

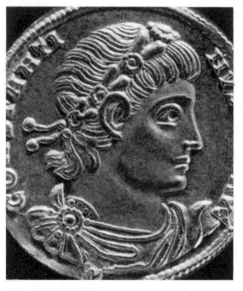

401 CONSTANTINE

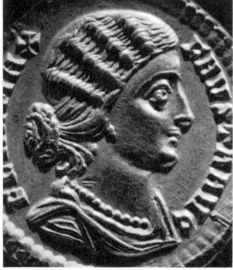

402 FAUSTA

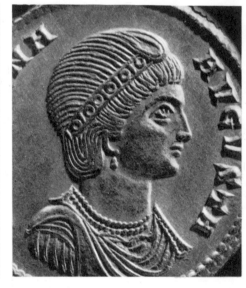

403 HELENA

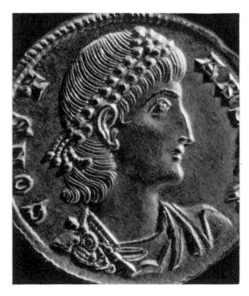

404 CONSTANS

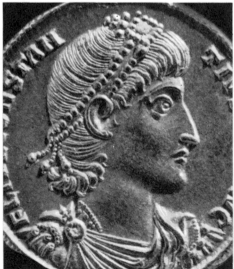

405 CONSTANTIUS II

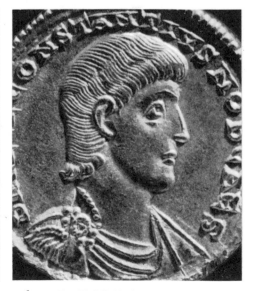

406 CONSTANTIUS GALLUS

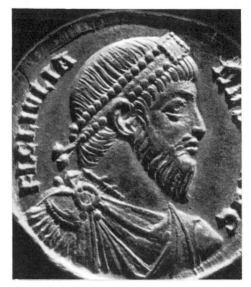

407 JULIAN THE APOSTATE

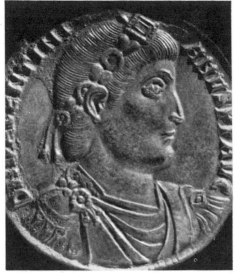

408 VALENTINIAN I

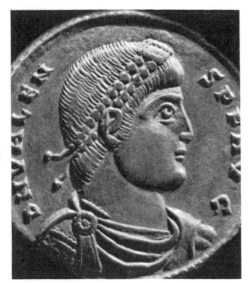

409 VALENS

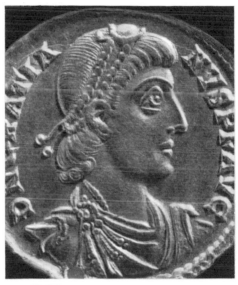

410 GRATIAN

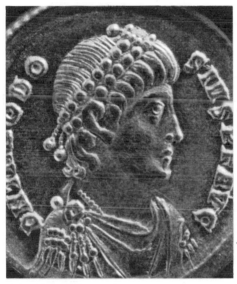

411 THEODOSIUS I

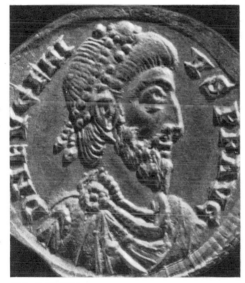

412 EUGENIUS

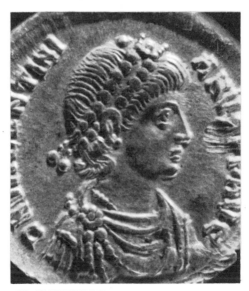

413 VALENTINIAN II

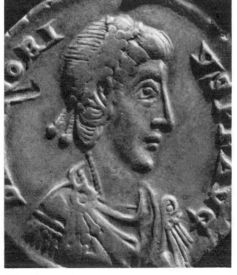

414 HONORIUS

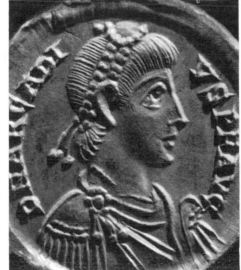

415 ARCADIUS

393

Plans and Reconstructions

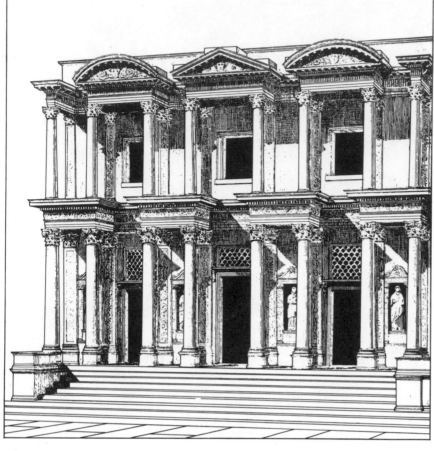

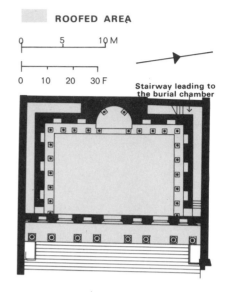

Stairway leading to
the burial chamber

417 EPHESUS: LIBRARY-MAUSOLEUM OF CELSUS

416 EPHESUS: LIBRARY-MAUSOLEUM OF CELSUS. RECONSTRUCTION OF THE FAÇADE

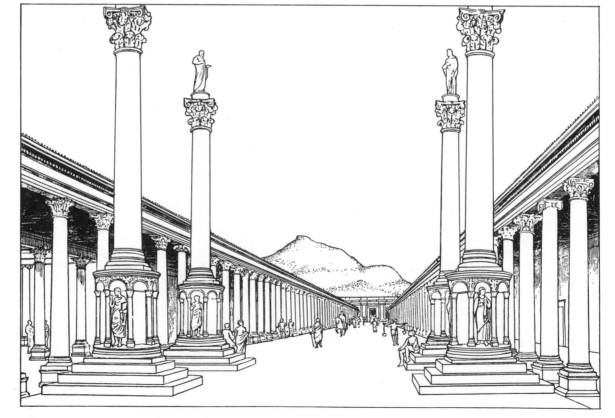

418 EPHESUS: THE SO-CALLED 'ARCADIAN' STREET OF COLUMNS. RECONSTRUCTION

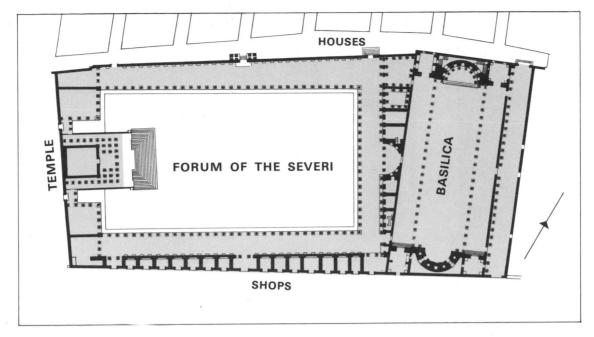

419 LEPTIS MAGNA: FORUM AND BASILICA OF THE SEVERI

ROOFED AREA

| 0 | 10 | 20 | 30 | 40 | 50 M |

| 0 | 50 | 100 | 150 F |

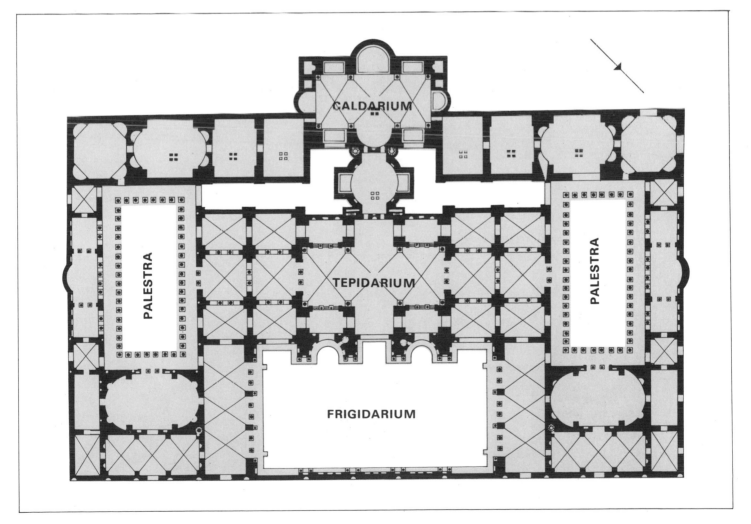

420 ROME: BATHS OF DIOCLETIAN. PLAN OF THE CENTRAL SECTION

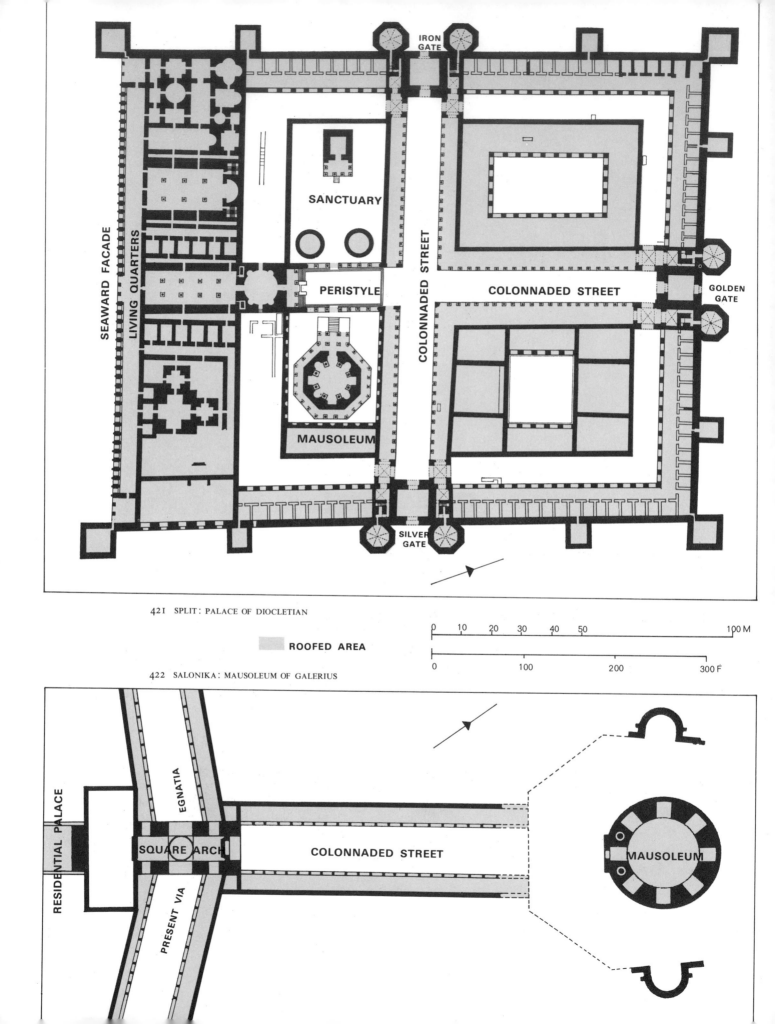

IRON GATE

SANCTUARY

SEAWARD FACADE

LIVING QUARTERS

PERISTYLE

COLONNADED STREET

COLONNADED STREET

GOLDEN GATE

MAUSOLEUM

SILVER GATE

421 SPLIT: PALACE OF DIOCLETIAN

ROOFED AREA

422 SALONIKA: MAUSOLEUM OF GALERIUS

| 0 | 10 | 20 | 30 | 40 | 50 | 100 M |

| 0 | 100 | 200 | 300 F |

RESIDENTIAL PALACE

EGNATIA

SQUARE ARCH

PRESENT VIA

COLONNADED STREET

MAUSOLEUM

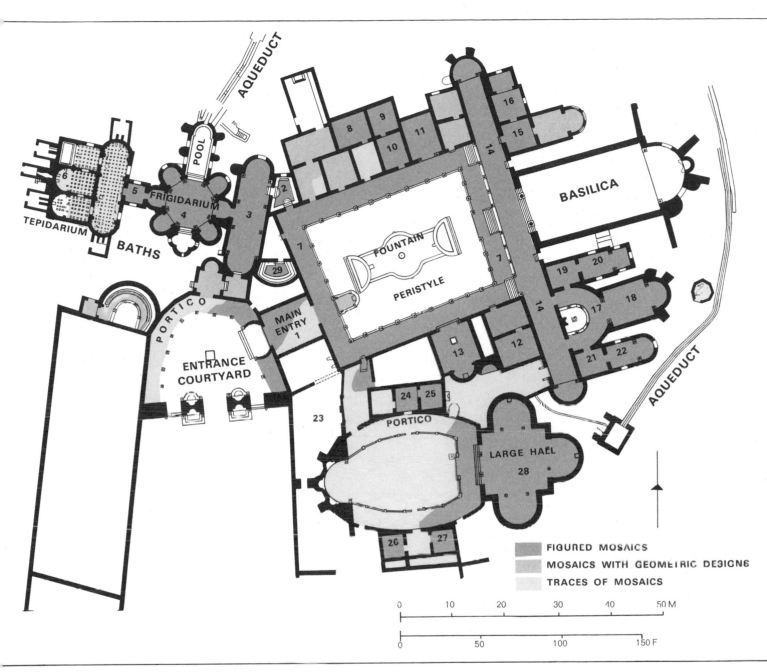

AQUEDUCT

TEPIDARIUM

BATHS

POOL

FRIGIDARIUM

6

5

4

3

2

29

PORTICO

ENTRANCE
COURTYARD

MAIN
ENTRY
1

23

PORTICO

8

9

10

11

16

15

14

FOUNTAIN

PERISTYLE

7

7

14

BASILICA

19

20

17

18

13

12

21

22

24

25

LARGE HALL

28

26

27

AQUEDUCT

■ FIGURED MOSAICS
▨ MOSAICS WITH GEOMETRIC DESIGNS
▢ TRACES OF MOSAICS

0 10 20 30 40 50 M

0 50 100 150 F

423 PIAZZA ARMERINA: ROMAN VILLA

The numbers refer to the mosaics.
The following are reproduced in the present work:

No. 7 Medallions with animal heads, pl. 224, 225
No. 11 The Little Hunt, pl. 199
No. 14 The Great Hunt, pl. 226
No. 20 Children hunting, pl. 227
No. 28 Triumphs and exploits of Hercules, pl. 229

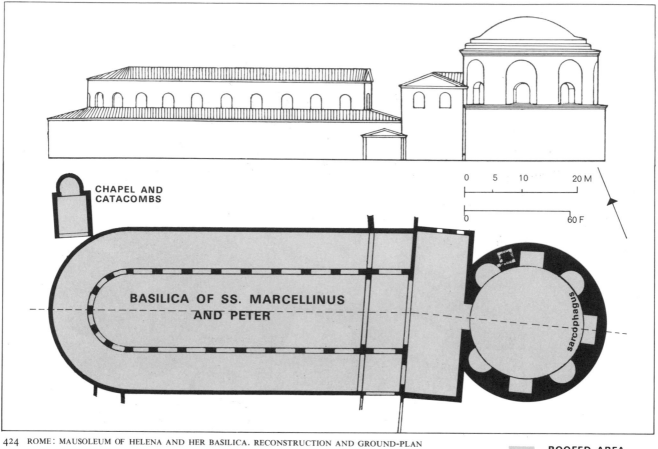

CHAPEL AND
CATACOMBS

BASILICA OF SS. MARCELLINUS
AND PETER

sarcophagus

0 5 10 20 M

0 60 F

424 ROME: MAUSOLEUM OF HELENA AND HER BASILICA. RECONSTRUCTION AND GROUND-PLAN

ROOFED AREA

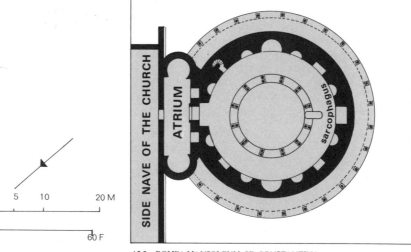

SIDE NAVE OF THE CHURCH

ATRIUM

sarcophagus

0 5 10 20 M

0 60 F

425 ROME: MAUSOLEUM OF CONSTANTINA

The plans were drawn by Claude Abeille

Chronological Table

MEN	EVENTS
190	
192. Assassination of Commodus.	190. On the death of Commodus the Treasury contains no more than 25,000 denarii.
193. Pertinax, the Praetorians' candidate, and Clodius Albinus (with some encouragement from the Senate) proclaim themselves joint Emperors. Septimius Severus is acclaimed by the Illyrian legions, marches on Rome, and wins recognition from the Senate.	
196. Marcus Aurelius Severus, known as Caracalla, the son of Severus, is made a Caesar.	197 (February). Battle of Lugdunum (Lyons) and death of Albinus. Severus campaigning against the Parthians. Organization of the province of Mesopotamia. Travels to Egypt and Syria.
200 198. Caracalla made an Augustus.	202. Severus returns to Rome. Ban on Jewish and Christian proselytization.
	203. The *Decennalia* of Severus's reign celebrated.
205. Papinian as Praetorian Prefect, with Ulpian as his adviser.	205. Rebellion in Britain.
210 211. Septimius Severus dies at York (Eburacum) on 4 February. Caracalla becomes Emperor, in association with his younger brother Geta.	
212. Assassination of Geta and Papinian.	212 (or 213?). *Constitutio Antoniniana*: Roman citizenship granted to the inhabitants of the provinces.
	214–5. Caracalla defends the Danube against the Quadi and the Goths. Expedition against the Parthians.
217. Caracalla killed at Carrhae.	
218. Marcus Aurelius Antoninus, known as Elagabalus, the supposed son of Caracalla, proclaimed Emperor (16 May).	
220 222. Elagabalus murdered by the Praetorians. Alexander Severus, Elagabalus's cousin, becomes Emperor, under the guidance of his mother Mamaea and Ulpian the Praetorian Prefect.	
c.226. In Iran, Ardashir proclaims himself King, and replaces the Parthian dynasty by that of the Sassanids.	
230	230. Ardashir invades Mesopotamia and Cappadocia.
235. Alexander Severus and Mamaea killed by the troops of Mainz, who proclaim as Emperor an officer named Maximin, a former Thracian peasant.	
238. Gordian, the proconsul of Africa, together with his son, proclaimed Augusti by the landed aristocrats of the province, but killed by the legate of Numidia. The Senate proclaims Balbinus and Pupienus Emperors. They are killed by the Praetorians, and the young Caesar Gordian III is proclaimed Emperor.	238. The Goths cross the Danube and invade Moesia.
240	
	243. Antioch freed from the Persian threat.
244. Gordian killed in the East. Philip the Arab, Praetorian Prefect, becomes Emperor.	247 (21 April). Rome's thousandth anniversary. Philip frees Dacia from occupation by the Goths.
250 249. Philip killed near Verona. The Goths are defeated, and the army proclaims its victorious general Decius as Emperor.	c.250. The city of Hatra destroyed by Shapur I.
251. Decius and his son Herennius are killed. Hostilian, another of Decius's sons, dies of the plague. The *dux* of Moesia, Trebonianus Gallus, negotiates a bought peace with the Goths and is proclaimed Emperor.	250. Barbarians threatening the Rhine. Systematic persecution of the Christians: all citizens obliged to obtain a certificate showing that they had performed sacrifice. The Goths, under the leadership of their King Kniva, occupy Philippopolis (Plovdiv) in Thrace.
253. In Rhoetia, the Rhine army acclaims Valerian, who takes as his associate his son Gallienus.	254. The Marcomanni in Pannonia and at Ravenna.
	c.256. Destruction of Dura-Europos.
	257–8. Edict against the Christians. Martyrdom of St Cyprian. The Goths pillage Asia Minor.
260	260. Valerian taken prisoner by King Shapur I near Edessa. Invasion of Gaul by the Franks and Alamanni.
261. Saloninus, Gallienus's son, acclaimed as Emperor in Cologne, but killed by his tutor, Posthumus, who proclaims himself Emperor in Gaul, and defends the country against the Alamanni.	
268. Gallienus eliminated at Milan by a junta of Illyrian officers. Claudius proclaimed Emperor, and halts the advancing Alamanni close to the Lago di Garda.	267. Zenobia, widow of Odeynat (who defended the Empire against the Persians), attempts to set up an independent kingdom at Palmyra for her son Waballath. The Goths invade the Balkans and Greece by land and sea.

THE ARTS	THOUGHT	
		190
	197. Tertullian writes his *Apologeticum*.	
	201. Death of Galen.	200
	202. Edict of Septimius Severus: it is now permissible to be a Christian, but not to become one.	
203. Arch of Septimius Severus on the Forum Romanum in Rome. Arch of Septimius Severus at Leptis Magna.	203. Origen succeeds Clement as head of the School of Alexandria.	
204. Gateway dedicated to Septimius Severus on the Forum Boarium, in Rome.	*c.* 205. Birth of Plotinus, at Lycopolis (Egypt).	210
Between 210 and 215 Paintings in the barracks of the Seventh Cohort, City Police (*Vigiles*) in Rome.		
216. Inauguration of the Baths of Caracalla in Rome (begun 212).	215. Clement of Alexandria finishes writing his *Stromateis* ('Miscellanies' – literally, 'Bedspreads' or 'Carpets').	
		220
	*c.*222. Death of Bardesanes, Syrian Gnostic thinker and historian, born at Edessa in 154.	
*c.*225. Rome, Mithraeum of S. Prisca.		
227. Rome, Baths of Alexander Severus (enlargement of the Baths of Nero).	229. Second consulate of Dio Cassius, the historian (born at Nicaea in Bithynia). His *Roman History* covers the period from the origins to the year of his second consulate.	230
c. 230–5 In Rome: Gallery of the Flavians in the Catacombs of Domitilla. Tomb of Clodius Hermes in S. Sebastiano (Via Appia). Hypogaeum of the Aurelii (Viale Manzoni).	*c* 232. Birth of Porphyry, who afterwards became the disciple of Plotinus.	
238. Rome, sarcophagus from Acilia.		
*c.*240. Rome, Villa under the Church of S. Sebastiano (Via Appia).		240
	242. Manes preaching his religion (Manichaeism) in Iran.	
*c.*245. Rome, Attic sarcophagus representing the legend of Achilles (Museo Capitolino). Rome, Catacombs of Domitilla, Chapel of the Good Shepherd. Ostia, Isola Sacra, paintings from the tomb of Septimia Tyche.	248. Origen publishes his *Contra Celsum*.	
	*c.*250. Philostratus II writes his *Imagines*.	250
251. Rome, large sarcophagus representing a battle between Romans and Barbarians, Ludovisi Collections (Museo Nazionale).	251. Cyprian's treatise *De Unitate Ecclesiae Catholicae* ('On the Unity of the Catholic Church').	
	252–3. Death of Origen.	
	260. Edict of Gallienus: Christianity now a 'permitted religion', *religio licita*.	260
262. Rome, Arch of Gallienus.		

	MEN	EVENTS
270	270. Aurelian is acclaimed Emperor by the army at Sirmium (where Claudius had died of the plague).	269. Claudius defeats the Goths at Naïssus.
		271. The Romans evacuate Dacia and move south of the Danube (the province is finally abandoned in 274).
		273. Submission of Palmyra. The town is largely destroyed.
		274. Monetary reforms. Triumph of Aurelian, in which Zenobia figures as a captive.
	275. Aurelian assassinated near Perinthus. The Senate designates Tacitus.	275. The Franks invade Gaul and occupy Bavay, Paris, Trèves, Metz; the Alamanni occupy Strasbourg and the Rhône Valley.
	276. Tacitus assassinated in Asia. The army chooses its victorious general, Probus.	277. Probus delivers Gaul from the Franks and Alamanni, and Rhoetia from the Vandals (278–9).
280		280. Probus drives the Goths back from the Danube and makes peace with the Persians.
		281. Probus's triumph in Rome.
	282. Probus is assassinated at Sirmium. The army proclaims the Praetorian Prefect, Carus, who nominates his two sons Carinus and Numerianus as Caesars.	282. Probus settles Barbarians in the devastated regions.
	283 (summer). Carus dies at Ctesiphon. Carinus Emperor in the West, Numerian in the East.	
	284. Death of Numerian. The armed forces stationed near Nicomedia proclaim Diocletian (20 November).	
	285. Carinus killed in Moesia.	
	286. Maximian, general in Pannonia, nominated as Caesar by Diocletian.	286. Usurpation of Carausius, commander of the fleet at Boulogne.
	287. Diocletian and Maximian, Augusti, and take the titles, respectively, of *Jovius* and *Herculius*.	287. Diocletian re-establishes Rome's influence in Armenia, and her former outposts in Mesopotamia.
290	293. Constantius Chlorus nominated Caesar by Maximian in Milan (March); Galerius nominated Caesar by Diocletian in Nicomedia (May).	293. Constantius takes Boulogne. Galerius drives back the Goths from the Danube.
		294. Carausius killed in Britain, and replaced by Allectus.
		297. Fiscal reforms in Egypt (Edict of Optatus).
		298. Maximian sojourns at Aquileia after having pacified Africa. Galerius annexes for Rome the Persian territories beyond the Tigris, and establishes a protectorate over Armenia.
300		301. Diocletian's Edict fixing a maximum tariff for prices.
		302–3. Persecution of the Christians.
		303. Celebrations in honour of the Caesars' tenth, and Diocletian's twentieth, year in power.
	305. Abdications of the Augusti (1 May): Constantius Chlorus First Augustus, Galerius Second Augustus; Caesars, Severus and Maximin Daia.	305. Diocletian retires to the palace he has built himself at Split.
	306. Death of Constantius (July). Usurpation by Constantine (recognized by Severus), and usurpation by Maxentius, son of Maximian (October).	
	307. Maxentius eliminates Severus. Maximian returns and seeks refuge in Gaul.	
310	310. Maximian dies in Marseilles.	311. At Nicomedia, Galerius decrees complete freedom of worship for Christians.
	311. Death of Galerius.	
	312. Maxentius defeated and slain at the Milvian Bridge by Constantine (28 October). Constantine allies himself with Licinius, who is nominated Augustus at Carnuntum, in 308.	313. The Milan Conference between Constantine and Licinius.
		314. War between Constantine and Licinius.
		316. Constantine leaves Trèves and establishes his residence at Sirmium (Sremska Mitrovica).
		317. The sons of the two Augusti nominated as Caesars.
320	324. Constantine sole Augustus. He chooses Byzantium as his capital.	319. Constantine settles at Serdica (Sofia).
		325. The Council of Nicaea, at which certain theological questions concerning the Catholic Church are settled with Constantine's participation in the proceedings.
		326. Constantine has Crispus (his son) and Fausta (his wife) executed.
330		330 (11 May). Dedication of the Imperial Residence at Constantinople.
	337 (22 May). Death of Constantine. Constantine II in the West (Gaul), Constantius in the East.	333. Tension with Persia. Shapur II temporarily occupies Armenia.

THE ARTS	THOUGHT	
	270. Death of Plotinus (*Enneads*).	270
271. Rome, establishment of the City *enceinte* by Aurelian.		
274. Rome, Temple of 'The Invincible Sun'.		
c.275. Rome, sarcophagus of a *Praefectus Annonae* (Museo Nazionale).		
c.280. Rome, sarcophagus of Peregrinus, with philosophers (Museo Torlonia).		280
	283. Nemesianus publishes his *Cynegetica*.	
		290
295. Rome, altar dedicated by Orfitus, dated (Villa Albani). Salonika, Arch of Galerius (297–305).	297 (31 March). Edict against the Manichaeans.	
298. Rome, Maximian begins the construction of the Baths of Diocletian.		300
303(?). Base of the *Decennalia* of the Tetrarchy in the Forum Romanum. Porphyry images of the Tetrarchs in Venice.	c.303. Death of Porphyry, Plotinus's disciple.	
305. Luxor (Egypt), painting in the Temple of the Imperial Cult.	304. Death of Pope Marcellinus.	
		310
	c.313. Eusebius of Caesarea writes his *Ecclesiastical History*.	
315. Rome, Arch of Constantine.	315 (or 318). The beginning of Athanasius's theological quarrel with Arius.	
	317. Lactantius, a Christian rhetorician from Africa, is summoned by Constantine to undertake the education of his son Crispus.	
	320. Licinius persecuting the Christians.	320
c.325. Rome, 'theological' sarcophagus (Lateran, no. 104).	321. Constantine's edict of toleration for the Donatists.	
	325. The Council of Nicaea condemns Arius.	
c.326. Trèves, Imperial Basilica.	c.325. The death of Lactantius.	
	c.327. Death of Arnobius, Christian apologist from Africa.	
c.331. Rome, basilica of the consul Junius Bassus.	328. Athanasius becomes Bishop of Alexandria.	330
c.335. Mosaics from the Constantinian villa in Antioch (Louvre).	c.330. Death of Iamblichus, the founder of the Neoplatonist school in Syria.	
337. Hispellum (Umbria), temple of the *gens Flavia*.		

	MEN	EVENTS
340	341. Constans in Britain.	343. Constantius II occupies Adiabene.
350	350. Death of Constans. 351. Constantius II nominates Gallus as Caesar in the East. 354. Gallus recalled and put to death. 355. Julian nominated as Caesar in Gaul (November).	350. Shapur II's assault on Nisibis. 355. The revolt of Silvanus the Frank triggers off a new Barbarian invasion. 356. Julian's campaign in Gaul, stabilization of the Rhine frontier.
360	360. Julian 'the Apostate' proclaimed Emperor at Lutetia (Paris), in February. 363. Death of Julian (26 June). 364. Valentinian becomes Augustus (February), and takes Valens as his associate (March). 366. Valentinian installs himself at Trèves. 367. Valentinian bestows the title of Augustus on his son Gratian. 369. Theodosius nominated *comes* in Britain.	361. Constantius II returns to the West with the intention of taking the field against Julian, but dies *en route* (November). Julian in Constantinople (December 361–May 362) and Antioch (July 362–March 363). 364. The Goths repudiate their agreement and resume their incursions. 365. The Alamanni invade Gaul. Campaigns of Jovinus, Master of the Horse. 367. Picts, Scots and Saxons invade Britain, and advance across the Channel. 369. Break between Valentinian and the senatorial aristocracy; persecution of the latter.
370	375. Death of Valentinian I. Gratian Emperor. Proclamation of Valentinian II. 378. Valens falls in the Battle of Adrianople. 379. Theodosius I becomes Emperor (19 January).	373. Campaign by Theodosius in Africa. The Quadi and Alamanni invade Pannonia. 375. The Huns occupy the kingdom of the Ostrogoths as far as the Dniestr. 376. The Goths cross the Danube; the Alamanni invade Gaul and are defeated, in 378, by Gratian, near Colmar. 378. Battle of Adrianople (9 August) against the Visigoths ends in a defeat.
380	383. Death of Gratian. Valentinian II in Milan. Theodosius nominates his son Arcadius as an Augustus. 384–5. Aurelius Symmachus Prefect of Rome.	380. Vandal and Goth *foederati* installed in Pannonia. 383. Hadrian's frontier-line in Britain abandoned. 389. Britain: evacuation of the Yorkshire fortresses.
390	392. Usurpation of Eugenius (August 392–September 394). 395. Death of Theodosius I in Milan (17 January). Division of the Empire between his two sons: Honorius in the West, under Stilicho, Arcadius in the East, under Rufinus and, latterly, Eutropius.	395. Famine in Rome as a result of the transport-boycott carried out by Gildon, leader of the Moors and Governor of Africa (revolts in 397). Alaric in Thrace and Macedonia. Hunnish incursions into Thrace.
400		398. Eutropius victorious against the Huns. 402. The Western Court transferred to Ravenna. 406 (31 December). Great invasion of Gaul.
410	408. Death of Stilicho.	410 (24 August). Rome taken by Alaric, chief of the Visigoths and Governor of Illyria.

THE ARTS	THOUGHT	
	339. Athanasius, Bishop of Alexandria, exiled for the second time.	340
340–50. Rome, paintings in the hypogaeum of Trebius Justus.	343. Council of Sardica.	
	c. 344. Birth of Jerome at Stridon (Dalmatia).	
	345. Death penalty imposed for adherence to pagan cults.	
	346. Athanasius reinstated at Alexandria. Libanius opens his school at Nicomedia.	
	c. 347. Conversion to Christianity of Firmicus Maternus, writer (born in Sicily).	
	348. Repression of the Donatists in Africa. Council of Carthage.	
c. 350. Antioch, mosaic with Earth and *karpoi*. Taunton (Somerset), mosaic with the legend of Dido, Low Ham Villa.	351. Reopening of the Arian controversy. Arianism enjoys a brief moment of triumph (357).	350
354. Roman calendar of Philocalus the calligrapher.		
356. Rome, paintings including St Petronilla in the Catacombs of Domitilla.	356. Athanasius exiled for the third time.	
359. Rome, sarcophagus of the City Prefect Junius Bassus (Caves of the Vatican).	357. Visit of Constantius to Rome (April-May). The Altar of Victory is removed.	360
	361. Julian makes a definitive break with Christianity.	
	362. Pagan cults re-established; Christians debarred from teaching in schools.	
	364. Reaction against Julian's work.	
c. 365. Rome, paintings of the private catacomb on the Via Latina.	365. Libanius completes his two *Funeral Panegyrics* for Julian.	
	366. Damasus elected Pope (until 384). The partisans of Damasus and Ursinus, the anti-pope, come to blows inside the Basilica Liberiana (S. Maria Maggiore).	
		370
	373. Death of Athanasius.	
	374–97. Ambrosius Bishop of Milan.	
c. 378. Jerusalem, Church of the Ascension.		
	380 (28 February). Edict of Theodosius, Gratian and Valentinian II, dated from Thessalonika, making it obligatory for all their subjects to live as Christians according to the formula of the Bishops of Rome and Alexandria.	380
	c. 381. Ammianus Marcellinus, born at Antioch but resident in Rome, finishes his *Roman History* (from Nerva to Valens).	
386–94. Constantinople, column of Theodosius.	382. The statue of Victory is removed from the Senate House, and State contributions to the upkeep of pagan cults are abolished.	
c. 390. Constantinople, base of the obelisk of Theodosius.	386. Edict ordering the destruction of the pagan temples.	390
	391–2. Edicts of condemnation against paganism.	
	c. 393. Death of Ausonius, poet who wrote *The Moselle*.	
	c. 396. The *Lausiac History* of Palladius (monachism).	
	399. Death of Evagrius Ponticus, Christian writer and ascetic.	
401–21. Constantinople, column of Arcadius.		400
		410

Bibliography

The most important references are preceded by an asterisk. They have been singled out either for their special relevance to this study, or for the excellent bibliographies they contain.

GENERAL WORKS

REFERENCE BOOKS

1 BIANCHI BANDINELLI (Ranuccio) and BECATTI (Giovanni) eds., *Enciclopedia dell'Arte Antica Classica e Orientale*, Rome, Istituto della Enciclopedia Italiana, 1958–66, 7 vol.

2 DAREMBERG (Charles), SAGLIO (Edmond), and POTTIER (Edmond) eds., *Dictionnaire des antiquités grecques et romaines d'après les textes et les monuments*, Paris, Hachette, 1877–1919, 9 vol. in 5.

3 DEICHMANN (Friedrich Wilhelm) ed., *Repertorium der christlich-antiken Sarkophage*, I, Rom und Ostia, Wiesbaden, Steiner, 1967.

4 ESPÉRIANDIEU (Émile), *Recueil général des bas-reliefs de la Gaule romaine*, 'Collection de documents inédits sur l'histoire de France', I–XV, Paris, Imprimerie nationale and E. Leroux, 1907–66.

5 GERKE (Friedrich), *Die christlichen Sarkophage der vorkonstantinischen Zeit*, 'Studien zur spätantiken Kunstgeschichte', XI, Berlin, W. de Gruyter, 1940.

6 KLAUSER (Theodor) ed., *Reallexikon für Antike und Christentum*, Leipzig-Stuttgart, Karl and Anton Hiersemann, 1941–69, 7 vol. so far published (from A to F).

7 KIRSCHBAUM (Engelbert) ed., *Lexikon der christlichen Ikonographie*, I, Rome, Herder, 1968.

8 MAURICE (Jules), *Numismatique constantinienne* . . . , Paris, E. Leroux, 1908–12, 3 vol.

9 PALLOTTINO (Massimo) ed., *Enciclopedia universale dell'arte*, Venice-Rome, Istituto per la Collaborazione Culturale, 1958–67, 15 vol. English edn. McGraw-Hill, New York.

10 UNGER (Frederic Wilhelm), *Quellen der byzantinischen Kunstgeschichte*, 'Quellenschriften', R. Eitelberger and Edelberg, XII, Vienna, Baumüller, 1878.

GENERAL SURVEYS

11 AYMARD (André) and AUBOYER (Jeannine), *Rome et son empire*, 'Histoire générale des civilisations', II, Paris, Presses universitaires de France, 1954.

12 BARLÖWEN (Wolf D. von) ed., *Abriss der Geschichte antiker Randkulturen*, 'Oldenbourgs Abriss der Weltgeschichte', Munich-Vienna, R. Oldenbourg, 1961.

13 BIANCHI BANDINELLI (Ranuccio) with contributions by EGGERS (Jürgen) and COARELLI (Filippo), *Romana Arte*, Rome, Istituto della Enciclopedia Italiana, 1965. (Extract from the *Enciclopedia dell'Arte Antica Classica e Orientale*, VI.)

14 BORDA (Maurizio), *La pittura romana*, 'Le grandi civiltà pittoriche', Milan, Società Editrice Libraria, 1958.

15 BYVANCK (Alexander Willem), *De Kunst der Oudheid*, V, Leiden, E. J. Brill, 1965.

16 FROVA (Antonio), *L'arte di Roma e del mondo romano*, 'Storia universale dell'arte', II, Turin, U.T.E.T., 1961.

17 GRABAR (André), *The Beginnings of Christian Art, 2000–395*, 'The Arts of Mankind', London, Thames and Hudson, 1967, and under the title *Early Christian Art*, New York, Odyssey, 1968.

18 GRABAR (André), *L'Art de la fin de l'Antiquité et du Moyen Age*, Paris, E. de Boccard, 1968, 3 vol.

19 GRANT (Michael), *The World of Rome*, London and New York, 1960.

20 KÄHLER (Heinz), *Wesenzüge der Römischen Kunst*, Saarbrücken, Universität des Saarlandes, 1958.

21 KÄHLER (Heinz), *Rome and Her Empire*, 'Art of the World Library', London, Methuen, and New York, Crown, 1963.

*22 KRAUS (Theodor), *Das römische Weltreich*, 'Propyläen Kunstgeschichte', II, Berlin, Propyläen Verlag (A. Springer), 1967.

23 KRAUTHEIMER (Richard), *Early Christian and Byzantine Architecture*, 'The Pelican History of Art', Harmondsworth, Middlesex, Penguin Books, 1965.

*24 LEVI (Doro), 'L'arte romana. Schizzo della sua evoluzione e sua posizione nella storia dell'arte antica', in *Annuario della Scuola archeologica italiana di Atene*, XXIV–XXVI, 1946–8, Rome, 1950, pp. 229 sq.

25 MOREAU (Jacques), *Die Welt der Kelten*, Stuttgart, Klipper, 1958.

*26 MOREY (Charles Rufus), *Early Christian Art. An Outline of the Evolution of Style and Iconography in Sculpture and Painting from Antiquity to the Eighth Century*, Princeton, N.J., The Princeton University Press, 1941.

*27 PICARD (Gilbert-Charles), *L'Art romain*, 'Les Neuf Muses', Paris, Presses universitaires de France, 1962.

28 VOLBACH (Wolfgang Fritz) and HIRMER (Max), *Early Christian Art*, London, Thames and Hudson, 1961.

29 WHEELER (Sir Mortimer), *Rome beyond the Imperial Frontiers*, London, G. Bell and Sons Ltd., 1954; Harmondsworth, Middlesex, Penguin Books, 1955.

CATALOGUES

*30 Under the auspices of the Académie des Inscriptions et Belles-Lettres, *Inventaire des mosaïques de la Gaule et de l'Afrique*, Paris, E. Leroux, 1922 – (so far 3 vol., in 5, and 6 albums have been published).

31 *Koptische Kunst. Christentum am Nil*, catalogue of the Villa Hügel Exhibition, Essen, 1963, Essen-Bredeney, Verein Villa Hügel e.V., 1963.

32 *Kunstschätze in Bulgarischen Museen und Klöstern*, catalogue of the Villa Hügel Exhibition, Essen, 1964, Essen-Bredeney, Verein Villa Hügel e.V., 1964.

*33 MENDEL (Gustave), *Catalogue des sculptures grecques, romaines et byzantines des musées impériaux ottomans*, Constantinople, Imperial Museum, 1912–14, 3 vol.

34 *Musée archéologique de Plovdiv*, Sofia, Bulgarski Hudojnik, 1964.

35 *Musée archéologique de Stara Zagora*, Sofia, Bulgarski Hudojnik, 1965.

36 *Musée archéologique de Varna*, Sofia, Bulgarski Hudojnik, 1964.

37 *Römer in Rumänien*, catalogue of the exhibition held jointly by the Römisch-Germanisches Museum and the Historical Museum of Cluj, both in Cologne, 1969.

*38 AMELUNG (Walter), *Die Skulpturen des vaticanischen Museums*, Berlin, Georg Reimer distrib., 1903–36, 4 vol.

39 BECATTI (Giovanni), *Mosaici e Pavimenti marmorei, Scavi di Ostia IV*, 2 vol., Rome 1961.

*40 BLÜMEL (Carl), *Katalog. Römische Bildnisse*, 'Katalog der Sammlung antiker Skulpturen' (Staatliche Museen zu Berlin), Berlin, Verlag für Kunstwissenschaft, 1933.

41 BRAEMER (François), *L'Art dans l'Occident romain*, catalogue of an exhibition held in the Palais du Louvre, Paris, 1963, Paris, Ministère d'État chargé des Affaires culturelles, 1963.

42 CAGIANO DE AZEVEDO (Michelangelo), *Le antichità di Villa Medici*, Rome, Libreria dello Stato, 4th edn., 1951.

43 COCHE DE LA FERTÉ (Étienne), *Les Portraits romano-égyptiens du Louvre*, Paris, Éd. des Musées nationaux, 1953.

44 DE MAFFEI (Fernanda), 'La civiltà figurativa armena', in *Architettura medievale Armena*, exhibition catalogue, Rome, Istituto di Storia dell'Arte dell'Università di Roma e Accademia delle Scienze della Rep. Soc. Soviet. Armena, 1968.

45 EDGAR (Campbell Cowan), *Graeco-Egyptian Coffins, Masks and Portraits*, 'Catalogue général des Antiquités égyptiennes du Musée du Caire', XXVI, Cairo, Imprimerie de l'Institut français, 1905.

46 FELLETTI MAJ (Bianca Maria), *Museo Nazionale Romano. I Ritratti*, 'Cataloghi dei Musei e Gallerie d'Italia', Rome, Lirereria dello Stato, 1953.

47 FORLATI (Bruna), *Guida del Museo Civico di Oderzo*, Milan, Pleion, 1957.

48 FOUCHER (Louis), *Inventaire des mosaïques: Sousse*, Tunis, Institut national d'archéologie et d'arts, 1960 (sheet no. 57 of the Archaeological Atlas).

49 HATT (Jean-Jacques), *Strasbourg, Musée archéologique. Sculptures antiques régionales*, 'Inventaire des collections publiques françaises', 9, Paris, Éd. des Musées nationaux, 1964.

50 HAVERFIELD (Francis John), *Catalogue of the Roman Inscribed and Sculptured Stones in the Grosvenor Museum*, Chester, R. Griffith, 1900.

*51 HELBIG (Wolfgang), *Führer durch die öffentlichen Sammlungen klassischer Altertümer in Rom*, Tübingen, Ernst Wasmuth, 1966–9, 3 vol. (4th edn. revised under the editorship of Hermine Speier).

*52 JONES (Henry Stuart), *A Catalogue of the Sculptures preserved in the Municipal Collections of Rome*, Oxford, The Clarendon Press, 1912–26, 2 vol.

53 PARIBENI (Enrico), *Catalogo delle Sculture di Cirene*, Rome, 'L'Erma' di Bretschneider, 1959.

54 RICHTER (Gisela M.), *Greek, Etruscan and Roman Bronzes in the Metropolitan Museum of Art*, New York, 1915.

55 *Römer am Rhein*, catalogue of the exhibition held in 1967 by the Römisch-Germanisches Museum, Cologne, 1967.

56 ROSENBAUM (Elizabeth), *A Catalogue of Cyrenaican Portrait Sculpture*, London, Oxford University Press, 1960.

57 SUSINI (Giancarlo), *Il Lapidario greco e romano di Bologna*, 'Le Collezioni del Museo Civico di Bologna), Bologna, Comune di Bologna, 1960.

58 VOLBACH (Wolfgang Fritz), *Elfenbeinarbeiten der Spätantike und des frühen Mittelalters*, 'Römisch-Germanisches Zentralmuseum', 7, Mainz, Römisch-Germanisches Zentralmuseum, 1952.

SPECIAL STUDIES

THE ROMAN EMPIRE
AD 192–495.

59 'The Imperial Crisis and Recovery', in *The Cambridge Ancient History*, XII, Cambridge, University Press, 1939.

60 DILL (Samuel), *Roman Society in the Last Century of the Western Empire*, London, Macmillan and Co., 1925.

*61 FRANK (Tenney) ed., *An Economic Survey of Ancient Rome*, Paterson, New Jersey, Pageant Books Inc., 1933–40; reissued 1959, 5 vol.

62 GAGÉ (Jean), *Les Classes sociales dans l'Empire romain*, Paris, Payot, 1964.

63 HARTKE (Werner), *Römische Kinderkaiser. Eine Strukturanalyse römischen Denkens und Daseins*, Berlin, Akademie-Verlag, 1951, 2 vol.

*64 JONES (Arnold Hugh Martin), *The Later Roman Empire 284–602. A Social, Economic and Administrative Survey*, Oxford, Basil Blackwell, 1964, 4 vol.

65 LEVI (Mario Attilio), *L'Italia antica*, Milan, Mondadori, 1968, 2 vol.

*66 MAZZARINO (Santo), *Aspetti sociali del quarto secolo. Ricerche di storia tardoromana*, Rome, 'L'Erma' di Bretschneider, 1951.

67 MAZZARINO (Santo), *La fine del mondo antico*, 'Saper tutto', Milan, Garzanti, 1959. (English trs., *The End of the Ancient World*, London, Faber and Faber, 1966.)

68 RÉMONDON (Roger), *La Crise de l'Empire romain de Marc-Aurèle à Anastase*, 'Nouvelle Clio', XI, Paris, Presses universitaires de France, 1964.

*69 ROSTOVTZEFF (Mikhail), *Social and Economic History of the Roman Empire*, 2nd edn., revised P. M. Fraser, Oxford, The Clarendon Press, 1957, 2 vol.

*70 VOGT (Joseph), *Constantinus der Grosse und sein Jahrhundert*, Munich, F. Bruckmann, 2nd edn., 1960.

CHRISTIANS AND PAGANS

71 ALFÖLDI (Andreas), *A Conflict of Ideas in the Late Roman Empire*, trs. Harold Mattingly, Oxford, The Clarendon Press, 1952.

*72 CUMONT (Franz), *Oriental Religions in Roman Paganism*, New York, Dover, 1956.

*73 CUMONT (Franz), *Recherches sur le symbolisme funéraire des Romains*, Paris, P. Geuthner, 1942.

*74 FESTUGIÈRE (André Jean), *Antioche païenne et chrétienne*, 'Bibliothèque des Écoles françaises d'Athènes et de Rome', Paris, E. de Boccard, 1959.

*75 FESTUGIÈRE (André Jean), *Hermétisme et mystique païenne*, Paris, Aubier-Montaigne, 1967.

76 GEFFCKEN (Johannes), *Der Ausgang des griechisch-römischen Heidentums*, 'Religionswissenschaftliche Bibliothek', VI, Heidelberg, Carl Winter, 1920.

77 KENNER (Hedwig), *Puer Senex*, 'Academia scientiarum et artium Slovenica', Acta archaeologica, XIX, Ljubljana, 1968, pp. 68–73.

*78 MARROU (Henri Irénée), 'Mousikos aner', *Études sur les scènes de la vie intellectuelle figurant sur les monuments funéraires romains*. Grenoble, Impr. Allier, 1938, new edn. 1964.

*79 MOMIGLIANO (Arnaldo), *The Conflict between Paganism and Christianity in the Fourth Century*, 'Oxford-Warburg Studies', Oxford, The Clarendon Press, 1963.

80 VOGT (Joseph) and SESTON (William), *Die konstantinische Frage*, in Xe Congrès international des sciences historiques, VI, Rome-Florence, 1955, pp. 733–99.

THE HISTORY OF ART

THE END OF ANTIQUITY

*81 AINALOV (D.V.), *The Hellenistic Origins of Byzantine Art*, trs. from Russian by Elizabeth and Serge Sobolevich, 'The Rutgers Byzantine Series', New Brunswick, New Jersey, Rutgers University Press, 1961. The Russian title, literally translated, is *Christian Monuments from the Chersonese*.

82 ALFÖLDI (Andreas), *Die Geburt der kaiserlichen Bildsymbolik*, 3, *Parens Patriae*, in Museum Helveticum, IX, pp. 191–215 and X, pp. 103–24, Basle, 1952 and 1953.

*83 BIANCHI BANDINELLI (Ranuccio), 'Continuità ellenistica nella pittura di età medio e tardo-Romana, in *Archeologia e cultura*, Milan-Naples, R. Ricciardi, 1961, pp. 360–444.

84 BIANCHI BANDINELLI (Ranuccio), 'La crisi artistica del mondo antico' (1952), in *Archeologia e cultura*, Milan-Naples, R. Ricciardi, 1961, pp. 189–233.

85 BIANCHI BANDINELLI (Ranuccio), 'Naissance et dissociation de la koinè hellénistico-romaine', in *Le Rayonnement des civilisations grecque et romaine sur les cultures périphériques* (VIIIe Congrès international d'archéologie classique, Paris 1963), E. de Boccard, 1965, pp. 441–63.

86 BONICATTI (Maurizio), *Studi di storia dell'arte sulla tarda antichità e sull'alto medioevo*, Rome, De Luca Editore, 1963.

87 BONICATTI (Maurizio), 'Criteri di indagine sulla continuità della cultura provinciale nel primo medioevo', in

Archeologia classica, XVI, Rome, 1964, pp. 272–83.

88 BREASTED (James Henry), *Oriental Forerunners of Byzantine Painting*, Chicago, University of Chicago Press, 1924.

*89 BRUNS (Gerda), 'Staatskameen des 4. Jahrhunderts n. Chr. Geburt', in *Winckelmanns-programm*, CIV, Berlin, W. de Gruyter, 1948.

*90 BUDDE (Ludwig), *Die Entstehung des antiken Repräsentationsbildes*, Berlin, W. de Gruyter, 1957.

91 DORIGO (Vladimiro), *Pittura Tardoromana*, Milan, Feltrinelli, 1966 (see the review by André Grabar, in *Cahiers archéologiques*, XVIII, pp. 245–7).

*92 GRABAR (André), 'Plotin et les origines de l'esthétique médiévale', in *Cahiers archéologiques*, I, Paris, Klincksieck, 1945, pp. 15–34.

93 GULLINI (Giorgio), *Maestri e botteghe in Roma, da Gallieno alla Tetrarchia*, 'Publicazioni della Facoltà di Lettere di Torino', XII, 2, Turin, Società Editrice Internazionale, 1960.

*94 L'ORANGE (Hans Peter), *Studien zur Geschichte des spätantiken Porträts*, 'Institutet for Sammenlignende Kulturforskning', Serie B, XXII, Oslo, H. Aschehoug and Co. (W. Nygaard), 1933.

95 L'ORANGE (Hans Peter), *Art Forms and Civic Life in the Late Roman Empire*, Princeton, New Jersey, Princeton University Press, 1965.

96 NEUSS (Wilhelm), 'Formzerfall und Formaufbau bei dem Übergang von der antiken zur mittelalterlichen Kunst', in *Jahrbuch des Deutschen archäologischen Instituts*, XLIV, Berlin, W. de Gruyter, 1929, pp. 184 sq.

*97 PELIKÁN (Oldrich), *Vom antiken Realismus zur spätantiken Expressivität*, Státni pedagogické nakladatelstvi, Prague, 1965.

*98 RIEGL (Alois), *Die spätrömische Kunstindustrie nach den Funden in Österreich-Ungarn*, I, Vienna, Verlag der Kaiserlich-königlichen Hof- und Staatsdruckerei, 1901, 2 vol. (Afterwards republished under the title *Spätrömische Kunstindustrie*, Vienna, Österreichische Staatsdruckerei, 1927.)

99 RODENWALDT (Gerhart), 'The Transition to Late Classical Art', in *Cambridge Ancient History*, XII, Cambridge, The University Press, 1939, pp. 544–70.

100 RODENWALDT (Gerhart), 'Zur Begrenzung und Gliederung der Spätantike,' in *Jahrbuch des Deutschen archäologischen Instituts*, LIX, LX, Berlin, De Gruyter, 1945, pp. 81 sq.

101 RUMPF (Andreas), *Stilphasen der spätantiken Kunst. Ein Versuch*. 'Arbeitsgemeinschaft für Forschung des Landes Nordrhein-Westfalen', 44 Opladen, Westdeutscher Verlag, 1957.

*102 SCHWEITZER (Bernhard), *Die spätantiken Grundlagen der mittelalterlichen Kunst*, 'Leipziger Universitätsreden', 16, Leipzig, Johann Ambrosius Barth, 1949.

*103 STRZYGOWSKI (Josef), *Orient oder Rom?* Leipzig, Hinrichs, 1901.

*104 SWOBODA (Karl Maria), *Über die Stilkontinuität vom 4. zum 11. Jahrhundert in Spätantike und Byzanz*, 'Forschungen zur Kunstgechichte und Christliche Archäologie', I, *Neue Beiträge zur Kunstgeschichte des I. Jahrtausends*, Baden-Baden, Verlag für Kunst und Wissenschaft, 1952.

105 VOGT (Joseph), *The Decline of Rome. The metamorphosis of ancient civilisation*, New York, New American Library, 1967. (Cf. the review by P. Petit in *Gnomon*, 38 [1966] pp. 716–20.)

106 WIEACKER (Franz), 'Vulgarismus und Klassizismus im Recht der Spätantike', in *Sitzungsberichte der Heidelberger Akademie der Wissenschaften*, Heidelberg, III, 1955, pp. 7 sq.

SPECIAL TOPICS

*107 ALFÖLDI (Andreas), 'Insignien und Tracht der Römischen Kaiser', in *Mitteilungen des Deutschen archäologischen Instituts. Römische Abteilung*, L, Munich, 1935, pp. 1 sq.

*108 ANDREAE (Bernhard), Studien zur Römischen Grabkunst', in *Mitteilungen des Deutschen archäologischen Instituts, Römische Abteilung*, IX supplement, Heidelberg, 1963.

*109 BECATTI (Giovanni), *La colonna coclide istoriata*, Rome, 'L'Erma' di Bretschneider, 1960.

110 BECATTI (Giovanni), 'Alcune caratteristiche del mosaico bianco-nero in Italia', in *La Mosaïque gréco-romaine*, 'Colloques internationaux du C.N.R.S.', Paris, C.N.R.S., 1965, pp. 15–25.

111 BLANCK (Horst), *Wiederverwendung alter Statuen als Ehrendenkmäler bei Griechen und Römern*, Rome, 'L'Erma' di Bretschneider, 1969.

112 BRILLIANT (Richard), 'Gesture and Rank in Roman Art', in *Memoirs of the Connecticut Academy of Art and Sciences*, XIV, New Haven, Connecticut, Connecticut Academy, 1963.

*113 DELBRÜCK (Richard), 'Die Consulardiptychen und verwandte Denkmäler', in *Studien zur spätantiken Kunstgeschichte*, II, Berlin, W. de Gruyter, 1929.

*114 DELBRÜCK (Richard), *Antike Porphyrwerke*, Berlin, W. de Gruyter, 1932.

*115 DELBRÜCK (Richard), 'Spätantike Kaiserporträts von Constantinus Magnus bis zum Ende des Westreiches', in *Studien zur spätantiken Kunstgeschichte*, VIII, Berlin, W. de Gruyter, 1933.

*116 FRIEDLÄNDER (Paul), 'Spätantiker Gemäldezyklus in Gaza', in *Studie e Testi*, LXXXIX, Vatican, 1939.

*117 GNECCHI (Francesco), *I Medaglioni romani*, Milan, U. Hoepli, 1912, 3 vol.

118 HAMBERG (Peer Gustav), *Studies in Roman Imperial Art with Special Reference to the State Reliefs of the Second Century*, Copenhagen, Ejnar Munksgaard, 1945.

119 HÖLSCHER (Tonio), *Victoria Romana*, 'Römisch-Germanisches Zentralmuseum zu Mainz', Mainz, Ph. von Zabern, 1967.

120 JENNY (Wilhelm Albert von), *Keltische Metallarbeiten*, Berlin, Verlag für Kunstwissenschaft, 1935.

121 KASCHNITZ-WEINBERG (Guido von), 'Spätrömische Porträts', in *Die Antike*, II, Berlin, 1936, pp. 36 sq. (Reissued in G. von Kaschnitz-Weinberg, *Ausgewählte Schriften*, II, *Römische Bildnisse*, published by G. von Kleiner and H. von Heintz, Gebr. Mann, Berlin, 1965, pp. 55 sq.)

122 LA BAUME (Peter), *Römisches Kunstgewerbe zwischen Christi Geburt und 400*, 'Bibliothek für Kunst- und Antiquitä-

tenfreunde', XVIII, Brunswick, Klinkhardt and Biermann, 1964.

*123 LEHMANN-HARTLEBEN (Karl), 'The *Imagines* of the Elder Philostratus', in *The Art Bulletin*, XXIII, New York, 1941, pp. 16–44.

124 PICARD (Charles), 'Pouzzoles et le paysage portuaire', in *Mélanges d'archéologie et d'histoire*, XVIII, Paris, E. de Boccard, 1959, pp. 23 sq.

125 RENARD (Marcel), 'Sphinx à masque funéraire', in *Apulum* (Acta Musei Apulensis), VII, I, Alba Julia, 1968, pp. 273–305.

*126 RODENWALDT (Gerhart), 'Uber den Stilwandel in der antoninischen Kunst', in *Abhandlungen Berliner Akademie*, 3, Berlin, W. de Gruyter, 1935, pp. 1–27.

*127 RODENWALDT (Gerhart), 'Zur Kunstgeschichte der Jahre 220 bis 270', in *Jahrbuch des Deutschen archäologischen Instituts*, LI, 1–2, Berlin, W. de Gruyter, 1936, pp. 82 113.

*128 SCHWEITZER (Bernhard), 'Die europäische Bedeutung der römischen Kunst', in *Vermächtnis der Antiken Kunst*, F. H. Kerle, Heidelberg, 1950, pp. 143–67.

129 SCOTT RYBERG (Inez), 'Rites on the State Religion in Roman Art', in *Memoirs of the American Academy in Rome*, XXII, Rome, 1955.

*130 STERN (Henri), *Le Calendrier de 324. Étude sur son texte et sur ses illustrations.* 'Institut français d'archéologie de Beyrouth. Bibliothèque archéologique et historique', LV, Paris, P. Geuthner, 1953.

131 STRONG (D.E.), *Greek and Roman Gold and Silver Plate*, 'Handbooks of Archaeology', London, Methuen, 1966. (Cf. the review in *Gnomon* XL [1968] pp. 295 sq.)

132 SUNKOWSKY (R.), 'Wesensform und Manufaktur antiker Gläser', in *Jahreshefte des Österreichischen archäologischen Instituts*, XXXVII, Vienna, 1948, pp. 287 sq.

133 TURCAN (Robert), *Les Sarcophages romains à représentations dionysiaques. Essai de chronologie et d'histoire religieuse*, 'Bibliothèque des Écoles françaises d'Athènes et de Rome', CCX, Paris, E. de Boccard, 1966.

*134 WIRTH (Franz), *Römische Wandmalerei vom Untergang Pompejis bis ans Ende des 3. Jahrhunderts*, Berlin, Verlag für Kunstwissenschaft, 1934.

ILLUSTRATED MANUSCRIPTS

*135 BIANCHI BANDINELLI (Ranuccio), *Hellenistic-Byzantine Miniatures of the Iliad*, Olten, Urs Graf, 1955.

136 BIANCHI BANDINELLI (Ranuccio), 'La composizione del Diluvio nella Genesi di Vienna', in *Mitteilungen des Deutschen archäologischen Instituts. Römische Abteilung*, LXII, Heidelberg, 1955, pp. 66 sq.

*137 CAVALLO (Guglielmo), 'Ricerche sulla maiuscola biblica', in *Studi e testi di papirologia dell' Istituto G. Vitelli*, University of Florence, Florence, Le Monnier, 1967, 2 vol.

*138 GERSTINGER (Hans), *Die Wiener Genesis*, 'Nationalbibliothek in Wien', Vienna, Filser, 1931, 2 vol. (facsimile).

*139 WEITZMANN (Kurt), *Illustration in Roll and Codex*, Princeton, Princeton University Press, 1947.

MONUMENTS, BY PROVINCES

Rome

140 APOLLONJ GHETTI (B.M.), FERRUA (A.), JOSI (E.), and KIRSCHBAUM (E.), *Esplorazioni sotto la confessione di San Pietro in Vaticano*, Vatican, 1951.

141 BARBIER (Edmond), 'La signification du cortège représenté sur le couvercle du coffret de "Proiecta", in *Cahiers archéologiques*, XII, Paris, Klincksieck, 1962, pp. 7–33.

142 BECATTI (Giovanni), 'Case Ostiensi del Tardo Impero', in *Bollettino d'Arte*, 2, pp. 102–28; 3, pp. 197–224, Rome, 1948.

*143 BECATTI (Giovanni), *Edificio con opus sectile fuori Porta Marina, Scavi di Ostia* VI, Rome, Istituto poligrafico dello Stato, 1969.

*144 BRILLIANT (Richard), 'The Arch of Septimius Severus in the Roman Forum', *Memoirs of the American Academy in Rome*, XXIX, Rome, American Academy in Rome, 1967.

145 CAGIANO DE AZEVEDO (Michelangelo), *Un sarcofago di Villa Medici con scena di iniziazione bacchica*, 'Istituto di Archeologia e Storia dell'Arte', Opere d'arte, 13, Rome, Istituto poligrafico dello Stato, 1942.

*146 CALZA (Raissa), 'Sui ritratti ostiensi del supposto Plotino', in *Bollettino d'Arte*, 38, Rome, 1953, pp. 203-10.

*147 DEICHMANN (Friedrich Wilhelm) and TSCHIRA (Arnold), 'Das Mausoleum der Kaiserin Helena und die Basilika der hl. Marcellinus und Petrus an der via Labicana', in *Jahrbuch des Deutschen archäologischen Instituts*, LXII, Berlin, Gruyter, 1957, pp. 44-110. 110.

148 FELLETTI MAJ (Bianca Maria), 'Le pitture di una tomba della Via Portuense', in *Rivista dell'Istituto nazionale di archeologia e storia dell'arte*, n.s. II, Rome, 1953, pp. 3 sq.

149 FRANCHI (Luisa), 'Ricerche sull'arte di età severiana in Roma', in *Studi Miscellanei*, IV, Rome, 1964, pp. 5–45.

*150 GÜTSCHOW (Margarete), 'Das Museum der Prätextat-Katakombe', in *Memorie della Pontificia Accademia Romana di Archeologia* IV, 2, Vatican, Pontificia Accademia di Archeologia, 1938.

*151 HANFMANN (George Maxim Anossov), 'The Season Sarcophagus in Dumbarton Oaks', *Dumbarton Oaks Studies*, II, Cambridge, Mass, 1951, 2 vol.

152 HEINTZE (Helga von), 'Studien zu den Porträts des III. Jahrhunderts. Hostilianus', in *Römische Mitteilungen*, LXIV, Heidelberg, 1957, pp. 69 sq.

*153 KÄHLER (Heinz), *Das Fünfsäulendenkmal für die Tetrarchen auf dem Forum Romanum*, Cologne, Dumont Schauberg, 1964.

154 KRAUTHEIMER (Richard), 'Mensa-Coemeterium-Martyrium', in *Cahiers archéologiques* (Fin de l'Antiquité et Moyen Age), XI, Paris, Klincksieck, 1960, pp. 15–40.

155 LAWRENCE (Marion), 'The Velletri Sarcophagus', in *American Journal of Archaeology*, LXIX, Princeton, 1965, pp. 207–22.

*156 LEHMANN (Karl) and OLSEN (Erling C.), *Dionysiac Sarcophagi in Baltimore*, Baltimore, The Walters Art Gallery, 1942.

157 L'ORANGE (Hans Peter), 'I ritratti di Plotino e il tipo di San Paulo nell'arte tardo-antica', in *Atti del VII Congresso internazionale di archeologia classica*, II, Rome, 1961, pp. 475 sq.

*158 L'ORANGE (Hans Peter) and GERKAN (Armin von), *Der spätantike Bildschmuck des Konstantinsbogens*, 'Studien zur spätantiken Kunstgeschichte', x, Berlin, W. de Gruyter, 1939, 2 vol. (One volume of text and one of plates.)

159 MATZ (Friedrich), *Ein Römisches Meisterwerk. Der Jahreszeiten-Sarkophag Badminton-New York*, Berlin, W. de Gruyter, 1958.

160 PALLOTTINO (Massimo), *L'Arco degli Argentari*, Rome, Danesi, 1946.

161 POGLAYEN-NEUWALL (Stephan), 'Über die ursprünglichen Besitzer des spätantiken Silberfundes vom Esquilin', in *Mitteilungen des Deutschen archäologischen Instituts. Römische Abteilung*, XLV, Munich, 1930, pp. 124–36.

*162 RODENWALDT (Gerhart), 'Eine spätantike Kunstströmung in Rom', in *Mitteilungen des Deutschen archäologischen Instituts. Römische Abteilung*, XXXVI-XXXVII, Berlin, 1921–2, pp. 58–110.

*163 RODENWALDT (Gerhart), 'Der Klinensarkophag von S. Lorenzo', in *Jahrbuch des Deutschen archäologischen Instituts*, XLV, 2, Berlin, W. de Gruyter, 1930, pp. 116–89.

*164 RODENWALDT (Gerhart), 'Jagdsarkophag in Reims', in *Mitteilungen des Deutschen archäologischen Instituts. Römische Abteilung*, LIV (1944), Munich, 1946, pp. 191–203.

165 RUYSSCHAERT (José), 'Essai d'interprétation synthétique de l'Arc de Constantin', in *Rendiconti della Pontificia Accademia Romana di Archeologia*, XXXV, Vatican, 1963, pp. 79 sq.

166 SCHMIDT (Margot), *Der Basler Medeassarkophag*, 'Monumenta Artis Antiquae', III, Tübingen, Ernst Wasmuth, 1968.

167 SCHUMACHER (Walter Nikolaus), 'Cubile sanctae Helenae', in *Römische Quartalschrift für Christliche Archäologie*, LVIII, 1963, pp. 196 sq.

168 SCOTT RYBERG (Inez), *Panel Reliefs of Marcus Aurelius*, 'Monographs on Archaeology and the Fine Arts', XIV, New York, Hafner, 1967.

*169 SICHTERMANN (Hellmut), *Späte Endymion-Sarkophage. Methodisches zur Interpretation*, 'Deutsche Beiträge zur Altertumswissenschaft', XIX, Baden-Baden, Bruno Grimm, 1966. (Cf. the review by A. H. Borbein, in *Gnomon*, XL (1968), 6, pp. 599–604.)

170 VACCARO MELUCCO (Alessandra), 'Sarcofagi Romani di caccia al leone', in *Studi Miscellanei. Seminario di Archeologia, Università di Roma*, 11, Rome, De Luca, 1966, pp. 9–60.

*171 VERMASEREN (Marten Jan) and VAN ESSEN (Carel Claudius), *The Excavations in the Mithraeum of the Church of Santa Jrisca in Rome*, Leiden, E. J. Brill, 1965.

Northern Italy and Illyria

172 BESCHI (Luigi), 'I bronzetti romani di Montorio Veronese', in *Memorie dell' Istituto Veneto di Scienze, Lettere e Arti*, XXXIII, 2, Venice, 1962, pp. 3 sq.

173 CALVI (M. Carina), *I vetri Romani del Museo di Aquileia*, 'Pubblicazioni dell'Associazione Nazionale per Aquileia', VII, Aquileia, Associazione Nazionale per Aquileia, 1968.

174 DYGGVE (Ejnar), *Ravennatum Palatium Sacrum*, 'Medd. Dansk. Vid. Selsk.', III, 2, Copenhagen, Munksgaard, 1941.

*175 DYGGVE (Ejnar), 'Nouvelles Recherches au péristyle du palais de Dioclétien à Split', in *Acta ad archaeologiam et artium historiam pertinentia*, I, Rome, 'L'Erma' di Brétschneider and Oslo, Universitets-forlager, 1962, pp. 1–6.

176 GRBIC (Miodrag), 'La Plastique grecque et romaine en Yougoslavie', in *Le Rayonnement des civilisations grecque et romaine sur les cultures périphériques* (VIIIe Congrès international d'archéologie classique, Paris, 1963), Paris, E. de Boccard, 1965, pp. 347–53.

177 MANSUELLI (Guido Achille), 'Problemi dell'arte romana nell'Italia settentrionale', in *Cisalpina*, Istituto Lombardo, Accademia di Scienze e Lettere, Milano, 1959, pp. 315–27.

178 MANSUELLI (Guido Achille), 'Les Monuments commémoratifs romains de la vallée du Pô', in *Monuments et Mémoires Piot*, LIII, Paris, Presses universitaires de France, 1964, pp. 19–93.

*179 MANSUELLI (Guido Achille) and other collaborators, *Arte e Civiltà romana nell' Italia settentrionale dalla Repubblica alla Tetrarchia* (VI mostra biennale d'arte antica), Bologna, Edizioni Alfa, 1964–5, 2 vol.

180 MANSUELLI (Guido Achille), 'Le Caractère provincial de l'art romain de l'Italie du Nord avant le Bas-Empire', in *Le Rayonnement des civilisations grecque et romaine sur les cultures périphériques* (VIIIe Congrès international d'archéologie classique, Paris, 1963), Paris, E. de Boccard, 1965, pp. 187 sq.

181 PANCIERA (Silvio), *Vita economica di Aquileia in età romana*, Aquileia, Associazione Nazionale, 1957.

182 STRZYGOWSKI (Josef), 'Split, ein Markstein der romanischen Kunst bei ihrem Übergange vom Orient nach dem Abendlande', in *Studien aus Kunst und Geschichte für Friedrich Schneider*. Freiburg im Breisgau, Herder, 1906.

183 TORELLI (Mario), 'Monumenti sepolcrali con fregio dorico', in *Dialoghi di Archeologia*, II, 1, Milan, il Saggiatore, 1968.

Noricum and Pannonia

184 DIEZ (Erna), 'Der provinziale Charakter der römischen Skulptur im Norikum', in *Le Rayonnement des civilisations grecque et romaine sur les cultures périphériques* (VIIIe Congrès international d'archéologie classique, Paris, 1963), Paris, E. de Boccard, 1965, pp. 207–12.

185 KRÜGER (Marie Louise), *Rundskulpturen des Stadtgebietes von Carnuntum*, 'Corpus Signorum Imperii Romani', I, 1, Cologne-Graz, Böhlau, 1967.

186 KUZSINSKY (Bálint), *Emlétek és Leletek: Császári Sirleletek* (Discoveries in the Imperial tombs), in *Archaeologiai Ertesitö* (Archaeological Treasuretrove), II, 2, Budapest, 1902, pp. 31–33.

187 NOLL (Rudolf), *Kunst der Römerzeit in Österreich*, Salzburg Akademischer Gemeinschaftsverlag, 1949.

188 PELIKÁN (Oldrich), 'Zur nordpannonischen Limes-Skulptur', in *Sbornik práci filosof. facult. Brněnský Univers.*, XV, Brno, 1966, pp. 89 sq.

189 PRASCHNIKER (Camillo) and EGGER (Rudolf), 'Österreichs ältester Römergrabstein', in *Anzeiger der Akademie der Wissenschaften in Wien*, Philol.-Histor. Klasse, LXXV, Vienna, 1938, pp. 14–25.

190 SCHOBER (Arnold), *Die Römerzeit in*

Österreich, Vienna, Rudolf M. Rohrer, 2nd edn. 1953.

Gaul and the Rhineland

191 BENOIT (Fernand), *L'Art primitif méditerranéen dans la vallée du Rhône*, 'Annales de la Faculté des Lettres d'Aix-en-Provence', Gap, Ed. Ophrys, 2nd edn., 1955.

192 BEQUIGNON (Yves), 'Statue gauloise découverte à Saint-Aubin-sur-Mer', in *Monuments et Mémoires Piot*, XLIII, Paris, Presses universitaires de France, 1949, pp. 83–97.

193 BIANCHI BANDINELLI (Ranuccio), 'Gusto e valore dell'arte provinciale', in *Storicità dell'arte classica*, Firenze, 1943; 2nd edn. Milan, 1950, pp. 229–44.

194 DOPPELFELD (Otto), *Römisches und Fränkisches Glas in Köln*, 'Schriftenreihe der archäologischen Gesellschaft', XIII, Cologne, Greven Verlag, 1966.

195 DURAND LEFEBVRE (Marie), *Art gallo-romain et Sculpture romaine. Recherches sur les formes*, Paris, H Laurens, 1938.

196 DUVAL (Paul-Marie), 'L'Originalité de l'architecture gallo-romaine', in *Le Rayonnement des civilisations grecque et romaine sur les cultures périphériques* (VIIIe Congrès international d'archéologie classique, Paris, 1963), Paris, E. de Boccard, 1965, pp. 121–44.

197 FELLMAN (Rudolf), *Die Schweiz zur Römerzeit*, Basle, Historisches Museum, 1957.

198 HAHL (Lothar), *Zur Stilentwicklung der provinzialrömischen Plastik in Germanien und Gallien*, Darmstadt, L. C. Wittich Verlag, 1937.

199 HATT (Jean-Jacques), *Histoire de la Gaule romaine*, Paris, Payot, 1959; 2nd edn., 1966.

200 HATT (Jean-Jacques), 'Les Grands Courants artistiques dan l'evolution de la sculpture romaine provinciale de Gaule, de 50 av. J.-C. à 300 apr. J.-C.', in *Le Rayonnement des civilisations grecque et romaine sur les cultures périphériques* (VIIIe Congrès international d'archéologie classique, Paris, 1963), Paris, E. de Boccard, 1965, pp. 545–51.

201 LAMBRECHT (Pierre), 'La Persistance des éléments indigènes dans l'art de la Gaule Belgique', in *Le Rayonnement des civilisations grecque et romaine sur les cultures périphériques* (VIIIe Congrès international d'archéologie classique, Paris 1963), Paris, E. de Boccard, 1965, pp. 153–63.

202 LAUR-BELART (Rudolf), 'Keltische Elemente in der Kunst der römischen Schweiz', in *Le Rayonnement des civilisations grecque et romaine sur les cultures périphériques*, (VIIIe Congrès international d'archéologie classique, Paris, 1963), E. de Boccard, 1965, pp. 165–76.

*203 LEHNER (Hans), 'Römische Steindenkmäler von der Bonner Münsterkirche', in *Bonner Jahrbücher*, CXXXV, Bonn, 1930.

204 MARTIN (Roland), 'Informations archéologiques, circonscription de Dijon: Saint-Germain-Sources-Seine', in *Gallia*, XXII, Paris, C.N.R.S., 1964, pp. 302–6.

205 MINGAZZINI (Paolino), 'La datazione dell'arco di Orange', in *Mitteilungen des Deutschen archäologischen Instituts. Römische Abteilung*, LXXV, Heidelberg, 1968, pp. 163 sq.

206 PETRIKOVITS (Harald von), 'Die Originalität der römischen Kunst am Rhein', in *Le Rayonnement des civilisations grecque et romaine sur les cultures périphériques* (VIIIe Congrès international d'archéologie classique, Paris, 1963), Paris, E. de Boccard, 1965, pp. 145–52.

*207 PICARD (Gilbert-Charles), 'Glanum et les origines de l'art romano-provençal', in *Gallia*, XXI, Paris, C.N.R.S., 1963, pp. 111 sq.

*208 PIGANIOL (André) in collaboration with AMY (R.), DUVAL (P. M.), FORMIGÉ (J.), HATT (J.-J.), PICARD (C.), PICARD (G.-C.), *L'Arc d'Orange*, XVth Supplement to *Gallia*, Paris, C.N.R.S., 1962, 2 vol.

*209 ROLLAND (Henri), 'Sculptures à figures découvertes à Glanum', in *Comptes rendus de l'Académie des Inscriptions et Belles-Lettres*, XIV, I, Paris, Imprimerie nationale, 1967, pp. 111–19.

*210 ROLLAND (Henri), 'Sculptures hellénistiques découvertes à Glanum', in *Comptes rendus de l'Académie des Inscriptions et Belles-Lettres*, XV, I, Paris, Imprimerie nationale, 1968, pp. 99–114.

211 SCHOPPA (Helmut), 'Bemerkungen zur Herkunft der Augusteischen Plastik am Rhein', in *Le Rayonnement des civilisations grecque et romaine sur les cultures périphériques* (VIIIe Congrès international d'archéologie classique, Paris, 1963), Paris, E. de Boccard, 1965, pp. 176–83.

212 SCHOPPA (Helmut), *Die Kunst der Römerzeit in Gallien, Germanien und Britanien*, 'Deutscher Kunstverlag', n.d.

213 STERN (Henri), 'Ateliers de mosaïstes rhodaniens d'époque gallo-romaine', in *La Mosaïque gréco-romaine*, 'Colloques internationaux du C.N.R.S.', Paris, C.N.R.S., 1965, pp. 233–40.

Trèves

*214 ALFÖLDI (Andreas), 'Zur Erklärung der Konstantinischen Deckengemälde in Trier', in *Historia*, Zeitschrift für alte Geschichte, IV, Wiesbaden, 1955, pp. 131–50.

215 KEMPF (Theodor Konrad), *Aus der Schatzkammer des antiken Trier*, Trier, Verlag des Bischöflichen Museums, 1951.

216 LAVIN (Irving), 'The Ceiling Frescoes in Trier and Illusionism in Constantinian Painting', in *Dumbarton Oaks Papers*, XXI, Cambridge, Mass., 1967, pp. 99–113.

217 MOREAU (Jacques), *Das Trierer Kornmarktmosaik*, 'Monumenta Artis Romanae', II, Cologne, Dumont Schauberg, 1960

The Iberian Peninsula

218 BALIL (Alberto), 'Algunos mosaicos hispano-romanos de época tardía', in *Principe de Viana*, C, CI, Pamplona, 1965, pp. 281 sq.

219 GARCIA Y BELLIDO (Antonio), *Esculturas romanas de Espana y Portugal*, Madrid, Consejo Superior de Investigationes Cientificas, 1949, 2 vol.

220 GARCIA Y BELLIDO (Antonio), 'La villa romana del Soto del Ramalete', in *Archivo español de Arqueologia*, XXVI, Madrid, 1953, pp. 214–17.

221 GARCIA Y BELLIDO (Antonio), 'Nombres de artistas en la España Romana', in *Archivio español de Arqueologia*, XXVIII, Madrid, 1955, pp. 3–19.

The British Isles

222 BOON (George Counsell), *Roman Silchester*, London, W. J. Millington. Synge, 1957.

223 BRAILSFORD (John William), *The Mildenhall Treasure. A Provisional Handbook*, London, The British Museum, 1947, 2nd edn., 1955.

*224 DOHRN (Tobias), 'Spätantikes Silber aus Britannien', in *Mitteilungen des Deutschen archäologischen Instituts. Römische Abteilung*, II, Munich, 1949, pp. 67–147.

225 HARRISON (David), *Along Hadrian's Wall*, London, Cassell, 1956.

226 HAVERFIELD (Francis John) and JONES (H. Stuart), 'Some Representative Examples of Romano-British Sculpture', in *The Journal of Roman Studies*, II, London, 1912, pp. 144 sq.

227 LIVERSIDGE (Joan), *Britain in the Roman Empire*, London, Routledge and Kegan Paul, 1968.

*228 MACDONALD (George), *The Roman Wall in Scotland*, Oxford, The Clarendon Press, 2nd edn., 1934.

229 MEATES (Geoffrey Wells), *Lullingstone Roman Villa*, London, Heinemann, 1955.

230 MORGAN (Thomas), *Romano-British Pavements*, London, Whiting, 1886.

*231 RICHMOND (Ian Archibald), *Roman Britain*, London, Collins, 1947.

232 SMITH (D. J.), 'Three Fourth-Century Schools of Mosaic in Roman Britain', in *La Mosaïque gréco-romaine*, 'Colloques internationaux du C.N.R.S.', Paris, C.N.R.S., 1965, pp. 95–116, 18 fig.

*233 TOYNBEE (Jocelyn Mary Catherine), *Art in Britain under the Romans*, Oxford, The Clarendon Press, 1964.

Africa Proconsularis and Cyrenaica

234 AURIGEMMA (Salvatore), *Tripolitania, I, 1, I mosaici; I, 2, Le pitture di età romana*, 'L'Italia in Africa', Le scoperte archeologiche, a cura del Ministero degli Affari Esteri, Rome, Istituto poligrafico dello Stato, 1960–2.

235 BALLU (Albert), *Les Ruines de Timgad, antique Thamugadi. Sept années de découvertes* (1903–10), Paris, Neurdein Frères, 1911.

*236 BÉRARD (Jean), 'Mosaïques inédites de Cherchel (Mosaïques des travaux champêtres)', in *Mélanges d'archéologie et d'histoire de l'École française de Rome*, LII, Rome-Paris, 1935, pp. 113 sq.

237 BIANCHI BANDINELLI (Ranuccio), CAPUTO (Giacomo) and VERGARA CAFFARELLI (Ernesto), *Leptis Magna*, Milan, Mondadori, 1964. English edn. London, Weidenfeld and Nicolson, 1966.

238 CARANDINI (Andrea), 'La villa di Piazza Armerina, la circolazione della cultura figurativa africana nel tardo impero ed altre precisazioni', in *Dialoghi di Archeologia*, I, 1, Milan, il Saggiatore, 1967, pp. 93–120.

239 FENDRI (Mohamed), 'Evolution chronologique et stylistique d'un ensemble de mosaïques dans une station thermale à Djebel Oust (Tunisie)', in *La Mosaïque gréco-romaine*, 'Colloques internationaux du C.N.R.S.', Paris, C.N.R.S., 1965, pp. 157–71.

240 FÉVRIER (Paul Albert), *Djemila*, Algiers, Direction des Affaires culturelles de la république Algérienne, 1968.

241 FOUCHER (Louis), 'Influence de la peinture hellénistique sur la mosaïque africaine aux IIe et IIIe siècles', in *Cahiers de Tunisie*, 26–7, Tunis, 1959.

242 FOURNET-PHILIPENKO (Hélène), 'Sarcophages romains de Tunisie', in *Karthago*, 2, Paris, Klincksieck, 1961–2, pp. 77–163.

243 LASSUS (Jean), 'Mosaïque de la vendange à Cherchel, Tennis Club', in *Lybica* (Arch. Épigr.), VII, 1958, pp. 257–69, fig. 29–36.

244 LASSUS (Jean), 'Vénus marine', in *La Mosaïque gréco-romaine*, 'Colloques internationaux du C.N.R.S.', Paris, C.N.R.S., 1965, pp. 175–88.

*245 LEGLAY (Marcel), *Saturne Africain. Histoire*, 'Bibliothèque des Ecoles françaises d'Athènes et de Rome', CCV, Paris, E. de Boccard, 1966.

*246 PICARD (Gilbert-Charles), *La Civilisation de l'Afrique romaine*, 'Civilisations d'hier et d'aujourd'hui', Paris, Plon, 1959.

247 PICARD (Gilbert-Charles), 'Mosaïques africaines du IIIe siècle apr. J.-C.', in *Revue archéologique*, II, Paris, 1960, pp. 17–49.

248 PICARD (Gilbert-Charles), 'La Datation des mosaïques de la maison de Virgile à Sousse', in *Atti del VII Congresso internazionale di Archeologia*, Roma, 1961, III, Rome, 1961, pp. 243–49.

249 PICARD (Gilbert-Charles), 'Un thème du style fleuri dans la mosaïque africaine', in *La Mosaïque gréco-romaine*, 'Colloques internationaux du C.N.R.S.', Paris, C.N.R.S., 1965, pp. 125–32.

250 POINSSOT (Claude), *Les Ruines de Dougga*, Tunis, Secrétariat d'État à l'Éducation nationale de Tunisie, 1958.

251 POINSSOT (Claude), 'Quelques Remarques sur les mosaïques de la maison de Dionysos et d'Ulysse à Dougga', in *La Mosaïque gréco-romaine*, 'Colloques, internationaux du C.N.R.S.', Paris, C.N.R.S., 1965, pp. 219–30.

252 REYNOLDS (Joyce Maire), WARD-PERKINS (John Bryan) and others, *The Inscriptions of Roman Tripolitania*, London, The British School of Archaeology at Rome, 1952.

*253 ROMANELLI (Pietro), *Storia delle province romane dell'Africa*, 'Studi Pubblicati dell'Istituto Italiano per la Storia Antica', 14, Rome, 'L'Erma' di Bretschneider, 1959.

254 SALOMONSON (Jan Willem), 'Late-Roman Earthenware with Relief Decoration Found in North Africa and Egypt', in *Oudheidkundige Mededelingen uit het Rijksmuseum van Oudheden te Leiden*, XLIII, Leiden, 1962, pp. 51–95, pl. XI-XXXII.

*255 SALOMONSON (Jan Willem), 'La Mosaïque aux chevaux de l'Antiquarium de Carthage', in *Archeologische Studiën van het Nederlands Historisch Instituut te Rome*, I, The Hague, Imprimerie nationale, 1965, pp. 208 sq.

256 THOUVENOT (Raymond), 'L'Art provincial en Maurétanie Tingitane. Les Mosaïques', in *Mélanges d'archéologie et d'histoire*, LIII, Paris, E. de Boccard, 1936, pp. 25 sq.

257 VERGARA CAFFARELLI (Ernesto), 'Ghirza', in *Enciclopedia dell'arte Antica Classica e Orientale*, III, Rome, 1960, pp. 864–69 (with bibliography).

258 VILLE (Georges), 'Essai de datation de la mosaïque des gladiateurs de Zliten', in *La Mosaïque gréco-romaine*, 'Collo-

ques internationaux du C.N.R.S.', Paris, C.N.R.S., 1965, pp. 147–54.

259 WARD-PERKINS (John): 'Severan Art and Architecture at Leptis Magna', in *The Journal of Roman Studies*, XXXVIII, London 1948, pp. 59–80.

*260 WARD-PERKINS (John), 'The Art of the Severan Age in the Light of Tripolitanian Discoveries', in *Proceedings of the British Academy*, XXXVII, London, 1951, pp. 269–304.

Egypt

*261 COCHE DE LA FERTÉ (Étienne), 'Le Verre de Lycurgue', in *Monuments et Mémoires Piot*, XLVIII, 2, Paris, Presses universitaires de France, 1956, pp. 131 sq.

262 GRAINDOR (Paul), *Bustes et Statues-portraits d'Égypte romaine*, Cairo, Imprimerie Barbey, n.d.

263 GUIMET (Émile), 'Les portraits d'Antinoé au musée Guimet Le châle d'Antinoé', in *Annales du musée Guimet*, Bibliothèque d'art, v, Paris, 1913, pp. 21 sq., pl. XIII.

*264 HACKIN (Joseph) ed., 'Nouvelles recherches archéologiques à Begram', *Mémoires de la Délégation archéologique française en Afghanistan*, XI, Paris, Presses universitaires de France, 1954.

*265 MONNERET DE VILLARD (Ugo), 'The Temple of the Imperial Cult at Luxor', in *Archaeologia*, XCV, Oxford, 1953, pp. 85 sq.

*266 PARLASCA (Klaus), *Mumienporträts und verwandte Denkmäler*, Wiesbaden, F. Steiner Verlag, 1966.

267 PAVLOV (Victor V.), *Egipetskii Portret I-IV Vekov*, 'Is Istorii Mirovogo Iskusstva', Moscow, Izdatel'stvo Iscusstvo, 1967.

268 PICARD (Charles), 'Sur quelques représentations nouvelles du Phare d'Alexandrie et sur l'origine alexandrine des paysages portuaires', in *Bulletin de Correspondance hellénique*, LXXVI, Paris, E. de Boccard, 1952, pp. 61–95.

Greece and Macedonia

*269 GINOUVÈS (René), 'La Mosaïque des mois à Argos', in *Bulletin de Correspondance hellénique*, LXXXI, Paris, E. de Boccard, 1957, pp. 216–68.

270 GIULIANO (Antonio), *Il commercio dei sarcofagi attici*, 'Studia archaeologica', 4, Rome, 'L'Erma' di Bretschneider, 1962.

271 GIULIANO (Antonio), *La cultura artistica delle province della Grecia in età Romana*, 'Studia archaeologica', 6, Rome, 'L'Erma' di Bretschneider, 1965.

*272 GRABAR (André), 'A propos des mosaïques de la coupole de Saint-Georges, à Salonique', in *Cahiers archéologiques*, XVII, Paris, Klincksieck, 1967, pp. 59–81.

*273 SCHÖNEBECK (H. von), 'Die zyklische Ordnung der Triumphalreliefs am Galeriusbogen in Saloniki', in *Byzantinische Zeitschrift*, XXXVII, Leipzig-Berlin, 1937, pp. 361–71.

274 SCRANTON (Robert L.), 'Glass Pictures from the Sea (The Cenchreae Expedition)', in *Archaeology* XX, New York, 1967, pp. 163–73.

Thrace, Moesia, and Dacia

275 BORDENACHE (Gabriella), 'Il deposito di sculture votive di Tomis', in *Eirene*, IV, 1965, pp. 67 sq.

276 BORDENACHE (Gabriella), 'Temi e motivi della plastica funeraria di età romana nella Moesia Inferior', in *Dacia*, n.s. IX, Bucharest, 1965, pp. 253 sq.

*277 DIMITROV (Dimiter P.), 'Le système décoratif et la date des peintures murales du tombeau antique de Silistra', in *Cahiers archéologiques*, XII, Paris, Klincksieck, 1962, pp. 35–52.

*278 FLORESCU (Florea Bobu), *Monumentul de la Adamklissi, Tropaeum Traiani*, 'Monografii de Monumenti', II, Bucharest, Academia Republicii Populare Romîne, second edition (enlarged), 1961.

*279 VULPE (Radu), 'Dion Cassius et la campagne de Trajan en Mésie Inférieure', in *Studi Clasice* VI, Bucharest, 1964, pp. 205–32.

Asia Minor, Syria, and Mesopotamia

280 BICKERMAN (Elias J.), 'Symbolism in the Dura Synagogue', in *The Harvard Theological Review*, LVIII, I, Cambridge, Mass., 1965, pp. 127 sq.

281 BOYSAL (Yusuf), 'Yunuslar Köyünde Bulunan Lâhit', in *Türk Arkeoloji Dergisi*, VIII, Ankara, 1958, pp. 77–81.

*282 CUMONT (Franz), *Fouilles de Doura-Europos (1922–1923)*, Paris, P. Geuthner, 1926.

283 EICHLER (Fritz), 'Zwei kleinasiatische Säulensarkophage', in *Jahrbuch des Deutschen archäologischen Instituts*, LIX (1944–1945), Berlin, 1946, pp. 125–36.

284 FERRARI (Gloria), 'Il commercio dei sarcofagi asiatici', in *Studia archaeologica*, 7, Rome, 'L'Erma' di Bretschneider, 1966.

285 FILARSKA (Barbara), *Studia nad dekoracjami architektonicznymi Palmyry*, 'Studia Palmyrenskie', II, Warsaw, Wydawnictwa Uniwersytetu Warszawskiego, 1967.

*286 GERKAN (Armin von), *Der Nordmarkt und der Hafen an der Löwenbucht*, 'Milet', Ergebnisse der Ausgrabungen und Untersuchungen, herausgegeben von Theodor Wiegand, I, 6, Berlin-Leipzig, W. de Gruyter, 1922.

287 KITZINGER (Ernst), 'Stylistic Developments in Pavement Mosaics in the Greek East from the Age of Constantine to the Age of Justinian', in *La Mosaïque gréco-romaine*, 'Colloques internationaux du C.N.R.S.', Paris, C.N.R.S., 1965, pp. 341–50.

*288 KOLLWITZ (Johannes), *Oströmische Plastik der theodosianischen Zeit*, 'Studien zur spätantiken Kunstgeschichte', XII, Berlin, W. de Gruyter and Co., 1941.

289 KRAELING (Carl H.), 'Color Photographs of the Paintings in the Tomb of Brothers at Palmyra', in *Les Annales archéologiques de Syrie*, XI–XII, Damascus, 1961-2, pp. 13–18 (42 fig. on 16 pl.).

290 LAVIN (Irving), 'The Hunting Mosaics of Antioch and their Sources', in *Dumbarton Oaks Papers*, XVII, Cambridge, Mass., 1963, pp. 181–286, 142 fig.

291 LAWRENCE (Marion), 'Additional Asiatic Sarcophagi', in *Memoirs of the American Academy in Rome*, XX, Rome, 1951, pp. 119–66.

*292 LEVI (Doro), *Antioch Mosaic Pavements*, Princeton, Princeton University Press, 1947, 2 vol.

293 RODENWALDT (Gerhart), 'Säulensarkophage', in *Mitteilungen des Deutschen archäologischen Instituts*,

Römische Abteilung, XXXVIII, XXXIX, 1–2, Berlin, 1924, pp. 1–40.

*294 RODENWALDT (Gerhart), 'Ein Lykisches Motiv', in *Jahrbuch des Deutschen archäologischen Instituts*, LV, 1–2, Berlin, 1940, pp. 44–57.

294a ROSTOVTZEFF (Mikhail), *Dura-Europas and its Art*, New York, Oxford University Press, 1938.

294b ROSTOVTZEFF (Mikhail), *Excavations at Dura-Europas*, New Haven, Connecticut, Yale University Press (reports 1929–59).

295 TSONTCHEW (Dimiter), 'Monuments funéraires thraces des néoi héroes en Bulgarie', in *Hommage à Albert Grenier*, III, Brussels Éd. Latomus, 1962, pp. 1507–22.

296 WILBERG (Wilhelm), 'Die Fassade der Bibliothek in Ephesos', in *Jahreshefte des Österreichischen archäologischen Instituts*, vol. XI, Vienna, 1908, pp. 118–35.

*297 WILBERG (Wilhelm) and KEIL (Josef), *Forschungen in Ephesos. V. Die Bibliothek. Das Gebäude. Die Inschriften*, 'Forschungen in Ephesos herausgegeben vom Österreichischen archäologischen Instituts', V, I, Vienna, M. Rohrer, 2nd edn., 1953.

Constantinople

298 BECKWITH (John), *The Art of Constantinople. An Introduction to Byzantine Art*, London and New York, Phaidon Press, 1961.

*299 BRUNS (Gerda), *Der Obelisk und seine Basis auf dem Hippodrom zu Konstantinopel*, 'Istanbuler Forschungen', vol. VII, Istanbul, Universum-Drucherei, 1935.

300 BYVANCK (Alexander Willem), 'Rome en Constantinopel en de vierde eeuw', in *Mededelingen van het Nederlands Historisch Instituut te Rome*, n.s. XXXI. The Hague, 1961, pp. 73 sq.

*301 CRUIKSHANK-DODD (Erika), 'Byzantine Silver Stamps', in *Dumbarton Oaks Studies*, VII, Washington, 1961.

302 CRUIKSHANK-DODD (Erika), 'Tesori', in *Enciclopedia dell'Arte Antica Classica e Orientale*, VII, Rome, 1966, pp. 753–60 (with bibliography).

*303 JANIN (Raymond), *Constantinople byzantine, développement urbain et répertoire topographique*, 'Archives de l'Orient chrétien', IV, A, Paris, 1950: 2nd edn., Institut français d'études byzantines, 1964.

304 MATZULEWITSCH (Leonid), *Byzantinische Antike. Studien auf Grund der Silbergefässe der Ermitage*, Berlin-Leipzig, W. de Gruyter, 1929.

305 MAYER (Robert), *Byzantion Konstantinopel Istanbul: eine genetische Stadtgeographie*, 'Sitzungsberichte der Akademie der Wissenschaften in Wien', LXXI, 3, Vienna, A. Holtzhausen, 1943.

*306 VOGT (Joseph), 'Der Erbauer der Apostelkirche in Konstantinopel', in *Hermes*, LXXXI, Wiesbaden, 1953, pp. 111–17.

INDEX TO THE BIBLIOGRAPHY

FRANCHI, 149.
FRANK, 61.
FRIEDLÄNDER, 116.
FROVA, 16.

GAGÉ, 62.
GARCIA Y BELLIDO, 219–221.
GEFFCKEN, 76.
GERKAN, 158, 286.
GERKE, 5.
GERSTINGER, 138.
GINOUVÈS, 269.
GIULIANO, 270, 271.
GNECCHI, 117.
GRABAR, 17, 18, 92, 272.
GRAINDOR, 262.
GRANT, 19.
GRBIC, 176.
GUIMET, 263.
GULLINI, 93.
GÜTSCHOW, 150.

HACKIN, 264.
HAHL, 198.
HAMBERG, 118.
HANFMANN, 151.
HARRISON, 225.
HARTKE, 63.
HATT, 49, 199, 200, 208.
HAVERFIELD, 50, 226.
HEINTZE, 152.
HELBIG, 51.
HIRMER, 28.
HÖLSCHER, 119.

Imperial Crisis and Recovery (The),
 59

Inventory of the mosaics of Gaul and
 Africa, 30.

JANIN, 303.
JENNY, 120.
JONES (A. H. M.), 64.
JONES (H. S.), 52, 226.
JOSI, 140.

KÄHLER, 20, 21, 153.
KASCHNITZ-WEINBERG, 121.
KEMPF, 215.
KENNER, 77.
KIRSCHBAUM, 7, 140.
KITZINGER, 287.
KLAUSER, 6.
KOLLWITZ, 288.
Koptische Kunst. Christentum am Nil,
 31.
KRAELING, 289.
KRAUS, 22.
KRAUTHEIMER, 23, 154.
KRUGER, 185.

Kunstschätze in bulgarischen Museen
 und Klöstern, 32.
KUZSINSKY, 186.

LA BAUME, 122.
LAMBRECHT, 201.
LASSUS, 243, 244.
LAUR-BELART, 202.
LAVIN, 216, 290.
LAWRENCE, 155, 291.
LEGLAY, 245.
LEHMANN, 156.
LEHMANN-HARTLEBEN, 123.
LEHNER, 203.
LEVI (D.), 24, 292.
LEVI (M. A.), 65.
LIVERSIDGE, 227.
L'ORANGE, 94, 95, 157, 158.

MACDONALD, 228.
MANSUELLI, 177–180.
MARROU, 78.
MARTIN, 204.
MATZ, 159.
MATZULEWITSCH, 304.
MAURICE, 8.
MAYER, 305.
MAZZARINO, 66, 67.
MEATES, 229.
MENDEL, 33.
MINGAZZINI, 205.
MOMIGLIANO, 79.
MONNERET DE VILLARD, 265.
MOREAU, 25, 217.
MOREY, 26.
MORGAN, 230.

NEUSS, 96.
NOLL, 187.

OLSEN, 156.

PALLOTTINO, 9, 160.
PANCIERA, 181.
PARIBENI, 53.
PARLASCA, 266.
PAVLOV, 267.
PELIKÁN, 87, 188.
PETRIKOVITS, 206.
PICARD (CH.), 124, 208, 268.
PICARD (G.-CH.), 27, 207, 208, 246–249.
PIGANIOL, 208.
Plovdiv, Musée Archéologique de, 34.
POGLAYEN-NEUWALL, 161.
POINSSOT, 250, 251.
POTTIER, 2.
PRASCHNIKER, 189.

RÉMONDON, 68.
RENARD, 125.
REYNOLDS, 252.
RICHMOND, 231.

RICHTER, 54.
RIEGL, 98.
RODENWALDT, 99, 100, 126, 127, 162–
 164, 293, 294.
ROLLAND, 209, 210.
ROMANELLI, 253.
Römer am Rhein, 55.
Römer in Rumänien, 37.
ROSENBAUM, 56.
ROSTOVTZEFF, 69, 294a, 294b.
RUMPF, 101.
RUYSSCHAERT, 165.

SAGLIO, 6.
SALOMONSON, 254, 255.
SCHMIDT, 166.
SCHOBER, 190.
SCHÖNEBECK, 273.
SCHOPPA, 211, 212.
SCHUMACHER, 167.
SCHWEITZER, 102, 128.
SCOTT RYBERG, 129, 168.
SCRANTON, 274.
SESTON, 80.
SICHTERMANN, 169.
SMITH, 232.
Stara Zagora, Musée Archéologique
 de, 35.
STERN, 130, 213.
STRONG, 131.
STRZYGOWSKI, 103, 182.
SUNKOWSKY, 132.
SUSINI, 57.
SWOBODA, 104.

THOUVENOT, 256.
TORELLI, 183.
TOYNBEE, 233.
TSCHIRA, 147.
TSONTSCHEW, 295.
TURCAN, 133.

UNGER, 10.

VACCARO MELUCCO, 170.
VAN ESSEN, 171.
Varna, Musée Archéologique de, 36.
VERGARA CAFFARELLI, 237, 257.
VERMASEREN, 171.
VILLE, 258.
VOGT, 70, 80, 105, 306.
VOLBACH, 28, 58.
VULPE, 279.

WARD-PERKINS, 252, 259, 260.
WEITZMANN, 139.
WHEELER, 29.
WIEACKER, 106.
WILBERG, 296, 297.
WIRTH, 134.

Notes on the Illustrations

Abbreviations: H = Height, B = Breadth, D = Diameter

Frontispiece. Art of Roman Egypt. ALEX-
ANDRIA. Aureus of Maximin Daia
(305–13). 311–13. Paris: Bibliothèque
Nationale, Cabinet des Médailles
(Beistegui Collection, no. 197). Gold.
D 0.019 m. Ph. U.D.F.-La Photo-
thèque.
*Nominated Caesar for the East when
the existing Caesars, Galerius and Con-
stantius Chlorus, became Augusti on the
abdication of Diocletian and Maximian
Hercules. Legend: Maximinvs P(ius)
F(elix) Avg(ustus).*
*On the reverse: Soli Invicto. (Cf.
257.)*

1 Art of Roman Africa. CONSTANTINE.
Triumph of Neptune and Amphitrite.
Paris: Musée du Louvre. Mosaic. H
3.80 m. B 2 m. Ph. U.D.F.-La Photo-
thèque.

2 Roman art. ROME, Ludovisi Collection.
Large sarcophagus with battle-scene
attributed to the Emperor Hostilian
(detail): a barbarian (cf. 54). Date: 251.
Rome: Museo Nazionale. Marble. H
of head: 0.12 m. Ph. U.D.F.-La Photo-
thèque.

3 Roman art. ROME. Portrait of the
Emperor Claudius II Gothicus (detail).
Date: 268–70. Rome: Museo Nazio-
nale Marble. H 1.30 m. B of entire
relief: 0.90 m. Ph. Deutsches archäo-
logisches Institut, Rome.
*The relief shows the Emperor in the
act of sacrificing.*

4 Roman art. ROME. Sarcophagus with
lion-hunt (detail). About 310–15.
Rome: S. Sebastiano Museum.
Marble. H 1.59 m. Ph. Deutsches
archäologisches Institut, Rome.

5 Roman art. ROME(?). Portrait of a boy.
Date: 150–80. Florence: private collec-
tion. Marble. H 0.26 m. Ph. R. Bianchi
Bandinelli.
*Formerly in the Howells Collection,
Florence.*

6 Roman art. ROME. Portrait of a young
prince. Mid-third century. Rome:
Museo Nazionale (not on display).
Marble. H 0.22 m. Ph. U.D.F.-La
Photothèque.

*The subject is probably Quintus
Herennius Etruscus, the elder son of
Decius, and joint-emperor from 249 to
251.*

7 Roman art. ROME. Baths of Alexander
Severus. Head from a capital (cf. 366).
Before 227. The Vatican: Giardino
della Pigna. Marble. Ph. Archivio
fotografico Gallerie e Musei Vaticani.

8 Roman art. ROME. Portrait of the
Emperor Decius. Date: 249–51. Rome:
Museo Capitolino. Luni marble. H
with bust: 0.78 m. Ph. U.D.F.-La
Photothèque.

9 Roman art of Gallia Narbonensis.
CARPENTRAS, honorific arch. Relief:
prisoners at the foot of a trophy. First
century. Carpentras: Palais de Justice.
Limestone. H of monument: 10 m.
Ph. U.D.F.-La Photothèque.

10 Roman art. ROME, Via Casilina.
Sarcophagus (detail): female bar-
barian prisoner. Date: 180–90. Rome:
Museo Nazionale. Marble. Ph. U.D.F.
-La Photothèque.
*The sarcophagus probably belonged
to one of Marcus Aurelius's generals.*

11 Roman art. AQUILEIA. Portrait of a
man. Third century. Aquileia: Museo
Nazionale. Marble. H 0.27 m. Ph.
Gabinetto fotografico nazionale,
Rome.

12 Roman art. ROME. Sarcophagus
(detail): mourners around a dying man.
Third century. Rome: Museo Torlo-
nia. Marble. H 0.36 m. B of sarco-
phagus: 1.57 m. Ph. Gabinetto foto-
grafico nazionale, Rome.

13 Roman art. OSTIA, necropolis on the
Isola Sacra. Slab covering a tomb
(detail): funeral banquet. Third cen-
tury. *In situ.* Marble. H 0.61 m. B of
entire relief: 2.13 m. Ph. U.D.F.-La
Photothèque.
This relief belonged to tomb no. 11.

14 Roman art. ROME, Via Dandolo. Sanc-
tuary of the Oriental Gods. Portrait of
a young Oriental. First half of third
century. Rome: Museo Nazionale (not

on display). Marble. H 0.26 m. Ph.
U.D.F.-La Photothèque.
*Stylistic considerations suggest that
this piece may have been the work of a
Syrian sculptor.*

15 Roman art. OSTIA. Supposed portrait of
Plotinus. About 260. Ostia: Museo
Ostiense. Marble. Ph. U.D.F.-La
Photothèque.
*This piece comes from a building
which, it is thought, housed a school of
philosophy. Two other portraits of the
same person have been found in Ostia (a
fourth is preserved in the Vatican,
Braccio Nuovo). It could, alternatively,
portray another philosopher, who, we
know, lived and taught in Ostia. Aelius
Samius Isocrates, a native of Nicomedia.
(Cf. H. von Heintze, in Helbig, 'Führer',
4th edn., 1963, I, no. 412.)*

16 Roman art. AQUILEIA. Sarcophagus-
lid (detail): portrait of a woman.
Third century. Aquileia: Museo Nazi-
onale. Marble. H 0.33 m. Ph.
Gabinetto fotografico nazionale,
Rome.

17 Roman art. OSTIA, necropolis on the
Isola Sacra. Sarcophagus-lid (detail):
portrait of a high priest of Cybele.
About 280–90. Ostia: Museo Ostiense.
Marble. H of the head: 0.27 m. B of
lid: 2.20 m. Ph. U.D.F.-La Photo-
thèque.

18 Roman art. ROME (?). Apotheosis of
the Emperor Caracalla. About 217.
Nancy: Bibliothèque municipale.
Cameo. H 0.071 m. B 0.06 m. Ph.
U.D.F.-La Photothèque.

19 Roman art. ROME, Catacombs of Pre-
testato (Praetextatus). Sarcophagus-
lid (detail): the Emperor Balbinus.
Date: 238. Rome: Catacombs of Pre-
testato, Museum. Marble. H of the
head: 0.29 m. Ph. U.D.F.-La Photo-
thèque.
*The image of the Emperor (and of
his wife) is placed on the bed (klinè)
which forms the lid of the sarcophagus.
The front of the sarcophagus itself is
decorated with scenes showing a sacri-
fice, and the marriage of the Imperial
couple. When it was first unearthed, it*

NOTES ON THE ILLUSTRATIONS

still preserved traces of colouring on the background and clothing, while the hair and the borders of the garments showed signs of gilding. See Margarete Gütschow, p. 106.

20 Roman art. PORCIGLIANO. Portrait of the Emperor Philip (the Arab). Date: 244–9. The Vatican: Braccio Nuovo. Marble. H of entire bust: 0.71 m. Ph. Archivio fotografico Gallerie e Musei Vaticani.

21 Roman art. ROME (?). Statue of the Emperor Trebonianus (detail). Date: 251–3. New York: The Metropolitan Museum of Art, Rogers Bequest, 1905. Bronze. H of entire statue: 2.46 m. H of the head: 0.248 m. Ph. M.M.A.
This statue – probably discovered in Rome – was formerly (1852) in a private collection in St Petersburg, but subsequently (1905) purchased by the Metropolitan Museum.

22 Roman art. ROME. Portrait of the Emperor Diocletian. Date: 284–305. Rome: Villa Doria Pamphili. Marble. H of the head: 0.30 m. Ph. Deutsches archäologisches Institut, Rome.
The attribution was suggested by M. H. P. L'Orange ('Römische Mitteilungen', XLIV, 1929, pp. 180 sq.). The top of the head was covered by a (recently eliminated) toga.

23 Roman art. ROME, Arch of Constantine. Portrait of the Emperor Constantius Chlorus. Date: 312–15. In situ. Marble. H 0.175 m. Ph. Deutsches archäologisches Institut, Rome.
This portrait is from the medallion which represented Hadrian making an offering to Hercules (north side, last medallion on the right). According to H. P. L'Orange, it portrays Licinius.

24 Roman art. ROME, Forum, House of the Vestals. Portrait of the Emperor Gallienus. Date: 260–8. Rome: Museo Nazionale. Marble. H including the neck: 0.38 m. Ph. U.D.F.-La Photothèque.

25 Roman art. PAVIA. Constantine with the Christian monogram on his helmet. Date: 315. Munich: Staatliche Münzsammlung. Silver. D 0.028 m. Ph. S.M.

26 Roman art. ROME. Colossal portrait of Constantine. Date: 330–40. Rome: Palazzo dei Conservatori. Bronze. H 1.85 m. Ph. U.D.F.-La Photothèque.
This head probably belonged to a gigantic seated statue. In 1471 it was transported from the Lateran to the Capitol. Formerly identified as one of

Constantine's sons, but now as Constantine himself (weighty arguments advanced by Kähler, 'Jahrb. d. Inst.' LXVII, 1952, pp. 22 sq.).

27 Roman art. AQUILEIA. Medallion of Constantius II. Date: 338. Berlin; Staatliche Museen, Münzkabinett. Gold. D 0.04 m. Ph. S.M.

28 Roman art. MILAN. Coin of Theodosius I. About 395. Rome: Museo Nazionale. Gold. D 0.02 m. Ph. U.D.F.-La Photothèque.

29 Roman art. TRÈVES. Coin of Valentian I and Valens. Date: 367–75. Rome: Museo Nazionale. Gold. D 0.02 m. Ph. U.D.F.-La Photothèque.

30 Roman art. CONSTANTINOPLE (?). Wing of a diptych: Adam in Paradise. Late fourth century. Florence: Museo Nazionale. Ivory. H 0.295 m. Ph. Alinari, Florence.
The other wing of this diptych shows three anecdotes involving St Paul. The piece was at Mainz for a time, and latterly in the Carrand Collection.

31 Roman art. MILAN (?). Diptych of Stilicho. About 400. Monza Cathedral: Treasure. Ivory. H 0.32 m. B 0.165 m. Ph. Alinari Florence.
Stilicho is armed, and wearing consular attire: on his left stand his wife Serena and their son Eucherius.

32 Roman art. NORTHERN ITALY. Fragment of the diptych of the Lampadii: the magistrate, from his box, is watching a four-horse chariot-race. First half of the fifth century. Brescia: Museo Cristiano. Ivory. H 0.29 m. B 0.11 m. Ph. Direzione Musei e Pinacoteca, Brescia.

33 Roman art. ROME, Gardens of Licinius. Portrait of a consul (detail). About 400. Rome: Palazzo dei Conservatori. Marble. H of the whole statue: 2.36 m. Ph. U.D.F.-La Photothèque.

34 Roman art. ROME. Portrait of a lady: Eudoxia (?). About 400. Rome: Museo Torlonia. Marble. H 0.70 m. Ph. Gabinetto fotografico nazionale, Rome.

35 Roman art. ROME, between the Quirinal and the Gardens of Sallust. Portrait of a young man. About 400. Rome: Museo Nazionale. Luni marble. H of the head: 0.30 m. Ph. U.D.F.-La Photothèque.
A recent attempt has been made to identify this portrait as one of Constan-

tius Gallus (325–54), Constantine's nephew and the brother of Julian the Apostate: but on stylistic grounds the hypothesis remains unconvincing. (S. Stucchi, 'Bollettino d'Arte', 1951, p. 205, and M. Napoli, 'Bollettino d'Arte', 1959, p. 109.)

36 Roman art. ROME. The spring. Early fifth century. Rome: Museo Nazionale. Mosaic. Side of square, including border: 0.81 m. Ph. U.D.F.-La Photothèque.

37 Roman art. ROME. Oval sarcophagus (detail): Dionysus and Ariadne. About 210. Moscow: Pushkin Museum of Fine Arts. Marble. H 0.80 m. B 2.20 m. Ph. P.M.F.A.
Until 1843 this sarcophagus was at Rome, in the Palazzo Altemps: subsequently it formed part of the Serge Uvaroff Collection at Poreccie (between Moscow and Smolensk).

38 Roman art. ROME. Attic sarcophagus (detail): vintaging scene. Early third century. Rome: S. Lorenzo fuori le mura. Marble. Ph. U.D.F.-La Photothèque.
This sarcophagus is of Athenian origin.

39 Roman art. ROME. Attic sarcophagus: Achilles at the court of Lycomedes. About 250. Rome: Museo Capitolino. Marble. H of the 'tub': 1.30 m. H of the lid: 1.06 m. B 2.93 m. Ph. U.D.F.-La Photothèque.
This sarcophagus is of Athenian origin.

40 Roman art. ROME. Asiatic sarcophagus (detail): Muses and man of letters. Second half of third century. Rome: Museo Nazionale. Marble. B 2.30 m. Ph. U.D.F.-La Photothèque.

41 Roman art. VELLETRI. Sarcophagus (detail): Hercules bringing back Alcestis. About 150. Velletri: Museo Civico. Marble. H 1.45 m. Ph. U.D.F.-La Photothèque.

42 Roman art. ROME. Fragment of sarcophagus: the Prometheus myth. Date: 290–300. The Vatican: Museo Pio Clementino. Marble. Ph. Deutsches archäologisches Institut, Rome.

43 Roman art. ROME. Sarcophagus (detail). About 250–70. Pisa: Camposanto. Marble. Ph. Deutsches archäologisches Institut, Rome.

44 Roman art. ROME. Sarcophagus (detail): Bacchic initiation and meet-

426

ing with Ariadne. About 190–200. Rome: Villa Medici (Académie de France). Marble H 0.425 m. B of fragment 2.04 m. Ph. U.D.F.-La Photothèque.

Front of sarcophagus built into the façade of the villa (second half of the sixteenth century).

45 Art of Roman Egypt. ANTINOE. Hanging known as the 'Veil of Antinoe': above, the birth of Bacchus, below, a Dionysiac rout. Fourth or fifth century. Paris: Musèe du Louvre. Muslin with stencilled designs. H 1.23 m. B 3.37 m. Ph. U.D.F.-La Photothèque.

This piece is the subject of a forthcoming study by Fr du Bourguet.

46 Roman art. ROME (?). Sarcophagus with the story of Medea (detail): the dying spouse. Late second century. Basle: Antikenmuseum. Marble. H of the sculptured frieze: 0.65 m. Ph. B.A.

47 Roman art. ROME, Borghese Collection. Sarcophagus (detail): the fall of Phaethon. About 190. Paris: Musée du Louvre. Marble. Ph. U.D.F.-La Photothèque.

48 Roman art. ROME. Fragment of sarcophagus: the death of Meleager. About 190–220. Paris: Musée du Louvre. Marble. Ph. U.D.F.-La Photothèque.

49 Italian art of the Renaissance. FLORENCE. Giuliano da Sangallo: Funerary monument of Francesco Sassetti (detail). About 1485–8. Florence: S. Trinità. Sandstone. H of the detailed portion: 0.163 m. Ph. Alinari, Florence.

50 Roman art. ROME. Sarcophagus (detail): lion-hunt. About 250. Rome: Palazzo Mattei. Marble. Front of sarcophagus: H 1.33 m. B 2.25 m. Ph. U.D.F.-La Photothèque.

51 Roman art. ROME. Sarcophagus of Publius Peregrinus (detail): Muses and philosophers. About 280. Rome: Museo Torlonia. Marble. H 1.33 m. B of sarcophagus: 2.22 m. Ph. Deutsches archäologisches Institut, Rome.

52 Roman art. ROME, Palazzo Sanseverino. Christian sarcophagus (detail): the true philosophy. About 270–300. Rome, Palazzo Sanseverino-Rondanini. Marble. H 0.54 m. B 1.46 m. Ph. Pontificia Commissione di Archeologia sacra.

53 Roman art. ROME, Vigna Maccarani. Christ's Sermon on the Mount. About

270–310. Rome: Museo Nazionale. Marble. H 0.92 m. B 1.13 m. Ph. Pontificia Commissione de Archeologia sacra.

It is uncertain whether this piece formed part of a sarcophagus or was a slab used to close a tomb.

54 Roman art. ROME, Ludovisi Collection. Large sarcophagus with battle-scene attributed to the Emperor Hostilian (cf. 2). Date: 251. Rome: Museo Nazionale. Carrara marble. H 1.53 m. B 2.73 m. Ph. U.D.F.-La Photothèque.

The leader gliding above the battle on horseback has been identified as Hostilian, who died of the plague in Rome, while his brother Herennius and the Emperor Decius (their father) were killed fighting the Goths. Since their bodies were not recovered, this battle-sarcophagus was also a memorial tribute in their honour, under the sign of initiation in the Mithras cult (sign on Hostilian's brow). See Heintze, 1957.

55 Roman art. ACILIA. Fragment of sarcophagus: supposed designation of Gordian III. About 238(?). Rome: Museo Nazionale. Marble. H 1.49 m. Ph. Gabinetto fotografico nazionale, Rome.

56 Roman art. Rome, Via Latina. Sarcophagus of an official responsible for the commissariat. About 275. Rome: Museo Nazionale. Marble. H 0.88 m. B of entire sarcophagus: 2.08 m. Ph. Anderson, Rome.

57 Roman art. ROME, Forum Romanum, Arch of Septimius Severus. The Genius of Autumn. Date: 203. *In situ.* Marble Ph. U.D.F.-La Photothèque.

The images of the Seasons are to be found above the Victories which decorate the central opening of the monument. Autumn and Spring are located on the side facing the Capitol (West).

58 Roman art. ROME, Forum Romanum, Arch of Septimus Severus. A river. Date: 203. *In situ.* Marble. H of detail as shown: about 2 m. Ph. U.D.F.-La Photothèque.

Personification of a river, on the side facing the Capitol (West), above the small opening on the right side.

59 Roman art. ROME, Forum Romanum, Arch of Septimus Severus. Small frieze (detail): triumphal procession. Date: 203. *In situ.* Marble. H 0.60 m. Ph. U.D.F.- La Photothèque.

The small frieze is set above the smaller arches.

60 Roman art. ROME. Sarcophagus-lid: procession with images of divinities. Third century. Rome: S. Lorenzo fuori le mura, entrance hall. Marble. Ph. U.D.F.-La Photothèque.

The procession bearing the images of the gods is followed by two persons who occupy the full height of space available; behind them comes another procession with elephants.

61 Roman art. ROME. Sarcophagus-lid (detail): banqueting-scene. Fourth century. The Vatican: Museo Chiaramonti. Marble. Ph. Anderson, Rome.

62 Roman art. ROME, Forum Romanum, Arch of Septimius Severus. One of the major reliefs. Date: 203. *In situ.* Marble. H 4 m. B about 4.90 m. Ph. Deutsches archäologisches Institut, Rome.

This relief is to be found on the south-west face.

63 Roman art. ROME, Forum Romanum, Arch of Septimius Severus. Detail of Relief (cf. 62). Date: 203. *In situ.* Marble. Ph. U.D.F.-La Photothèque.

64 Roman art. ROME, near the Forum Boarium. Honorific gateway (detail): Septimius Severus and Julia Domna offering sacrifice. Date: 204. *In situ.* Marble. H of panel: 1.70 m. B 1.17 m. Ph. Alinari, Florence.

65 Roman art. ROME. Funerary stele of a centurion in the Praetorian Guard. Early third century. The Vatican: Galleria Lapidaria. Marble. H 1.25 m. Ph. Archivio fotografico Gallerie e Musei Vaticani.

66 Roman art. ROME, Arch of Constantine. North façade. Date: 312–15. *In situ.* Marble. H about 21 m. Ph. Gabinetto fotografico nazionale, Rome.

67 Roman art. ROME, Arch of Constantine. Frieze (detail): the siege of Verona. Date: 312–15. *In situ.* Marble. H 1.04 m. B of this panel of the frieze: 5.39 m. Ph. Anderson, Rome.

68 Roman art. ROME, Arch of Constantine. Frieze (detail): Constantine's battle against Maxentius. Date: 312–15. *In situ.* Marble. H 1.02 m. B of this panel: 5.47 m. Ph. Anderson, Rome.

69 Roman art. ROME, Arch of Constantine. Frieze (detail): Constantine's address. Date: 312–15. *In situ.* Marble. H 1.04 m. B of this panel: 5.41 m. Ph. Anderson, Rome.

427

70 Roman art. ROME, Arch of Constantine. Frieze (detail): distribution of largesse. Date: 312–15. *In situ*. Marble. H 1.02 m. B of this panel: 5.38 m. Ph. Anderson, Rome.

71 Roman art. ROME, Arch of Constantine. Detail of Constantine's address (cf. 69). Date: 312–15. *In situ*. Marble. Ph. Deutsches archäologisches Institut, Rome.

72 Roman art. ROME, Barberini Collection. Sarcophagus with emblems of the Seasons. About 330. Washington: Dumbarton Oaks Collection. Marble. H 1.09 m. B 2.24 m. Ph. Dumbarton Oaks Collection.

73 Roman art. ROME. Christian sarcophagus (detail): arrest of the Apostle Peter, and the miraculous spring. About 325. The Vatican: Museo Paolino (branch depot of the Museo Laterano). Marble. Ph. Alinari, Florence.

74 Roman art. ROME, Arch of Constantine. Column-base decorated with a Victory. Date: 312–15. *In situ*. Marble. H 2.23 m. B 1.20 m. Ph. U.D.F.-La Photothèque.

75 Roman art. ROME, Basilica of Constantine. Fragment of a colossal statue of Constantine. Date: 312–15. Rome: Palazzo dei Conservatori, courtyard. Marble. H of the head, neck included: 2.60 m. Ph. U.D.F.-La Photothèque.

76 Roman art. ROME. Statue of Dogmatius (detail). Date: 326–33. The Vatican: Museo Paolino (branch depot of the Museo Laterano). Marble. H of the head: 0.21 m. Ph. Deutsches archäologisches Institut, Rome.

Caius Caelius Saturninus Dogmatius was a high official under Constantine. A list of his various titles is preserved in an inscription (C.I.L., VI, 1704, 1705). This portrait was found below the Quirinal on the site of the Palazzo Philippani.

77 Roman art. ROME, Via Appia, Roman villa under the Basilica S. Sebastiano. Mural decoration. About 235. *In situ*. Fresco. Ph. U.D.F.-La Photothèque.

78 Roman art. ROME, Via Appia, Roman villa under the Basilica S. Sebastiano. Decoration on wall and vaulting (detail). About 235. *In situ*. Fresco. Ph. U.D.F.-La Photothèque.

79 Roman art. OSTIA, 'Cortile dell'Aquila' (Reg. IV, Ins. 5). Remains of mural decoration. About 200–35. *In situ*. Fresco. Ph. U.D.F.-La Photothèque.

80 Christian art of Rome. ROME, Via delle Sette Chiese, Catacombs of Domitilla. Cubiculum of the Good Shepherd. About 230. *In situ*. Fresco. Ph. Pontificia Commissione di Archeologia sacra.

81 Roman art. ROME, Forum Romanum. Base of a monument from the Tetrarchy (detail). Date: 305. *In situ*. Marble. Ph. Deutsches archäologisches Institut, Rome.

This monument was erected to commemorate the tenth year of Diocletian's Tetrarchy. It consisted of five bases, on each of which stood a column supporting the images of the four sovereign rulers and of Jupiter. This monument can be seen in the 'address' relief on the Arch of Constantine (cf. 69).

82 Roman art. ROME, Mithraeum beneath S. Prisca. Initiate leading a ram (detail). Date: 202–29. *In situ*. Fresco. Ph. U.D.F.-La Photothèque.

83 Roman art. ROME, Mithraeum beneath S. Prisca. *The deified Sun*. Date: 202–29. Rome: S. Prisca, Antiquarium. Marble inlay-work. H about 0.50 m. Ph. U.D.F.-La Photothèque.

84 Roman art. OSTIA, 'Caseggiato di Ercole' (Reg. IV, Ins. 11). Altercation before a judge. Date: 230–50. Ostia: Museo Ostiense. Fresco. Ph. U.D.F.-La Photothèque.

85 Roman art. OSTIA, 'Caseggiato di Ercole' (Reg. IV, Ins. 11). Detail of an altercation before a judge (cf. 84). Date: 230–50. Ostia: Museo Ostiense. Ph. U.D.F.-La Photothèque.

86 Roman art. ROME, house on the Caelian. Water-carrier. Fourth century. Naples, Museo Nazionale. Fresco. Ph. U.D.F.-La Photothèque.

87 Roman art from Tripolitania. GARGARESH, tomb of Aelia Arisuth. Candle-bearer (cf. 242). Fourth century. *In situ*. Fresco. Ph. U.D.F.-La Photothèque.

88 Roman art. ROME, Basilica of Junius Bassus. The consul among the Circus factions. Date: 330–50. Formerly in the Palazzo del Drago, Rome. Marble, hard stones and glass paste. Ph. G. Pozzi-Bellini, Rome.

This piece (and the other one from the same source, pl. 270) are at present in judicial custody pending a decision as to whether they are the property of the Italian State. Meanwhile they have been lodged in the Palazzo Vecchio, Florence.

89 Roman art. ROME, Basilica of Junius Bassus. Detail of the consul among the Circus factions (cf. 88). Date: 331–50. Formerly in the Palazzo del Drago, Rome. Ph. G. Pozzi-Bellini, Rome.

90 Roman art. ROME, Basilica of Junius Bassus. Decoration in marble inlay-work: calf attacked by a tigress. About 331. Rome: Palazzo dei Conservatori. Hard stones and marble. H 1.24 m. B 1.85 m. Ph. U.D.F.-La Photothèque.

The basilica, erected by Junius Bassus on the Esquiline, was pulled down during the seventeenth century to make room for the monastery of S. Antonio. The walls, however, were incorporated in the new building: they reveal a rectangular ground-plan 18.30 m × 14.25 m. The decoration is known from several Renaissance sketches. A Junius Bassus held the consulship in 317: according to one theory, the basilica was erected by him. He could have been the father of the Junius Bassus who was City Prefect and died in 359, and whose magnificent sarcophagus (with Christian iconography) was found (1597) in the crypts of the Vatican.

91 Roman art. OSTIA, Christian edifice by the Porta Marina. Frieze of coloured marble. Late fourth century. Ostia: Museo Ostiense (not on display). Marble and glass paste. Ph. Archivio Centro Studi mosaico romano, Rome.

Detail from the decoration of a chamber covered with marble inlay-work (see the bibliography in Becatti, 1969: reconstruction, pl. 58, 88–89). The room, when excavated, was ztill unfinished. The interruption of the work may be connected with the anti-Christian insurrection of 393–4 under the Praefectus Annonae, Numerius Proiectus, and, more generally, with the political activities of Virius Nicomachus Flavianus, who committed suicide after the anti-Christian faction suffered a defeat. The latest coins found in the ruins of this chamber belong to the period of Eugenius and Honorius: they were struck in 393, by the Aquileia mint.

92 Roman art. ROME, the Esquiline Treasure. Wedding-casket of Secundus and Projecta. About 379–82. London: British Museum. Silver. H 0.28 m. B 0.55 m. Ph. U.D.F.-La Photothèque.

93 Roman art. ROME, the Esquiline Treasure. Wedding-casket of Secundus and

Projecta (detail of the lid): Venus (cf. 92). About 379–82. London: British Museum. Ph. U.D.F.-La Photothèque.

94 Roman art. BONDONNEAU. Dish-handle: Venus in a shell borne by Tritons. Third century. Paris: Musée du Louvre. Silver. D 0.31 m. Ph. U.D.F.-La Photothèque.

95 Roman art. ODERZO. Bird-snaring, with owl. Second or third century. Oderzo: Museo Civico. Mosaic. Ph. Scala, Florence.

96 Roman art. AQUILEIA. Altar with offering to Priapus. First century. Aquileia: Museo Nazionale. Marble. H 0.65 m. B 0.425 m. Ph. Gabinetto fotografico nazionale, Rome.

97 Roman art. RIMINI. Stele of Ignatia Chila. First century. Rimini: Museo Comunale. Local stone. H 1.66 m. B 0.60 m. Ph. A. Villani e Figli, Bologna.

98 Roman art. AQUILEIA. Funerary monument of Lucius Alfius (detail): a master mason's tools. Late first century BC or early first century AD. Aquileia: Museo Nazionale. H of detail as shown: 0.89 m. Ph. Gabinetto fotografico nazionale, Rome.
The tomb is in the shape of a large altar, decorated with a Doric frieze.

99 Roman art. AQUILEIA. Funerary monument (detail): a blacksmith's forge. First or second century. Aquileia: Museo Nazionale. Limestone. Ph. Gabinetto fotografico nazionale, Rome.

100 Roman art. AQUILEIA. Funeral stele of Octavius Cornicla. Second half of first century. Verona: Museo Maffeiano. Limestone. H 1.36 m. B 0.59 m. Ph. Andrea Pagliarani, Verona.

101 Roman art. MODENA. Funeral stele of Caius Salvius. Second or third century. Modena: Museo Lapidario Estense. Limestone. Ph. Cav. Bandicri William, Modena.

102 Roman art. BOLOGNA. Funeral stele of Alennia family. First cent. Bologna: Museo Comunale. Limestone. H 2.496 m. B 0.67 m. Ph. A. Villani, Bologna.
A family of freedmen, one of whom had discharged the office of 'sevir'. The names appear to be Graecophone.

103 Roman art. AQUILEIA. Portrait of a woman (fragment). Second or third century. Aquileia: Museo Nazionale. Limestone. H 0.21 m. Ph. Gabinetto fotografico nazionale, Rome.

104 Roman art. AQUILEIA. Portrait of an elderly woman. Second century. Aquileia: Museo Nazionale. Limestone. H 0.22 m. Ph. Gabinetto fotografico nazionale, Rome.

105 Roman art. AQUILEIA. Funeral stele of a merchant. Second century. Aquileia: Museo Nazionale. Stone. Ph. Gabinetto fotografico nazionale, Rome.

106 Roman art. AQUILEIA. Draped funerary statue of a woman. Second century. Aquileia: Museo Nazionale. Stone. H 1.95 m. Ph. Gabinetto fotografico nazionale, Rome.

107 Roman art. AQUILEIA. Portrait of a man. Second century. Aquileia: Museo Nazionale. Stone. H 0.29 m. Ph. Gabinetto fotografico nazionale, Rome.

108 Roman art. AQUILEIA. Funeral stele of two women. Second century. Aquileia: Museo Nazionale. Stone. Ph. Gabinetto fotografico nazionale, Rome.
The stele is inscribed with the name 'Optata Fadia'.

109 Roman art. BOLOGNA. Fragment of an ornamental harness-attachment: barbarian in flight. Second or third century. Bologna: Museo Comunale. Bronze. Ph. A. Villani, Bologna.

110 Roman art. MOGILOVO. Fragment of an ornamental harness-attachment: wounded Amazon. Third century. Stara Zagora: Archaeological Museum. Bronze. H 0.13 m. B 0.215 m. Ph. Antonello Perissinotto, Padua.

111 Roman art. PIEDMONT. Ornamental harness-attachment: battle-scene. Second or third century. Aosta: Museo Archeologico. Bronze. Ph. Avignone, Aosta.

112 Hellenistic art. MONTORIO VERONESE. Water-carrier. First half of second century BC. Vienna: Kunsthistorisches Museum. Bronze. H 0.23 m. Ph. Erwin Meyer, Vienna.
This statuette was found with another, slightly smaller and less fresh-looking, which (it has been suggested) derived from a matrix taken from the first (Inv. no. 339). The two formed part of a group comprising about twenty small bronzes, discovered about 1830. The water-carrier is probably of Egyptian manufacture (Alexandria), and the duplicate casting local work. Other pieces seem to be of Greek or Syrian origin. The local pieces suggest that the hoard was buried at the end of the second century, in Commodus's reign.

113 Roman art. BRESCIA. Ornament from a trophy: prisoner. Second century. Brescia: Museo Romano. Bronze. H 0.68 m. Ph. Direzione Musei e Pinacoteca, Brescia.

114 Roman art from Dacia. ALBA JULIA. Funeral stele. Second century. Alba Julia: Regional Historical Museum. Limestone. H 2.17 m. B 1.12 m. Ph. R.H.M.
The inscription tells us that the stele was set up by Artorius Victor in memory of his wife Ulpia Maximilla.

115 Roman art of Noricum. WAGNA. Funeral stele. First century. Graz: Landesmuseum Joanneum. Limestone. Ph. L. J.-M. H. Rath.

116 Roman art of Noricum. AU (Vorarlberg). Stele of Umma, with 'Noricum hat'. First half of first century. Vienna: Niederösterreichisches Landesmuseum. Limestone. Ph. Lichtbildwerkstätte 'Alpenland', Vienna.
The stele (as the Latin inscription proclaims) is dedicated to Umma, daughter of Tabico, and wife to Ito, Iiedo's son: these are all Celtic names belonging to the local population. Equally typical are the leather hat and the pin (fibula) which has been used to fasten the dress.

117 Roman art. KOSTOLAC. Fragment of stele: scene portraying tax-payment. Second century. Belgrade: Narodni Muzej. Marble. Ph. Antonello Perissinotto, Padua.

118 Roman art. PETRONELL. Iphigeneia carrying the idol of Tauric Artemis (detail). First century. Klagenfurt: Landesmuseum. Fresco. Ph. Österreichisches Bundesdenkmalamt, Vienna.

119 Roman art of Thrace. SANDANSKI. Funeral stele with portraits and 'Thracian horseman'. Second century. Sofia: National Archaeological Museum. Marble. H 0.785 m. Ph. Antonello Perissinotto, Padua.

120 Roman art. SPLIT. Aerial view of the part of the town which formed Diocletian's former palace. In situ. Ph. Danilo Kabíc, Split.

121 Roman art. SPLIT, Palace of Diocletian. The peristyle (cf. 421). Opening years of the fourth century. In situ. 28 m × 12.50 m. Ph. Jerko Marasovic – Urbanisticxi Zavod Dalmacije, Split.

122 Roman art. SALONAE. Sarcophagus

with Christian symbols and statues of the deceased. Early fourth century. Split, Archaeological Museum. Limestone. B about 2.50 m. Ph. Antonello Perissinotto, Padua.

123 Roman art of Dacia. ALBA JULIA. Statue of Nemesis Regina. Late second century. Alba Julia: Regional Historical Museum. Limestone. H 0.85 m. Ph. R. H. M.

The inscription on the plinth records the following dedication: '(Deae Ne) mesi Reginae/C(aius) Iul(ius) Valens harus(pex)/ (C)ol(oniae) Apul(ensis) et ant(istes) huiusc(e) loc(i) somnio monitus l(ibens) p(osuit)'. The image, then, was put up as an offering by a high priest, the religious head of the 'colonia', as the result of a dream.

Other images of Nemesis explicitly portray the gesture of the right hand as a tugging at one's robe in order to spit in one's bosom, this being an apotropaic designed to avert bad luck.

124 Roman art in Pannonia. CSASZAR. Stele of Aurelius Januarius. Third century. Budapest: Hungarian National Museum. Limestone. H 2.81 m. B 1.05 m. Ph. H.N.M.

Below the figured section the stele carries an inscription, from which we learn that it was set up in memory of Aurelius Januarius, a cavalry trooper in the Ist (Severan) Legion, of his wife Ulpia Anuria, and of their two children, a girl of twelve and a boy.

125 Roman art of Noricum. BAD DEUTSCH ALTENBURG. Stele of Aptomarus and Brigimarus. First half of the first century. Bad Deutsch Altenburg: Museum Carnuntinum. Stone. H about 1.50 m. Ph. H. Kral, Hainburg/D.

126 Roman art of Noricum. MATREI (Tyrol). Stele of Popaeius Senator. First century BC or AD. *In situ.* Stone. H about 1.60 m. Ph. Lottersberger, Matrei.

The stele is in fact of an honorific rather than the normal funerary type. C. Praschniker and R. Egger have argued that it commemorates the person who first led Roman speculators to the country's rich mineral deposits, exploited by the Celts ever since the sixth century BC. (Anzeiger d. Akad. d. Wissenschaften in Wien, phil.-hist. Kl. 1938, pp. 14 sq.)

127 Gallic art of the Roman period. MONT-BOUY. Votive image. First century. Orléans: Musée historique de l'Orléanais. Wood. H 0.58 m. Ph. U.D.F.-La Photothèque.

This image, along with many others, was found in a sacred well.

128 Gallic art of the Roman period. MONT-BOUY. Votive image. First century. Orléans: Musée historique de l'Orléanais. Wood. H 0.22 m. Ph. U.D.F.-La Photothèque.

129 Romano-Gallic art. LA MALMAISON. Funerary pillar (fragment). Second century (?) Bar-le-Duc: Musée barrois. Limestone. Original H 1.62 m. H of the preserved portion: 1.03 m. B 0.32 × 0.29 m. Ph. U.D.F.-La Photothèque.

130 Gallic art. ENTREMONT. Pillar of a portico decorated with severed heads. About the mid-second century BC. Aix-en-Provence: Musée Granet. Limestone. H of each head: 0.28 m. to 0.30 m. Ph. Deutsches archäologisches Institut, Rome.

131 Roman art of Gallia Narbonensis. SAINT-RÉMY-DE-PROVENCE. Mausoleum of the Julii. Between 35 BC and 25 BC. *In situ.* Limestone. H 18 m. B at the base: 4.33 m. Ph. U.D.F.-La Photothèque.

132 Hellenistic art of Gallia Narbonensis. SAINT-RÉMY-DE-PROVENCE. Figured capital. Mid-second century BC. Saint-Rémy-de-Provence: archaeological repository (Hôtel de Sade). Limestone. H 0.78 m. B 0.68 m. Ph. Henri Rolland, Saint-Rémy-de-Provence.

133 Roman art of Gallia Narbonensis. SAINT-RÉMY-DE-PROVENCE, Mausoleum of the Julii. A relief from the base (detail). 35–25 BC. *In situ.* Limestone. H 2.19 m. B 3.37 m. Ph. Atzinger, Avignon.

134 Roman art of Gallia Narbonensis. ORANGE, commemorative arch. North façade. Between 30 BC and AD 26. *In situ.* Limestone. H 19.21 m. B at the base: 19.57 m. Ph. U.D.F.-La Photothèque.

135 Hellenistic art in Etruria. TARQUINIA. Etruscan sarcophagus (detail). Late fourth or early third century BC. Tarquinia: Museo Nazionale. Local volcanic stone (*nenfro*). H 0.66 m. B of sarcophagus: 1.99 m. Ph. Anderson, Rome.

This piece figures as no. 96 in Herbig's catalogue (R. Herbig, 'Die jünger-etruskischen Steinsarkophage', Berlin, 1952.)

136 Roman art of Gallia Narbonensis.

ORANGE, commemorative arch. Detail of north façade (cf. 134). Between 30 BC and AD 26. *In situ.* Limestone. Ph. U.D.F.-La Photothèque.

137 Roman art of Gallia Narbonensis. ORANGE, commemorative arch. East side (detail): trophies. Between 30 BC and AD 26. *In situ.* Limestone. B 8.40 m. Ph. U.D.F.-La Photothèque.

138 Roman art of Gallia Narbonensis. ORANGE, commemorative arch. North façade (detail): battle-scene (cf. 134). Between 30 BC and AD 26. *In situ.* Limestone. Ph. Abel, Orange.

139 Roman art. ARLES. Funerary group: Medea and her children. First century. Arles: Musée lapidaire païen. Limestone. H 1.20 m. Ph. U.D.F.-La Photothèque.

140 Roman art. MARSEILLES. Sarcophagus-lid: in the middle, Medea meditating the murder of her children: on the right, Oedipus and the Sphinx; on the left, Odysseus and Euryclcia. First century. Marseilles: Musée d'archéologie Borély. Limestone. H 0.88 m. B 1.58 m. Ph. L. Borel, Marseilles.

141 Celtic art in Ireland. DESBOROUGH. Mirror. First century. London: British Museum. Engraved bronze. B with the handle: 0.36 m. Ph. U.D.F.-La Photothèque.

142 Roman art in Gaul. SAINTES. Fragment of relief. Second or third century. Saintes: Musée archéologique. Limestone. H 0.92 m. B 0.62 m. Ph. Bernard Biraben, Bordeaux.

This fragment, with two others from the same monument, shows a scene of tax-payment. (Espériandieu, 'Recueil', II, no. 1341.)

143 Romano-Gallic art. NARBONNE. Stele with funerary images. Early first century. Narbonne: Musée lapidaire. Limestone. H 0.41 m. B 0.46 m. Ph. A. Villani e Figli, Bologna.

The stele originally terminated in a triangular pediment, and had a third bust on the right-hand side – probably that of the husband (of the lady whose bust is preserved), the father of the little girl in the middle. The inscription gives his name: 'L. Sergius Gallicanus'.

144 Romano-Gallic art. SOULOSSE. Funeral stele of Iassia. Second century. Metz: Musée central. Limestone. H 1.50 m. Ph. Prillot, Metz.

For the inscription cf. C.I.L., XIII, no. 4695.

145 Romano-Gallic art. WEISENAU. Funeral stele of a married couple. Mid-first century. Mainz: Mittelrheinisches Landesmuseum. Limestone. H 1.50 m. B 0.82 m. Ph. U.D.F.-La Photothèque.

146 Romano-Gallic art. NEUMAGEN. Fragment of relief: scene of tax-payment. Late second century. Trèves: Rheinisches Landesmuseum. Limestone. H 0.56 m. B 1.39 m. Ph. R.L.

147 Romano-Gallic art. SAINT-AMBROIX. Funerary pillar of Mansuetus. Second century. Saint-Germain-en-Laye: Musée des Antiquités nationales. Limestone. Overall H: 1.90 m. B 0.75 m. D 0.65 m. Ph. U.D.F.-La Photothèque.

148 Romano-Gallic art. REIMS. The god Cernunnos between Apollo and Mercury. First century. Reims: Musée historique et lapidaire. Limestone. H 1.25 m. B 1.10 m. Ph. U.D.F.-La Photothèque.

149 Romano-Gallic art. TOUGET. Hunting deity. First century. Saint-Germain-en-Laye: Musée des Antiquités nationales. Limestone. H 0.745 m. Ph. U.D.F.-La Photothèque.

150 Romano-Gallic art. MONT-SAINT-JEAN. Hunting and woodland deity. Early second century. Saint-Germain-en-Laye: Musée des Antiquités nationales. Limestone. H 0.565 m. Ph. Éditions des Musées nationaux.

151 Roman art of the Rhineland. BONN. Local divinities known as the 'Matronae Aufaniae'. Date: 164. Bonn: Rheinisches Landesmuseum. Limestone. H 1.32 m. Ph. R.L.
This little monument was dedicated by the Governor of Cologne, Quintus Vettius Severus. Along with other pieces, it was found re-employed as building material for the construction of a Christian edifice (martyrion) under the principal church in Bonn. The inscription bears the consular date 164, the oldest of this entire group of monuments. (C.I.L., II., no. 5413.)

152 Roman art of the Rhineland. BONN. Offering to the 'Matronae Aufaniae'. Late second century. Bonn: Rheinisches Landesmuseum. Limestone. H 1.62 m. Ph. R.L.
This monument, of the same provenance as the preceding item, was dedicated by a certain Marcus Pompeius Potens.

153 Romano-Gallic art. BAR-LE-DUC. Goddess on a throne. Bar-le-Duc: Musée barrois. Limestone. H 1.57 m. B 0.93 m. Ph. U.D.F.-La Photothèque.

154 Romano-Gallic art. CHALON-SUR-SAÔNE. Lion pouncing on a gladiator. First century. Chalon-sur-Saône: Musée Denon. Limestone. H 1.10 m. Ph. U.D.F.-La Photothèque.

155 Gallic art of the Roman period. AVIGNON. The 'Tarasque', an anthropophagous monster. Avignon: Musée lapidaire. Stone. H 1.18 m. Ph. U.D.F.-La Photothèque.

156 Gallic art of the Roman period. AVIGNON. The 'Tarasque' (detail): a masculine face. (cf. 155). Avignon: Musée lapidaire. Ph. U.D.F.-La Photothèque.

157 Gallic art of the Roman period. AVIGNON. The 'Tarasque' (detail): a masculine face (cf. 155). Avignon: Musée lapidaire. Ph. U.D.F.-La Photothèque.

158 Roman art in the Rhineland. NIEDERBIEBER. Portrait of an Emperor. First half of the third century. Bonn: Rheinisches Landesmuseum. Bronze. H 0.40 m. Ph. R.L.
This portrait represents either Gordian III (238–44) or else Alexander Severus (222–35).

159 Iberian art of the Roman period. PORCUNA. Bear holding a portrait-herm. Madrid: Museo arqueológico nacional. Limestone. H 0.63 m. B 0.65 m. Ph. Museo arqueológico nacional.

160 Roman art in Gaul. VAISON-LA-ROMAINE. Fragment of frieze (detail): the exploits of Hercules. Second century. Avignon: Musée lapidaire. Stone. H 0.62 m. B 0.90 m. Ph. M. L.
Hercules wrestling with the Nemean Lion and the giant Antaeus.

161 Roman art in Gaul. BRIANÇON. Upper part of a stele: the myth of Andromeda: Eros driving chariots. First century. Gap: Musée départemental des Hautes-Alpes. Stone. H 0.61 m. B 0.82 m. Ph. Frévillez, Gap.

162 Romano-Gallic art. Portrait of a Celtic chieftain. First century. Berne: Bernisches historisches Museum. Bronze. Ph. B. H. M.

163 Romano-Gallic art. AVENCHES. Head of a female barbarian. First century. Avenches: Musée romain. Gilded bronze. H 0.15 m. Ph. René Bersier, Fribourg.

This ornamental piece originally formed part of a representation of a trophy.

164 Romano-Gallic art. NEUMAGEN. Funerary monument (detail): the cheerful sailor. Early third century. Trèves: Rheinisches Landesmuseum. Limestone. Ph. Provinzialmuseum, Trèves.
The funerary monument of which this detail forms part was designed as a ship, laden with barrels of wine, and must have celebrated the river-traffic on the Rhine and Moselle.

165 Roman art. TRÈVES. The Porta Nigra in the *enceinte* of the residential quarter. Fourth century. *In situ.* Limestone. H 30 m. B 34.50 m. thickness, 21.50 m. Ph. Landesmuseum, Trèves.

166 Roman art. TRÈVES, chamber beneath a Constantinian church. Coffered ceiling (detail): allegorical figure with halo (cf. 167). Between 315 and 326. Trèves, Bischofliches Museum. Ph. B.M.

167 Roman art. TRÈVES, chamber beneath a Constantinian church. Coffered ceiling (detail). Between 315 and 326. Trèves: Bischöfliches Museum. Fresco (?). Picture with bust: H 1.21 m. B 1.30 m. Picture with figures of Eros: H 1.145 m. B 0.84 m. Ph. B.M.

168 Roman art. COLOGNE. Glassware from the Cologne factory; double-headed vase. Second or third century. Cologne: Römisch-Germanisches Museum. Glass. Ph. U.D.F.-La Photothèque.

169 Roman art. COLOGNE. Glassware from the Cologne factory: vase shaped like a bunch of grapes. Second or third century. Cologne: Römisch-Germanisches Museum. Glass. Ph. U.D.F.-La Photothèque.

170-173 Roman art. COLOGNE. Glassware from the Cologne factory. Third century. Cologne: Römisch-Germanisches Museum. Ph. U.D.F.-La Photothèque.

174 Roman art in Spain. OSUNA. Fragment of a memorial monument: soldier blowing bugle. About 45 BC. Madrid: Museo arqueológico nacional. Stone. H 1.10 m. B 0.57 m. Ph. M.A.N.

175 Roman art of Spain. CORDOVA. Fragment of stele: olive-picking. First or second century. Cordova: Museo arqueológico provincial. Limestone. H 0.60 m. B 0.60 m. Ph. M.A.P.-A. Salmorab.

431

176 Roman art in Spain. SEVILLE. Bust of a woman (full-face, cf. 177). Late first century. Seville: Museo arqueológico provincial. Terracotta. H 0.25 m. Ph. Alberto Palau, Seville.

177 Roman art in Spain. SEVILLE. Bust of a woman (back view, cf. 176). Late first century. Seville: Museo arqueológico provincial. Ph. Alberto Palau, Seville.

178 Roman art in Spain. MERIDA. Portrait of a woman (the so-called 'Gypsy Girl'). First century. Merida: Museo arqueológico. Marble. H 0.37 m. Ph. Deutsches archäol. Inst., Madrid.

179 Roman art in Spain. AMPURIAS. Portrait of a lady (full-face, cf. 180, 181). Late first century. Barcelona: Museo arqueológico. Bronze, eyes inlaid with enamel. H 0.38 m. Ph. Enric Gras, Barcelona.

180 Roman art in Spain. AMPURIAS. Portrait of a lady (profile, cf. 179, 181). Late first century. Barcelona: Museo arqueológico. Ph. Enric Gras, Barcelona.

181 Roman art in Spain. AMPURIAS. Portrait of a lady (back view, cf. 179, 180). Late first century. Barcelona: Museo arqueológico. Ph. Enric Gras, Barcelona.

182 Roman art in Spain. MARCHENA. Rein-guides: fight with an Amazon. Second or third century. Paris: Musée du Louvre. Bronze. H 0.18 m. Ph. U.D.F.-La Photothèque.

183 Roman art in Spain. SPAIN. Ornament from a receptacle: going hunting. Third century. Madrid: Museo arqueológico nacional. Bronze. B 0.285 m. Ph. M.A.N.

184 Iberian art of the Roman period. SALAS DE LOS INFANTES. Funeral stele (detail). Second or third century. Burgos: Museo arqueológico. Limestone. H 0.98 m. B 0.39 m. Ph. Club, Burgos.
For the inscription see C.I.L., II, Supplement, no. 5798.

185 Romano-Iberian art. TUDELA, Villa El Ramalete. Mosaic of the hunter 'Dominus Dulcitius'. Fourth or fifth century. Pamplona: Museo de Navarra. Marble mosaic. Ph. M.N.
The mosaic was in the middle of an isolated octagonal room, reached by a corridor that ran along the front of the villa. It had a border of floral motifs, which formed garlands round a number of medallions, the latter containing geometrical designs.

186 Romano-Iberian art. MERIDA. Anniponus's workshop. Dionysus and Ariadne. Fifth or sixth century. Merida: Museo arqueológico. Mosaic. Ph. M.A.

187 Roman art. TRÈVES. Coin: the Emperor Constantius Chlorus being welcomed by the City of London. About 306. Trèves: Rheinisches Landesmuseum (electrotype copy). Gold (original). Ph. U.D.F.-La Photothèque.

188 Roman art in Great Britain. Between CARLISLE and NEWCASTLE. Hadrian's Wall. Date: 119. *In situ*. Stone wall. Ph. Ministry of Public Building and Works, London. British Crown Copyright.

189 Roman art in Great Britain. BIRDOSWALD. Seated woman. Carlisle, Museum and Art Gallery. Stone. H 2.37 m: B 1.35 m. Ph. M.A.G.
The woman is sitting in a wicker basket-chair, which has led some students to suppose that this is a funerary rather than a cult statue.

190 Roman art in Great Britain. CIRENCESTER. Capital with busts of divinities. Cirencester: Corinium Museum. Limestone. H 1.14 m.; upper D 1.06 m. Ph. C.M.

191 Roman art in Great Britain. COLCHESTER. Funerary monument: anthropophagous sphinx. First century. Colchester: Colchester and Essex Museum. Stone. Ph. Charles Seely, Colchester.

192 Roman art in Great Britain. COLCHESTER. Funeral stele of Longinus. First century. Colchester: Colchester and Essex Museum. Stone. Ph. Charles Seely, Colchester.

193 Roman art. BRIDGENESS. Inscription on the Antonine Wall (detail): sacrificial scene (cf. 194). About 142–5. Edinburgh: National Museum of Antiquities of Scotland. Ph. National Museum of Antiquities of Scotland.

194 Roman art. BRIDGENESS. Inscription on the Antonine Wall. About 142–5. Edinburgh: National Museum of Antiquities of Scotland. Marble. H 1.20 m. B 2.79 m. Ph. N.M.A.S.
From the inscription we learn that the IInd Legion built 4,652 ft of the wall (between Bridgeness and the Avon). C.I.L., VII, 1088.

195 Roman art. CASTLE HILL(?) Inscription on the Antonine Wall. About 142–5.

Glasgow: The University, The Hunterian Museum. Marble. B 1.37 m. Ph. H.M.
The inscription informs us that the IInd Legion (whose badge, an eagle above the sign of Capricorn, can be seen on the right-hand side) built 3,666 and one-half yards of the fortification-wall (C.I.L., VII, 1130). The relief on the left shows a Victory beside a spear-carrying horseman, with two naked prisoners below.

196 Roman art. MILDENHALL. Basin. Between 350 and 375. London: British Museum. Silver. D 0.30 m. Ph. U.D.F.-La Photothèque.
One of four similar pieces accidentally discovered in 1942, together with numerous other items, together comprising the 'Mildenhall Treasure'. These dishes were formerly thought to be the work of craftsmen in Alexandria (Egypt): now, however, they are generally attributed to workshops in Italy or Gaul, active during this period, which have yielded similar specimens. Work of this sort has also turned up in Switzerland, Germany, and elsewhere in Great Britain.

197 Roman art. MILDENHALL. Basin with lid surmounted by a Triton. About 370–90. London: British Museum. Silver. Overall H: 0.191 m. D 0.23 m. Ph. U.D.F.-La Photothèque.
For the workshop of manufacture cf. no. 196. Found in the same hoard. It is not certain whether the lid in fact belongs to this basin.

198 Roman art in Great Britain. TAUNTON, Low Ham Villa. Story of Dido and Aeneas. About 350. Taunton: Castle Museum. Marble mosaic flooring. Ph. R. C. Sansome, Taunton.

199 Roman art of Africa. PIAZZA ARMERINA (Sicily), Roman villa. 'The Little Hunt' (detail). About 315–50. *In situ*. Marble mosaic. Ph. Colorvald, Valdagno.

200 Art of Roman Africa. SILIANA. Funerary relief known as the 'Boglio Stele': deities and harvesting scenes. Late third or early fourth century. Tunis: Bardo National Museum. Limestone. H 1.55 m. B 0.61 m. Ph. B.N.M.

201 Local art of Roman Tripolitania. GHIRZA, tomb. Frieze: harvesting scene (detail). Late third century. Tripoli Museum. Limestone. Ph. U.D.F.-La Photothèque.

202 Art of Roman Africa. DOUGGA, Temple

of Saturn. Heroic-style statue of a devotee (detail). Third century. Tunis: Bardo National Museum. Marble. Ph. U.D.F.-La Photothèque.

203 Art of Roman Africa. MASSICAULT. Funerary statue of an initiate. Second half of the third century. Tunis: Bardo National Museum. Marble. H about 1.70 m. Ph. U.D.F.-La Photothèque.
The deceased appears disguised as Eleusinian Hercules, thus showing himself to be an initiate in the Mysteries.

204 Roman art of Africa. TUNIS. Portrait of a priest. Third century. Tunis: Bardo National Museum. Marble. H 0.29 m. Ph. U.D.F.-La Photothèque.

205 Art of Roman Africa. CARTHAGE. Sarcophagus of the Four Seasons. Fourth century. Tunis: Bardo National Museum. Marble. Ph. U.D.F.-La Photothèque.

206 Art of Roman Africa. Villas by the seaside (detail). Tunis: Bardo National Museum. Third century (?). Mosaic flooring. Ph. U.D.F.-La Photothèque.

207 Art of Roman Africa. TABARKA. Country villa with towers and portico. Fourth century. Tunis, Bardo National Museum. Mosaic. H 3.50 m. B 5.40 m. Ph. U.D.F.-La Photothèque.

208 Art of Roman Africa. CARTHAGE, Villa of Dominus Julius. Scenes of country life round a villa. Second half of fourth century. Tunis: Bardo National Museum. Mosaic. Ph. U.D.F.-La Photothèque.

209 Art of Roman Africa. SOUSSE. Horses and grooms. Early third century. Sousse Museum. Mosaic. H 1.90 m. B 1.10 m. Ph. U.D.F.-La Photothèque.
The light patches indicate modern restoration-work.

210 Art of Roman Africa. TIMGAD. Marine Venus. 120–40. Timgad Museum. Mosaic. H 2.45 m. B 2.20 m. Ph. Marcel Bovis, Paris.

211 Art of Roman Africa. BÔNE. Wild beast hunt. Fourth century. Bône Museum. Mosaic. H 3.75 m. B 6.70 m. Ph. Marcel Bovis, Paris.

212 Art of Roman Africa. SOUSSE. Achilles at the court of King Lycomedes. Late second or early third century. Sousse Museum. Mosaic. Ph. U.D.F.-La Photothèque.

213 Art of Roman Africa. DOUGGA. Pirates transformed into dolphins by Dionysus. About 250–70. Tunis: Bardo National Museum. Mosaic. Ph. U.D.F.-La Photothèque.

214 Art of Roman Africa. SOUSSE, House of the Triumph of Dionysus. Composition: animals, flowers, and still life. Early third century (?). Sousse Museum. Mosaic. H 1.90 m. B 4.40 m. Ph. U.D.F.-La Photothèque.

215 Art of Roman Africa. SOUSSE, House of the Triumph of Dionysus. The triumph of Dionysus. Early third century. Sousse Museum. Mosaic. H 4.00 m. B 4.50 m. Ph. U.D.F.-La Photothèque.

216 Christian art. AQUILEIA, Basilica of Bishop Theodore. The story of Jonah (detail). 308–19. *In situ.* Mosaic. Ph. Scala, Florence.

217 Art of Roman Africa. SOUSSE, House of the Triumph of Dionysus. Fishermen and fish (detail). Early third century (?). Sousse Museum. Mosaic. Overall dimensions of the mosaic: H 3.55 m. B 4.55 m. Ph. U.D.F.-La Photothèque.

218 Art of Roman Africa. SOUSSE, House of Virgil. The poet Virgil with the Muses Clio and Melpomene. Early third century (?). Tunis: Bardo National Museum. Mosaic. H 1.23 m. B 1.22 m. Ph. U.D.F.-La Photothèque.

219 Art of Roman Africa. TIPASA. Berber prisoners. Third century. Tipasa Museum. Mosaic. Ph. U.D.F.-La Photothèque.

220 Art of Roman Africa. TIPASA. Head of a woman prisoner (detail, cf. 219). Third century. Tipasa Museum. Ph. U.D.F.-La Photothèque.

221 Art of Roman Africa. DJEBEL OUST, Roman baths. The four Seasons. Second half of the fourth century. *In situ.* Mosaic. Ph. Direction des Monuments historiques et sites archéologiques de la République tunisienne, Tunis.

222 Art of Roman Africa. DJEBEL OUST, Roman baths. Bust of a Season: Summer (cf. 221). Second half of fourth century. *In situ.* Ph. A. Carandini, Rome.

223 Art of Roman Africa. HENCHIR EL-KASBAT, House of the Animals. Animals in wreath-framed medallions (detail). Fourth century. *In situ.* Mosaic. Ph. A. Carandini, Rome.

224 Art of Roman Africa. PIAZZA ARMERINA, Roman villa. The great courtyard, detail (cf. 423). 315–50. *In situ.* Mosaic. Ph. U.D.F.-La Photothèque.
Discussion continues on the dating of the mosaics in each of the Piazza Armerina Villa's rooms. The present writer has given dates according to his own personal judgment, though limitations of space preclude any possibility of justifying them here.

225 Art of Roman Africa. PIAZZA ARMERINA, Roman villa. The great courtyard (detail): lion's head *(cf. 423).* Date: 315–50. *In situ.* Mosaic. Ph. Servicio Editoriale Fotografico, Turin.

226 Art of Roman Africa. PIAZZA ARMERINA, Roman villa. 'The Great Hunt' detail (cf. 423). Date: 315–50. *In situ.* Mosaic. Ph. U.D.F.-La Photothèque.

227 Art of Roman Africa. PIAZZA ARMERINA, Roman villa. Children hunting, detail (cf. 423). Date: 315–50. *In situ.* Mosaic. Ph. U.D.F.-La Photothèque.

228 Art of Roman Egypt. ANTINOE. Tapestry with medallions (detail). Between 400 and 500. New York: The Metropolitan Museum of Art (Don Edward S. Harkness, 1931). Wool. Ph. Metropolitan Museum of Art.

229 Roman art. PIAZZA ARMERINA, Roman villa. Room with three apses: the exploits of Hercules, detail (cf. 423). *In situ.* Mosaic. Ph. U.D.F.-La Photothèque.

230 Art of Roman Africa. EL-DJEM. Coursing a hare. Late third century. Tunis: Bardo National Museum. Mosaic. H 3.28 m. B 3.37 m. Ph. U.D.F.-La Photothèque.

231 Art of Roman Africa. DJEMILA. Wild beast hunt. Late fourth or early fifth century. Djemila Museum. Mosaic. Ph. Marcel Bovis, Paris.

232 Art of Roman Africa. CARTHAGE. Rural sanctuary of Diana and Apollo (detail). Mid-fourth century. Tunis: Bardo National Museum. Mosaic. Ph. U.D.F.-La Photothèque.

233 Art of Roman Africa. GAFSA. Circus and spectators (detail). Fifth or sixth century. Tunis: Bardo National Museum. Mosaic. H 3.40 m. B 4.70 m. Ph. U.D.F.-La Photothèque.

234 Art of Roman Africa. CHERCHELL. Work in the fields (detail): ploughing and sowing (cf. 236). Middle of the

433

third century. Cherchell: Archaeological Museum. Ph. U.D.F.-La Photothèque.

235 Art of Roman Africa. CHERCHELL. Work in the fields (detail): digging (cf. 236). Mid-third century. Cherchell: Archaeological Museum. Ph. U.D.F.-La Photothèque.

236 Art of Roman Africa. CHERCHELL. Work in the fields. Mid-third century. Cherchell: Archaeological Museum. Mosaic. H 5.50 m; B 3.60 m. Ph. U.D.F.-La Photothèque.

237 Art of Roman Africa. CHERCHELL. Vintaging. Mid-third century. Cherchell: Archaeological Museum. Mosaic. H 2.07 m. B 1.22 m. Ph. U.D.F.-La Photothèque.

238 Art of Roman Africa. CHERCHELL. Treading out the grapes. Mid-third century. Cherchell: Archaeological Museum. Mosaic. Ph. U.D.F.-La Photothèque.

239 Roman art of Tripolitania. LEPTIS MAGNA, House of Orpheus. Composite mosaic. Third century. Tripoli Museum. Mosaic. H 2.00 m. B 2.07 m. Ph. U.D.F.-La Photothèque.

240 Roman art of Tripolitania. LEPTIS MAGNA, the Nile Villa. Fishing scene (detail). Late second or early third century. Tripoli Museum. Mosaic. Overall dimensions of mosaic: H 1.20 m. B 3.78 m. Ph. U.D.F.-La Photothèque.

241 Roman art of Tripolitania. DAR BUC AMMERA, Roman villa. Decoration of a covered passage (detail). Late second or early third century. Tripoli Museum. Fresco. H 0.395 m. B 0.945 m. Ph. U.D.F.-La Photothèque.
This detail formed part of the decoration on the vaulting of a covered passage-way (cryptoporticus); the central figure was Dionysus on a panther, with masks and some very lightly traced leaf-and-branch decorative motifs. The entire decoration is reproduced in a sketch by Aurigemma, published in 1962.

242 Roman art of Tripolitania. GARGA-RESH, tomb of Aelia Arisuth. Mural decoration. Fourth century (? second half). *In situ.* Fresco. H (from the upper edge of the niche to the base): 2 m. B of the niche: 2.55 m. Ph. U.D.F.-La Photothèque.

243 Roman art of Tripolitania. GAR-

GARESH, tomb of Aelia Arisuth. Loculus (detail): portrait of Aelia Arisuth (cf. 242). Fourth century (? second half). *In situ.* Ph. U.D.F.-La Photothèque.

244 Roman art of Tripolitania. LEPTIS MAGNA. Statue of Iddibal Caphada Aemilius (detail). About 15. Tripoli Museum. Marble. H of the head: 0.25 m. Ph. U.D.F.-La Photothèque.

245 Roman art of Tripolitania. LEPTIS MAGNA, Severan Forum. The structure and arches of the portico. Date: 210-16. *In situ.* Marble. Ph. U.D.F.-La Photothèque.

246 Roman art of Tripolitania. LEPTIS MAGNA, Severan Basilica. Decoration of the pilasters (detail). Date: 210-16. *In situ.* Marble. Ph. U.D.F.-La Photothèque.

247 Roman art of Tripolitania. LEPTIS MAGNA, Arch of the Severi. Septimius Severus taking part in a sacrifice (detail). Date: 203-4. Tripoli Museum. Marble. H 1.72 m. Ph. U.D.F.-La Photothèque.

248 Roman art of Tripolitania. LEPTIS MAGNA, Arch of the Severi. The Emperor and his sons on the Triumphal Chariot. Date: 203-4. Tripoli Museum. Marble. H 1.72 m. Ph. U.D.F.-La Photothèque.

249 Roman art of Tripolitania. LEPTIS MAGNA, Honorific Arch of the Severi. Sacrifice before a temple. Date: 203-4. Tripoli Museum. Marble. H 3.60 m. Ph. U.D.F.-La Photothèque.

250 Roman art of Tripolitania. LEPTIS MAGNA, Honorific Arch of the Severi. A Victory. Date 203-4. Tripoli Museum. Marble. Ph. U.D.F.-La Photothèque.

251 Roman art of Cyrenaica. CYRENE. Statuette of Leda (ornamental attachment). First century BC or AD. Cyrene: Museum of Sculpture. Marble. H with the plinth: 0.95 m. Ph. U.D.F.-La Photothèque.
This piece was probably a table support.

252 Roman art of Cyrenaica. CYRENE. Portrait of a man. Second half of the third century. Cyrene: Museum of Sculpture. Marble. H 0.375 m. Ph. U.D.F.-La Photothèque.

253 Art of Roman Egypt. Portrait of a woman. About 80-100. Berlin: Staat-

liche Museen. Marble. H 0.395 m. Ph. U.D.F.-La Photothèque.

254 Art of Roman Egypt. ABOUKIR, necropolis. Funerary portrait. Mid-third century. Alexandria: Graeco-Roman Museum. Marble. H 0.67 m. B 1.39 m. Ph. U.D.F.-La Photothèque.
What we have here is not a sarcophagus-lid; the sculpture covered a 'loculus'.
The object in the man's right hand is a leather purse.

255 Art of Roman Egypt. ALEXANDRIA. Statue of the priest Hor. Early second century. Cairo: Egyptian Museum. Basalt. H 0.86 m. Ph. U.D.F.-La Photothèque.

256 Art of Roman Egypt. CONSTANTINOPLE. Group of Tetrarchs. Date: 300-15. Venice: St Mark's. Porphyry. H 1.30 m. Ph. Scala, Florence.

257 Art of Roman Egypt. ALEXANDRIA. Aureus of Maximin Daia (cf. frontispiece). Date: 311-13. Paris: Bibliothèque Nationale, Cabinet des Médailles (Beistegui Collection, no. 197). Ph. U.D.F.-La Photothèque.

258 Art of Roman Egypt. ATHRIBIS. Portrait of Galerius (?). About 305-11. Cairo: Egyptian Museum. Porphyry. H of bust overall: 0.75 m. H of the head: 0.17 m. Ph. U.D.F.-La Photothèque.
This portrait was for long identified as either the Emperor Licinius, or else as Maximin Daia, or as Diocletian. However, more recent iconographic investigations make it more probable that this was, in fact, a portrait of Galerius.

259 Art of Roman Egypt. EGYPT. Shroud: Anubis escorting the deceased. About 175-200. Moscow: Pushkin Museum of Fine Arts. Painting on cloth. H about 1.79 m. B 1.24 m. Ph. P.M.F.A.

260 Art of Roman Egypt. THE FAYUM. Portraits of two brothers. Second century. Cairo: Egyptian Museum. Painting in distemper on wood. D 0.61 m. Ph. U.D.F.-La Photothèque.

261 Art of Roman Egypt. EGYPT. Portrait of small girl with offerings. Cairo: Egyptian Museum. Painting in distemper on wood. H 0.85 m. B 0.24 m. Ph. U.D.F.-La Photothèque.

262 Art of Roman Egypt. THE FAYUM or THEBES(?). Female portrait. Second or third century. Paris: Musée du Louvre. Painting in distemper on wood. H

about 0.29 m. B about 0.175 m. Ph. U.D.F.-La Photothèque.

263 Art of Roman Egypt. THE FAYUM. Portrait of a lady. About 325–50. Cairo: Egyptian Museum. Encaustic painting on wood. H 0.315 m. B 0.125 m. Ph. U.D.F.-La Photothèque.

264 Art of Roman Egypt. THE FAYUM. Portrait of a young girl. Early third century. Berlin: Staatliche Museen. Encaustic painting on wood. H 0.35 m. B 0.172 m. Ph. U.D.F.-La Photothèque.

265 Art of Roman Egypt. ANTINOE. Portrait of Ammonius with a bunch of flowers. Third century. Paris: Musée du Louvre. Painting in distemper, on canvas. H 0.51 m. B 0.215 m. Ph. U.D.F.-La Photothèque.

266 Art of Roman Egypt. LUXOR, Temple of the Imperial Cult. Wilkinson: water-colour after the original paintings in the temple. The paintings: 284–305. The water-colour: mid-nineteenth century. Oxford: Griffith Institute, Ashmolean Museum. Water-colour on paper. Ph. A.M.

267 Late Empire art. CONSTANTINOPLE(?). The Iliad, Bk XIII: Idomeneus dragging off the body of Othryoneus (enlarged detail). Model: mid-third century. Miniature: early sixth century. Milan: Biblioteca Ambrosiana. Miniature on parchment. H 0.11 m. B 0.22 m. Ph. B.A.
The miniature forms part of Cod. Ambros. F 205 Inf., and bears the number XLII. A group of miniatures in this codex is thought to derive from models created at Alexandria (Egypt) in the mid-third century (cf. 350).

268 Art of Roman Egypt. BEGRAM. Glass with the lighthouse of Alexandria on it. Late second or early third century. Kabul Museum. Glass. Ph. Musées nationaux – Délégation archéologique française en Afghanistan.
This glass, along with various other objects in glass, plaster and ivory, forms part of the treasure from the palace of Begram, discovered by the French Archaeological Mission under J. Hackin.

269 Art of the Roman period. The glass of Lycurgus. Late third or early fourth century. London: British Museum. Cut glass. H 0.20 m. D 0.13 m. Ph. B.M.
The silver-gilt bordering of leaves under the rim dates from the eighteenth century. The relief is effected partly by

moulding, and partly by soldering on prefabricated pieces. This item has been known since 1845: from 1851 onwards it belonged to the Rothschild family in London. Its original manufacture could have been in either a Syrian or an Alexandrian workshop.

270 Art of Roman Egypt. ROME, Basilica of Junius Bassus. Panel: Hylas carried off by the Nymphs (cf. 88). Date: 330–50. Formerly in the Palazzo del Drago (Rome). Hard stones and glass paste. Ph. Scala, Florence.

271 Art of Roman Egypt. EGYPT. Medallion on cloth: the Nile. Early fourth century. Moscow: Pushkin Museum of Fine Arts. Linen and wool material. D 0.255 m. Ph. P.M.F.A.
This piece has a counterpart in the bust of Terra (Earth) preserved in the Hermitage Museum at Leningrad.

272 Art of Roman Egypt. EGYPT. Fragment of wall-tapestry: Pan and Bacchus. Third or fourth century. Boston: The Museum of Fine Arts. Woollen material. H 0.375 m. B 0.410 m. Ph. U.D.F.-Drueger.

273 Art of Roman Greece. LUKU (Peloponnese). Portrait of Memnon. About 150–60. Berlin: Staatliche Museen. Marble. H 0.273 m. Ph. U.D.F.-La Photothèque.
Memnon the African was one of Herodes Atticus's best pupils; and Herodes Atticus is known to have owned a villa in the area where this piece was found.

274 Art of Roman Greece. PROBALINTHOS (Attica). Portrait of Herodes Atticus. About 150–70. Paris: Musée du Louvre. Marble. H 0.62 m. Ph. U.D.F.-La Photothèque.

275 Art of Roman Greece. ATHENS. Portrait of Polydeuces. About 150. Berlin: Staatliche Museen. Marble. H 0.545 m. Ph. U.D.F.-La Photothèque.
Polydeuces was Herodes Atticus's favourite pupil, and several copies of his portrait survive.

276 Art of Roman Greece. ATHENS. Portrait of a *kosmetes*. About 240–50. Athens: National Museum. Marble. H 0.31 m. Ph. U.D.F.-La Photothèque.

277 Art of Roman Greece. SALONIKA. Sarcophagus: battle of Amazons. Second or third century. Salonika: Archaeological Museum (Old Museum). Marble. B 2.50 m. Ph. U.D.F.-La Photothèque.

278 Art of Roman Greece. SALONIKA. Battle of Amazons, detail (cf. 277). Second or third century. Salonika: Archaeological Museum (Old Museum). Ph. U.D.F.-La Photothèque.

279 Art of Roman Greece. ATHENS(?). Sarcophagus (short end): Phaedra languishing with love. Early third century. Agrigento: S. Nicola. Marble. H 1.17 m. Ph. Alinari, Florence.

280 Roman art. SALONIKA, Arch of Galerius. One of the pillars: the exploits of Galerius (cf. 422). Date: 297–305. *In situ*. Marble. H of pillar: about 5 m. B of pillar: 3.80 m. Ph. U.D.F.-La Photothèque.

281 Roman art. SALONIKA, Arch of Galerius. Cyma of a pillar, detail (cf. 280). Date: 297–305. *In situ*. Marble. Ph. U.D.F.-La Photothèque.

282 Roman art. SALONIKA, Arch of Galerius. Relief on a pillar (detail). Date: 297–305. *In situ*. Marble. Ph. U.D.F.-La Photothèque.

283 Roman art. SALONIKA. Fragment of a small arch of Galerius. About 305. Salonika: Archaeological Museum (New Museum). Marble. H 1.16 m. B 2.43 m. Ph. U.D.F.-La Photothèque.

284 Art of Roman Moesia. VARNA. Funeral stele of Dionysogenos. Second century. Varna: Archaeological Museum. Marble. H about 0.55 m. Ph. Antonello Perissinotto, Padua.

285 Art of Roman Thrace. VRANJA. Stele with funeral banquet. Second or third century. Sofia: National Archaeological Museum. Limestone. H about 0.62 m. Ph. Antonello Perissinotto, Padua.

286 Art of Roman Thrace. VARVARA. Cult-relief known as the 'Thracian Hero'. Second century (?). Sofia: National Archaeological Museum. Limestone. H about 0.325 m. Ph. Antonello Perissinotto, Padua.

287 Art of Roman Thrace. PLOVDIV. Cult-relief of the tricephalous (three-headed) hero. Second or third century. Plovdiv: Archaeological Museum. Limestone. H 0.38 m. Ph. Antonello Perissinotto, Padua.

288 Art of Roman Thrace. KRITCHIM. Cult-relief of the Thracian hero. Second or third century. Plovdiv: Archaeological Museum. Limestone. H 0.23 m. Ph. Antonello Perissinotto, Padua.

289 Art of Roman Thrace. EZEROVO. Cult-relief with horseman. Second century. Sofia: National Archaeological Museum. Limestone. H 0.395 m. Ph. Antonello Perissinotto, Padua.

290 Art of Roman Moesia. ADAMKLISSI, Monument to Trajan's victories. Metope: a horseman. About 109. Adamklissi Museum. Limestone. B 1.16 m. Ph. Historical Monuments Service, Bucharest.
In the reconstruction of the monument this piece figures as item no. 1.

291 Art of Roman Moesia. ADAMKLISSI, Monument to Trajan's victories. Metope: Trajan and one of his lieutenants. About 109. Adamklissi Museum. Limestone. B 1.16 m. Ph. Historical Monuments Service, Bucharest.
Metope no. XLIV.

292 Art of Roman Moesia. ADAMKLISSI, Monument to Trajan's victories. Relief from a crenelle: prisoner. About 109. Adamklissi Museum. Limestone. B at upper level: 0.88 m. Ph. Historical Monuments Service, Bucharest.

293 Art of Roman Moesia. ADAMKLISSI, Monument to Trajan's victories. Metope: barbarian family on an ox-cart. About 109. Adamklissi Museum. Limestone. B 1.16 m. Ph. Historical Monuments Service, Bucharest.
Metope no. IX.

294 Art of Roman Moesia. ADAMKLISSI, Monument to Trajan's victories. Metope: Dacians killed in battle. About 109. Adamklissi Museum. Limestone. B 1.16 m. Ph. Historical Monuments Service, Bucharest.
Metope no. XXIV.

295 Art of Roman Moesia. ADAMKLISSI, Monument to Trajan's victories. Metope: soldier fighting the Dacians. About 109. Adamklissi Museum. Limestone. B 1.16 m. Ph. Historical Monuments Service, Bucharest.
Metope no. XXXI.

296 Art of Roman Moesia. ADAMKLISSI, Monument to Trajan's victories. The great trophy. About 109. Adamklissi Museum. Limestone. H 9.10 m. Ph. Historical Monuments Service, Bucharest.

297 Roman art in Moesia. ADAMKLISSI, Monument to Trajan's victories. The ruins. About 109. *In situ.* Stone and brick. D of tumulus: about 31 m. Ph. Antonello Perissinotto, Padua.

298 Art of Roman Moesia. THE DOBRUDJA. Funeral stele in a barbarian style. Third century(?). Varna: Archaeological Museum. Limestone. H about 0.50 m. Ph. Antonello Perissinotto, Padua.

299 Roman art of Thrace. PASTOUCHA. Portrait of a man. Late second or early third century. Plovdiv: Archaeological Museum. Marble. H 0.255 m. Ph. Antonello Perissinotto, Padua.

300 Roman art in Moesia. NICOPOLIS AD ISTRUM, near Nikup. Portrait of Gordian III. About 238–44. Sofia: National Archaeological Museum. Bronze. H 0.365 m. Ph. Antonello Perissinotto, Padua.

301 Roman art in Thrace. BREST (Pleven). Portrait of a man (fragment of statue). Late third century. Sofia: National Archaeological Museum. Limestone. H 0.27 m. Ph. Antonello Perissinotto, Padua.
This portrait used to be identified as one of Diocletian. Iconographically speaking, it would seem more likely to be Galerius. However, the non-monumental proportions suggest that it may not portray an emperor at all.

302 Art of the Roman period in Moesia. GIGEN. Asia Minor *atelier.* Fragment of an ornament. Early third century. Sofia: National Archaeological Museum. Ph. Antonello Perissinotto, Padua.

303 Roman art in Tripolitania. LEPTIS MAGNA, Severan Basilica. Decoration of a pilaster, detail (cf. 246). Date: 210–16. *In situ.* Marble. Ph. U.D.F.-La Photothèque.

304 Roman art in Moesia. CONSTANTZA. Tyche (Chance) as protectress of the town of Tomis. Late second or early third century. Constantza: Muzeul de Arheologie. Marble. H 1.65 m. Ph. Antonello Perissinotto, Padua.

305 Roman art in Thrace. STARA ZAGORA, General Stoletov Street. Mosaic with fishing and hunting motifs. Third century. *In situ.* Mosaic. Ph. Antonello Perissinotto, Padua.

306 Art of Roman Moesia. SILISTRA, tomb. Paintings on the walls and vaulting. Second half of the fourth century. *In situ.* Fresco. Dimensions of the chamber: H 2.30 m. 3.30 m. × 2.60 m. Ph. Antonello Perissinotto, Padua.

307 Art of Roman Moesia. SILISTRA, tomb. Sepulchral chamber: ceiling panels, detail (cf. 306:307: another detail). Second half of the fourth century. *In situ.* Ph. Antonello Perissinotto, Padua.

308 Art of Roman Moesia. SILISTRA, tomb. Sepulchral chamber: ceiling panels, detail (cf. 306; 307: another detail). Second half of the fourth century. *In situ.* Ph. Antonello Perissinotto, Padua.

309 Art of Roman Egypt. VARNA. Jar in the form of a portrait-bust. Second or third century. Varna Archaeological Museum. Bronze. H 0.09 m. Ph. Antonello Perissinotto, Padua.

310 Art of Roman Egypt. VARNA. Jar in the form of a portrait-bust. Second or third century. Varna: Archaeological Museum. Bronze. Ph. Antonello Perissinotto, Padua.

311 Art of Roman Egypt. CENCHREAE. A landscape (detail). About 350. Corinth Museum. Mosaic in glass paste. H 1 m. B 1.90 m. Ph. Hassia, Paris.

312 Art of Roman Egypt. CENCHREAE. Homer. About 350. Corinth Museum. Mosaic in glass paste. H 1.90 m. After Robert L. Scranton, 'Glass Pictures from the Sea (the Cenchreae Expedition)', in *Archaeology* XX, 3, 1967, cover photograph.
These glass mosaic panels were found near the port, still partly enclosed in the wooden packing-cases that had been used to transport them – confirmatory evidence for the theory that they came from some overseas workshop.

313 Art of pre-Byzantine Greece. ARGOS. Mosaic of the Months (detail): July and August. Late fifth century. Argos Museum. Marble mosaic. Ph. Publication Ionian and Popular Bank of Greece, S.A., 1961.

314 Art of Roman Syria. ANTIOCH. Drinking contest between Dionysus and Heracles. Late third century. Princeton University: the Art Museum. Mosaic. Ph. P.U.A.M.

315 Art of Roman Syria. ANTIOCH, Villa at the foot of Moussa Dagh. Dionysus and Ariadne. Late second or early third century. Antioch: Museum of Mosaics. Mosaic. Ph. Princeton University, Department of Art and Archeology.

316 Art of Roman Syria. ANTIOCH, 'Constantinian villa'. Wild beast hunt (cf.

317: another detail). About 330. Paris: Musée du Louvre. Mosaic. Overall dimensions: H 6.60 m. B 6.60 m. Ph. U.D.F.-La Photothèque.

317 Art of Roman Syria. ANTIOCH, 'Constantinian villa'. Offering to Diana: personification of Autumn (cf. 316: another detail). About 330. Paris: Musée du Louvre. Mosaic. Ph. U.D.F.-La Photothèque.

318 Art of Roman Syria. TYRE, necropolis. Tomb-paintings: Heracles and Alcestis. About 150. Beirut: National Archaeological Museum. Fresco. Ph. A. der Simonian, Beirut.

319 Roman art. ROME, Torre Nuova. Sarcophagus (detail): the Bath of Diana. About 150. Paris: Musée du Louvre. Marble. Ph. U.D.F.-La Photothèque.

320 Art of Roman Asia Minor. EPHESUS, Temple dedicated to Hadrian. Decoration on the arcature (detail). About 150. In situ. Marble. Ph. Antonello Perissinotto, Padua.

321 Art of Roman Asia Minor. EPHESUS, main street through the agora. Plinth of a column (cf. 418). Second century. In situ. Marble. H 2.50 m. Ph. Antonello Perissinotto, Padua.

322 Art of Roman Asia Minor. EPHESUS. Monument of Marcus Aurelius and Lucius Verus, detail (cf. 323: another detail). Date: 166-70. Vienna: Kunsthistorisches Museum. Marble. Ph. V.K.M.

323 Art of Roman Asia Minor. EPHESUS. Monument of Marcus Aurelius and Lucius Verus, detail (cf. 322: another detail). Date: 166-70. Vienna: Kunsthistorisches Museum. Marble. Ph. V.K.M.

324 Art of Roman Asia Minor. APHRODISIAS, Baths. A corbel (detail). Third century. In situ. Marble. Ph. Antonio Giuliano.

325 Art of Roman Asia Minor. IASOS. Sarcophagus with garlands (detail). Third century. Istanbul: Archaeological Museum. Marble. H about 3 m. Ph. U.D.F.-La Photothèque.

326 Art of Roman Asia Minor. YUNUSLAR. Sarcophagus: the Labours of Hercules. About 210-50. Konya: Archaeological Museum. Marble. H 1.18 m. B 2.50 m. Ph. K.A.M.

327 Art of Roman Asia Minor. SIDAMARA.

Sarcophagus, end (cf. 328: side). Third century. Istanbul: Archaeological Museum. Marble. H about 3 m. B 4 m. Ph. U.D.F.-La Photothèque.

328 Art of Roman Asia Minor. SIDAMARA. Sarcophagus: figures in front of porticoes with pediments (cf. 327: end). Third century. Istanbul: Archaeological Museum. Ph. U.D.F.-La Photothèque.

329 Roman art. BELGRADE. Fragment of cameo. Fourth century. Belgrade: National Museum. Sard. Ph. Antonello Perissinotto, Padua.

330 Roman art. ROME. Coin (follis) of Constantine (with the title of) Caesar. Date: 306-7. Naples: Museo Nazionale, Medagliere. Silvered bronze. D 0.025 m. Ph. N.M.N.

331 Roman art. THESSALONIKA. Medallion of Constantine I, multiple of one-and-a-half solidi. Date: 327. Paris: Bibliothèque Nationale, Cabinet des Médailles (Beistegui Collection, no. 234). Gold. D 0.027 m. Ph. U.D.F.-La Photothèque.
Anepigraphic obverse, with portrait of Constantine, wearing the Imperial diadem, eyes upturned to heaven as though in prayer. On the reverse: 'Gloria Constantini Avg(usti)'.

332 Roman art in Constantinople. ISTANBUL. Enceinte of Theodosius II (detail). In situ. Ph. Antonello Perissinotto, Padua.

333 Roman art in Constantinople. ISTANBUL. Fragment of the Column of Theodosius I. Date: 386-93. Istanbul: Baths of Bayazid. Marble. Ph. Deutsches archäol. Inst., Istanbul.

334 Italian art of the sixteenth century. VENICE (?). Drawing of the Column of Theodosius I (detail). Mid-sixteenth century. Paris: Musée du Louvre, Cabinet des Dessins. Ink on paper. H 0.43 m. Ph. U.D.F.-La Photothèque.
This sketch has sometimes been attributed to Battista Franco.

335 Roman art in Constantinople. ISTANBUL, Hippodrome. Sculptor 'A'. Base of Theodosius I's obelisk, the S.W. and S.E. faces (cf. 365). About 390-3. In situ (at Meydani). Marble. H about 4.28 m. B 3.10 m. Ph. U.D.F.-La Photothèque.

336 Roman art in Constantinople. ISTANBUL, Hippodrome. Sculptor 'B'. Base of Theodosius I's obelisk, N.W. face,

detail (cf. 365). About 390-3. In situ. Marble. Ph. U.D.F.-La Photothèque.

337 Roman art in Constantinople. ISTANBUL. Statue of a person in a toga. Fourth century. Istanbul: Archaeological Museum. Marble. H 1.22 m. Ph. U.D.F.-La Photothèque.

338 Roman art in Constantinople. ALMENDRALEJO. 'Missorium': Theodosius I flanked by Valentinian II (on his right) and Arcadius. Date: 387-8. Madrid: Academia de la Historia. Silver. D 0.74 m. Ph. David Manso Martin, Madrid.

339 Art of Roman Asia Minor. APHRODISIAS, Baths. Statue of Valentinian II, detail (cf. 341). 387-90. Istanbul: Archaeological Museum. Ph. U.D.F.-La Photothèque.

340 Roman art in Constantinople. ISTANBUL. Portrait of Arcadius. Date: 387-90. Istanbul: Archaeological Museum. Marble. H 0.325 m. Ph. U.D.F.-La Photothèque.

341 Art of Roman Asia Minor. APHRODISIAS, Baths. Statue of Valentinian II (cf. 339). Date: 387-390. Istanbul: Archaeological Museum. Marble. H 1.785 m. Ph. U.D.F.-La Photothèque.

342 Art of Roman Asia Minor. APHRODISIAS, Baths. Statue of a magistrate wearing the chlamys. Early fifth century. Istanbul: Archaeological Museum. Marble. H 1.75 m. Ph. U.D.F.-La Photothèque.

343 Roman art. OSTIA. Statue of a person wearing a toga. About 390-410. Ostia: Museo Ostiense. Marble. H 1.70 m. Ph. U.D.F.-La Photothèque.
It has been suggested that this might be a portrait of Quintus Aurelius Symmachus: senator from 383, died some time after 402, panegyricist and fierce upholder of the Roman (and pagan) cultural tradition, and one of the last men still to wear the toga.

344 Art of Roman Asia Minor. APHRODISIAS, Baths. Statue of a magistrate wearing the chlamys, detail (cf. 342). Early fifth century. Istanbul: Archaeological Museum. Ph. U.D.F.-La Photothèque.

345 Roman art. CONSTANTINOPLE (?). Colossal statue of an emperor (detail). About 370-450. Barletta: public square. Bronze. H of the statue: 5.10 m. H of the ancient part: 3.55 m. Ph. Deutsches archäologisches Institut, Rome.

437

The legs below the tunic, the right arm below the elbow, and the left arm beyond the drapery are not part of the original bronze. The upper part of the head is lost. The piece is referred to, in a document from the reign of Charles of Anjou (1309), as lying in Barletta harbour.

346 Art of Roman Asia Minor. EPHESUS, theatre. Portrait of a man. Mid-fifth century. Vienna: Kunsthistorisches Museum. Marble. H of the head: 0.59 m. H 0.85 m. Ph. V.K.M.

347 Roman art in Constantinople. ISTANBUL. Relief with a Victory. Date: 350–400. Istanbul: Archaeological Museum. Marble. H 2.68 m. max. B 1.50 m. Ph. U.D.F.-La Photothèque.

348 European art of the sixteenth century. The base of Arcadius's Column. 1574. Cambridge: Trinity College Library. Drawing, ink on paper. Ph. T.C.L.
Formerly in D. W. Freshfield's collection, Cambridge.

349 European art of the seventeenth century. Drawing of Arcadius's Column (details). Late seventeenth century. Paris: Bibliothèque Nationale, Cabinet des Estampes. Pen-and-ink sketch on paper. Ph. B.N.
Formerly in Roger de Gaignières' collection, Paris.

350 Pre-Byzantine art of Constantinople. CONSTANTINOPLE. The Iliad, Bk XV (detail): with Apollo's aid the Trojans advance. Early sixth century. Milan: Biblioteca Ambrosiana. Miniature on parchment. Ph. Alinari, Florence.
The Cod.Ambros. F 205 contains a number of miniatures which went with the text of the 'Iliad'. These have been cut out of a codex which came from Byzantium, during the seventeenth century. The miniatures fall into separate groups, each of which looks back to a different model, from a different period. One group, however, reveals a style which predominated in Byzantine circles at the beginning of the sixth century. Miniature no. XLV (of which a detail is here illustrated) belongs to this group (cf. 267).

351 Pre-Byzantine art. ANTIOCH or CONSTANTINOPLE (?). Genesis: The Flood. First half of the sixth century. Vienna: Nationalbibliothek (Cod.Vindob.theol.gr.31, p. 3). Miniature on purple parchment. 0.31 m. × 0.25 m. Ph. V.N.

352 Art of Roman Syria. ANTIOCH. The Judgment of Paris. Second century, Paris; Musée du Louvre. Mosaic. Ph. U.D.F.-La Photothèque.

353 Merovingian art. JOUARRE, Abbey, north crypt. Sarcophagus of Bishop Agilbert: the Last Judgment (detail). About 680. In situ. Local limestone. Ph. U.D.F.-La Photothèque.

354 Byzantine art. SALONIKA, Church of Haghios Georgios. Mosaics in the dome (detail): St Porphyry. About 400. In situ. Mosaic in glass paste. Ph. Hirmer Fotoarchiv, Munich.

355 Art of Roman Asia Minor. MILETUS. Gateway of the agora. Date: 170. Berlin, Staatliche Museen. Marble. Ph. U.D.F.-La Photothèque.

356 Roman art. ROME, Forum Romanum. Arch honouring the Emperor Septimius Severus. Date: 203. In situ. Marble. H 20.88 m. Ph. U.D.F.-La Photothèque.

357 Roman art in Africa. TIMGAD. Gateway at the entrance of the new quarter built under the Severi. Late second century. In situ. Marble. Ph. Marcel Bovis, Paris.
The town of Thamugadi was founded about 100 as a residential base for the Third Legion (Augusta). Trajan's military architects laid down strictly regular plans for it. At the end of the second century the enceinte was breached on the west side. Here, above the main street (decumanus maximus), was erected this monumental gateway, beyond which spread the new quarter of the town (enlarged, though in an unplanned fashion, under the Severi).

358 Roman art. ROME, the Aurelian Wall. Porta S. Sebastiano. Enceinte: 275–300; towers: 401–2. In situ. Brickwork. Ph. U.D.F.-La Photothèque.

359 Roman art. TRÈVES, Basilica. View of the nave. About 310. In situ. Brickwork construction. H 32 m. B 67 m; Depth 27.50 m. Ph. U.D.F.-La Photothèque.
The basilica has undergone a thorough restoration; the ancient walls are standing as far as the roof, which is modern. This edifice, which was used as a law-court, dates from Constantine's reign. It stood between the Baths and the two twin churches: of the latter (built in 326) one became the Cathedral, and the other the Liebfrauenkirche (or Church of Our Lady). The odd feature about this basilica is that it has no internal division.

360 Roman art. ROME, basilica of Maxentius. View of one of the side-aisles. About 307–13. In situ. Bricks and masonry. B of the central nave: about 90 m: Depth about 60 m. Ph. U.D.F.-La Photothèque.

361 Roman art. ROME, Baths of Diocletian. Interior of the frigidarium, detail (cf. 420). 298–306. In situ. Brick and limestone. Ph. U.D.F.-La Photothèque.

362 Roman art. OSTIA. House of Cupid and Psyche (detail). Early fourth century. In situ. Marble and brick. Ph. U.D.F.-La Photothèque.

363 Roman art. ROME, 'Temple of Minerva Medica.' Large domed pavilion in the Gardens of Licinius. About 320. In situ. Bricks and masonry. Interior diameters: 25 m and 23.50 m. Ph. U.D.F.-La Photothèque.

364 Art of Roman Africa. GHIRZA, north necropolis. Tombs. Late third century. In situ. Limestone. Ph. Department of Antiquities, Tripoli.
These tombs (known as A, B, and C) have now been partly removed to the Tripoli Museum. The illustration shows them still in situ, 150 miles south-east of Tripoli, in the Libyan desert. The ancient name of this important military station is unknown.

365 Roman art. ISTANBUL, Hippodrome. Obelisk of Theodosius I (cf. 335, 336). About 390–5. In situ (at Meydani). Base of marble, obelisk of pink granite. Overall H 23.90 m. H of obelisk: 19.65 m. Ph. U.D.F.-La Photothèque.

366 Roman art. ROME, Baths of Alexander Severus. Figured capital. Before 227. The Vatican: Cortile della Pigna. Marble. H 1.245 m. Ph. Archivio fotografico Gallerie e Musei Vaticani.

367 Roman art. AUGST. Statuette of Victory holding up a shield. Late second or early third century. Augst: Roman Museum. Bronze. Ph. Elisabeth Schulz, Basle.

368 Art of Roman Syria. PALMYRA. Magharat-el-Djelideh, south-west necropolis, the so-called 'Tomb of the Three Brothers'. Victory holding up a shield with a portrait. About 159. In situ. Fresco. After C. H. Kraeling, 'Color Photographs of the Painting in the Tomb of the Three Brothers at Palmyra', in Annales archéologiques de Syrie, XI, XII, Damascus, 1961–2, pl. VI.
The illustration shows a detail from

the decoration in the 'Three Brothers' hypogaeum. The walls are covered with whole series of similar portraits, the pattern continuing as here.

369 Art of Roman Egypt. ROME, Mausoleum known as 'Tor Pignattara'. Sarcophagus of Constantine's mother Helena (cf. 424). About 336–50. The Vatican: Museo Pio Clementino. Pink porphyry. H 2.42 m. B 2.68 m. Depth 1.84 m. Ph. De Antonis, Rome.

This sarcophagus formerly stood in the monumental tomb on the Via Labicana. It was used for the burial of Pope Anastasius IV (1153–4) in the forecourt of the Lateran Basilica. Between 1778 and 1787 it was restored and transferred to the Vatican: almost all the heads are modern.

370 Art of Roman Egypt. ROME, S. Costanza. Sarcophagus of Constantine's daughter Constantina (cf. 425). About 360. The Vatican: Museo Pio Clementino. Pink porphyry. H 2.25 m. B 2.33 m. Depth 1.55 m. Ph. De Antonis, Rome.

This sarcophagus originally stood in Constantina's mausoleum on the Via Nomentana, subsequently the Church of S. Costanza. In 1467 it was moved to the Piazzetta S. Marco in Rome near the Palazzo Venezia. Since 1788 it has been in the Vatican. The base is partly restored, but all the rest (apart from the polishing-work) is more or less intact.

371 Roman art. ROME. Medallion of Clodius Albinus (193–7). Between 194 and 195. Paris: Bibliothèque Nationale, Cabinet des Médailles, no. 344 A. Bronze. D 0.040 m. Ph. U.D.F.-La Photothèque.

Albinus was made a Caesar by Septimius Severus, but broke with him in 196, and was defeated near Lyons in February 197. Legend: 'D(ecimus) Clodivs Septimivs Albinvs Caes(ar)'. On the reverse: 'Fortvnae Redvci Co(n)s(ul) II'.

372 Roman art. ROME. Medallion of Septimius Severus (193–211). Struck between December 194 and spring 195. Paris: Bibliothèque Nationale, Cabinet des Médailles, no. 347. Bronze. D 0.046 m. Ph. U.D.F.-La Photothèque.

Born at Leptis Magna in Syrtica, Septimius Severus was acclaimed Emperor at Carnuntum, by his legions, on the death of Pertinax in 193: he died at York in 211. Legend: 'L(ucius) Septimivs Severvs Pertinax Avg(ustus) Imp(erator) IIII'. On the reverse: 'Dis Avspicibvs P(ontifex) M(aximus) Tr(ibunicia) P(otestate) III Co(n)s(ul) II P(ater) P(atriae)'.

373 Roman art. ROME. Medallion of Julia Domna personifying Concord. Between 196 and 211. Berlin: Staatliche Museen, Munzkabinett, Silver, with traces of gilding. D 0.04 m. Ph. S.M.

Julia Domna was born in Syria, and married Septimius Severus about 185. The mother of Caracalla and Geta, she committed suicide in 217 at Antioch. Legend: 'Ivlia Avgusta'. On the reverse: 'Vesta Mater'.

374 Roman art. ROME. Aureus of Caracalla (211–17). Date: 215. Paris: Bibliothèque Nationale, Cabinet des Médailles, no. 1154. Gold. D 0.020 m. Ph. U.D.F.-La Photothèque.

The son of Septimius Severus, his real name was Marcus Aurelius Antoninus, but he became known as Caracalla because of the cloak (caracalla) which he usually wore. Legend: 'Antoninvs Pivs Avg(ustus) Germ(anicus)'. On the reverse: 'P(ontifex) M(aximus) Tr(ibunicia) P(otestate) XVIIII Co(n)s(ul) IIII P(ater) P(atriae)'.

375 Roman art. ROME. Aureus of Elagabalus (218–22). Paris: Bibliothèque Nationale, Cabinet des Médailles, Beistegui Collection, no. 145. Gold. D 0.020 m. Ph. U.D.F.-La Photothèque.

This was Caracalla's cousin, like him named Marcus Aurelius Antoninus: he took the name of the Sun-God El Gabal, to whom he vowed a special personal cult. Legend: 'Imp(erator) Caes(ar) M(arcus) Avr(elius) Antoninvs Avg(ustus)'. On the reverse: 'Victor(ia) Antonini Avg(usti)'.

376 Roman art. ROME. Aureus of Julia Maesa. Paris: Bibliothèque Nationale, Cabinet des Médailles, no. 1231. Gold. D 0.021 m. Ph. U.D.F.-La Photothèque.

The sister of Julia Domna, mother of Julia Soaemias and Julia Mamaea, and grandmother of Elagabalus and Alexander Severus. Legend: 'Ivlia Maesa Avg(usta)'. On the reverse: 'Saecvli Felicitas'.

377 Roman art. ROME. Medallion of Alexander Severus (222–35). Date: 228. Paris: Bibliothèque Nationale, Cabinet des Médailles, no. 397. Bronze. D 0.036 m. Ph. U.D.F.-La Photothèque.

Alexander Severus was adopted and made joint-emperor by his first cousin Elagabalus. Legend: 'Imp(erator) Caes(ar) M(arcus) Avrel(ius) Sev(erus) Alexander Pivs Felix Avg(ustus)'. On the reverse: 'P(ontifex) M(aximus) Tr(ibunicial) P(otestate) VII Co(n)s(ul) II P(ater) P(atriae)'. Alexander Severus offering sacrifice in front of a temple.

378 Roman art. ROME. Sestertius of Maximinus Thrax (235–8). Date: 236. Berlin: Staatliche Museen, Münzkabinett. Bronze. D 0.03 m. Ph. U.D.F.-La Photothèque.

Born in Thrace, and a shepherd in his youth, Maximin afterwards took up a military career, and was proclaimed Emperor by his troops. The Senate opposed him vigorously, and both he and his son Maximus were killed in 238. Legend: 'Imp(erator) Maximinvs Pivs Avg(ustus)'. On the reverse: 'Tr(ibunicia) P(otestate) III Co(n)s(ul) P(ater) P(atriae)'.

379 Roman art. ROME. Sestertius of Pupienus (238). Date: 238. Paris: Bibliothèque Nationale, Cabinet des Médailles, no. 4020. Bronze. D 0.030 m. Ph. U.D.F.-La Photothèque.

Nominated Emperor by the Senate at the same time as Balbinus. Legend: 'Imp(erator) Caes(ar) M(arcus) Clod(ius) Pvpienvs Avg(ustus)'. On the reverse: 'Concordia Avgg (Augustorum) S(enatus) C(onsulto)'. Concord seated on the left.

380 Roman art. ROME. Sestertius of Balbinus (?38). Date: 238. Paris: Bibliothèque Nationale, Cabinet des Médailles, no. 4019. Bronze. D 0.029 m. Ph. U.D.F.-La Photothèque.

Nominated Emperor by the Senate, which did not recognize the Thracian officer Maximin (acclaimed by his troops at Mainz on the death of Alexander Severus). Legend: 'Imp(erator) Caes(ar) D(ecimus) Cael(ius) Balbinvs Avg(ustus). On the reverse: Liberalitas Avgvstorum S(enatus) C(onsulto)'. Balbinus, Pupienus, and Gordian Caesar on a dais, presiding over the distribution of largesse.

381 Roman art. ROME. Medallion of Gordian III (238–44). Date: 238. Berlin: Staatliche Museen, Münzkabinett. Bronze. D 0.0386 m. Ph. S.M.

Imposed as Caesar by the crowd after the designation of Pupienus and Balbinus as Augusti; when they were murdered, the Senate nominated him an Augustus. According to various sources he was either thirteen or sixteen at the time. Legend: 'Imp.Caes M(arcus) Ant(oninus) Gordianvs Avg(ustus)'. Reverse: 'Adlocvtio Avtvsti'.

382 Roman art. ROME. Medallion of Philip the Arab (244–9). Paris: Bibliothèque Nationale, Cabinet des Médailles, no. 88. Silver. D 0.030 m. Ph. U.D.F.-La Photothèque.

Assumed power after the murder of

Gordian III. Legend: 'Imp(erator) Caes(ar) M(arcus) Ivl(ius) Philippvs Avg(ustus)'. On the reverse: 'Aeqvitas Pvblica'.

383 Roman art. ROME. Double sestertius of Decius (249–51). Date: 249–51. Paris: Bibliothèque Nationale, Cabinet des Médailles, no. 459. Bronze. D 0.032 m. Ph. U.D.F.-La Photothèque.
The first emperor of Illyrian origin. Legend: 'Imp(erator) C(aius) M(essius) Q(uintus) Traianvs Decivs Avg(ustus)'. On the reverse: 'Felicitas Saecvli S(enatus) C(onsulto)'.

384 Roman art. ROME. Quinarius of Herennius Etruscus (250–1). Date: 251. Paris: Bibliothèque Nationale, Cabinet des Médailles, no. 1316. Gold. D 0.019 m. Ph. U.D.F.-La Photothèque.
Decius's eldest son. Legend: 'Imp(eratori) C(aio) Q(uinto) Her(ennio) Etr(usco) Mes(sio) Decio Avg)usto)'. On the reverse: 'Princ(ipi) Ivvent(utis)'. Representation of Apollo holding a branch.

385 Roman art. ROME. Aureus of Hostilianus (250–1). Date: 251. Paris: Bibliothèque Nationale, Cabinet des Médailles, no. 1319. Gold. D 0.020 m. Ph. U.D.F.-La Photothèque.
Decius's second son, taken as joint-emperor by Trebonianus Gallus, after the death of Decius. Legend: 'C(aius) Valens Hostil(ianus) Mes(sius) Qvintvs N(obilissimus) C(aesar)'. On the reverse: 'Principi Ivventvtis'. Hostilianus in military uniform, holding a spear and an ensign.

386 Roman art. ROME. Aureus of Trebonianus Gallus (251–3). Paris: Bibliothèque Nationale, Cabinet des Médailles no. 1320. Gold. D 0.019 m. Ph. U.D.F.-La Photothèque.
Had himself proclaimed Emperor after the defeat and death of Decius in the Dobrudja. Legend: 'Imp(erator) Cae(sar) Vib(ius) Treb(onianus) Gallvs Avg(ustus)'. On the reverse: 'Adventvs Avgg' for Augustorum. Representation of the Emperor making his entry into the City.

387 Roman art. ROME. Medallion of Valerian (253–60). Paris: Bibliothèque Nationale, Cabinet des Médailles, no. 94. Silver. D 0.033 m. Ph. U.D.F.-La Photothèque.
Valerian was defeated in the East by Shapur I, and ended his days in captivity. Legend: 'Imp(erator) C(aesar) P(ublius) Lic(inius) Valerianvs P(ius) F(elix) Avg(ustus)'. On the reverse: 'Moneta Avg(usta)'.

388 Roman art. ROME. Medallion of Gallienus (253–68). Struck during the joint reign of Gallienus and Valerian (253–9). Paris: Bibliothèque Nationale, Cabinet des Médailles, no. 490. Bronze. D 0.040 m. Ph. U.D.F.-La Photothèque.
Gallienus, Valerian's son, at first exercised power, as Augustus, conjointly with his father, and then (after Valerian's capture by Shapur I) alone. Legend: 'Imp(erator) Gallienvs P(ius) F(elix) Avg(ustus) Germ(anicus)'. On the reverse: 'Adlocvtio Avgg' for Augustorum.

389 Roman art. COLOGNE. Aureus of Postumus (259–68). Date: 264. Paris: Bibliothèque Nationale, Cabinet des Médailles, no. 1406. Gold. D 0.020 m. Ph. U.D.F.-La Photothèque.
Charged with the defence of the Rhine frontier, Postumus usurped power, and founded the Gallic Empire, at a time when Gallienus was under attack on all the Imperial frontiers. Legend: 'Postvmvs Pivs Avg(ustus)'. On the reverse: 'P(ontifex) M(aximus) Tr(ibunicia) P(otestate) VI Co(n)s(ul) III P(ater) P(atriae)'.

390 Roman art. ROME. Aureus of Claudius II Gothicus (268–70). Paris: Bibliothèque Nationale, Cabinet des Médailles, no. 1462. Gold. D 0.021 m. Ph. U.D.F.-La Photothèque.
An Illyrian officer, proclaimed Emperor by the army which took the field against Aureolus, at Milan, after the assassination of Gallienus. Legend: 'Imp(erator) Clavdivs Avg(ustus)'. On the reverse: 'Victoria Avg(usta)'. A Victory holding a crown and a palm, with two captives at her feet.

391 Roman art. ROME. Aureus of Aurelian (270–5). Struck after the monetary reform of 274. Paris: Bibliothèque Nationale, Cabinet des Médailles, no. 1468. Gold. D 0.022 m. Ph. U.D.F.-La Photothèque.
A native of Upper Pannonia, Aurelian was proclaimed Emperor by his troops at Sirmium, where Claudius Gothicus had died of the plague. Legend: 'Imp(erator) C(aesar) Avrelianvs Avgvstvs'. On the reverse: 'Oriens Avg(ustus)'. The Sun holding a globe, with two captives at his feet.

392 Roman art. ROME. Medallion of Probus (276–82). Paris: Bibliothèque Nationale, Cabinet des Médailles, no. 540. Bronze. D 0.039 m. Ph. U.D.F.-La Photothèque.
A native of Sirmium, Probus was proclaimed Emperor by the legions of

Egypt after the death of Tacitus. Legend: 'Imp(erator) Probvs P(ius) Avg(ustus)'. On the reverse: 'Moneta Avgvsta'. The three types of money: gold, silver, and bronze.

393 Roman art. ROME. Aureus of Carinus (283–5). Date: 283. Paris: Bibliothèque Nationale, Cabinet des Médailles, no. 161. Gold. D 0.020 m. Ph. U.D.F.-La Photothèque.
Son of Carus, the Prefect of the Praetorians, he was proclaimed Emperor by the army in Rhaetia after Probus's murder at Sirmium. Legend: 'M(arcus) Avr(elius) Carinvs Nob(ilissimus) Cae(sar)'. On the reverse: 'Pax Aeterna'.

394 Roman art. ROME. Aureus of Diocletian (284–305). Struck before the reform of 294. Paris: Bibliothèque Nationale, Cabinet des Médailles, Beistegui Collection, no. 168. Gold. D 0.020 m. Ph. U.D.F.-La Photothèque.
Proclaimed Emperor at Nicomedia, after the death of Numerianus, Diocletian subsequently originated the scheme of a Tetrarchy, in which the power was shared between two Augusti, assisted by two Caesars. He took the title of Jovius. Legend: 'Diocletianvs P(ius) F(elix) Avg(ustus)'. On the reverse: 'Iovi Conservatori'.

395 Roman art. TRÈVES. Aureus of Maximianus Hercules (286–305). Date: 293-4. Paris: Bibliothèque Nationale, Cabinet des Médailles, Beistegui Collection, no. 172. Gold. D 0.019 m. Ph. U.D.F.-La Photothèque.
Co-opted as an Imperial ruler by Diocletian, first as a Caesar (286), and then, the following year, as an Augustus. Diocletian bestowed on him the title of 'Herculius': thus both of them became fictitiously attached to a dynasty descended from Jupiter and Hercules. Legend: 'Maximianvs P(ius) F(elix) Avg(ustus)'. On the reverse: 'Hercvli Debellat(ori)'.

396 Roman art. TRÈVES. Medallion of Constantius Chlorus, multiple of 4 aurei. Date: 305. Paris: Bibliothèque Nationale, Cabinet des Médailles, Beistegui Collection, no. 230. Gold. D 0.041 m. Ph. U.D.F.-La Photothèque.
Adopted as a Caesar by Maximianus Herculius. Legend: 'Imp(erator) Constantivs Pivs Felix Avg(ustus)'. On the reverse: 'Temporvm Felicitas'. The Tetrarchs, Constantius Chlorus, Galerius, Severus and Maximin offering sacrifice before a temple. On the exergue: 'PTR (Percussum Treveris)'. This medallion was struck to celebrate the establishment of the Second Tetrarchy.

397 Roman Art. NICOMEDIA. Aureus of Galerius (295-May 311). Date: 294. Paris: Bibliothèque Nationale, Cabinet des Médailles, no. 1648. Gold. D 0.020 m. Ph. U.D.F.-La Photothèque.
A native of Dacia, Galerius (Caius Gelerius Valerius Maximianus) was adopted as Caesar by Diocletian, whose daughter Galeria Valeria he married; he died in May 311, shortly after issuing an Edict of Toleration in regard of the Christians. Legend: 'Maximianvs Nob(ilissimus) Caes(ar)'. On the reverse: 'Iovi Conservatori, Jupiter'.

398 Art of Roman Egypt. ALEXANDRIA. Aureus of Maximin Daia, 305-13 (cf. frontispiece). 311-13. Paris: Bibliothèque Nationale, Cabinet des Médailles, Beistegui Collection, no. 197. Ph. U.D.F.-La Photothèque.
The son of one of Galerius's sisters, Maximin Daia was made a Caesar by Galerius in 305, and an Augustus in 309. He was opposed by Licinius, who inflicted a defeat on him in Thrace. Legend: 'Maximinvs P(ius) F(elix) Avg(ustus)'.

399 Roman art. ROME. Argenteus of Maxentius (306-12). Date: 307-11. Paris: Bibliothèque Nationale, Cabinet des Médailles, no 2507. Silver. D 0.021 m. Ph. U.D.F.-La Photothèque.
Maxentius, son of Maximianus Herculius, assumed power in Rome on 25 July 306, and was defeated by Constantine at the Milvian Bridge on 28 October 312. Legend: 'Maxentivs P(ius) F(elix) Avg(ustus)'. On the reverse: 'Temporvm Felicitas Avg(usti) N(ostri)'.

400 Roman art. ANTIOCH. Aureus of Licinius (308-24). Date: 311-13. Paris: Bibliothèque Nationale, Cabinet des Médailles, Beistegui Collection, no. 180. Gold. D 0.020 m. Ph. U.D.F.-La Photothèque.
A companion-in-arms of Galerius, Licinius became his fellow-Augustus as a result of the Carnuntum Conference. Legend: 'Licinivs P(ius) F(elix) Avg(ustus)'. On the reverse: 'Consvl P(ater) P(atriae) Proconsvl'. Licinius in consular attire.

401 Roman art. ROME. Solidus of Constantine (306-37). Date: 335. Paris: Bibliothèque Nationale, Cabinet des Médailles, Beistegui Collection, no. 185. Gold. D 0.012 m. Ph. U.D.F.-La Photothèque.
Son of Constantius Chlorus and Helena. Legend: 'Constantinvs Max(imus) Avg(ustus)'. On the reverse: 'Victoria Constantini Avg(usti)'. A Vic-

tory holding a shield on which is inscribed: 'VOT(a) XXX'.

402 Roman art. PAVIA (Ticinum). Aureus of Fausta (executed in 326). Date: 324-5. Paris: Bibliothèque Nationale, Cabinet des Médailles, Beistegui Collection, no. 186. Gold. D 0.019 m. Ph. U.D.F.-La Photothèque.
Daughter of Maximianus Herculius, and wife to Constantine. Legend: 'Flav(ia) Max(ima) Favsta Avg(usta)'. On the reverse: 'Salvs Reipvblicae'.

403 Roman art. PAVIA (Ticinum). Medallion of Helena. Date: 324-5. Paris: Bibliothèque Nationale, Cabinet des Médailles, no. 18. Gold. D 0.037 m. Ph. U.D.F.-La Photothèque.
Wife of Constantius Chlorus, and mother of Constantine. Legend: 'Fl(avia) Helena Avgvsta'. On the reverse: 'Secvritas Reipvblicae'.

404 Roman art. ANTIOCH. Solidus of Constans (337-50). Paris: Bibliothèque Nationale, Cabinet des Médailles, Beistegui Collection, no. 192. Gold. D 0.022 m. Ph. U.D.F.-La Photothèque.
Son of Constantine. Legend: 'Constans Avg(ustus)'. On the reverse: 'Victoria Avgvstorvm'. A Victory holding a shield on which is inscribed: 'Vot(a) XXX'.

405 Roman art. ANTIOCH. Solidus of Constantius II (337-61). Paris: Bibliothèque Nationale, Cabinet des Médailles, Beistegui Collection, no. 194. Gold. D 0.022 m. Ph. U.D.F.-La Photothèque.
Son of Constantine. Legend: 'Fl(avius) Ivl(ius) Constantivs Avg(ustus) Perp(etuus)'. On the reverse: 'Gloria Reipvblicae'.

406 Roman art. NICOMEDIA. Solidus of Constantius Gallus (351-64). Paris: Bibliothèque Nationale, Cabinet des Médailles, Beistegui Collection, no. 200. Gold. D 0.022 m. Ph. U.D.F.-La Photothèque.
Son of Julius Constantius, Constantine's first cousin. Legend: 'D(ominus) N(oster) Fl(avius) Cl(audius) Constantivs Nob(ilissimus) Caes(ar)'. On coins the effigy of Constantius Gallus always appears without crown or diadem. On the reverse: 'Gloria Reipvblicae'.

407 Roman art. ANTIOCH. Solidus of Julian the Apostate (361-3). Paris: Bibliothèque Nationale, Cabinet des Médailles, no. 1843. Gold. D 0.022 m. Ph. U.D.F.-La Photothèque
Julian was Constantius Gallus's half-

brother, son of Julius Constantius, and first cousin to Constantine. Legend: 'Fl(avius) Cl(audius) Ivlianvs P(ius) F(elix) Avg(ustus)'. On the reverse: 'Virtvs Exercitvs Romanorvm'.

408 Roman art. THESSALONIKA. Medallion of Valentinian I (364-75). Multiple of three miliarensia. Date: 364-7. Paris: Bibliothèque Nationale, Cabinet des Médailles, no. 196 A. Silver. D. 0.039 m. Ph. U.D.F.-La Photothèque.
Legend: 'D(ominus) N(oster) Valentinianvs P(ius) F(elix) Avg(ustus)'. On the reverse: 'Virtvs Romani Exercitvs'. The Emperor holding the labarum surmounted by the chrism.

409 Roman art. ARLES. Miliarensis of Valens (364-78). Date: 364-7. Paris: Bibliothèque Nationale, Cabinet des Médailles, no. 201. Silver. D 0.025 m. Ph. U.D.F.-La Photothèque.
Legend: 'D(ominus) N(oster) Valens P(ius) F(elix) Avg(ustus)'. On the reverse: 'Salvs Reipvblicae'. Four ensigns.

410 Roman art. TRÈVES. Medallion of Gratian (367-83). Date: 375-8. Paris: Bibliothèque Nationale, Cabinet des Médailles, no. 53. Gold. D 0.028 m. Ph. U.D.F.-La Photothèque.
Legend: 'D(ominus) N(oster) Gratianvs P(ius) F(elix) Avg(ustus)'. On the reverse: 'Gloria Romanorvm.' Rome (with helmet) and Constantinople (turreted) sitting on a throne.

411 Roman art. SIRMIUM Solidus of Theodosius I (379-95). Date: 393-5. Paris: Bibliothèque Nationale, Cabinet des Médailles, Beistegui Collection, no. 208. Gold. D 0.020 m. Ph. U.D.F.-La Photothèque.
Legend: 'D(ominus) N(oster) Theodosivs P(ius) F(elix) Avg(ustus)'. On the reverse: 'Victoria Avgggs': Auggg, indicating the three Augusti; S, for Officina Secunda.

412 Roman art. LYONS. Solidus of Eugenius (392-4). Date: 392-5. Paris: Bibliothèque Nationale, Cabinet des Médailles, no. 2006. Gold. D 0.021 m. Ph. U.D.F.-La Photothèque.
Legend: 'D(ominus) N(oster) Evgenivs P(ius) F(elix) Avg(ustus)'. On the reverse: 'Victoria Avgg' (Augustorum).

413 Roman art. CONSTANTINOPLE. Solidus of Valentinian II (375-92). Date: 383-8. Paris: Bibliothèque Nationale, Cabinet des Médailles, no. 1971. Gold. D 0.021 m. Ph. U.D.F.-La Photothèque.

Legend: 'D(ominus) N(oster) Valentinianvs P(ius) F(elix) Avg(ustus)'. On the reverse: 'Concordia Avggg' for Augustorum indicating the three Augusti.

414 Roman art. ROME. Multiple of three miliarensia of Honorius (393–423). Date: 403. Paris: Bibliothèque Nationale, Cabinet des Médailles, no. 221. Silver. D 0.035 m. Ph. U.D.F.-La Photothèque.

Legend: 'D(ominus) N(oster) Honorivs P(ius) F(elix) Avg(ustus)'. Reverse struck at the Senate's request in 403, in celebration of the victory over Alaric.

415 Roman art. MILAN. Solidus of Arcadius (383–408). Date: 394–5. Paris: Bibliothèque Nationale, Cabinet des Médailles, no. a. f. 15. Gold. D 0.021 m. Ph. U.D.F.-La Photothèque.

Legend: 'D(ominus) N(oster) Arcadivs P(ius) F(elix) Avg(ustus)'. On the reverse: 'Victoria Avggg' indicating the three Augusti.

416 Art of Roman Asia Minor. EPHESUS. Library-mausoleum of Celsus. Reconstruction (after W. Wilberg) of the façade (cf. 417). About 115–50. (After *Forschungen in Ephesos*, V, 1, Vienna, 1953, pl. II.)

417 Art of Roman Asia Minor. EPHESUS. Library-mausoleum of Celsus. Ground-plan. About 115–50. (After *Forschungen in Ephesos*, V, 1, Wien, 1953, p. 3, fig. 3.)

Built by Tiberius Julius Aquila, consul in 110, as a Heroön to commemorate his father, who had been proconsul of Asia about 106 and died about 115. In the crypt beneath the library we have the sepulchral chamber, with the sarcophagus of Celsus Polemaeanus, and an inscription in Greek and Latin. The sarcophagus is the type with garlands, supported by small figurines; the lid is gabled. (Cf. 416.)

418 Art of Roman Asia Minor. EPHESUS. The so-called 'Arcadian' Street of Columns. Reconstruction. (After *Forschungen in Ephesos*, I, Vienna, 1906, p. 132, fig. 59.)

This street was 11 m. broad, paved with marble slabs, and flanked by porticoes (width 5 m.). It ran for a distance of approximately 550 m., from a double arch near the theatre to the maritime port, where it terminated in a splendid gateway. This gateway, dating from

Hellenistic times, was at a lower level than the road-surface of the Roman period. Nevertheless, the general plan must have been Hellenistic in origin. For the type of column-plinth, with niche and statue, see 321.

419 Roman art of Tripolitania. LEPTIS MAGNA. Forum and Basilica of the Severi. Ground-plan. 210–16. (After R. Bianchi Bandinelli, G. Caputo, and E. Vergara Caffarelli, *Leptis Magna*, Milan, Mondadori, 1964.)

420 Roman art. ROME. Baths of Diocletian. Ground-plan of the central section (cf. 361). Date: 298–306. (After the *Enciclopedia dell'arte antica classica e orientale*, VI, Rome, Istituto della Enciclopedia italiana, 1965, p. 869, fig. 983.)

421 Roman art. SPLIT. Palace of Diocletian. Ground-plan (cf. 121). Early fourth century. (After Theodor Kraus, *Das Römische Weltreich*, 'Propyläen Kunstgeschichte', II, Berlin, Propyläen Verlag, 1967, p. 194, fig. 34.)

422 Roman art. SALONIKA. Mausoleum of Galerius. Reconstructed ground-plan (cf. 280). Date: 297–305. (After Theodor Kraus, *Das Römische Weltreich*, 'Propyläen Kunstgeschichte', II, Berlin, Propyläen Verlag, 1967, p. 197, fig. 39.)

423 Roman art. PIAZZA ARMERINA. Roman villa. Ground-plan. (After the *Enciclopedia dell'arte antica classica e orientale*, VI, Rome, Istituto della Enciclopedia italiana, 1965, fig. 160.)

List of mosaics according to the numbers on the plan: 1. Reception scene (adventus). 2. Lady with two children and two servants. 3. Large composition: circus-races. 4. Central marine composition: in the apses, persons dressing. 5. Massage after the bath. 6. Torch-races. 7. Medallions with animal heads (cf. 224, 225). 8. Dancers. 9. Amorini fishing. 10. The Seasons. 11. The Little Hunt (cf. 199). 12. Ten young girls in 'bikinis'. 13. Orpheus. 14. The Great Hunt (cf. 226). 15. Odysseus and Polyphemus. 16. Erotic scene. 17. Amorini fishing. 18. Marine scene: Arion. 19. Contest between Pan and Eros, with spectators. 20. Children hunting (cf. 227). 21. Children on chariots drawn by birds (the 'Little Circus'). 22. Musicians, actors, women plaiting garlands. 23. Mosaics with geometrical patterns. 24. Amorini as vintagers.

25. Amorini at the wine-press. 26-27. Amorini fishing. 28. Triumphs and exploits of Hercules; the myth of Lycurgus (cf. 229). 29. Small latrine.

424 Roman art. ROME. 'Tor Pignattara'. Mausoleum and basilica of Helena. Reconstruction and ground-plan (cf. 369). First quarter of fourth century. (After Theodor Kraus, *Das Römische Weltreich*, 'Propyläen Kunstgeschichte', II, Berlin, Propyläen Verlag, 1967, p. 198, fig. 40.)

425 Roman art. ROME. Mausoleum of Constantina, daughter of Constantine (S. Costanza). Ground-plan (cf. 370). Date: 337–354. (After Theodor Kraus, *Das römische Weltreich*, 'Propyläen Kunstgeschichte', II, Berlin, Propyläen Verlag, 1967, p. 198, fig. 40.)

426 Map of the Roman Empire at the death of Theodosius I (395) and according to the 'Notitia Dignitatum'. (After A. H. M. Jones, *The Later Roman Empire 284–602*, Oxford, Blackwell, 1964, map II, and R. Rémondon, *La Crise de l'empire romain*, 'Nouvelle Clio', Paris, P.U.F., 1964, map 4.)

The 'Notitia Dignitatum', of which we possess five manuscripts (fifteenth and sixteenth century) was printed for the first time at Basle, in 1552, from a sixth MS now lost. It is a list of all official posts, both civil and military, which comprised the administration of the Roman Empire, following the prefectorial divisions laid down by Diocletian. The text would appear to have been composed about 390, and to have had additions inserted up to about the year 425. It is illustrated with drawings which supplement the material presented in the text.

427 Plan of Rome at the time of Constantine.

428 Plan of the Christian churches and mausoleums founded in Rome by Constantine. (After A. Grabar, *The Beginnings of Christian Art*, 200–395, 'The Arts of Mankind', London, Thames and Hudson, 1967, and under the title *Early Christian Art*, New York, Odyssey, 1968, fig. 311.)

429 Plan of Constantinople. (After the *Enciclopedia dell'arte antica classica e orientale*, II, Rome, Istituto della Enciclopedia italiana, 1959.)

The entries for coins and medallions from the Bibliothèque Nationale, Paris, were compiled by Claude Brenot

Glossary - Index

ABOUKIR. *Pl. 254.*

ACHAEA. 110.

ACHILLES. Hero of Greek legend, from Thessaly; one of the protagonists in Homer's *Iliad*, 231; *pl. 39, 212.*

ACILIA. Italian village nine miles southwest of Rome, on the road to Ostia, 59; *pl. 55.*

ACTIUM. 32.

ADAM. 35; *pl. 30.*

ADAMKLISSI or ADAMCLISI. Locality in the Dobrudja (Rumania), 36 miles south-west of Constantza. Here there stand the ruins of a monument put up about 109 in memory of Trajan's victories over the Dacians and other tribes: 311–314, 317; *pl. 290–297; map 426.*

AENEAS. Hero known from the Homeric poems, the son of Aphrodite; in later legend he abandons Troy, and brings his ships to Carthage, ruled over by Dido. Dido is said to have committed suicide when Aeneas abandoned her and led his fleet on to Latium, thus – according to Virgil's version of the legend, in the *Aeneid* – becoming the mythical ancestor of the Romans: 211; *pl. 198.*

AGILBERT, Saint (*c.* 680–90). Born in Paris, Bishop first of Wessex and then of Paris (*c.* 667–*c.* 675); died at Jouarre: *pl. 353.*

AGRIGENTO. Italian town (southern Sicily), ancient Greek foundation, colonized by Gela (583–582 BC): 302.

AGRIPPA (Marcus Vipsanius Agrippa), 62–12 BC. General, admiral, and friend of the Emperor Augustus, whose only daughter Julia he married: 142.

AGRIPPINA the Elder (14 BC–AD 33). Her title was given her to distinguish her from Agrippina the Younger, her daughter. She was the child of M. Vipsanius Agrippa, general and admiral, and Julia, Augustus's daughter. She

became the wife of Germanicus, and was sent into exile by Tiberius, where she died: 114.

AIX-EN-PROVENCE. Town in the South of France (Bouches-du-Rhône), formerly an *oppidum* of the Gaulish Salyes, then a Latin *colonia*, under the name of *Aquae Sextiae*, and during the Late Empire capital of the province Gallia Narbonensis II: 11, 139.

AIX-LA-CHAPELLE (AACHEN). Town of West Germany (Rhineland-Westphalia), formerly Aquae Grani, the residence of the Carolingian emperors: 178.

ALAMANNI. A Germanic tribe, first mentioned in 213, when Caracalla fought them on the Main; in 260 they breached the Roman frontier on the Danube, occupying the territory of what is now Bavaria; in 450, they crossed the Rhine, penetrating as far as Alsace and the Meuse region. Their name probably indicates a combination of several Suevian tribes: 106, 175, 183.

ALBA JULIA. Town in Rumania, on the site of ancient *Apulum*, situated on the right bank of the Murech (Regional Historical Museum): 127, 132, 134; *pl. 114, 123.*

ALCESTIS. In Greek legend, wife of King Admetus, whom Apollo allowed to escape death on condition that some other person volunteered to die in his place. Since no one else was willing to do so, not even the King's aged parents, his wife sacrificed herself; but Heracles brought her back from the nether regions. Subject of *Alcestis*, a tragedy by Euripides: 46; *pl. 41, 318.*

ALEXANDER THE GREAT (356–323 BC). King of Macedonia (336–323). He conquered the Persian Empire (which also included Egypt). It was with this conquest that the 'Hellenistic' period began: 1, 27, 350.

ALEXANDER SEVERUS (Marcus Aurelius Severus Alexander), 208–35. Nominated Emperor in 222, assassinated by

the troops in 235, together with his mother, Julia Mamaea, who had been the real power behind the throne: 6, 41; *pl. 366, 377.*

ALEXANDRIA. Town of Egypt, capital of Lower Egypt, on the Mediterranean: 93, 129, 208, 215, 223, 262, 263, 267, 277, 281, 291, 292, 294, 328, 334, 373, 374; *frontispiece, pl. 255, 257, 268; map 426.*

ALFOLDI (Andreas). American archaeologist and historian (b. 1894); of Hungarian origin: 130, 177.

ALGERIA. In antiquity, this part of North Africa largely corresponded to ancient Numidia, with a population composed of Numidians, Moors, and Gaetulians; after 46 BC it became a Roman province (Mauretania Caesariensis and Mauretania Sitifensis): 35, 102, 211, 215, 248, 267.

ALLECTUS. Usurper of imperial power in Great Britain from 293 to 296, after murdering Carausius, whose Praetorian Prefect he was: 197.

ALLOBROGES. Gaulish tribe from the northern part of Gallia Narbonensis (Dauphiné and Savoie): 139.

ALMENDRALEJO. Small Spanish town 60 miles south of Cáceres: 357.

AMAZONS. 184, 297; *pl. 110, 182, 277–278.*

AMITERNUM. Roman *municipium* in Sabine territory, now San Vittorino, near Aquileia, in the Abruzzi: 111.

AMMONIUS. *Pl. 265.*

AMPHITRITE. In Greek mythology, a Nereid who married Poseidon (Neptune), the God of the Sea: 226; *pl. 1.*

AMPURIAS. Spanish town (Catalonia), near La Escala. Greek colony, founded about 580 BC by Phocaeans: ruins still visible on the Gulf of Rosas. Known in antiquity as Emporiae, it eventually became a Roman *colonia*, probably under Julius Caesar: *pl. 179–181.*

ANDALUSIA. Region of Southern Spain, on the Atlantic and Mediterranean seaboard; occupied by the Romans in the third century BC, and made a province by Augustus, with the name of Baetica: 183.

ANDREAE (Bernhard). Contemporary German archaeologist: 46, 60.

ANDROMEDA. 169; *pl. 161.*

ANTEFIX. Ornament fixed on the edge of the cornice to mask the ends of rows of hollow tiles: 12.

ANTINOE. Town of ancient Egypt, on the right bank of the Nile, founded by Hadrian (130–1) in honour of his favourite Antinoüs (whence the Greek name, Antinoopolis), today Shekh Abadeh: 50; *pl. 45, 228, 265.*

ANTIOCH (ANTAKYA). City of ancient Syria, founded by Seleucus I in 300 BC, and known as Antioch-on-the-Orontes or Epidaphné, from the name of its magnificent suburb; cosmopolitan centre, and capital of the province of Syria under the Romans. It continued to flourish, in increased splendour, down to the time of the Late Empire; then in 526 it was devastated by an earthquake, and in 540 it succumbed to the Persian invasion. Though Justinian recaptured it, it never recovered its former importance in antiquity: 14, 100, 208, 229, 281, 292, 334–336, 349; *pl. 314–317, 351, 352; map 436.*

ANTONINUS PIUS (Titus Aelius Hadrianus Antoninus Pius), 86–161. Roman Emperor (138–61) adopted by Hadrian. His family was from Gallia Narbonensis. Founder of the Antonine dynasty: 7, 8, 169, 197, 199, 205; *pl. 193–195.*

ANTONINES (The). 5, 41, 205, 339, 374.

ANTONY (Marcus Antonius, known as Mark Antony), 82–30 BC. In 42 BC, together with Octavian (the future Augustus) and Lepidus, he formed an alliance which is known as the Second Triumvirate; its object was to hunt down Julius Caesar's murderers, and to win power by conquest: 142.

ANUBIS. Egyptian god, regarded as the great funerary deity and patron of embalmers. Represented in the form of a jackal. His most famous temple was at Cynopolis in Middle Egypt: 283; *pl. 259.*

AOSTA. Town of Northern Italy, in the region of the same name, formerly part of the territory occupied by the Salassian Gauls; from 25 BC on, a Roman colony, under the name of Augusta Praetoria: 123.

APAMEA. City of ancient Syria, on the Orontes; founded by the Seleucid dynasty towards the end of the fourth century BC, and destroyed in AD 540 by Chosroes I: 258, 350; *map 426.*

APHRODISIAS. Ancient city of Asia Minor, on the Phrygian-Carian border; its ruins lie near modern Gierah, in Turkey (American excavation in progress): 268, 319, 344, 347, 357, 360, 363, 375; *pl. 324, 339, 341, 342, 344; map 426.*

APOLLO. 73, 158, 250, 350; *pl. 148, 232.*

APOSTLES. Disciples of Jesus Christ, twelve in number, who afterwards propagated His teachings: 63, 250, 305, 350, 352, 377.

AQUILEIA. Town of Northern Italy (Friuli); Latin *colonia* from 181 BC. Under the Late Empire it became an imperial residence and a winter base for the legions; in the fourth century it was made the centre of an ecclesiastical diocese: 11, 12, 107, 110–115, 123, 127, 175, 178, 199, 228, 234, 306; *pl. 11, 16, 27, 96, 98–100, 103–108, 216; map 426.*

AQUITAINE. Region of south-west France between the Pyrenees and the Atlantic, formerly inhabited by Iberian and Celtic tribes (Bituriges); from 16 or 13 BC a Roman province; divided by Diocletian into two provinces, Aquitania and Novempopulania; in 418 occupied by the Visigoths: 157, 158.

ARCADIUS (Flavius Arcadius), c. 377–408. Roman Emperor (17 January 395–1 May 408). Son of Theodosius I; allotted the Eastern half of the Empire: 38, 352, 356–358, 360, 363–365, 367, 373; *pl. 340, 348, 349, 415.*

ARGOS. City of ancient Greece, on the east coast of the Peloponnese: 328, 329; *pl. 313.*

ARIADNE. In Greek legend, daughter of Minos, King of Crete, by Pasiphaë. She helped Theseus to escape from the Labyrinth, and fled with him; however, he abandoned her on Naxos while she was asleep. She was awoken by Dionysus, and became his bride: 50, 193, 229, 233, 336; *pl. 37, 44, 186, 315.*

ARLES. Town in the South of France (Bouches-du-Rhône); a Roman *colonia* from 46 BC (Musée lapidaire païen): 175; *pl. 139.*

ARLON. Town in southern Belgium, ancient Orolaunum, on the trade-route between Trèves and Reims; destroyed in 451 by the Huns: 158.

ARMENIA. Territory to the north of Mesopotamia, seat of an ancient culture; subjugated by Rome in 69 BC, and a bone of contention between Rome and Parthia from the mid-second century onwards. Between the fourth and the tenth century it developed its own religious architecture: the oldest surviving examples of this are the cathedrals of Dvin and Echmiazin, and the churches of Kasakh and Diraklar. Armenia today is divided between Turkey (which holds four-fifths of it) and the Soviet Union: 306, 334.

ARMINIUS (18 BC–AD 19). Chief of a Germanic tribe, who became a Roman *eques*; he took part in the revolt of Pannonia (AD 6–9), organizing armed resistance against the Romans, on whom he inflicted a crushing defeat in the Teutoburg Forest, destroying three legions and halting Roman expansion beyond the Rhine: 105.

ARNOBIUS the Elder (d. 327). Christian apologist (early third century onwards); based on Sicca Veneria (Le Kef) in Africa Proconsularis: 215.

ARTEMIS. *Pl. 118.*

ARVERNI. An ancient Celtic people dwelling in what is now the Auvergne region (capital Gergovia); by the second century BC they had unified a large part of Gaul, and under their leader Vercingetorix (q.v.) put up the strongest resistance against Romanization: 139.

ASCANIUS. Son of Aeneas and Creusa; said to have founded Alba Longa: 211.

ASTARTE. Phoenician goddess of Fecundity and Voluptuousness. Identified by the Greeks with Aphrodite: 271.

ATESTINE (civilization). Name given to the culture of the Veneto-Illyrian tribes of the first Iron Age (early first millennium BC), whose territory centred on the modern town of Este (northern Italy, near the Adriatic coast): 110.

ATHANASIUS (295–373). Patriarch of Alexandria (Egypt) in 328, and the fiercest opponent of Arianism at the Council of Nicaea (325): 215.

ATHENS. Capital of Greece, and the most famous centre of art and culture

of the classical era: 42, 208, 297, 344; *pl. 275, 276, 279; map 426.*

ATHRIBIS. Ancient city of Egypt, near Benha, 30 miles north-east of Cairo: 282; *pl. 258.*

AU. Small town in Austria (Vorarlberg), 51 miles from Feldkirch: *pl. 116.*

AUGST. Swiss village 7 miles east of Basle, in antiquity Augusta Raurica: *pl. 367.*

AUGUSTUS (Caius Iulius Caesar Octavianus Augustus), 63 BC–AD 14. The first of the Roman emperors: his reign began in 27 BC: 77, 93, 114, 142, 145, 178, 183, 197, 216, 252, 263, 284, 374.

AUGUSTINE, Saint (Aurelius Augustinus), 354–430. Christian writer and Doctor of the Church; born at Tagaste in Numidia, afterwards Bishop of Hippo Regius: 215.

AURELIAN, Lucius Domitius Aurelianus (214–75). Roman Emperor (270–5); re-established the unity of the Empire by driving the Gauls back from Pannonia and the Alamanni out of Italy, but was forced to abandon Dacia. He safeguarded Rome by building a new city-wall, nearly 12 miles long, which still survives: 14, 334; *pl. 358, 391.*

AURELIUS AURELIANUS. 129.

AURELIUS JANUARIUS. 134; *pl. 124.*

AUSONIUS, Decimus Magnus Ausonius (310–93). Latin poet and professor of rhetoric at Bordeaux; summoned to the Imperial Court at Trèves as tutor for the future Emperor Gratian (359–83): 175.

AUTUN. Town in France (Saône-et-Loire), known as Augustodunum during the Roman occupation, and taken over in 420 by the Burgundians: 157.

AVENCHES. Town in Switzerland (Vaud), south of Lake Morat: the Aventicum of antiquity (Roman Museum): 169; *pl. 163.*

AXIOCHUS. Dialogue falsely attributed to Plato, and in fact datable to the first century BC: 48.

BAAL HAMMON. Divinity worshipped at Carthage as the God of Fertility; the Romans confused him with an African deity, Jupiter Ammon. He was represented as a bearded old man with ram's horns: 216.

BABYLON. Important city of ancient Mesopotamia; its ruins are near the modern village of Hilla. In 331 BC it was captured by Alexander of Macedon, and completely devastated by the Parthians in 126–5 BC: 65.

BACCHUS. *See* DIONYSUS.

BAD DEUTSCH ALTENBURG. Town in Austria, 27 miles east of Vienna. Its museum houses the antiquities from ancient Carnuntum, on the right bank of the Danube, which served as a base for the Roman legions of Upper Pannonia (Museum Carnuntium): 134; *pl. 125.*

BALBINUS (Decimus Caelius Calvinus Balbinus), 178–238. Roman Emperor, May–July 238; nominated by the Senate, murdered by the Praetorians: 23, 60; *pl. 19, 380.*

BANQUET, FUNERAL. Typology of certain funerary reliefs, in which the deceased is represented in 'heroic' guise, reclining on a couch beside which food is set, and attended by mortals (members of the family) who are serving him: 65, 129, 192, 306; *pl. 13, 61, 285.*

BAR-LE-DUC. Town in northern France (Meuse) [Musée barrois]: 158, 162, 199; *pl. 153.*

BARLETTA. Town of southern Italy (Apulia), ancient port of Canosa: 363; *map 426.*

BECATTI (Giovanni). Italian archaeologist, b. 1912: 98, 352, 365.

BEGRAM (ancient Kapici). In Afghanistan, 24 miles north of Kabul, capital of the Graeco-Indian kings, and subsequently a summer residence for the Indo-Scythian kings; on the caravan-route from Syria to India and China. Excavations were carried out there by a French team, who discovered (1937–9) a treasure which included glassware, plaster plaques, Graeco-Roman bronzes, lacquered Chinese boxes and Indian ivories: 291; *pl. 268.*

BELGRADE (BEOGRAD). Capital of Yugoslavia, at the confluence of the Save and the Danube (Narodni Muzej): *pl. 329.*

BELLINI (Gentile) or GENTILE BELLINI (1429–1507). Venetian artist of the Renaissance; in 1479/80 sent as portrait-painter to the court of Sultan Mahomet II at Constantinople: 352.

BÉRARD (Jean), 1908–57. French archaeologist and historian: 259.

BERBERS. 216, 218, 237; *pl. 219.*

BIRDOSWALD. 199; *pl. 189.*

BOLOGNA. Italian city (Emilia); its Etruscan name, Felsina, was changed after its occupation by the Boii from Gaul. Roman *colonia* from 189 BC: 109, 110, 114; *pl. 102, 109.*

BONDONNEAU. French hamlet (Drôme), 3 miles south-east of Montélimar: 102; *pl. 94.*

BONE. *See* HIPPO REGIUS.

BONIFACE (Bonifatius). Roman general in the service of Honorius, who revolted in 429 and died near Rimini in 432: 251.

BONN. West German city on the Rhine, now capital of the German Federal Republic, in antiquity Castra Bonnensia (Rheinisches Landesmuseum): 158, 160; *pl. 151, 152.*

BREASTED (James Henry), 1865–1935. American archaeologist and Oriental scholar: 334.

BRESCIA. Town in northern Italy (Lombardy). A Roman *colonia* under Augustus, with the name of Brixia (Museo Cristiano): 123; *pl. 113.*

BREST. Village in Bulgaria (Pleven) near the Rumanian frontier, 6 miles east of Gigen: *pl. 301.*

BRIANÇON. *Pl. 161.*

BRIDGENESS. 199; *pl. 193, 194.*

BRITISH ISLES. Known by the Phoenicians on account of their zinc mines, and occupied in 55/54 by Julius Caesar; but it was not until 43, during Claudius's reign, that Rome won firm control over them. In the campaign of 77–83 the Romans extended their conquest as far as the Firth of Forth. Under Antoninus Pius a defence-wall was built along this line; another wall, in a less advanced position (Solway Firth), had been erected by Hadrian (122–7). In 407 all Roman troops were withdrawn, and the province abandoned: 106, 127, 149, 150, 153, 157, 195, 197–211; *map 426.*

BRUNS (Gerda). Contemporary German archaeologist: 355.

BULGARIA. Present-day Bulgaria includes part of ancient Thrace in the south, and

of Moesia in the north. The principal archaeological museums are those of Sofia, Plovdiv, Stara Zagora and Varna: 309.

BURGOS. Town in northern Spain, capital of Old Castile (Museo Arqueológico): 192, 193, 195.

BYZACIUM. Ancient name for an ill-defined region of Africa between the modern Gulf of Hammamet and the Lesser Syrtis: 215, 223, 261.

BYZANTIUM. City on the Bosphorus, now Istanbul; founded as a Dorian colony at the end of the seventh century BC. In AD 330 it became the capital of the Roman Empire, under the name of Constantinople, and from the sixth century until its capture by the Turks in 1453, it was the capital of the Byzantine Empire: 14, 32, 38, 63, 68, 73, 80, 83, 85, 157, 223, 229, 247, 264, 271, 272, 291, 305, 329, 334, 347, 349, 350, 356–358, 363, 367, 374, 377.

CAESAR (Caius Julius Caesar), 100–44 BC. Roman general and politician. Between 58 and 51 he completed the conquest of Gaul; during his civil war against Pompey (q.v.) he won control over every Mediterranean province as far as the Bosphorus, and was made dictator in perpetuity. On 15 March 44 he was assassinated, as the result of a conspiracy supported by the more conservative senators: 139, 183, 184, 197, 199.

CAESAREA. Ancient residence of the Numidian kings (Jugurtha I and II); afterwards capital of the Roman province of Mauretania Caesariensis, and today Cherchell, in Algeria: 216, 237, 252, 258, 259, 367; pl. 234–238; map 426.

CALIGULA (Caius Caesar Augustus Germanicus), 12–41. Roman Emperor (37–41). His surname (from caliga, a military boot) recalls his childhood with the troops: 153.

CAMULOS. Gaulish war-god, assimilated to Mars: 199.

CARACALLA (Marcus Aurelius Severus Antoninus Caracalla), 176–217. Roman Emperor, son of Septimius Severus and Julia Domna, born at Lyons; joint-emperor with his father, and subsequently reigned alone from 211 to 217. The name Caracalla was given him as a nickname, because of a Gallic-type cloak, with a hood, that he used to wear when he was little. In 212 he promul-

gated the Constitutio Antoniniana; under this law almost all the free inhabitants of the Empire were granted Roman citizenship – though its aims, at least to begin with, were primarily fiscal: 15, 19, 32, 41, 63, 70, 367, 271, 349; pl. 18, 374.

CARANDINI (A.). Contemporary Italian archaeologist: 246.

CARAUSIUS (Marcus Aurelius Maus [aeus?] Carausius). Usurper of the imperial power between 287 and 293 in Great Britain, where the Emperor Maximianus Herculius had sent him as commander of the fleet: 197.

CARINUS (Marcus Aurelius Carinus). Roman Emperor 283–5; son of the Emperor Carus: 32; pl. 393.

CARLISLE. Pl. 188.

CARNUNTUM. Ancient city of Pannonia, 24 miles east of Vienna: modern Petronell: 127, 281.

CARPENTRAS. Town in the South of France (Vaucluse), ancient Carbantorate: 8, 145; pl. 9.

CARTHAGE. Phoenician city on the North African coast, founded by Tyre in the ninth century BC, and destroyed by the Romans in 146 BC. It was refounded as a Roman colonia by Julius Caesar in 44 BC, and subsequently became the main city of Roman Africa. It was captured in turn by the Vandals (439), the Byzantines (533), and the Arabs (698): 12, 103, 183, 215, 216, 222, 225, 237, 245, 250, 251, 264; pl. 205, 208, 232; map 426.

CARTHAGO NOVA (New Carthage). 183; map 426.

CASTLE HILL or CASTLEHILL. 205; pl. 195.

CATULLUS (Caius Valerius Catullus), c. 87–54 BC. Latin poet; born in Verona, imitator of Greek poetry, famous for his love-poems and his epigrams against Julius Caesar: 110.

CAVALLO (Guglielmo). Contemporary Italian palaeographer: 291.

CELTS. An Indo-European people who settled about 500 BC, in Gaul, part of Spain, the British Isles, and northern Italy; by 400 they had penetrated the Danube region, and from the third century BC we find them also in Asia

Minor: 106, 110, 114, 127, 137, 153, 158, 164, 192, 197; pl. 162.

CENCHREAE. One of ancient Corinth's two ports, on the Saronic Gulf (or Gulf of Aegina): 328; pl. 311, 312.

CERES. Roman vegetation-deity, assimilated to the Greek goddess Demeter; from the second century BC onwards essentially a corn-goddess, wheat being a commodity of vital importance for Rome: 208.

CERNUNNOS. Celtic divinity characterized by a long beard and stag's antlers, a Gaulish collar (torque) round his neck; generally shown squatting, legs crossed: pl. 148.

CHALON-SUR-SAÔNE. Town in eastern France (Saône-et-Loire), founded by the Aedui, and captured by the Romans in the first century BC: ancient Cabillonum (Musée Benon): 157, 164; pl. 154.

CHARLEMAGNE (742–814). King of the Franks and Lombards, son of Pépin the Short, founder of the Carolingian Empire: crowned 'Roman Emperor' by Pope Leon III on Christmas Day 800: 105.

CHERCHELL. See CAESAREA.

CHIUSI. Town of central Italy, originally an important Etruscan centre, afterwards a Roman colonia; known in antiquity as Clusium: 145.

CIRENCESTER. Small town in Great Britain (Gloucestershire), 18 miles south-east of Gloucester: ancient Corinium (Corinium Museum): 211; pl. 190.

CLAUDIUS (Tiberius Claudius Caesar Augustus Germanicus), 10 BC–AD 54. Roman Emperor (41–54): 153, 197.

CLAUDIUS II GOTHICUS (Marcus Aurelius Claudius Augustus Gothicus), 219–70. Roman Emperor (268–70) who won a victory at Naissus (Moesia) over the Goths. Died of the plague at Sirmium: 3, 175; pl. 3, 390.

CLEMENT OF ALEXANDRIA (Titus Flavius Clemens Alexandrinus), c. 150–c. 215. Writer and thinker who became head of the Christian school in Alexandria during the persecution by Septimius Severus (202–3): 215.

CLIO. Muse of History: 236; pl. 218.

CLODIUS ALBINUS (Decimus Clodius

Septimius Albinus). Proclaimed Roman Emperor by the troops in Britain, where he was Governor (193), and at first accepted as a Caesar by Septimius Severus. In 196 he proclaimed himself Augustus, and was defeated and killed at the battle of Lugdunum (Lyons) in February 197: 1, 218; *pl. 371.*

CODINUS (Georgios o Kodinos). Byzantine writer, supposed author of various chronicles, and a description of the antiquities of Constantinople, the text of which dates mainly from the tenth century: 349.

COLCHESTER. English town in East Anglia (Essex); a Roman *colonia* from 43 under the name of Colonia Victricensis Camulodunum: 199; *pl. 191, 192.*

COLOGNE (KÖLN). West German city (Rhineland-Westphalia) on the Rhine, known in antiquity as Colonia Agrippinensis (Römisch-Germanisches Museum): 14, 158, 178; *pl. 168–173; map 426.*

COLONIES, ROMAN. The colonies founded by Rome were, first and foremost, military posts in recently conquered areas. The territory of the *colonia* was taken from that of the defeated inhabitants. The colonies of the Republican era fall into two categories: Latin *coloniae*, and those consisting of Roman citizens. The former were independent communities, with their own institutions and laws, allied to Rome and supplying her with auxiliary troops. The citizen-colonies had a mixed population of Romans and natives. The colonists remained on their tribal-rolls in Rome, and had no autonomy: 109, 110.

COMMODUS (Lucius Aelius Aurelius Commodus), 161–92. Roman Emperor (180–92), the son and successor of Marcus Aurelius: ix, 1, 3, 8, 41, 66, 83, 86, 106, 112, 272, 339, 341.

CONSTANS (Titus Flavius). Praetorian Prefect (165–7): 162.

CONSTANS I (Flavius Iulius Constans), c. 320–50. Roman Emperor (337–50): *pl. 404.*

CONSTANTINE THE GREAT (Flavius Valerius Constantinus), 285–337. Roman Emperor (306–37). Nominated Caesar by his troops, he came to terms with Licinius, Augustus of the East, and won a victory over Maxentius, Augustus of the West, at the gates of Rome (312: battle of the Milvian Bridge). It

was this occasion which gave rise to the legend that the Christian Cross had appeared in a vision, as a symbol of victory. Constantine did, undoubtedly, give the Christians freedom of worship; in 325 he presided over the Council of Nicaea, at which the theological doctrines of Arius were condemned. From 324 he was sole Emperor, transferring the capital of the Empire to Byzantium, which was renamed Constantinople in his honour: 8, 15, 29, 31, 32, 38, 68, 70, 73, 75, 78, 80–85, 102, 103, 175, 177, 178, 198, 208, 222, 228, 229, 237, 250, 251, 281, 334, 336, 349, 350–352, 355, 357, 363, 367, 374, 377, 378; *pl. 22, 25, 26, 66–71, 75, 316, 317, 330, 331, 339, 401; maps, 427, 428.*

CONSTANTINA, also known as CONSTANTIA (c. 318–54). Eldest daughter of Constantine I; died in Bithynia (354), buried in a mausoleum built for her at Rome, on the Via Nomentana (later to become the baptistry of S. Costanza): 102, 103, 281; *pl. 370, 425.*

CONSTANTINE. Town of Roman Africa, in Algeria, once identified with ancient Cirta, capital of Numidia, but more probably the Punic city of Sarin Batin, which under the Romans, in Augustus's day, became Colonia Iulia Iuvenalis Honoris et Virtutis Cirta: *pl. 1.*

CONSTANTINOPLE (ISTANBUL). City in Turkey, on the Bosphorus; from 330 onwards the new capital of the Roman Empire. Founded by Constantine, whose name it took: 35, 78, 100, 103, 208, 211, 248, 250, 259, 271, 278, 291, 334, 336, 347, 349–367, 373, 377; *pl. 30, 256, 267, 332, 333, 335–337, 340, 345, 350–351, 365; maps 426, 429.*

CONSTANTIUS II (Flavius Iulius Constantius), 317–61. Roman Emperor (337–61): 31, 336, 350; *pl. 27, 405.*

CONSTANTIUS CHLORUS (Flavius Valerius Constantius Chlorus), c. 265–306. Father of Constantine, nominated as Caesar by Diocletian, became Augustus of the West in 305, and died in 306: 198, 281; *pl. 23, 187, 396.*

CONSTANTIUS GALLUS (Flavius Claudius Constantius Gallus), 325–54. Son of a blood-brother of Constantine I, and himself brother to Julian the Apostate, he was nominated a Caesar in 351 by Constantius II, who three years later had him beheaded for his cruelties: *pl. 406.*

CONSTANTZA or CONSTANZA. Rumanian town on the Black Sea, formerly

Tomis, founded by Greeks from Miletus in the seventh century BC. During Augustus's reign the poet Ovid was banished there: *pl. 304.*

COPT. A native Egyptian Christian. The term 'Coptic art' is applied to the artistic products of Egypt – pagan as well as Christian – between the third and the ninth century: 294, 295, 374.

CORDOVA. 184; *pl. 175.*

CREMONA. Italian town (Lombardy) in the Po Valley. Latin *colonia* from 218 BC: 110.

CSÁSZÁR. *Pl. 124.*

CTESIPHON. Hellenistic military settlement, on the left bank of the Tigris, linked to Seleucia by a bridge (near modern Baghdad); subsequently capital of the Persian Empire (129 BC–AD 637) under the Parthians and the Sassanids: 65, 66.

CUCUTÉNI. District of north-eastern Rumania, centre of a Neolithic culture stretching from the Carpathians to the Ukraine (the Tripolje culture near Kiev), characterized by painted pottery with spiral decorations, dating from the mid-third to the end of the second millennium BC: 151.

CUICUL. Ancient city of Numidia; afterwards a colony of Roman veterans; today Djemila, in Algeria: 63, 216, 248, 262; *pl. 231.*

CUMONT (Franz Valéry Marie), 1868–1947. Belgian archaeologist and religious historian: 334.

CUNOBELLINUS (d. 43). King of the Trinobantes, with his seat at Camulodunum (Colchester): 199.

CYBELE. Greek divinity, originally the mother of Zeus, but very early identified with the Great Mother Goddess of Oriental religions, who was worshipped in Phrygia with orgiastic ceremonies. Her itinerant eunuch priests were welcomed at Rome in the third century: 19, 271; *pl. 17.*

CYPRIAN, Saint (Caecilius Thascius Cyprianus), c. 205–57. Christian writer and polemicist, Bishop of Carthage, died a martyr: 12, 14, 15, 215.

CYRENE. Town in the Arab Republic of Libya; founded in the seventh century BC by Dorian colonists; a flourishing Hellenistic centre, which afterwards

became the capital of the Roman province of Crete and Cyrenaica: *pl. 251, 252; map 426.*

CYZICUS. Ancient city on the Propontis, situated on a peninsula of the Sea of Marmara; its ruins lie near modern Erdek (Turkey): 281, 349.

DACIA. Territory more or less corresponding to present-day Rumania north of the Danube; incorporated as a Roman province after Trajan's wars (101–2, 105–7). Once the Goths had settled on the shores of the Black Sea and along the Danube basin (238), Dacia was under constant threat of barbarian invasion. The province was finally abandoned under Aurelian (270–5): 83, 110, 127, 132, 134, 157, 162, 199, 306, 312; *pl. 294, 295; map 426.*

DAMASUS I, Saint. Elected Head of the Roman Church on the death of Pope Liberius (September 366), though only by a part of the clergy; his rival Ursinus was exiled by the Emperor Valentinian I. Damasus nevertheless remained Pope until his death in 384. (The epitaph he composed for Projecta figures as No. 51 in the collection of *Epigrammata Damasiana* published by Fr A. Ferrua, Rome, 1927): 100.

DAR BUC AMMERA. *See* ZLITEN.

DECENNALIA. Celebrations in honour of the tenth year of an emperor's reign: 90, 281, 357.

DECIUS (Caius Messius Quintus Traianus Decius), *c.* 200–51. Roman Emperor, born at Sirmium (Sremska Mitrovica, on the banks of the Save, Yugoslavia); acclaimed Emperor by his troops in 249, died in 251 while fighting the Goths at Abrittus (Moesia): 6, 59; *pl. 8, 383.*

DE FRANCOVICH (Geza). Italian art-historian, born in 1902: 50.

DELOS. Ancient city on the island of the same name, situated in the Cyclades; cult-centre of Apollo, and during the late Hellenistic period inhabited by merchants of Italian origin: 112.

DENIS OF ALEXANDRIA, Saint (d. 265). Bishop of Alexandria (Egypt) from 247/8 to 264/5: 215.

DESBOROUGH. *Pl. 141.*

DIANA. 50, 158, 250, 336; *pl. 232, 317, 319.*

DIDIUS JULIANUS (Marcus Didius Severus Julianus), 133/137–93. Extremely

wealthy Roman senator, proclaimed Emperor on the death of Commodus (31 December 192), died 1 June 193: 1.

DIDO. *See* AENEAS.

DINARIC (race). 115.

DIOCLETIAN (Caius Aurelius Valerius Diocletianus), 240–316. Roman Emperor (284–305). Son of an Illyrian freedman, and commander of the Praetorian Guard, he was proclaimed Emperor and appointed his fellow-countryman Maximian co-regent. In 286 the two Emperors, who each had the title of Augustus, nominated two deputy rulers, to be known as Caesars. The whole Empire was reorganized into four Prefectures (Milan, Trèves, Sirmium, Nicomedia) and a dozen dioceses, which supervised the 101 provinces. In 303 there was published an edict laying down maximum price-tariffs and salaries. Two years later, in accordance with their own plans for reform Diocletian and Maximian abdicated (305). Diocletian retired to his palace near Salonae (Split), where in 316 he died: 1, 23, 27, 80, 130, 131, 175, 183, 278, 281, 282, 291, 306; *pl. 22, 120, 121, 361, 394, 420, 421.*

DIO CASSIUS or CASSIUS DIO (Cassius Dio Cocceianus), 155–*c.* 235. Born at Nicaea in Asia Minor (Phrygia), and Governor of several provinces under the Antonines; the author of a *Roman History*, in Greek, from Aeneas's day to the year 229: 1, 312.

DIO CHRYSOSTOM or OF PRUSA (30–117). Greek rhetorician and philosopher, born at Prusa: 85.

DIONYSOGENOS. *Pl. 284.*

DIONYSUS. Greek divinity identified with Bacchus, of Thracian origin; god of Nature and Wine, and attended by a rout of Satyrs, Maenads and Nymphs, mingled with lions and panthers. There was also an orgiastic side to his cult; in Orphic doctrine he showed his origin as a god of the Nether World: 49, 50, 107, 193, 229, 231, 233, 258, 263, 294, 329, 336, 375; *pl. 37, 44, 45, 186, 213–215, 217, 272, 314, 315.*

DIOSCURI. Etymologically the 'sons of Zeus', the twin brothers Castor and Pollux were regarded as the patrons and protectors of navigators and combatants: 216.

DJEBEL OUST. Tunisian village 18 miles south of Tunis; a thermal spa of the

Roman period has been found here: 237; *pl. 221, 222.*

DJEMILA. *See* CUICUL.

DOBRUDJA. 311, 312; *pl. 298.*

DOGMATIUS (Caius Caelius Saturninus Dogmatius). One of Constantine I's closest collaborators; held various appointments (senator, provincial legate, Praetorian Prefect). Died about 336: 85; *pl. 76.*

DOLICHENUS. Roman title given to the local god of the town of Dolichè in Commagene (Anatolia); introduced into the West by the merchants of Asia Minor, and identified with Jupiter; during the second and third centuries his cult was extremely widespread in Rome: 19.

DOMITIAN (Titus Flavius Domitianus), 51–96. Roman Emperor (81–96): 277, 312.

DOMITIUS ALEXANDER (Lucius). Born in Phrygia; appointed *vicarius* of the province of Africa by the Emperor Maxentius. In 308 he had himself proclaimed Emperor by the troops of Carthage, and died at Cirta three years later (311): 251.

DORCHESTER. Small English town (Dorsetshire) 8 miles north of Weymouth: the ancient Durnovaria: 211.

DOUGGA. *See* THUGGA.

DUMBARTON OAKS. Near Washington, D.C. Institute for the study of Byzantine civilization, with library and museum: 81.

DURA-EUROPOS. Town founded by Seleucus I, in the Hellenistic period, on the Middle Euphrates; later a frontier town of the Roman province. Captured by the Parthians in 272, destroyed and abandoned: 334, 367, 373; *map 426.*

ECIJA. Spanish village (Seville); in the church there is a Christian sarcophagus, decorated with sculptures representing scenes from the Old Testament. This is local workmanship, though influenced by the *ateliers* of Italy and Provence; it would appear to date from the mid-fifth century, and has Greek inscriptions on it. (H. Schlunk, *Madrider Mitteilungen*, III, 1962, *pl. 119–132*): 195.

EGNATIA (Via). Roman road running from Dyrrachium to Thessalonika, and

(from the fourth century) as far as Constantinople: 305.

EGYPT. In antiquity, a vast kingdom, known as far back as *c.* 3400 BC; occupied by the Persians in 525; from 332 until 30 BC a Hellenistic kingdom, founded by Alexander the Great of Macedon, and governed by the Ptolemaic dynasty; latterly a Roman province, under the direct authority of the Emperor. In 634 it was occupied by the Arabs: 16, 90, 95, 96, 98, 103, 111, 178, 193, 215, 223, 245, 275, 277–295, 328, 355, 374; *pl. 259, 261, 271, 272; map 426.*

ELAGABALUS or HELIOGABALUS (Marcus Aurelius Antoninus Elagabalus), 204–22. Roman Emperor (218–22), proclaimed at the age of fourteen; high priest of the sun god worshipped at Emesa, in Syria, under the name of Elagabalus: 19, 41, 223; *pl. 375.*

EL-DJEM. *See* THYSDRUS.

EMESA (HOMS). Ancient town of Coele-Syria in the Orontes Valley, capital of a principality conquered by the Romans; reached its peak of prominence under the Severi, as the native city of Julia Domna, Elagabalus, and Alexander Severus: 19, 70.

ENDYMION. In Greek myth, a handsome young man, the leader of the Aeolians during their emigration from Thessaly. Selene (the Moon, Diana) fell in love with him when she saw him asleep in a cave: 50.

ENFIDAVILLE. Small Tunisian town, some 26 miles north of Sousse: 252.

ENTREMONT. Village in the South of France, near Aix-en-Provence; capital of the Gaulish Salyes, but in 123 BC destroyed by forces from Marseilles, with Roman assistance: 11, 139, 153; *pl. 130.*

EPHESUS. City of Asia Minor at the mouth of the Menderes (Maeander); colonized by the Ionian Greeks, and renowned for its cult of Artemis (Diana). It retained its importance under Roman rule. In 263 it was ravaged by the Goths, and subsequently restored; later still its harbour silted up, and it lost its importance as a maritime port, being finally abandoned in 1426. Its ruins, excavated by Austrian archaeologists, lie near the Turkish village of Selçuk: 8, 14, 130, 339, 341, 344, 347, 357, 363, 375; *pl. 320–323, 346, 416–418; map 426.*

EPICTETUS. Stoic philosopher, born in Phrygia about 60, died 140. Came to Rome as a slave; expelled in 89 with all other *philosophi,* after which he founded a school at Nicopolis, in Epirus: 16.

ÉPINAL. Town in eastern France (Vosges), on the banks of the Moselle (Musée départemental): 158.

EROS. God of Love; known since the beginning of the fifth century BC. Said to be the son of Ares and Aphrodite. Represented as a winged child; portraits of him multiply during the Hellenistic and Roman periods: 45, 46, 100, 127, 169, 211, 233, 262, 275.

ESTE. Town in northern Italy (Padua) formerly the centre of the Atestine culture (q.v.): 11.

ETCHMIADZIN or ECHMIADZIN. Town of the U.S.S.R. (Republic of Armenia), to the west of Erevan: 334.

EUCHERIUS. 35.

EUDOXIA (Aelia Eudoxia Augusta), d. 404. Daughter of the Frankish chieftain Bauto; married Arcadius (393), and ruled in his name: 38; *pl. 34.*

EUGENIUS (Flavius Eugenius), d. 394. Roman usurper of the West (392–4): *pl. 412.*

EURYCLEIA. *See* ODYSSEUS.

EUSEBIUS OF CAESAREA (*c.* 265 or 340). Pupil of Pamphilus, Bishop of Caesarea (*c.* 316), and the author of numerous works, including a monumental *Ecclesiastical History*: 350.

EUTROPIA (Galeria Valeria Eutropia). Wife of Maximianus Herculius, by whom she bore Maxentius and Fausta. A Christian, she retired to Palestine: 38.

EUTROPIUS. Official at the court of the Emperor Valens (364–78), and author of a digest of Roman history from the foundation to the year 364 (*Breviarium historiae Romanae ab Urbe condita*): 278.

EZEROVO. Bulgarian village on Lake Burgas, 6 miles west of Burgas: 311; *pl. 289.*

FATES (PARCAE). Goddesses of human destiny, three in number: 48.

FAUSTA (Flavia Maxima), *c.* 289–326. Married to Constantine the Great (307), she was afterwards executed for adultery: 175; *pl. 402.*

FAUSTINA THE YOUNGER (Annia Galeria Faustina Minor), 154–75. Wife of the Emperor Marcus Aurelius: 50.

FAYUM, THE. Vast depression around Medinet el-Fayum (ancient Crocodilopolis) in Egypt; the climate here, being exceedingly dry, accounts for the preservation of numerous documents from Roman and Coptic antiquity (paintings, papyri): 284; *pl. 260, 262–264.*

FESTUGIÈRE (André Jean). French scholar specializing in Hellenistic religions; Dominican priest; born 1898: 48.

FÉVRIER (Paul Albert). French teacher and archaeologist, born 1931: 250.

FIRMUS. Mauretanian prince, and a federal ally of Rome. Proclaimed himself Emperor of the Roman provinces in Africa (372–5); supported by the Donatist Christians. Committed suicide to prevent himself falling into the hands of Theodosius: 88, 147, 184, 251.

FLAVIANS. Dynasty including Vespasian, Titus and Domitian, which lasted from 69 until 96: 284.

FORRER (Robert Eduard), 1866–1947. German prehistorian and numismatist, active in Strasbourg: 169.

FORTH. Scottish firth (river): 197.

FRANK (Tenney), 1876–1939. American historian and Latinist: 223.

FRANKS. A group of Germanic tribes from the right bank of the Rhine; from the third century they made several incursions into Gaul. About 500 they established the Merovingian kingdom: 106, 175, 183, 208.

FRESHFIELD (D.W.). English collector of the sixteenth century; his collection is now in Cambridge: 365.

FRIEDLÄNDER (Paul). German philologist, born 1882: 367.

FURTWÄNGLER (Adolf), 1853–1907. German archaeologist and teacher, who in his day enjoyed the highest authority: 106.

GAFSA. Town of southern Tunisia, the Capsa of antiquity; originally Numidian, incorporated by Diocletian into Byzacium (q.v.): 251; *pl. 233.*

GALATIANS. A group of Gaulish tribes which, in the early third century, entered Asia Minor, but were halted by the Kings of Pergamum: 8, 344.

GALERIUS (Caius Galerius Valerius Maximianus), *c.* 250–311. Roman Emperor (305–11). The adopted son – and son-in-law – of Diocletian, who had made him a Caesar during the first Tetrarchy (293–305): 73, 281, 282, 305, 306; *pl. 258, 280–283, 397, 422.*

GALLIENUS (Publius Licinius Egnatius Gallienus), *c.* 218–68. Roman Emperor (253–68), co-regent with his father Valerian until 260, when the latter was made a prisoner of war by the Persian king Shapur I: 16, 27, 59, 63, 80, 208, 231; *pl. 24, 388.*

GARGARESH. Oasis of Tripolitania, 4 miles distant from Tripoli, where some Late Empire tombs have been found: 95, 264, 265; *pl. 87, 242, 243.*

GAUL, GAULISH (GALLIC). Name given to those Celtic tribes which occupied the territories between the Rhine and the Pyrenees (including the Po Valley and Northern Italy), and at the time of the Roman conquest had reached varying levels of social development and organization. (The conquest of northern Italy took place at the beginning of the second century BC; Gallia Narbonensis became a province in 118 BC; the rest of Gaul was conquered by Caesar between 58 and 51 BC): 11, 73, 105, 106, 109, 110, 139–149, 157, 158, 162–164, 175, 178, 197, 199, 228, 374, 375; *map. 426.*

GEBEL DOUKHAN. Mountain in Egypt, 30 miles from the Red Sea, known in antiquity by the name of Mons Porphyrites: 281.

GENESIS. First Book of the Bible, which tells the story of the Creation, the Patriarchs, and the Generations of Man: 367; *pl. 351.*

GERASA. Ancient Hellenistic city, subsequently part of the Decapolis, which became extremely wealthy from the first century onwards. It lay on the site of modern Djerach, 36 miles north of Amman (Jordania): 350.

GERMANY, UPPER and LOWER (GERMANIA SUPERIOR and INFERIOR). The two Roman provinces established on German soil during the first century, one (Superior) with its capital at Mogontiacum (Mainz), the other (Inferior) with its capital at Colonia Agrippinensis (Cologne): 106, 149, 157, 158, 162.

GETA (Publius Septimius), 189–212. Younger son of Septimius Severus: Caesar in 198, Augustus in 209, Emperor in 211, conjointly with Caracalla, who in 212 had him assassinated: 267, 271; *pl. 248.*

GHIBERTI (Lorenzo), 1378–1455. Florentine sculptor, jeweller and architect of the Renaissance: 377.

GHIRZA. Village in southern Tripolitania, about 66 miles south of Beni Ulid, with surviving remains – *enceinte* and architecturally structured tombs – of an unidentified Roman settlement (third or fourth century): 218; *pl. 201, 364.*

GIANTS. In Greek mythology, the sons of Gaia (Earth) who rebelled against the gods of Heaven. The latter brought them to battle and defeated them. From the Hellenistic period onwards they were represented as half-human, half-animal (serpent body, lion's head, wings, etc.): 46.

GIGEN. Bulgarian village (Pleven) near the Rumanian frontier: the Oescus of antiquity: 319; *pl. 302.*

GILDON or GILDUS. Brother of the usurper Firmus, appointed *comes* of Africa in 385. Ten years later he began to starve Rome out by cutting down on grain shipments; in 397 he openly revolted, but was defeated in 398: 251.

GLANUM. *See* SAINT-RÉMY-DE-PROVENCE.

GLASS. The manufacture of glass, from quartzose substances, had been practised as early as the third millennium BC; but it took a great step forward with the discovery of the glass-blowing technique. This took place in Phoenicia (first century BC) and rapidly spread to Italy and Gaul: 178; *pl. 168–173, 311, 312.*

GLYCON. Human-headed serpent alleged to be a reincarnation of Aesculapius. This cult, introduced into Paphlagonia under Antoninus Pius by a hoaxer, flourished during the third century, spreading throughout the Eastern provinces, including Moesia and Thrace: 162.

GNOSIS. A religio-philosophical creed, of an eclectic nature, which developed in intellectual circles during the first and second centuries, and for long continued to exert an influence over the various mystical movements: 48, 216.

GORDIAN III, known as THE PIOUS (Marcus Antonius Gordianus Pius) *c.* 224–44. Roman Emperor (238–44). Proclaimed at the age of thirteen (or sixteen), 23, 60, 169, 319; *pl. 55, 158, 300, 381.*

GOYA Y LUCIENTES (Francisco da), 1746–1828. Spanish painter, famous for his satirical etchings. 16.

GRABAR (André). French archaeologist and art-historian, born 1896: x, 86, 103.

GRAINDOR (Paul), 1877–1938. Belgian archaeologist: 278.

GRATIAN (Flavius Gratianus), 359–83. Roman Emperor (367–83); the eldest son of Valentinian I, he took up residence at Trèves, where he had been the pupil of the poet Ausonius (q.v.): 175, 177; *pl. 410.*

HACKIN (Joseph), 1886–1941. French archaeologist and Oriental scholar, and Director of the *Délégation archéologique française* in Afghanistan; discovered the Begram treasure: 291.

HADRIAN (Publius Aelius Hadrianus), 76–138. Born at Italica in Spain; adopted by Trajan; Roman Emperor from 117 to 138: 5, 8, 29, 41, 81, 130, 193, 197, 226, 229, 267, 284, 313, 339, 344; *pl. 188, 320.*

HADRUMETUM. *See* SOUSSE.

HALATTE (forest of). Situated between the Nonette Valley to the south, and that of the Oise to the north, near Senlis: 137.

HANNIBAL. Carthaginian general (246–183 BC), and the Romans' most formidable adversary: 110.

HATRA. Ancient town and fortress in the Mesopotamian desert (now al-Hadr, 56 miles south-west of Mosul); capital of a small independent state which was temporarily occupied by a Roman legion during the first half of the third century, and destroyed, about 250, by the Sassanids, who left it in ruins. Sculptures in the Baghdad Museum (Iraq): 70, 334, 373.

HATT (Jean-Jacques). French archaeologist, born in 1913: 169.

HEINTZE (Helga von). Contemporary German archaeologist: 59.

HELENA, Saint (Flavia Julia Helena), *c.* 250–324. Mother of the Emperor Constantine; born in Asia Minor, concu-

bine to the Emperor Constantius Chlorus: 38, 103, 281, 350; *pl. 369, 403, 424.*

HENCHIR EL-KASBAT. *See* THUBURBO MAIUS.

HERACLIUS I (Flavius Heraclius), 575–641. Roman Emperor of the East (610–41): 363.

HERCULES. Latin name of the Greek hero Heracles, son of Zeus and Alcmene, later deified; symbol of force put into action for the good of mankind (Labours of Hercules): 46, 73, 169, 221, 246, 271, 336, 344; *pl. 41, 160, 229, 314, 318, 326.*

HERENNIUS (Quintus Herennius Etruscus Messius Decius). Eldest son of Decius; killed in a battle against the Goths on the Pleven plateau (June 251): *pl. 384.*

HERMES. *Pl. 159.*

HERMETIC PHILOSOPHY (HERMETISM). Mystical doctrine, most popular in the Roman world from the second century onwards; based on certain Egyptian theological texts which took, as their central divinity, Thoth (identified with 'thrice-great', *trismegistos*, Hermes): 19, 48, 329, 375.

HERMOPOLIS (ACHMOUNEIN). Ancient city of Upper Egypt, near the great necropolis of Touna el Djebel; cult-centre of the god Thoth, identified by the Greeks with Hermes: 291.

HERODES ATTICUS (L. Vibullius Hipparchus Tiberius Claudius Herodes Atticus), 107–78. Athenian millionaire, consul in 143; orator and sophist who founded a school and a professorial chair in Athens: 297; *pl. 274.*

HERODIAN (*c.* 170–*c.* 240). Greek historian, born in Syria. His work covers the period between 180 and 238: 65, 66.

HIPPOLYTUS. According to legend, the son of Theseus and Antiope. When he rejected the amorous advances of his stepmother Phaedra, the latter engineered his death: 50, 193, 302.

HIPPO REGIUS. Ancient city, residence of the kings of Numidia, near the modern town of Bône, in Algeria. Romanized under the name of Hippo Regius, it had as its bishop St Augustine, who died there at the time of the siege by the Vandals (430): 216, 228, 237; *pl. 211; map 426.*

HOMER. Greek poet of the eighth century

BC, credited with having written two epic poems, the *Iliad* and the *Odyssey*, which were a source of literary and artistic inspiration throughout antiquity: 328; *pl. 312.*

HONORIUS (Flavius), 384–423. Emperor of the West (395–423): 373; *pl. 414.*

HOR son of HOR. Egyptian priest of the god Thoth; his portrait-statue has been preserved: 278, 282, 287; *pl. 255.*

HOSTILIAN (Caius Valens Hostilianus Messius Quintus). Son of the Emperor Decius, made Caesar in 249 and Augustus in 251; died the same year of the plague: *pl. 385.*

HYLAS. Youth of remarkable beauty, beloved by Heracles. He was carried off by the Naiads when he was drawing water, in Mysia: 96, 292; *pl. 270.*

IASOS (IASUS). Ancient city of Caria, on the Aegean; its ruins lie 6 miles west of Mylasa (Milas): *pl. 325.*

IDOMENEUS. Grandson of Minos, King of Crete, and commander of the Trojan contingent during the Trojan War. Famous for his heroism: 291; *pl. 267.*

ILIAD. Epic poem traditionally attributed to Homer, which deals with the Wrath of Achilles and its consequences during the Trojan War: 291, 367; *pl. 267, 350.*

ILIAS AMBROSIANA. Sixth-century codex, the surviving fragments of which are now in the Biblioteca Ambrosiana, Milan: 59, 291, 367; *pl. 267, 350.*

IPHIGENIA. Daughter of Agamemnon and Clytemnestra. In order to placate Artemis, her father was obliged to sacrifice her at Aulis; but the goddess wafted her away, to be her priestess in Tauris: *pl. 118.*

ISIS. Egyptian divinity, whose cult – as a beneficent mother-goddess – was widespread both in Greece and the Orient, from the third century BC, and was officially adopted, at Rome and in the provinces, under the Empire: 19, 267.

ISTANBUL. Former capital of Turkey, on the Bosphorus: ancient Byzantium and Constantinople: 278, 281, 350; *pl. 334, 347, 348, 349.*

ISVAILOVGRAD. Small town in Bulgaria, 37 miles from Krumovgrad, and 3 miles west of the (north-east) Greek frontier: 319, 325.

ITALICA. Ancient Spanish city, 6 miles north-west of Seville: founded by Scipio: 193.

JOHN CHRYSOSTOM (Saint), *c.* 349–407. Patriarch of Constantinople (398–403), famous for his skill in theological exposition and debate. Father of the Eastern Church: 335.

JONAH. Hebrew prophet of the eighth century BC. The Book of Jonah, included among the 'Minor Prophets', does not in fact contain any prophecies, but is rather his *Life*, written at least three hundred years later. His adventures – especially his encounter with the 'Great Fish' – have been allegorically illustrated as a descent to the Kingdom of the Dead: 234; *pl. 216.*

JOSHUA (Y'hoshua). Moses' successor as leader of the Jewish people, whose tribulations are recorded in the Book of Joshua: 68.

JOUARRE. Ancient Benedictine Abbey in France, near La Ferté-sous-Jouarre (Seine-et-Marne) founded about 630 by St Adon: 373; *pl. 353.*

JUBA II (*c.* 52 BC–AD 23/24). King of Mauretania (25 BC–AD 23/24): 252.

JULIA DOMNA (*c.* 158–217). Born at Emesa in Syria; wife of the Emperor Septimius Severus by whom she became the mother of Caracalla: 19, 70, 271; *pl. 64, 373.*

JULIA MAESA. Sister of Julia Domna, mother of Mamaea Augusta, and grandmother of two emperors, Elagabalus and Alexander Severus; died in 223: 19; *pl. 376.*

JULIAN known as THE APOSTATE (Flavius Claudius Julianus), 331–63. Roman Emperor (361–3). He attempted to restore paganism and Neoplatonist philosophy, and died in battle against the Persians. His *Letters* and other literary works survive. The son of Julius Constantius, he was proclaimed Emperor at Lutetia (Paris) in 360; the death of Constantius in November 361 left him the legitimate Emperor. His philosophical education was acquired in Asia Minor and at Athens: 335, 355; *pl. 407.*

JUNIUS BASSUS. Consul in 331; father of the City Prefect of the same name whose sarcophagus is preserved in the Caves of the Vatican; built a basilica decorated with marble inlay-work: 81, 96, 292; *pl. 88, 89, 90, 270.*

JUSTINIAN I (Flavius Petrus Sabbatius Justinianus), 482–565. Roman Emperor of the East (527–65), who attempted to restore the unity of the Empire by making a temporary conquest of the Western provinces: 268, 334.

KÄHLER (Heinz). Contemporary German archaeologist: 306.

KEF (Le). Town in Tunisia, 30 miles east of the Algerian frontier; the Sicca Veneria of antiquity: 228.

KOLLWITZ (Johannes). Contemporary German archaeologist: 357.

KOSTOLAC. Town in Yugoslavia, on the right bank of the Danube, at its confluence with the Mlava. Known in antiquity as Municipium Aelium, it was in the year 240 renamed Viminacium: *pl. 117.*

KRITCHIM. Bulgarian village, 18 miles west of Plovdiv: 309; *pl. 288.*

LACTANTIUS (L. Caecilius Firmianus Lactantius), *c.* 250–317. Christian apologist; of African origin, he became professor first at Nicomedia, then in Trèves, where Constantine made him responsible for the education of his son Crispus: 215.

LAELIANUS (Ulpius Cornelius Laelianus). Usurped power in Gaul (267): 106, 175.

LAMASBA. Ancient town in Numidia, on the road which runs from Thamugadi and Lambaesis to the interior of what is now Algeria: 223.

LAMPADII. 35; *pl. 32.*

LAOCOON. In Greek legend, a priest of Apollo at the time of the Trojan War, who with his two sons was killed by serpents as a punishment; the subject of a famous Hellenistic sculpture found at Rome during the Renaissance: 3.

LASSUS (Jean). French archaeologist, born 1902: 259.

LAVIN (Irving). Contemporary American art-historian: 229, 248, 336.

LEDA. Daughter of Thestus, wife of Tyndareus. Zeus became enamoured of her, and she bore him the Dioscuri, Clytemnestra and Helen: 275; *pl. 251.*

LEPTIS MAGNA. Ancient town of Tripolitania, east of Tripoli; originally a Phoenician colony. Birthplace of the Emperor Septimius Severus: 1, 27, 229, 233, 261, 263, 267–275, 300, 319, 344, 364; *pl. 239, 240, 244–250, 303, 419; map 426.*

LIBANIUS (314–c. 393). Greek rhetorician of Antioch, friend of Julian the Apostate, and St John Chrysostom's teacher: 335, 367.

LICINIUS (Valerius Licinianus Licinius), *c.* 250–325. Roman Emperor (308–24); first the colleague, but latterly the opponent of Constantine: 73, 281, 282, 349; *pl. 363, 400.*

LIGURIANS. A non-Indo-European tribe who in the earliest historical period occupied the area of southern Gaul and northern Italy around Genoa: 109, 139.

LIVIA (Livia Drusilla), 58 BC–AD 29. Wife of the Emperor Augustus, mother of Tiberius: 114.

LIVY (Titus Livius Patavinus), 59 BC–AD 17. Born at Padua (Patavium). The most important Roman historian. His work covered a period from Rome's foundation until the year 9 BC (death of the Elder Drusus, Livia's son): 110.

LORICHS or LORCH (Melchior), *c.* 1527–83. Danish painter and engraver: 365.

LUCIUS VERUS (Lucius Aelius Aurelius Verus Augustus), 130–69. Roman Emperor (161–9), adopted by Antoninus Pius, and Marcus Aurelius's son-in-law: 339, 341; *pl. 322, 323.*

LUCRETIUS (Titus Lucretius Carus), *c.*97–55 BC. Latin poet, author of a work entitled *De Rerum Natura* ('On the Nature of Things') in which the doctrines of Epicurus (341–270 BC), which were to free mankind from the fear of death and the gods, are treated with great poetic imagination and originality: 375.

LUKU. Country of the Peloponnese: 297; *pl. 273.*

LUXOR. Town in Upper Egypt, on the right bank of the Nile (405 miles south of Cairo), near the site of ancient Thebes: 291; *pl. 266; map 426.*

LYCHNON. A kind of elongated basket, used to conceal phallic symbols during the celebration of the Dionysiac Mysteries: 107.

LYCOMEDES. King of the Dolopians, in the island of Skyros, at whose court Achilles hid himself in girl's clothing: 231; *pl. 39, 212.*

LYCOPOLIS (ASSIOUT). Town in Upper Egypt, on the Nile: 16.

LYCURGUS. King of the Edonians, in Thrace. He fought and beat the army of Dionysus, who afflicted him with madness. After killing his son Dryas, Lycurgus was removed from the throne: 292; *pl. 269.*

LYONS. Town in the French Midi (Rhône), founded in 43 BC by Munatius Plancus under the name of Lugdunum; capital of one of the Roman provinces of Gaul. Every year a congress of delegates from all three Gallic provinces used to meet here. Lugdunum was destroyed during the war between Septimius Severus and Albinus in 197; it was a centre of Christianity, which in 177 provided several martyrs. About 450 it was devastated by the Huns, under Attila: 106, 142, 157, 175; *map 426.*

LYSIPPUS. Greek sculptor of the fourth century BC, pioneer of Hellenistic naturalism: 349.

MAESTRO DELLA GESTA DI TRAIANO ('MASTER-ARTIST OF TRAJAN'S GREAT ACHIEVEMENTS'). Conventional title given to the artist who conceived the sculptures on Trajan's Column in Rome, and other reliefs portraying Trajan's military and civil activities as Emperor (98–117): 21, 145, 314, 341.

MAINZ. West German city, capital of the Rhineland-Palatinate; an important Roman military base-camp, near which arose the centre known as Mogontiacum, capital of the usurpers who during the third century (258–73) created a Gallic Empire. Now houses the main museum of Romano-Germanic antiquities (Römisch-Germanisches Zentralmuseum): 158.

MALMAISON (LA). *Pl. 129.*

MANSUELLI (Guido Achille). Italian archaeologist, born 1906: 109.

MANUSCRIPTS, ILLUSTRATED. 59, 102, 259, 291, 367.
Calendar of: 354, 102.
Genesis of Vienna: 367; *pl. 351.*
Gospels (Paris Cod. gr. 74): 259.
Ilias Ambrosiana: 59, 291; *pl. 267, 350.*
Nicander (Paris, Supplém. gr. 247): 259.

MAPPA. Napkin that was thrown down into the arena as a signal for the races to begin: 35, 329.

MARCUS AURELIUS (Marcus Aurelius

Antoninus), 121–80. Roman Emperor (161–80): 1, 8, 14, 23, 50, 66, 68, 216, 297, 306, 241, 252, 264; *pl. 10, 322, 323.*

MARCHENA. *Pl. 182.*

MARCIANUS (396–457). Roman Emperor of the East (450–7); in 452 he challenged and met the attack of Attila, King of the Huns, in Italy: 363.

MARCION (*c.* 85–*c.* 150). Heresiarch; born at Sinope, the son of a bishop, and almost certainly a bishop himself. He taught that the Creation was the work of a just God; but that over and above this deity there stood the Good God incarnated by Jesus Christ. He rejected all the Old Testament and a large proportion of the New: 216.

MARCOMANNI. *See* QUADI.

MARIUS. Emperor of Gaul in 270: 175.

MARSEILLES. City and port of the French Midi, capital of the Bouches-du-Rhône Département; founded about 600 BC by Greeks from Phocaea, and in contact with Rome from the time of the Second Punic War (218–201 BC). Having taken Pompey's side during the Civil War, it was occupied by Julius Caesar; but always, even under the Roman Empire, kept its status as a free and federally allied town: 139; *pl. 140.*

MARTIAL (Marcus Valerius Martialis), *c.* 40–102. Latin poet, author of fifteen Books of *Epigrams*: 184.

MARTIN (Roland). French archaeologist, born in 1912: 153.

MASSICAULT. Small town in Tunisia, 18 miles south-west of Tunis: *pl. 203.*

MATREI. Small town in Austria (Eastern Tyrol), 12 miles south of Innsbruck; ancient Matreium: 137; *pl. 126.*

MATRONAE AUFANIAE. Divinities (three in number) represented as seated women, dressed in long robes, and the object of special veneration in the Rhineland during the period of Roman rule there. They symbolized maternity and the creative force of Nature: 160; *pl. 151, 152.*

MAURETANIA. Kingdom on the west coast of North Africa, permanently occupied by the Romans in 45, and subsequently divided into two provinces: Tingitana (Morocco) and Caesariensis (western Algeria): 215, 223, 252, 261.

MAXENTIUS (Marcus Aurelius Valerius Maxentius), *c.* 278–312. Son of the Emperor Maximianus Herculius; had himself proclaimed Emperor at Rome in 306. Fought against Constantine, and was defeated by him at the Battle of the Milvian Bridge outside Rome (28 October 312): 73, 83, 175, 251; *pl. 68, 360, 399.*

MAXIMIANUS HERCULIUS (Marcus Aurelius Valerius Maximianus), *c.* 250–310. Roman Emperor of the West (286–305), born at Sirmium in Illyria. He was a member of the First Tetrarchy, reassumed the purple in 306, together with his son Maxentius, and in 310 committed suicide in Marseilles: 38, 175, 278; *pl. 395.*

MAXIMIN DAIA (Caius Galerius Valerius Maximinus). Roman Emperor (309–13): 281, 282; *pl. frontispiece, 257, 398.*

MAXIMIN THE THRACIAN (Caius Iulius Verus Maximinus Thrax), 173–238. Roman Emperor (235–8), son of a Thracian peasant, acclaimed by the soldiers and subsequently assassinated by them: 23, 25; *pl. 378.*

MAXIMUS (Magnus Maximus). Roman Emperor (383–8): 175.

MEDEA. Heroine of Greek myth and drama. Endowed with magical powers, she took vengeance on Jason (who had abandoned her) by sending his new wife, Creüsa, a poisoned robe (which occasioned her death), and by killing the children which she herself had borne to Jason: 50, 149; *pl. 46, 139, 140.*

MELEAGER. In Greek legend, the son of the King of Aetolia; represented as the hunter of the Calydonian boar. This hunt gave rise to a scuffle in which Meleager lost his life; thus the goddess Artemis was revenged on him: 50; *pl. 48.*

MELPOMENE. Muse of tragedy and music: 236; *pl. 218.*

MELQART. Male divinity of Tyre, the protector of navigators. His name means 'God of the City': 271.

MEMNON THE AFRICAN. Pupil of Herodes Atticus: 297; *pl. 273.*

MERCURY. Roman divinity identified with the Greek god Hermes, but particularly emphasizing the latter's role as protector of commerce: 48, 158; *pl. 148.*

MERIDA. Spanish town (Estremadura) on

the Guadiana; Roman *colonia* from 25 BC under the name of Emerita Augusta, an important centre of river-borne and maritime traffic: 183, 184, 193; *pl. 178, 186; map 426.*

MILAN. Italian city, capital of Lombardy: ancient Mediolanum, conquered by Rome in 222 BC: 14, 35, 73, 102, 208; *pl. 28, 31.*

MILDENHALL. Small town in Great Britain (Suffolk) where (1942) an important hoard of silverware dating from the Roman period was discovered (British Museum): 206, 208; *pl. 196, 197.*

MILETUS. One of the chief Ionian cities on the west coast of Asia Minor: 277; *pl. 355.*

MINGAZZINI (Paolino). Italian archaeologist, born 1895: 145.

MINTURNAE. Small Italian town in southern Latium, which in 1879 reassumed the name of an ancient city near the mouth of the Garigliano; the latter became Roman in 314 BC, and was subsequently traversed by the Appian Way: 16.

MITHRA. Persian divinity associated with Light and the Invincible Sun (Sol Invictus). His cult was extremely popular among the troops, and during the third century rivalled that of Christianity: 19, 59, 265, 375.

MITHRAEUM. 93; *pl. 82, 83.*

MODENA. Town in northern Italy (Emilia), formerly Mutina: Roman *colonia* from 183 BC: 114; *pl. 101.*

MOESIA. Roman province lying south of the Lower Danube, and extending as far as the Black Sea and the northern side of the mountains forming the Balkan chain, between Dacia and Thrace; today its territory is divided between Rumania and Bulgaria: 110, 127, 129, 153, 306, 319, 325, 374.

MOGILOVO. Bulgarian town (Stara Zagora district): *pl. 110.*

MONTBOUY. French village (Loiret), 10 miles south of Montargis, where a number of wooden images have been found, ex-voto offerings from a Romano-Gallic sanctuary (Orléans, Musée historique de l'Orléanais): 137; *pl. 127, 128.*

MONTORIO VERONESE. Italian village, 4 miles from Verona: 123; *pl. 112.*

456

PAUL, Saint (*c.* 5–*c.* 67). Born at Tarsus. The most vigorous missionary for the propagation of Christianity, which he transformed from a Jewish sect into a universal religion. Executed in Rome under Nero: 19, 35, 350, 377.

PAULINUS OF NOLA, Saint (Meropius Pontius Anicius Paulinus), *c.* 353–431. Born at Bordeaux, of a patrician family, and a pupil of Ausonius. After a brilliant public career he was converted to Christianity, and became Bishop of Nola in southern Italy. He is the author of poetical and religious works: 175. 175.

PAVIA. Italian town (Lombardy) at the confluence of the Tessin and the Naviglio: ancient Ticinum: 29; *pl. 25.*

PENTHEUS. In Greek myth and tragedy, a Theban king who attempted to ban the cult of Dionysus, and was torn to pieces by the Bacchants, amongst whom was his own mother, Agave: 231.

PEREGRINUS (Lucius Publius). Officer (centurion) in the Roman army; his sarcophagus, decorated with images of philosophers and the Muses, still survives (Rome, Museo Torlonia): 56; *pl. 51.*

PERGAMUM (BERGAMA). Greek city of Asia Minor (Mysia), capital of the Hellenistic kingdom of the Attalids: centre of an eclectic school of sculpture, the influence of which continued to make itself felt under the Roman Empire: 8, 233, 237, 246, 267, 277, 336, 341, 375.

PERPETUA, Saint (Vibia Perpetua), *c.* 180–203. Of a noble family; executed as a Christian on 7 March 203, together with Felicity, Satura, Saturninus and Revocatus: 215.

PERTINAX (Publius Helvius Pertinax) 126–93. Roman Emperor from 1 January until 28 March 193; acclaimed by the Praetorians after the murder of Commodus, and was then himself assassinated: 1.

PESCENNIUS NIGER JUSTUS (Caius) *c.* 140–94. Governor of Syria, proclaimed Emperor by the Eastern legions in 193 (on the death of Commodus), but defeated on the plain of Issus in Cilicia by Septimius Severus (194), and killed while fleeing to the Parthians: 1, 349.

PHAEDRA. Heroine of a Greek tragedy by Euripides; in love with Hippolytus: 50, 193, 302; *pl. 279.*

PHAETHON. 50; *pl. 47.*

PHEIDIAS (*c.* 490–*c.* 431 BC). The most famous sculptor of classical Greece; between 447 and 437 he directed the construction of the Parthenon in Athens, which housed one of his masterpieces, a colossal statue of Athena, inlaid with gold and ivory: 349.

PHILIP THE ARAB (Marcus Iulius Philippus), 198–249. Roman Emperor (244–9); son of an Arab chieftain from Trachonitis: 23; *pl. 20, 382.*

PHILOSTRATUS THE ELDER. Greek writer and rhetorician from Lemnos. Tutor to the sons of the Emperor Septimius Severus, and author of a work (*Eikones*) which contains a literary description of several mythological paintings (early third century): 231.

PIACENZA. Town in northern Italy (Emilia): with Cremona, the oldest Roman *colonia* in the northern part of the peninsula (218 BC). From 187 BC traversed by the Via Emilia, which ended at Rimini; it was here, in AD 271, that the Emperor Aurelian was defeated by the Alamanni and Marcomanni: 110.

PIAZZA ARMERINA. Town in eastern Sicily (Enna), close to which a grandiose Roman villa was brought to light. The mosaic flooring and pavements of this villa are still intact; their date is still the subject of controversy (late third century, or 320–60): 237, 244–246, 248, 336; *pl. 199, 224–227, 229, 423; map 426.*

PICARD (Gilbert-Charles). Contemporary French archaeologist: 142, 143.

PLATO (427–347 BC). Famous Greek philosopher: 328.

PLAUTIANUS (Caius Fulvius). Friend and collaborator of the Emperor Septimius Severus; senator; Praetorian Prefect from 197. In January 205 Caracalla, who had married his daughter Plautilla, had him murdered in Severus's presence: 267.

PLAUTILLA. Daughter of C. Fulvius Plautianus. In 202 she married Caracalla, who subsequently banished her to the Lipari Isles, and in 212 ordered her execution there: 267.

PLEBEIAN (ART). Name given to that trend in Roman art which derives from the Italic tradition, as opposed to 'official' art, which stands closer to Hellenism. Another label sometimes used to

denote this trend is that of 'Popular Art': 11, 35, 42, 58, 63, 65, 70, 73, 78, 80, 81, 111, 113, 132, 148, 153, 154, 169, 184, 205, 221, 306, 314, 341, 363, 373, 374.

PLINY THE ELDER (Caius Plinius Secundus Maior), 23–79. Roman admiral and writer, author of an encyclopedia entitled *Naturalis Historia*, dedicated to Vespasian: 105, 184, 223, 378.

PLOTINUS (*c.* 204–70). Philosopher, born at Lycopolis in Egypt; founder of Neoplatonism. Came to Rome (244) where he entered the Court circle around the Emperor Gallienus: 16, 19, 42, 56; *pl. 15.*

PLOVDIV. Town in southern Bulgaria: formerly Philippopolis (Thrace; south of Marica: Archaeological Museum): *pl. 287.*

POLYDEUCES (Ioulios) or in Latin POLLUX (Julius). A favourite pupil of the philosopher and writer Herodes Atticus, in Athens; born at Naucratis about the middle of the second century; died young: 297; *pl. 275.*

POMERANIA. Ancient kingdom situated on the edge of the Baltic, between the Oder and the Vistula: 291.

POMPEII. City of southern Italy, destroyed AD 79 by eruption of Vesuvius: 86, 88, 178, 231, 261, 284.

POMPEY THE GREAT (Cn. Pompeius Magnus), 106–48 BC. Roman general and politician; after putting down the pirates and defeating King Mithridates VI, he formed the First Triumvirate, together with Julius Caesar and Crassus (60 BC), but afterwards fell in the civil war against Caesar (49–48 BC): 139, 183, 184.

POPAEIUS SENATOR. 137; *pl. 126.*

PORCIGLIANO. Locality near Rome: *pl. 20.*

PORCUNA. Town in Spain (Jaén): known to the Romans as Obuleo: *pl. 159.*

PORPHYRY, Saint (*c.* 348–420). Born at Thessalonika; a monk first in Egypt, then in Palestine; Bishop of Gaza: *pl. 354.*

PORPHYRY. A red stone of volcanic origin; very solid and extremely difficult to work. The quarries were in Egypt (Mons Porphyrites, now the Gebel Doukhan, on the Isthmus of Suez).

Porphyry was used during the Imperial Roman era, especially the Late Empire, for statues of emperors and ornaments connected with the imperial person or cult: 103, 278, 281, 282, 350, 374; *pl. 256, 258* (e.g.).

POSTUMUS (Marcus Cassianius Latinius Postumus). Roman officer who revolted against Gallienus at the same time as the Alamanni broke into Italy, and established an independent Empire in Gaul, which he kept going from 258 until 267: 106, 175; *pl. 389.*

PRIAPUS. God of fertility, originally from Asia Minor; protector of gardens and vineyards: 107; *pl. 96.*

PROBALINTHOS (Attica): *pl. 274.*

PROBUS (Marcus Aurelius), 232–82. Roman Emperor (276–82): *pl. 392.*

PROCLUS. Prefect of Constantinople in 390: 356.

PROCONNESUS. Small island in the Sea of Marmara: 45.

PROCOPIUS OF GAZA (d. 530). Master of rhetoric, born at the close of the fifth century. Pronounced the funeral panegyric on the Emperor Anastasius I (*c.* 512–15) at Gaza: 367.

PROJECTA and SECUNDUS (Lucius Turcius Secundus Asterius). Husband and wife: he was the son of a City Prefect, and himself served in turn as quaestor, praetor, and consul *suffectus*; while Projecta (his second wife) was the daughter of a certain Florus, who had founded a church in Rome. Their names are inscribed on a silver casket, an important item in a hoard of silverware discovered on the Esquiline (main items now in the British Museum). Projecta died in 383, at the age of sixteen, and her epitaph was composed by Pope Damasus. Since it was illegal to marry a girl when she was under twelve, the wedding must have taken place between 379 and 382, which enables us to date the casket: 100, 102, 334; *pl. 92, 93.*

PROMETHEUS. In Greek mythology, a Titan who stole fire from Heaven and gave it to mankind, an act for which he was cruelly punished by Zeus; he afterwards created men, whom he modelled in clay, their souls (in the form of a butterfly) being bestowed on them by Athena: 48; *pl. 42.*

PROSERPINE. Latin name for the goddess Persephone, daughter of Zeus and Ceres

(Demeter), who married Pluto, god of the Underworld: 46.

PROTESILAUS. Thessalian hero of Greek mythology, the first man to fall before Troy; he survived in legend as an example of conjugal love that endured even beyond the grave: 46.

PUNIC. Name given to the Phoenicians of Carthage and to their culture: 70, 139, 183, 192, 215, 216, 218, 237, 267.

PUPIENUS (Marcus Clodius Pupienus Maximus). Emperor of Rome; nominated by the Senate in April 238, and murdered by the Praetorians after a three months' reign: 23, 60, 169; *pl. 379.*

QUADI and MARCOMANNI. Germanic tribes who attacked the Roman frontiers on the Danube from about the middle of the second century: 106, 149.

QUADRUMVIR or QUATUORVIR. One of the four magistrates responsible, in Rome, for the upkeep of public highways; in the provinces, municipal senators: 113, 162.

RAVENNA. Italian city (Romagna) near the coast of the Adriatic; from 404 the residence of the Emperor in the West, and subsequently the capital of the Gothic kings: 102, 175, 250, 271, 291, 367, 373; *map 426.*

REIMS. Town in northern France (Marne), centre of those Gaulish tribes known as the Remi: latterly a Roman town in Belgica Secunda, under the name of Durocortorum: 158; *pl. 148.*

RIEGL (Alois), 1858–1905. Austrian art-historian: 333.

RIMINI. Italian town (Romagna) on the Adriatic coast. Roman *colonia* from 268 BC; ancient Ariminum (Museo Comunale): 110; *pl. 97.*

RODENWALDT (Gerhart), 1886–1945. German archaeologist: 5, 66.

ROLLAND (Henri). French archaeologist, born 1887: 142.

ROME. Capital of Italy; centre of the Roman Empire until the foundation of Constantinople in 330: *maps 426–428.*

Antonine Column: 31, 66, 67, 306, 341, 352, 364.
Arch of Constantine: 8, 68, 73–83, 334, 339, 363, 374; *pl. 23, 66–71, 74.*
Arch of Septimius Severus: 27, 63, 65–67, 70, 73, 374; *pl. 57, 58, 59, 62, 63, 356.*

Arch of Titus: 63, 73.
Arch of Trajan: 63.
Arcus argentariorum: 70, 272.
Basilica of Maxentius: 83; *pl. 360.*
Basilica of S. Sebastiano (Via Appia): 86; *pl. 77, 78.*
Baths of Alexander Severus: 6; *pl. 7, 366.*
Baths of Diocletian: *pl. 361, 420.*
Campus Martius: 6.
Catacombs, Christian: 88; *pl. 80.*
Catacombs on the Via Latina: 46, 102, 265.
Forum Boarium: 70; *pl. 64.*
Forum Romanum: 63, 83, 90, 306; *pl. 57–59, 62, 63, 81, 356.*
Forum Traiani: 83.
Golden House (Domus Aurea): 231.
Mausoleum of St Helena (Tor Pignattara): 103, 350; *pl. 369, 424.*
Porta S. Sebastiano: *pl. 358.*
S. Costanza: 102, 103, 233; *pl. 370, 425.*
S. Lorenzo fuori le mura: 42.
S. Maria Maggiore: 68, 259.
S. Prisca: 93; *pl. 82, 83.*
Temple of Minerva Medica: *pl. 363.*
Villa Medici: 50.

ROSTOVTZEFF (Mikhail Ivanovich), 1870–1952. Eminent Russian historian, who in 1920 emigrated to the United States: 15.

RUFINUS (Flavius Rufinus), *c.* 335–95. Prefect of the Praetorians in Constantinople (392), assassinated at Stilicho's instigation: 373.

RUMPF (Gustav Andreas Christian), 1890–1966. German archaeologist: 259.

SABAZIUS. A divinity much akin to Dionysus, originally from Phrygia; his cult and mysteries were introduced to Rome during the second century BC: 375.

SABRATHA. Ancient Roman town in Tripolitania, on the Mediterranean, 42 miles west of Tripoli: 261.

SAINT-AMBROIX. French village (Cher), 17 miles south-west of Bourges: ancient Ernodorum: 158; *pl. 147.*

SAINTES. French town (Charente-Maritime): ancient Mediolanum Santonum: 157; *pl. 142.*

SAINT-RÉMY-DE-PROVENCE or SAINT-RÉMY-DES-ALPILLES. Town in the South of France (Provence): formerly Glanum, in Gallia Narbonensis. It grew and flourished during the Hellenistic period as a trading entrepôt for Marseilles; Romanized about the middle of the first century

BC, with artistic contacts in Magna Graecia (southern Italy). After the occupation of Marseilles (49 BC) it became a Roman centre. Important monuments still survive: 139, 142, 143, 145, 147, 170; *pl. 131–133.*

SALAS DE LOS INFANTES. Spanish village (Burgos), 34 miles to the southeast of Burgos: *pl. 184.*

SALONAE (SOLIN). Ancient Roman town 4 miles north-east of Split: 130; *pl. 122.*

SALONIKA (THESSALONIKA). City of northern Greece; capital of the Roman province of Macedonia; residence of the Emperor Galerius (305–11): 258, 259, 297, 305, 357, 375, 377; *pl. 277, 278, 280–283, 354, 422; map 426.*
Arch of Galerius: *pl. 280–283.*
Haghios Georgios: 258, 259, 305; *pl. 354.*

SALYES. A Celtic people from southern Gaul: 139.

SANDANSKI. Bulgarian village, 100 miles south of Sofia: *pl. 119.*

SANGALLO (Giuliano Giamberti, known as Giuliano da), 1445–1516. Florentine sculptor and architect of the Renaissance: 50; *pl. 49.*

SARAGOSSA (ZARAGOZA). Town of north-east Spain (Aragon); in antiquity a centre for the Celtiberians (Salluvia). Under Augustus it became a Roman *colonia* (Caesarea Augusta), and was an important city in the province of Hispania Citerior: 103.

SARMIZEGETUSA. Rumanian town (Southern Carpathians) near which stand the ruins of the Roman *colonia* known as Ulpia Traiana, capital of the province Dacia Apulensis; the ancient capital of free Dacia (Sarmizegethusa) lay some 25 miles distant: 163.

SARVISTAN. A village in Iran, 57 miles south-east of Shiraz: 334.

SASSANIDS. A Persian dynasty, which ruled from the downfall of the Parthian dynasty (defeated in 227 by Ardashir) until the Arab Conquest of 651: 80, 193, 294, 334.

SASSETTI (Francesco). Florentine merchant (d. 1485) who built a chapel to contain the tombs of his family, complete with frescoes and monuments, in the Church of S. Trinità in Florence: 50; *pl. 49.*

SCHLUNK (Helmut). Contemporary German archaeologist: 195.

SCHMARSOW (August von), 1853–1936. German art-historian: 333.

SCHOBER (Arnold). Contemporary Austrian archaeologist: 106.

SCHOPPA (Helmut). Contemporary German archaeologist: 106.

SEASONS. The four seasons (spring, summer, autumn, winter) first received iconographic representation in Hellenistic art; this treatment was adopted by art of the Roman period, and widely employed on monuments from the latter half of the second century AD. It now also became loaded with symbolic significance of one sort or another (the ages of man; death and resurrection; the pleasant gifts of life, and the happiness which awaits us in the life hereafter, etc.): 48, 63, 81, 222, 237, 245, 329, 336; *pl. 36, 57, 72, 205, 221, 222, 317.*

SECUNDUS. *See* PROJECTA.

SELEUCIA. City founded by Seleucus I, in 312, on a canal between the Euphrates and the Tigris, 42 miles east of Babylon; important commercial centre; destroyed in AD 164, during Lucius Verus's campaign against the Parthians, it ceded its position to the town of Ctesiphon (q.v.), on the other bank of the Tigris: 65.

SENECA (Lucius Annaeus Seneca). *c.*4 BC AD 65. Roman senator, a native of Cordova (Spain). A Stoic philosopher and playwright, Seneca was forced by Nero to commit suicide in 65: 16.

SEPTIMIUS SEVERUS (Lucius Septimius Severus), 144–211. Roman Emperor (193–211), born at Leptis Magna (Tripolitania), died at Eburacum (York, Great Britain): 1, 8, 19, 27, 41, 63, 65, 67, 70, 73, 130, 233, 261, 267, 271, 349, 357, 374; *pl. 57–59, 62–64, 247, 303, 356, 372.*

SERAPIS. An originally Babylonian divinity, introduced into Egypt by King Ptolemy I (306–285 BC), with an official cult that included mysteries. This cult became widespread under the Roman Empire, when Serapis was regarded as an eschatological deity who promised salvation (*soteria*) in the life to come: 70, 267.

SERDICA (Colonia Ulpia Serdica). Town in Thrace, where Trajan established a colony corresponding to modern Sofia (Bulgaria): 73, 319.

SERENA (366–410). Niece and adopted daughter of Theodosius; married Stilicho: 35.

SETIF. Algerian town 78 miles west of Constantine, the ancient Sitifis: 226.

SEVERI, The. 27, 41, 50, 66, 70, 236, 248, 261, 267, 268, 271, 322, 350; *pl. 245–248, 250, 357, 422.*

SEVILLE. Town in south-west Spain (Andalusia) on the Guadalquivir: in antiquity, an Iberian centre known as Hispalis, which in Julius Caesar's time became a Roman *colonia* under the name of Colonia Iulia Romula; conquered by the Vandals in 411: 184; *pl. 176, 177; map 426.*

SHEIK ZOUEDA. Village in Egypt, near which the ruins of a fortified site have been discovered, on the main road between Palestine and Egypt. In the ruins is a mosaic, with a (highly barbarized) mythological subject, and a long Greek inscription which has been dated to about 350 (J. Clédat, *Annales du Service des Antiquités de l'Égypte,* XV, 1915, *pl. III*): 193.

SHEPHERD, THE GOOD. Representation of a virile figure carrying a lamb on his shoulders. This image turns up in the early art of Asia Minor, and subsequently in Greek art as well; it became a stock pagan symbol for love of one's fellow-men, and entered Christian iconography as a symbol of Jesus Christ, the 'Good Shepherd', who saves even the weakest lamb in his flock from all danger: 88, 132; *pl. 80.*

SIDAMARA. Site in Anatolia (Cilicia) where sarcophagi have been found with figures in column-niches: 344, 347; *pl. 327, 328.*

SIDI ABICH. Tunisian village, 3 miles from Enfidaville: site of a three-aisled basilica flanked by a baptistry: 252.

SILIANA. Small town in Tunisia, 12 miles north-east of Maktar: 216, 218; *pl. 200.*

SILISTRA. Bulgarian town (Dobrudja) on the right bank of the Danube; formerly Durostorum in Lower Moesia, and from Hadrian's time a Roman *municipium*. After 376 the Goths settled on its territory, with Imperial consent and approval: 325; *pl. 306–308; map 426.*

SIRMIUM. Town in ancient Illyria, where

TEUTOBURG (Forest). The place where, in AD 9, three Roman legions under Varus were totally defeated by German tribes led by Arminius (Hermann). There is no certainty that the part of Westphalia which today bears this name is in fact the same place as Tacitus the historian describes: 153.

THEBES. Ancient Egyptian city on the right bank of the Nile; it embraces the two modern towns of Luxor and Karnak: *pl. 262.*

THEODORE. Bishop of Aquileia during the fourth century: 234; *pl. 216.*

THEODOSIUS I, known as THE GREAT (Flavius Theodosius), *c.* 346–95. Roman Emperor (379–95), born at Cauca in Spain. On his death the Empire was divided between his sons, Arcadius taking the East and Honorius the West: ix, 31, 35, 251, 258, 347, 350, 352, 357, 358, 364, 365, 367, 373, 377; *pl. 28, 333–336, 338, 365, 375, 411; map 426.*

THEODOSIUS II (Flavius Theodosius Junior), 401–50. Roman Emperor of the East (408–50), grandson of Theodosius I; he built a new *enceinte* round Constantinople, and gathered together in the *Theodosian Code* all Imperial decrees promulgated since the time of Constantine I: 352, 363; *pl. 332.*

THEODOSIAN CODE. 32, 211.

THESSALONIKA. *See* SALONIKA.

THOTH. Egyptian lunar god, in the form of an ibis; main centre of worship at Hermopolis: 277.

THRACE. Territory lying east of Macedonia and south of the Balkans, covering parts of modern Greece, Bulgaria, and Turkey: an independent kingdom that was even prepared to stand up against the kings of Macedonia, and was not reduced to provincial status by the Romans until AD 46, during the reign of Claudius: 73, 106, 110, 129, 153, 197, 199, 306, 311, 319, 325, 344, 374, 375; *map 426.*

THRACIAN HORSEMAN. Image of a hunter on horseback, which we find repeated on a great number of cult-reliefs from ancient Thrace, sometimes with the epigraphic attribution of 'Hero' (in Greek). They first turn up at the beginning of the second century, and sometimes continue into the third; we have a few isolated cases from the beginning of the fourth. The horseman is generally portrayed as a young man, but in a few instances he is bearded, or even given three heads. The style of these popular reliefs is influenced by Hellenistic Greek art: 129, 309, 311; *pl. 119, 286–289.*

THUBURBO MAIUS. Ancient city of Tunisia, 34 miles south of Tunis, near Henchir el-Kasbat; made a Roman *colonia* in 27 BC: *pl. 223.*

THUGGA. Ancient name for the village of Dougga (northern Tunisia), 66 miles south-west of Tunis: formerly Punic and Numidian, afterwards Roman. Important remains of the latter period survive: 216, 218, 231; *pl. 202, 213.*

THYSDRUS. Ancient name for the village of El-Djem (eastern Tunisia) near Sousse. During the second and third centuries it enjoyed a special period of prosperity as a trading-centre (wheat and olive-oil). Gordian I was proclaimed Emperor there in February 238: 248; *pl. 230.*

TIBERIUS (Tiberius Iulius Caesar), 42 BC–AD 37. Roman Emperor (14–37); the son of Livia (q.v.), and adopted by Augustus, whose successor he became: 15, 139, 145, 267.

TIMGAD. Modern name for the ancient town of Thamugadi in Numidia (Algeria). Founded in 100 by Trajan as permanent quarters for the Third Legion, it grew rapidly. It still visibly preserves its original structure, as well as its monuments, in a way unmatched by any other Roman site in Africa: 216; *pl. 210, 357.*

TIMOTHY (first century). Born at Lystra, the friend and companion of St Paul (q.v.), he is considered as the first Bishop of Ephesus: 350.

TIPASA. Town in Algeria, 40 miles west of Algiers, on the Mediterranean: 237; *pl. 219, 220.*

TITUS (Titus Flavius Vespasianus), 39–81. Roman Emperor (79–81), son of Vespasian: 63, 73, 277.

TOMIS or TOMI. *See* CONSTANTZA.

TOUGET. French village (Gers), 16 miles from Lombez: 158; *pl. 149.*

TRAJAN (Marcus Ulpius Traianus), 53–117. Roman Emperor (98–117), born in Italica (Spain). After conquering the Dacians in two campaigns (101–2, 105–7) he made Dacia (the territory of which roughly coincides with modern Ru-

mania) a Roman province: 41, 63, 66, 73, 81, 83, 123, 193, 311, 314, 334, 339, 352, 364; *pl. 290–297.*

TRALLES. Ancient Greek city, overrun in the sixth century BC by the Persians; its ruins lie one mile from Aydin (Turkey): 349.

TREBONIANUS (Caius Vibius Trebonianus Gallus). Roman Emperor (251–3); former Governor of Lower Moesia, and descended from an ancient Etruscan family: 27; *pl. 21, 386.*

TRÈVES (TRIER). City of West Germany (Rhineland-Palatinate) on the Moselle; ancient Augusta Trevirum, which was to become one of the capitals of the Roman Empire: 73, 106, 158, 175–178, 197, 198, 208, 211; *pl. 29, 165–167, 187, 359; map 426.*

TRIPOLI. City of the Arab Republic of Libya, in North Africa: ancient Oea: 218, 261, 264; *map 426.*

TRIPOLITANIA. Part of the Arab Republic of Libya, in North Africa. In antiquity it formed part of the Roman province of Africa, and was thus named because there were only three towns in this area: Oea (Tripoli), Leptis, and Sabratha (qq.v.): 1, 95, 215, 223, 261–275, 374.

TRIPOLJE. *See* CUCUTÉNI.

TUDELA. Spanish town (Navarre) on the Ebro: ancient Tutela: 193; *pl. 185.*

TUNIS. Capital of the Republic of Tunisia, near the site of ancient Carthage (Bardo National Museum): *pl. 204.*

TYCHE. Greek goddess much akin to Roman Fortuna. She symbolized the hazards, whether good or ill, of human destinies – which explains why all cities built her a temple: 306, 322; *pl. 304.*

TYRE (SOUR). Important Phoenician trading-port, on an island off the Syrian (now the Lebanese) coast; linked to the mainland by a causeway which Alexander the Great built (332 BC): 103, 336; *pl. 318; map 426.*

ULYSSES. *See* ODYSSEUS.

UTHINA. Ancient city in Tunisia; its ruins are near Udna, 12 miles south of Tunis: 237.

VAISON-LA-ROMAINE. Town in the South of France (Vaucluse), formerly the capital of the Vocontii, a Gaulish tribe (Vasio): 169; *pl. 160.*

A monk from Trebizond, who lived in Constantinople during the eleventh century; wrote an epitome of Dio Cassius's history, from the war between Caesar and Pompey down to the death of Septimius Severus: 312.

YUNUSLAR. Turkish village, near Konya: ancient Pappa Tiberiopolis: *pl.326*.

ZENOBIA. Queen of Palmyra; from 267 to 272 she ruled on behalf of her son Wabalath, who was a minor; then she was taken prisoner by the Romans under Aurelian, and her town was destroyed: 334.

ZLITEN. Place in Libya (eastern Tripolitania), now Dar Buc Ammera; a large Roman villa was discovered here: 263; *pl. 241*.

ZOSIMUS (fifth-sixth century). Greek historian, pagan by inclination; about 500 he composed a historical work (*New History*) covering the period from Augustus (whose reign began 27 BC) down to the year 410: 349.

Maps

THE ROMAN EMPIRE AT THE DEATH OF THEODOSIUS I (395)
ACCORDING TO THE 'NOTITIA DIGNITATUM'

THE DIOCESES (END 4TH – BEGINNING 5TH CENTURY)

REPUBLICAN ROME (ABOUT 50 BC)

IMPERIAL ROME AT THE DEATH OF THEODOSIUS I (395)

GATES IN THE REPUBLICAN WALLS

A FLUMENTANA
B CARMENTALIS
C FONTINALIS
D SANQUALIS
E SALUTARIS
F QUIRINALIS
G COLLINA
H VIMINALIS
I ESQUILINA
J CAELEMONTANA
K QUERQUETULANA (?)
L CAPENA
M NAEVIA
N RAUDUSCULANA
O LAVERNALIS
P TRIGEMINA

GATES IN THE AURELIAN WALLS

A FLAMINIA
B PINCIANA
C NOMENTANA
D TIBURTINA
E ASINARIA
F METRONIA
G LATINA
H APPIA
I ARDEATINA
J OSTIENSIS
K PORTUENSIS
L AURELIA
M SEPTIMIANA

STRUCTURES INSIDE THE REPUBLICAN WALLS

1 AEDES IOVIS OPTIMI MAXIMI....................TEMPLE OF JUPITER
2 AEDES IUNONIS MONETAE..............TEMPLE OF JUNO MONETA
3 COMITIUM .. COMITIUM
4 AEDES FORTUNAE ET MATRIS MATUTAE
 TEMPLE OF FORTUNE AND THE MATER MATUTA
5 AEDES CIBELES.........................TEMPLE OF CYBELE
6 CIRCUS MAXIMUS.........................CIRCUS MAXIMUS
7 AEDES FORTUNAE (?)..................TEMPLE OF FORTUNE (?)

STRUCTURES OUTSIDE THE REPUBLICAN WALLS

8 PORTICUS AEMILIA.........................AEMILIAN PORTICO
9 HORREA GALBIANA.........................GRANARIES OF GALBA
10 THEATRUM AD AEDEM APOLLINIS.............................
 THEATRE NEAR THE TEMPLE OF APOLLO
11 AEDES APOLLINIS ET AEDES BELLONAE.........................
 TEMPLES OF APOLLO AND BELLONA
12 PORTICUS METELLI.......................PORTICO OF METELLUS
13 AEDES HERCULIS ET MUSARUMTEMPLE OF HERCULES AND THE MUSES
14 CIRCUS FLAMINIUS.........................CIRCUS FLAMINIUS
15 AEDES NEPTUNI (?).......................TEMPLE OF NEPTUNE (?)
16 THEATRUM POMPEI.........................THEATRE OF POMPEY
17 PORTICUS POMPEIANA.........................PORTICO OF POMPEY
18 AREA SACRA ('LARGO ARGENTINA').........................
 REPUBLICAN TEMPLES OF THE 'LARGO ARGENTINA'
19 AEDES LARUM.........................TEMPLE OF THE LARES
20 SAEPTAELECTORAL PRECINCT
21 AEDES AESCULAPI IN INSULA.........................
 TEMPLE OF ASCLEPIUS ON THE INSULA TIBERINA

BRIDGES AND HARBOUR

22 SUBLICIUS (?)
23 AEMILIUS
24 FABRICIUS
25 CESTIUS
26 NAVALIA (ARSENAL)

STRUCTURES INSIDE THE AURELIAN WALLS

1 AEDES IOVIS OPTIMI MAXIMI....................TEMPLE OF JUPITER
2 ARX (AEDES IUNONIS MONTAE)..CITADEL (TEMPLE OF JUNO MONETA)
3 AEDES FORTUNAE ET MATRIS MATUTAE....................
 TEMPLE OF FORTUNE AND THE MATER MATUTA
4 ARA MAXIMA HERCULIS...............GREAT ALTAR OF HERCULES
5 CIRCUS MAXIMUS.........................CIRCUS MAXIMUS
6 AEDES CERERIS.........................TEMPLE OF CERES
7 AEDES LUNAE.........................TEMPLE OF THE MOON
8 AEDES MINERVAE.........................TEMPLE OF MINERVA
9 AEDES IUNONIS REGINAE..................TEMPLE OF QUEEN JUNO
10 AEDES DIANAE.........................TEMPLE OF DIANA
11 DOMUS ET THERMAE SURAE.............HOUSE AND BATHS OF SURA
12 AEDES BONAE DEAE.................TEMPLE OF THE GOOD GODDESS
13 TEMPLUM DIVI CLAUDII.......TEMPLE OF THE GOD CLAUDIUS
14 AMPHITHEATRUM AMPHITHEATRE
15 LUDUS MAGNUS.........................GLADIATORS' QUARTERS
16 THERMAE TITI.........................BATHS OF TITUS
17 THERMAE TRAIANI.........................BATHS OF TRAJAN
18 NYMPHAEUM (AUDITORIUM MAECENATIS).........................
 NYMPHAEUM (MAECENAS'S RECITAL-ROOM)
19 ARCUS GALLIENI.........................ARCH OF GALLIENUS
20 AEDES IUNONIS LUCINAE.......TEMPLE OF JUNO LUCINA
21 AEDES FORTUNAE.........................TEMPLE OF FORTUNE
22 PORTICUS AEMILIA.........................AEMILIAN PORTICO
23 HORREA GALBIANA.........................GRANARIES OF GALBA
24 HORREA LOLLIANA.........................GRANARIES OF LOLLIUS
25 SEPULCRUM C. CESTII.........................PYRAMID OF CESTIUS
26 SEPULCRUM SCIPIONUM.........................TOMB OF THE SCIPIOS
27 HORTI ANNIANI ET HORTI LATERANI.........................
 GARDENS OF ANNIANUS AND GARDENS OF THE LATERAN
28 NYMPHAEUM (TEMPLUM MINERVAE MEDICAE)..................
 NYMPHAEUM (TEMPLE OF MINERVA THE HEALER)
29 CAMPUS COHORTIUM PRAETORIARUM.........................
 EXERCISE-GROUND OF THE PRAETORIAN GUARD
30 CASTRA PRAETORIA.........CAMP OF THE PRAETORIAN GUARD
31 AEDES VENERIS ERYCINAE.............TEMPLE OF VENUS ERYCINA
32 MAUSOLEUM AUGUSTI..................MAUSOLEUM OF AUGUSTUS
33 ARA PACIS.........................ALTAR OF PEACE
34 SOLARIUM AUGUSTI.........................SUNDIAL OF AUGUSTUS
35 AEDES DIVI HADRIANI...............TEMPLE OF THE GOD HADRIAN
36 ISEUM ET SERAPEUM.................TEMPLES OF ISIS AND SERAPIS
37 SAEPTA.........................ELECTORAL PRECINCT
38 THERMAE AGRIPPAE.........................BATHS OF AGRIPPA
39 PANTHEON PANTHEON
40 THERMAE NERONIANAE.........................BATHS OF NERO
41 STADIUM DOMITIANI.........................STADIUM OF DOMITIAN
42 THEATRUM POMPEII.........................THEATRE OF POMPEY
43 PORTICUS POMPEIANA.........................PORTICO OF POMPEY

→

IMPERIAL ROME AT THE DEATH OF THEODOSIUS I (395)

```
44  CIRCUS FLAMINIUS......................CIRCUS FLAMINIUS
45  THEATRUM BALBI.........................THEATRE OF BALBUS
46  PORTICUS OCTAVIAE....................PORTICO OF OCTAVIA
47  THEATRUM MARCELLI...................THEATRE OF MARCELLUS
48  ARCUS CONSTANTINI....................ARCH OF CONSTANTINE
49  BASILICA......BASILICA OF MAXENTIUS COMPLETED BY CONSTANTINE
50  THERMAE CONSTANTINI.................BATHS OF CONSTANTINE
51  THERMAE DIOCLETIANI..................BATHS OF DIOCLETIAN
52  THERMAE ANTONINIANAE................BATHS OF CARACALLA
53  DOMUS LATERANORUM......................LATERAN PALACE
54  AMPHITHEATRUM CASTRENSE............MILITARY AMPHITHEATRE
55  THERMAE HELENAE...........................BATHS OF HELEN
```

STRUCTURES OUTSIDE THE AURELIAN WALLS

```
56  MAUSOLEUM HADRIANI.................MAUSOLEUM OF HADRIAN
57  CIRCUS CAII.......................CIRCUS OF CAIUS (CALIGULA)
```

BRIDGES

```
58  AELIUS
59  NERONIANUS
60  AGRIPPAE
61  FABRICIUS
62  CESTIUS
63  AEMILIUS
64  SUBLICIUS
65  PROBI
66  NOT IDENTIFIED
```

CHRISTIAN CHURCHES AND MAUSOLEUMS FOUNDED IN ROME BY CONSTANTINE

```
67  BASILICA VATICANA.......................VATICAN BASILICA
68  BASILICA OSTIENSIS.............ST PAUL'S WITHOUT THE WALLS
69  MEMORIA APOSTOLORUM........HOLY APOSTLES (ST SEBASTIAN'S)
70  BASILICA IN AGRO VERANO....ST LAWRENCE'S WITHOUT THE WALLS
71  SANCTA SANCTORUM.......................ST JOHN LATERAN
72  SESSORIUM...................THE HOLY CROSS OF JERUSALEM
73  MAUSOLEUM CONSTANTINAE.................ST CONSTANTIA'S
74  MAUSOLEUM HELENAE.......................ST HELENA'S
```

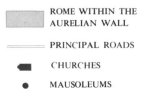

ROME WITHIN THE AURELIAN WALL

PRINCIPAL ROADS

CHURCHES

MAUSOLEUMS

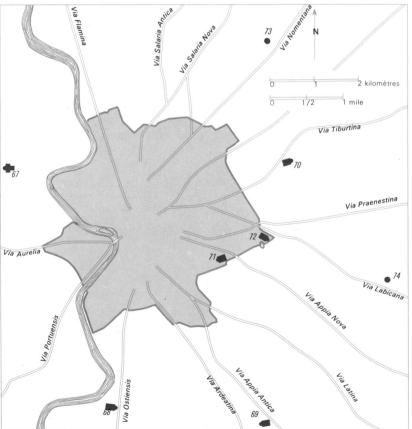

428 CHRISTIAN CHURCHES AND MAUSOLEUMS FOUNDED IN ROME BY CONSTANTINE

GOLDEN HORN

XIV
Blachernae
Palace

Royal
Gate

Gate of Charisius
or Hadrianople

Cistern of Aetius

Cistern of Aspar

XIII
SYCAE

Pempton
Gate

Gate of
St Romanus

Lycus

Church of the
Holy Apostles

X

Aqueduct of Valens

Neorion

Column of
the Goths

Acropolis

XI

Column of
Marcian

VII

St Irene

Polyandriou
Gate

Amastrianon

Philadelphion

Cisterns

VI

V **IV** **II**

Cistern of
St Mocius

Forum
Bovis

Forum of
Theodosius

Cistern

St Sophia

XII

Forum of
Arcadius

IX **VIII**

Forum of
Constantine

Milion
Augusteon

Gate of Kalagrou

III

Imperial Palace

Pegae Gate

I

SS. Carpus and Papylus

HARBOUR
OF
THEODOSIUS

HARBOUR
OF
ELEUTHERIUS

HARBOUR OF JULIAN
or
HARBOUR OF SOPHIA

BOUCOLFON
HARBOUR

Xylokerkou Gate

St John
in Studion

Golden
Gate

P R O P O N T I S

	TERRITORY WITHIN THE THREE WALLS		RIVER
	WALL OF SEPTIMIUS SEVERUS		AQUEDUCT
	WALL OF CONSTANTINE		CISTERNS
	WALL OF THEODOSIUS II		STREETS AND SQUARES
I – XIV	QUARTERS OF THE CITY		BUILDINGS

429 PLAN OF CONSTANTINOPLE

The maps were executed by Jacques Person

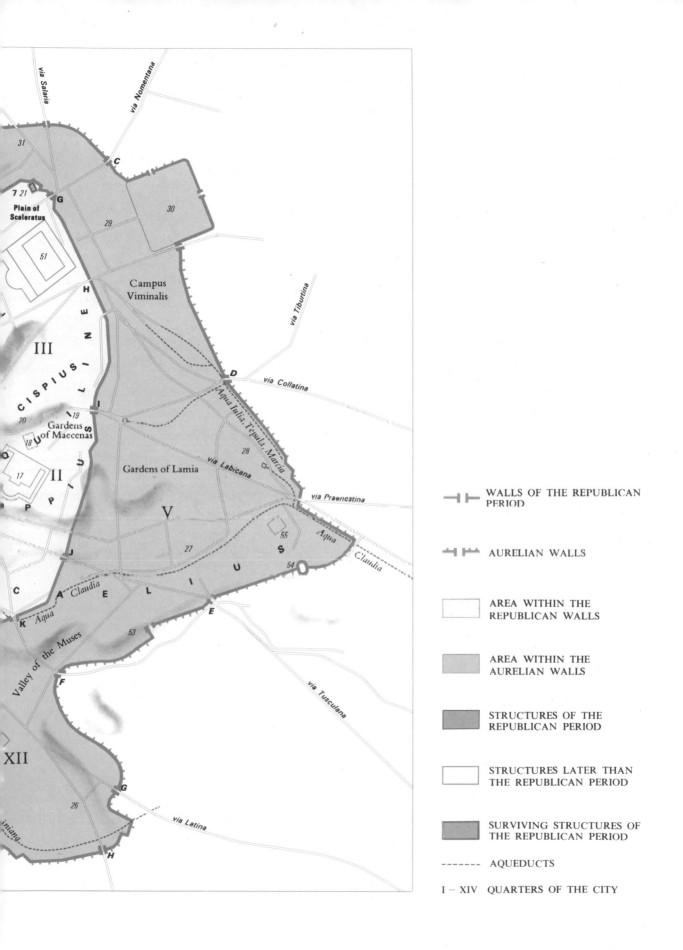

WALLS OF THE REPUBLICAN PERIOD

AURELIAN WALLS

AREA WITHIN THE REPUBLICAN WALLS

AREA WITHIN THE AURELIAN WALLS

STRUCTURES OF THE REPUBLICAN PERIOD

STRUCTURES LATER THAN THE REPUBLICAN PERIOD

SURVIVING STRUCTURES OF THE REPUBLICAN PERIOD

-------- AQUEDUCTS

I – XIV QUARTERS OF THE CITY

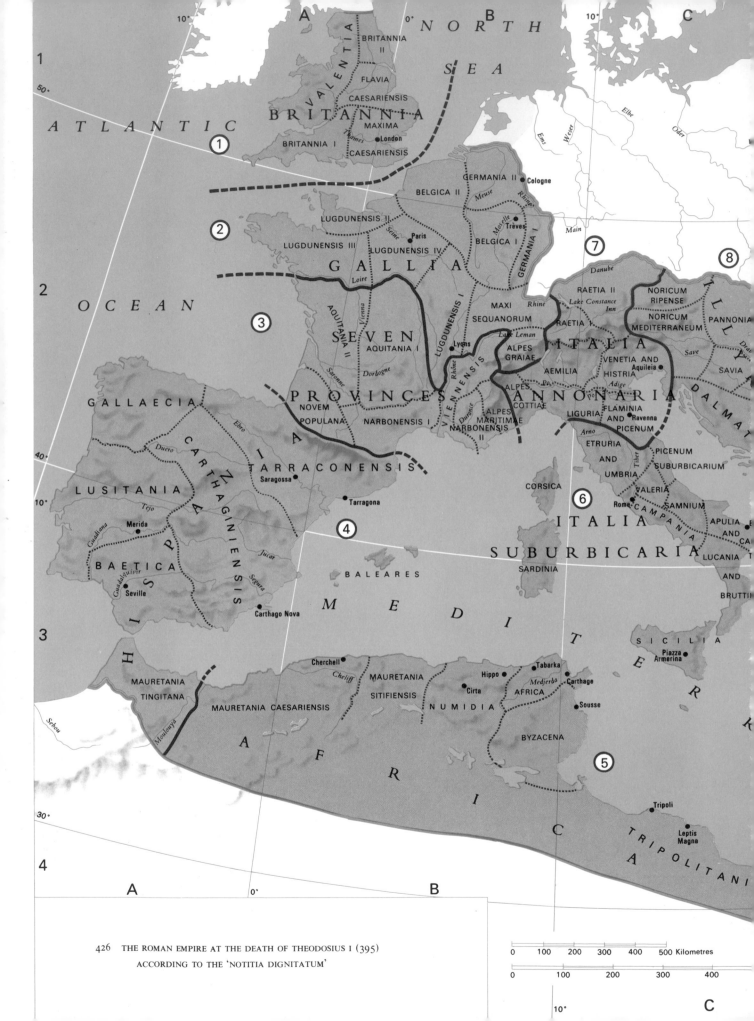

ATLANTIC

OCEAN

NORTH SEA

A B C

1

2

3

4

50°

40°

10°

30°

10° 0° 10°

BRITANNIA

VALENTIA
BRITANNIA II
FLAVIA CAESARIENSIS
MAXIMA CAESARIENSIS
BRITANNIA I
●London
Thames

GERMANIA II ●Cologne
BELGICA II
Meuse
LUGDUNENSIS II
Rhine
LUGDUNENSIS III
Seine ●Paris
LUGDUNENSIS IV
BELGICA I
Trèves●
Moselle
GERMANIA I

GALLIA

Loire

Main
Danube

SEVEN

AQUITANIA II
Vienne
AQUITANIA I
Dordogne
Saronne

MAXI
SEQUANORUM
Lyons●
Rhône
ALPES
GRAIAE

RAETIA II
NORICUM
RIPENSE
Lake Constance
Inn
RAETIA I
NORICUM
MEDITERRANEUM

ILLYRI

PANNONIA

Save
Dra

ITALIA

PROVINCES

ANNONARIA

DALMAT

NOVEM
POPULANA
NARBONENSIS I
ALPES
COTTIAE
ALPES
MARITIMAE
NARBONENSIS II
Durance
Lake Leman

VIENNENSIS

AEMILIA
Po
Adige
VENETIA AND
HISTRIA
Aquileia●

SAVIA

LIGURIA
FLAMINIA
AND
PICENUM
Ravenna●
Arno
ETRURIA
AND
UMBRIA
Tiber
PICENUM
SUBURBICARIUM
VALERIA
SAMNIUM
Rome●
CAMPANIA

APULIA
AND
CA
LUCANIA
AND
BRUTTII

GALLAECIA

Ebro
Duero

CARTHAGINIENSIS

TARRACONENSIS
Saragossa●
●Tarragona

LUSITANIA
Tejo
Jucar
Merida●
Guadiana

BAETICA
Segura
Guadalquivir
Seville●

HISPANIA

Carthago Nova●

CORSICA

ITALIA
SUBURBICARIA

SARDINIA

BALEARES

MEDITER

SICILIA
Piazza
Armerina●

MAURETANIA
TINGITANA
Sebou
Moulouya

Cherchell●
Cheliff
MAURETANIA
SITIFIENSIS
MAURETANIA CAESARIENSIS

NUMIDIA
Hippo●
Cirta●
Tabarka●
Medjerda
AFRICA
Carthage●
●Sousse
BYZACENA

AFRICA

TRIPOLITANI

Tripoli●
Leptis
Magna●

Ems *Weser* *Elbe* *Oder*

A 0° B C

① ② ③ ④ ⑤ ⑥ ⑦ ⑧

426 THE ROMAN EMPIRE AT THE DEATH OF THEODOSIUS I (395)
ACCORDING TO THE 'NOTITIA DIGNITATUM'

0 100 200 300 400 500 Kilometres

0 100 200 300 400

10°
C

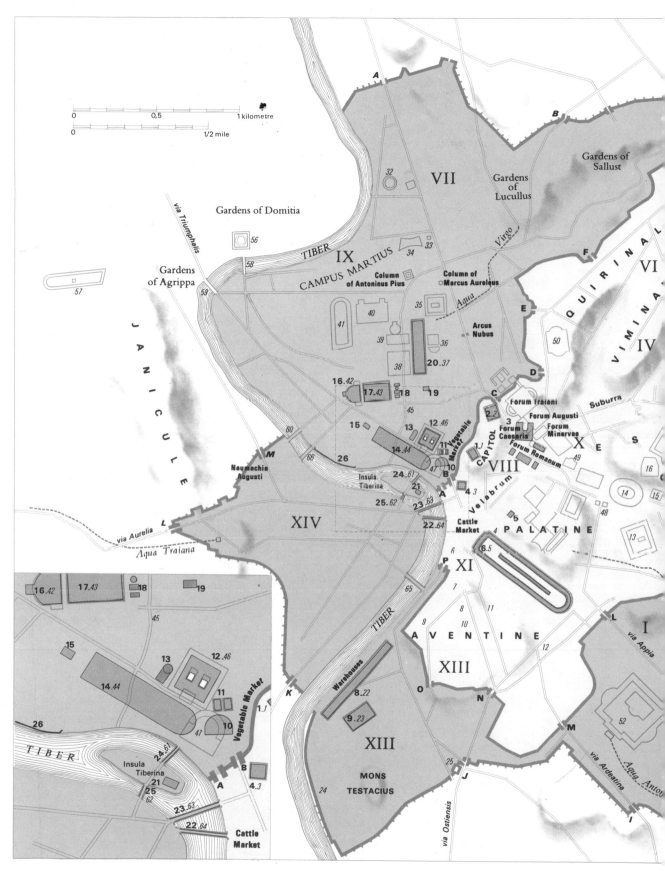

Gardens of
Sallust

Gardens
of
Lucullus

VII

32

Gardens of Domitia

56

TIBER

IX

33

34

Virgo

F

CAMPUS MARTIUS

B

Gardens
of Agrippa

58

Column
of Antoninus Pius

Column of
Marcus Aureleus

QUIRINAL

VI

57

59

35

Aqua

E

Arcus
Nubus

50

VIMINAL

IV

41

40

39

36

D

38

20.**37**

C

16.**42**

17.**43**

18

19

Forum Traiani

Suburra

X

45

2.**2**

3

Forum Augusti

E

S

Naumachia
Augusti

15

13

12.**46**

11 Vegetable
Market

CAPITOL

Forum
Caesaris

Forum
Minervae

49

60

M

14.**44**

1.**1**

VIII

Forum Romanum

16

66

26

47

10

B

4.**3**

14

15

XIV

Insula
Tiberina

24.**61**

21

A

Velabrum

48

25.**62**

23.**63**

Cattle
Market

13

J A N I C U L E

22.**64**

P A L A T I N E

via Aurelia

L

6

P

6.**5**

Aqua Traiana

XI

7

L

I

65

8

11

via Appia

TIBER

9

10

12

A V E N T I N E

O

N

XIII

M

via Ardeatina

Aqua Anton

52

Warehouses

8.**22**

K

9.**23**

25

XIII

J

24

MONS
TESTACIUS

I

via Ostiensis

Inset (lower left):

16.**42**

17.**43**

18

19

45

15

13

12.**46**

14.**44**

11

Vegetable Market

1.**1**

26

47

10

TIBER

Insula
Tiberina

24.**61**

B

4.**3**

21

A

25
62

23.**63**

22.**64**

Cattle
Market

Scale:
0 0,5 1 kilometre
0 1/2 mile

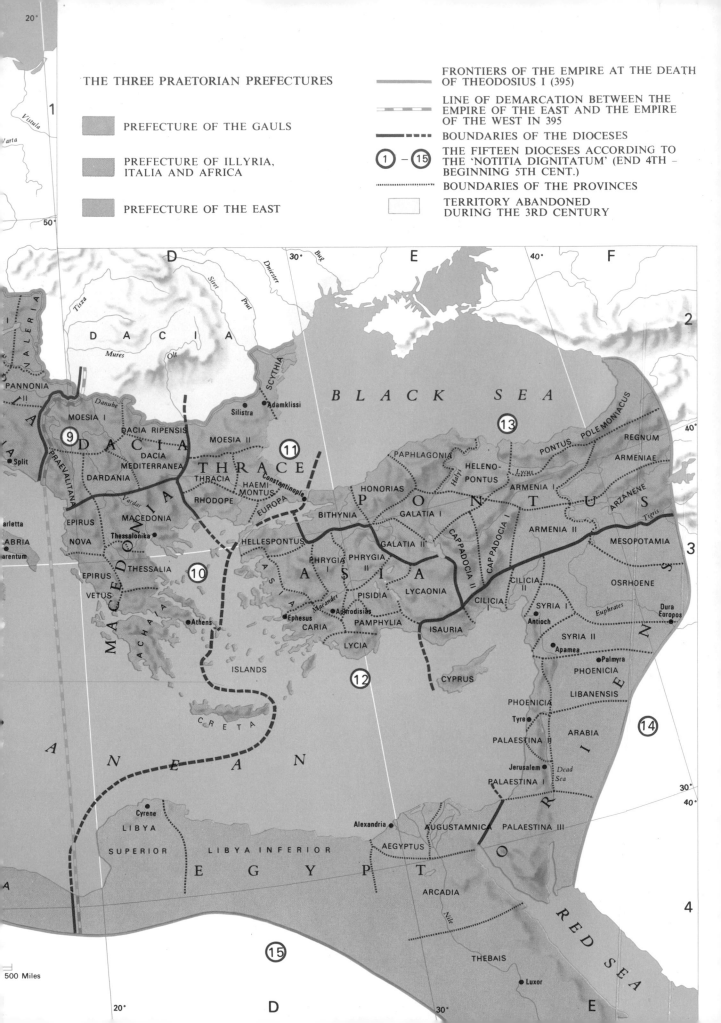

THE THREE PRAETORIAN PREFECTURES

PREFECTURE OF THE GAULS

PREFECTURE OF ILLYRIA, ITALIA AND AFRICA

PREFECTURE OF THE EAST

FRONTIERS OF THE EMPIRE AT THE DEATH OF THEODOSIUS I (395)

LINE OF DEMARCATION BETWEEN THE EMPIRE OF THE EAST AND THE EMPIRE OF THE WEST IN 395

BOUNDARIES OF THE DIOCESES

①–⑮ THE FIFTEEN DIOCESES ACCORDING TO THE 'NOTITIA DIGNITATUM' (END 4TH – BEGINNING 5TH CENT.)

BOUNDARIES OF THE PROVINCES

TERRITORY ABANDONED DURING THE 3RD CENTURY

500 Miles

BLACK SEA

DACIA

PANNONIA II

MOESIA I

DACIA RIPENSIS

⑨

Split

PRAEVALITANA

DARDANIA

DACIA MEDITERRANEA

MOESIA II

THRACE

THRACIA

HAEMI-MONTUS

RHODOPE

EUROPA

Constantinople

⑪

Adamklissi

Silistra

SCYTHIA

PAPHLAGONIA

HELENO-PONTUS

HONORIAS

BITHYNIA

PONTUS

GALATIA I

ARMENIA I

PONTUS POLEMONIACUS

REGNUM

ARMENIAE

⑬

ARZANENE

EPIRUS NOVA

MACEDONIA

Thessalonika

EPIRUS VETUS

THESSALIA

⑩

HELLESPONTUS

ASIA

PHRYGIA I

PHRYGIA II

GALATIA II

CAPPADOCIA I

CAPPADOCIA II

ARMENIA II

Tigris

MESOPOTAMIA

OSRHOENE

Dura Europos

Euphrates

ACHAIA

Athens

Maeander

Ephesus

Aphrodisias

CARIA

PISIDIA

PAMPHYLIA

LYCAONIA

ISAURIA

CILICIA II

CILICIA I

SYRIA I

Antioch

SYRIA II

Apamea

Palmyra

LYCIA

⑫

CYPRUS

PHOENICIA

PHOENICIA LIBANENSIS

Tyre

PALAESTINA II

ARABIA

⑭

ISLANDS

CRETA

Jerusalem

Dead Sea

PALAESTINA I

Cyrene

LIBYA SUPERIOR

LIBYA INFERIOR

Alexandria

AEGYPTUS

AUGUSTAMNICA

PALAESTINA III

O R I E N S

EGYPT

ARCADIA

Nile

RED SEA

⑮

THEBAIS

Luxor

Vistula

Varta

Tisza

Mures

Danube

Dniester

Prut

Siret

Olt

Bug

Vardar

VALERIA

THIS, THE SEVENTEENTH VOLUME OF 'THE ARTS OF MANKIND' SERIES, EDITED BY ANDRÉ MALRAUX AND ANDRÉ PARROT, HAS BEEN PRODUCED UNDER THE SUPERVISION OF ALBERT BEURET, EDITOR-IN-CHARGE OF THE SERIES, ASSISTED BY JACQUELINE BLANCHARD. THE BOOK WAS DESIGNED BY ROGER PARRY, ASSISTED BY JEAN-LUC HERMAN. THE TEXT WAS FILMSET BY FILMTYPE SERVICES LTD., SCARBOROUGH. THE TEXT AND THE BLACK-AND-WHITE PLATES WERE PRINTED BY LES ÉTABLISSEMENTS BRAUN ET CIE, MULHOUSE-DORNACH; PLATES IN COLOUR BY DRAEGER FRÈRES, MONTROUGE; PLANS AND MAPS BY GEORGES LANG, PARIS. THE BINDING, DESIGNED BY MASSIN, WAS EXECUTED BY BABOUOT, GENTILLY.